SIMON SCHAMA

The Story of the Jews

Finding the Words
1000 BCE – 1492 CE

THE BODLEY HEAD
LONDON

Published by The Bodley Head 2013

2 4 6 8 10 9 7 5 3 1

Grateful acknowledgement is made to: Princeton University Press for permission to excerpt
from *The Dream of the Poem: Hebrew Poetry From Muslim and Christian Spain 950–1492* by Peter Cole;
Gefen Publishing House for permission to excerpt from *Grand Things to Write a Poem On: A Verse
Autobiography of Shmuel Hanagid* by Hillel Halkin; Schocken Books for permission to excerpt from
Yehuda Halevi, by Hillel Halkin; The University of Alabama Press for permission to excerpt from
Jewish Prince in Moslem Spain: Selected Poems of Samuel Ibn Nagrela, trans. Leon J. Weinberger;
Oxford University Press, Inc. for permission to excerpt from *Wine, Women and Death:
Medieval Hebrew Poems on the Good Life*, by Raymond P. Scheindlin.

First published in Great Britain in 2013 by
The Bodley Head
Random House, 20 Vauxhall Bridge Road,
London SW1V 2SA

www.bodleyhead.co.uk
www.vintage-books.co.uk

Addresses for companies within The Random House Group Limited can be found at:
www.randomhouse.co.uk/offices.htm

The Random House Group Limited Reg. No. 954009

A CIP catalogue record for this book
is available from the British Library

ISBN 9781847921321 (Hardback)
ISBN 9781847921338 (Trade Paperback)

The Random House Group Limited supports the Forest Stewardship Council® (FSC®),
the leading international forest-certification organisation. Our books carrying the FSC label are
printed on FSC®-certified paper. FSC is the only forest-certification scheme supported by the
leading environmental organisations, including Greenpeace. Our paper procurement policy can be
found at www.randomhouse.co.uk/environment

Set in Dante 11.5/14 pt
Typeset by Palimpsest Book Production Limited, Falkirk, Stirlingshire
Printed and bound in Great Britain by
Clays Ltd, St Ives PLC

For Chaya and Avraham Osea
in loving memory

All the rivers run into the sea; yet the sea is not full; unto the place from whence the rivers come, thither they return again.

<div align="right">Ecclesiastes 1:7</div>

CONTENTS

M A P S

FOREWORD

I can't say I wasn't warned. '*My sonne*', the wintry-wise preacher of *Ecclesiastes* admonishes, '*of making many bookes there is no end and much studie is a wearinesse of the flesh*'. Anyone venturing into Jewish history has to be dauntingly aware of the immense mountain ranges of multi-volume scholarship towering behind him. Nonetheless, forty years ago, I agreed to complete a history of the Jews left unfinished at the death of one of those scholars, Cecil Roth, whose entire life had been devoted to that subject. At the time, I was at work on a book on the Rothschilds and Palestine. Together with a friend and colleague at Cambridge University, Nicholas de Lange, a scholar of Jewish philosophy in late antiquity and Amos Oz's translator, I had been educating myself at the students' expense in post-biblical history through an informal seminar held in my rooms at Christ's College. For a couple of hours after supper, the sages, false messiahs, poets and rabble-rousers came into our little company as we cracked walnuts and jokes, and drank wine and the brimming cup of Jewish words.

But Nicholas and I had brought the gatherings together for a serious reason. Outside of rabbinics there seemed to us no other place for history or literature students to meet and discuss Jewish culture, and that itself was a sign of how separate the subject had become from the academic mainstream. By the time the invitation to complete the Roth volume came along, there were other pressing reasons to want to make a connection between the history of the Jews and everyone else. It was 1973. The Yom Kippur Arab–Israeli War had just taken place. Despite another Israeli military success, the mood was as sober as it had been euphoric seven years earlier, after the Six Day War. This last conflict had been a close-run thing, especially during the bold Egyptian

advance over the Suez Canal and into Sinai. The sands were shifting; something which had seemed secure no longer was. The years which followed saw Jewish history at both ends of its multi-millennia chronology become fiercely self-critical of triumphalism. Biblical archaeology took a radically sceptical turn. Painful truths began to air about what exactly had happened between Jews and Palestinians in 1948. The realities of prolonged occupation, and eventually of facing the first intifada, sank in. It became impossible to talk to non-Jews about Jewish history without the subject being swamped by the Israeli–Palestinian conflict. Over everything else, understandably, the crematoria smoke still hung its tragic pall. The unparalleled magnitude of that catastrophe seemed to demand silence before its enormity, both from Jews and Gentiles.

But, whatever the cost of breaking it, silence is not a historian's option. I believed that by writing a post-medieval history for a general readership, one that gave full weight to shared experience, not all of which was invariably a story of persecution and massacre, I could act as an interlocutor, persuading readers (and makers of history syllabuses) that no history, wherever and whenever its principal focus of study, was complete without the Jewish story, and that there was a lot more to it than pogroms and rabbinics, a chronicle peopled by ancient victims and modern conquerors.

This was the instinct I'd grown up with. My father was obsessed in equal measure with Jewish and British history, and assumed the fit between them. He would take the tiller at the back of a little boat on the Thames, puttering along between Datchet and Old Windsor, with some strawberries, scones and a pot of jam in a basket, and talk of Disraeli one minute as though he had known him personally ('*Baptised? What difference did that make?*') and the next of the seventeenth-century false messiah Shabbetai Zevi through whom my dad (and the ancestral Schamas) had *obviously* seen. ('*What a momser!* [bastard]') Or who'd got their Jews right? Walter Scott or George Eliot, the caricaturing Dickens of *Oliver Twist* or the sentimental Dickens of *Our Mutual Friend*? We would moor under the willows to wrestle with the pain of Shylock. It was from my parents, too, that I inherited the sense that the Old Testament was the first written history of all, that for all the poetic excesses of miracles, it was the scroll of enslavements and liberations, of royal hubris and filial rebellions, of sieges

and annihilations, of lawgiving and lawbreaking: the template on which every other subsequent history would be laid. If my dad had written it, his history would have been called 'From Moses to Magna Carta'. But he didn't.

And neither did I, not in 1973. I tried, following on from Cecil Roth's narrative, but for whatever reasons the graft wouldn't take. And then I went on forty years of wandering, not exactly in the wilderness but to parts remote from my Jewish background, to Holland and South Carolina, Skara Brae and Jacobin Paris. But through all that time, the lines of the story I might have told stayed dimly present in my thoughts and memories, like relatives tugging gently but insistently at my sleeve at family weddings or funerals (which sometimes they did). Never underestimate the power of a Jewish auntie much less the silent, patient reproach of a mother.

So in 2009, when Adam Kemp of the BBC arranged a meeting to talk about an idea for a new television documentary series 'which you'll either love or hate', I knew, somehow, before it was out of his mouth just what was in the offing. There was, I admit, a fleeting Jonah moment. A voice inside me said, 'Flee to Joppa, book berth on first ship leaving for Tarshish.' But then what good had it done him? So I took hold of the project abandoned all those decades before, with every kind of gratitude and trepidation. This time, the story would have the persuasive power of television behind it, and through the two media – writing and filming – organically interconnected but not identical, I hoped to build exactly that bridge between Jewish and non-Jewish audiences which somehow seemed to elude me forty years earlier.

For all the immeasurable challenges (three millennia of history in five hours of television and two books), this has been, and still is, a great labour of love. However unequal to the task of telling this story, it's one I rejoice to be narrating, not least because the source materials, visual as well as textual, have been so transformed over the past few decades. Archaeological finds, especially inscriptions from the biblical period, have given a fresh impression of how that text, which would become the heritage of a large part of the world, came into being. Mosaics have been uncovered from one end of the Jewish world to the other that radically alter not just our sense of what a synagogue and Jewish worship was, but how much of that religion was shared

in its forms with paganism and early Christianity. Without forcing the narrative into feel-good pieties, and without downplaying the many sorrows that have spotted the story with tears, the history that unfolds is one of the heroism of everyday life as much as that of the grand tragedies. This book and the television films are full of such little revelations that add up to a culture, the prosaic along with the poetic: a doodle on a child's Hebrew exercise page from medieval Cairo; battling cats and mice on a sumptuously illustrated Bible from Spain; the touchingly meagre dowry of an Egyptian slave girl from the fifth century BCE married to a local Jewish temple official; the aggravation of an NCO sweating it out on a hilltop fort while the Babylonians are closing in; the plangent lines of the priestly benediction engraved in archaic Hebrew on a tiny silver amulet from the reign of King Josiah.

This is the small stuff of common experience. But the Jewish story has been anything but commonplace. What the Jews have lived through, and somehow survived to tell the tale, has been the most intense version known to human history of adversities endured by other peoples as well; of a culture perennially resisting its annihilation, of remaking homes and habitats, writing the prose and the poetry of life, through a succession of uprootings and assaults. It is what makes this story at once particular and universal, the shared inheritance of Jews and non-Jews alike, an account of our common humanity. In all its splendour and wretchedness, repeated tribulation and infinite creativity, the tale set out in the pages which follow remains, in so many ways, one of the world's great wonders.

PART ONE

papyrus, potsherd, parchment

I

IN EGYPT

In the beginning – not the imagined beginning of patriarchs and prophets, and certainly not the beginning of the whole universe, just the documented beginning of ordinary Jews – in *that* beginning, a father and mother were worrying about their son.

This son, a soldier boy, was called Shelomam, an Aramaic version of my Hebrew name, Shelomo. His father's name was Osea, which was the middle name of my own *aba*.[1] The time was two and a half millennia ago, in 475 BCE, the tenth year of the reign of Xerxes, the Achaemenid king of Persia who, though much bloodied in Greece, was still ruler in Egypt, where Shelomam and Osea lived. Xerxes had another decade on the throne before being murdered by his most trusted officer, Artabanus the Hyrcanian, who did the deed in cahoots with a helpful eunuch. Jesus of Nazareth would not be born for half a millennium. If the several writers of the Hebrew Bible are to be believed, it had been around eight hundred years since Moses had led the enslaved Israelites from Egypt into the desert mountains where, in possession of the laws given directly by Yahweh – indeed written with His very finger – they turned, despite recurring flings with idolatry and a yen for many other gods, into something resembling Jews.

The exodus from the flood valley of the Nile, the end of foreign enslavement, was presented by the Bible writers as the condition of becoming fully Israelite. They imagined the journey as an ascent, both topographical and moral. It was on the stony high places, way stations to heaven, that YHWH – as Yahweh is written – had revealed Himself (or at least His back), making Moses' face hot and shiny with reflected radiance. From the beginning (whether in the biblical or archaeo-logical version), Jews were made in hill country. In Hebrew, emigrating

to Israel is still *aliyah*, a going up. Jerusalem was unimaginable on the low fluvial plain. Rivers were murky with temptation; the sea was even worse, brimming with scaly monsters. Those who dwelled by its shores or shipped around upon its waves (like the Phoenicians or the Greeks) were to be detested as shifty, idolatrous and unclean. To go back to *Egypt* then, in the eyes of those for whom the exodus was the proper start of everything Jewish, was a fall, a descent to brazen idolatry. The prophets Ezekiel and Jeremiah – the latter even when he had gone to Egypt himself – had warned against this relapse, this un-Jewing. Those who fully succumbed, Jeremiah warned, would become 'an execration and an astonishment, a curse and a reproach'.

Heedless, the Israelites not for the first or last time disobeyed, trotting back to Egypt in droves. Why not, when the northern kingdom of Israel had been smashed by the Assyrians in 721 BCE, and a century later the kingdom of Judah was likewise pulverised by the Babylonians? All these misfortunes could, and were, interpreted by the writers of the Bible narratives as YHWH's chastisement of back-sliding. But those on the receiving end could be forgiven for thinking: much good He has done us. Some 30,000 rams and ewes sacrificed for Passover in the Temple by King Josiah; a mass rending of raiment in contrite penitence for flirting with false gods; no help at all in fending off whichever hellish conquerors came out of Mesopotamia with their ringlets and their panthers and their numberless ranks of archers and javelin-men.

So the Israelites went down from their lion-coloured Judaean hills to the flood country of Egypt, to Tahpanhes on the delta, and Memphis halfway south, and especially to Pathros, the south country. When the Persians arrived in 525 BCE, they treated the Israelites not as slaves but often as slave owners, and above all as tough professional soldiers who could be depended on, as much as Arameans, Caspians or Carian Greeks from the western Anatolian littoral, to suppress Egyptian uprisings against Persia. They would also police the turbulent southern frontier where Nubian Africa began.

Shelomam, Osea's boy, was one of these young men, a mercenary – it was a living – who had been posted south all the way to the garrison of the Hayla hayahudaya, the Judaean Troop, on the island of Elephantine, just downstream from the first cataract of the Nile. Perhaps he had been assigned to caravan convoy, guarding the tribute

of elephant tusks, ebony and Ethiopian boys that had been the pharaoh's due from Nubia and was now sent to the Persian governor in his place.

The father, Osea, was writing from Migdol, probably located on the eastern branch of the Nile delta, where Shelomam had previously been stationed. His letter, sent five hundred river miles south to await the soldier boy's arrival on Elephantine, was written in Aramaic, the daily tongue of the region and the entire empire, on the pressed-reed writing surface of papyrus. Patched together though this particular piece was, papyrus degrades very slowly. If kept from light, the ink remains dark and sharp. The square-form script, the same elegant style in which Hebrew would be written from the time of the Second Temple to our own, is still crisply legible. In Jewish memory it is as though Osea had written just yesterday. A worried father is a worried father. He can't help letting the boy know how he feels, right away, at the top of the letter: 'Well-being and strength I send you but from the day you went on your way, my heart, it's not so good.' And then, the inevitable clincher, the three words Shelomam must have known were coming, even without Osea having to write them, the phrase all Jewish boys hear at some point; the phrase from which history unfolds: 'Likewise your mother.'

A classic pre-emptive strike. My own father, Arthur Osea, was known to resort to it shamelessly when, as in the case of Egyptian Osea, he was on the back foot, worrying that the news which followed might not make his son altogether happy. 'Don't worry . . . your mother's a bit upset about this but . . .' Now what might get his pride and joy, his Shelomam, all bent out of shape? Trouble with pay and kit? Oh, don't get in a snit. 'That tunic and the garment you wrote about, they're made, all right? Don't get angry with me because I couldn't bring them to Memphis in time (for your journey south). I'll bring them so you have them on your way back.' The pay? Yes, well, bit of a problem there, my boy. 'When you left Migdol, they wouldn't send us your money.' Worse, when Osea made enquiries about the back pay owing, he got the brush-off default mode for the minions of empires. Tremendously sorry, actually not my department, you see, but please *do* by all means forward your complaint to the appropriate officials. 'When you come back to Egypt, give them what for and they'll give you your pay.' So listen, my son, Osea goes on, brushing

off any notion that he'd failed his boy in the crucial matter of the kit: 'don't cry. Be a man . . . Your mother, the children, everyone's well.'

It would be good to know in more detail how Shelomam lived in the frontier world of Jewish soldiers on Elephantine, but the letter stayed there, so perhaps he never made it to Elephantine, never got his tunic or his pay. Or perhaps he did, and left the note behind. At any rate, there it remained for two and a half millennia until an American amateur Egyptologist and ex-journalist for the *New York Herald Tribune*, Charles Edwin Wilbour, bought clay pots full of papyri from women digging for *sebagh* fertiliser on the island mounds in 1893. 'All these pap. from Kom shown me by three separate women at different times,' Wilbour wrote in his diary. But once he saw the papyri were Aramaic, and twenty-seventh dynasty, he lost interest. Grander, older, pharaonic antiquities were his game.

Twenty years before, he had left Manhattan in a hurry when his crony, the king of city graft Boss Tweed, who had put some nice contracts Wilbour's way for his paper business, had been booted out of town. In Paris, ancient Egypt gave Wilbour a new life, its stupendous history learned from the eminent scholar Gaston Maspero. He rigged out a *dahabiyeh* so that he and his wife, Charlotte Beebee, an ardent suffragist, could sail the Nile with all conveniences, stopping by to help with digs in Karnak, Luxor, Thebes. High-domed Germans, French and British Egyptologists found his Yankee enthusiasm entertaining, sometimes even useful. Occasionally Wilbour would go and see Flinders Petrie in his rude tent and thought the British archaeologist ostentatiously spartan for camping like an Arab.

Sporting a prophetic beard, Wilbour made the Nile his living room for nearly two decades. When, near the end of that time, he stood on the mounds of Elephantine amid the grubbing women, he knew that the *sebagh* they were after for their crops was the pulverised debris of ancient mud bricks, with enough hay and stubble mixed in to give it nitrous potency. But he was certainly unaware that somewhere beneath his feet was a decomposed Jewish city, the first we can reconstruct in the thrumming drone of its daily business: its property-line disputes over rooms and houses, exits and access; its marriages and divorces; its wills and prenups; its food and its dress; its oaths and its blessings. Oblivious to all this, Wilbour took the

papyri, neatly folded and bound, addressees on the outside as they had been in the fifth and fourth centuries BCE, to the Paris lodging where he expired in 1896.

Ten years later more extensive troves were found by German expeditions who picked at their content, took them to Berlin and Paris, and published a little more. Needless to say the British, whose pith-helmeted dominion Egypt had become, were not far behind. Papyri and inscribed clay potsherds – ostraca – duly ended up in the usual destinations – Oxford and the British Museum – and when the archaeological proconsuls chose to be grandly magnanimous, in Cairo. Some papyri were published in the early twentieth century but it was when the papyrus hoard passed to the Brooklyn Museum that the curtain truly rose on the marvel of Jewish Elephantine.

Fragmentary letters and inscriptions written on pottery shards in classical, linear Hebrew (from three and two centuries earlier than the Elephantine papyri) survive – Judaean shouts and cries half lost in the gusting wind of time: a farm worker whose garment has been nabbed by an unscrupulous creditor; a beleaguered quartermaster facing the oncoming horde of the Babylonians, urgently needing oil and grain; a junior officer in another citadel, peering in vain for the beacon warning flares of neighbouring hill forts.

And the Hebrew Bible? Unless we suppose (along with the ultra-Orthodox Jews and Christians) that it is the directly dictated word of God to Moses and the prophets, much of the stupendous poetic narrative of the scripture is no more than what another archaeologist has characterised as an 'echo' of the historical truth. And sometimes, as with the entirely undocumented exodus story, written nearly half a millennium after it was supposed to have happened, it is probably not even that. There is a point in the epic where the storyline and the reality of Jewish history do indeed converge, but the Hebrew Bible is the imprint of the Jewish mind, the picture of its imagined origins and ancestry; it is the epic of the YHWH treaty-covenant with Israel, the single formless God moving through history, as well as the original treasure of its spiritual imagination.

The tawny papyri of Elephantine, with their neat, black scribal hand, give us something entirely different, something more earthily human and mundane: the quotidian record of the lives of the expat Judaeans and Israelites with whom we can keep company as naturally

and materially as if we were living in their neighbourhood: tough guys, anxious mothers, slave-girl wives, kibitzers and quibblers, hagglers over property lines, drafters of prenups, scribes, temple officials, jailbait indignant that they were set up for a fall, big shots and small fry. We know their names, such unapologetically Jewish names ending in the theophoric 'yah' that embedded YHWH in their identity even as it claimed His protection for their lives: Berechiah, Ananiah, Delaiah, Mahseiah, Shemaiah, Gedaliah, Jedaniah, Mibtahiah, Pelaliah, Malchiah, Uriah, Jezaniah, Gemariah, Azariah, Zechariah.

There they all were, the people of YHWH, jostled together on the club-shaped little island in the Nile. Not a home for lotus-eaters, perhaps, but all things considered, not such a bad place: shady in the slamming heat; famous for the fig trees that never dropped their foliage; the peculiar dom-nut palms with their topknot of sprouting leaves, found only in the south country of the Nile; rushes fringing the shoreline; acacia, cassia and mulberry inland a little – a tight clump of green at the point where the cultivable floodplain on the west bank of the river had receded to a thin ribbon below the golden dunes. On the east bank, still more arid, rose the quarries of Syene, beneath which a camp of Arameans, both soldiers and stone labourers, were housed. Slabs of local grey granite, freckled with rose pink or blood red, were laboriously loaded onto boats and barges and sent downstream for the master builders to make temples and mausoleums, as if the Egyptian lords were still pharaonic masters and not, since the conquest by Cambyses in the late sixth century BCE, the subjugated creatures of Persian whim. One such slab was so enormous that an entire royal shrine could be made from it – or so Herodotus (who could be guilty of exaggeration) tells us. The same slab, he insists, was so imposing that it took three years and the haulage of two thousand men to reach its downstream destination at Sais in the western delta.

Elephantine – 'Yeb' to the locals, from the Egyptian *Iebw* meaning 'place of elephants' (though no one, not even Herodotus, knew quite why, although the bald, rounded pale grey rocks in the river certainly suggest the domes of wallowing pachyderms) – was famous as the last place of true Egypt, the edge of its civilisation before it evaporated into Nubian sand and rock. It was where the lethargically oozy river, carrying its cargo of fertilising sludge, suddenly underwent a

radical change of personality, running mad over the granite outcrops that sped boats towards the cataract. Only the 'Boatmen of the Rough Waters', neighbours of the Jews whose manners were notoriously as rude as the churning river, were capable of riding its furies, navigating the upstream whitewater with the help of ropes hooked to the sides of the overhanging rocks. The geographer Strabo – every Greek traveller worth his salt came to fifth-century BCE Elephantine – has them doing water stunts to impress the tourists. The spumy torrent held mysteries: the quick of Egyptian life. For between the twin hills of Crophi and Mophi that rose from the banks, or so Herodotus claimed an Egyptian priest had told him, was the wellspring of the Nile so unfathomable none could sound its bed. Pharaoh Psamtik I had tried not that much before to plumb the depth with a twisted cable a thousand fathoms long, and still touched nothing but its swirling waters. That pull beneath the surface was the fluvial valve that divided the torrent, sending half south to burning Nubia, and half north to feed the flood valley. The ram-headed god Khnum was worshipped in Elephantine, since it was he who assured the annual inundation without which local cultivators were condemned to famine. The sacred rams of Khnum have their own special mausoleum on the island, their mummies reposing where the sculptors enjoyed themselves fashioning fat and fleecy animals from the limestone. A Nilometer positioned at steps leading to the bank measured the constancy of Khnum's benevolence.

As well as myths and rites, men, money and arms flowed with the river to the island fortress. Together with Syene, it had been the sentinel of the south country, the pressure valve of classical Egypt. It needed maintaining, watching, policing – but what kind of job was that for Judaeans? What were they doing there? Had they been deaf to the warnings of Jeremiah? But few of the books of the prophets had yet been written, and fewer still disseminated, by the time that Israelites and Judaeans, from north and south of Palestine, journeyed down once more to the Nile Valley probably sometime in the late seventh century BCE.

Jewish identity would eventually be formed somewhere between the two cultural poles of the Nile and the Euphrates, but the magnetic needle of attraction and repulsion swung unevenly. Bible writing

happened in Judaea and in Babylon, not in Egypt. In the mind and
the writings of the Hebrew sages, scribes and the prophets – all those
who, between the seventh and the fifth centuries BCE, were antholo-
gising and redacting the memories, oral traditions, folklore and writ-
ings that would eventually be turned into the canonical Bible – there
was a good migration (Mesopotamia) and a bad (Egypt). Both were
captivities by the despotisms of the waterlands: both supporting
teeming urban populations from the plains irrigated with flooding
rivers; both generating grain and fruit from the alluvium. Both city
states were enriched and ordered by hieroglyphs and lettered-writing,
laws and epics, pyramids and ziggurats. Although both were brutal
annihilators, both in the grip of sacrificial cults (Marduk and Ra) and
both equally in thrall to voracious idolatry, the land between the Tigris
and the Euphrates never figured quite as demonically in the proto-
Jewish mind as the Nile Valley. If there was one thing that Egyptian
memorialists and the Hebrew Bible writers agreed on, it was the
difficulty of living Jewish in Egypt.

To live in Egypt was to live uncleanly, or to be in bondage – so the
writers of Genesis and Exodus pictured it. In Deuteronomy, the book
that more than any other defined the obligations of Jewish memory,
God is defined as He had been in Exodus as He 'who brought you
forth *out* of the Land of Egypt'. This was most likely written some-
time around the seventh and sixth centuries BCE, precisely at the
moment when Jews went back there. To the 'Deuteronomists', who
also reworked oral history into the narrative of Judges and Kings, any
such return would be a disgraceful violation of the covenant.

Exile in Babylon after the sack of Jerusalem in the sixth century
BCE, on the other hand, was in some mysterious, punitive way, known
to the God who had ordained it, as a *return* to the well-head: the
source of the covenant-urge. The writers of Genesis, chronicling
Abraham's journey towards a visionary communion with YHWH,
and the origination of the idea of a separate people under His special
guidance and protection, set the place of Abraham's birth as Chaldea,
Mesopotamia. So the *ur*-cradle of monotheism was Ur, the city state.
This is what gave special meaning to the destruction of the polluted
Jerusalem Temple by Babylonians led by Nebuchadnezzar in 587 BCE.
The people from whom the Israelites had first departed to make
their way in history were now made the instrument of YHWH's

manner of reconnecting them with that original covenant. Babylon obliterated the Temple. From Babylon – or its Persian successor empire – would come its purified restoration, when, after half a century of exile, the Persian king Cyrus decreed they be allowed to return to Jerusalem.

In the Bible-writing mind, Babylonia–Persia had been co-opted as the instrument of divine will. Egypt was always the obstinate enemy of YHWH's plans for history. This feeling of perennial irreconcilability may have been mutual. The very first time that 'Israel' appears on any historical artefact is on the famous late-thirteenth-century BCE triumphal inscription of Pharaoh Merneptah, son of Rameses II, the latter traditionally identified with the 'stiff-necked' pharaoh of the exodus. 'Israel is laid waste,' it says, 'its seed is no more,' the hieroglyph leaving no doubt that by Israel is meant a people rather than a place. The history of Egypt by the priest-grammarian Manetho (written in the third or second century BCE and known to us through the work of the Romano-Jewish historian Flavius Josephus in the first century CE) chronicles a departure of the Israelites from Egypt – but as an expulsion of an unclean pariah population of slaves and perhaps banditti, not the victorious exodus of the YHWH-protected Children of God.

In this sense, the liberation epic of the Torah (the five books of Moses that begin the Bible) was a reversal of that indignity – the identity of Israel established not just as a separation from Egyptian bondage, but as a reversal of Egypt's triumphant master-narrative. Babylon might destroy Jerusalem and the Temple, but it would not wipe out the faith; the divine plan for exile might even sustain it. Egypt was another matter entirely – to go back, as Jeremiah warned when he was taken there, was to court perdition, spiritual as well as physical. Never return to the Nile.

But Jews did just that, over and over again, so often and so incorrigibly that it is difficult to think of Jewish history as in any way separable from Egypt. Egypt was the ultimate Them; but Egypt has also been, generation after generation, unmistakably Us. The most Jewish of all names, that of Moses the deliverer, in whose epic a nation was first defined, was probably Egyptian. Never mind that one of King Solomon's wives was the daughter of a pharaoh. 'Go not into Egypt for horses,' Isaiah warned King Hezekiah of Judah, because he knew

that for centuries the Israelites and Judahites had been doing exactly that, buying stud for the great stables in north Palestine.

Whatever the risks, when the Assyrians had embarked on devastating conquests out of Mesopotamia in the late eighth century BCE, the Egyptian connection became critical for survival for the kings and peoples of both Israel and Judah. The last kings of Israel at that time, their capital in Samaria, made a tactical Egyptian alliance (although it was in the end no impediment to their destruction; probably the reverse). Trapped in Jerusalem by Sennacherib's besieging Assyrian army in the closing years of the eighth century BCE, King Hezekiah built the subterranean water tunnels that might make the difference between capitulation and survival, but still needed help from Egypt.

What happened when Sennacherib's huge army surrounded Jerusalem in 715 BCE is one of the great mysteries. The Bible and Herodotus tell us that the Assyrian army fell to some unidentifiable plague (Herodotus picturesquely claims an army of mice nibbled through the bowstrings of their archers). Sennacherib's own triumphal inscription brags of all the Judaean towns destroyed and looted by his army, and of locking up Hezekiah within his royal citadel 'like a bird in a cage', but concedes he failed to vanquish him. Most startling of all – but historically plausible – is the claim in Egyptian sources that it was an army under the Nubian pharaoh of the twenty-fifth dynasty that broke the Assyrian siege and preserved both the Kingdom of Judah and its capital, Jerusalem. Egypt had become the rescuer of Judah.

During the two centuries that followed – the epoch when the Bible began to be written – Judah played off Mesopotamians and Egyptians against each other. The turning point for the re-establishment of Jews in Egypt came after Nebuchadnezzar's first siege of Jerusalem in 597 BCE, when many of the elite of Judah – priests, nobles, scribes – were deported to the Euphrates, leaving common folk – farmers, shepherds, artisans – to fend for themselves. Ten years later, the Babylonians delivered the *coup de grâce*, destroying Jerusalem and Solomon's Temple and inflicting terrible devastation on the Judaean countryside. Many of those who chose not to stay amid the ashes and the rubble migrated south to what were already well-established colonies of Jews at Tahpanhes, Memphis, and what Jeremiah called Pathros, the south province, whose capital was at Elephantine.

Aware that Jews had gone back to escape the hardship, famine and terror visited on Judaea, Jeremiah went to Egypt to warn against false hopes of sanctuary: 'it shall come to pass that the sword which you feared shall overtake you there in the land of Egypt and the famine thereof ye were afraid shall follow close after you there in Egypt and there you shall die'. The deliriously fulminating prophet Ezekiel, writing from a Babylonian work camp by the Chebar canal, was if anything even more ferocious in his warnings. Channelling the voice of YHWH, he addressed Pharaoh directly:

I am against thee, Pharaoh king of Egypt, the great dragon that lieth in the midst of his rivers, which hath said, My river is mine own, and I have made it for myself. But I will put hooks in thy jaws, and I will cause the fish of thy rivers to stick unto thy scales and I will bring thee up out of the midst of thy rivers . . . And I will leave thee thrown into the wilderness . . . I have given thee for meat for the beasts of the fields . . . and I will make the land of Egypt utterly waste and desolate, from Migdol to Syene even unto the border of Nubia. No foot of man shall pass through it, nor foot of beast shall pass through it, neither shall it be inhabited forty years.

Even more than Jeremiah, Ezekiel, notwithstanding his Babylonian address, seemed to know exactly where the Jews had settled after the destruction of Jerusalem, specifically in 'the land of Pathros' which would be, the prophet warned again in the voice of YHWH, 'the basest of kingdoms'. But the Jews of the south country did not waste away in a land doomed to forty years of desolation; on the contrary, they prospered. So that by the time of the Persian conquest in 515 BCE, led by Cyrus' son Cambyses, the military Jews of Elephantine were in a position to do something extraordinary: they built a temple, a House of YHWH, or in Aramaic, 'Yahu', the deity they called the God of Heaven. This they did in spite of the explicit and strict prohibition (recorded in Kings and Chronicles, and laid down not once but twice, first in the reign of Hezekiah and then again in the reforming reign of Josiah at the end of the seventh century BCE) that there must be no temples outside Jerusalem.

What was more, the Elephantine Temple for the Jewish soldiers and their families, and the whole buzzing community around them,

was no hole-in-the-corner provincial affair. Modelled either on what had been known of the First Temple from the Bible of the original Sanctuary, its five stone gates opened onto a spacious courtyard with a holy dwelling place at the centre for Ark and Torah. The door of the inner sanctum had bronze hinges, there was a cedar roof and gold and silver vessels within.[2] Worse still, in flagrant violation of the biblical prohibitions, it regularly made animal sacrifices along with offerings of grain and incense, for this was, after all, the dwelling place of YHWH and (almost as if he were another local deity) his needs had to be provided for.[3] So there was much sprinkling of blood and curling of smoke for the 'burnt offerings', usually of sheep and lambs – which, given the prominence of the cult of the ram-god Khnum in the Egyptian Temple just the other side of the 'Street of the King', was dangerously tactless. It ought to have been an outrage to the restored authorities in Jerusalem: the priests and the scribes and the writers of the prophetic books. But the Elephantine Jews took unrepentant pride in *their* temple, which they describe as having been so important that when Cambyses destroyed those of the Egyptians, he made sure to preserve the House of YHWH.

The existence of a temple of YHWH in Upper Egypt means one of two things for our understanding of what Jews were like at this embryonic moment in their collective existence. Either they were pre-biblical, aware only of some of the legal codes of the Torah and some of the elements of the founding epic, but had not yet taken in Deuteronomy, the book written two centuries earlier, ostensibly the 120-year-old dying Moses' spoken legacy to the Israelites, which codified more rigorously the much looser and often contradictory injunctions of Leviticus. Or the Elephantine Jews *did* have the Mosaic strictures of Deuteronomy, and perhaps even knew all about the reforms of kings Hezekiah and his great-grandson Josiah making the Jerusalem Temple the sole place of sacrificial ritual and pilgrimage, but had no intention of surrendering to its monopoly. The Elephantine Yahudim were Yahwists who were not going to be held to the letter of observance laid down by Jerusalemites any more than, say, the vast majority of Jews now who believe themselves to be, in their way, observant, will accept instruction on what it means to be Jewish (or worse, who is and who isn't a Jew) from the ultra-Orthodox.

It is even possible that the priests, elders and officials who looked after the Elephantine Temple, and were the elite on the island, may have believed their sanctuary to be *more* faithful to the Solomonic original than the modestly rebuilt structure in Jerusalem (only completed in 515 BCE). Some of them may have come to Egypt in the seventh century BCE in hostile reaction to King Manasseh's reversion to polytheism and built a structure modelled on the style and proportions of the tabernacle sanctuary described in the Bible.[4] As in Palestine, synagogues, places of prayer assembly, were as yet unknown. A temple would be the sole monumental focus of the community, the built expression of their particular religion. It seems likely that at the centre of it was a free-standing cultic pillar, a *massebah* very much like the one that stood in another fortress sanctuary, that of Arad at the northern end of the Negev Desert. There might well have been a horned stone sacrificial table, also standard to the temple shrines outside Jerusalem.

Even so, as a Jewish mother understandably asked of her son, the curator of the Brooklyn Museum's show about the Wilbour papyri some years ago, were these Egyptian, pre-biblical, much-travelled Jews '*really* Jewish?' Their names – the Zechariahs, Gemariahs, Jedaniahs, Haggais, Mahseiahs and Mibtahiahs – unmistakably proclaimed them Yahudim, and naming was no light matter in the ancient world. They had the lunar calendar of their fathers, with all its beautiful names (Marcheshvan, Kislev, Tishri, Nissan), the year divided in time for them as it still is for Jews two and a half millennia on. They seem to have circumcised their sons, but then everyone in Egypt did, though not all in infancy, let alone on the eighth day after birth.[5] They blessed and sometimes cursed and took solemn oaths, signed legal contracts and began and ended letters by invoking the 'God of Heaven and Earth': 'I bless you by YHWH', 'May YHWH bless you', 'May YHWH cause you to hear good news every day', 'May YHWH make this day a good one for you'. Although they were occasionally known to invoke Aramean, Phoenician and even Egyptian gods, where perhaps it was expected as a matter of form, it had long been unproblematic in Judaea itself to profess devotion to YHWH as well as the consort commonly believed to be paired with him, Asherah. The strictures of the most exclusivist prophets, like the so-called 'second Isaiah' who added twenty-odd chapters to the book perhaps two centuries after the

original, and who demanded a devotion to 'Yahweh alone', may well not have registered with the Elephantine Jews, whose immigrant-ancestors had come to Egypt still steeped in the traditions and magic of popular Israelite religion.

Although the Sabbath is not mentioned in Deuteronomy (nor for that matter is the Day of Atonement), we know that the Elephantine Jews kept it (or, like the majority of Jews today, knew they were supposed to keep it). There were plenty of Shabbetais in the colony – though some of them may have been Aramean and about the day of rest they may have had the same mixed feelings when it came to business and the conveniences of life that Jerusalemites exhibited when they allowed non-Jewish Tyrian merchants to sell goods on the Sabbath day within and without the city walls. If today Tel Aviv and Jerusalem have strikingly different attitudes to what may and may not be permitted on the Sabbath, Elephantine was bound to have been more like Tel Aviv. But a letter, written on a pottery shard, to one Islah in the town, certainly reveals how steamed up they could get about doing what had to be done before the Sabbath break from work: 'Look, I am sending you vegetables tomorrow. Get there tomorrow [at the dock] before the boat comes in on account of the Sabbath [*bsbh* in Aramaic] so they don't spoil. If you don't I swear on the life of YHWH I will kill you! Don't rely on Meshullemeth or Shemaiah [two Jewish theophoric names again] to take care of it. In return sell the barley for me.' And in case Islah hadn't got the point, a repetition of the threat 'now by the life of YHWH if you don't do this, you will foot the bill'.

Even more clearly than Sabbath observance, it was (and is) the coming together for Passover that made Jews Jews. Elephantine Passovers must have been a little peculiar since their YHWH was defined as the deliverer from Egypt and the exodus as the true moment of separation, of religious and national birth – the necessary condition of receiving the Law that had set Jews apart. But obviously the Jews of Elephantine were not entirely apart, and for sure, they weren't going anywhere, not of their own accord anyway. The earliest Haggadah, the narrative ordering of the Seder ritual at the beginning of Passover, dates from the ninth century CE, so we have no idea what was or was not recited on the Passover eve by Egyptian Jews – at Tahpanhes and Memphis, as well as Elephantine. (The formal Seder 'order' itself was, like so much

else assumed to be immemorial, an institution of the rabbis no earlier than the third century CE, probably in response to the Christian Easter Eucharist, not the model for it.)

The Jerusalem elders of the fifth century BCE, much agitated by 'foreign' contaminations, wanted to put the stamp of their authority on the wayward practices of Jews abroad. Ezra, the 'Scribe of the God of Heaven', was sent west by King Artaxerxes to correct the loose practices of those who had stayed behind in Palestine after the sack of the Temple and who were suspected by Babylonian exiles of impure ways, of relapsing to pagan habits and marrying 'foreigners'. In 419 BCE, one Hananiah, quite possibly a brother or kinsman of the returned governor of Judaea, Nehemiah, wrote a letter to the head of the Jewish community in Elephantine, Jedaniah bar Gemariah, laying down the law for standard Passover observance.[6] He may even have brought the letter to Egypt in person. At some point Hananiah showed up in Elephantine, and with him came trouble.

Not infrequently at such moments of Jewish history, one Jew is to be found telling another Jew how things are supposed to be done. Hananiah makes sure not to repeat the threatening tone of Ezekiel and Jeremiah demanding an exit from the accursed country – what would be the point of that? – but the details of Hananiah's corrections suggest a dim view of the looseness with which the Elephantines celebrated the feast of departure. An earlier pottery shard on which one correspondent asks another 'let me know when you will be celebrating Passover' implies a conveniently movable feast. So Jedaniah is instructed by Hananiah on exactly which day in the month of Nissan the feast begins (the fifteenth), how long it continues, and that the essential thing was to eat exclusively unleavened bread, the matzo. Since the Egyptians of this period were great bread eaters, this would certainly have marked a decisive break from their domestic routine. As for the other staple of their diet, beer, during Passover they were to abstain from 'fermented drink'. Modern observance has made up for that alcohol ban by requiring four cups of wine at the Seder. 'Do not do work on the fifteenth or twenty-first day of Nissan', and 'be pure'. There was nothing impure about sex in the Jewish tradition (unless taking place during menstruation), so this last instruction was either a command to make animal sacrifice in keeping with the purification rituals of the Jerusalem Temple, or else to avoid

absolutely any contact with the dead, which in heavily embalmed Egypt was no small matter. What to do about the *chametz*: those stray crusts, loaves and crumbs, or anything that had made contact with them, so exhaustively eradicated from Orthodox Jewish houses today as Passover approaches? Shockingly to modern guardians of the law, Hananiah ordered that *chametz* be brought *into* Jewish houses, stored in pots and vessels, and sealed up for the duration of the feast! The custom would dismay Talmudically observant modern Jews for whom invisibility is not the point, though the Mishnah (the first written version of the Oral Torah) and Talmud (the immense anthology of commentaries including the Mishnah) allow for the temporary 'sale' of leaven foods and objects to non-Jewish neighbours.

Whether Jedaniah bar Gemariah did as he was told and led the Elephantine Jews to a purer observance of Passover we can't be sure, but Hananiah's mission to impose conformity suggests a high level of anxiety among the Jerusalemites about the wayward customs of the Egyptian Jews. They were not altogether wrong to be suspicious. For in one other crucial respect, the issue that went to the heart of the matter of what it meant to be a Jew – the conditions on which Jews could marry Gentiles – the troop and its hangers-on took a decidedly relaxed view. But then they were encouraged by their Persian masters to make households. Do not imagine a dusty barracks of bachelor grunts, sweating out their time at the end of the world, lost in dirt, drink and boredom. Elephantine was, in its way (like the cosmopolitan garrisons on Hadrian's Wall), a family town, and its Judaean soldiers were supposed to produce boys who in their turn would grow up to serve the *brigade*, the frontier regiment. Beyond the garrison the Jews – temple officials, scribes, merchants, artisans – lived in grey, mud-brick houses, often two storeys, with cooking hearths and stables on the ground floor and surprisingly spacious living quarters above. Their doorways gave on to streets narrower than grandiose names like 'Street of the King' would suggest, but still, excavations since the 1990s have uncovered a real town: flagstone steps lead from one level to the other, high walls, long straight alleys and winding lanes. It takes no imagination at all to wander the streets of Elephantine, hear the gossip and smell the cooking pots. This was not a closed Jewish quarter. Their neighbours were Persians, Caspians and of course Egyptians. And sometimes, as the papyrus

contracts tell us, they married them. It helped if the outsider was brought into the community of YHWH, but even so the Books of Exodus and Deuteronomy took a dim view of the practice ('Neither shalt thou make marriages with them,' Deuteronomy 7:3), as did later books of the Bible and of the Talmud.

But while Judaea was being assaulted by invasions and obliterations, when much of its population was in Babylonia or Egypt, and Palestine itself was a parade ground for marching mercenaries, those who felt themselves charged with the preservation and restoration of the religion of the one God 'of Heaven and Earth' were understandably defensive. The scribes and prophets thought the Judahites and Israelites left behind in the hills and valleys of Palestine especially vulnerable to pagan backsliding. Should they marry 'Edomites' or other doubtful pagans, their resolution to obey the injunctions of the Law might be weakened by their husbands' and wives' notorious attachment to 'abominations'. They might eat the flesh of swine; Egyptian or Phoenician influence might turn YHWH into the crescent moon god; tree pillars might start to appear in their houses and burial caves. They would be no better than the pagan nations. Much of the Book of Ezra, written around the time of Elephantine's flourishing in the mid-fifth century BCE, and more or less contemporary with the events it describes, is devoted to ordering Jerusalemites and Judaeans who had stayed on after the destruction of the Temple and intermarried with locals that they must 'put aside' their foreign wives.

Not so the Elephantines who had an entirely different way, as they saw it, of being good devotees of YHWH. One of their officials, a *lechen* of the Temple of Yahu, Ananiah bar Azariah, thought – or more likely knew – so little of the strict prohibitions laid on the Jerusalemites that he married a teenage Egyptian slave handmaiden, Tapemet, known as Tamet.[7] Tamet, however, was not her husband's own slave. Her left forearm was tattooed with the mark of her owner, Meshullam, another prominent figure in the crowded world of Elephantine. It seems likely that Meshullam had originally acquired Tamet as collateral for a loan of silver pieces he'd made to a Jewish woman, Jehohen. Such human pledges were common and on this one Meshullam, who had been charging 5 per cent on the loan, and who had specified in the loan contract that if arrears went into a second

year he could seize whatever he chose from the woman's possessions, collected.

How Ananiah bar Azariah met his future wife is anyone's guess, so I'll hazard one. Perhaps it was at Meshullam's house when he was visiting, for the two men knew each other well. As far as the slave owner was concerned it would have been Ananiah's business whether he wanted the Egyptian girl as his concubine and even, as happened, when she bore him the boy child Pilti. For his part Ananiah could have left it at that: an occasionally visiting father. But he didn't; instead, in 449 BCE he married Tamet the Egyptian. 'She is my wife and I am her husband from this day and forever' the legal 'document of wife-hood' reads. Whatever the affection that moved the freeman Ananiah to wed the slave girl they were certainly uncomplicated by anything mercenary. All that Tamet brought to the marriage as her dowry was 'one garment of wool', a cheap mirror (this was Egypt after all), a single pair of sandals, and a few handfuls of balsam oil (precious) and castor oil (less so but not to be sneezed at), the whole lot valued at a paltry seven shekels. It was all the girl-mother could have had, all she could bring to what was clearly a love match. Meshullam, the owner of the bride, was evidently unmoved. Legally Tamet's status as a new wife did nothing to liberate her from her master, even if she went to live with her husband. But Meshullam drove a harder bargain, demanding (for he was a practical man) that, should they divorce, he would retain his ownership rights to the boy Pilti. Should either of the couple die, he would get half of whatever property they might share. The newly-weds weren't having this, went to law and got a rewrite of the agreement. If Meshullam reclaimed Pilti he would get a steep fine, and he was cut out of the half-share of property if one of the couple died – a satisfying result for Tamet and Ananiah.

Where they went to live – or indeed whether they lived together from the start – is unknown. These are legal documents rather than a journal of a marriage. But twelve years after he married Tamet, Ananiah bought a broken-down house belonging to the Caspians, Bagazushta and Whyl, and he got it for the rock-bottom price of fourteen shekels. But then it wasn't much to look at; just a dilapidated place not far from the Temple. There was a muddy yard, window frames, but no roof beams, yet somehow it was – rather belatedly – the couple's fixer-upper. Three years later when Ananiah had made it

fit for living, he formally gave an 'apartment' – in effect a single room
– to Tamet in her own right. This didn't happen to slave girls – even
koshered-up ones. Almost certainly, the occasion was the birth of
another child, the girl Jehoishima.

Somehow, in the fortress world of the high-walled lanes, the slave
owner, the one-time slave girl, the Temple official and their children
all became an extended family. In 427, when Jehoishima was just seven,
her legal owner, the hard-bargaining Meshullam, perhaps with some
prodding, gave the little girl and her mother Tamet their manumis-
sion, a not-quite unconditional portion of freedom – 'released', in the
lovely Egyptian formula, 'from the shade to the sun'. There was, of
course, a catch. The girl would become part of Meshullam's family,
and if they so wished, his children could still demand her service. All
the signs, though, were that at least one of her adopted siblings,
Meshullam's son Zaccur, became a true brother to his little adoptive
sister. Seven years later, when she was fourteen and marrying a man
with the same first name as her father Ananiah, it was Zaccur who
made sure she wedded in grander style than her mother. For a start,
there was what every teen bride needed: a proper wardrobe – a brand-
new striped wool dress, a long shawl, linen robe, a 'fringed garment',
a 'palm-leaf chest' to store all these clothes in as well as another chest
of papyrus reeds, a third for her jewels, bronze cups and utensils,
fancy Persian sandals, and along with the usual oils, one described as
scented. Thanks to her big brother the teen bride was well endowed.
And she had a place to live, since before the wedding, her father had
given her the legal right to reside in the half of the house not occupied
by her older brother Pilti.

Sixteen years later, in 404, forty-five years after the slave girl and
the lechen had married, Ananiah deeded the property, now very much
a family home, to his daughter, on his death, partly at least in consid-
eration of 'the support' she had shown her father in his old age. A
good girl, Jehoishima. At the end of the carefully delineated property
description, the dry document says, 'This is the measurement of the
house I gave Jehoishima my daughter in love.' But she didn't have to
wait around for the funeral. A year and half later Ananiah changed
the title to take effect forthwith. 'You, Jehoishima, my daughter, have
a right to it from this day forever and your children have the right
after you.'[8] Perhaps by this time old Meshullam had gone to the island

cemetery and the slave woman and her daughter were at last truly
'released from the shade to the sun'.

Elephantine may have been a soldier town, but its women were far
more powerful presences, both legally and socially, than their coun-
terparts back in Jerusalem and Judaea. 'Lady' Mibtahiah, daughter of
Mahseiah bar Jezaniah, hailed from the opposite end of the social
scale from Tamet.[9] Mibtahiah's family was among the leaders of the
community, the notables of the Temple. This did not, however,
preclude her from taking two of her three husbands from the local
Egyptian population, both of them master builders. One, Eshor
(renamed Nathan), was described as 'builder to the king'. Over the
course of her long life Mibtahiah – as confident and glamorous as
Tamet had been modest and unassuming – would end up with three
houses as well as three spouses, beginning by joining herself to a
neighbour, Jezaniah. Her bridal gifts were lavish – as well as jewellery
and chests, a papyrus reed bed. But she also came to the marriage as
a householder, the gift of her well-to-do father, who gave her the
property in her own right. 'To whomever you love, you may give it,
and so may your children after you,' as the deed of transfer put it.
Her husband, on the other hand, in case he didn't know his place,
just had the *use* of the house for as long as their marriage lasted.
Which turned out to be not that long, due to Jedaniah's early death.

Husband number two, an Egyptian called Peu, wouldn't do, and
the documents dealing with the divorce settlement make it clear that
in Jewish Egypt, unlike anything sanctioned by the Torah (then and
now), women were entitled to initiate the separation. Deuteronomy
24:1–4 gave husbands a unilateral right of divorce by mere delivery of
a statement that they had 'found some uncleanness'. Should a man
decide he 'hated' his wife, the same bill of divorce would end the
marriage and 'send her out of the house'. But that was not how it
was done at Elephantine, certainly not for Lady Mibtahiah anyway,
whose substantial dowry had to be returned. She and Peu went to
court over division of goods, but it was Mibtahiah who won the case
– after taking an oath on the name of the local Egyptian goddess Sati,
something that would have appalled the guardians of the Torah in
Jerusalem but was a matter of form for the Jews of the Nile.

So, in this first Jewish society we know anything much about, the
families of the troop could be Jews after their own style – open to

the practices of Egyptians without surrendering their own beliefs, much less their names or identity. Hananiah's mission to impose conformity – since he couldn't or wouldn't exhort them to depart Egypt altogether as the prophets wanted – ran up against generations of practices documented by the Elephantine papyri that resisted such instruction. After all, theirs was a community that had been shaped before Torah law had hardened; and there was sufficient distance to allow for its own customs and laws to become a shared inheritance.

In other words, notwithstanding the fact that a garrison town on the Nile frontier of Upper Egypt doesn't sound like an exemplary case for the subsequent unfolding of Jewish history, it actually was. Like so many other Jewish societies, planted among the Gentiles, the Jewishness of Elephantine was worldly, cosmopolitan, vernacular (Aramaic) not Hebrew, obsessed with law and property, money-minded, fashion-conscious, much concerned with the making and breaking of marriages, providing for the children, the niceties of the social pecking order and both the delights and the burdens of the Jewish ritual calendar. And it doesn't seem to have been especially bookish. The only literature found in the archive was the 'Book of Wisdom', the Words of Ahiqar. And at the core of their community, rising monumentally above the crowded streets they shared with Aramean, Caspian and Egyptian neighbours, was their temple, a little ostentatiously done up, but very much their own.

It is the suburban ordinariness of all this that seems, for a moment, absolutely wonderful, a somewhat Jewish history with no martyrs, no sages, no philosophical torment, the grumpy Almighty not much in evidence; a place of happy banality; much stuck into property disputes, dressing up, weddings and festivals; tough army boys living next door to the even tougher *goyishe* boatmen of the rough waters; a place of unguents and alleys, throwing stones in the river and lingering under the palms; a time and a world altogether innocent of the romance of suffering. But, wouldn't you know it, trouble came, all the same.

Like so many similar Jewish communities that would take root outside Palestine in the centuries and millennia that followed, the Elephantines were perhaps a little complacent in their easy-going assumption that relations between themselves and their neighbours were as good as if not better than could be expected and would stay undisturbed, as long as the benign Persian power was there to

safeguard against ugly local jealousies. But that was precisely the problem. When imperial powers fray at the edges, ethnic groups perceived to be the beneficiaries of their trust suddenly start to look like aliens not natives, however long they may have been settled. This was exactly what happened at the end of the fifth century BCE, when Egypt, which had gone into outright rebellion in 486 and 464–454 BCE, and towards the end of the century, began once more to be aggressively restive against their overstretched Persian overlords. Suddenly (as would happen again 2,500 years later in twentieth-century Egypt) the Elephantine Jews were stigmatised as colonists, tools of the Persian occupiers, their social practices an anomaly, their religion a desecrating intrusion. If Persian toleration had allowed them to flourish as their imperial stooges, the mark of native Egyptian rebellion would be to stigmatise them as occupiers, marginalise and intimidate them, to unpick and tear them out of the body of local culture.

The papyri report riots and looting – ancient forms of proto-pogrom. Six women who had been waiting for their husbands at the gate of Thebes – all of them married to Jews but some of them, as was often the case in Elephantine, with Egyptian names like Isireshwet – were arrested without explanation. Mauziah wrote to Jedaniah that he had been framed for fencing a stolen jewel that had been found in the hands of merchants and thrown into prison, until a commotion at the injustice became so serious he was finally released. But his tone is edgy and nervous. Frantic with gratitude for the help he has had in getting out of jail, he tells Jedaniah to look after his saviours – 'Give them whatever they desire!'

In the last decade of the fifth century BCE, things that had seemed secure suddenly turned shaky. The Yahudim of Egypt pointed fingers at interfering outsiders from Judaea who didn't understand their way of life. Mauziah blamed the presence of Hananiah, the Passover envoy from Jerusalem, for provoking the priests of Khnum to become aggressive, even against the Jewish garrison itself. The well used to supply drinking water when the troop was mobilised and called to the fort was stopped up. A wall dividing the garrison compound abruptly and mysteriously appeared. But these were merely provocations. True calamity followed.

Three years after the disaster, Jedaniah, the communal leader, together with 'the priests who are in Elephantine' reported to the

Persian governor of Judaea, Bagavahya, the sad history of the destruc-
tion of the Temple of YHWH in the year 410 BCE. The tone is exactly
that of scripture: a chronicle steeped in anger and lament. The commun-
ity was still in shock, still wearing sackcloth in mourning. 'We fast,
our wives are made as widows. [That is, they have forsworn conjugal
sex.] We neither anoint ourselves with oil nor do we drink wine.'

The trouble which brought down the Temple of Yahu was perhaps
unavoidable. It specialised, after all, in sacrificing animals, most of
which were undoubtedly sheep, exactly the creatures venerated by
their next-door neighbours at the Temple of Khnum; handsome rams'
head profiles carved on its gates. It was not as if the Jewish rites were
easily ignored. There would have been constant activity from within
the walls of its compound: smoke, blood, chants. And as if angrily
elbowing their irreverent neighbours, the priests of Khnum were
expanding their own premises, pressing against the narrow boundary
separating the two ritual houses. Indeed in places they seem to have
shared abutting walls. At some point, the priests of Khnum mobilised
resentment against the Jewish troop as the hirelings of the Persians
to be rid of their temple if not of their soldiers and families. They
persuaded the commandant of the island, 'the wicked Vidranga' (as
the Jewish petition of complaint and lament called him) to act. A
letter had been sent to Vidranga's son Naphaina, the commanding
officer of the Egyptian-Aramean garrison at Syene, encouraging the
soldiers there to attack and demolish the Temple of YHWH.

'They forced their way into the temple, razed it to the ground,
smashing the stone pillars . . . the five gateways of hewn stone were
wrecked; everything else burned: the doors and their bronze hinges,
the cedar roof. The gold and silver basins and anything else they could
find they looted for themselves.'

With an eye to Persian susceptibilities, Jedaniah spoke feelingly of
the antiquity of the Temple, built in the days of the Egyptian kings
and respected by King Cambyses when he conquered the country. He
reminded the Persian governor that he had already sent one letter to
Jerusalem, addressed to the Lord Bagavahya, to the high priest
Jehohanan and to 'the nobles of Judah' in the city, but they had not
deigned to reply! (Could it be that the Jerusalemites, increasingly
insistent on their monopoly of temple worship, were not altogether
unhappy about the destruction of the unauthorised unorthodox

Elephantine building?) Neither had the elders at Elephantine received any satisfaction from a letter sent to the sons of the governor of Samaria, Sanballat.

The prayers had not gone entirely unanswered. The guilty, from 'Vidranga the dog' down, had indeed been punished, Vidranga's loot taken from him, 'and all those who did evil to the Temple killed and we gazed upon them'. But now the only true satisfaction was not revenge but the restoration of the Temple of YHWH the God. Should it be granted then 'the meal offering, the incense and the burnt sacrifice will be offered on the altar of YHWH the God in your name and we shall pray for you at all times; us, our wives and our children'.

Eventually there came a reply. Permission granted, more or less. The authorisation was for the Temple to be rebuilt 'as it was formerly and on its site'. Pointedly, the permission was on the strict condition that henceforth offerings were to be only of grain and incense, not animal sacrifices. Someone in Jerusalem had got to the governor; or perhaps the Elephantine Jews wanted to reconcile the Jerusalemites to their cause. At any rate, they accepted the principle that burnt offerings were to be made only within the sacred precincts of the Jerusalem Temple. Accepting their secondary status, perhaps relieved that they were allowed to build a temple at all, which was still in violation of the monopoly of worship, a final letter from 'The Board' – Mauzi, Shemaiah, two Hoseas and Jedaniah himself – solemnly promised that sacrifices of 'sheep and ox and goat' would no longer be made. Just to make sure, they offered a sweetener of silver and shipments of barley.

The Second Temple of Elephantine was indeed rebuilt, but it lasted only as long as Persian power over Egypt. It was shaken to the core by another all-out Egyptian revolt in 400 BCE, and had collapsed completely by the middle of the fourth century BCE before the oncoming power of Alexander the Great and his generals. With the demolition of Persian Egypt went the Jewish troop and its world of soldiers, slave girls, oils and incense, property disputes and marriage alliances; vendors, Temple notables and bargemen all disappeared back into documentary darkness, beneath the stones of the island in the Nile.

Outside of a circle of scholars, this first, rich, Jewish story has had virtually no purchase on the common memory of Jewish tradition.

Perhaps this is not surprising. For if that story is set up from the very beginning as one of clear-cut separation, then the mishmash Jewish–Egyptian–Persian–Aramean world of Elephantine is bound to seem an anomaly, a marginal curiosity, nothing to do with the creation of a pure and distinctive Jewish culture. Around the time of Elephantine's flourishing, it is thought, two formative books of the Hebrew scripture – Ezra and Nehemiah – were being written in Jerusalem with the express aim of purging Jewish society of 'foreign' elements: a winnowing out of foreign women, foreign cults, foreign habits – even when they had long been mixed into the daily life of Judaean society. The writers of those books and their successors may have looked back at the Egyptian episode – its heretically unauthorised temple; the audacity with which it presumed to offer sacrifices; perhaps to call itself a society of Yahudim at all – with horror, and told themselves that the fate which eventually overtook it was YHWH's will, another punishment for those who strayed from the narrow path.

But suppose there is another Jewish story altogether, one in which the line between the alien and the pure is much less hard and fast; in which being Jewish did not carry with it the requirement of shutting out neighbouring cultures but, to some degree at least, living in their company; where it was possible to be Jewish and Egyptian, just as later it would be possible to be Jewish and Dutch or Jewish and American, *possible* (not necessarily easy or simple) to live the one life in balance with the other, to be none the less Jewish for being the more Egyptian, Dutch, British, American.

This second kind of story is not meant to displace the first. The two ways – exclusive and inclusive, Jerusalem and Elephantine – have coexisted as long as there have been Jews at all. If both are legitimate ways of thinking about Jewish history, of telling its story, Elephantine could be seen not as an anomaly but as a forerunner. And, of course, it was not the end of a truly Jewish history in Egypt, but just another beginning.

THE WORDS

Nehemiah, so his book says, rides by moonlight.[1] He can't sleep. The broken walls of Jerusalem, to which he has returned, make a desolation in his heart.

It is 445 BCE, nearly a century and a half since the Nebuchadnezzar catastrophe and the captivity of the Israelites in Babylonia. Although the Babylonians have long gone from Jerusalem, their soot is rubbed into the city's honey-coloured limestone. Beyond the walls, the Persian province of Yahud is still barely peopled; village after village has been abandoned or reduced to primitive subsistence.[2] The city is filthy, poor, twenty times less populous than in the last years of the Judaean kings, its remaining inhabitants withdrawn into huddled dwellings beside the half-demolished walls.

Decades have passed since the Persian king Cyrus, in keeping with the Persian policy of returning deportees and restoring local cults (hoping to bind their allegiance with that favour), authorised the Israelite return to Yahud in a decree 'in the first year of his reign', according to the Book of Ezra.[3] The princeling Zerubbabel, with a claim to kinship with the ancient Davidian line of royalty, had been appointed to lead a few thousand back to Jerusalem, together with Yeshua the high priest. A start had been made on a second temple at the razed site of Solomon's House of YHWH. 'When the builders set the foundation . . . they set the priests in their apparel with trumpets and the Levites . . . with cymbals and they sang together . . . and all the people shouted with a great shout.'[4] After it had been completed in 515 BCE, it was seen to be a modest rebuild, but enough for there to be the sprinkling of blood and the roasted sacrifices that the Holiness Code of Leviticus required, enough to command the reverence of pilgrims on days of harvest festivals.

The Cyrus decree remained a precious authorisation, so much so that the Book of Ezra goes to the length of dramatising an archival search for the text, as a response to malicious objectors, generations later in the reign of Darius.[5] Sure enough a copy is found in Babylon specifying the size and height of the rebuilt Temple, that its costs were to be paid for from the royal treasury, and the gold and silver vessels plundered by Nebuchadnezzar returned. Even more gratifyingly, the decree threatens anyone attempting to alter it by so much as a word with having the timber pulled down from their house, with hanging from a gallows erected on the debris, and that house 'be made a dunghill'. As fragments of the Cyrus Cylinder text have been identified on a different cuneiform tablet (found on a dig in 1881), it is entirely possible that Ezra and his contemporaries were in possession of a copy that gave them the details of the authorising decree.[6]

The children and grandchildren of those who had come back would have needed to hang on to the promise and reassurance of the Cyrus decree, since they still lived every day amid the weedy rubble of destruction. And there were so pitifully few of them, probably no more than two thousand souls. Nehemiah wells with sorrow as he rides beside the low ruins. Behind him, at a shadowy, baffled distance, trot the few chosen men he had roused from their beds. The rest of Jerusalem, such as it is – the priests, the scribes, the local notables, Edomites and the like, who lord it over the tattered Jews, puffed up with the aggravated authority they imagine they hold from the Persian court – snores on oblivious. Nehemiah is cup-bearer to the Persian king Artaxerxes in the palace at Susa, his trusted man and deputed governor. The descendants of the Judaean king Jehoiachin, who was deposed and carried away by the Babylonians, still like to give themselves the airs of the House of David, but the truth is that there is no king in Judaea, and this exiled puppet court depends on Babylonian bureaucrats for its rations of oil.[7] So Nehemiah is the next best thing – the man who holds decrees with the names of Persian emperors inked on them.

He sits upright in his saddle as the horse picks a careful way through the shattered stones. Through the Dung Gate goes Nehemiah, the stars over his head, the Judaean summer night pleasingly cool; past the deep well where the people say a dragon lies, allowing its waters to flow only when he sleeps with his wings furled, the claws retracted beneath his scaly body; on past the Water Gate, on to Siloam and the brook

of Kidron, skirting the heaps of trash and the meandering line of ruin, on until his horse has no more room amid the rubble to trot or even to walk. Nehemiah guides the animal through the waste, and back into the alleys of the city. He can rest now. He knows what must happen.

In Elephantine at this time the Judaeans live as well as could be expected amid the Egyptians. Their neighbours are still Arameans, Carians, Caspians and Greeks. They have their own temple, their own way. Nehemiah understands this very well, but it is not his way and, so he tells us in his 'memoir' (one of the most powerful of the Bible), neither does he believe it is YHWH's way.

The next day Nehemiah calls a meeting of the priests, chief men and scribes. 'You see the distress we are in, how Jerusalem lieth waste, its gates burnt with fire; come, let us build up the wall that we be no more a reproach.' Heartened, they follow the lead of the man who seemed to speak with the authority of the king. 'Let us rise up and build.' When local officials – Sanballat the Horonite and Geshem the Arabian – jeer at the temerity, Nehemiah stiffens. 'The God of heaven will prosper us; but you have no portion or right nor memorial in Jerusalem.'

The Book of Nehemiah, short but exceptionally vivid, is called a 'memoir' even by the most sober scholars. Unlike other books of the Hebrew Bible (although like the Book of Ezra, with which it is always paired even to the point of reading them as a single narrative), it was almost certainly written close to the time of the events it describes.[8] The long quotations from Persian royal decrees and charters invoked in Ezra correspond persuasively to Persian court-legal style of exactly the mid-fifth century BCE. They are, in effect, direct quotations. The overwhelming impression is of documentary immediacy, a book that in its material load of iron, stone and timber, seems physically of its moment.

That mid-fifth century BCE moment is weighty with formative significance. Something is being built, and it is not just masonry – although it is in Nehemiah that actual building happens: timber beams are aligned; stone slabs cleaned; rubbish carted away; studded gates are set again on massive, dependable hinges; the locksmiths busied. Nehemiah studiously lists the work gangs and their bosses and the local big shots of each quarter of the broken city: 'the dung gate repaired Malchiah the son of Rechab, the ruler of part of Beth-haccerem, he built it, and

set up the doors thereof, the locks thereof and the bars thereof. But the gate of the fountain repaired Shallun the son of Col-hozeh, the ruler of part of Mizpah; he built it, and covered it . . . After them the Tekoites repaired another piece, over against the great tower that lieth out, even unto the wall of Ophel.' It is as if we are riding with Nehemiah on a tour of inspection: the non-stop hammering, the governor making sure his scribe takes careful notes so that no one responsible for construction or beautification would be forgotten, like modern donors who expect to have their names inscribed on grateful walls.

The work proceeds apace over local opposition, which becomes so incensed that the gangs have to work with weapons by their side in case of attack. Nehemiah must arm the labourers who work with a trowel in one hand, a sword in the other or propped against the stone. He has to see that farmers and traders do not exploit the sudden need for provisions by charging outrageously for food; or worse, that the local Jewish elite doesn't extort money from those who had mortgaged olive groves and pasture to join the effort. The repair of the walls is done in fifty-two days.

Walls separate; they may enclose and exclude. Even though Nehemiah's message to Sanballat the Horonite and Geshem the Arabian was hostile – that they had no 'portion' or 'memorial' in Jerusalem – we must not make him a security-fencer of the fifth century BCE, although his walls were certainly meant to give the smashed and exposed city ruin some shape and definition (as they still do), and a sense of shared community to the people inside them, as well as those camped beyond and in the Judaean hills, groves and valleys of the country. That sense, however, could not be conveyed merely by stone, timber, brick, iron and mortar. Ultimately the house of common fate was – as it would be for millennia – built from words. So a month after the completion of the repairs to the walls, a second ceremonious action was called for.

According to Nehemiah's fantastic enumeration, on the first day of Tishri exactly 42,360 of the Jews of Jerusalem, their manservants and maidservants (another 7,337), and certainly the 245 singing men and women (for there was and is no Israelite religion without music) were summoned to the open street before the restored Water Gate. Although the numbers are an absurd exaggeration (probably fewer than 40,000 Jews were then living in the entirety of Judaea and Samaria), there was some sort of crowd.

At the centre of what was orchestrated as a second moment of self-definition is Ezra, who, unusually, is both priest and scribe. This double vocation mattered, for it was scribal writing that was about to be sanctified. Ezra brings with him 'the book of the Law of Moses which the Lord had commanded to Israel'. The congregation (which Nehemiah makes a point of saying consisted of women as well as men, and, like all the earliest sources, with no hint of separation) knew that a solemn moment was at hand. Ezra stood on an elevated wooden platform, designed for the occasion perhaps, on the rebuilt ramparts. To his right and left were a throng of priests and Levite scribes surveying the crowd which waited in silent expectation. When Ezra opened the scroll, everyone stood. Before proceeding to the reading, 'Ezra blessed the Lord, the great God and all the people answered Amen, Amen, lifting up their hands and bowing their heads.' Then the scribe began. For those out of hearing range there were Levite repeaters at hand, their names carefully listed by Nehemiah as if they were themselves involved in the production of the words, which in fact they were. Since the first language of many of their listeners would have been Aramaic not Hebrew, the Levites were needed to 'cause the people to understand' – a matter of both trans-lation and explanation.

If the reading was not exactly call and response, it was nonetheless intensely participatory. The audience was not a passive receiving station for the words of God. Nehemiah (admittedly the official impresario) says it was the people *themselves*, 'gathered as one man', who took the initiative, asking Ezra to bring the scroll of Moses. This active connec-tion between listener and reader was something new in the world of the ancient Near East, where people were more usually summoned to be stupefied by the power and sacred grandeur of the words of the king, required to attend to his acts of judgement, and venerate his cult image carried in procession. But the processions of Judaism have at their devotional centre a scroll of words (treated with all the bowing and worshipful kissing through the fringes of a prayer shawl that would have been given to a cultic statue). Moreover, this was a kingless moment, and the urgency of the listeners and the high pitch of the declamation fastened together a unified community of the attentive. In all the scholarly concerns with flattening the differences between Israelite religion and the conventions, practices and images

of its neigbours, it is easy to miss how momentous was this distinc-
tively Judaic foregrounding of 'the people' in bonded, direct covenant
with their single God, whose presence was embodied in sacred words.
Whether errant or obedient, penitent or heedless, they are actors in
their own history, not just a faceless chorus summoned or dismissed
by priests, princes and scribes. From the start, Judaism – uniquely at
the time – was conceived as a people's religion.

The public reading before the Water Gate rehearsed ancient customs
of oral recitation. The Hebrew for reading presupposes vocalisation
before an audience: the word *qra* means literally 'to cry out', and *miqra*
derived from it is the noun form of a gathering of listeners and readers.[9]
That same reading obligation would become *the* characteristic practice
of Jewish observance outside the Temple, where the spectacle of sacri-
fice defined membership of the believing community. While Temple
sacrifice was a hierarchically organised business in the hands of the
priestly caste, reading was intrinsically a shared, common experience,
the impact of its vocalisation not even dependent on literacy. What
was said was now becoming a written literature, but it is telling that
the written form paradoxically exalted a long and cherished history of
moments of dictation, all the way back to Moses himself taking dicta-
tion directly from the Almighty. Deuteronomy had imagined Moses
being ordered to 'read the Torah in the presence of all Israel, in their
ears. Gather together the People, men, women and children and the
strangers in your gates, that they may hear, learn.'[10] Ezra's elevation
above the rapt multitude is not just a reiteration of that first Mosaic
transcription but a self-conscious re-enactment of it. Nehemiah writes
about it as though it was to reacquaint people who had lost those
words with their substance: the Law and the history revealed as if
freshly given, brought to life by the spark of public voice. The scroll
itself must have been significant too: the compact roll of portable
memory, something that had a chance of being carried through the
fires of disaster.

Nehemiah, the orchestrator of the spectacle, knew what he was
doing. Though Mesopotamian law codes were of immense significance
in establishing the king as sovereign adjudicator, Babylonian and
Persian court rituals, often enacted before monumental statuary, were
principally designed to astonish the eye. The performance assigned to
Ezra was all about mouth and ear, about the living force of words. It

established, very early on, the Jewish philosophy of reading as unquiet. Jewish reading in the style of the Hebrew Bible, at the dawn of this people's self-consciousness, is not done in silent solitude (the invention of monastic Christianity); nor is it done for the enrichment of the reflective conscience (though that is not entirely ruled out). Jewish reading is literally loud-mouthed: social, chatty, animated, declamatory, a demonstrative public performance meant to turn the reader from absorption to action; a reading that has necessary, immediate, human implications; reading that begs for argument, commentary, questioning, interruption and interpretation; reading that never, ever shuts up. Jewish reading refuses to close the book on anything.

Ezra's performance takes on the austerity of a legal code – the Torah – into the realm of collective public theatre: a holy show. It is the climax of a three-act drama of reconsecration and reawakening: first the repair of Jerusalem's walls; then the building of a second Temple in situ, and finally the public manifestation of the law of Moses without which the other two acts would have had no meaning. None of these deeds were merely ceremonial. Together they meant to assert an unapologetic Jewish singularity: the Yahwist difference. The rebuilt walls were an architectural declaration that Jerusalem was the citadel of David, that the core of the Yahwist royal cult had risen again even though there was no longer any king in Judaea. The rebuilt House of YHWH would stand as the only true Temple of the Jews, the arbiter of what was and what was not proper observance, and the authorised Law of the Land as, in effect, the Jewish constitution. The words of the Torah, giving people the governing content of their singularity, did not need a king, much less a god-king, for their authority. Behind them stood the belief in an invisible YHWH, whom Talmudists much later would even depict as consulting a pre-existent Torah, before proceeding to create the universe![11]

As long ago as the seventeenth century, Baruch Spinoza, inaugurating biblical criticism by insisting that the Pentateuch was a historical document written by human authors many generations after the events described, identified Ezra as the most likely candidate for prime authorship.[12]

All this was needed because Ezra and Nehemiah were acutely conscious of the difficulties they faced in redefining who was and who was not a true member of this community of YHWH. Both scribe and governor

belonged to the elite uprooted by Nebuchadnezzar, along with the royal clan, its judges and magistrates, perhaps most of the literate class, and taken to Babylon in 597 BCE. Perhaps some of the rest of the Judahite population (their ranks swollen by the descendants of the thousands of Israelites from the north who had come to Jerusalem after the Assyrian destruction of their kingdom in 721 BCE) followed in the train of the elite class. There were, after all, no less than three mass deportations – in 597 BCE, in 587 BCE and then again in 582 BCE. The archaeological record shows an indisputably brutal shrinkage in the number of villages in the Judaean highlands in the sixth century BCE. Vineyards, olive groves and pasture went to waste. Soldiers were left to fend for themselves as the foothill fortresses of Judaea fell one by one and travelled, as the Book of Jeremiah suggests, to Egypt, to the Nile cities and to Pathros, the south country of the first cataract.

Though the population collapse was extreme, Judaea and Samaria were not entirely emptied. Some thousands must have clung to their terraces and ancient villages in the hope of subsisting after the flares of war had turned to cold ash. In the traumatic circumstances of the Babylonian onslaught, there is every reason to suppose that those who did stay behind clung for comfort and hope not just to YHWH, but to the household and local gods and cults of their own ancient traditions. Cultic pillars, amulets, even inscribed references to gods other than YHWH – not least his female consort Asherah – have survived from an earlier generation, even at the time when the scribally written books were doing all they could to promote uncompromising monotheism. In Samaria in particular – where some of those most badly affected by the Babylonian fire invasion must have fled – the survivors would have been open to gods other than the one who had manifestly failed them against Nebuchadnezzar.

The targets of Ezra's and Nehemiah's public proclamations of Torah Rule were precisely local survivors suspected of acquiring 'foreign' cult practices along with 'foreign' wives. The truth was that it was the fierce 'Yahweh Alone' book-fixed monotheism that was the novelty, not the ancestral habits of keeping a little, full-breasted hearth goddess figurine at home or in larger houses even a small uninscribed standing stone. But the Ezra–Nehemiah exclusivism now held co-religionists to a higher stricter standard, and they presented their version of YHWH worship as having *always* been that demanding, even though

this was historically not the case. For the first time (but not the last), the 'who is a Jew' debate was sounded, with Ezra launching a comprehensive and merciless winnowing out of those considered to have been contaminated by 'foreign' cults. This happened at *precisely* the time – the mid-fifth century BCE – when the Yahudim of Elephantine, innocent of the new Judaean puritanism, were marrying Egyptians and cheerfully invoking in their solemn vows the pagan gods of their Aramean neighbours, sometimes in the same breath by which they also swore by YHWH. The argument between a narrow and a broad view of what it means to be Jewish had got under way.

Ezra was hardline, fasting out of mortification that 'the children of the captivity' had taken 'strange wives', thus compounding 'the trespass of Israel'. In keeping with his assumption that those who had intermarried needed to be shamed from their sin, the final twenty-five long verses of the Book of Ezra consist of nothing except a list of the ignominious, including many priests and Levites. (Needless to say we do not hear the names of their unfortunate wives.) The culprits 'gave their hands that they would put away their wives and being guilty offered a ram of the flock for their trespass'. In reality there would have been many thousands. Ezra's motivation was precisely to weed out heterodoxy, to make Jerusalem the sole Temple for pilgrim festivals and sacrifices, and to place in the hands of the Temple priests the judgement over those who could, and those who could not, be admitted to this reborn, re-covenanted nation.

The scroll-book itself was supreme as the object of orthodox allegiance, exalted by Ezra as both law and history. It was the instituted cult of the Book and the obligation of shared reading out loud which, more than the worship of a single god, made this Israelite Yahwist religion unique in its time and place. The eighteenth-dynasty pharaoh Akhenaten in Egypt had also proclaimed the exclusive cult of a single sun god and effaced all images of him save the sun-disc. Egyptian, Babylonian and Zoroastrian cults were embodied in statuary and relief sculpture, both in fixed specific shrines and temples, and the great epic inscriptions that proclaimed the divine judgements and wisdoms of the king were likewise inscribed – in cuneiform – on immovable, monumental stone. When Assyrian and Babylonian armies went into battle they did so with just the images of gods and deified kings to fortify them. Israelites, on the other hand, were commanded to take with them their sacred scrolls.[13]

The genius of the Israelite–Judahite priestly and scribal class (together with their free outriders, the itinerant visionary prophets and their patron kings, with whom they were often at odds) was to sacralise movable writing, in standardised alphabetic Hebrew, as the exclusive carrier of YHWH's law and historic vision for his people.[14] Thus encoded and set down, the spoken (and memorised) scroll could and would outlive the monuments and military force of empires. It was fashioned to be the common possession of elite and ordinary people, and for the vicissitudes of political and territorial imperma- nence. The desert tabernacle sanctuary that was said originally to house the Torah, and thus be the residence of YHWH amid His people, was nothing more than a modest-sized if somewhat orna- mented tent; and within it the specifications of the chest of the Ark make it smaller than your kitchen cabinets. But it was the obsession of the makers of Israelite book-religion to make the Torah ubiquitous, inescapable, not just established at some sacred site, but available in miniaturised forms on property and person. Instead of an image of a divine creature or person hung over a doorpost to repel demons, it was the Torah writing of the mezuzah that would keep Jews safe. Phylactery boxes, the tefillin, were made so that its words would even be bound on the head and arms of the observant as they prayed. Protective amulets worn around the neck or on the chest for luck and health, which in other cults would have had the image of a god, now likewise bore the words of the Torah. No part of life, no dwelling or body, was to be free of the scroll-book.

The Torah, then, was compact, transferable history, law, wisdom, poetic chant, prophecy, consolation and self-strengthening counsel. Just as the sanctuary could be erected in safety and dismantled in crisis, the speaking scroll was designed to survive even incineration, because the scribes who had composed and edited it had memorised its oral traditions and its texts as part of their basic education. Some debate surrounds the exact nature of the role of mazkr, inappropriately translated in the King James Version as 'herald'. But the Israelites had no heralds. The root of the word is zkr, or in rabbinic Hebrew zakhor, memory, so such a person, lay or priestly, would have been a memo- rialist, a recorder. With writing and human memory in sync, the people of YHWH could be broken and slaughtered but their book would be indefatigable.

So we should not wonder that the Book itself, as physical object, features in some of the most powerful scenes in the Hebrew Bible. It was not, of course, our kind of modern book, with serially consecutive pages, a story-casing which, in its early form of a codex of gathered and folded sheets, would appear only with the Romans. The scroll-book appears in the Hebrew Bible in potent, magical forms. The fantastical priest-prophet Ezekiel (probably writing in exile, so clinging to the scroll with particular intensity) has a vision of a hand holding a scroll, full of warnings and lamentations, but he is ordered by one of the four-faced, four-winged Living Creatures who feature in the dream not to read it but to eat it – in fact chomp, and swallow it right down. 'Son of man cause thy belly to eat and fill thy bowels with this roll that I give thee. Then did I eat it and it was in my mouth as honey for sweetness.' Only after the Bible-muncher had physically crammed his mouth with the contents of the book, and literally digested its contents, could that same mouth become the organ of prophetic eloquence.

This is heady stuff, but the same scroll-book makes an even more dramatic appearance in the reign of the boy king, Josiah. His story is narrated twice in the Hebrew Bible, first in Kings 2:22–3, and then in more elaborate form by the author of Chronicles 2:34–5. Both versions were composed at moments of prolonged crisis. The original account in Kings was most likely penned in the late eighth or early seventh century BCE with the memory of the destruction of the northern kingdom of Israel by the Assyrians in 721 BCE still sharp. The much later rewrite in Chronicles would have been composed in the mid-fifth century BCE, contemporary with Ezra and Nehemiah, so that it is a self-conscious prologue to the performance-reading of the Torah at the Water Gate.

The Josiah story is a fable of recovered innocence. Josiah becomes king at the age of eight following a nadir in Judahite history: the long reign of his grandfather Manasseh, who according to the Bible writers was unparalleled in his eagerness to profane the Temple with pagan 'abominations', and his father, Amon, named for the sun-worship of Egypt, which says it all. Generations alternated between piety and impiety. Manasseh's father before him, King Hezekiah, had been a purist reformer, co-opted retrospectively by the writers of Kings as a smasher of idols, heeding the warnings of Isaiah, the patron of scribes

who were writing the books of what would become the Bible. Subsequent annalists – and the scribal vocation ran in families – attributed Jerusalem's narrow escape from the Assyrian invaders (who succumbed to epidemic sickness) to Hezekiah's Yahwist zeal.

Manasseh chooses the opposite path. Living dangerously between Egypt and Assyria, he had been not only indifferent to Yahwist purism, but, according to the distaste of priestly scribes, an enthusiastic polytheist, raising up altars to the Phoenician god Baal, building altars for 'all the host of heaven' (astral deities), making a pagan grove, 'using enchantments', 'familiar spirits and wizards' and most infamously of all resorting to child sacrifices including his own son who, according to the horrified Bible writers, is made to 'pass through the fire' to Moloch. The response to this catalogue of iniquity (much of it, of course, the repertoire of popular religion throughout Palestine) is YHWH's vow to 'wipe Jerusalem as a man wipeth a dish'.

Heavenly washing-up is put on hold for a bit. 2 Kings was almost certainly written (or rewritten) by the 'Deuteronomist' historians, the sixth- and fifth-centuries BCE generation of priests and scribes aggressively committed not just to YHWH as a supreme deity, but to His exclusive identity as the *only* God. The Book of Deuteronomy had been added to the first four books of the Torah as the spoken valedictory counsel of the dying Moses himself, reiterating (and editing) the details of the Sinai-given law (including the Ten Commandments), offering foreign-policy advice to the tribes ('meddle not with Edom, Distress not Moab'), formalising blessings and curses – a common Near Eastern tradition ('cursed be he that lieth with his mother-in-law'), and solemnising a renewed covenant but also with the express commandment to remember and repeat (out loud) the exodus story. Running throughout both Deuteronomy, and the later Book of Kings, is a red ribbon of mistrust – both in the capacity of the people to keep to the Mosaic straight and narrow, and, as in the case of Manasseh's exotic crimes and transgressions, in the willingness of the monarchs of the House of David to enforce righteousness. At issue is whether Hezekiah or Manasseh represents the norm for Judaean kings of the line of David. The story of Josiah gives a decisive answer.

The drama unfolds while Josiah is still young, succeeding to the throne after the murder of his father, the iniquitous Amon. The Book of Kings has the decisive event for Josiah happen in his eighteenth

year; the Chronicler, anticipating the possibility of questions arising from a ten-year gap between accession and vocational self-discovery, advances the epiphany to twelve. But the heart of the story is the same. The Temple is in a shocking state of disrepair and pollution, neglected and desecrated by Manasseh. Repudiating the 'abominations' of his errant grandfather for the strictures of the Heavenly Father, the boy king orders taxes in silver to be collected from the people of Judah to restore the purity and beauty of the Temple. (And to be sure there are surviving pottery shards commanding such payments.) The work of restoration duly commences with 'carpenters and masons and builders' under the supervision of the high priest, Hilkiah, the personification of Yahwist orthodoxy.

While the building works are proceeding, lo and behold, Hilkiah happens to stumble across a lost 'Book of the Lord' half buried in the construction debris. He gives it to the scribe-counsellor Shaphan, who wastes no time in reading it aloud to the young king. Josiah is thunderstruck by what he hears and is also filled with some foreboding, not least because the book is (surprise!) Deuteronomy, with that exhaustive list of curses. For failure to obey the Mosaic command-ments, 'Cursed shalt thou be in the city, and cursed shalt thou be in the field. Cursed shall be thy basket and thy store . . . The Lord will smite thee with the botch of Egypt, and with the emerods, and with the scab, and with the itch, whereof thou canst not be healed.' No wonder then that Josiah felt 'Great is the wrath of the Lord that is poured out upon us, because our fathers have not kept the word of the LORD, to do all that is written in the book'.

The king does not leave it at that. In an anticipation of Ezra's staged reading in front of the gated walls of Jerusalem, Josiah assembles priests, Levites, 'and all the people great and small' and reads 'in their ears all the words of the book of the covenant found in the House of the Lord'. He 'stands in his place' and makes before the entire assembly a public profession of penitently renewed covenant. Then, around the year 620 BCE, he sets about a thorough cleansing operation, starting with the Temple where he executes the Passover to end all Passovers. Thirty thousand lambs and kids, exactly 2,006 'small cattle' and three hundred oxen are rounded up, so everyone can keep the Passover properly. Sacrificial slaughter proceeds round the clock; much blood sprinkling; and then roasted meat divided up for the people.

'In all the days of the Kingdom,' the Chronicler exclaims, a little redundantly, 'there was no Passover like that kept by Josiah.' And with the Temple redeemed from the profanities of Manasseh, the king (or his priests and counsellors) rules it to be the only site for the ritual sacrifices and festival pilgrimages that made up the calendar of religious observance.

The Josiah story of the fortuitously rediscovered Book is the most artful of the Deuteronomist makeovers of Jewish/Israelite identity in the image of exclusive Yahwism. At the heart of their sacred fiction is the scribal denial of their own authorships of the Deuteronomist Bible. The literary pretence is that it has existed immemorially and independent, of course, of any human hand; even Moses is merely taking dictation. So the Words, the Writing and the Book have a life entirely separate from the kings who are their provisionally appointed guardians, but who for the most part prove themselves wayward and untrustworthy, easily corrupted by foreign practices and – as in the case of Solomon's thousand wives, among them the Egyptian princess – foreign women. (Women, trapped in the Jezebel paranoia of the Deuteronomist writers, are repeatedly cast as demons of temptation.) By repudiating his evil grandfather, the boyish Josiah manages to recover the legacy of David and Solomon (and overlook their own manifold transgressions) to restore the credentials of the House of David as fit custodians for the Book.

But it is the speaking Book itself which is the agent of the reformation, lying in wait for Hilkiah's 'discovery' and Josiah's true coming-of-age, a kind of royal bar mitzvah, as the conscious inheritor of Mosaic Law and the story of its revelation. It was Moses who was speaking again, directly through Josiah, just as God had spoken through Moses. So it is the glimmering mystique of that Lost Book, its words awaiting eyes to read them and mouths to speak them, left somewhere half buried amid the detritus of disbelief, awaiting resurrection, that is the core of the narrative. The economy of the mystery is the genius of the story. Its force lies not in triumphal statuary, mines of precious metals, or an innumerable army, but a mere scroll of words: which is why the Greek 'Deuteronomy' ('Second Law') is much better rendered from the Hebrew *dvarim*, meaning 'words'. From the beginning of the culture's own self-consciousness, to be Jewish was to be Bookish.

Notwithstanding YHWH's repeated promises to lay the mighty low at the feet of the covenanted, however, the Book never guaranteed invulnerability, not even to its rediscoverer, Josiah. The Book may have supplied great detail on which birds were permissibly edible and which not (no osprey, bearded vulture, kite or eagle; and forget about lapwing, bat or owl), but it was not much help in offering strategic guidance for the beleaguered kings of late-seventh-century BCE Judah. Having escaped the Assyrians, the cramped little hill-country realm was squeezed two generations later between two aggressive expansionist river powers of the Nile and the Euphrates. In Mesopotamia, the Babylonians had all but finished off Assyria and, recognising the threat, Pharaoh Necho II (who in all likelihood had his Jewish mercenaries stationed at Elephantine) decided in 609 BCE to come to the aid of the besieged Assyrians and confront Babylonia before it was too late to stop its armies establishing themselves as an unassailable hegemonic power. Forced to choose, Josiah bet on Babylonia, putting his own army, and himself, squarely in the way of the Egyptian advance north.

The Chronicler, writing after the disaster, dramatises the story by having Necho send ambassadors to Josiah imploring him to stand aside: 'I come not against thee but against the house wherewith I have war. Forbear thee from meddling with God that he destroy thee not.' But it may be that Josiah gave little credence to the word of God purporting to come from the mouth of a pharaoh, and gave battle to the Egyptians at Megiddo in the north of the country. An arrow from the Egyptian archers found its mark. Mortally wounded, Josiah was taken back to Jerusalem 'and he died and was buried in one of the sepulchres of his fathers. And all Judah and Jerusalem mourned for Josiah.'

The Josian moment proved a false dawn for the alliance of holiness and power; rather it was a prelude to catastrophe. In the aftermath of Megiddo, Josiah's son Jehoiahaz, who was crowned in his father's place, was unceremoniously driven from his throne by Necho and taken as captive to Egypt, and his brother Jehoiakim was put in his place as a dependable Egyptian ally. Four years later, in 605 BCE, two devastating defeats for Necho's armies at the hands of the Babylonians, at Carchemish and Hamath, made Jehoiakim rethink the strategy of survival. Through the better part of a decade, he played both the bigger powers off against each other, but could never (perhaps

understandably) make up his mind, siding with whichever of the two seemed to have the military upper hand. When he died, either by the hand of an assassin or in defence of Jerusalem in the spring of 597 BCE, he was already paying the price for prematurely assuming the worst of the Babylonian threat was over.

After the final destruction, the Book of Jeremiah (whose author was in all likelihood Jeremiah's own secretary-scribe, Baruch) gives a tellingly scribal explanation for Jehoiakim's death: the stopping of his ears, his obstinate refusal to listen to the speaking Book. In one of Jeremiah's most vivid scenes, Chapter 36, the king who has been ignoring the prophet's warnings sits before the fire in his 'winter house', grudgingly allowing his counsellor Yehudi to read the latest gloomy pronouncements from the scroll: 'And it came to pass that when Yehudi had read three or four leaves, he [Jehoiakim] cut it with the penknife, and cast it into the fire that was on the hearth until all the roll was consumed in the fire.' Needless to say, Jeremiah is commanded by YHWH to have Baruch rewrite the burned scroll – with some additions – bringing more bad news that Jehoiakim's dead body would be cast out to rot in the heat of the day and freeze in the chill of the night. You can stop your ears, you can burn the Book, you can ignore it, you can pulp it. Its message will still ultimately get through, loud and clear.

Without a new Hezekiah or Josiah (kings who paid attention when the Book spoke), there would be no 'Assyrian miracle'. Jehoiakim's son, confusingly called Jehoiachin, lasted three months before being deposed by Nebuchadnezzar and carried off, with 'princes' and 'men of Judah', as prisoner to Babylon. In his place, the youngster's uncle, Zedekiah – the last son of Josiah and, as it turned out, the last king of Judah – was set on the throne.

It was not quite over. The kingdom had been turned into a puppet state of the Babylonians, but neither Zedekiah nor the people of Judah were reconciled to their subjugation, something that irked prophets like Jeremiah who preached that Babylon was carrying out the punishment of YHWH. Those prophets may have reviled Zedekiah, but their opinion was not necessarily shared. We have documented evidence that for almost ten years, Zedekiah and those in the hill country south and west of Jerusalem flirted with revolt, and gave the Babylonians continuous trouble. Towards the end of the decade, the fortresses with

which kings from David onwards had studded the hilltops, heavily provisioned from the abundant countryside of the Shephelah, held out even when, in 588 BCE, Jerusalem itself was encircled. The hope of the commanders of these strongholds must have been that if Zedekiah could hang on, and the Hezekian water supplies hold out, then the new pharaoh, Apries (with, perhaps, Jewish mercenaries from the Nile), might yet pull the iron from the fire. For once, the hope of Judah lay in Egypt.

But Apries was more interested in securing his southern frontier against Nubians and Ethiopians, and abandoned Palestine and Syria to the Babylonians. It was only a matter of time before the immense machine of Babylonian military force ploughed into what was left of the Judahite kingdom. And from exactly that period, 588–587 BCE – the very last years of Judaean independence – we hear from a Jew on the front line, in fragmentary letters written in Hebrew on clay, by an officer, Hoshayahu, in the great walled stronghhold of Lachish, commanding the road from Ashkelon on the coast to Hebron in the hills.

Hoshayahu – like everyone else in Judaea in the nervous summer of 587 BCE – is sweating out a waiting game. His voice, allowed its full colloquial gruffness by his scribe, is understandably testy given his situation, attempting to get messages through to a senior officer else-where. He seldom minces his words and is habitual in taking the name of YHWH if not in vain then certainly in his stride. Presumably answering the request of a superior officer, 'Lord Yaush', for some information about troops or supplies, Hoshayahu writes back: 'Why should you think of me? I am (after all) nothing but a dog. May YHWH help you get the news you need.' For the moment, crucially the Jerusalem road is still open, but as the horizon darkens, Hoshayahu's letters are punctuated with arrests, confiscations, ominous interruptions of correspondence. One of them, near the end, mentions that from Lachish he cannot see the fire signal of another hill citadel closer to Jerusalem, Azekah. Romantic interpretations have read this to mean the fire has been extinguished by the Babylonians taking the fort, but it is just as likely to be an expression of Hoshayahu's defensive vigilance about the visibility of Azekah's beacon along the chain of signals.[15]

Two Jewish stories approach us, then, from the same agitated time, written alongside each other, one from the archaeological record, one

through the infinitely edited, redacted, anthologised, revised work that will end up as the Hebrew Bible. One is poetic, the other prosaic, but no less vivid a record of Jewish life for being so. One exalts the name of YHWH; the other uses it casually (though unlike the Elephantine Jews not with the names of other local deities attached) as part of vernacular speech. One voice is hard-bitten and practical; the other seer-like, poetic and high-pitched. One is concerned with oil and wine and troop placements and defence beacons; the other with ecstatically singing the praises of YHWH or prescribing the sufficiency of animal slaughter for sacrifice, with imprinting on the wards of YHWH the obligation to observe the strictures of Moses' farewell commandments. One kind of voice is attempting to reach fellow Jews over the next hill; the other is trying to reach Jews through all eternity. One cannot imagine the future after an apocalypse; the other is frantically trembling with its imminence.

Just how much of the books of the Hebrew Bible (and which ones) were written *before* the mass deportation of 597 BCE and the final destruction of Jerusalem ten years later, and how much afterwards, we will never know with absolute certainty. But the most ancient elements of it (epic songs of triumph like the 'Song of the Sea' in Exodus 15, exulting over the drowning of Pharaoh and the army pursuing the Israelites) have been identified by some scholars as having been composed as early as the eleventh century BCE – in other words *before* the reign of David![16] The style of the song – 'I will sing unto the Lord, for he has triumphed gloriously: / the horse and the rider hath he thrown into the sea' – has been convincingly associated with Canaanite mythic poetry in which the challenging god Baal conquers the sea in a great storm. So while the first editors and scribes putting together their narratives, perhaps as early as the late tenth century BCE, were wanting to single out YHWH as their distinctive supreme local deity, they owed some of the most distinctive passages to the poetic tradition of their neighbours. When they came to write their histories of more relatively recent events, they made sure to incorporate those ancient forms of chorus and refrain into their narratives, to give the identity-forming written book a strong sense of immemorially inherited oral memory. It's no accident that in their epic pitch they bring to mind the near contemporary war chants of the *Iliad*.

But in the Hebrew–Israelite case, they are presented as a common inheritance for a shared audience. They echo poundingly with authentically archaic chant and dirge, whether in exultant triumph ('Song of Deborah', Judges 5: 'Speak, ye that ride on white asses, ye that sit in judgement, and walk by the way. / They that are delivered from the noise of archers in the places of drawing water . . . Awake, awake, Deborah: awake, awake, utter a song'), or the tragic 'Lament of David' in 2 Samuel 1, over the death of Saul and Jonathan: 'Tell it not in the squares of Gath; proclaim it not in the streets of Ashkelon; lest they rejoice, the Philistine maidens . . . I am distressed for thee, my brother Jonathan; very pleasant hast thou been unto me: thy love to me was wonderful, passing the love of women. How are the mighty fallen, and the weapons of war perished!'[17]

The epic poems and chants lend the scribal compilations of the Bible narrative their air of deep antiquity, so that they could work backwards from the relatively recent history of David (a century and a half before) recorded in Samuel, through Judges and Joshua's conquests, to the great, seminal foundation myth of the Exodus; then further back to its patriarchal prequel, the meandering in and out of Egypt, stumbling through the dramatic epiphanies of trial and covenant: Sarah's nonagenarian pregnancy; the near sacrifice of Isaac; Jacob's exploitation of the famished Esau; Joseph's many-coloured coat and the interpretation of Pharaoh's dreams. All these fables of origination continued to be embellished, enriched, varied and repeated over many generations, to give Israelites the strong sense of divinely ordained history and imagined collective ancestry their scribes and priests believed were necessary to sustain a common identity under threat from painful historical reality.

Four separate threads of narrative were identified by the German Bible scholars of the late nineteenth century – above all Julius Wellhausen, the formidable inaugurator of the 'Documentary Hypothesis', which holds that the first five books of the Bible originated from independent cultures, each of which styled the supreme deity differently. Each of them offers distinctive versions of the same events – even the Creation – which get written over twice, and different tonal accents that testify to their respective preoccupations.

The early Jahwist or 'J' text calls the Israelite God YHWH, and since forms of that name occur in south Canaan and desert worlds,

the narrative is thought to have been initiated by southern scribes. The Elohist or 'E' text that hails God as '*El*', identical with the name of the supreme Phoenician-Canaanite deity, marks it as the work of a more northern culture. In the eighth century BCE, probably in the reign of the reforming Hezekiah, those texts were brought together. It may be that scribes responsible for the 'E' text, or their descendants (both vocational and familial), came south to Jerusalem after the destruction of the Kingdom of Israel in 721 BCE by the Assyrians, and there wove their narrative into the Judahite 'J' text. At some point in the seventh century BCE, probably in reaction to the flagrant polytheism of Manasseh, a self-consciously Priestly or 'P' text is put together with its corrective, compulsive obsessions with the minutiae of observance, the structure of the Temple, and the sacred hierarchy of tribe and people. The same thunderous trumpet note of Deuteronomy sounds towards the end of that century, as Josiah revived the reforms of his great-grandfather Hezekiah, and along with it a trenchant reworking and expansion of the histories of Joshua, Samuel, Judges and Kings: the Deuteronomist or 'D' version.

With the later prophets, though, a fifth strain registers, more poetically high-pitched and more viscerally beautiful than anything that has gone before – albeit in an occasionally trippy-delirious Ezekelian vein. It reaches its acme with whoever was responsible for 'Second Isaiah', the Book's last twenty-six chapters. References to the decrees of Cyrus the Persian date the addition to the sixth and even possibly fifth centuries BCE, and much of the writing is evidently a response to living in a world of pagan colossi and the reverence of cult images and statuary.

Second Isaiah is the first book of the Hebrew Bible to insist unequivocally not just on the supremacy of YHWH but on the exclusiveness of His reality. 'I am God and there is none else. I am God and there is none like me,' the book has the deity proclaim; 'I am the First and the last and beside me there IS no other God.' But the chapters do more than simply make a flat declaration, or give warnings against idolatry, the absurdity of which is painted in Chapter 44. A carpenter is seen at work, with his rule, compass and plane making a sculpture 'after the beauty of a man'. Then the writer switches to a vision of cypresses, cedars and oaks falling to the axe so that the same carpenter may bake bread and roast meat. 'He burneth part thereof in the fire;

with part thereof he eateth flesh; he roasteth roast, and is satisfied; yea, he warmeth himself, and saith, Aha, I am warm. I have seen the fire. And the residue thereof he maketh a god . . . he falleth down unto it, and worshippeth it, and prayeth unto it, and saith, Deliver me; for thou art my god.' By contrast YHWH is 'verily the God that hide thyself', a god without human or any other form, a god of voice and words. 'The Lord God hath given me tongue.'

Second Isaiah is conscious that his words are doing something new; not just recycling immemorial memory, an injunction to Mosaic obedience, but providing an anthem of consolation ('comfort ye, comfort ye my people'), expectation and patient hope. Through its verses runs a strain of contempt for the worldly power of empires that could not have been in stronger contrast to the triumphal inscriptions of Egypt, Assyria and Babylonia: 'Behold, the nations are as a drop in the bucket, and are counted as the small dust of the balance . . . All nations before him are as nothing; they are counted to him as less than nothing and vanity.' This is indeed a voice tuned to the needs of the powerless, the 'captive' and the uprooted. The 'new song' it sings seems tailored for those destined for displacement, for relentless journeyings and uncertain sojourns. The waters and fires of Mesopotamia lap and flicker through its verses: 'When thou passest through the waters I will be with thee, and through the rivers they shall not overflow thee; when thou walkest through the fire thou shalt not be burned.'

A central fact, possibly *the* central fact, about the Hebrew Bible is that it was not written at a moment of apogee, but over three centuries (eighth to fifth BCE) of trouble. That is what gives the Book its cumulative sobriety, its cautionary poetic, and saves it from the coarseness of triumphal self-congratulation found in imperial cultures. Even when it claims a covenanted bond with YHWH that no other nation could share, any temptation to brag of exceptionalism is undercut by the confounding epic of division, betrayals, turmoil, deceptions, atrocities, disasters, transgressions and defeats that unfolds in its pages. David's best-loved son, Absalom, is killed in a particularly horrifying way while in rebellion against his father. Solomon's imperially aggrandising kingdom lasts not even one generation after his death. King Manasseh institutes the horror of child sacrifice by fire. The Egyptians are always at one gate and the Mesopotamian empires at the other.

This is not to say, though, that the Bible was made *primarily* as a

document of solace, that from the start its scroll was spotted with tears. That would be to read backwards, to reinforce the anachronistic impression that the Jewish story is clouded with tragic foreknowledge from the start, that its words were always set down with the presentiment of impending annihilation: Babylonian, Roman, medieval, fascist. That would be to endorse the romantic tradition of the wailing Hebrew – hair-tearing, breast-beating, the *schreiyer* in the ashes. That is not to say there has been nothing to grieve for in the long story that follows – the Hebrew Bible and much subsequent history do indeed walk through the shadow of the valley of death – but its pages, and the history of Jews over the millennia, exit from the bonefield to better places, and Jewish voices change their pitch from dirge to fullthroated song more often than you would suppose.

The many generations of Bible writers made their book not assuming the worst but preparing for its possibility. That, as any Jew will tell you, is a big difference; the difference, actually, between life and death. Much of the speaking Book is not a rehearsal for grief but a struggle against its inevitability; another big difference. It is the adversary, not the enabler, of fatalism.

It is not as if the long years during which the Hebrew Bible came into being are shrouded in silence beyond the writing cells of the scribes who made it. For over a century, archaeology has liberated from mute oblivion a surprising chatter of Hebrew voices, running alongside the sonorities of biblical diction. Inevitably, their sentences are as broken as the potsherds on which they are often inscribed. Sometimes they are no more than the equivalent of a Hebrew tweet, serving notice that this wine or oil jar belongs to such-and-such, or (very often) a *lmlk* seal impression, indicating the property of the king. But sometimes (and we mere historians owe this magic unfolding to the perseverance of epigraphers) the tweets turn into true texts: stories of grievances, anxieties, prophecies, boasts. The sheer cacophonic abundance of those voices, the welter of their traffic, make it clear that there was a life in Judah and Samaria – the territory of the old united kingdom, distinct from, and not absolutely dominated by, the core narrative of the Bible. It was the difference between parchment and potsherd; the animal skin, drawn, primed, carefully inscribed, meant for ceremonious memory and public recitation; the other, ink-written

on whatever scrap of broken pottery happened to be at hand. These were simple, poor, rough-and-ready materials for whoever wanted to use them. You imagine heaps of them stacked up somewhere in the corner of a room or courtyard. The mere physical *fact* of these densely written texts, letters about a millimetre high, packed into the available space of the shard, the hand curling over the often curved surface, the scrappy to-handedness of them, is itself evidence of the craving for chatter, the uniquely irrepressible unquietness of Hebrew and Jewish culture. Sometimes the writing is so marvellously crowded onto the pottery shard that it feels the equivalent of Jews (we all know) talking over each other, not letting the other get a word in edgeways. The edgeways on these fragments are up for grabs too.

This hectic chat was not utterly separated from classical Hebrew, spoken or written. It used the same standardised alphabet; more or less the same letter forms, grammar and syntax, even though it might be written *either* right to left or the other way round. But the Hebrew of everyday life, evolving from Canaanite-Phoenician language, was unedited; fractured, packed with clumsy exclamatory energy. The Bible's eloquence is poetic; the eloquence of the clay fragments and papyri is social. But its mundane din nonetheless carries through the walls of scriptural meditation to make the Jewish story uniquely vocalised among the books of the monotheism. The Bible may have shaped Hebrew but it did not create it; rather, as Seth Sanders has illuminatingly written, it travels *through* an animated early tongue that, by the eighth century BCE, is already available for being reworked for the purposes of history, law and the necessities of genealogy and ancestry – all answers to the perennial questions: who are we, and why is this happening to us?[18] The crossovers – between sacred and social language, between oral and written, between what is distinctively Hebraic-Yahwist and what is very close indeed to neighbouring cultures (Moabite, Phoenician, even Egyptian) – all work both ways, feeding back and forth between scripture and society. If the Bible owes its infinite vitality, its pulse of earthly life amid all the visions and mysteries (the deviousness of Jacob, the irritability of Moses, the lusty charisma of David, the cowardice of Jonah, but also its harps and trumpets, its figs and honey, its doves and its asses) to its importing winningly unheroic versions of humanity from the animated matrix of spoken and written Hebrew, it is likewise true that daily existence

in Judah was also imprinted by the Bible – by its prayers and portents, laws and judgements.

The sensuous exuberance of the Bible text owes much to a writing that does not supersede the spoken language so much as cohabit with it, retaining its spirited bounce and shout. The fact that those key stories of the repeatedly Discovered Book involve both a reader and the read-to, does not mean that the listeners sit in a state of passive obedience (any more than in, say, a reading of the Passover Haggadah text now). Sometimes they take offence at the presumption that they must be read to at all. Hoshayahu, our military officer, holed up in the beleaguered fortress town of Lachish on the eve of the Babylonian invasion, found time and space to wax indignant at the assumption of his senior officer, Lord Yaush, that he was illiterate. After the usual polite preliminaries ('May YHWH send you good news') Hoshayahu lets Lord Yaush have it. 'Now then would you please explain to me just what you meant by the letter you sent last night? I've been in a state of shock ever since I got it. "Don't you know how to read a letter?" you said. By God nobody ever had to read *me* a letter! And when I get a letter once . . . I can recite it back verbatim, word for word!'[19] The letter – one of sixteen found in a guardroom by the monumental gateway when Lachish was excavated in the 1930s – is not only evidence that literacy in Judah had spread well beyond the scribal, priestly and court elite, but that ordinary soldiers like Hoshayahu, much given to 'son of a dog that I am' veteran vernacular, would make an issue of their ability to read. This letter alone goes some way to answer the question of who might be a readership for the written scrolls of the Bible, as well as a listening audience for their reading.

Education in at least the rudiments of reading and writing went back at least three centuries before the short-fused Hoshayahu. 'Abecedaries', the linear alphabet and the West Semitic script evolving from Canaanite into recognisable Hebrew (the basis for Greek and all subsequent alphabetical writing), have recently been discovered at Tel Zayit, a little inland from the coastal port of Ashkelon, dating from the Davidian–Solomonic period of the tenth century BCE, and at the northern Sinai outpost of Kuntillet Ajrud dating from the eighth century BCE. Both have all twenty-two letters of the Hebrew alphabet (though with some significant changes in order) that mark a break

from the dominant writing systems of their bigger neighbours – Assyrian and Persian cuneiform and the earlier Egyptian hieroglyphs.[20]

It may be that these practice and training alphabets were a feature of scribal education, and (pushing the evidence a bit) there have been suggestions that scribal schools could have been established throughout the country by the eighth century BCE. But it's the *commonplace* quality of the abecedaries, their strong sense of being practice tablets, stone jotters – with the direction of the word formation still variable (left to right or, as now in Hebrew, right to left) – rather than any sort of official instructional form that is actually startling and original.

Both Tel Zayit (where the letters are cut into a limestone boulder) and Kuntillet Ajrud are remarkable for being culturally provincial but nonetheless crossroads of trade, military movements and local cults. So it is entirely possible that the much greater simplicity of the linear alphabet over cuneiform meant that literacy skills – even if often exercised on functional prosaic messages – could have been spread far beyond and below the elite. The bundle of blessings, curses, hymns of praise and – most remarkable of all – stylised drawings (of women playing lyres, a cow feeding a calf and the like) at Kuntillet Ajrud suggest a kind of exuberant hubbub that spills back and forth between the realm of the sacred and the business of everyday life. In the same style, a famous ninth-century BCE farming almanac found at Gezer, in the Shephelah lowlands about twenty miles west of Jerusalem, with its months divided into agricultural routines ('a month of making hay / a month of harvesting barley / a month of vine-pruning / a month of summer fruit') also suggests a kind of writing entirely apart from the formal scribal-bureaucratic style that was the monopoly of those who ran the royal state elsewhere in the region. Sanders convincingly characterises the phenomenon as a home-grown craft writing, rather than the product of any 'Solomonic enlightenment'.

Something profound happened between the eighth and fifth centuries BCE, when the Bible was being put together, in the parallel world that surrounded the scribes and Temple priests. As a writing medium, Hebrew evolved from Phoenician-Canaanite into a standard form that was much the same language up and down Palestine (and east over the Jordan): a unified tongue, even though the kingdoms of Israel and Judah were divided (or in Israel's case, destroyed). It was a language that extended beyond the Yahwist kingdoms, for the ninth-century BCE

stone of Mesha, king of the Moabites, celebrating the liberation of his people from Israel, was nonetheless written in vigorous classical Hebrew, the language of his enemy.

Within Judah and Samaria, that same Hebrew connects rather than divides different classes of the population. Those who write petitions and those who entertain them are not cut off from each other by different language worlds. Part of the continuity may be due to the way the scribes who write on behalf of petitioners express themselves, but the same Hebrew undeniably lives in many different places, socially and geographically. It has been found (and the finds keep on coming, in what is unfolding as an exceptionally fruitful generation of excavations) in the storehouses of Arad, another military garrison town in the northern Negev, where the quartermaster, Elyashib ben Eshyahu, facing the Babylonian threat, receives letter after letter requisitioning oil, wine, wheat and flour by the donkey-load.[21] Twenty or so years earlier, a farm labourer in a frontier coastal region close to Ashdod, where a Judaean fort was holding out against the Egyptian advance against Josiah, appealed to someone in authority in the garrison for the return of a shirt or coat that had been taken from him as collateral for a loan, notwithstanding the biblical prohibition of such confiscations.[22] 'After I finished my harvesting a few days ago he took your servant's [the way the petitioner describes himself] garment . . . All my companions who were harvesting with me in the heat of the sun will testify that what I have said is true. I am innocent of any offence . . . If your governor does not consider it his obligation to return your servant's garment do it from pity. You must not remain silent.' It's a sad story but it speaks to us of more than just the desperation of a labourer to get back the shirt that had been, as he saw it, stolen from his back. It also presupposes that the petitioner knew something about the biblical law code, especially the injunctions in Leviticus and Deuteronomy against harsh treatment of the poor. It is as though elements of the 'social' commandments enshrined in the Torah had already become internalised, not just as semi-official and legal precepts, but somehow as part of the expectations of the people, protected by the Yahwist king.

Alphabetic writing is shared between God and men. YHWH, who by the sixth century BCE at the latest, is said to be the only real God, may be faceless and formless, but there are occasions when He resolves

into one revealed aspect: the writing finger. In one of the accounts of the theophany to Moses, that finger writes the commandment directly onto the stone tablet; in the Book of Daniel it writes the warning on the wall to the feasting King Belshazzar. God is the finger; God is writing; God is, above all else, words. But He doesn't keep them to Himself. Any attempt by the temple priests to make writing conditional on religious obedience is defeated by the liberated versatility of the form. The genie is out of the bottle. In fact it was at large and circulating before the Bible bottled it in the first place. So that this Hebrew writing, like so much of Jewish life that would follow, is connected, but not slavishly tied, to observance. It is off and having its own stupendous, argumentative, undisciplined, garrulous life.

There is no more dramatic instance of this independent vigour than a Hebrew inscription chiselled into the wall at the southern end of a tunnel dug by King Hezekiah's military engineers, to take water diverted from the spring of Gihon at Siloam, fed to a capacious cistern-reservoir within the city defences. The creation of the water tunnel was part of Hezekiah's strategic preparations designed to withstand the siege of Sennacherib's Assyrian armies at the end of the eighth century BCE once he had decided to trust in YHWH (whose Temple he had cleaned out of pagan rites and images) and defy the Assyrian king's relentless demands for tribute. But despite being an extraordinary feat – 643 metres long and cut clean through limestone, without the help of any vertical air or light shafts, part of a hydraulic system unknown anywhere else in the ancient world of that time – the new conduit receives only the briefest mention in 2 Kings 20 ('he made a pool and a conduit and brought water into the city') and, slightly less perfunctory, in the much later 2 Chronicles 32 ('this same Hezekiah also stopped the upper watercourse of Gihon and brought it straight down to the west side of the city of David'). But here is another way of describing, or rather dramatising what actually happened at the climax of the work itself. Remarkably, it announces itself as a true-life tale, a miniature history, the first we have of ordinary Jews getting a job done:

and this is the story [dvr] of the tunnel . . . while the men wielded the pickaxes, each man towards his fellow and while there were still three cubits to go there was heard a man's voice calling to his fellow for

there was a fissure in the rock on the right and [on the left]. And on
the day it was broken through, the hewers struck [the rock] each man
towards his fellow, axe against axe. And the water flowed from the
spring towards the pool for one thousand and two hundred cubits. And
a hundred cubits was the height of the rock above the heads of the
hewers.

The full 180 words constitute the longest, continuous ancient classical
Hebrew inscription we know of; and its subject, unlike the stones of
Babylon and Assyria, Egypt or even little Moab, is not the deeds and
renown of the ruler, nor the invincibility of their gods. It celebrates,
rather, the triumph of regular Jews, workmen – pickaxe-swingers. It
is not meant for monumental public view, but for those who, some
day, might happen upon it, wading through the sloppy watercourse.
It is a kind of ante anti-Bible; something left for posterity, but with
the casual spontaneity of someone scrawling graffiti, yet unlike graf-
fiti, cut into the rock in perfect, large (three-quarters of an inch)
Hebrew letters. All of which certainly makes it a Jewish story, too.

3

DELVING,
DIVINING . . .

How could they all have missed the tunnellers' story from two and a half millennia before? How could the procession of pink-faced Anglos – Bible scholars, missionaries, military engineers, mappers and surveyors, kitted out with their measuring tapes, their candles, notebooks, sketchbooks and pencils, accompanied by their NCOs and fellah-guides, all of them sloshing, wading and then perforce crawling on their hands and knees through the cavernous water-filled tunnel – have failed to notice those six lines of Hebrew cut into the rock wall? Or was it difficult enough making a way through the snaking passage, trying to breathe with water coming up to your chin, your candle-hand stretched to stop it guttering, without being on the lookout for inscriptions – which you expected to be out in the open air, in the light of day, not glimmering in the subterranean darkness?

None of these complications got past a schoolboy.[1] Jacob Eliyahu was sixteen in 1880, born in Ramallah where his mother had gone to escape the cholera in Jerusalem. His parents were Sephardi Jews who had come to Palestine from Turkey but had been converted to Christianity by the London Mission. Multilingual and naturally curious, Jacob had long been intrigued by the stories of the water tunnel said to wind two hundred feet beneath the Temple Mount rock, from the spring called the Virgin's Fount to the Pool of Siloam. Tall tales that a ghost or a dragon (the same that gave the name to the Dragon's Well past which Nehemiah rode) lurked within only piqued his curiosity. It was also said that the tunnel might have been built by gangs working from either end and meeting in the middle. So he recruited a friend, Samson, to start at the Virgin's Fount while he began his

exploration from the Pool of Siloam where the entrance was nearly five feet high.

Knowing it would quickly shrink to a dark, confined space, Jacob went well prepared, taking candles mounted on wooden floats and a supply of matches that he strung around his neck. But as he waded deeper the matches got soggy, the floating candles were a lost cause and Jacob inched forward, feeling his way with his fingers along the wall, the scummy wash rising up his legs. No one knew why the tunnellers had made the passage serpentine, though there was speculation that they could have been avoiding the tombs of the Judaean kings hidden somewhere beneath the Temple.

About thirty metres from the Siloam entrance, Jacob sensed an abrupt change on the face of the rock, smoothing out into what felt like a carved panel an inch or so deeper than the surface. Within this space were letters, many lines of them. The lines continued all the way down to the rising water level, perhaps even below its surface, and still he could feel little prick-points hammered in, separating the groups of letters that formed words.

Sixteen-year-olds are habitually on the lookout for secret messages. Who knew who had written this one in its mysterious hand, or when. A spy? A prisoner? A soldier? Bursting with his find, Jacob splashed excitedly to the Virgin's Fount to tell his school friend Samson the news. But Samson, a less daring boy, had long since exited back into the open. With his eyes not yet adjusted to the light, he pounced happily on the boy-shaped form he assumed was his friend. It was when the Arab woman screamed at the sodden water-spirit emerging from the tunnel that Jacob realised his mistake, not quickly enough to fend off the other women washing their clothes in the Virgin's Fount from attacking him. Once extricated from their screams and blows, Jacob lost no time in giving the news to his teacher at the Industry School of the Boys Mission, Herr Conrad Schick.

Though he had a strong hunch about its importance, Schick could not immediately decipher the palaeo-Hebrew lettering. That would have to wait for the inspection of the learned Professor Archibald Sayce, the Oxford Assyriologist who came to Jerusalem from Cyprus and squatted in the water scrutinising the letters low down on the wall, and complaining about the discomfort, while his patient helper John Slater held the candle and was eaten alive by mosquitoes. Despite

the difficulty of reading, for the incised letters had been obscured by lime silicate that had washed over them with the tunnel water, Sayce knew from characteristics like the 'conversive *vav*' – the letter 'v' made from three strokes with a short line through the long vertical shaft – and the long horizontal line at the base of the '*bet*' that were unique to Hebrew of the ninth to sixth centuries BCE, that this was Judahite writing from before the fall of the kingdom. Schick, with whom Sayce collaborated in publishing the find, had no doubt this must have been made by Hezekiah's tunnellers. They had found the lost voice of eighth-century BCE Judah.

Like everyone else interested in Jerusalem's history, Schick had read the *Biblical Researches* of the dean of modern Bible exploration, the Connecticut Yankee Dr Edward Robinson, who had plumbed the depths of the tunnel in 1838 with his learned companion the Reverend Eli Smith. It was Robinson who had first concluded that it would have needed two gangs working from either end to cut their way through 1,700 feet of rock. It had taken them two expeditions into the tunnel, 'stripping off our shoes and stockings and rolling our garments above our knees', proceeding the first eight hundred feet until the rock ceiling descended and the waters rose so alarmingly that even when crawling on all fours, progress became impossible without better preparation. So Robinson and Smith 'traced with candle smoke the initials of our names', retreated, and returned three days later to go the full distance. Though Robinson was exhaustively observant he missed the inscription, but he had seen enough to be persuaded that Hezekiah's tunnel is evidence that the Bible, or at least Kings and Chronicles where the tunnel was mentioned, was not just sacred scripture but actual, empirically verifiable history. By such discoveries, Robinson wrote, 'we are thus enabled to rescue another ancient historical fact from the long oblivion or rather discredit into which it had fallen for so many centuries'.[2]

Making the Bible fact as well as faith was Conrad Schick's obsession too. As a young, rather lonely Württemberger 'Pilgrim-Brother' in Jerusalem in 1846, he had taken solitary walks around the walls plotting the route Nehemiah had taken on his night ride in the mid-fifth century BCE. He knew every inch of walls and gates, and no one, not even the British military engineers who had made the Ordnance Survey map between 1867 and 1870, had Schick's mole's-eye familiarity with

the warren of tunnels and passages beneath the Haram al-Sharif, the Temple Mount. Between 1873 and 1875, whenever he could escape his instructional duties at the carpenter's bench in the Industry School he would study the tunnels and conduits, miles of them, as well as the tanks, cisterns and reservoir pools holding millions of gallons, that wound beneath the mosques of the Haram.

Schick had been dreaming of this place, sacred and profane, above ground as well as below, ever since he had been a young brother at the Chrischona Mission of Pilgrims at Basel, the seminary founded by the evangelical banker C. F. Spittler, who envisioned his young men manning a chain of missionary hermitages down the great rift from Jerusalem and the Dead Sea all the way to Ethiopia. As a first step, Spittler sent young Conrad to Jerusalem where he lodged grimly with another unhappy young Pilgrim-Brother, Johannes Ferdinand Palmer, took in Arab orphan urchins from the street to spare them a life of begging and, when he could, tended to his lathe and plane, making olive-wood figurines he hoped to sell to monasteries, along with the occasional cuckoo clock.

Biblical carpentry was his true passion. Had not God seen fit to bring the Saviour up in a woodworker's shop? So Conrad Schick found his true vocation as a biblical modeller. His first piece (which amazingly survives to this day) had been of the Haram al-Sharif, fashioned when he was a young seminarian in Basel; but he went on to make many more. So fine and intricate were these scale models that they drew gasps of admiration from the linen-suited classes in squalid, violent, broken-down Jerusalem, and gave credence to Schick's other claim that he was a true builder – in fact, a Jerusalem architect. Funds from a Swiss-German bank were made available for him through Jewish and Gentile entrepreneur-partners to build model (in the other sense) dwellings for impoverished Jews, without any obligation, though the evangelical side of the money naturally hoped for the admission of Gospel Light along with the natural kind. The district which filled with the Orthodox became known as Mea Shearim which, were it known to be the work of ardently Christian hands, might surprise its present-day residents.

Schick's models were praised by the British, German and Austrian consuls, and so fulsomely that it occurred to the Turkish governor, Izzet Pasha, that it might be a fine idea were Schick to make another

of the Haram that could be displayed at the upcoming International Exposition in Vienna in 1873, advertising in an elegantly indirect manner the scrupulous care the Ottoman government said it lavished on the holy places of the three monotheisms. Schick duly obliged, and in addition to his fee was given special and extremely unusual access, both to the interior of the Haram courtyards and to the excavations that were taking place during repair works to the foundations of the Dome of the Rock in the 1870s. Down the construction shafts the blinking mole clambered, then straightening out, took the detailed notes he hoped would allow him to construct the model of models, not just of the surface building but also what he called, in his mangled English, 'the substructions' below.

The Anglos – especially the engineers sent by the Palestine Exploration Fund to survey Jerusalem, above ground and below – had been there before him, in the substructions, making up in military gumption and engineering exactness what they lacked in Schickian inch-by-inch familiarity. One of them, Captain Charles Warren, rafted along the sewage using a wooden door as a punt. When the water rose so high and the roof descended, sewage punting had to be abandoned for heavy wading, the onrushing foul water lapping about his face. Its unexpected force caused Warren to swallow the pencil held between his teeth, triggering a choking fit that almost did for him. Only the timely help of his trusty Sergeant Birtles saved him – and just as well, for 'what honour', Warren wrote in his *Underground Jerusalem*, 'would there be dying face down, like a rat in sewage?'

All those stout Victorians who braved the underground effluent remarked that it ought to be possible to separate foul Jerusalem water from fair. To prove his point, Dr Robinson, with Yankee daring, sampled its quality and lived to pronounce it not altogether disagreeable. After all, it came from the natural spring of Gihon in the Kidron Valley. Above ground, though, the water available to Jerusalem's people was repellently contaminated with animal viscera and offal as well as sewage, a cholera-friendly broth that every few years would take a terrible toll. Rainwater, which by Middle Eastern standards was abundant enough in the Jerusalem winter and spring, simply ran off the stone, for want of systematic conduits and reservoirs to hold it. To those who knew both surface and substructure of the old city, this

was another shocking instance of how far Judaea had fallen from its
royal antiquity.

It was an age when, for Europeans, especially the pale northern kind,
public virtue was measured by sanitation. In Victorian Britain, Disraeli
– the Jerusalem tourist, writer of Holy Land novels and leader of the
Conservatives – had pronounced that from sanitary improvements
flowed 'most of the civilising elements of humanity', and his motto of
'sanitas sanitorum, omnia sanitas' had, he felt sure, saved lives. And if
such improvements were possible in the British Jerusalem, why not the
real thing? Holy Land tourism was booming in the middle of the century
of Improvement. Books about travel on the Nile and Jordan were being
published every year for an apparently insatiable market. The reason
was evident. Thomas Carlyle's ominous prophecy that the 'age of the
machine' would crush the spirit had not materialised – quite the oppo-
site in fact. The more industrial European society became – and espe-
cially at its leading edge in Britain – the more ardent it waxed in its
religious and spiritual enthusiasms. Machines might not have souls, but
those who paid for them and those who worked them, high-minded
opinion supposed, certainly did.

Machines could even deliver the truths of the Bible more effectively
than ever before. By the 1850s the first photographs of the Holy Land
were being printed from giant plates, replacing or enhancing litho-
graphs, paintings and steel engravings that had been the conventional
means of illustration. It would not be until the invention of half-tones
in the 1880s that those photographs could be printed up in the books
themselves, but in the meantime commercial exhibitions and albums
were available. The *look* of Palestine, of its ruins, its landscape, its
people of the three faiths, imprinted itself in the Victorian mind.[3] In
1862, when the Prince of Wales had been sent off on a tour of peni-
tence and Christian correction to the Holy Land in the company of
the Dean of Westminster, Arthur Stanley (for his mother found it
painful to be in the same room as him since she blamed Bertie's
philandering for the death of his father Albert), Britain knew all about
it and some got to see the photographs that Francis Bedford took on
the trip.

So the temptation to connect biblical antiquity with Modern
Improvement, to marry together spiritual renascence with sanitary –
and political – reform, to deliver health to the decayed Palestine,

became irresistible for the Good and the Great of Victorian Britain. Those, moreover, who were most ardent were the least literal and fundamentalist in their recovery (a word they used a lot) of the Bible for the Modern Day. Just like the German (and indeed Jewish) scholars of their time who were asserting against the most literal believers that the Book was entirely the work of divine dictation, the engineers of refreshed spirit scoffed at the more puerile claims of miracle in order to insist on the essential historical reality of the core of the Hebrew Bible as well as the New Testament. The latter required the former as its necessary precondition. Jesus was – constitutively, not incidentally – a Jew; the Old and the New Testaments were organically connected. Jewish history was the father of Christian history.

In that spirit, as much scientific as theological, they needed to know the verifiable truth of the Hebrew Bible. They thought that knowledge, not blind superstition, must be the midwife of faith. And sound, incontrovertible knowledge of what had actually happened to the Jews over the Bible centuries could only be gleaned by direct and immediate contact with the Holy Land itself. That is what Edward Robinson had meant by the title of his popular work, *Biblical Researches*. He had, he wrote, grown up with the names Samaria, Jerusalem, Bethlehem, all of which generated 'the holiest feelings', but 'in my case these had subsequently become connected to a scientific motive. I had long meditated the preparation of a work on biblical Geography.'

Two sacred books guided the most fervent of the biblical geographers: the Old Testament, and *The Engineers and Machinists' Assistant*, written by David Scott, published in 1853, the inaugural decade of continuous Bible Land exploration and learned tourism. The generation that came after missionaries and scholars like Robinson, the men who most forcefully propelled the modern effort to understand the Bible as factual history, were engineers before they were archaeologists.

The most dynamic and inexhaustible of their number was George Grove. He is remembered today almost entirely for the astonishing achievement of his *Dictionary of Music and Musicians*, but though his life in music – as champion of the hitherto under-appreciated Schubert, director of music and concerts at the Crystal Palace in its Sydenham home, and director of the Royal College of Music – was prodigious, Grove had another life as a Bible scholar, and it irked him that that

was not as well recognised. 'People will insist on thinking of me as a musician which I am really not in the least degree,' he complained. 'I took quite as much interest into the natural features and little towns of Palestine which I did for Smith's *Dictionary of the Bible* and for Arthur Stanley's *Sinai and Palestine* . . . perhaps more so.'

William Smith, the extraordinary lexicographer, had indeed hired the indefatigable Grove to help him with the concordances of Hebrew place names listed in the Bible, a great part of which Grove had already accomplished with his wife, even while running music at the Great Exhibition and after it closed at the Crystal Palace. He liked bolting things together, biblical or mechanical. Having trained as a civil engineer (the only Victorian calling arguably as exalted as the clergy), Grove had specialised in cast-iron lighthouses in the West Indies, worked with Robert Stephenson on the Britannia Bridge crossing the Menai Straits, became friend and colleague of all the engineering prometheans (Brunel and Sir Charles Barry, as well as Stephenson), and was also on familiar terms with the grandees of Victorian Britain: the Earl of Derby and the Duke of Devonshire, the scholarly William Thompson, Archbishop of York, the publisher John Murray and, crucially, the great Jewish philanthropist, mover and shaker Sir Moses Montefiore. Montefiore in particular was resolved to shake Palestinian Jews from what he believed to be their lethargy, degradation and unfortunate myopia to the blessings of the modern world; blessings he believed which in his own person had been shown to be fully compatible with Progress. After all, Montefiore's company had brought gas lighting to illuminate regions of the world that had stumbled in darkness. He liked to think of cultural and technical light in the same way. No wonder he and Grove got along. Both of them had visited Palestine itself, Grove most recently in 1859 and 1861.

Another practical-biblical tourist, visiting the country to sketch proposals for the modernisation of Palestine (including rebuilding the port of Jaffa), was the civil engineer John Irwine Whitty who, through the good offices of the British consul James Quinn and his son Alexander, had been allowed to go down into the tunnels and look at what he called 'a vast subterranean lake', and (citing Tacitus) 'a fountain of perennial water'. In 1862 he buttonholed Dean Stanley during the royal tour of the Holy Land, arguing that the insanitary and lethal horrors of the city (*everyone* complained of the reeking effluvia) would

be a thing of the past were the ancient royal Judaean water system renovated for the modern age. Back in London Whitty became a tireless champion of the Old-New Jerusalem water, lectured on it at the Syro-Egyptian Society early in 1864, and then published his visionary ideas as 'The Water Supply of Jerusalem, Ancient and Modern' in the spring 1864 issue of the *Journal of Sacred Literature and Biblical Record*.[4] To this day, for anyone interested in the history and fate of public health, a subject which has not gone away with the passing of time, Whitty's essay makes exciting reading. It is a work of hydraulic imagination and constructive urgency in the spirit of the great Roman hydraulic engineer Frontinus, in whose steps he felt he was treading.

Whitty wrote about the water needs of Jerusalem's 20,000 people as an extension of the endeavours that had tried to satisfy those of the mightily populated London and New York. He described Jerusalem as 'the metropolis of the Christian and the Hebrew nations', startlingly but typically neglecting the fact that Muslims might feel the same way about al-Quds. Jerusalem, he wrote to shock his readers, had a greater rainfall between December and March (a saturating sixty-five inches) than London experienced all year. But the water was immediately fouled by the filthy streets through which it ran, many of them with open sewage, and it was this dangerously contaminated water that was stored in the cisterns that were the city's only means of conservation. That water, the Ordnance Survey of Jerusalem reported, 'can only be drunk in safety after it is filtered and freed from the numerous worms and insects that breed in it'. And by early summer, the cisterns were in any case mostly dry. Jerusalem residents without domestic tanks sunk beneath their own houses had the choice of either buying water from the vendors who drew it from the Pool of Siloam (where women still did heavy laundry) and carried it in goatskins to their place on the street or market, or going to get it themselves the same way.

What could be done to improve matters? The answer, Whitty thought, lay in the Bible, and particularly in the Hezekian conduits beneath the Temple Mount, expanded in the time of the Hasmoneans and Herod the Great in the first century BCE. If those passages and channels could be cleared of their obstructing rubbish and impedimenta, and protected from the jettisoning of entrails and the pollution of sewage, then the waters might easily slake the thirst of the

city, and from that would come such a blossoming of Jerusalem as
hadn't been seen since the Roman destruction. 'It is manifest,' he
wrote, 'Jerusalem has in itself the necessary elements of strength
and prosperity and that without any miracle, the people in its behalf
can be fulfilled to render it a mighty city more glorious than it has
been.'

The grandees of Victorian virtue paid close attention. Dean Stanley,
who had already sold 200,000 copies of his own book about the Holy
Land, described Whitty's scheme as invested with 'a sacred halo'. The
fact that it could be economically effected with a mere £8,000 drew
acclaim from the Athenaeum to the *Jewish Chronicle*. Much was made
of Whitty's promise that this would be a joint enterprise of both Jews
and Christians. A Jerusalem Water Relief Society, patronised by the
Montefiores and Rothschilds as well as members of the British clergy
and nobility, was set up in 1864.

A year later, on 12 May 1865, many of those most passionate about
the union of biblical antiquity with modern science gathered – where
else? – in the panelled Jerusalem Chamber of Westminster Abbey
(where the usurper-king Henry IV had died in lieu of going on a
penitential crusade). Along with Dean Stanley was the learned and
zealous Archbishop of York, William Thompson, who like Stanley
had twice visited Palestine and was the author of yet another Holy
Land book, and George Grove. There too was the second-richest
woman in England (after Queen Victoria): Angela Burdett-Coutts,
daughter of a great parliamentary Radical, and granddaughter of a
banker, thus perfectly designed to be a social zealot, creator of model
homes for the East End slum dwellers, friend of Dickens and of fallen
women, inaugurator of night classes for the London poor (not to
mention patroness of the British Goat Society, president of British
Bee-Keepers, and of the newly formed Horological Society). Twin
passions had brought this extraordinary gathering together: the
biblical and the scientific, for in high Victorian England it was not
only possible but in these circles *expected* that one would be an enthu-
siast for both.

Like Edward Robinson, on whose inaugural topographies they all
relied, the founders of what became the Palestine Exploration Fund
believed that while it was wise to retain a degree of healthy scepticism
about the more improbable miracles offered up in the Old Testament

(the stopping of the sun over Ai for Joshua's military convenience, say, or Jonah's weekend in the cetacean belly), modern science – above all the sciences of accurate mapping and learned archaeology – would vindicate the Bible as, in *essence*, the true history of the Israelites, and thus the ancestry of the Saviour. The Fund, once established (and blessed, as it was bound to be, by Queen Victoria), would lend its powers to the only empire that mattered, the empire of knowledge. The mapping of the Holy Land, as they liked to call it, *pace* the inexhaustible Robinson, had barely begun and was still full of vast lacunae and unfeatured wilderness emptiness. The work that purported to provide information on biblical sites, William Smith's *Dictionary of the Bible*, was all very well, but it was an armchair gazetteer. Grove, its assistant editor, was the first to acknowledge as much. What was needed was first-hand, strictly precise observation. The Fund would be the godparent to that mighty enterprise, mapping, surveying, identifying, publishing. A true history of the Hebrews would emerge, to live for the modern age alongside its sacred Testament.

So, with Lady Burdett-Coutts's largesse in hand, the Palestine Exploration Fund was created. George Grove was to be its prime mover and, should he not be detained elsewhere with music, its secretary.[5] Military engineers would be dispatched to survey the Holy Land, beginning with Jerusalem but ultimately encompassing the length and breadth of what they called 'Western Palestine' from Mount Hermon to the southern Negev, and from the Jordan to the Mediterranean.

Subsequently, Sinai, the desert of the theophany, God's appearance to Moses and the reception of the Law – now an utterly blank zone in the map of modern knowledge – would get the same exacting treatment. No one was confident of ever mapping the journeyings of Abraham and the patriarchs from Chaldea to Canaan and Egypt – Genesis was unhelpfully vague about routes and place names, barring Bethel and the oaks of Mamre – but of the Sinaitic Exodus, somewhat more plotted, they had no doubt. It was where everything formative for the Jews, and thus for the Christianity that was its purer descendant, had truly originated. Statistical survey would sort fact from fancy, and establish exactly what the truth of the Hebrew Bible and the ancient history of the Israelites had been. Along with topographical measurement would go its kindred enquiries: botanical and zoological, hydraulic investigation and archaeology. Since this was a modern

enterprise in search of ultimate ancestry, a camera would record its steps. But first and foremost there had to be the maps.[6]

George Grove took the Fund in hand right away as its honorary secretary (Walter Besant was its working secretary) and steered it towards the union of practical science – surveying and engineering – and biblical history. What was needed were troops in the field: corps of heroes, unselfish young men who, without thought for their health or wealth, would volunteer to map, tunnel and dig for the Fund. Graduates from the Royal Military Academy at Woolwich, many of them already deployed on its British Ordnance Survey maps, were called to step up. The Palestine Exploration Fund required that they should be young men whose intelligence and integrity would be matched by the physical courage and perseverance expected from frontiersmen of the empire of knowledge. Some did indeed die from diseases, especially yellow fever; others were murdered in the desert or, like Claude Conder – the brilliant young Ordnance Surveyor, Kitchener's companion in the *Survey of Western Palestine* in the 1870s – were attacked so brutally that they never completely recovered from their wounds.

They came forward nonetheless, the Woolwich sappers. The first and most senior was the Liverpudlian Charles Wilson, who had been sent to begin the authorised surveying of the Jerusalem tunnels, tanks and water courses even before the formal founding of the Palestine Exploration Fund. His work, completed with the help of Conrad Schick's expertise, was impressive enough for him to be asked to carry out an on-the-spot 'feasibility' enquiry for a complete survey of 'Western Palestine'.

Wilson and his little corps took their theodolites and measuring chains all the way down from the Lebanon and western Syria in the winter and spring of 1866, through Galilee, where he got excited about identifying synagogues dating from the time of Christ or just a little later. The results landed Wilson the plum job at home of chief engineer of the Ordnance Survey of Scotland, leaving to those who followed – Charles Warren, Claude Conder and the young Herbert Kitchener – the work of the Survey of Palestine.

But Wilson languished in the heather and was restive at being merely a member of the Palestine Exploration Fund committee. In 1868, when it was proposed to take the survey south beyond Palestine proper into

the wastes of Sinai, he was quick to put himself forward. For those who wanted an answer to the biggest question of all – what was the route of the Exodus? (Or for the more courageous minds, had it really happened the way the Bible related?) – this was the expedition that would count most. Who knew, perhaps they would find remains of the Tabernacle, the debris of ancient Israelite encampments? Somewhere amid the desert mountains must lie answers about how the Israelites put a different mark on the history of the world; how Moses (whose historical reality no one among the Palestine Exploration Fund brigades doubted) received directly from God the laws which created the first father-monotheism and made the Israelites Jews.

Dean Stanley put the question that would guide Wilson's expedition of 1868–9: 'can a connection be traced between the scenery, the features, the . . . situation of Sinai and Palestine and the history of the Israelites?'⁷ And the composition of the corps reflected the mix of biblical piety and modern investigation: Edward Palmer was an extraordinary linguist and Arabist (whose first foreign language had been Romany, learned from the gypsy camps near Cambridge where he had grown up); the Bible scholar Reverend F. W. Holland; the naturalist Wyatt on the lookout for gazelles and mountain goats; another engineering officer, H. S. Palmer (no relation); and, indispensably Colour Sergeant James Macdonald, who was there as photographer and who produced from his elaborately made wet collodion plates images of the expedition's progress through Sinai.

By the time the Wilson expedition arrived in Egypt towards the end of 1868, a small but thriving native business had developed to service the Moses trackers. There were camels to be bought, guides to be hired, provisions that would survive the broiling heat and sandstorms that could blow in with the *qhamsin*. One establishment in Cairo owned by Carlo Peni, handily located near the British consulate, became *the* place to go for coffee, oil, tobacco, lentils, dates and dried apricots, candles, lanterns, waterskins properly seasoned so they did not taste too aggressively of goat, and the indispensable bottles of brandy that were much preferred to local beer or wine. Garrulous guides competed to offer first-hand *exclusive* knowledge as to the whereabouts of unmapped wadis and oases, desert monasteries and hermitages offering lodging, and most touted of all, a familiarity (so their custodians claimed) with Arabic place names, lore and legends

that could make *this* the rock that Moses smote for water, or *that* the valley where manna was gathered.

The expeditionaries were not, of course, entirely gullible. Edward Robinson as early as the 1830s came armed not just with a pair of old muskets but with a shrewd degree of scepticism about these oral 'traditions' and with a small library representing the accumulated wisdoms of previous generations of scholar-explorers: Burckhardt's *Travels in Syria and the Holy Land*; the seventeenth-century Dutch professor Adriaan Reland's *Palaestina ex monumentis veteribus illustrata*; and Laborde's *Voyages de l'Arabie Petrée*, which came with large folding maps of Sinai. Other favourites of the trackers of the 1840s were the works of Samuel Sharpe, the Unitarian Egyptologist, and the German theologian Ernst Wilhelm Hengstenberg's *Book of Moses Illustrated with Egyptian Monuments*. Robinson and Smith travelled simply, riding horseback, with their cook on a mule, and the Arab guides and servants on the eight camels of the baggage train. By the time that the artist R. H. Bartlett arrived for his 'Forty Days in the Desert on the Track of the Israelites', the recommended train and supplies had grown considerably, and it was now de rigueur to ride dromedary yourself and to write about the experience (seldom pleasant) for the readers back home. Wilson's Ordnance Survey team was a veritable caravan numbering a hundred camels strung out along the desert.

Whether scholars, artist-amateurs, 'biblical geographers' or engineers, the questions which determined their itinerary were always the same. Where exactly was the 'Land of Goshen'? Where was the most likely location for the passage of the Red Sea? Could that miraculous escape be explained by east-wind driven storms? (Whole volumes attempted modernising explanations of the ten plagues: the blooding of the Nile was an unusual freight of the red silt; cattle murrain was . . . cattle murrain; the darkness an eclipse, and so on.) Which among contending springs and wells had produced the 'bitter waters' of Marah that the Israelites were forced to swallow prior to setting off into the wilderness? (The travellers always made a point of tasting the waters at Ayn Musa, the Well of Moses, to sample its bitterness and usually pronounced it unobjectionable.) Which of the two likely candidates for the true Mount Sinai (complicated by the fact that Deuteronomy called it Mount Horeb) was the real one: Djebel Musa, the tallest peak and the site of the famed St Catherine's Monastery, or Djebel Serbal,

some way away with its spectacularly wild ravines and multiple peaks? Which of the two had beneath it a plain big enough to hold the two *million* Israelites (600,000 men plus wives and children, if you do the Bible sums that way), not to mention their flocks and herds, said to have assembled beyond the Red Sea, with a clear view of Moses descending with the tablets of the Law?

The Moses-hunters thought of themselves as modern men, but equally, like Dean Stanley, they were eager to surrender themselves to transports of identification with the Israelites and their leader. 'We were undoubtedly on the track of the Israelites,' he wrote excitedly in 1852; he believed the wild thorny acacia that dotted the desert were the wood of *shittim*, prescribed for the Tabernacle in Exodus 30, but which must also have been the Burning Bush. A piece of the learned divine wanted to be on guard against ridiculous fables, but at Ayn Musa – which claimed to be the place of landing and setting-forth – Arthur Stanley dissolved into a full-on Victorian scriptural romance. 'I saw tonight both at sunset as the stars came out and later still by the full moon, the white sandy desert on which I stood, the deep black river-like sea and the dim silvery mountains of Atakah on the other side.'[8]

In Edward Palmer, the Wilson Survey had its eccentric lyric poet as well as its ethnographer of the Bedouin, scholar of the Muslim variants and traditions of the Moses epic. He carried with him a healthy scepticism about the usual guff peddled by guides and monks to the Sinai pilgrims and tourists, but there were places out in the deep mountainous fastness where he too surrendered to ecstatic wishful thinking: 'whatever we think of the authenticity of some of these traditions we cannot quite divest ourselves of reverence'. At a cleft in the rock face at Ras Sufsafeh, Palmer pushed science well to the back of his mind and surrendered to theophany, registered with a burst of Ruskin-like mountain-poesy: 'a stately awful-looking mass as if it is rearing its giant brow above the plain as if in scornful contemplation of the world beneath. What scene so fitting to witness the proclamation of the primeval law as those hoary rocks?'[9] Illuminations arrived, one succeeding the next. 'At this secluded spot Moses may have separated from the Elders as it requires but little imagination to believe that from the cleft itself the Ten Commandments were proclaimed . . . Who can say that it was not on the very

blackened earth before us that hungry Israel was tempted to sin and ate the offerings of the dead?'

The optimism of 'sacred geography', as they called it, began to overwhelm the obligations of science. Even when the Ordnance Survey map of Sinai was published in its great blue folio volumes in 1870, the relevant chapters and verses from Exodus were printed above its place names. Hence the Plain of Raha was superscripted 'Exodus XIX, 12' to identify it as the place of Israelite assembly before the true, smoking Mount Sinai/Horeb. Palmer's optimistic claim that stone foundations found at a desert oasis must be the untouched remains of an Israelite encampment went unchallenged. And in another crucial aspect, the work of the Sinai Survey served to make Exodus 'real' in the minds of those who followed in their footsteps – archaeologists, surveyors, soldiers – as well as the vast reading public of Europe and America, through the astounding photography of James Macdonald.

Despite all the extreme physical difficulty of making wet collodion plates in the broiling desert, allowing for interminable exposure times and then developing in his tent, Macdonald's theatrically sublime images of the Sinai ranges imprinted themselves on the imagination of those who wanted to visualise where Moses had stood and received the commandments and the law from God. He knew exactly what he was doing, finding small natural amphitheatres closed off from the valley below and sheer cliffs rising to fortress-like needle peaks that seemed to touch the heavens. The colour sergeant may even, like Edward Palmer, have been shaken into absolute belief himself. But there is no doubt that those who bought his stunning album of a hundred prints (of three hundred taken), or the even more spectacular stereoscopic images, thought they were looking at the place where the creation of true Mosaic monotheism had occurred.

It was, then, the alliance of word, image, survey and map that actualised this formative moment in the story, which was only instrumentally that of the Israelites but had taken place, as the sacred geographers saw it, for all of humanity. The narrative was resoundingly clear. Out of the pagan world, a liberated slave people, fitfully exposed by the patriarchs to Jehovah's covenant in remotest antiquity, had been reborn, almost certainly sometime in the thirteenth century BCE during the reign of Rameses II, through the exodus theophany. The law received by Moses and passed on, as Deuteronomy related,

as legacy before his death at Mount Nebo, gave the Israelites their sense of covenanted uniqueness as they entered Canaan with conquering Joshua, and created eventually the Davidian state centred on Jerusalem. That uniqueness would be differentiated by its devotion to a single formless faceless God amid the empires of the many-gods, would be encoded in the Bible, physically instituted in the Temple, and endured beyond all worldly destructions.

The fact that these core truths were communicated in the language of modern science invested the Bible with its historicity. The most improbable miracles might be discounted as poetic licence, but just as philologists were identifying and roughly dating the several threads that made the biblical text, so this late-nineteenth-century generation reckoned it was pioneering the rediscovery of the Bible as history. It was the birthing moment of biblical archaeology, all innocent of any sense of oxymoron. The empirical vindication that Dean Stanley had hoped for at the time of the Palestine Exploration Fund's foundation would become the vocation of generations of archaeologists from Charles Flinders Petrie at the turn of the century, through to William Foxwell Albright, the missionary's son, between the world wars, and Israeli soldier-archaeologists like Yigal Yadin.

Disappointingly, no trace of evidence that Israelites had ever exited Egypt, wandered in the Sinai wilderness for forty days much less forty years, before conquering Canaan from the east, would ever come to light, despite an ongoing hunt of a century and a half. The sole Egyptian mention of Israelites from the period of the eighteenth dynasty is that triumphal record of their defeat and scattering. But then, as biblical optimists have pointed out, why would the Egyptians have wanted to commemorate the annihilation of their own army?

But before the exodus is dismissed as fictitious epic, one question, albeit speculative, won't go away. No scholar quarrels with the archaic antiquity of the earliest elements of the Hebrew Bible: the Song of the Sea and of Moses. A strong consensus exists that their form is consistent with other similar archaic 'song' literature from the late Bronze Age Near East of the twelfth century BCE. If that's correct, even though the Song of the Sea has much in common with the Phoenician epic of the storm god Baal's conquest of the sea, why would early Israelite poets have created, perhaps just a century after the purported event, their own identity-epic, in which the degrading

element of enslavement and liberation is entirely distinct from other archetypes, if there was nothing to it lodged in the folk memory? The most sceptical view presupposes an indigenous subset of Canaanites, settled in the Judaean hills, differentiating themselves from the rest of Canaanite tribes and states, through a mythic history of separation, migration and conquest, all with exceptionally detailed topography. Why *that* story?

So this is where we are in the true story of the Jews. No evidence outside the Hebrew Bible exists to make the exodus and the law-giving dependably historical, in any modern sense. But that does not *necessarily* mean that at least some elements of the story – servile labour, migration, perhaps even incoming conquest – might not, under any circumstances, have happened. For some chapters of the Bible story, as we have already seen, if only in the depths of Hezekiah's watercourse, were incontrovertibly true.

History, though, cannot be constructed from absences or negative inferences. In 1973, it was another crossing of the northern, Suez branch of the Red Sea (where the Victorians believed Pharaoh's armies had foundered) that triggered a wave of aggressive academic scepticism about the premises on which biblical archaeologists since the Palestine Exploration Fund mappers had based their enquiries. On Yom Kippur Egyptian armies crossed the waters in a surprise attack on the Israeli Defence Forces' advance positions on the canal. A bitter, difficult war followed. Israel's power survived, but the country was irreversibly chastened by the shock of the reverse exodus.[10]

And the archaeological excavations undertaken in the 1950s and 60s designed to deepen Israel's connections with its ancient antiquity were themselves attacked for making the discipline merely a branch of biblical vindication. Archaeology in Palestine, it was said, should cast aside its obsession with hunting for verification of the Joshua conquests, traces of David's citadel or Solomon's Temple, for the good reason that independent archaeology would never find what the biblical wishful-thinkers wanted, because the cold scientific facts were that outside of the literary fictions of the Book, none of it had ever existed.

Looked at coolly, impartially, dispassionately, what could be reliably said from the archaeological record? That by his own account, an Egyptian pharaoh had triumphed in a thirteenth-century BCE northern

campaign over Israel, not the reverse; that there had been massive destruction of ancient rich Canaanite cities in Palestine like Hazor around the same time, but that the devastation was most likely inflicted by 'sea peoples', not the wandering, hill-country Israelites; that settlements in the Judaean hills in the twelfth and eleventh centuries BCE suggested nothing more than rudimentary pastoral hamlets; that Jerusalem itself, built on the remains of Jebusite structures, was a modest, rustic enclave; that there were no signs whatsoever of Davidian or Solomonic imperial structures, much less anything truly resembling an Israelite-Judahite 'state' with a literate bureaucracy akin to Egypt, Phoenicia or Mesopotamia. The monumental gates, walls, storehouses and purported stables excavated by Yadin at Megiddo and other similar places were evidence not of Solomonic grandeur, but were works dating from the late ninth century BCE – so the dean of the 'low chronology' critics, Israel Finkelstein, argued. This would have them built by the descendants of Omri, the king of the northern kingdom of Israel. The most likely master builder was the ruler attacked by Elijah in the Book of Kings, Ahab, whose Phoenician queen, Jezebel, reintroduced the pagan polytheism of her native country into Israelite worship. In this sceptical view the powerful structures at Megiddo and Hazor could not have been the work of the kings of the 'United monarchy' stretching from the northern Galilee to Beersheba, for the reason that no such realm ever existed. Rather, two separate mini-kingdoms, Israel and Judah, grew up side by side; the former more ambitious both politically and architecturally, more likely to flirt with Phoenician paganism, and sufficiently sophisticated to produce its hill-fort cities.

The effect of this flattening 'negative archaeology' was, of course, political as much as scholarly. The narrative of Jewish singularity, of a 'peculiar people' separated out from the 'nations', especially Egyptians and sea-people Philistines, by virtue of the exodus and the law-giving on Sinai, and their conquest of Canaan in accordance with the Abrahamic covenant, was now held to be profoundly unhistorical. The epic of self-discovery, of separation into distinctiveness (if not uniqueness) was, in this view, the retrospective invention of the Hebrew Bible written in exile, not the true story of the Israelites at all. That real story would reveal a tribal subset of indigenous Canaanites who, after the collapse of their culture at the end of the Bronze Age, moved east

(not west from Transjordan) into the safer but more primitive hills of Judaea, and eventually took over the ancient Jebusite citadel of Jerusalem. But that version of Canaanites-with-a-difference would have diluted Israelite distinctiveness rather than sharpened it in the way myths of ethnic origins require. The Jews would become just another un-peculiar variety of western Semites. And so they remained for many centuries in tribal rusticity. In all likelihood, in this sceptical view, King David never lived or reigned, except in the romantic imagination of the Bible writers of the Babylonian exile.

What was added by historians of early Israelite religion subverted the myth of distinctiveness still further. Instead of a dramatic mass conversion to exclusive worship of the formless, faceless YHWH around the time of the revelation on Sinai, archaeological evidence from Palestine showed how close Israelite religion was, especially in what had been thought to be its formative period from the twelfth to tenth centuries BCE, to that of its surrounding neighbours.[11] 'El', the Hebrew word for God in the 'E' text of the Bible – and in Jewish prayers ever since – was shared with the Phoenician religion, as was the plural-sounding derivative 'Elohim'. The storm god who appears to the Israelites in a smoking volcanic cloud, and who drives the sea apart, was likewise close to identical with the Phoenician Baal. The very cult objects, images and practices which the prophets castigate as idolatry in Judges, Kings and Chronicles – stylised trees and 'pillar' figurines in the form of women supporting full and heavy breasts (which must have had associations with fertility) – appear throughout Palestine, north and south, including Jerusalem and Judaea, to at least the ninth century BCE.[12]

Those figurines have often been associated with the persistent cult of Astarte or 'Asherah', the consort-wife of God, common throughout the region.[13] A famous eighth-century BCE inscription at Kuntillet Ajrud mentions 'YHWH of Samaria and his Asherah', allowing little room for doubt that in the religion of the people, rather than the one prescribed by the priests of the Temple, Asherah and YHWH were not seen as mutually exclusive but actually a celestial couple.[14] Of course, the biblical prophets are constantly railing against the habitual reversion of the fickle Israelites and Hebrews to worshipping false gods and idols. The impression given by the Bible is of a cyclical swing between the cult of many gods and the cult of a single exclusive

YHWH. But there may have been a prolonged period in which YHWH
was worshipped as top God rather than the only God. Even the first
of the commandments says 'Thou shalt have no other gods before
me', presupposing that there were others – a matter of seniority rather
than exclusiveness. It is only with 'Second Isaiah' as late as the fifth
century BCE, that the first explicit statement of 'Yahweh Alone' is made
categorical. For many centuries, a much more pluralist and syncretist
religion – of the domestic hearth, the farm and the town, featuring
especially the cultic pillars, the unfeatured standing stones called
massebot found all over Palestine – coexisted alongside the strictures
of priestly law coming from the Temple. At Arad, the fortress town
in the northern Negev, a tenth-century BCE small 'temple' has been
identified, built on the site of an earlier cultic place, complete with a
stone altar, with the usual horns at the corners, for the sacrifice of
animals and birds, and in a raised niche two *massebot*, one painted red.
Potsherds found nearby have names from priestly Jerusalem families
mentioned in the books of Jeremiah and Ezra. The Arad mini-temple
was precisely the kind of transitional cult place, full of ritual objects,
that the purges of Hezekiah and Josiah struggled to suppress. When
the site was excavated the small subsidiary altars were found over-
turned and plastered over, which does indeed suggest an official ending
to the henceforth unauthorised satellite temple.[15]

What does this all add up to? The contention of these ultra-
revisionists is that the Bible should be treated as nothing more than
the fantasy of exiles, played back in time, and answering to the need
for a myth of 'coming-into-being' as a distinctive people. That biblical
epic of ancestry relates the history of a nation fully formed at its
moment of origination as one-God worshippers, who then take that
cult with them into Canaan and institute it in the Jerusalem Temple.
It is not to be confused with history.

But this 'minimalism' has been a massive over-correction, now
confounded by much recent archaeology and sensitive revisiting of
earlier evidence like the Siloam Hezekiah Tunnel inscription. It is
already apparent that the 'minimalist' view of the Bible as wholly ficti-
tious and unhooked from historical reality, may be as much of a mistake
as the biblical literalism it sought to supersede. Though a work of many
centuries and generations, the Hebrew Bible itself could not have *begun*
in the Babylonian exile, much less have been mostly written still later

in the Persian and Hasmonean periods as the ultra-revisionists claim. For a precious amulet – in the form of two tiny silver scrolls, one of them bearing the Hebrew verses of the priestly blessing, originally written in the Book of Numbers, and to this day used in synagogue services on holy days – was found in 1979 in one of the burial caves of Ketef Hinnom, south-east of Jerusalem, by the archaeologist Gabriel Barkay. In all likelihood the scrolls were worn in rolled form on the upper body, as a talisman, invoking the blessings of God against evil and misfortune. Whoever wore them had substituted the words of the Torah for what elsewhere would have been an image of a protective deity. And startlingly, irrefutably, they have been dated with precision to the late seventh century BCE, the reign of the reforming Temple-cleanser and Book 'discoverer', Josiah.

So although the earliest complete texts of books of the Bible are the Dead Sea Qumran Scrolls securely dated to the third and fourth centuries BCE, the silver scrolls of Ketef Hinnom push the date of writing back to the late-Judaean monarchy. Since Aramaic largely replaced Hebrew as both spoken and written language by the fourth century BCE, it seems unlikely that most of the Bible could have been written by that date. Even with Hebrew preserved as the language of the priestly and scribal classes, it's known from the much later apocryphal and wisdom books among the Dead Sea Scrolls that Hellenistic 'modern' Hebrew is of a drastically different character and style from the 'classical' Hebrew in which most of the Bible is written. It was always improbable that amid the devastation and depopulation that followed the Babylonian destruction, the kind of literary exuberance and power needed to put the Bible together could have been flourishing in the sixth and fifth centuries BCE. It makes much more sense to see the Bible texts arising from the yeasty Hebrew – shared by the people's tongue, the priestly poetry and the scribal skills – in the late eighth century BCE monarchy of Hezekiah's Judah. The later, sterner strictures of the Deuteronomists – their religion of the 'empty throne', wiped clean of any cultic figures, the sacred shrine occupied only by the Torah and the *kabod* (the ineffable glory of YHWH) – then gave the Bible its harder form, two centuries later, before and after the Babylonian disaster.

With every new discovery a more nuanced picture of the earliest history of the Jews is being sketched in – one not of course identical

with the narrative of the Hebrew Bible, but one not *entirely* discon-
nected from it either. In 1993, a ninth-century BCE stone stele was
discovered at Tel Dan in far northern Israel, bearing an Aramaic
inscription of the Aram king Hazael celebrating his victory over the
king of Israel and, explicitly, in line 31, the 'House of Dwt'. So much,
then, for the minimalist assumption that David and his dynasty
were the imaginary invention of later generations of scribes. The
story of the emergence of a distinctive Israelite state and Hebrew-
language culture needs to be uncoupled from the story of the Jewish
monotheism, brought together by the Bible writers as though, from
the very start, the latter defined the former. That is manifestly not
the case. But the two elements of a distinctive Jewish history – state
and story – *did* evolve and in some connected way, the one braiding
around the other, often fraying, sometimes torn off altogether, long
before they found the tight weave of the canonical Bible text.

There is no longer any doubt that a Jerusalem-centred mini-state
– with a probable population in the time of Josiah and Hezekiah of
around 40,000 in the city alone – was far more than the largely illit-
erate 'cow town' to which ultra-minimalists have relegated it. Provincial
city-forts like Gezer and Hazor were formidable establishments,
boasting six-chambered gates, fortified quarters for local officials, paved
ways and piazzas, capacious storehouses and stables. And they were
constructed not of rubble stone but ashlar – dressed and smoothed
masonry, often of imposing size. The organised labour and engineering
needed to make such places presupposes the heft and hierarchy of an
ambitious military state. Ramat Rahel, on the southern side of
Jerusalem, had what Y. Aharoni and Ephraim Stern confidently describe
as 'the last royal Judaean palace' built of fine limestone masonry, a
courtyard decorated with proto-Aeolic capitals and carved window
balustrades made of exquisitely scroll-like heads and 'fallen leaf' motifs,
entirely apt for a place facing Assyrian destruction.

From little, often minute things, a big picture emerges. Those small
objects are seal impressions, pressed into clay or wax by seals cut from
hard semi-precious stones, and which were once attached to docu-
ments written or sent by officials of the king. Fifty-one of them alone
were found in excavations in the City of David. Sometimes they are
no more than the petalled rosettes (very beautiful in their simplicity)
that seem to have been the personal stamp of the Judaean kings. But,

in the Near Eastern way, often they picture beasts, birds, heavenly bodies: beetles; a winged sun-disc; the roaring lion of Shema, servant of Jereboam (most likely King Jereboam II of Israel); a monkey; a lily; an ass; the lyre that indicated a royal princess, Ma'adanah, daughter of the king. Looking at them under the glass restores to life not only the important men 'Over the House', as the bureaucratic phrase went – a *sar'ir*, governor of the city – but the many under the House: the craftsmen and artisans who fashioned the seals. And others too, suddenly brought together in the community of picturing and writing: those who incised letters into pots and jar handles, often *lmlk* for the king, but also signifiers of property – Shalomit, daughter of Zerubbabel; Avanyahu, servant of the king.

These are not masterpieces and that is the point. Unlike some Egyptian and Mesopotamian sites, what the fragmentary potsherd documents, the seals and jar-handle inscriptions suggest is a great web of connections wound across the territories of Israel and Judah, from Samaria through the Judaean hills and down into the Negev, binding together the worlds of religion, military power, the operations of the law, the gathering of taxes, the needs of the table, the delight of the eye (those proto-Aeolic capitals!), the stamp of ownership, the authority of the king, and even the calendar of the farming life.

For those who remain unconvinced that this has any connection to a world pictured in the Hebrew Bible, even inscriptions in the name of 'Gedaliah Over the House' – the governor appointed by the Babylonians after the destruction of Jerusalem – or Gemaryahu son of Shaphan specifically mentioned in the Book of Jeremiah, won't be enough to undercut the conviction that the Bible was exilic retrospective fantasy.[16]

But then there is the view from Khirbet Qeiyafa. I first saw it in the early spring of 2011 with the archaeologist Yossi Garfinkel of the Hebrew University of Jerusalem, who is continuing to excavate the site.[17] The low hill is in the Shephelah, thirty kilometres south-west of Jerusalem, on what has always been assumed to be the frontier zone between the Philistine-dominated plain and the Jerusalem hill state of the Judaean monarchy. In early April the countryside is spectacularly fertile, so lushly green you can forgive the Victorian travellers for constantly making comparisons with Kent and Yorkshire. Winter rains have filled brooks and ponds; ancient oaks are already bright

with leaf; meadows are sprinkled with wild flowers. One of them, a wild lupin peculiar to a neighbouring hillside, grows so intensely blue that it draws botanical pilgrims from all over Israel to marvel at its dense, brief flowering. Later that week I'd met Jerusalemite writers, embattled as usual with the country's trials, who wanted to do nothing but talk, for once, of lupins.

But Khirbet Qeiyafa sits in a place of unflowery strife, past and present. Its hill, like the neighbouring sites of Socoh and Azekah, mentioned in Joshua 15:35, commands the ancient roadway between the hill cities of Hebron and Jerusalem and the coastal plain of Philistia. To the west would have been the Philistine stronghold of Gath (located at the present site of Tel Safi). Because the valley of Elah below Qeiyafa is the site where, according to the Book of Samuel, the shepherd boy David slew the Philistine warrior-giant Goliath, the Bible-tracking Victorians all made sure to pass through without paying close attention to the low wall on the brow of the hill, facing (as it still does) the encampment where Bedouin come to park their flocks in the bright pasture. Khirbet, after all, means 'ruin' in Arabic, and the Victorian mappers had already seen enough to last a lifetime. This one was 'just a pile of stones', Conder wrote shruggingly.

It took some time to realise that Khirbet Qeiyafa was far more than that. That it was a site of some significance had been clear from the 700-metre wall encircling the five-acre settlement on the crest of the hill. But from the relatively small size of the stones visible on the wall it looked to be a structure of the Hellenistic period between the late fourth and second centuries BCE. It was only when Saar Ganor, then one of Garfinkel's students surveying the site in 2003, noticed a glaring size difference between the stones on the superstructure and much larger blocks below, half concealed by a rising curtain of weeds, that it became apparent that there might be a much older dwelling at the base. Clearing away the brush, the scale of these stones revealed themselves as megalithic, some as much as three metres long, some of them weighing as much as five tons. These were building blocks that would have required massive mobilisation of labour, nothing that an isolated peasant village could have accomplished. Better yet, beneath that layer of what the archaeologists call 'cyclopean' (that's to say, gigantic) stones was solid bedrock. So unlike many sites that had experienced periods of habitation and

destruction, this one had been built, inhabited then suddenly aban-
doned and only reoccupied during the period of its Hellenistic
topping. There would be no jumbling of artefacts to muddle its
chronology.

Excavations beginning in 2007 exposed a densely inhabited fortress-
settlement home to around five or six hundred people, divided into
a lower city and an acropolis on the summit. The defensive perimeter
was casement: an outer and an inner wall separated by space enough
for stores, guards or even rudimentary accommodation. Since case-
ment walls largely disappear from such sites after the tenth century
BCE, this is another indication of an earlier date, most likely from
the united not the divided monarchy. Directly abutting the walls
were numerous domestic dwellings, many of them four-chambered.
In the middle of the western face of the wall was, unmistakably, a
broad monumental gateway, its stones some of the most 'cyclopean'
of the site. Later excavations exposed what Garfinkel believes (not
uncontested) to be a second gateway at the other end of the fort,
persuading him that Khirbet Qeiyafa (or, as the Israelis have now
called it, 'Elah Fortress') is in fact the uniquely two-gated Sha'arayim
mentioned in Samuel.

Yossi Garfinkel is not a biblical romantic. He does not see himself as
a recruit in the Bible wars, between old-style zealots who insist on a core
of historicity in the books, and those who believe them to be an entirely
literary construction, especially in their depiction of a centralised
Jerusalem-based monarchy ruled by the imaginary David. 'I'm not reli-
gious!' he protests to me on a visit a year later. 'My wife grew up on the
only kibbutz to raise pigs. I have no stake in making the Bible true or
false. I just see what's in front of me.' Whether he likes it or not, though,
Garfinkel is caught in the crossfire, especially since before excavating
Khirbet his speciality was Paleolithic and Neolithic history, and the way
he sighed while explaining the battles that had come his way above the
valley of Elah, there are days I suspect he might sometimes wish to go
back to that earlier, quieter age. But he is stuck with Qeiyafa because
the implications of what has been revealed are so explosive.

What can hardly be disputed (though naturally it has been) is the
antiquity of the fort. Burnt olive pits found on site, subjected to
exacting carbon-dating examination in faraway Oxford, were dated to
the late twelfth or early eleventh century BCE. This makes Qeiyafa

indisputably an Iron Age stronghold, but *whose* citadel? Its strategic importance is self-evident, but it is right on the moving frontier between the Philistine power on the plain and Judaean settlements in the hills; Gath in one direction, Jerusalem in the other.

With no axe to grind, Garfinkel became convinced it had to be a work of Israelite Judaea, not Philistia. He insists the back casement walls doubling as the front walls of domestic dwellings are unknown on Canaanite sites, and anticipate identical configurations at other indisputably Judaean forts at Arad, Gezer and Beersheba. It is also true that in late-Canaanite culture, new settlements and fortifications are generally built atop the remains of anciently inhabited sites. Iron Age Khirbet Qeiyafa on the other hand, was raised on a completely fresh strategic hilltop site, strongly arguing for it being an outpost of a new, rapidly emerging warrior and cult-driven state.

Then there is the matter of what was *not* found at Khirbet Qeiyafa, namely the bones of pigs. Bone remains from every other known domesticated animal – goats, sheep, donkeys and cattle – were discovered in their *thousands*, but not one from the swine forbidden by the dietary strictures of Leviticus and Deuteronomy. Sceptics have been quick to point out that abstinence from pork was widespread in the entire region, so that the absence of pig remains is not, of itself, any kind of evidence of Judaic settlement. But the pork aversion, due probably to trichinosis brought on by the infection of pigs by roundworm larvae, is usually dated two centuries later than the olive stones of Qeiyafa. And the single local culture which persisted in eating pork was the very one directly confronting the hill fort: the Philistines.

And then, in a water conduit, on one of the annual summer digs, a clay potsherd, inscribed with alphabetic words written in ink, was momentously discovered by one of the student volunteers – as potentially momentous in its way as the abecedary of Tel Zayit or the tunnel story at Siloam. There are six lines of writing, but many of the words and letters remain teasingly indecipherable, either because of the faded condition of the ink, or because it is not yet indisputably clear which language they are written in. The letters might be proto-Phoenician, the alphabetic language out of which 'old' Hebrew eventually emerged, or they might as easily be an embryonic stage of that Hebrew itself, consistent with the spread of literacy in the Shephelah controlled by the Judaean kingdom the minimalists believe never

existed. Taken together with the Tel Zayit abecedary, of an equally early date, though, evidence is mounting that the spread of alphabetic, scribal writing in the western hinterland of Jerusalem was burgeoning, almost certainly earlier than has yet been acknowledged.

None of this is quite enough, however, for those who have rushed to proclaim the site as not just an outpost of the Davidian state, but a place aware of a Bible that must have been written before the eighth century BCE.[18] A Haifa University historian, Gershon Galil, proposed a reading of the pottery shard – 'judge the widow and the orphan . . . restore the poor at the hands of the king; protect the poor and the stranger' – that makes it sound like a rehearsal of ethical precepts uncannily like those found in Exodus, Isaiah and Psalms. Galil also had no trouble seeing words like 'asah' ('it is done') that were unique to Hebrew. Those who fiercely dispute Galil's reading as overly imaginative fail to see such words, and those they do see are said to appear in non-Hebrew texts elsewhere. Haggai Misgav, the epigrapher asked by Garfinkel to study the inscription, makes out far fewer decipherable words, although one of them does indeed seem to be the Hebrew for 'judge'. But versions of the message can also be read to disclose cryptic hints of revenge, or even the names of persons.

What is apparent, though, is that the writing in Qeiyafa consists of something more than just an arbitrary assembly of disconnected words; that they form a continuous text and most likely a communi- cation of some sort from someone to someone else. Not enough? Enough at any rate to make Sha'arayim somewhere that like Arad later was a strategic outpost, a place to write to, to enclose a hum of inhabitants – soldiers, their wives and children, scribes, farmers and traders – by the standards of the Iron Age a little town. And it's the remains of that world, its daily routines, that fire my imagination most excitedly as we stand in the sweet spring air of the Shephelah: the standing stones of one chamber that Garfinkel believes are the hitching posts of a small stable, probably for draught animals. Further down on the site we squat to look at Iron Age kitchenware: a grind- stone; another with raised points that could have been used to rasp and grate. On one of the digs, along with all kinds of bright red domestic ceramicware – jugs and amphorae – a very beautiful baking tray was found. I am suddenly at home in this kitchen, preparing a meal, reaching for the oil.

Yossi stands up, arms akimbo, and surveys the whole place, antici-
pating another season of the dig coming in the summer, imagining
the 'pile of stones' as an educational archaeological park for school-
children from all over Israel. He is not remotely a zealot, not the kind
of archaeologist like Palmer who went to the Holy Land with a trowel
in one hand and the Bible in the other. All he is after, he says, is the
truth. Something between a smile and a frown settles on his friendly,
owlish face. 'Look, you need real builders to make such a place, the
steps, the streets, the casemate walls; it's not something a bunch of
shepherds could or would do. You need some sort of state that can
draft the labour to get stones this big here – some of them are even
more than five tons apiece. You need taxes, a written culture. And
this isn't the Philistine version.'

He looks down to the ancient war-zone borderland below. His
battles will go on elsewhere, in the pages of learned journals, in
conference sessions and museum conservation labs. There will be
shouting, much exchange of mutually dismissive retorts, barely this
side of outright abuse. Garfinkel has already been accused of being
an accomplice of the resurrected 'maximalists' merely by describing
Khirbet Qeiyafa as belonging to 'the time of David', as if to invoke
him is to make an imaginary figure illegitimately real.

But with every season, the evidence pointing to a First Temple
Israelite military outpost accumulates with persuasive power. Thousands
of weapons, sword and spear blades, shafts and arrows have been
discovered. There are, however, no agricultural implements at Khirbet
Qeiyafa, which for Garfinkel confirms that the fort took tax and tribute
from the cultivators and pastoralists working the fields below – another
sign of the assertion of lordship power. The notion that a First Temple
dating means buying into the biblically imagined 'palaces' of David
and Solomon, he dismisses as missing the point. 'Look, I am not arguing
that the Israelite state that built this place was an *empire* or even a big
kingdom. No, the Jerusalem that built this was a little state – like Moab
and other neighbours – but a real state nonetheless, reliant on some
literacy, capable of mobilising labour, raising taxes, engineering walls
and gateways, organising defences.'

This does not, itself, make Iron Age Khirbet Qeiyafa Israelite. But
the most recent excavation has turned up objects which may turn out
to give the site its undeniable, clinching identification: two small

portable, model shrines, one in pottery, the other limestone. They were found in one of the three cult rooms of the site: chambers where *massebot* standing stones were also discovered. Some of those rooms are a little larger than the regular living spaces as if dedicated to devotion, and one of them – where the shrines were found – has an unmistakable flight of steps that passes through a small fountain, evidently used for ritual purification, a drain leading off and outward beside and through the walls.

Is this starting to sound familiar, just a little bit *kosher*, even? Fight as any dug-in sceptic against biblical association must, it is the little portable shrines, the clay no more than twenty centimetres tall, the stone thirty-five, which, when put together with all the other evidence, do seem to point in one inescapable direction. To begin with, the cult rooms themselves are part of the domestic dwellings, even if it is easy to imagine they might have been used in common by immediate neighbours. But in keeping with the emphasis in Israelite religion on the ubiquitousness of the sacred – sanctifying the local – the mini-shrines would have brought a material version of the Tabernacle or even Temple into those houses as a focus of veneration. To be sure, private, domesticated cult objects are found all over the Semitic Near East, but they are mostly images of the deities themselves or of celestial kings or their animal embodiments, as one would expect from pagan polytheism. And there are open-ended Canaanite model shrines, but those almost always enclose cult figurines. At Khirbet Qeiyafa there is no sign of having had anything inside the shrines except miniature unfeatured stone. It is equally possible that they were representations of the sacred emptiness that would become the hallmark of Judaism; a vacuum filled only by the scroll of revealed words. The stylised portico of the pottery mini-shrine is startlingly elaborate: two pillars each side, guardian lions at their feet, doves atop the roof. It is the furled textile curtain, fashioned by the potter's fingers to suggest a swag, that is most extraordinary, evoking exactly the curtain-veil *parochet* said by Kings to have covered the entrance to the Holy of Holies and which would be a famous feature of descriptions of both Jerusalem Temples. The tearing of the *parochet* would be defined as the ultimate act of desecration by the destroyers of the Temple so that a tradition has it that when Titus tore at the curtain with his spear, blood welled from the fabric.

The slightly larger limestone mini-shrine, its original red paint still

visible in places, is no less eloquent. For while it lacks curtain and guardian animals, it has the multiply recessed doorway described as the entrance of the Temple and, still more strikingly, the 'triglyph' roof with seven three-planked beams, seen end-on, characteristic of temple architecture elsewhere in the region. In addition, black basalt mini-altars, in the same scooped and horned forms that would become the norm, have shown up in the cult rooms. It is this unmistakable sense of a religion – without the usual bodies and faces of pagan deities, a religion of physical emptiness and conceptual fullness – made portable, domestic, local, that seems to breathe so deeply of what would become Judaism. And suddenly, at Khirbet Qeiyafa, denying its possibility seems obtusely dogmatic.

Yossi Garfinkel is not saying the shrines *prove* that Khirbet Qeiyafa was built and inhabited when Solomon's Temple was standing in Jerusalem, only that it seems impossible not to see the shrines as expressions of a religious culture not dissimilar from the one described in the Hebrew Bible. Not to be open to that possibility, he says, is perverse. One of Garfinkel's critics has complained in some desperation that he wants 'book-free archaeology', by which he means Bible-free; an archaeology that clears its head of scripture altogether and, unlike the Victorians and William Foxwell Albright and Yigal Yadin and Benjamin Mazar whose descendants still quarrel about it, just sees and studies what is before it, as if that Book had never been written at all. It seems to me, though, that an archaeology in this country that has *nothing* to do with the Bible is just as self-deceiving as that 'sacred geography' that had nothing *but* the Bible in mind when it mapped and dug.

In this story you don't escape the words, the writing. One afternoon I find the minute silver scrolls from the burial cave at Ketef Hinnom, sitting under helpful illuminated magnification in a vitrine at the Israel Museum. They are exceptionally beautiful things, the incised letters with their strong vertical strokes nothing that any Jew today would remotely recognise as Hebrew, but the real thing nonetheless. The micro writing (which will become in another age a Jewish speciality) is not directly *from* the Bible, but surely of its devotional poetry. 'Graciousness to those who love him and keep his commandments . . . He is our restorer and rock,' says one, but it is the other one, KH2 as it is labelled, that stirs something deep in me: 'May be . . .

blessed . . . the rebuker of evil . . . bless and make shine his face upon you and give you peace.' That something is the gravitational pull of memory, the hurtling together of an ancient Then with the fleeting Now, that is the occupational hazard of anyone venturing into the Jewish story.

I am nine years old again and standing in my synagogue. Earlier in the service the Torah had been lifted high, and then, before the reading, taken round the congregation in procession. Before Judaism it was images of gods that were processed and received veneration, but here it is the Book that is the object of our adoration, our *tallitim*, prayer shawls, extended to the passing scrolls for a touch. The Torah and its words are so pure in their holiness that no direct manual contact is permitted. The scribe who writes them must wash his hands on each occasion of his writing; the reader who chants them must touch the scroll only with a silver simulacrum of a finger, the *yad*. And we must not touch the handwritten Sefer Torah directly, but only with the edge of our *tallit* which we hold to our lips in kissing devotion.

Twice this procession of the Book takes place, before and after the reading. But now the priests, the Cohanim, are standing, raised above the congregation on the carpeted steps in front of the Ark, their prayer shawls pulled over their heads, joined together to make a canopy. We Jewish hoi polloi are forbidden from looking at them as they deliver their blessing, but of course I can't help peeping. The faded cream canopy, striped with black, nods and bobs while the men beneath it chant, some bending from the waist. 'May the Lord bless you and keep you,' they are saying, as if reciting from a scroll just rediscovered in the reign of Josiah, 'may he make his face shine upon you and give you peace. *Omayn*.' The *Omayn* – amen – rings through the panelled synagogue and not ten years on from the end of the annihilating war I somehow feel safe.

4

CLASSICAL
JEWS?

I. No Moses, no Plato?

What was it to be: the nude or the word? God as beauty or God as writing? Divinity invisible or an eyeful of perfect body? As far as Matthew Arnold was concerned, Hellenes and Hebrews were oil and water.¹ Both were 'august' and, in their respective ways, 'admirable', but they didn't mix. Greeks pursued self-realisation; Jews struggled at self-conquest. 'Be obedient' was the sovereign command of Judaism; 'be true to your nature' was what mattered to the Hellene. But Arnold's pretence of neutrality was unconvincing. Who would want to live waiting for the next round of fire and brimstone when you could be a seeker after sweetness and light?

Grow up in the classical tradition and you believe Europe begins with the defeat of the invading Persians, recounted by Herodotus. Grow up Jewish and a piece of you wants the Persians to win. They were, after all, the restorers of Jerusalem; Esther became their queen – how bad could they be? The villain, Haman, who wanted to wipe the Jews out, was surely just a freakish monster who got his comeuppance at the hands of the Persian king. On the other hand, the Greek Seleucid king, Antiochus IV Epiphanes – who threw circumcised infants from the walls of Jerusalem, along with their mothers – seemed, according to the First Book of the Maccabees, wholly of a piece with his culture. It was Hellenism that was the enemy as much as the demented monarch. The Second Book of the Maccabees is even more sensational in its catalogue of Greek atrocity. Clandestine Sabbath observers are burned alive in their caves. The Jewish historian

Flavius Josephus lays on the sadism even more horrifyingly. Those who persisted with observance, he writes, 'were whipped with rods and their bodies torn to pieces and were crucified while still alive and breathing'.[2]

What Greeks hated (in this view) was the obstinacy of Jewish difference, marked by the cut they made on their male member, the break they made in their week, the restrictions they placed on their diet, the uniqueness they claimed for their faceless, perpetually cross deity, their exasperating refusal to *be like everyone else*. Greek philosophy presupposed discoverable, universal, truths; Jewish wisdom seemed the private treasure of a locked-off culture. Greek temples, built according to the principles of cosmic harmony, were designed to draw people to them; the Jerusalem Temple was off limits to 'foreigners'. Greek statuary and monuments were meant to outlast the states that built them. The Torah was meant to outlast architecture. For Greeks the cult of nature, especially wild nature, was where ecstasy was to be found. But for Jews sacred groves were places where you would be lost amid pagan abomination. The ecstatic maddening of the senses was at the heart of the Dionysian cult. In the Judaic tradition, strong drink was when bad things happened: Noah lying stupefied and naked before his leering son Ham; the disobedient Israelites capering around the Golden Calf. Being drunk amid *vegetation* was worst of all, so when Antiochus forced Jews to celebrate Bacchus in processions 'wreathed with ivy', as the author of 2 Maccabees writes, the Greek cult of wild nature had displaced the Jewish obligation to master it.

A Hellenised Jew, then, was an oxymoron. Except it wasn't – not for countless Jews from Cyrenaica in Libya through the great metropolis of Alexandria, into Judaea, the Galilee and out into the isles of the eastern Mediterranean. During the two hundred or so years between Alexander the Great's conquests in the fourth century BCE and the domination of the Romans, the notion that Greek and Judaic culture were mutually exclusive would have seemed baffling if not outlandish. For those multitudes, Hellenism and Judaism were not mutually incompatible at all. Their manner of living exemplified something like the opposite: unforced convergence; a spontaneous (if not untroubled) coexistence. Before the discovery of the Dead Sea Scrolls in 1947 and the Ketef Hinnom silver amulet in 1979, the oldest continuous Hebrew text (found in 1898) came from the Hellenised Fayyum

region of the mid-Nile, now securely dated to the mid-second century BCE. Written on the papyrus are the Ten Commandments (in a slightly different order from the way Jews and Christians now have them), together with the daily affirmation prayer, the *shema*. The Talmud suggests that it was once conventional to read the Decalogue before the recitation of the *shema*, so the papyrus has miraculously preserved the daily routine of an observant Egyptian Jew living in the midst of an intensely Hellenised world and yet sustaining without difficulty the defining habits of his religious identity.

In the towns of the Fayyum region, a life lived under both Graeco-Egyptian *and* Torah-prescribed law (often read in its Greek translation, the Septuagint) was routinely unproblematic, both for the Ioudaioi and their Gentile neighbours. A rich archive of papyri surviving from Herakleopolis, south of Cairo – where, as elsewhere, the Jews constituted an autonomous, self-governing *politeuma* – reveals that while they had the right to use Torah law in matters of marriages, divorce or contracted loans, they did so only when it was likely to help their case. Mostly they ran their daily affairs according to local Graeco-Roman-Egyptian law. Under that law women could own property and reclaim dowries on the dissolution of a marriage (as they had in Elephantine), and lenders could charge the steep interest rates (as high as 20 per cent) prevailing along the Nile.

But when it suited Egyptian Jews to invoke Torah law to reinforce their case they did so. Peton, the son of a Jew called Philoxenes, for instance, appealed to the local police chief Ktesias against what he claimed was an extortionate attempt to charge double rent on land leased from the crown. When arguing before his local religious authorities he knew exactly which Torah passage to invoke against the seizure of certain goods (like the shirt off his back) as collateral against payment.[3]

These were Jews who spoke common ('*koine*') Greek as their everyday language, and whose names were Demetrius, Arsinoe (like the Ptolemaic queen), Herakleides and Aristobulus. Yakovs became Yakoubis, Yehoshua became Jason and there were many Jewish Apolloniuses. Some of them had Greek names that invoked the one almighty God, like Dorotheus. The Hasmonean king who ruled over the most territorially extensive Jewish state there had ever been was himself called Alexander. They dressed indistinguishably from other

citizens of the Greek empires, and inhabited cities like Antioch and Alexandria where (in the latter case) they were said to constitute a third of the population.

It was the Hellenistic-Jewish world that invented the synagogue, even though it was almost always called *proseuche.* Originally signifying an assembly or gathering (for the reading of the Torah, not for prayers), it eventually came to mean the buildings themselves created to serve the needs of Jews who lived far from Jerusalem. There were *proseuchai* in Cyrenaica, in Krokodopolis, Schedia and Alexandria in Egypt, in Sparta, in the great Lydian mercantile city of Sardis, and on the islands of Cyprus, Kos and Rhodes. One of the very oldest synagogues on Delos was *so* like a villa that for a long time it was supposed to be just that – and may actually have been converted from private use.

Nearly always they were built in what we would immediately recognise as classical Greek temple style: pedimented porticos, entablatures, colonnaded aisles and richly decorative mosaic floors. In some Jewish accounts, including the Talmud, they are sometimes called *basilicas*, and inscriptions on some of their facades proclaimed them devoted to *theos hypsistos* – a direct translation of the Hebrew *El Elyon*: the God Most High.[4] They had synagogue notables (an *archisynagogos*) who dressed in grand style, beadles (the *chazzan* – not yet a cantor), caretakers, and on occasion their own tough guards on the lookout for evil-doers. In Alexandria they welcomed and lodged Jews from elsewhere in the already widely dispersed Jewish world, and many of the *proseuchai* were granted the unusual and precious right of affording asylum. Some added *exedra* as additional assembly rooms. All of them needed running water for ritual purification as well as for the convenience of their lodgers. And it seems likely, from Jewish Egypt's cemeteries, they may have helped with burials. In many of these respects – with the exceptions that none of them segregated the sexes, and their strong taste for mosaic floors – the original Judeo-Greek synagogue is recognisable as the protoype of our own. (One historian assumed from a description of the Great Synagogue in Alexandria grouping congregants by trade and business that it must have been more of a marketplace than a house of holiness, a distinction revealing an innocent unfamiliarity with the modern *shul*.)

This was a culture in which Jews could and did write poetry, philosophy, drama (like 'Ezechiel's' *Exagoge* version of the departure from

Egypt, including a dream in which, surprisingly, God's heavenly throne is vacated for Moses to occupy). Jews wrote history, of a sort, and the fiction-narratives that some scholars call the first Greek 'novels'. All this literary activity was accomplished without any loss of faithfulness to the distinctive rites and laws that made them Jews; in fact these Greek forms became the vehicle of expressing that Jewishness. The last books to be included in the biblical canon themselves reflect something of that hybrid character. Ecclesiastes is a 'Wisdom Book' that owes something to Persian-Babylonian proverbial literature but at times can sound just like an epicurean philosopher ('Be not over-righteous and be not over-wise for why should you bring desolation upon yourself?'), as do the apocryphal books like the Wisdom of Jesus ben Sirach. Both books have the tone of Greek writing even when what they are teaching is transcendence from the base matters of the earthly realm.

All this crossover culture was possible in the Hellenic–Egyptian world of the Ptolemies and the Syrian north-eastern empire of the Seleucids, because the sovereigns of both realms had continued the Persian policy of tolerating and subsidising local religions. In fact the internecine conflict between the *diadochi* – Ptolemies and Seleucids contesting the succession of Alexander the Great – often made them compete for the allegiance of the Judaean population lying strategically between their realms. Antiochus IV Epiphanes may well have committed all the infamies chronicled in the Maccabees and in Josephus' *Antiquities of the Jews*, written two centuries later; but he and whichever of the Ptolemies it was who ordered Alexandrian Jews trampled to death in the hippodrome by drunken war elephants were the exception, not the rule. There was nothing about the conduct of the first Seleucid to rule Palestine, Antiochus III, to suggest intolerance, much less persecution. And even Antiochus IV, defeated and dying somewhere in the wildernesses of Asia Minor, is said by the author of 2 Maccabees to have undergone deathbed repentance, ordering his government to restore its protection and tax subsidy for the Jewish Temple. Once the fiercest fighting between Jews and Greeks was over, it was perfectly possible for the older working mutualism to be restored. The Greek ruler would once again accept the autonomy of Jewish laws and religious traditions, and the Jewish leader, the Hasmonean Jonathan, in a gesture implying formal submission, would receive the high priesthood from the hands of the Seleucid king.

Though the Jewish and classical worlds (both Greek and Roman) would end up locked in murderous, catastrophic conflict with each other, culminating in the Roman obliteration of Jerusalem, there was no presumption on the part of Jews that the cultures were so mutually hostile, that the apocalypse was just a matter of timing. Quite the opposite was the case. Almost from the beginnings of their experience of the dominant Greek world, Jews wanted to believe they had much in common. In the minds of many of their writers and philosophers, Judaism was the ancient root and Hellenism the young tree. Zeus was just a paganised version of the Almighty YHWH, and Moses was the moral legislator from whom all ethical law-giving had originally sprung. The Jewish Aristobulus of Paneas, writing in the mid-second century BCE, wanted his readers to believe that Plato had painstakingly studied the Torah and that Pythagoras owed his theorem to ancient Jewish learning. Given this common trunk of wisdom, it must have seemed eminently possible that the two worlds would understand each other.

For the most part, this was a one-way passion. Before Alexander's conquests, Greeks would have encountered Judaeans as fellow mercenaries in Elephantine, or as soldiers serving Judaean officers in coastal forts like Mazad Hashavyahu at the end of Josiah's reign in the seventh century BCE. It is a fact – though to modern instincts a surprising one – that to much of the ancient world west of Babylon, the Jews would have been most familiar as spears for hire. But there are occasional glimpses in the ancient literature of another kind of early-Greek curiosity in Jews as finders and keepers of ancient oriental wisdom. In the nineteenth century the scholar Jacob Bernays – son of a famously devout chief rabbi of Hamburg and uncle of Sigmund Freud's wife, Martha – first noticed that Aristotle's prize student and successor as head of the Peripatetic Academy, Theophrastos of Eresus, had expressed fascination with the Jews, whom he characterised as a subset of 'Syrians'. In his book *On Piety*, Theophrastos characterises the Jews as 'philosophers by birth' (a phrase that must have made Jacob Bernays happy) who 'talked constantly to each other about the deity and who at night made observations of the stars, gazing at them and calling on God in prayer'.[5] Despite the fact that Theophrastos could fantastically assert that Jews engaged in live sacrifices, basting the roasting carcasses with honey and wine, Jews did not entirely run away from this early reputation as custodians of ancient cosmology and divination. It made

them the guardians of an esoteric oriental wisdom (even if some Greeks insisted on supposing they had originated in India). Mostly, though, Jewish writers in the classical world represented their religion as simultaneously ethics, history and prophecy, all of which, if they knew what was good for them, ought to command the attention of pagan empires.

In this slightly self-congratulatory spirit, Josephus offers the legendary story of Alexander the Great, in 332 BCE, the year of his Palestine and Egyptian campaigns, being so moved by the pious humility of the Jerusalem priests and people that he proclaims the unity of God.[6] Though we have no absolute proof that in the year of his long siege of Tyre, Alexander did *not* go to Jerusalem, it seems prohibitively unlikely. But Josephus' picturing must have owed something to an already long-established story tradition, and as is often the case when he wanders from documented truth, the narrative is brilliantly vivid.

Josephus describes the Jews of Jerusalem, gratefully faithful to the end to the collapsing Persian Empire, trembling before what they imagine will be a terrible Macedonian retribution. But their high priest Jaddua is visited by a dream in which he is told 'to take courage, adorn the city and open the gates'. The people were to assemble before the Greek conqueror clad in the white of humility, while he and his Temple priests should dress themselves magnificently as befitted their sacred station. A combination of purity and majesty: how could the Greeks not be won over as Alexander's triumphal progress halts before 'a place called Sapha, meaning "prospect"'? So it is with *that* view of the towers and walls and the Temple on its hill that the victorious general encounters the white-garbed multitude, at their head the high priest attired in 'scarlet and purple with his tiara sewn with a gold panel on which was inscribed the tetragrammaton name of God'. Greetings are exchanged. Alexander improbably blurts out that he 'adores' this God, for, as he explains to a surprised aide, he too had had a vision in which the high priest, dressed exactly in this manner, would bestow divine blessing on his conquest of the Persians. Alexander then 'gives the priest his right hand', and makes sacrifice to YHWH in the Temple 'according to the high priest's direction'. The next day, after being shown the Book of Daniel prophesying his triumph (tricky, since in 332 BCE it had yet to be written), he repays

the confidence by guaranteeing, as all good Greek rulers did, 'the laws of their forefathers'. Alexander waives Jewish tribute in the sabbatical year and promises (since the Jews were such accomplished soldiers) that those who joined his army would live undisturbed according to their traditions.[7]

But this compliment to superior Jewish wisdom is nothing compared to another story in which a Greek ruler becomes such an admirer of Judaism that he showers every honour imaginable on its custodians. *The Letter of Aristeas* was a drama about a book, or rather, The Book. Written in the second century BC it purported to be the account given by the chief bodyguard and high counsellor to Ptolemy II Philadelphus, of how the Hebrew Bible came to be translated into Greek in Alexandria. Josephus includes an abbreviated version of the tale in his *Antiquities*, but the original manuscript was important enough to have survived in at least twenty copies into the early Christian era, when this Greek translation of the Hebrew Bible known as the Septuagint was, for all intents and purposes, treated as the definitive text of what had become called the 'Old Testament'.

The rabbis creating the Mishnah and the Talmud centuries later saw no reason to take any notice of *The Letter of Aristeas*. The Septuagint was a Christian Bible; theirs had been restored to Hebrew. *The Letter of Aristeas*, in which Greeks and Jews together ponder the wisdom of the Bible, would have jarred with rabbinical assumptions that the Torah was an exclusively Jewish possession. Modern scholars have thought that the *Letter*, with its idyll of inter-cultural harmony, might have been triggered by a need to defend Judaism from Egyptian calumnies that from time to time put the community in Alexandria in real peril. Imploring Jerusalem priests and scribes to come to Alexandria and make the translation, the king sounds an improbably sensitive note: 'if ever evil has been done to your people through the passions of the mob I have made them reparation'. For the most part the *Letter* is written as if the mutual understanding and shared concerns of Greeks and Jews were the most natural thing in the world. Thus the mover of the whole enterprise, Alexandria's royal librarian Demetrius of Phaleron, tells Ptolemy: 'I have been at pains to discover the God who gave them the law is the same God who maintains your kingdom . . . they [the Jews] worship the same God, the Lord and Creator of the Universe though we call him by different names such as Zeus . . . He

is the one through whom all things are endowed with life.' Though there were certain markers that seemed to set Jews apart – the miniature scroll *mezuzah* on the doorpost and the *tefillin* hand phylactery, both containing the daily prayer in praise of the single God and passages from the Torah's laws (the first mention of either object in any source) – they were simply prompts reminding YHWH's devotees never to separate themselves from the presence of that God or His teachings.[8]

The real Aristeas, of course, had no hand in the fictitious *Letter*, but the Jewish author was an astute impersonator of the voices of Greek courtiers and scholars, the better to persuade Greek-speaking Alexandrian Jews that there was indeed a fit between Torah and Greek philosophy. It helped that for more than a century after Alexander's conquests, the Ptolemies ruled in Judaea as well as Egypt, so that it was perfectly plausible for the king to send an exploratory mission to his city of Jerusalem to persuade the high priest to come to Alexandria with his battalion of translators in tow.

The education of the Greek envoys in the marvels of Jewish Jerusalem starts almost as soon as they have arrived. Given the hydraulic tour, Demetrius and Aristeas express their astonishment at 'the wonderful and indescribable cisterns underground' that drained off blood from Temple sacrifices yet stored uncontaminated drinking water for the population. So much classical history can be written in its plumbing.

Fancy costume was similarly likely to impress the Greeks. Eleazar the high priest is robed as majestically as any potentate: golden bells hanging from his gown, ringing delicate changes as he moves. His garment is sewn with pomegranates (whose 613 seeds were said to represent the commandments of the Torah), and on his gold pectoral is 'The Oracle of God' encrusted with jewels. His tiara bears the tetragrammaton name of God. Seven hundred priests go about their duties in the Temple with the utmost quiet and grave decorum. It is just as well, then, that the decorated triangular table sent by Ptolemy as a sweetener for the Temple is a calculated masterpiece of hybrid Graeco-Jewish style. Featuring 'wreaths of wavework, engraved in ropes, marvellously wrought' it also bears – what else? – the *meander* – the essence of Greece brought to Jerusalem – studded with rubies, emeralds, onyx, crystal and amber. The feet are carved in the forms of drooping lilies and acanthus.

How could they decline the royal invitation? Eleazar and seventy-two scribes, six for each of the tribes of Israel, journey to Alexandria and are loaded with compliments and gifts by the awed king, and housed in elegant quarters on the island of Pharos, connected to the city by a causeway. Before they get to work on the translation in their airy quarters, they are treated to a week-long banquet which turns into a Greek-style symposium, albeit with kosher catering. The king asks courteously deferential questions about how best to reign, indeed how best to *live*, and receives decidedly Jewish answers:

KING: What is the good life?

ELEAZAR: To know God.

KING: How to bear troubles with equanimity?

ELEAZAR (*sounding remarkably like Ecclesiastes and Jesus ben Sirach*): Have a firm grasp of the thought that all men are appointed by God to share the greatest evil as well as the greatest good.

KING: How to be free from fear?

ELEAZAR: When the mind is conscious it has wrought no evil.

KING: What is the grossest form of neglect?

ELEAZAR: If a man does not care for his children or devote every effort to their education.

There were also enough questions taken from the standard repertoire of political mentoring (as Aristotle had tutored Alexander) to leave no doubt that pseudo-Aristeas had the Greek stoic-epicurean truisms off pat:

KING: What is the essence of kingship?

ELEAZAR: To rule oneself well and not be led astray by wealth or fame to immoderate desires.

KING: What is the most precious possession for a ruler?

ELEAZAR: The love of his subjects.

And together they move into the realms of Platonic mind-enquiry:

KING: How can one sleep without disturbing thoughts?

ELEAZAR: You have asked me a difficult question for we cannot bring our true selves into play during the hours of sleep but are held fast

by our imaginations which cannot be controlled by reason. For our souls possess the feeling that they actually see the things that enter into our consciousness during sleep. But we make a mistake if we suppose we are actually sailing in boats or flying through the air.

This is exactly what pseudo-Aristeas' home readers in Alexandria must have wanted: confidence that not only were the Jews on a level intellectual footing with the Greeks, but that from the storehouse of their own venerable wisdom they might even have something to teach the Gentiles. There is a strong sense in the tone of the Letter that Hellenised Egyptian Jews wanted to go beyond a reputation for arcane devotion to an abstract 'God Most High' and to demonstrate the rationality of the Bible as wisdom literature. Hence the urge to insist that even its more baffling minutiae – the dietary laws, for example – are not just arbitrary taboos, or vulgar forms of pest control concerned with 'weasels and mice'. Rather, in banning predators and scavengers like kites and eagles, they followed the natural human abhorrence of eating creatures that had already eaten other creatures. It was altogether more wholesome to consume 'clean' grain-nibbling birds like 'pigeons, turtle doves, partridges, geese and . . . [according to Leviticus] locusts'.[9] 'All the rules laid down as to what is permitted in the case of these animals and birds he has laid down with the object of teaching us a moral lesson.' And then quite bafflingly, 'the rules governing the division of claws and hoof are meant to teach us to discriminate in our individual actions'. In the same spirit of asserting the natural ethical wisdom of the Torah, Eleazar points out that while other nations were capable of violating even their mothers and daughters, such abhorrent practices – along with homosexual copulation – was forbidden to Jews.[10] (This last might not have gone down so well with the Hellenes.) The same compulsion to make Greek sense of the Bible moved 'Demetrius the Numerologist', the nearest thing to a Jewish-Alexandrian historian, to subject the fantastic genealogies and chronologies of the Bible to logical enquiry. Was it credible for Jacob starting at the age of seventy-seven to have sired twelve children in seven years? By Demetrian calculation, most certainly!

The combination of ancestral wisdom and rational criticism works its spell. The company of translators, greeted by Ptolemy every morning prior to starting their work, complete their task in

seventy-two days (six times the twelve tribes – the same number as the translators), and are honoured by the king who, genuflecting seven times before the Book, declares it unthinkable (and possibly illegal) to change a word. But then, in these wishfully thought literary creations, Egyptian rulers are constantly bowing to the moral rectitude, political astuteness and learned authority of Clever Jews. Before Moses, according to Genesis, Joseph had risen to commanding power in the government of Pharaoh. (Indeed in a work called the *Ioudaikon*, the Jewish author gets carried away by crediting Joseph with the Egyptian system of canals and irrigation – probably in response to Egyptian histories like that of the priest-grammarian Manetho that characterised the Israelites as indigents and lepers.

In the story of *Joseph and Asenath* (sometimes called 'the first Greek novel' and certainly a romance), the upwardly mobile young Israelite, a power in the land, is to be married to Asenath, the eighteen-year-old daughter of Pharaoh's counsellor Poti-Phar, or Pentephres. Veiled and secluded Asenath, a notorious man-hater, is not delighted by the prospect until a peep at the Jew, as hunky as he is wise, throws her into an amorous swoon. At which point, of course, the Jew plays hard to get, demanding her full conversion as the price of the match. Trapped in a quandary, Asenath gets timely help from a pair of angels who show up in the nick of time to foil a plot by Pharaoh's son to rape her, kill his father and ascend the throne. Having established their problem-solving credentials, the angels feed Asenath the Bible in the form of a sacred honeycomb, from which a swarm of bees inconveniently emerge. But wait! The angels reappear, and transform the bees into stingless little accomplices of Asenath's connubial happiness and religious epiphany. What a miracle! The Pharaoh, unharmed thanks to the Jew and his team of angels, gives the bride away and bestows blessings on the happy Jewish couple. *Mazel tov*, let's drink.

The Alexandrian honeymoon between Judaism and Hellenism wouldn't last, but for two and a half centuries it was as vigorous, busy and creative a world as any of the diaspora cultures that would follow. It was possible to rise as high as Joseph and less fictitiously. The philosopher Philo's younger brother became royal tax collector for the Ptolemies, and his nephew Julius Tiberius Alexander would become Roman governor of the city in the first century CE, albeit as an apostate. Another who wandered on the fringe of the Jewish

community, Dositheos, son of Drimylos, climbed into the heights of the court, becoming royal archivist.

Well before these famous success stories, in the middle of the third century BCE there were established Jewish communities in Schedia, south-east of Alexandria, up the Nile in the ancient city of Krokodopolis, at Heracleopolis, in the districts of Kerkeosiris, Hephaistias and Trikomia, and in Thebes, Leontopolis (where Onias the priest, in flight from Jerusalem, established a rival Temple like Elephantine before it, in defiance of Jerusalem). Often Jews settled where their specialities called, which were often military and bureaucratic: cavalry in Thebes (including the perfectly named Sabbathaios, 'born on the Sabbath', who comes down to us from a mid-second-century BCE papyrus); customs guards in Schedia; infantry at Leontopolis. As was the custom they were paid for their service by grants of land which they in turn often rented out to peasant cultivators. The suburban districts on the edge of Krokodopolis were said to be green with flower and vegetable gardens where the Jews strolled with dangerous lordliness amid the toil of their tenants. They were themselves well off and populous enough to build a synagogue and dedicate it to Ptolemy III.

But Krokodopolis was not Alexandria, which was one of the great cities of Jewish history: nearly 200,000 Jews, a third of the population (though 4 per cent of all Egyptians).[11] While not formally restricted, most of them were concentrated in distinctive Jewish quarters east of the quays, especially in the Delta district 'on the harbourless shore' as the hostile grammarian Apion would put it, but not that far from the royal palace. There were synagogues all over the districts, and dedicatory inscriptions to high patrons including the Ptolemies themselves survive, suggesting the kind of bonding with local power that Jewish communities throughout diaspora history would express.

None, however, compared with the Great Synagogue, legendary even after the destruction of the community in the second century CE, not least to the sages of the Talmud like Rabbi Judah ben Ilai who insisted that 'he who has not seen it has not seen glory'. In his somewhat fantastical account, the Alexandria synagogue boasted rows of double columns, and seventy golden chairs (in honour of the Septuagint) for each of the elders of the synagogue, studded with pearls, plus seating sections for each of the Jewish crafts and trades

of the metropolis: goldsmiths, weavers, coppersmiths . . . The congre-
gation and the building were so vast that the chants of the reader
could get lost from the *bimah* – the platform for the reading of the
Torah – so the *chazzan* would stand on the dais and wave a large white
silk flag to alert the congregation to chant the amen when each of
the portions of the reading concluded.

As at Elephantine, a sense of the society of Jews – with one foot
in their Jewish *politeuma*, the other in the wider world – is vividly
registered in surviving papyri: in the Zenon archive of a tax official
of the Ptolemies travelling to Palestine in the middle of the third
century BCE; and even more richly in the Herakleopolis papyri from
the Fayyum region. Typical is the case, made to the *archon* or ruler
of the local community, by one Dorotheus, that out of the goodness
of his heart (and in observance of a Torah commandment) he had
taken his sick brother-in-law, Seuthes, into his house and looked after
him 'spending much of my means' throughout his illness. Not only
that, but Dorotheus had sprung his niece, Philippa, from debtor's
prison and brought her back home to be reunited with her ill father.
A real mensch? No, says Dorotheus, just doing what the Torah
requires. In return, before the invalid brother-in-law died, Philippa
had been formally adopted as a member of the Dorotheus household.
There she had stayed for four years. The domestic idyll had been
interrupted by the sudden appearance of Philippa's mother, Iona,
who took the young woman off to the house of her aunt, thus
depriving the said benefactor of a helpful member of the household.
To argue his claim that the girl should now be restored to him,
Dorotheus insisted that Philippa would return as cared-for and caring
orphan to her guardian, rather than a useful housegirl for a master
(heaven forfend). To the *archon*, Dorotheus invoked his faithful obser-
vance of the precept of Leviticus 25:35 that 'if thy brother is waxen
poor, he shall come not as a stranger into thy house', although there
was nothing in the Torah providing for the obligatory return of a
niece. The *archon*, perhaps because this was a classic case of conver-
gence between Jewish and Greek principles of guardianship, seems
to have sided with Dorotheus.[12]

Further down the Jewish pecking order, the record is more patchy.
Ahibi the merchant is known only from a papyrus scroll written to
his partner Jonathan recording shipments of barley and wheat, Tasa

the daughter of Hananiah (neither Hellenised in their names) only from the record of her accusation against the Greek who had raped her, and a betrothed couple from widely separated diaspora communities – 'the young man of Temnos' (on the western Anatolian coast) and 'the maiden of Kos' – from the marriage contract that bound them together. The feel of the place and its citizens has to be pieced together from potsherds, inscribed dedications on synagogues, and especially inscriptions from Jewish tombs. It was at this time that underground tombs were being turned from common charnels into chambers with niches cut for specific families and where some individuals were buried laid out, their heads resting on stone or earth cushions. There are such inscriptions as early as the third century BCE, although the most eloquent date from Roman Alexandria.

Arsinoe, the wayfarer: Stand by and weep for her . . . for her lot was hard and terrible. For I was deprived of my mother when I was just a little girl and when the flower of youth made me ready for a bridegroom. My father assented and Phoebus and Fate led me to the end of life when my first child was born.

Rachelis: Weep for Rachelis, chaste friend to all; about thirty; but do not weep vainly for me.

For beauteous *Horna*, shed a tear; three of us are here, husband, daughter Eirene and I.

This is classical funerary style, and when tombs are decorated, they are carved with architectural motifs – especially columns – indististinguishable from their Greek neighbours. Hebrew inscriptions, quotations from the Bible which would become formulaic in Jewish cemeteries, are entirely missing. Even in death, then, there is little sense that the Ioudaioi were in exile. Their connection to Jerusalem and Judaea was constant; the norms that made them Jews, perfectly clear, but not at odds with their homes in Hellenised Egypt. Yet they were not so deluded as to imagine they were universally loved by the host cultures amid which they lived. If they knew the third-century BCE history of the priest-grammarian Manetho, they would know that they were associated not just with the cast-out lepers but with the

Hyksos foreign kings who bore a reputation for harsh exploitation of native Egyptians. There was always the possibility that for all their settled existence, ugliness might be round the corner just as it had been for the Elephantine Judaeans before them.

This we know from the cautionary tale of the narrow escape from death by war elephants. Related in the so-called Third Book of the Maccabees, which itself was too apocryphal to make it into the Apocrypha (but is in the even less canonical Pseudepigrapha), the story was well-enough known among Egyptian Jews to be the basis for a local Alexandrian festival of deliverance organised in exactly the same way that Purim became the festival of a thwarted plot to massacre the Jewish population of Persia, and Hanukkah the festival of liberation from Seleucid tyranny. Akin to those parallel, contemporary histories, the Egyptian story features a crazed Jew-hater, the threat of mass killing, and more fabulously than in Susa or Jerusalem, a not-a-moment-too-soon intervention of angels.

3 Maccabees and Josephus disagree as to precisely which Ptolemy was involved and thus when the episode took place, but a convincing case has been made by the historian Joseph Modrzejewski for the earlier date of Ptolemy IV Philopator in the third century BCE. Campaigning, and briefly victorious against the Seleucids in Palestine, the king presumes to violate the sanctity of the Temple by forcing a royal entry. The result, of course, is that on the very threshold of his trespass he is paralysed, unable to move a limb. Consumed with hatred for the Jews who humiliated him, once back in Egypt Ptolemy orders the imprisonment in Alexandria's hippodrome of all the Jews. There (in a sinister and quite astounding anticipation of what would be visited on the Jews of Paris in the bicycling stadium of the Vélodrome d'Hiver in 1942) they are exposed to brutal heat and toil for forty days.

This, however, is not enough to slake the ruler's thirst for revenge, so, inspired by a vicious persecutor (whose name, Harmon, is suspiciously close to the villain of the Purim story, Haman), he orders five hundred war elephants to be maddened with incense and strong liquor, and set on the captive Jews. Farce briefly intervenes. The confused king forgets the plan only to remember it again the following day. On with the massacre! Summon the staggering pachyderms! Crowds converge on the hippodrome to watch the fun. Trumpeting jumbos, out of their skulls on booze, dopey with smoke, tromp through the

streets, followed by chuckling soldiery. At the last minute (as is their wont), two angels show up, flap their wings around a bit, and hey presto, the elephants go into reverse gear, swiftly wiping the smiles off grunts and plebs who get mashed underfoot in the melee. Duly impressed, the sadistic king repents and restores the Jews to life, limb and location.

It's a fabulous ending, but the writer of 3 Maccabees knew his story was a cautionary alert. Settled as they were, there might still come a time when the distant trumpeting of incensed heavyweights could again be caught on the breeze and the ease of their lives would disappear. That, after all, was what had happened in Jerusalem.

II. The Quarrel of the Priests

Approaching the city from the west, you would have smelled Jerusalem before you saw it: a pall of woodsmoke hanging over the roofs and walls, capturing the aroma of charring flesh. Fires at the Temple altar had to be kept stoked day and night, such was the demand for animal sacrifices offered to YHWH every morning and every afternoon as the Torah required.[13] The perpetual roasting was called the *tamid*, Hebrew for constant, but there was a Greek word too for such ritual cremation of whole animals, and that word was *holocaust*. This is something else the two societies had in common. Among all the cultures from Egypt to Mesopotamia and Persia, only Greeks and Jews made fire sacrifices of whole animals. So thousands of goats, sheep, cattle and oxen were driven into the city from the surrounding hill pastures and farms. For the new moon alone, a ceremonious Temple sacrifice of two young bullocks, one ram, seven lambs and a kid (as well as an offering of grain meal, oil and wine) was required by Numbers 28:11–15. Not all the sacrifices offered in the Temple were whole 'burnt offerings' (*olim*) – some were 'slaughter sacrifices' (*korban*) in which the carcass was divided into portions for consumption while rendered fat and collected blood were separated as the portion devoted to the Almighty and burned away in dedicated vessels. But around the turn of the second century BCE, whole animal roastings dominated

the offerings. While they were proceeding, Levites would chant psalms, but as yet there seem to have been no prayers.

The ritual of the *tamid* was elaborate and painstaking. At first sight, the shedding of so much animal blood seems jarringly at odds with the fierce ban on eating it, but the two sets of practices were connected. Animal sacrifice was so common *because* of the abhorrence of eating bloody flesh.[14] It may well be, as David Biale suggests, that the combination of bloody animal sacrifice and bloodless diet was meant to establish a counter-culture against the more sanguine dietary habits of the peoples around them. The Bible insists that in the blood of a creature was its *nefesh* – its vital essence, sometimes translated as 'soul'. So do not imagine a Temple courtyard saturated with sanguine. After being killed, most often by a priest, the blood would be fastidiously collected in a basin. What was not needed for the offering was drained away through sluices, leaving the sacrificial area clean. Then the animal would be flayed and the carcass fed to the fire, where it would remain until entirely consumed, bones and the occasional goat beard sometimes remaining. The much-prized skins usually went to the high priest who might bestow them on other priests; but there could be much contention over those hides.

On pilgrim festivals, the tempo of sacrifice increased, and with them the volume of spectators and participants thronging to Jerusalem for the solemnities and festivities. Physically, Greek Jerusalem around 200 BCE seems to have been growing fast, in population if not physical size. The figure given by Hecataeus of Abdera of 120,000 is entirely fantastic, but the people might have numbered in their tens of thousands, and the size of the city had expanded to around eight square kilometres. Certainly, the increased demand for food had prospered the surrounding countryside that had taken generations to recover from Babylonian destruction. The rolling Shephelah to the south-west, with abundant rainfall in winter and spring, was producing wheat again while the drier hillsides were dotted with olive groves, vines and pasture. To feed the multitudes of incoming pilgrims, the Judaean farms selling their produce on stalls near the walls were supplemented by vendors from further afield: Tyrians who brought fish; merchants from the coastal cities of Askelon, Ptolemais and Gaza who sold ceramics from the Aegean, increasingly in demand; northerners selling Phoenician glass.

Though there were already synagogues in and around the city, as much hospitality centres as places of reading and prayer, ultimately Jerusalem *was* the Temple, with its relentless conveyor belt of sacralised animal slaughter, the calendar of festive pilgrimage and atonement holy days, the Sabbath pause (an innovation in the ancient world) and the regular readings of the Torah that Ezra had inaugurated two and a half centuries earlier. Kingless, but rich with the literary ghosts of David as the purported author of the Psalms, and Solomon as the writer of his sensual Song and the apocryphal 'Wisdoms', the charisma of authority was concentrated in the imposing figure of the high priest, around whom the rhythm, the social meaning of the city, revolved.

With the royal dynasty broken, it mattered – for a little longer anyway – that the high priest was a lineal descendant of Zadok who had been at David's side and who had crowned Solomon. And it also mattered that Zadok was himself descended from the elder of Aaron's two sons, Eleazar – hence that latter name so often recurring in the high priesthood. Indeed, it was even possible to stretch the lineage all the way to Levi, the son of Jacob and Leah. So the high priest's public appearance in the Temple, and the rare, exclusive entries into the Holy of Holies, were consciously majestic and dense with symbolism. (The appearance of the miraculously clad high priest was the closest Jews got to the apparition of divine exaltation in human form.)

And yet, although a genealogy of succession has survived – with the names Simon and Onias recurring – almost nothing is known about individual high priests, nor even the details of their duties and ceremonies outside of biblical prescription (and not much of that). The epitome of rabbinical tradition remains the nebulous figure known as 'Simon the Just', although characteristically there is no agreement beyond placing his priesthood somewhere in the third century BCE, only that he exemplified the union of personal piety, Judaic justice and ceremonious authority. (Sensibly, there is no entry for him, for instance, in the otherwise exhaustive *Encyclopedia of Early Judaism*.)

We do know, however, that the high priest was not alone in his grandeur, wealth and power. He was at the centre of a dynastic establishment and a priestly aristocracy, all of whom came with extended families, estates, officials and hangers-on. Josephus also mentions a *gerousia*, a council of elders in Jerusalem, similar to the one that existed

in Alexandria and which might negotiate with the Greek overlords on the crucial and perennial matters of taxes, and subsidies for the upkeep of the Temple (another inheritance from the Persian period). Together, this Jerusalem–Judaean elite, increasingly managerial and worldly as much as spiritual, constituted a ruling establishment responsible for sustaining the distinctive social culture that Judaism was fast becoming.

Amid all this guesswork one startling fact leaps from the record (at least according to Josephus) and which speaks volumes about the pragmatic reality of the Temple aristocracy. Sometime towards the late third century BCE the High Priest Onias, the latest in the Zadokite line and son of Simon the Just (and, according to Josephus, endowed with itchy palms where money was concerned), married off his daughter to an aggressive man on the make from across the Jordan. This Tobiah became the godfather of a powerful clan on whom Josephus spends many pages, and their dramatic story might well have been relegated to another historical fable had not letters shown up in the Zenon archive from one 'Tubias', a commander of a fort on the east side of the Jordan. The letters were written to the Ptolemid treasury, and were obviously from a tax-collecting heavy, pretty much identical with Josephus' armed notable, and matrimonial prospect. Originally an Ammonite, thus not of the Judaean *ethnos*, Tobiah's wealth and power had made him Jewish *enough* to marry into the highest rank of the priestly aristocracy. The way that he had made his pile was to morph military function into tax farming on behalf of the Ptolemid government, increasingly pressed for funds to finance the endless wars with the Seleucids. Tobiah was delivering money up front to the finance minister Apollonius and recovering it – plus hefty bonuses – from the local population. In other words he was the kind of familiar figure who always thrives at times of constant war: a combination of local warlord, robber baron and government contractor, rich enough and Jewish enough to be a catch for the high priest's daughter.

Josephus makes a great deal of Tobiah and his son, Joseph, who in the way of the second generation polishes the rough edges off his father's fortune and rises to be the Indispensable Man, negotiating tricky arbitrations between the Ptolemies and Seleucids. But it was Tobiah's grandson, Hyrcanus, who, by transforming what the Zenon letters make clear was originally a local fortress into an opulent limestone palace

east of the Jordan, left the most spectacular architectural evidence of what the life of this Hellenised clan might have been like at the turn of the second century BCE.

Qasr el-abd (or Iraq al-Amir as it is now known), set in its fertile Jordanian valley, is one of the most seductive remains of the Hellenistic world anywhere. Graceful columns appear on the facade of its two storeys; more columns line the interior of the spacious courtyard; lions and panthers prowl on the limestone facade. One of the sculptors endearingly allowed his creative imagination to get the better of his zoological knowledge as he has a fully maned lion suckling a brood of cubs on the palace roof. Originally, the palace was encircled by an ornamental lake in which its graceful lines would have been mirrored. But that lake, as well as the platform on which the palace was raised, preserved in its elegance the lines of its original function as strong man's bastion. In all likelihood it was also the administrative centre of a Tobiad micro-state, with its full complement of scribes, officials and tax collectors. When the High Priest Jason (who had deposed his brother, the incumbent Onias III, by offering to the new Seleucid king Antiochus IV the treasure and tribute needed for yet another campaign against the Ptolemies) was himself replaced by an even more fawning ingratiator, Menelaus, it was to Hyrcanus' palace in 'Ammonitis' that Jason fled. There he gnashed his teeth and bided his time, before mobilising a private army that, when the moment was opportune, would march on Jerusalem.

It could well be that Hyrcanus' grandiose palace, removed as it was from the Judaean centre, is typical of nothing except the dynastic pretensions and ruthless power of the Tobiads, although as a rival power centre to Jerusalem it played its part in igniting the great upheaval that was about to take place in Judaea. At the very least it speaks of a culture in which a Jewish identity (for the Tobiads certainly identified with that) and Torah observance coexisted alongside Greek taste and culture, without the two being mutually exclusive. Likewise, the Hasmoneans who would recreate the first Jewish state since the Babylonian conquest, and who every Hebrew school student is brought up to believe were the antithesis of the Hellenes, turn out to be their imitators.

Hellenistic and Jewish culture were coming together in subtle, material ways, mainly in the look of towns and the dwellings within

them. Recent excavations in and around Jerusalem have uncovered houses and villas of surprising size and splendour, boasting spacious rooms with fresco-decorated walls. Vines curl, lilies unfurl, pomegranates press against the calyx. Amid the rubble and ruin, blood-red ceramicware made in the Greek city of Megara, richly decorated with flowers and flirtations, has been found; also, tall Rhodian jars and amphorae, and pearly, slender-necked Phoenician glassware. In and around Jerusalem, the local blond limestone was being used for the first time for drinking vessels, not least because stone was deemed impervious to ritual impurity (unlike ceramic). Local pottery also flourished and developed sweetly decorative forms, the most common being freehand floral painting on shallow dishes and bowls. With larger rooms, chandeliers and candlesticks became bigger, holding more and more candles on crimson-coloured disc or saucer forms.

This was chapter one in the long history of Jewish shopping. On the Mediterranean coast, the new demand for Aegean goods made busy port centres of older towns like Gaza, Dor and Ashkelon, and created one major new port city in coastal Galilee: Ptolemais (later, Acco). Further inland at a crossroads between the Jezreel Valley and Lower Galilee, beside the hilltop site of an ancient Canaanite fortress town, Beit She'an became the Greek *polis* of Scythopolis, named for the Scythian mercenaries from the region between the Black and Caspian seas, who settled there, far from Persia. In many of these urban centres there were brick houses built on stone foundations, sometimes decorated with plaster, and colonnaded avenues boasting the three institutions that defined Greek civic life: the gymnasium, the school-cum-academy known as the ephebeum and the theatre.

Those places were still on the periphery of Jewish life, and it seems unlikely that Jews migrated there yet in any significant numbers, although Sepphoris, near Nazareth (which was to become the great urban, mixed-culture centre of Lower Galilee), had a Jewish as well as Greek population from the beginning. Increasingly, the quasi-Hellenised, Greek-speaking Jews of heartland Judaea felt the magnetic pull of such places. For many the cultural flirtation with Hellenism would have met its sternest test at the door of the gymnasium, since exercises were performed in the nude and the circumcised penis prompted cackles of derision from the Greeks whose pride in the lengthy, tapered prepuce can be seen on innumerable vases and

amphorae. Especially baffling and the subject of much sniggering was the notion that Jews deliberately cut away their foreskin to deprive themselves of sexual pleasure. Strabo the geographer even believed that Jews practised clitoral excision for the same misguided reason. And some of Philo's fierce defence of the practice as intrinsic to leading the moral life (not to mention matters of cleanliness) only confirmed the pagan world in its bewildered contempt for Jewish self-denial. As far as they were concerned, showing off your finely elongated prepuce was so de rigueur among the very flower of Greek athletes that some took to wearing the *kynodesme*, or 'dog leash', a thin leather thong that would loop round your back, winding under the scrotum to be tied in a fetching little bow just where you wanted it.

For Jews for whom acceptance as a full citizen of the *polis* was more important than the covenant, and aware that graduation from the ephebeum academy would require nude gymnastics, partial fore-skin restoration known as epispasm was available. Since circumcision in antiquity seems to have involved less than the removal of the entire prepuce, the remaining vestige could be stretched by traction, the skin mollified with honey or lotion from the pressed thaspia plant, a treat-ment routinely used for Gentiles who thought themselves short-changed in the prepuce department, and who suffered from inadvertent exposure of the glans with consequent outbreaks of embarrassing tittering in the gym.[15] When, as was inevitable, those who had gone through epispasm suffered stretchers' remorse, the rabbis (who took all this with the utmost seriousness, for the covenant was involved) debated whether complete re-circumcision was mandatory for a return to Judaism or whether it was too dangerous an operation. But from then till now, along with repeated Talmudic insistence that the prepuce was intrinsically revolting, the Mishnaic requirement for the *brit milah* ceremony has involved complete and irreversible foreskin removal. Nothing done by halves.[16]

And yet it was a high priest who proposed establishing a gymnasium in Jerusalem, making Jews (in the shocked description of 2 Maccabees) 'wear Greek hats' (hats being a very big deal to Jews), and who was pleased to send a delegation of Hellenised Jews to the cinquennial games at Tyre. This daringly renegade high priest was the usurper Jason, who in 172 BCE had displaced his brother, the incumbent Onias III, by bribing his way to the office. The gymnasium was but one part

of a larger scheme launched by Jason to transform Jerusalem into a Greek *polis*. Once its people had been through the ephebeum that was also to be created, they would qualify as citizens and their city would henceforth be known as 'Jerusalem in Antioch'. The quasi-apostasy of a high priest amounted to a repudiation of the founding act of Israelite difference: the covenant made between Abraham and YHWH, dramatically renewed when the excited Zipporah flung the bloody foreskin of her son at her husband Moses and proclaimed, '*Now* thou art a bridegroom to me.' The Seleucid king, Josephus writes, wanted the Jews to be like everyone else, but the desire sprang in the first place from the wholly Jewish high priest, Jason.

The force of this development is especially shocking because nothing about the Seleucids had suggested that they were bent on coercive Hellenisation as a matter of policy any more than the Ptolemies. When the cavalry of Antiochus III (conspicuous for the top-to-toe armour enveloping not just its troops but also their mounts) had smashed the Ptolemid army of Scopas at the battle of Banion on the foothills of Mount Hermon in 200 BCE, one of the earliest actions of the victorious king was to issue edicts promising to be, if anything, an even more solicitous protector of the 'ancestral laws and practices' of the Jews, banning foreigners from the Temple precincts and the import of forbidden meats and animals, including (perhaps redundantly) leopards and hares from Jerusalem. Temple sacrifices were to be maintained, damages from the war made good, and the priests permanently exempted from taxes, the rest of Jerusalemites for three years.

Antiochus III's decrees were everything the old Jerusalem Temple establishment could have asked for and in keeping with three centuries of the relationship between imperial overlords and the Jews, but they did not survive the campaigns or the life of the king himself. Tempted into overreach, Antiochus III rashly tried to exploit his advantage by taking the war to Egypt itself where he was routed by the coming power of the Romans at the battle of Magnesia. It was a turning point. The Romans exacted a ferocious indemnity and took young Antiochus (later the IV) hostage in Rome where (according to Polybius) he established a precocious reputation for peevish eccentricity. But the strain on the military chest for the Seleucid north was such that they may have regretted the easy-going hands-off largesse that Antiochus III had promised Jerusalem.

Under his successor, Seleucus IV, that shortage of funds became so acute that the king could no longer afford to keep his hands off the much-publicised gold and silver of the Temple. A raid by the finance minister Heliodorus may or may not have happened, but it became the subject of yet another miracle story when the would-be plunderer is stopped in his tracks by – naturally – the angelic rescuers who got around fast in the world of Judeo-Hellenic fantasy literature.

It was this very specific, entirely pragmatic fiscal-military predicament of an insecure mini-empire, not any sort of preordained clash of religious cultures, that triggered the events leading to the great Hasmonean rebellion. It certainly *became* a war of Jewish resistance against cultural and even ethnic annihilation, and the Books of the Maccabees, committed to depicting the Hasmoneans as guardians of the Torah, present it that way.

The truth is more squalidly complicated and thus more historically credible. Sensing what the Seleucid governments wanted, rival factions of the Temple elite competed in monetised ingratiation in return for official favour for their party in the high-priesthood wars. *Both* contenders for the office after the accession of Antiochus IV Epiphanes – Jason and his rival in bribery, Menelaus – were Hellenisers, each outbidding the other in offering monetary sweeteners to the Seleucids. Three years into his high priesthood, Jason was the loser. Since his successor Menelaus had Onias (the original high priest and Jason's brother) assassinated, Jason lost no time in getting himself across the Jordan to Hyrcanus' palace fort.

A little giddy at finding himself the high priest to end all high priests (literally), Menelaus authorised the establishment of the *akra* citadel for foreign troops, which had the effect of turning Jerusalem into an occupied city (notwithstanding that it was supposed to be a free *polis*). The building of the citadel required the demolition of a swathe of property in an increasingly crowded town.[17] And demolition politics in Jerusalem has always been a recipe for trouble. The wrecking crews moved in, triggering violent riots. So the war between Jews and Greeks did not start with the Maccabee revolt in Modi'in but an urban insurrection against the citadel (albeit armed with just sticks, knives and stones) and Menelaus' brother, the deputy high priest Lysimachus, and his officers. According to 1 Maccabees, the crowds also threw ashes at their enemies. Supposing any of the 'dust' or 'ash' landed on

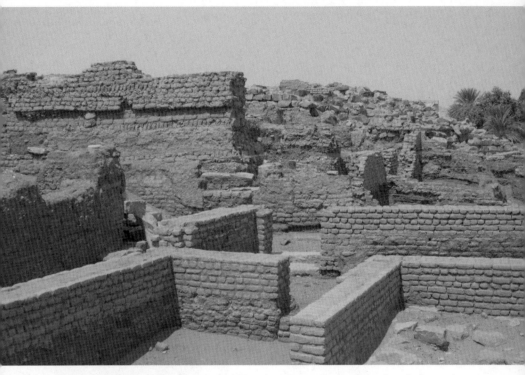

The streets and houses of Elephantine, fifth century BCE, built of mud and clay and a little granite; the tightly packed world of the Judaean Troop and their families.

The fortress town of Khirbet Qeiyafa,
looking down on the valley of Elah.

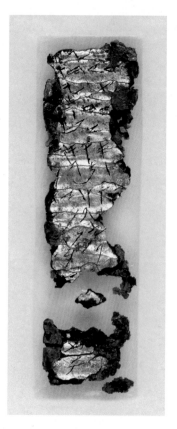

A model cult shrine from Khirbet Qeiyafa,
dating from the eleventh or tenth century BCE.
There are vestigial doves on the roof, and a
textile motif suggesting a hanging curtain.

A silver benediction amulet with an
archaic Hebrew inscription, from one
of the funeral chambers of Ketef Hinnom,
late seventh century BCE.

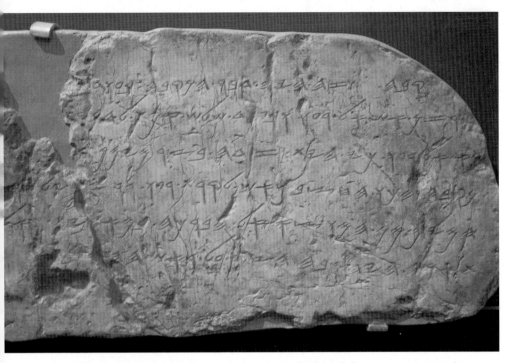

Siloam tunnel inscription from the reign of Hezekiah, eighth century BCE, Israel, on which the tunnellers tell the story of their achievement; the first self-celebration of ordinary Jewish workmen.

Asherah pillar figurines, found all over Palestine and Judaea, from the ninth through to the seventh century BCE. The breast-cupping gesture symbolises fertility.

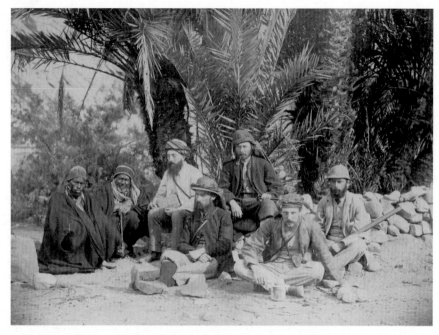

Photograph of the Palestine Exploration Fund Sinai Survey team, 1868, taken by Sgt James Macdonald. Seated in the centre of the picture at the back is Charles Wilson, with Edward Palmer on his right.

The Plain of Er Rahah seen through the cleft on Ras Sufsafeh in the Sinai range, the speculative site of the lawgiving of Moses, photographed by Sgt James Macdonald.

A limestone ossuary from the second/first century BCE, decorated in the style of a Hellenistic house.

Ossuary of the High Priest Caiaphas, with rosette decoration, dating from between the first century BCE and the first century CE.

Iraq al-Amir in Jordan, the fortress palace of the Tobiads, second/first century BCE. Limestone columns, panthers, fountains and colonnades evoke the magnificence of a baronial magnate with High-Priest connections.

Ceramic candelabrum from the second/first century BCE

A *pruta* coin of the Hasmonean monarchy with pomegranate and cornucopia motifs.

Lion suckling cubs on the roof of Iraq al-Amir.

The Hellenistic 'Tomb of Zechariah' in the valley of Kidron on the edge of Jerusalem.
Its spectacular, monumental elegance shows Hasmonean-period Jews following the
dominant cultural style of the pagan world.

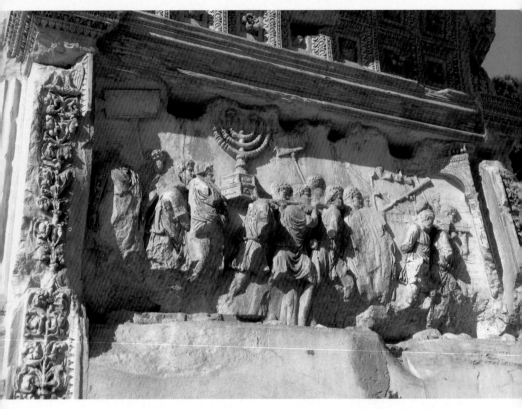

A frieze on the Arch of Titus in Rome, showing spoils taken from
the Jerusalem Temple, first century CE.

Colossal masonry slabs from the western wall of the Jerusalem Temple,
dislodged by Roman troops following the siege.

its targets, it is unlikely to have caused the oppressors much discom-
fort, but the point of the gesture was symbolic: the residue of the
sacrifices flung on those who had outlawed them.

However he heard about the riot, Jason, sitting in Hyrcanus' big-cat
palace across the Jordan, knew this was a precious political opportunity.
Now he could pose as the defender of Jewish tradition. Believing his
own propaganda, and giving off waves of unmerited righteousness,
Jason mustered the spear carriers.

His timing was determined by a report that Antiochus IV was dead.
The Seleucid had marched south to mix it up as usual with the
Ptolemies, had been thwarted by the Romans but had survived –
indeed, had come to some sort of agreement with the victors.[18] Jason,
meanwhile, believed this to be his moment. Leading a small army he
had raised with the help of Hyrcanus, he crossed the Jordan, attacked
Jerusalem and slaughtered not just the foreign troops and mercenaries
defending the city for the Seleucid king, but thousands of Jews who
he decided had been accomplices of the Greeks.

But in fact Antiochus IV was very much alive. Released from his
Egyptian predicament by a treaty with the Romans, he turned
apoplectic at Jason's coup. Thwarted in one military theatre, he was
not about to have Seleucid power humiliated in another. So the king
turned monster, and the jokes that he was not, as represented on his
coins, *epiphanes* (God-manifest), but *epimanes* (lunatic), suddenly became
serious. It was, moreover, madness with a method, or at least a pre-
cedent. Jason – and the enthusiastic reception he had received from
many quarters in Jerusalem – had put Judaea out of bounds of civilised
consideration and made it liable to be treated as 'captive of the sword',
no longer bound by the agreements Antiochus III had made, but deliv-
ered to the absolute power of the conqueror for him to deal to its
people, holy places, customs and property whatever he wished.

And what he wished was grim: a three-day butchery which
according to the Books of the Maccabees took 40,000 lives, including
women and children, and an equal number enslaved who were shipped
off to be sold on the Phoenician slave markets for sums that would
ease the Seleucid treasury problem. The author of 1 Maccabees adds,
with sinister poetic indirection, that the trauma threatened the biolog-
ical survival of the Jews, since 'virgins and young men were made
feeble and the beauty of women was changed'.[19]

Then came the cultural annihilation, famous from the Books of the Maccabees: the ban on all the rituals that made Judaeans Jews: Torah reading, circumcision, ritual purification, Sabbath observance. Instead of abstaining from pork, Jews were forced to eat it. By robbing the Temple of all its vessels and ritual furnishings – the golden altar, the shewbread table and its array of loaves and meal offerings, the menorah candlestick with its deep meaning of the blossoming of light, and the curtain veil that defined the Holy of Holies – Antiochus not only made it impossible for any sort of sacrifices or the cereal and bread offerings to be made, but for the Temple to exist at all as the defining focus of Judaism. What replaced them – the statuary, the parodic sacrifice of pigs at a new altar, the Dionysiac cults, the harlots, the ivy-processions to Bacchus – were a footnote to this comprehensive eradication. Just as would be the case when the Roman armies finally put an end to the Jewish insurrection, the Temple had to all intents and purposes ceased to exist. When the troops of Apollonius, the general whom Antiochus had sent on a follow-up expedition of retribution, ran through the streets of Jerusalem, killing all in their way *on the Sabbath*, it served notice that henceforth the Jews were the helpless prisoners of a terror state.

Back in his palatial fortress Hyrcanus took the hint. Not waiting for the fate to be visited on him, the last of the Tobiads fell on his sword, observed by the limestone panthers. Deprived of his shelter, Jason – who, by the lights of the writer of 2 Maccabees, had initiated this chain of catastrophe – now became a houseless fugitive, running 'from city to city, pursued before all men as the hated forsaker of the law', fleeing first into Egypt and then further to the land of the Lacedemonians where he died, fittingly, in Greek exile. 'He that had cast out many unburied had none to mourn for him nor any solemn funeral at all nor sepulchre with his fathers.'[20]

III. Maccabiad

When everything else had been consumed in the Babylonian annihilation, a single perpetuated flame of the Temple's sacrificial fire was carried away into exile by the priesthood. The flame was preserved

in a secret pit, but when its guardian, Nehemiah, came to recover it for the restoration of Jerusalem, the pit had filled with 'thick water' and the fire was extinct. When the time came for a burnt offering, Nehemiah told the baffled priests to sprinkle that water on the wooden kindling. Bemused, they did as they were told, at which moment a ray of supernal sun appeared and transubstantiated the saturation into self-igniting fuel. The ancestral sacred fire had been restored.[21]

Or so the author of the Second Book of the Maccabees, his literary imagination itself a leaping flame, wants his Jewish readers to believe. Though they are radically dissimilar, the Maccabees 1 and 2 together constitute the liberty-epic of the Jews, in their way every bit as stupendous, fantasy-filled and thrilling as the foundation story of the Mosaic exodus.[22] The miracle of the oil for the rededicated Temple lamp, sufficient for one day yet burning for eight, is not among those wonders recorded by either book. That legend, understood by all modern Jews to be the central meaning of Hanukkah, is a purely rabbinic invention, added at least three centuries later. But the Maccabiad in both its versions – especially in the second book – is packed with marvels as well as history: a mélange of factual chronicle and fabulous invention, of exactly the Greek flavour the Maccabees were supposed to be repudiating.

Both books were written late in the second century BCE as propaganda histories on behalf of the Hasmonean-Judaic kingdom which had been established forty years earlier amid the fraying remnant of Seleucid power. The epic story of the patriarch Mattathias (significantly of priestly descent) and his five sons who led the revolt against the Antiochus persecution, was meant to legitimise the claims of the Hasmonean dynasty (neither Zadokite nor Davidian) as simultaneously *both* kings and high priests, a shockingly unprecedented innovation. Tellingly, neither book professes any concern about the violation of a separation of roles established as far back as Moses and Aaron. And the 'Asideans' – sometimes rendered in Hebrew, a little misleadingly, as Hasidim, or the Pious Ones – were among the most militant of the Hasmoneans' rebel allies, though there is no indication yet that they thought of themselves as a purer-than-pure vanguard of Torah orthodoxy, much less as the founding generation of Pharisees. On their guard against accusations of usurping the priesthood (the Hasmonean king Alexander Jannaeus would be pelted with citron

fruit by a Jerusalem mob when he tried to lead the celebration of Tabernacles in the Temple), the Hasmoneans needed to present themselves as the makers of divinely wrought miracles, simultaneously military and religious, the appointed guardians of Torah Judaism against Hellenistic contaminations, even when the true story was a lot more ambiguous. For the first time, too, Jewish power presumed to amend Torah commandments when they put its side at a disadvantage. After the defenceless population of a Judaean village was put to the sword on a Sabbath, Judas Maccabeus, 'the Hammerer', resolved that, if necessary, they could and would fight on the day of rest, a decision vindicated by a turning of the tide. There is every sign that, just like the ego-giddy emperors of the pagan world, the Hasmoneans came to believe their own sense of divine appointment. The official festival they invented – Hanukkah – enshrined them as the cleansers and reconsecrators of the defiled Temple.

Heady with unexpected – though not invariable – success against far bigger Greek armies, pragmatically exploiting a tactical alliance with the Romans and the continuing feuding of rival Seleucids, the Hasmoneans quickly discovered a muscular confidence that made the Jewish state more territorially ambitious and more aggressively proselytising than any of the Israelite kingdoms it claimed to restore. Moving out of the Judaean hill-country heartland where the rebellion had started, their armies – including sizeable detachments of foreign mercenaries – pushed through Samaria into Galilee, to the Greek coastal city of Ptolemais and up into the foothills of Mount Hermon to the plateau now called Golan, and even into south-western Syria, then across the Jordan into the mountains of Moab and the Ammonite valleys, and south into the Negev Desert, taking ancient port cities like Jaffa, Gaza and Askelon that had anciently been Philistine and Phoenician. And as they conquered, they converted, sometimes forcibly, a less physically painful process than sometimes imagined since some of the local populations would, in any case, have been practising circumcision.[23]

This mini-empire, Torah triumphant, was, literally, new-minted. John Hyrcanus was the first Jewish ruler ever to issue coinage, albeit the *prutot* of small denominations and tiny size. While one face often bore images of horns of plenty (from classic sources) and pomegranates (from Jewish ones), the other was self-consciously inscribed in

the proto-Hebraic lettering that had already mostly been abandoned in favour of the square-form Assyrian-Aramaic in which Hebrew is written to this day. Instead of using the king's familiar Greek name, Hyrcanus, the inscription describes him as '*Yochanan Cohen Gadol, Rosh Hever Hayehudim*', 'Jonathan, high priest and leader of the Council of the Jews'.

In the same fashion, 1 Maccabees, originally written in Hebrew but known only in its Greek version, presents itself as the foundation epic of the reborn Judaic kingdom and is close in narrative style to the history books of the canonical Hebrew Bible. 2 Maccabees, on the other hand, is richer in mythic extravagance and poetic invention, all of which suggest an authorship in Hellenised Egypt where that kind of Graeco-Judaic literary confection, like the Joseph and Asenath story, was in demand. It is also distinctive in presenting, self-consciously, the voice of the author-historian, claiming to abridge an earlier five-volume work by one Jason of Cyrene.

2 Maccabees begins with a letter (ostensibly in a Jerusalemite voice) to the Jews of Egypt, including the story of the miraculously preserved sacrificial fire, the implication being that whatever happens to worldly powers, the spark of Judaism could be carried from place to place. Conscious, like the writer of the 'Passover papyrus' addressed to the Elephantine Jews three centuries earlier, that Egyptian Jews needed to be brought under the authority of Jerusalem through the ritual calendar of observance, it is careful to specify the date – the 25th of Kislev, the day of Temple rededication – on which the new official Hasmonean liberation festival of Hanukkah is to be celebrated. In fact, the writers of the Maccabees, as if instructed by the new Hasmonean priest-kings, make it clear they wish Hanukkah to be observed not just for the same eight days of the Feast of Tabernacles, explicitly cited as a model of rejoicing, but with the same holiness status as the three pilgrim festivals of Passover, Pentecost and Tabernacles. Whether or not this ever came about, rabbinical teaching would reject this just as it kept the Books of the Maccabees out of the biblical canon. It was almost as if the rabbis decided, in retrospect, that there was something suspiciously worldly about the Hasmonean invention. For all the efforts of both Maccabean writers to represent the liberation as the equivalent – and vindication – of the formative Exodus, the analogy never quite took.

But whoever the author of 2 Maccabees was (and however closely or freely he worked from 'Jason of Cyrene'), he certainly knew how to write an epic in the classical, post-Homeric style, a tale packed with the kind of wonders, curses and marvellous improbabilities that would appeal to a literate, Hellenised readership: a Greek style pitched against Greek triumphalism. In 1 Maccabees, the crazed and chastened Antiochus IV dies off in Asia Minor 'through great grief in a strange land', regretting the persecution that had caused him so much trouble with the Jews. In 2 Maccabees, on the other hand, his last days are described graphically, expiring in the reeking, unstoppable, spasms of diarrhoea that God had inflicted on him. 'And the man that thought a little beforehand that he could reach to the stars of heaven, no man could now endure to carry for his intolerable stink.'[24] In the foulness of his agony the tormented king goes as far as wanting to be converted to Judaism, and should he recover, to wander the world preaching the Torah.

Likewise, although both books narrate a martyrology of Jews rejecting the Antiochene laws, the high-pitched author of 2 Maccabees delivers a Greek-style drama of much more elaborate cruelty and family tragedy. The ninety-year-old scribe Eleazar, 'a man of well-favoured countenance', has his jaws prised open and stuffed with pork but 'choosing rather to die gloriously than live stained with such an abomination, [spat] it forth and came of his own accord to the torment'. Collaborators who take pity suggest he might smuggle kosher meat in and eat it as though it were pork but Eleazar says 'it becometh not our age . . . in any wise to dissemble'. A mother of seven sons watches as cauldrons are prepared to cook her children. The first to speak has his tongue cut out and member hacked off and then fried in a pan, with his brothers watching, resolving to stay true. In turn they are subjected to excruciating ends – scalping and much worse – but all remain steadfast. Frustrated, the wily Antiochus spares the seventh and asks the grieving mother to persuade the lone survivor to accept his will and repudiate Judaism, for which conversion he would be loaded with riches and royal favours. Instead, of course, the mother asks her son 'to have pity on me that bore thee nine months in my womb, gave thee suck three years and nourished thee . . . take thy death that I may receive thee again in mercy with thy brethren'. The son replies that he will defy the commandment of the king but

obey 'the commandment of the law that was given by Moses to our fathers'. Irked, Antiochus orders the young man's treatment to be even worse than that of his brothers, though given the exhaustive repertoire of prior torture and mutilation it's hard to imagine what that could have been.

Since Hasmonean legitimacy is tied to dynastic heroism, both books have at their heart a series of family romances. The austerity of the provincial setting where the rebellion begins is the rough and rustic opposite of silky Hellenised ways. The father, Mattathias, in his town of Modi'in, has his own way of reacting to a Jew wanting to go through a sacrificial ritual the way Antiochus IV prescribed, and that way was to run the party through with his broadsword. By way of precedent, 1 Maccabees invokes 'Phineas', or Pinehas, who, in the Book of Numbers, impales, with one skewering, an Israelite man and a Midianite woman who are in the throes of copulation inside the sacred tent of the Israelites. Such, the text implies, are the wages of pagan promiscuousness, an unnatural union in contrast to the orthodox union of the Jewish family clan.[25]

'Whosoever is zealous of the law and maintaineth the covenant let him follow me,' declares Mattathias, taking his five sons with him into the fastness of the hills from which they wage guerrilla war against their enemies. Families, including women and children, flocks and herds, driven from the corrupted towns and cities come to the Hasmonean encampment and from that free natural citadel they launch a purifying war, demolishing pagan altars. 'What children they found within the coast of Israel uncircumcised [the only area with Philistine-Phoenician traditions where that might have been true] they circumcised valiantly.' So the reference to remaking the original blood-covenant of Abraham and Moses is taken very literally in the Maccabean campaign of fleshly purification.

Before he dies, Mattathias gathers his sons and delivers a speech connecting his own fatherhood with Jewish patriarchs and prophets from Abraham to Daniel, conferring special authority of generalship on Judas Maccabeus and the next oldest brother Simon, 'a man of counsel' who would in his own turn 'be a father unto you'. It is in the same spirit of benevolent patriarchy that Judas, appointing 'captains' from the people for his rebel army, sends home all those who are already committed to a family life: 'those who were betrothed,

those who were building a house or planting a vineyard'.²⁶ His own family makes sacrifices so that an explicitly Jewish state, grounded in Torah observance, can be established. One after the other, the brothers fall in pursuit of that mission. Judas prevails over a series of massive armies and arrogant generals sent against him. One of the most implacable, Nicanor, has his head and the arm that had been outstretched towards Judas cut off and displayed as trophies. His fame is such, claims 1 Maccabees, 'that all nations talked of the battles of Judas'. In fact, between 164 and 160 BCE Judas and his forces suffer a series of setbacks and defeats. 1 Maccabees has him perish through underhand ambush, though not before both Rome and Sparta have recognised the liberated commonwealth as an ally.

Judas' brother Eleazar dies when the war elephant whose underbelly he was stabbing from beneath falls on top of him. Their sibling Jonathan is the spiritual purifier, replacing as high priest the last of the Zadokite line, Alcimus, who after being prematurely acclaimed as the restorer of Torah observance, reveals himself to be just another self-serving Helleniser. But Jonathan's priesthood is authorised not by an assembly of the Jews but by the Seleucid contender he has chosen to support, in return for the status quo that had existed before Antiochus IV. The result is that he too falls victim to the machinations of the Greek factions.

Which leaves at the end the second brother, Simon. Given that the author of 1 Maccabees is writing during the reign of Simon's son, John Hyrcanus, and possibly that of Simon's grandson, Alexander Jannaeus, it's not surprising that the most florid passage in the book is a vision of a Simoniad-Jewish idyll. The other brothers, especially Judas, had invoked the ancient patriarchs and nation-fathers from Moses through David. Simon becomes the heir of those ancestors as priest, prince, judge and general. It is he who finally succeeds in cleaning out the Jerusalem Akra citadel of foreign troops, ending its occupation and turning the subject status of the Jewish state into a true, independent kingdom. The moment (in the year 142 BCE) becomes a jubilant climax of the epic, celebrated with 'thanksgiving and branches of palm trees and with harps and cymbals, viols and hymns and songs: because there was destroyed a great enemy out of Israel'.

A golden age of peace and prosperity then comes to pass under Simon's rule. The wars between Jews and Greeks – and indeed between

Jews and Jews – are brought to an end. Hellenised cities like Scythopolis, which had refrained from harbouring enemy soldiers, are spared and, renamed as Beit She'an, become home to Jews and Greeks alike. The borders of the state expand. A grand new harbour is built at Jaffa; trade opens 'to the isles of the sea'. Romans and Spartans are impressed, but not as much as the writer of 1 Maccabes who paints a scene of multi-generational harmony and benevolent quasi-despotism. The last books of the biblical canon and some of the Apocrypha were imagined to be authored by Solomon, and Simon appears in 1 Maccabees as his reincarnation, presiding over a Judaic paradise on earth:

> then did they till their ground in peace, and the earth gave her increase, and the trees of the field their fruit. The ancient men sat in the streets, communing together of good things, and the young men put on glorious and warlike apparel. He [Simon] provided victuals for the cities and set in them all manner of munition so that his honourable name was renowned to the end of the world. He made peace in the land and Israel rejoiced with great joy: for every man sat under his vine and his fig tree and there was none to fray them, neither was there any left in the land to fight them: yea the kings themselves were overthrown in those days. Moreover he strengthened all those of his people who were brought low: the law he searched out, and every contemner of the law and wicked person he took away. He beautified the sanctuary, and multiplied the vessels of the temple.[27]

Simon and his line declare themselves enthroned in permanent rule, although the added proviso – 'until a prophet [meaning a messiah or his herald] should appear' – is truly momentous (and recurs in the Qumran scrolls being written at that time). However, even this Jewish *basileus*, the godlike monarch, is not invulnerable to betrayal. As the Hasmoneans begin to live and rule like local Hellenistic potentates, they also die like them. Ensnared in the family feuds that will eventually bring down their dynasty in fratricidal civil war (the legend of the good band of brothers degenerated into the plots of the bad brothers), Simon is assassinated by his own son-in-law while feasting and drinking at a banquet given in his honour – par for the course in pagan antiquity. But like his father Mattathias before him Simon has

already summoned his sons, in particular the two eldest, to confer the priestly and regal succession, declaring that since he was old 'be ye in my stead of me and my brother and go and fight for our nation and the help from heaven be with you'.[28]

When he is murdered, Simon's body, like that of Mattathias and his brothers, Judas and Jonathan, is 'laid to rest in the tomb of his fathers'. That Hasmonean tomb is no longer a modest family grave site in their ancestral home town of Modi'in, if it ever had been. For the first time 1 Maccabees treats us to a detailed description of a lavish, heavily decorated edifice that is not the Temple. Simon has commissioned a pompous monumental structure, every bit as grandiose as the Hellenistic works to which the Hasmoneans were ostensibly (but unconvincingly) opposed. It features seven lofty towers, one for Simon's father and one for his mother, and five for his brothers and himself, each roofed by a pyramid. The pilastered facade was made of dressed, polished stone, and between the pilasters were reliefs of suits of armour paying homage to the Maccabean warriors, and images of ships. This construction was indistinguishable from the kind of edifice classical rulers liked to build for themselves, and its most obvious prototype was the fourth-century BCE wonder of the ancient world, the mausoleum of Halicarnassus at Rhodes, a place where there was already a significant Jewish colony.[29]

All of this seems not very Jewish; not in keeping with its disdain for the pretensions of stone pomp, compared with the imperishability of the word. And yet the point of the Hasmonean mausoleum was to impress foreigners with the message that the Jews had arrived as mighty players in the Hellenistic world. 1 Maccabees tells us that the seven-towered structure was set on a prominence high enough to be seen and marvelled at by ship-borne travellers arriving at the coast.

Monumental conspicuousness had arrived in Judaea. It was, self-evidently, the point of the rock-cut tombs dating from the same period of the late second and first centuries BCE and which still survive in the Kidron Valley on the edge of Jerusalem. Instead of subterranean vaults or ancient caves with common receptacles, the so-called 'Tomb of Absalom' and that of 'Zechariah', as well as the tombs of Jason and the wonderful Bnei Hazir family tomb with its two-column loggia, are all expressly designed to face out in the world, to make a definite impression on Jews and Gentiles alike. And their message is classical

elegance: families belonging to the priestly aristocracy (as these undoubtedly were) need not blush to boast tombs with Doric capitals and columns, internal stairs (as in the 'Absalom'), frieze inscriptions and, sometimes, the mildly orientalised look of the pyramid-hat conical roof. Just as innovative, as the archaeologist Rachel Hachlili has noted, are *kokhim* – niches for individuals from the same clan – and the provision of stone 'ossilegia' caskets for the secondary inhumation of bones, a year after the original burial. By the first century BCE those ossilegia would become objects of extraordinary, almost worldly beauty: made of limestone in which floral and plant decoration was cut (especially complicated rosettes). In one extraordinary example, the ossilegium was made to look like a Hellenistic house, complete with pediment, portico, arched (blank) windows: the last word in elegant urban accommodation for the dead. How telling is it that the word *nefesh* (soul or immaterial spiritual essence) now also became used to describe the very material structures constructed beside tombs?

What was true of these Hasmonean grandees of the rebuilt and quadruply expanded Jerusalem, was also true of the ruling dynasty. The Maccabees had led the revolution against the cultural and physical annihilations of the crazed Antiochus IV, but it took barely more than a generation for them to morph from rebels to players in the Seleucid world. Although they were great forced-converters, idol-smashers and tearers-down of pagan altars (as well as the temple of the Samaritans on Mount Gerizim), their war had never been with Hellenism at large because they had no reason to believe it was fundamentally incompatible with Judaism. Jewish Alexandria, a seat of cultural glory, seemed the living demonstration of the very opposite. Symbolic of this compatibility, Alexander Jannaeus inscribed on his *prutot* coinage both his Judaic name, Yohanatan in archaic Hebrew, and his modern name in Greek. He could be faithful to the Second Commandment by not putting his face on the coinage, but this did not mean he avoided images altogether. Quite the reverse was the case with the Hasmoneans, and their choice of those images was revealingly hybrid. One face of the little *pruta* bore the classical image of a garlanded, double cornucopia (in keeping with the Hasmonean propaganda of prosperity) between which was set the more authentically Judaic and Temple-associated symbol of the pomegranate. The other face of the Jannaeus coin took the image of an eight-pointed

star (sometimes read as an eight-spoked wheel) from a Macedonian prototype. But the star also alluded to the Moabite Balaam's prophecy, recorded in Numbers 24:17, that 'a star will rise from Jacob' – one which, like Alexander's mailed fist, would 'smash the brow' of Moab, Edom and other neighbouring nations.

Hanukkah, officially instituted by the Hasmoneans, was, like Tabernacles, eight days, and it was also the eight-day period corresponding to the pagan winter solstice festivities celebrating the return of light, lustily celebrated in Greece and Rome. Triumphal days in the Greek style – like the Day of Nicanor commemorating the defeat of that general – were added to the calendar.

The taste for classical grandeur, awkwardly superimposed on the more austere core of Judaism, is sometimes associated with Herod the Great's alleged adulteration of Judaism. What else would you expect, this argument goes, from an Idumean convert, the son of Antipater, a military adventurer from the Edomite south? But Herod was merely aggrandising the Judeo-classicism inaugurated by the Hasmoneans. Their annihilating enemy had been the lunatic Antiochus IV, not the Greeks. What could possibly be wrong with emulating their elegant style? Long before Herod, John Hyrcanus had built himself a sumptuous palace at Jericho complete with swimming baths and a colonnaded pleasure pavilion. On the site of the Akra – and thus not far from the purported site of a Davidian palace – the Hasmoneans constructed their own fortified residence, in keeping with their royal pretensions as priests-cum-generals-cum-'ethnarchs', as they were styled.

In their minds, then, and those who wrote their histories, there was no contradiction between invoking whenever possible the original Judaic monarchies they claimed to reincarnate, while serving as loyal allies to the later Seleucids. More than once, the Hasmoneans showed they were prepared to compromise the always tenuously defined autonomy of their Jewish state as the price of survival. A long and intense siege of Jerusalem by Antiochus VII from 134 to 132 BCE, which nearly brought Jerusalem to its knees, was lifted only when John Hyrcanus agreed to turn his realm into a tributary state, much as had been the case under the benevolent Antiochus III. It was only that regular gift of the Greeks – the king's sudden death on campaign – which enabled the Jewish dynasty to recover, for the time being, a semblance of independence.

Even this was thanks to the oncoming power of the Romans. Ever since Judas Maccabeus had sent Eupolemus to Rome in the first of three embassies at the end of the second century BCE, the Hasmoneans fancied themselves equal (if perhaps junior) partners in treaties of alliance. Those treaties, 1 Maccabees and Josephus tell us, were engraved on bronze tablets for public display in Jerusalem. Perhaps, for a while, the Hasmoneans were not entirely deluded in this swollen self-importance, since the march of the expansionist campaigns of Hyrcanus and Alexander Jannaeus may indeed have made the Jewish quasi-kingdom seem like the dominant power in a strategically crucial region between Egypt and Asia Minor.

But getting respect from the Gentile powers meant, inevitably, losing it with the priests who held themselves, not armed dynasts, to be the true guardians of Judaism. The shocking usurpation, as many saw it, of the high priesthood, rankled and broke open again the ancient arguments and jealousies between priests and princes. That argument – first raised by the writers of the Books of Kings, Judges and Chronicles, more than half a millennium before in their histories of Saul, David, Solomon and their posterity – was whether political power sustained piety or damaged it. This is a debate, of course, which after two millennia, has not exactly disappeared from Jewish life. Then, as now, it was all about the clash between politics and Torah. Judaism needed the state to protect it, but Israelite religion had been founded in an escape from Egyptian kingship and had been established in the Promised Land without it. Along with all the other pretensions the Hasmoneans liked to imagine they inherited from the Davidian line was this perennial dilemma.

Outside their court, those who believed themselves to be the guardians of Temple and Torah divided on this critical issue (as they still do). The aristocratic-government caste which Josephus tells us were known as Sadducees were, essentially, statists, untroubled by the concentration of sacerdotal and military power assumed by the Hasmoneans, and presumably elated by the imposition of Judaism at the point of the sword (and the circumciser's knife) on neighbouring peoples like the Itureans and Idumeans. Their adversaries, the Pharisees, on the other hand, had come to believe that the more swaggering Hasmonean power became, the more likely it was to violate the purity of Jewish law, and that, ultimately, the only sovereign in Israel was the Torah. The precise

meaning of the Aramaic word from which they took their name has been much argued over as signifying either 'clarification' or 'separation', but for their numerous followers, the one implied the other.

Hence the gradual but unmistakable estrangement of the ruling dynasty from the guardians of holiness as they saw themselves. 1 Maccabees and Josephus tell the powerful story of Hyrcanus, originally a 'disciple' of the Pharisees, and believing himself to be gifted with prophetic powers, indulging himself by asking them, at a feast, to ensure that when they thought he was straying from the straight and narrow, they would be bold enough to correct him. All dictators like to flatter themselves they can take it on the chin from the pious until they discover they don't like the upbraiding after all. One septuagenarian Pharisee, Eleazar, was naive enough to take the invitation at face value and spoke up to the effect that Hyrcanus ought to lay aside the priestly role and be contented with the lay power. When pressed for the reason, he explained that this was because Hyrcanus' mother (Simon's second wife) had been a captive in the time of the Antiochus IV persecution. This was a euphemism for saying she had been raped, casting doubt on Hyrcanus' own legitimacy. Infuriated, Hyrcanus then asked the Pharisees what punishment ought to be meted out for a speech of such temerity and was mortified when they suggested that a bit of a flogging might be enough.

The accusation of illegitimacy was repeated against his son Alexander Jannaeus, who was also subjected to an undignified rain of *etrogim* – the knobbly, enlarged and inedible lemon-like citrons carried by Jews at the Feast of Tabernacles (along with the furled *lulav* palm wand and sprigs of myrtle and willow). The citric pelting was triggered by Alexander's high-handed indifference to the prescribed procedure for the water-libation while he was officiating as high priest during Tabernacles, pouring it on his own feet rather than on the altar. Comic though the incident seems, it told the outraged Pharisees that the Hasmonean pose as guardians of the Torah was just that. What, after all, was the difference between those self-crowned king-priests and the scandalous ultra-Hellenisers they had deposed in the time of Judas? The indignation turned lethal, opening a murderous six-year Jewish civil war (not always sufficiently registered in popular histories of the Maccabean period), in which thousands of disaffected Jews joined the army of the Seleucid Demetrius (so recently the enemy), in the hopes

of overthrowing the iniquitous Hasmoneans. Fifty thousand were slaughtered in the bloody conflict, the climax of which was the rout of Jannaeus by Demetrius and his Jewish auxiliaries. But his throne and state were saved by the usual sudden need of the Greek ruler to retreat abruptly back north and east, allowing Jannaeus to return to Judaea and inflict a horrifying retribution on the disloyal. His revenge culminated in a mass crucifixion of eight hundred of the Jews he judged most guilty in front of the king-priest while he was feasting 'with his concubines', looking on as the wives and children had their throats slit before their crucified husbands and fathers.

The brutality of the Jannaean repression bought the Hasmoneans some time, but the wound that had opened between the dynasty and Pharisees would never close. At some point after the death of John Hyrcanus in 104 BCE, the *assumption* of an identity between Judaism and the Hasmoneans began to fray, and under his son Alexander Jannaeus it ripped violently and permanently apart. Intrinsic to that division was the profound question Judaism has always asked and continues to ask: what is the proper relationship between power and piety? Is a modicum of state force the condition of leading the good Jewish life, or is it most likely to corrupt and destroy it? The kingdoms of David and Solomon get the benefit of the doubt that they might have managed the problem only through documentary near-silence. We can infer a royal bureaucracy from all those *lmlk* jar impressions and seals, but we have little sense of how statehood and priesthood might have abrasively rubbed against each other, except where the Bible stages scenes of confrontation. Of course, those scenes – whether David confronted with his personal sins and overreaching war power, or Solomon with his Egyptian queen and the countless other consorts – come regularly enough in the Bible for us to sense that holiness and worldliness (both needed if anything like a Jewish state was to survive, let alone flourish) were in constant friction. That prophets like Jeremiah should characterise the defeat of the kingdom and even the destruction of the Temple itself – the whole Babylonian annihilation – as perfectly in keeping with God's plan, did not make the squaring of force and faith any simpler.

The bulk of the Bible, from generation to generation, was written when the weaknesses of state power were most apparent. The portable scroll-book became the countervailing force to the sword. Once

that happened, the idea that Jewish life *was* Jewish words, and they could and would endure beyond the vicissitudes of power, the loss of land, the subjection of people, took off into history. Since other monotheistic book-faiths allied word and sword rather than divorced them, this would turn out to be a uniquely Jewish vision.

At the time, when eastern and western civilisations were governed by the truism that without imperial force the sacred realm was of little consequence, this Judaic reversal of assumptions represented a radical rearrangement of the priorities of human existence. When it was restated with numinous insistence and clarity by an otherwise obscure Nazareth preacher, the doctrine of the power of the powerless began to draw the allegiance of millions. It could not have been more significant that the most effective creator of the Christian universe, Paul, began as an enthusiastic instrument of the state – enforcer, tax collector, bureaucrat – and then un-stated himself by falling from the high horse of his authority in a bolt of prostrating illumination – blinded by the light, overthrown by the gospel truth. But the minute Christianity itself turned imperial, the dilemma first played out by the biblical states – and then more fatefully and dramatically by the Hasmoneans – was laid upon the new church. Could empires ever be holy, much less Roman?

The Pharisees became important not just because they claimed to uphold the Torah more purely and uncompromisingly than the government of the Hasmoneans and their court-priest caste, the Sadducees. In circumstances where the Jewish state was unstable, the source of law-giving, and the encouragement of law-abiding, needed to come from somewhere else. Nor could the written Torah alone cope with the vicissitudes of year-round life that would come from an unsettled polity and society. So the Pharisees began the process of engaged addition, supplying an 'oral law' meant as not only an extension of the written, but also an organic, vital connection between the writ of the Commandments and the challenges of daily existence. Shockingly, they insisted that their own learned interpretations would have authority comparable with biblically revealed law. Thus was launched a system that was simultaneously open and closed, and which made the judgements of the Oral Law the object of interminable, multi-millennia argument. But from this momentous act of self-authorisation the beginnings of the Mishnah (two hundred years later) and eventually the authority of the entire Talmud would flow.

Negatively, too, the insuperable conditions of just *being* a state, or rather a state at perpetual war, played to the strengths of the Pharisaic emphasis on a realm of common succour beyond the institutions of power. Those who suffered most painfully from punishing taxes, conscription levies, the regular visitations of military brutality (along with its outriders, agrarian destruction, famine and epidemic), were naturally drawn to critics who claimed that, while God ordained sufferings, they had been aggravated by haughty and presumptuous men. The fact that the Temple establishment was in the hands of Sadducees close to the ruling caste, that somehow it had become a domain of personal Hasmonean display, only added fuel to popular fire and adherents to this Pharisaic disaffection.

All of which was a prelude to one of the more astonishing scenes in Jewish history (and one which doesn't get much play in lessons of Hanukkah and Tisha b'Ab, said to be the appointed day on which both the Babylonians and the Romans destroyed the Temple): the repudiation of the Hasmonean king-priests, in the name of Judaic righteousness. After the apparently unstoppable Roman general Pompey had conquered Damascus (and was moving his legions into Judaea), three Jewish delegations visited him there to persuade him to their cause. Two were embassies from each of the brothers, Hyrcanus II and Aristobulus, rivals for the Hasmonean succession. But a third, writes Josephus, claimed to speak with a truly Jewish voice and 'was of the nation that was against them both [and] which did not desire to be under kingly government because the form of government they received from their forefathers was that of subjection to the priests of the God they worshipped'.[30] The Hasmoneans had changed this form of government 'seeking to enslave them', so their request to Rome was to liquidate the pretension to be king and high priest at the same time, and restore the ancient separation of the worldly and holy realms. As far as the Pharisees were concerned it was unimportant which of the contenders was allotted that wordly power – Hyrcanus II, who together with his Idumean enforcer Antipater had summoned the Romans, or his brother Aristobulus. Let whoever wanted that power, or could take it, have it. The true power lay elsewhere.

IV. Roost of the Golden Eagle

o this is where the story had got to: a bitter contest between the Hasmonean dynasty which claimed to be the true embodiment of the Jewish commonwealth it had founded, and those who said it had become the obstacle to its survival. But when, towards the middle of the first century BCE, Hyrcanus and his enforcer Antipater brought a Roman army to the very gates of Jerusalem, had he made a nonsense of the claim to be a Jewish ruler? Would the Roman wolf suckle you and then eat you? Ironically, once the worst had come to pass and what had been a Jewish state was turned into a tributary of Rome, the aura of the deposed, impotent Hasmoneans, as the holders of the flame, actually grew. For Herod, and his successors, the refusal of the Hasmonean ghosts to die off altogether, their legend sustained by the Hanukkah story, was an aggravation. Herod's way of dealing with them was nothing if not versatile: marrying one of them, co-opting another and murdering the rest.

None of this particularly bothered the Pharisees, nor did the replacement of sovereignty by the dwarfish status of a Roman tributary state. To their way of thinking the end of independence would be the condition of a truly Jewish restoration, or at least a renewed separation of the sacred and lay realms. Our only source for what then happened is Flavius Josephus, born Joseph bar Mattathias, who was in a unique position to understand both sides of the matter since he came from a priestly family on his father's side and the Hasmoneans on his mother's. But Josephus wrote for a Roman audience, following the destruction of the Temple in 70 CE in which he had been not a neutral bystander but an active collaborator and guide with the exterminating army of Vespasian and Titus. So his account of Pompey the conqueror marvelling at the Temple is of a piece with the conviction that there was nothing *intrinsic* to Roman power that would make it the destroyer of Judaism.

There is Pompey, on the threshold of the Temple, after an aggravatingly protracted siege, involving the construction of colossal siege ramps, battering rams built at the Mount. Twelve thousand are killed in and around its precincts, yet Pompey notices that even as this

infernal carnage is proceeding, the Temple priests continue their cere-
monies. Brushing aside all the taboos against foreigners, the general
marches through the Temple, tearing aside the curtain veil and entering
the Holy of Holies where only the high priest was admitted. But then
Pompey is so awed by the golden altar and shewbread table and the
menorah candlestick (one tradition has him actually prostrated) that
he uncharacteristically refrains from plunder. On the following day
Pompey orders a cleansing of the Temple courtyards and the resump-
tion of sacrifices.

Replaying the Alexander scene – the conqueror chastened by the
spectacle of holiness – Josephus harmonises (at least in his imagina-
tion) the Judaism of his priestly family and the Romanism of his
citizenship. And in some ways he was right. Although the Romans
would reveal themselves to be more interventionist than the Seleucids
or the Ptolemies, and more exacting in their tax demands, and although
they replaced an independent state with a puppet kingdom, the first
seventy years or so of their domination was not a time in which
disaster looked like it was being merely postponed.

This was not due, however, to some benign fit between the two
cultures. Much of the credit goes to the brutally shrewd dynasty of
Hyrcanus II's military hard man, Antipater, who understood the
essence of the deal already anticipated by Pompey. Show us you can
take Syria and Palestine and keep it in order for us, went the Roman
side of the contract, and we won't interfere with your funny ways:
that thing you have about pork and prepuce; your annoying work
stoppage at the end of the week; all those burning animal carcasses;
the crowd-control problems you get yourselves into come pilgrimage
holidays. All your business. Just don't let it get out of hand. Go ahead,
make yourself a powerful little state; we'll call it a kingdom if it helps;
keep the peace, land hard on the least sign of revolt; deal with brig-
ands; send us the money on time. Don't give our procurators grief
and we can have an understanding. Why not?

Antipater and his sons, especially Herod, shook on the deal.
Paradoxically, they could make it stick (for now) not because Rome
was so strong but because it was, exactly at this time, so violently
divided. Pompey dies; Caesar is assassinated, his murderers are
vanquished; Mark Antony perishes; Augustus eventually triumphs. At
each stage, in moments of crisis, one or other of the parties (even

Cassius, who makes a visit to Judaea) needed the help that Herod in particular could provide. The Near East – from Egypt to the troubled Parthian border – was as important as Rome itself in deciding who would prevail. And all of them knew Herod. He had had to flee to Rome after a reverse in the fortunes of Hyrcanus II's army; his children were educated in the city; their clan became close to some of the most powerful families. Herod became their kind of Jew, which is to say a non-Judaean Jew, an Idumean from the territory south-west of the Dead Sea that had been conquered and forcibly converted by John Hyrcanus. Though Herod was mostly punctilious in his adopted Judaism, the Romans certainly felt that his ethnically different background made him less liable to be in thrall to the 'superstitio' that could spell trouble. Herod was the sort of Jew they thought they could depend on. His capacity for homicidal brutality (towards his own family if necessary – par for the course in Rome) was another sign of this dependability. Nor did it hurt that Herod was loaded with a kind of feral charisma: the smile of the predator. When he appeared before Octavian, shortly to be Augustus, as an ally of the defeated Antony and had the brass to tell the notoriously unsentimental victor 'judge me on my loyalty not by the person to whom I am loyal', Augustus was somehow disarmed.

So the conquerors kept their side of the bargain. The Senate officially proclaimed Herod King of the Jews, and Caesar generously enlarged his territories. The high priesthood was separated from the throne, and was no longer a dynastic prerogative but the appointee of the king. Tribute was paid to Rome and in turn sacrifices were received and made in the Temple in the name of *Senatus Populusque Romanus*.

That pragmatic mutual accommodation and the relative peace it brought (under the reign of the charismatic sociopath) enabled an extraordinary flowering of Jewish culture. Its magnitude and dynamism is most often measured architecturally, in the creation of spectacular cities like Caesarea, and the astounding expansion of the Temple. But it should not be forgotten that the Herodian period was also one of intense religious creativity within the Pharisaic community from which (according to later Talmudic traditions) the duelling schools of the scholars Hillel and Shammai sprang. Their disputes over rigid or more relaxed readings of the Torah's social prescriptions,

and Hillel's famous epigrammatic reductions of the commandments, were a kind of template on which the perennial disputations of the Mishnah and then the larger Talmud would eventually be constructed. No one, though, would ever compete with the moral elegance of Hillel's famous response to the demand that he deliver the essence of the Torah while standing on one leg. 'Do not do unto others what is hateful to you. All the rest is commentary. Now go study.'[31]

The notion that all this happened under the reign of a non-Judaean Jew, from a dynasty of converts – not to mention a king with a psychopathic streak to him – sits awkwardly in the narrative of Jewish history. Religious reform and revival is made to appear a reaction to the Herodian government rather than sheltered by it; and Herod himself a pseudo-Jew. Allusions in the contemporary Psalms of Solomon to 'a man foreign to our race' illegitimately occupying dominion have been thought to refer to the Herodian line, but could just as easily have meant Pompey himself.

For Herod was not, in fact, a pseudo-Jew or, as he is sometimes incorrectly characterised, 'a half Jew' (some Orthodox histories even describe him as an Arab): he was fully and uncontroversially a Jew whose converted family happened to come from Idumea. The response of priests and rabbis, Sadducees and Pharisees, to this rapid, cosmopolitan expansion of Jewish-controlled territory, begun under the Hasmoneans, was not to make sharper, purer, distinctions between Jews and non-Jews, but exactly the opposite: to establish procedures for conversion that would accept them fully into the community. Herod was entirely representative of this broadening of Jewish identity. And a keystone of his success was that his kingdom represented the integration of communities – Itureans as well as Idumeans and beyond – who had been converted, according to perfectly acceptable religious norms, into a wider commonwealth of Jews.[32] That this commonwealth was less ethnically and territorially narrow than those that had gone before it did not, in fact, make it any less Jewish. Quite the reverse was the case. It was Jewish in the way that many diaspora communities were already Jewish (and had been for centuries): living in towns and streets with non-Jews, living in cities that were classically designed and which boasted theatres, expansive marketplaces, forums and agoras, even gymnasia, alongside *proseuchai* or synagogues. In fact, it was exactly in these more mixed and open urban environments

and at this time that synagogues first began to spring up – as places of lodging, Torah reading, ritual purification and pilgrimage centres. Synagogues owed their beginnings not to rigid separations but to something like the opposite: a new sense of mobility, a sudden spurt of Jewish travel and resettlement – the capacity to go places and still be Jewish. So they appear in Jericho on the road to the Dead Sea, very much alive as a commercial waterway as we now know from anchors of this period discovered on its salty bed. Synagogues could be found in the ethnically mixed cities of Scythopolis (Beit She'an), on the edge of the Samaritan heartland, and in the elegant new Galilean town of Sepphoris, south-west of Tiberias.

Conversely, places that had been essentially off limits to Jews like Ptolemais on the Galilean coast, Askelon and Gaza, all now had growing populations of Jewish migrants settling into these societies of trade and shipping, looking outward into the Mediterranean towards Rhodes and Cyprus, the Aegean islands, south-west to Alexandria and Cyrenaica. And it was because of this social and economic gravitational pull that Herod decided to build at its geographical centre the spectacular coastal city named for his latest patron, Augustus – Caesarea Maritima. Boasting an enormous amphitheatre, a harbour made from sinking stonework foundation walls twenty fathoms deep, a showy marine palace with bathing pools, towers and colossi facing the ocean, Caesarea turned coastal Palestine into the new Phoenicia almost overnight. Jews poured into its elegant quarters, with others choosing Jaffa in the south or Ptolemais in the north. The expansion was so fast and so momentous that it was bound, in the end, to bring with it inter-ethnic trouble between Jewish and non-Jewish populations, as was also the case in both Rome and Alexandria. But as long as Herod was governing, that trouble was contained, and the demands of Roman procurators were kept within bounds so as not to provoke dangerous alienation.

At the other pole of Jewish life was Jerusalem. And just as the sense of a Jewish world pushed beyond Judaea towards the coast, south into the desert and north into Galilee and the Golan, was essentially a Herodian achievement, so the physical transformation of the Temple was likewise the accomplishment of the Idumean-Jewish king and master builder. Until Herod got to work on it, and for all its lavish ornamentation, the size of the Temple was still confined to the modest

scale of Zerubbabel and the returnees' design, four centuries before. Under the Hasmoneans, Jerusalem had grown more populous and the crowds pouring into the Temple districts in festival and high holy day seasons had created an impossible bottleneck of devotion (and less sacred clamour). Herod significantly enlarged the precinct area, quarrying and transporting massive slabs of dressed limestone to the Mount to create the great exterior wall of the precinct perimeter. Recently opened tunnels beneath modern Jerusalem have revealed the colossal scale of many of these slabs, especially immediately above the foundation level, and the Herculean labour that would have been mobilised to set them in place, without benefit of mortar or cement. Even by Roman standards, the masonry walls were so imposing that they gave rise to suspicions in Rome that the Jews were building an edifice that under pretence of religion was actually strategic; a defensive line that could defy any future besieging army. It now seems unlikely that many of those praying at the remnant Western Wall, or who extrapolate from it the Temple they yearn to see rebuilt, give much thought to the sociopathic Idumean Jew who constructed it.

For centuries Jerusalem had been the Temple: a cult and sacrifice centre of deep devotional importance to Jews. Without compromising that status, Herod wanted to turn it into a city that would rival the other great achievements of the ancient world: Athens, Alexandria and Rome. He thought big and built bigger. The immensity of the Temple, sitting on its urban mountain, visible from miles around, proclaimed to travellers the imperial scale of that vision. Beyond the Temple, too, the modest residential palace the Hasmoneans had built for themselves became a much grander building, both towered fortress and pleasure resort. There were now gardens, pools, elegantly paved streets, markets and arched bridges connecting the Temple Mount with Mount Zion. The Hezekian aqueducts and cisterns were renewed and expanded, another great one built from scratch to supply the needs of Caesarea. That city and Jerusalem became the magnetic poles of Jewish life in the Roman period: two entirely different ways of leading it (much as Tel Aviv and Jerusalem embody the same difference today), but both stamped with that distinctive culture. All of a sudden the Jews were seen as a force to be reckoned with in the eastern Mediterranean world.

Its aristocrats, lay and priestly, revelled in this new splendour. That

Sadducees saw no contradiction between their calling and the elegance of ornamental design we know from the recently discovered ossuary of Joseph, son of Caiaphas, the priest (and certainly a Sadducee) who, at the behest of Pilate, sat in judgement on Jesus of Nazareth. If Jesus' followers wanted to dramatise the difference between their messianic champion of the poor and the vanity of the Jewish priesthood, they could hardly have done better than the Caiaphas tomb with its exquisitely carved, inter-patterned rosettes. Provided that decoration did not violate the Second Commandment's prohibition on 'graven images' (generally assumed to be the representation of human figures), there was in fact nothing about ornament that was in plain contradiction to the Torah. *Hiddur mitzvah* – the 'glorification' of the commandment, in the phrase used in Exodus 15:2 – became understood as material beautification. No one can read the middle books of the Pentateuch without registering the relish its writers took in describing in minute detail the ornamentation of the Tabernacle, which was both rudimentary in its portable, travel-ready simplicity, and lavish in its decoration. Bezalel, the master artisan, designing everything from the tentpoles to priestly costume, became the first legendary hero of Jewish craft, nearly as important in his legacy to Judaism as Aaron. Almost certainly the multitudes of artisans – goldsmiths, jewellers, weavers, metal beaters, masons and the like – who transformed Jerusalem and added immensely to its prosperity in the Maccabean and Herodian years, thought of themselves as the descendants of Bezalel. And it was the patronage of the Herodian court, and the priestly and lay oligarchs – with their taste for public show and sumptuous houses – that transformed the reputation of the city in the classical world.

For the most part the Herodian monarchy was careful not to cross a line into idolatrous offensiveness. But the pull of Roman self-glorification was tempting nonetheless. At some point Herod had his emblem of a golden eagle mounted atop one of the outer Temple gates. It was not as bad as a likeness of himself, and it was not within the interior precincts, but still it was enough to provoke a gang of young *sophistai* – sophists: sticklers for the law, followers of Judas of Sepphoris in Galilee – into clambering down on ropes slung from the roof and hacking off the eagle with axes. Sticklers they may have been, but they still would not have dared do it unless they believed

the rumour circulating that Herod was entirely, rather than partially, consumed by worms. Unfortunately for the hackers he was not. Brought before the outraged king, and asked why they seemed merry when they were about to die for their crime, the sophists replied that they would 'enjoy greater happiness after they were dead'.[33] It seemed to cheer Herod up one last time to grant them their wish.

Hiddur mitzvah, or what was overdone in its name, still gave offence to the two other religious sects described by Josephus. The Pharisees – probably the most numerous, although no one was counting – made a great show of puritanical plainness, in keeping with their self-designation as keepers (and interpreters) of the Word. Although the canon of the Bible was not formally closed (there would be no grandiose proclamation), it was agreed that the age of prophecy had indeed passed. It was now possible then to inaugurate the first intensive exercises in *midrash*, a word which carries the same sense as the Greek *historia* of enquiry or questioning examination. In particular it was thought that at the time of their utterances the prophets, from Isaiah onwards, could not be prophetic *enough* to foresee how their words would be vindicated by changing circumstances, so the Pharisees especially set about doing, in effect, applied prophetics. And from that questioning came a still more radical development: the self-apportionment of an authority to make the interpretation of the Torah coeval with its text. No one was yet coining an 'oral law', but the assumptions that, ultimately, it would govern the way the Torah shaped daily lives was already at work in Pharisaic teaching. It was serious and lively enough to provoke an opposite reaction from Samaritans who insisted on the exclusive authority of the written law.

The Pharisees presented themselves as teachers and guides uncorrupted by the usurped grandeur of Sadducee institutional power. But for others it was impossible to achieve a state of pure observance – much less the intense and close-up investigation of meanings – while trapped inside the distracted world of populous, vainglorious, swarming Jerusalem. The north-western shore of the Dead Sea was only thirty-five miles from Jerusalem, yet remote enough to offer the community of ascetics that settled at Qumran at least an illusion of desert purification. For a long time now they have been identified with the Essene sect described by Josephus, and the description given by Pliny the Elder a generation later of the topography of their

settlement seems to coincide exactly with the desert-sea landscape at Qumran. Enough doubts about this identification have lately been registered to shake the assumption, but the word they sometimes used for 'community' – *yachad*, together – is poetically apposite enough to use without worrying too much about the exact degree of their Essenery. The first generation, led by a 'Teacher of Righteousness', may have come to Qumran during the Maccabean period or even earlier (the oldest of the 850 manuscripts discovered in the eleven caves are fourth century BCE). But their motivation – the escape from urban wordliness and the outward trappings of Judeo-royal power and governance – would have been the same. Their importance was to personify yet another model of Jewish devotion that remains very much alive today: self-contained, suspicious of outsiders, obsessed with purity (passages in the *Serek hayachad* – the Community Rule, present in Qumran in fifteen copies! – ponder in minute detail just which kind of skin blemishes disqualify a man from the community, and warn against a man not yet fully received into the covenant pressing ripe olives or figs at harvest time, lest he defile the juice with his imperfect touch and thus contaminate the community provisions). The Rule is compulsively obsessed with ablutions (before and after common meals), and ferocious in the punishment of backsliders.[34] Woe betide anyone falling asleep at meetings of the council (but how could anyone not? one wonders). As for the Sabbath, not only must there be no suggestion of work, but 'he shall not talk about any matter relating to work or wealth' (which would have disqualified my father and uncles from membership for a start, although they would have been heartened that another subject dear to their hearts – eating and drinking – was deemed permissible).[35]

We take this tripartite division of the sects on trust from Josephus (as we do everything else from this period) but there is no reason to suppose it fictitious. He was certainly exaggerating later – in his *Against Apion*, written to correct the delusions of the Gentiles – when he insisted on the unity of Jewish culture and practice (not a common view). But he was right to suggest that, the toxic politics of the high priesthood aside, the divisions of the sects would not necessarily have torn the Jewish community apart had not there been a fourth tendency, arising within the Pharisees but implacably hostile to both the Herodian government and their protectors and supporters: the

Romans. This was the beginning of Zealotry that would ultimately provoke the war of destruction in Palestine. Some of the Zealot leaders (whom, frustratingly, we know only from Josephus' intensely unsympathetic and caricatural characterisations, like John of Gischala) undoubtedly thought of themselves as called as much by religious fervour as a kind of Jewish tribal fury. Another was a mysterious Egyptian 'prophet' who was charismatic enough to lead a following of 30,000 to Mount Zion before fizzling out. But the Zealots and their increasingly embittered sensibility, their conviction (shared by the *yachad* at Qumran) that some sort of reckoning between the forces of light and darkness was at hand, meant that beneath the apparently adamantine surface of the Pax Herodiana all sorts of trouble was looming.

Some of that trouble was ethnic. Just because Tyrians (from Phoenician Tyre), Greeks, Syrians, Jews and scatterings of Egyptians and Romans shared the living space of the new towns didn't mean they especially liked each other or were oblivious to differences, especially below the level of the commonly Hellenised elites. Every so often in Ptolemais, Scythopolis, Caesarea or Jaffa, casual resentments boiled over into neighbourhood violence, each of the parties calling in government officials, and behind them Roman authorities and soldiers, to uphold their cause and punish their neighbourhood enemies. One particularly ugly outbreak of inter-communal violence and the perceived partiality of the Romans against the Jews would trigger the all-out revolt.

Social division was also making the Pax Herodiana harder to sustain. As with the usual way of such developments, the acceleration of a trading and market economy along the coast, with its concomitant flow into the Lower Galilean countryside and handsome new towns, had also created a populous underclass. Many of them are likely to have been itinerant pastoralists from barren, semi-desert environments, beyond the farms of Galilee and Jezreel, growing prosperous as they supplied the awakening urban markets with grain, oil and wine. They made up the labour pool for the great Herodian building projects, and they suffered accordingly when those works were done. Eighteen thousand alone of this casual labour force were put out of work when the Temple construction was completed. When Jesusite preachers told them they, not the rich, were likelier to enter heaven,

they must have listened attentively. The chances are that they were also a recruiting pool for more violent men who could see profit from working up a head of steam against Greeks or Samaritans or, if they were rash enough, even the Romans. Barabbas and Jesus of Nazareth were truly opposite sides of the same coin.

Anyone could be fair game. Something about Josephus' description of the *sicarii* (named for the curved daggers they concealed in their shirts and stuck in the guts of victims in the tight-packed crowds thronging Jerusalem on festival days, lifting purses and then joining the hue and cry) rings horribly true. This doesn't mean that the impoverished were divided into beggars and robbers. In his lordly way Josephus is inclined to classify any rebels or dissidents as 'brigands', but he could not have been wholly wrong either. Increasingly, the roads and hills and docks of Jaffa, Ptolemais and Caesarea were turning perilous. With mounting frequency the Herodian government turned to the Roman military for police and pacification operations. Predictably, those campaigns were blunt instruments that terrorised the innocent along with the guilty and began to make the Romans seem more like enemies than protectors.

It is not surprising, then, that this was all held together only as long as Herod himself was alive, and in spite of the murderous palace politics in which he dispatched, *inter alia*, his own wife and sons. This was routine procedure in the Roman world of course, and for that matter the later Hasmoneans had not invariably been a model family either. Famously, after killing off anyone in his own family who might pose a threat, Herod developed an impressive array of infections of the gut including colonic tumours, an 'intolerable itching of the intes-tines' and a gruesome suppuration of the genitals where conventions of worms assembled in places surprising even to his understandably nervous physicians. When he finally died in 4 CE, in satisfying agony to those who suspected they might be next on the hit list, and was buried according to instructions in the specially prepared tomb at Herodion, the palace complex he had built east of Jerusalem, the funeral procession, miles long, featured contingents of troops from all the nations he had managed to gather to the golden eagle – Greeks and Syrians and Galatians – more unexpectedly, Germans.

Twenty years later, the apparently imposing edifice the King of the Jews had built came under strain. The turbulent uncertainties of

succession in Rome translated into aggressively self-serving and ambitious procurators. With a sense that Roman authority was either weakened or becoming partial, populations in the new cities who had coexisted without more than the usual exchange of suspicions and prejudices, now traded insults, looking for excuses to bait and even attack each other. In Caesarea, the Greeks and the growing population of Jews who had shared the city now disputed whose town it really was. Greeks and Syrians insisted that since Caesarea boasted temples, theatre and a gymnasium it could hardly qualify as a Jewish city. The Jews responded (tellingly) that since a Jew, Herod, had built it, the opposite was true. Periodically the petty argument turned confrontational and even violent.

Little by little, piece by piece, the Pax Herodiana fell apart. Its twin pillars – that Rome was committed to protecting Jewish laws and traditions, and the assurance that Herod's dynasty was close enough to the centre of imperial power to pre-empt any threat to the integrity of Judaism – collapsed during the brief but sensationally lethal reign of Gaius Caligula. Of course, everybody had hindsight about the peculiar Caligula, though no one much saw the full, rich, operatic madness of his delusions beforehand – certainly not the Herodian children and grandchildren who had spent their youth in his company as well as Drusus, the son of Tiberius, and the limping Claudius who would reign after the dispatch of the lunatic. The aristocratic priestly Alexandrian Jewish philsopher Philo certainly thought it worthwhile going in person before the emperor to defend his fellow Jews from the abuse and physical attacks that were assailing them.[36]

And Caligula's insistence on placing statues of himself in every temple in the empire was not directed especially at the Jews. No one should take it personally, why so thin-skinned? Some of his best friends, etc. One of them, in fact, was Herod's grandson Agrippa, who, together with the procurator Petronius, had been saddled with the thankless task of seeing the statue project executed in Jerusalem. To Petronius' question 'Will you make war against Caesar?' the elders in Jerusalem had replied that although they offered sacrifices twice a day for Caesar and for the Roman people, 'if he would place images amongst them he would sacrifice the whole Jewish nation, and that they were ready to expose themselves with their children and wives to be slain'. After reports of this kind of thing, and in response to

Agrippa's personal appeals, Caligula uncharacteristically relented, but it was probably his assassination in 41 CE that ensured there would be no imperial change of mind. Nonetheless the vital trust in the Roman pledge to keep the Temple inviolate had been irreversibly damaged. For the first time, the external symbol of the bargain struck by Caesar and Augustus, the sacrifices received and made in the Temple for Rome, began to be questioned, interrupted and eventually – in a deliberately inflammatory act – discontinued.

The astute and not inhuman Claudius went out of his way to revert to the Augustan tradition, issuing edicts which expressly renewed and reiterated those promises, as well as trying to make peace between the now warring Egyptian and Jewish communities in Alexandria. But then came Nero – not that the new emperor repudiated the Claudian pledges, and nor was he particularly hostile to the Jews inside Rome or out. His second wife Poppaea was said to be a 'God-Fearer', one of those who enthusiastically followed Judaism without undergoing formal conversion which, given her famous sexual appetite, was just as well. For that matter Nero's favourite actor (an important issue for him) was the Jewish thespian Alytorus, the butt of the usual circumcision jokes when wearing loose costume onstage.[37] The principal damage done by Nero was to appoint the procuratorships in Palestine to men who treated the job as an opportunity for spoils (or at least he did not prevent such men from holding office). The worst of all, for Josephus, was Gessius Florus, who not only rubber-stamped the crimes of local extortionists but operated a protection racket in which he took the lion's share of the loot. Increasingly Jewish grievances were met with indifference or contempt; and while, in Caesarea, both Jews and Gentiles were evidently to blame for riotous behaviour, the sharp edge of ferociously punitive action was felt more by the former. More and more, the nation that under Augustus had been prepared to live as loyal Jews of a subject state of the Imperium Romanum was beginning to see the Romans as the descendants of Antiochus IV.

Even before Nero, there were signs that Roman soldiers – sometimes encouraged (or certainly not dissuaded) by their officers and governors – planned provocations guaranteed to end in riot, which would then be the pretext for Roman campaigns of plunder and massacre. During Passover, with crowds pouring into the Temple precincts, one of the guards stationed to prevent trouble decided instead to cause it: 'Pulling

back his garment, squatting down after an indecent manner, he turned his breech to the Jews and spoke such words as you might expect from such a posture.'[38] Outrage ensued, followed by stone-throwing. The procurator Cumanus called in the troops who came into the Temple 'cloisters', beating the rioters with such force that they fled in panic. But the gates were narrow; the people were many. Ten thousand, says Josephus, were killed in the trampling crush. Instead of Passover rejoicing, 'this feast became the cause of mourning to the whole nation'.

V. A Foot in Both Camps

The moment you know that Josephus is the first – and for many centuries, the only – truly Jewish historian is when, with a twinge of guilt, he introduces his mother into the action. He is with the Roman army to which, as former military governor of Jewish Galilee, he had defected. As usual he is imploring the Jerusalemites to 'come to their senses before it is too late' and accept the inevitability of the world-imperial omnipotence that is Rome, arguing that God must have assigned it the role of latest chastiser of the Jews for their repeated transgressions. There was still time, Josephus said over and over to the Jews inside the walls, whom he represents as captive to the ruthless egotistical machinations of the Zealot leaders, to avert the worst: destruction of Temple, city and people.

 While he is going on in this fashion, a stone thrown from the walls knocks him unconscious.[39] Delighted with hitting the target of the Jew they most loved to hate, there is a 'sally' by the defenders, and Josephus, still knocked out, is rescued by a flying squad of Roman soldiers sent by Titus. News spreads that he is dead. The Zealots and their followers are happy; the civilian Jews who Josephus likes to think are their hostages are unhappy, since now they have no chance of defecting to safety. And Josephus' mother, held in prison, shrugs. 'To those about her she said . . . she had always been of the opinion that since the siege of Jotapata [the place defended by the Jewish garrison which Josephus commanded, and the scene of his infamous desertion

to the future emperor Vespasian] she should never enjoy him alive
any more . . . she also made great lamentation privately to the maid-
servants that were about her and said that this was all the advantage
she had of bringing so extraordinary a person into the world; that
she would not be able even to bury that son of hers by whom she
expected to have been buried herself.'[40]

This, at least, has the ring of truth; simultaneously vainglorious,
sentimental and with a touch of the tortured wistfulness that settled
on Josephus in Rome, after the war, as he wrote his Jewish histories,
probably no later than five years following the destruction of the
Temple.[41] He would never get over the odium of Jotapata, but what
did he expect? The command had been conferred on him at the tender
age of twenty-six, presumably because he claimed to be from the
Hasmonean establishment on his mother's side, the scion of priests
on his father's. He was of course still known by his Hebrew name,
Yosef ben Matityahu. None of this was taken lightly. As a youth, his
autobiography tells us, he had gone into the desert to live with, and
in the manner of, an ascetic teacher, one Banus, 'wearing no clothing
other than what grew on trees' and taking cold baths night and day
to keep himself chaste.[42] A little later in 62 or 63 CE, surviving ship-
wreck en route, he was sent to Rome to try and liberate some priests
from captivity where, through the intermediary of Alytorus, he was
introduced to the emperor's wife Poppaea Sabina, the 'God-Fearer'.

His first experience of Rome may have given the young Hasmonean
priest a sense of the compatibility of Roman and Jewish culture –
enough at any rate to worry about the rising tide of alienation and
potential rebellion back home. In keeping with the relentless self-
exoneration that runs through his account of the terrible war that
follows, Josephus represents himself always in damage-containment
mode – trying to restrain hotheads, warning that to take on the might
of Rome was to court certain disaster, and only accepting command
in Galilee with this sober truth constantly on his mind. Always, he
listens to the distress calls coming from people trapped between
Roman legions and Zealot terror, and sympathises with towns like
Sepphoris, which in the end opt for peaceful subordination rather than
patriotic resistance. Writing about himself in the third person (as if
that gives the account more credibility), he has 'Josephus' rushing
back and forth disposing troops, doing what he can to organise the

chaotic Jewish forces in Galilee. Not all of this is self-serving fiction. On the vertiginous slopes of Mount Arbel above the Sea of Galilee, defensive caves had been cut, apparently by fugitives from the Herodian government, either brigand gangs or anti-Herodian Jewish armed bands, and in fact probably both. The caves were fortified during Josephus' command – and thus almost certainly on his orders – as guerrilla holdouts against the Romans, should that be the last resort of Jewish resistance.

Josephus' account of the forty-seven-day siege of Jotapata by Vespasian is anything but defeatist. He tries everything he has against the overwhelming numbers and 160 siege engines of the Romans. To protect those who were raising the height of the defensive walls against Roman stones and arrows, he creates a cover from the skins of freshly slaughtered oxen tough enough to take hits and damp enough to resist fire. Then he tries mind games. Since the Romans assumed (not incorrectly) the town was short of water, Josephus ordered the defenders to saturate their clothing and hang them from the ramparts so that water would run down the walls to deceive the assailants. At other moments he sallies forth at the head of raiding bands to burn Roman tents and sow confusion. And the historian is not beyond tall tales emphasising the power of the adversary. One ballista missile strikes a defender with such force it sends his head hundreds of metres; another hits a pregnant women whose baby sails out of her womb landing some distance from its mother.

The occasional resort to hyperbolic fantasy does not automatically discredit Josephus. Herodotus was notoriously free with fancies as well as facts, and even the critically severe Thucydides was not above 'imagining' just what it was that Pericles had probably said to the Athenians according to someone else who claimed to have heard him. Josephus told whoppers for the sake of entertainment, for which, given the relentless detail and many repetitions of his story, we must be duly thankful. But the climax of the story is so unflattering to the author that it seems inconceivable that Josephus would make it up.

On day forty-seven the Romans break through and slaughter everyone except women and children: 40,000, the historian claims. Vespasian sends an officer whom Josephus had known in Rome to persuade him to surrender, and he is only prevented from this by the anger of his comrades: 'O Josephus, are thou still fond of life; and

canst thou bear to see the light in a state of slavery?'⁴³ Turning phil-
osopher, the commander argues casuistically that since the battle was
over and the Romans were no longer threatening death, 'he is equally
a coward who will not die when he is obliged to die and he who will
die when he is not obliged to do so'. To expel from the body the
divine '*depositum*' was a reprehensible thing. True courage, he says, is
to go on living, which may be the face-saving of a moral worm, but
may also, in a Jewish tradition, be true. The argument cuts no ice
with his companions in arms. So Josephus proposes lots by which the
second drawer slays the first and so on down to the last man standing,
who then kills himself. Except that instead of falling on his own sword
Josephus presents it in short order to Vespasian's son, Titus, who was
to become friend, protector and imperial patron. It is Titus who
intervenes with his father to spare the life of the enemy commander
and presents Josephus in person. At which point the Jewish priest
assumes the attitude of prophetic grandeur, announcing to the Roman
commander that he bears a message from God, the gist of which is
that Nero is no more and Vespasian would be called to the purple. If
you knew all this in advance, courtesy of the Almighty, you might
have let the people of Jotapata in on the secret and spared everyone
a lot of grief, says Vespasian. Oh indeed I did, replies Josephus, implying
'But would they listen?' Josephus is liberated, given fine clothes and,
much more important, permission to marry one of the Jewish captives.
Two years later, when the prophecy comes true, the young Jewish
defecting soldier comes back to Vespasian's mind and he is made a
trusted collaborator of the new emperor and his son. He is not the only
Jew in such a position. Titus' second in command through the siege of
Jerusalem, Tiberius Julius Alexander, is none other than the Alexandrian-
Jewish philosopher Philo's nephew. If there was an ultimate test of
apostasy that would be it.

From Josephus' perspective, of course, who better than a turncoat
to be an impartial historian capable of seeing matters from both sides?
It is not that he is blind to the extortionate, brutal and corrupt conduct
of a succession of Roman procurators – though Vespasian, in whose
old apartment on the Quirinal Josephus is lodged when he goes with
the army back to Rome, can do little wrong. Likewise, Titus, the
imperial successor, according to Josephus, merely does what must be
done and often with reluctance. Just before the final breakthrough of

the walls of Jerusalem, Titus summons his officers to a council advising them against destroying the Temple, both from respect for its splendour (highly unlikely) and for reasons of religious respect (not much less so). Later Roman histories, in particular those of Tacitus and Cassius Dio, have Titus making a precautionary decision to obliterate, which sounds a lot more plausible. Tacitus even goes so far as to suggest that the Roman soldiers held back from firing the Temple until they knew they had explicit orders from their general. Josephus' version is a lot more flattering to his patron. Catastrophe happens when fire spreads from the outer gates (as ordered) into the main courtyard, and gets out of control, as do the Roman troops who had been warned against plunder.

Titus' fastidiousness – confirmed by not a single later source – is obviously wishful thinking on the part of the Jewish defector. And it is impossible to get from *The Jewish War* any nuanced account of the motivation of the Zealot rebels, much less their rank and file. Josephus has next to nothing to say, for example, about the Pharisaic 'school' of Shammai, whose young followers (in contrast to those of the more peaceable Hillel) were urged by their famously impassioned and intransigent teacher to commit themselves to resistance against the *Kittim* – the derogatory Hebrew word for the Romans. Instead, Josephus assumed the lofty stance of Jewish priest-aristocrat turned Roman patrician and imperial pensionary, and paints pasteboard caricatures of the rebel leaders, reducing them to sociopathic brigands (*leistei*): bloodthirsty, power-mad, loot-hungry thugs, leading the gullible people astray for their own villainous advantage. Josephus' personal nemesis in Galilee, John of Gischala, was 'a ready liar, yet very sharp in gaining credit for his fictions, he thought it a point of virtue to delude people . . . He was a hypocritical pretender to humanity but where he had hopes of gain he spared not the shedding of blood.'[44] Simon bar Giora is just as bad – not as cunning as John, but more of a monster of raw strength, a petty tyrant who enjoyed torturing the rich. It is when the two of them and their 'robber' armies fall back on Jerusalem, and terrorise the captive population which if left to its own devices would have surrendered, that the city's fate is sealed. The Zealots then appoint their own priests and pollute the Temple with drunken enormities from which, the distraught representative of the old priesthood Ananus says, the Romans themselves would have

refrained. Things go rapidly downhill. Gangs help themselves to prop-
erty and to women, having murdered their husbands. More astonish-
ingly John's toughs turn into cross-dressing, gay terrorists 'indulging
themselves in feminine wantonness . . . while they decked their hair,
put on women's garments and besmeared with ointments and imitated
not only the ointments but the lusts of women and invented unlawful
pleasures of that sort, rolling themselves up and down the city as in
a brothel . . . while their faces looked like the faces of women they
killed with their right hands'.[45]

Colourful though this is, it is some way from being an adequate
account of a mass social upheaval in the towns and villages of Palestine.
Something other than gangsterish intimidation was at work when,
after Vespasian's conquest of Galilee, tens (possibly hundreds) of
thousands of people follow the leaders of the rising into Jerusalem,
there to make their fortified stand against the Roman legions.
'Brigands' or 'bandits' have long been the terms which the propertied
classes (among whom Josephus was certainly numbered) have used
when facing a revolt by the overtaxed and dispossessed.[46] It is likely
that a rapidly expanding market economy pushing inland from the
trading coast had prompted the Jewish elite to invest in land, pushing
smallholders down into the status of tenants who could be taken or
evicted at will, and that it was from this class as well as a shifting
population of labourers, hired for the construction works that were
everywhere in Roman Palestine, that John and Simon recruited their
Zealot armies.[47] A more surprising, but critically militant, addition to
the rebel ranks came from Idumean veteran soldiers and their families
who (if Josephus is to be believed), while fiercely loyal to Judaism,
had been impoverished rather than enriched during the Idumean
monarchy, and embittered against both its aristocrats and the Romans
who protected them.[48]

The gates of the city are closed against them but when the Zealots
and Idumeans break in nonetheless, their first act, Josephus says, is to
massacre the guards, Jewish and Roman, who had tried to exclude
them, some 8,500 in a single night.[49] They then institute a reign of
terror to weed out anyone suspected of moderation – imprisoning,
slaughtering and leaving the dead (in contravention of Jewish
commandments) unburied, like 'a herd of unclean animals'. Among
the victims are the symbols of institutional temporising, above all the

ex-high priest Ananus bar Ananus, who had persevered in trying to dissuade the Zealots and Idumeans from all-out war, and whose public murder, Josephus believed, was the moment when a terrible fate for Jerusalem was determined. The Idumeans, though, insisted they were the ones who honoured 'the house of God'. The city, Josephus writes, was like 'a great body torn in pieces'. The paranoia intensified; anyone so much as suggesting compromise, much less surrender, was summarily killed – 12,000 of the young of the city, the historian claims.[50]

At this point, Josephus, recovered from his head wound, and with tears in his eyes, persists in trying to get the defenders to see reason and spare further misery. His posture of disinterested compassion might be stretching credibility were it not for the fact that there were intensely devout Jews, especially among the Pharisees, who were also arguing for peace. They believed that God had selected the Romans as the latest instrument of punishment for transgressions, that Rome had its place amid the list of appointed empires in the vision of Daniel, and that to continue fighting was therefore an act of futility against divine will. Hillel is described by the Talmud (centuries later) as debating the bellicose Shammai with exactly these arguments.

In Talmudic tradition, Hillel's youngest disciple, Yohanan ben Zakkai – who was in any case deeply suspicious of the Sadducee establishment – was the most anguished at the prospect of a last-ditch Zealot stand dooming the Temple. Three slightly different traditions have Yohanan and his two sons, Joshua and Eliezer, taking matters into their own hands by improvising an escape, probably no later than the spring of 68 CE, during a pause called by Vespasian, before his son Titus made the final onslaught. One version has Vespasian's spies within the city walls discovering that Yohanan might be an advocate of surrender if Rome promised to respect the traditions, texts and observances of Judaism. Apparently arrows had been fired over the walls with messages attached informing the Romans of the opportunity for a deal. The rabbi is then brought before a duly appreciative Vespasian who grants Yohanan's request to proceed to the southern town of Yavne with a group of his followers, establish an academy of Torah study and observe its commandments.

The two other versions are more inventive. Both involve the sage being smuggled out from Zealot-controlled Jerusalem as a corpse, in one story concealed in a coffin, complete with some persuasively

reeking object; in the other, one son holds his stiff body, and one supports Yohanan's head. In both these versions Vespasian has no clue who the petitioner clambering back to life might be, but is impressed by his courage, piety and certainly by his prophetic greeting of *vive imperator*. Unconvincingly affecting modesty, Vespasian protests that the salutations are premature and presumptuous and, if reported, likely to cost him his life. Yohanan assures him to have no doubt, for had not Isaiah prophesied that only a king would take Jerusalem and its Temple? Much taken by all this (and possibly recalling that he'd heard it before at Jotapata), Vespasian issues the grand authorisation: 'Go!'[51]

Whatever the truth or fiction of the story, its essence – that Judaism would continue even if the worst came to the worst and its outward material trappings were obliterated, and that a teacher, Yohanan, not a high priest, would henceforth be the source of Judaic authority – would leave a deep mark on Jewish memory. It was the foundation moment of the litany of endurance. Essentially, at this point Jewish time stops; the actuality of the Temple cult, its sacrifices and pilgrimages, become virtualised, the feasts themselves embalmed in a Judaism of loss. At Yavne, Yohanan is even said to have instituted a day of memorial mourning, probably the fast of the 9th of Ab. The adaptation of Judaism to its material displacement is best embodied in Yohanan's dispensation allowing the blessing to continue wherever Jews assembled for worship. The priestly motif of the raised hands transferred itself now to amulets and burial vessels, ossilegia, and eventually to tombstones so that even among the Jewish dead, in whichever far-off place, the priests were among them. Judaism itself had floated free from the grave of history. It was to be a perpetual present, endlessly reanimated in memory. And this tragic humbling, embodied by the Yohanan stories – that a beginning presupposed an epically consuming ending – cast a very long shadow on Jewish history. It was, in effect, as Yosef Hayim Yerushalmi says in his beautiful *Zakhor*, the moment when history is replaced by timeless memory.[52]

Which is, I suppose, why the originator of the story, Josephus, is the first, and for many centuries the only, Jewish historian. Not only does he assent to the condition by which Judaism's rebirth, the sustaining transfusion into the Bible, of the blood of commentary, is conditional on death and destruction, but he is also, in some acutely

poignant sense, the author of its unfolding. Looking back in some melancholy, I believe, from his Roman exile, Josephus too insisted that he was no traitor to God, only to John of Gischala and the misguided Zealots. On the contrary, when he tried to persuade his fellow Jews to surrender he was only speaking the manifest will of God who had abandoned Jerusalem and was fighting on the side of its foes; and that 'as long as I live I shall never be in such slavery as to forgo my own kindred or forget the laws of our forefathers. To be a true Jew, then required resistance, if not treason, to Zealotry.'[53]

The *coup de grâce* actually comes with famine rather than fire or sword, and Josephus gives us a set piece of horror, in the manner (and perhaps following the literary example) of Thucydides' account of the plague in Athens. Sealed tight by Titus' encircling army, Jerusalem is reduced to the last extremity. Made mad by starvation humans turn into feral scavengers, devouring not just the leather of their sandals, girdles and shields but, Josephus says, filthy things that even dogs wouldn't touch. Children stretch into the mouths and down the gullets of their elders to snatch boluses of half-masticated food for themselves; raiders shove spikes up the anuses of people they suspect have a few grains of meal hidden away somewhere. The nadir is reached with the story of a woman called Mary from across the Jordan, trapped in Jerusalem and reduced to such straits that she murders the baby boy sucking at her breast, roasts him, and slices him in two, eating one half and setting the other aside for later. The stench draws suspicion and rebel guards who threaten to slit her throat if she does not give them her hidden food. 'She replied that she had saved a very fine portion of it for them and withal uncovered what was left of her son. Hereupon they were seized with horror and amazement of mind and stood astonished when she said to them, "This is mine son and what hath been done was mine own doing! Come eat of this food for I have eaten of it myself. Do not pretend to be either more tender than a woman or more compassionate than a mother but if you be so scrupulous and abominate this my sacrifice as I have eaten the one half let the rest be reserved for me also."'[54] Appalled, the men depart; the story instantly gets round the city and people 'tremble as if this unheard of action had been committed by themselves'. Those that are starving to death beg for the end, and those already dead are thought fortunate not to have survived to witness such things. Titus

himself, even as the first smoke starts to drift across the walls, is brought to believe that whatever will now befall such people could not be worse than such inhuman atrocities.

The unfolding catastrophe is dispatched by Josephus with instructional grimness: thousands consumed in the flames; vast piles of treasure piled up in the Temple storehouse seized; men and women throwing themselves from the walls; and, to be sure, a distraught prophet called Jesus. This particular Jesus (there were a multitude of them) was the son of Ananus the priest, and four years before the war had begun he had made himself obnoxious at celebrations of the pilgrimage festivals by shouting, in the Jeremiad manner, 'Woe, woe to Jerusalem.' Flogged for his temerity until 'his bones were laid bare', he continued this cry for seven years and five months until at last the great calamity vindicated him, at which point a stone from one of the siege engines killed him in mid-lamentation.[55]

All that is now left for Josephus is counting. And so the historian, liquidating his own methodology, collapses back into biblical numerology. He has become a mere arithmetician of Jewish time. 'Now the number of years that passed from its first foundation which was laid by King Solomon, till this its destruction, which happened in the second year of Vespasian, are collected to be one thousand one hundred and thirty, besides seven months and fifteen days and from the second building of it which was done by Haggai in the second year of Cyrus the king till its destruction under Vespasian there were six hundred and thirty-nine years and forty-five days.'[56]

On the other side of the Western 'Wailing' Wall, with its throng of the rocking devout, lies an immense tumble of massive Herodian masonry dislodged by some pounding projectile or torn by the Romans from the heights of the south wall of the Temple. One of the stones retains a niche big enough for a man to stand, and the inscription by it identifies it as the place '[reserved] to the trumpeter', the shofar blower who sounded the horn at the beginning and close of the Sabbath and holy days. Silenced for good. And there is the so-called 'Burnt House', a tourist attraction in the Jewish Quarter where, amid the artfully arranged broken pots and a spearhead, there lies a telling roof beam, glossily carbonised, faintly blue like the plumage on a seabird's broken wing. The tourists are directed to a photograph sitting in its dusty frame on a back wall. Faded though the print is, it displays

the skeletal arm of a young girl found in the ruined basement, its outstretched finger-bones seeming to reach for something or someone and, without overdoing the Jewish tragic romance, one must suppose, to no avail.

VI. The Return of Yosef ben Matityahu

How did the new-minted 'Flavius Josephus', pensionary of the emperor Vespasian, feel as seven hundred chained Jewish captives processed before him in the triumph of his friend Titus?[57] Was he one of the victors or the vanquished? His new name extolled his benefactors, but the Flavians actually based their imperial authority above all else on the conquest of the Jews and the utter obliteration of Jerusalem. Obliged to relate the parade, he does so in extraordinary detail (this is the most elaborate description of a Roman triumph in any literature) but without much relish, despite the descriptions of the empurpled Vespasian and his son, the soldiery in their finery, the hails and salutations, the procession of pageants representing the battles and fires. One of those re-enactments, after all, was of the burning of the Temple.

At the conclusion of the passage he mentions the 'purple Babylonian veil' – the curtain screening the Holy of Holies – the golden table, and of course the seven-branched candlestick that would be reproduced in the frieze decorating the Arch of Titus. Along with the showier loot, 'last of all of the spoils', writes Josephus, 'was carried the Laws of the Jews'.[58] But though the shewbread table is there on the frieze, you look in vain for the scrolls. Perhaps they defied adequate representation, loot-wise? Furled, or unfurled, how could mere scrolls, parchment writing, have made much impression on admirers of Roman conquest? Could someone have belatedly appreciated the impossibility of capturing the words of the Torah, either in sculpted image or by military power? Could there have been a sudden, silent moment of embarrassment when the impotence of trophy display became inescapable? Unlike Simon bar Giora – led through the streets, a rope about his neck, to the Forum where he was tortured and dispatched, signalling the conclusion of the celebrations – the Sifrei Torah, the essence of

Jewish identity, could not, by definition, be done away with. The words beat the swords. The words floated free from their material embodiment like the *nefesh* from the body. So long as someone committed them to memory, so long as someone somewhere had copied them, the words would survive the annihilation of everything else. Yohanan ben Zakkai had been right. The solid trophies were taken to Vespasian's entertainingly named 'Temple of Peace' where, it was said (by the gloating victors, naturally), Jews would come and stare and sigh and the rest of Rome would marvel – for this was, in effect, the first public museum in the city.[59] Whether the display included the Torah is not known, but why would it have been there? It was just writing on parchment; nothing entertaining about that.

Perhaps Josephus understood this, for the most powerful (and relatively succinct) piece of writing he ever set down, *Against Apion*, becomes in its powerful and moving climax both explanation and praise of the imperishability and – paradoxically – the universalism of the Torah. There was still a lot of Yosef ben Matityahu, the son of priests and Hasmoneans, left in the house historian and protégé of the Flavians. Even before he closes the tragic story of the war, his tune changes, perhaps because this last dreadful finale had played out in 73 CE, barely two years before he began to write.[60]

The scene moves from Jerusalem to Masada, pre-emptively taken by the Zealots from the royal government, even before the hostilities proper had broken out. Dominating land-approaches from the west and looking out over the Dead Sea, Herod had built the palace fort with his usual megalomaniac resolution, strong enough to resist both disaffected Jews and the aggressive Queen of Egypt, Cleopatra, who bore him a steady hatred. Supplies were laid in and a stupendous system of trapping and storing water built. It was to this mountain fastness that the remaining survivors of the revolt, just under a thousand of them, escaped as Jerusalem burned. Josephus says they were mostly *sicarii*, the hardcore daggermen who had turned from their Passover crimes to last-ditch rebels, but it seems more likely to have been a mix of Zealot bands and families. Commanded by Eleazar, the third leader of the revolt, they camped amid the mosaics and pools and ritual baths, the storehouses and the terraces carved from the rock.

They hold out there for three years after Jerusalem has fallen. But

there is no escape. The pursuing general Silva laboriously constructs the ramp up which his siege engines and soldiers will ascend to seal the fate of the last rebels. So Josephus has Eleazar gather the survivors and propose collective suicide, 'Since we, long ago, my friends, resolved never to be servants to Rome nor to any other than to God himself who alone is the true and just lord of mankind the time is now come . . . that obliges us to make that resolution true in practice . . . we were the very first that revolted from them and we are the last that fight against them.'[61] God has chosen to make the unconquerable fortress conquerable. Everything is in the hands of the Romans except the power to die free. 'Let our wives die before they are abused and our children before they have tasted slavery and after we have slain them let us bestow that glorious benefit upon one another mutually and preserve ourselves in freedom as an excellent funeral monument for us.'

If this sounds both familiar and suspicious it is because transparently Josephus has scripted Eleazar to sound like a more virtuous performance of himself at Jotapata. This is what he would like to have said; this is what a piece of him, at any rate, would like to have done. This is the one voice which will echo through Jewish history, through the suicides of medieval Europe, all the way to the Warsaw Ghetto uprising of April 1943. Faced with understandable terror on the part of those he has urged to die, Eleazar then tries to reassure them by delivering a second speech affirming the immortality of the soul, liberated from the mere husk of the body. This gives Josephus another opportunity to allow his own restive conscience out for an airing. Those already dead, Eleazar says, should be deemed truly blessed 'for they are dead defending, and not in betraying, their liberty'. Those taken alive by the Romans are tortured and flogged to death; old men lie on the ashes of Jerusalem. 'Who is there so much his country's enemy or so unmanly . . . as not to repent that he is alive?'

Who indeed but the Historian of the misfortune? The gruesome tragedy unfolds, yet the last of the executioners does not, like Josephus, walk to the enemy, but contemplates a gory carpet of 960 bodies, then sets fire to the palace and 'with the great force of his hands ran his sword entirely through himself'. Among the Jews, only an old woman and five children, who hid in a cave, survive to tell the story.

Perhaps there were moments when Josephus did indeed wish for himself the fate of Eleazar, but he resolves instead, and perhaps to greater effect, to resist in an entirely different way. *The Antiquities of the Jews* and *Against Apion* were written probably twenty years after *The Jewish War*, by which time the middle-aged Josephus had time to take the measure of how Rome, and how its writers, in particular, felt about the Jews in their midst. There were about 30,000 of them, a sizeable number the descendants of captives taken on Pompey's original campaign, although an expulsion order of 139 BCE makes it clear that there was already a substantial community of Jewish merchants in Rome at that early date, another colony of the already widely dispersed settlement of Jews around the Mediterranean world.[62] Crowded *insulae* apartment blocks on the island of Trastevere had become home to many of the poorer families, as it would be for nearly another two millennia until the *razzia* of October 1943. Although the satires of Juvenal and the comedy of Petronius both have fun at the expense of circumcised, pork-averse Jewish beggars, what seems already to have been a synagogue first went up in the port city of Ostia during the reign of Claudius, so that there was again a more mercantile-oriented community of Jews settled further off from the press of the densest Roman streets.

Josephus was not among them, of course, but lodged in altogether grander style, courtesy of his patron Titus, the new emperor after his father, Vespasian, died in 79 CE. But any thought that he would be the sort of Jew who (like the Herodian family) might fit snugly and unproblematically into imperial society and culture must have been dispelled by the nose-holding distaste he would have noticed coming from at least some of his natural peers: the writing and speechifying classes of Rome. In some respects the Flavians' house historian would have been protected from the behind-the-hand sniggering, for there is no doubt that the imperial house had a love–hate thing about the Jews, starting with Titus himself who famously fell hard and deep for the older but devastatingly glamorous, Jewish, thrice-married sister of Agrippa II, Berenice (also said to be her brother's lover), to the point where some of the horrified patriciate assumed he might marry her.[63]

From Seneca to the playwright Martial and the satirist Juvenal, the refrains had been, and remained, depressingly predictable. Even though Judaism had been officially declared a *religio licita*, a tolerated religion,

writers like Tacitus would insist on its being more in the nature of a low and degraded *superstitio*.[64] Socially, it was said that Jews were misanthropes who sedulously kept themselves apart from the rest of society, refusing to eat with them, or (in a reversal of the Greek stereotype), despite their notorious addiction to lust, sleep with women of other nations. Tacitus would go even further in this paranoia about Jewish self-separation, claiming that while loyal to each other they showed 'only hate and enmity to the rest of mankind' ('*sed adversus omnis alios hostile odium*').[65] They circumcised to mark difference but also to enhance their bestially insatiable sexual appetites. They avoided pork because they worshipped the pig as the first animal who dug furrows in the soil with its snout. And they worshipped donkeys – erecting a golden ass in their Temple – because during the wanderings that followed their expulsion from Egypt as leprous and scabies-carrying pariahs, a donkey had led them to water when they were dying of thirst. Likewise their vaunted Sabbath (a pretext for idleness, many implied) originated in the disfiguring tumours of the groin which had afflicted the Israelites in the first six days of their wandering, becoming so disabling that they were forced to rest on the seventh!

Many of these detestable absurdities, Josephus wrote, had been perpetuated by the Alexandrian grammarian-librarian Apion. 'It is a great shame for a grammarian not to write true history.' But then it was sadly typical of someone coming from a culture that worshipped asps and crocodiles to imagine the Jews venerating donkeys. 'Asses are the same with us which they are with other wise men, viz creatures that bear the burdens we lay on them.'[66] Apion had left his mark on Roman memory when he had come before Caligula in the first century CE to explain why the Jews of Alexandria had drawn to themselves the opprobrium and indeed violence of the Egyptians. Opposing him was the Jewish philosopher Philo, brother of a tax collector-treasurer of the Ptolemies and uncle of Tiberius Julius Alexander who would later be second in command to Titus in the Jewish War. In an uphill effort, Philo attempted to make Caligula aware that his determination to have a statue of himself as god erected in synagogues as well as elsewhere was forbidden by Jewish law and tradition, and that the refusal had been a pretext for appalling violence visited on an innocent community, abetted by the Roman governor of Egypt, Flaccus. Not only had Egyptian Jews been suddenly deprived of the

long-established autonomy of their communities and redefined as aliens in the land of their birth, but mobs had driven Jews from four of their five districts in Alexandria into a single crowded quarter. They had then plundered and burned houses, assaulted families and razed synagogues to the ground.

Apion's retort had been to recycle the abusive, mythical version of Jewish history invented by the third-century BCE priest-grammarian Manetho: their expulsion during a plague year as unclean and infirm, the story of the helpful ass and the like. Such nonsense, Josephus writes in *Against Apion*, must be countered not just by righteous indignation but by an irrefutable indication of their impossibility, especially since the more sensationally vicious they are, the more likely they are to hold a grip on popular imagination. The myth of the Greek traveller, abducted by Jews and fattened for slaughter and cannibalistic consumption (repeated by, among others, the severe historian Tacitus), was a case in point. 'King Antiochus' (it is not clear which but presumably the 'civilising' Antiochus IV) was said to have made this discovery of a Greek tied up in the innermost court of the Temple howling for release, a table of fish, fowl and dainties laid before him. The legend had it that when properly plump and juicy he would be led to a deep wood and killed, after which a secret mass gathering of Jews would picnic on his entrails. Just for a start, wrote Josephus in grimly mordant if idiotically literal mood, was it likely that 'the entrails of one man be sufficient for thousands?'[67] Josephus' appalled dismay identifies the start of a demonology (secret, cannibalistic conclaves of Jews drawn from far and wide battening on the bodies of helpless Gentiles) that would run and run.

Josephus seems to have thought that the intensity of Roman phobia was a defensive response to the appeal of a single, invisible, even unnameable, deity. The attractiveness of Jewish monotheism to Gentile Romans at this time is often overstated, but it evidently was a concern of Roman writers and rhetoricians. Even in the reign of Nero, Seneca had written of the presumptuous superiority of Jewish monotheism that 'the vanquished give the law to the victors'. How could there not be anxiety about Judaism winning converts when the emperor's wife was said to be a sympathising 'God-Fearer', and other women from high imperial and court culture were likewise tempted? An expulsion of Jews in the year 19 CE was triggered by shock that a

Roman noblewoman, one Fulvia, had been converted. And it may have been startling to learn that the royal dynasty in Adiabene in north-eastern Assyria, a region where Roman legions were chronically embattled, had been converted to Judaism – its queen, Helena, was famously a visitor to Jerusalem and patroness of its Temple and people.

At the other end of society, slaves belonging to Jews were said to be offered liberty in exchange for conversion. Bravely if singularly, the scholar Marcus Terentius Varro attempted to approximate Judaism and Roman paganism by suggesting that the single, formless Jewish God was in fact identical with a proto-Jupiter, equally a *summum deum* who in the earliest, purest, days of Rome had likewise been aniconic and formless.

Some of the most phobic writing betrays a streak of acknowledgement that the Jewish loyalty to a single God whose nature transcended anything that could be fashioned from even the most precious materials, might indeed be attractive to, say, Platonists for whom the essential creative force lay in the realm of pure spirit. In a ferocious digression during his brief description of the Jewish War, Tacitus describes Jews as 'conceiving one god . . . with the mind alone . . . their supreme and eternal being is to them incapable of representation and without end. Therefore they set up no statues in their cities much less in their temples; this flattery is not paid their kings nor this honour given to Caesars.'[68] So although Tacitus characterises their rites as 'base and abominable', their manners 'sordid and mean', their 'earliest lesson' to 'despise the gods, to disown their country' and insists that 'the Jews regard as profane all that we hold sacred [while] permitting all we abhor', there is nonetheless a grudging sense of the not entirely contemptible peculiarity of their worship. The anxiety did not go away. Two further expulsions in the reign of Claudius, in 41 and 49 CE, were made in the name of 'public order', although Jews who were citizens and freemen seem to have been protected from the eviction.

The kind of backhand compliment represented by Tacitus' later admission of the mysterious power of invisible monotheism allowed Josephus his opening to educate the Gentiles on the truth of Jews and Judaism. They were humans not monsters (this evidently needed spelling out) – goodness, they might be toga'd like him – and their observances and rituals were humane and noble, not squalid and

sinister. Assuming that Tacitus' belief that Jewish parents were not honoured by their children, and vice versa, was already common among the Roman elite, Josephus was at pains to point out that the opposite was in fact true: that the joy and principal virtue of Jews was 'to educate our children well' and to 'observe the laws that have been given to us and keep those rules of piety handed down to us'.[69] Robbery, he goes on, contesting the early defamatory reputation for Jewish economic unscrupulousness, is alien to us, as are wars for enrichment, since 'we delight not in merchandise or the world of trade, our homeland being far from the sea and a fruitful country which we delight in cultivating'.

Moses, he patiently clarified, was not the leader of a horde of contaminated reprobates and lepers but 'the most ancient of legislators' moved by a vision of the immutable God that would be shared by Plato and the Stoics; God 'superior to all mortal conceptions of beauty and though known to us by his power yet unknown in his essence'. In the laws he passed were united the cultures of words and practices, while the Athenians had only the former and the Spartans the latter. The heart of being a Jew was inculcation in those laws, taught from early infancy. Ask 'our people about our laws and any one will more readily tell you them than he will his own name'. This is the consequence of having learned them almost as soon as Jews became conscious of anything, so that they were 'engraven on our souls'.

More surprisingly for the historian who had made so much of Jewish discord in the revolt (and rather implausibly), Josephus contends that the permanence of the Torah determined 'a wonderful agreement of minds amongst us all'. There was, moreover, nothing obscure or sinister, much less ridiculous or 'superstitious', about those laws. They prohibited drunken and sodomitic vices, the violation of virgins and adultery; they commanded prayer for the common welfare of all and the decently modest burial of the dead rather than the extravagance of funerary monuments; they required the honouring of parents and the avoidance of usury and (on pain of death) the taking of bribes by judges.

And though these social and religious precepts arose first among the Jews and are their particular and imperishable treasure, all civilised peoples including the Greeks have followed their guiding principles so that they have become to a degree universal property, starting with

the invention of the weekend. 'There is not any city of the barbarians nor any nation whatsoever where our custom of resting on the seventh day . . . is not observed.'[70] Other nations have followed the Jewish obligation to charity and 'mutual concord' and the moral strictures of justice in economic dealing. And all this has impressed itself without resort to conventional power but prevails merely 'by its own force', which Josephus emphasises as distinctively Jewish. The laws, he says, scarcely require further defence or elaboration, even in the cause of demystifying baseless defamations laid at the door of the Jews, for those laws are 'visible in their own true nature and teach not impiety but the truest piety in the world'. And as if replying to the imprecations of Tacitus, 'they do not make men hate each other but encourage people to communicate what they have to one another freely; they are enemies to injustice, they take care of righteousness, they banish idleness and luxury and instruct men to be content with what they have . . . they forbid men to make war from a desire of getting more but make men brave in defending the laws'.[71]

And at last, Flavius Josephus – who has lost his own people, and is so obviously and painfully estranged from those who had adopted him – addresses himself proudly and defiantly to the likes of Seneca, Martial and Tacitus who presumed they had nothing to learn from the barbaric superstitions of the low, rapacious, lubricious, secretive, conspiratorial, mankind-hating Jews, and gives voice to the only boast a Jew finds worthy of uttering: 'we are become the teachers of other men in the greatest number of things'.

VII. The End of Days?

How can God permit such a thing to happen to His People? That's what we always ask when cinders smart the eyes and we begin to spit soot. What happened to the covenant, to the promises that we should prevail over those who seek to annihilate us? Back comes the answer, time after time. Read the fine print! See the bit about the Righteous? What's been going on? Transgressions! Iniquities! Abominations, self-destructive malarkey, that's what! Time for a proper clean-out! Didn't

you listen to the prophets? Don't say you weren't warned. But, we
protest, we are humans; has there ever been a time when we have
not strayed, diet-wise, Sabbath-wise, from the strict and narrow? Look
at David and his lusts, Solomon and his polygamous vanities. They
weren't trampled in the dust, were they? So give us a break, won't
you? A few uncloven-hoofed, uncudded meals, the odd bag-carrier on
the Day of Rest, and Jerusalem is destroyed, multitudes incinerated?
Honestly? Again?

The question won't go away. If YHWH is the master of all things
and of Jewish history in particular, how come always such *tsurus*, such
trouble?

Jews of the Second Temple and of the time of its obliteration did
have an answer. It was unorthodox, unauthorised, not strictly biblical,
but it too was written and read, and not just by fringe eccentrics. This
we know, from fragments of fifteen separate copies of the Book of
Jubilees, further pieces of seven copies of the Book of Enoch, a
'Genesis Apocryphon' with a startlingly different version of how and
when the Jews received their Law (at Creation), and many other pieces
of a parallel or rather alternative scripture, all revealed amid the
850-odd manuscripts discovered between 1947 and 1955 in the caves of
Qumran.[72] The books of what would become the canon of the Hebrew
Bible are all there with the exception of Esther and (more mysteri-
ously, given its deep importance for the history of the Torah)
Nehemiah. One of them, Isaiah, is there in its completeness. Multiple
copies of Isaiah, Psalms and Deuteronomy were found, probably a
guide to what was most important to the *yachad*. Most are written in
Hebrew; one, the Book of Job has an Aramaic *targum* translation, and
there are commentaries (*pesharim*) on books such as Habakkuk and
Isaiah. There are telling differences in some of these Hebrew texts
from both the Greek Septuagint and the Masoretic (pronunciation
added) text authorised by the rabbis almost a thousand years later
towards the end of the ninth century.

But that, it turns out, is not the end of the story. Included among
the Qumran scrolls are also books of the Apocrypha: Tobit; the
Wisdom of Jesus ben Sirach; Judith; the two thrilling pieces of history
writing that are the Maccabees; the *Serekh*, working Rule for the ascetic
community or *yachad*; a whole litany of Thanksgiving Hymns and
Psalms; and most grippingly, a number of scripture-texts, most of

them written in the third and second centuries BCE, which, until their discovery in the desert caves, were known (and not widely) only from Ethiopian manuscripts of the fifteenth and sixteenth centuries CE, written in the Judeo-Ethiopian Ge'ez language (a startling connection in itself). To discover them in Hebrew, a millennium and a half older, changed the story utterly, for this strand of belief could not now be fitted into the narrative of East African monotheisms, but tracked back to the forming heart of Judaism. And it was among those books, at once abstruse and instantly spellbinding, that an answer to the question of wickedness in the world was ventured.

It is, to be sure, in the literal sense, a fantastic answer: one steeped in a Jewish story that seems closer to other ancient pagan religions; and to the dualistic battles between good and evil, light and dark, characteristic of Persian Zoroastrianism and which would persist in Gnostic texts. If these texts survived in any abundance (and there is no reason to assume they did not), it is easy to see why the rabbis excised them even from apocryphal memory. For on the face of it, it seems impossible for Jews to have read, still less believed, *both* the authorised story of the covenant-led Bible, and the version given in Jubilees, 1 Enoch (including the Book of Watchers and the Book of Giants) and the Genesis 'Apocryphon'.

In this alternative scripture, the One God is not alone in celestial space but surrounded by a host of angels over whom He exercises imperfect control. There are good angels, commanded by Michael who survives in the Testaments, but then there are also bad and insubordinate angels led by Belial, whose name is everywhere in these books, including in one of the very beautiful pseudo-biblical Thanksgiving Hymns, XV: 'As for me I am dumb; [my arm] is torn from its shoulder and my foot has sunk into the mire. My eyes are closed by the spectacle of evil and my ears by the crying of blood. My heart is dismayed by the mischievous design for Belial is manifest in their [evil] inclination.'[73] For their disobedience (in particular for refusing to accept the presence of godlike appearances in created man), they are ejected from heaven and sent, as 'Sons of Heaven' – or more ominously in 1 Enoch, as 'The Watchers' – to earth. There they copulate with human women who give birth to monstrous giants, the Nephilim. Evil is at large in the world and God retires in miffed splendour surrounded by the angels of Light to leave it to its fate.

Enoch, the first man of language, wanders from one end of the earth to the other, a witness to the horror and havoc, reporting that wickedness has overcome the earth. The deluge is summoned to wipe out the giants, but demonic spirits survive. They too are targeted, but the satanic master figure Mastema, a counter-Creator, successfully pleads for only nine-tenths of their presence to be confined to the deep places of the earth. Enough of them are unchained to work more mischief and sorrow.

Peculiar alterations to the biblical account follow, especially in the Genesis Apocryphon. Not only does Israel receive the covenant at Creation, but Abraham's wife Sarah – described with the warm-blooded sensuousness of the Song of Songs – so whets the appetite of a pharaoh that he abducts her and takes her as his wife for two years. Abraham escapes trouble by claiming she is his sister.

Strange but weirdly riveting anecdotes sprout. Lamech, the son of Methuselah, doubts that a son is actually his offspring. Oddly, this is not because he fathered him at the spry age of 182, but rather because he fears his wife Bathenosh may have been inseminated by an angel-watcher or one of the wicked Sons of Heaven: 'Very emotionally and weeping she answered me "O my Lord . . . remember the pleasure, the moment of intercourse and my ardent response."' And assures him, in effect, that their orgasm guarantees that the seed that grew into Noah was indeed his. Lamech remains unconvinced and runs to the even older Methuselah for reassurance.

The Sons of Heaven winkle their way into the biblical plot with disturbing regularity. Their prince and leader Mastema masterminds the sacrifice of Isaac, a suggestion God accepts, and Moses receives the law (again) from a band of angels as well as God. The cumulative impression is not that God has relinquished His creation but that, generation after generation, its sovereignty is contested between the forces of good and evil, with the certainty that, ultimately, in the last climactic battle heralding the End of Time (recounted in astounding, almost Homeric, detail in the longest scroll of all, twenty-eight feet of it), the Sons of Light will prevail over the Company of Darkness. 'On the day when the *Kittim* fall there shall be battle and terrible carnage before the God of Israel for that shall be the day appointed from ancient times for the battle of destruction of the sons of darkness.'[74] This is to continue for thirty-three years!

How eccentric were the writers and readers of this alternative story of the Jews and the world? Evidently they were made to disappear entirely from scripture and their recovery is something of an accidental miracle. Battle still rages between scholars like Geza Vermes who continue to believe that the Qumran community was entirely Essene, and the view argued by Norman Golb that the sheer diversity and size of the manuscript collection suggests a more eclectic Jerusalem library hurried from the besieged city for its own preservation. Though I'm still unpersuaded by Golb, his is, in fact, not such a wild theory. The distance was just thirty-five miles east, in a territory which, after the seizure of Masada to the south, was more or less controlled by the Zealots. Qumran would have been known to have been occupied by the ascetic *yachad* for many generations. So there is a *possibility* that the Dead Sea Scrolls are a combination (written, after all, in many hands and even languages) of Essene Rules and discipline, plus additional copies of what would be the Bible canon, plus apocrypha and mythic-scripture brought in from the outside.

The really startling adjustment to our assumptions about Jewish piety demanded by the scrolls is not whether they were the work and library of the Essenes or a more eclectic collection brought from Jerusalem, but the fact that Jews read together *both* the authorised and unauthorised, the rigidly montheist and the mythically dualist, sharply contradictory versions of their ancestral story. Some of the scrolls, like the Temple Scroll, are both a reworking of many of the sacrifice commandments and purity rules already detailed in the Torah, but with up-do-date rulings. Neither the wall gecko nor the sand gecko nor the 'great lizard' nor the chameleon, all found around Qumran, for example, are kosher. The scroll visualises an even more magnificently ornamented Temple. These hybrid forms, partly drawn from the Torah, partly not, open up the possibility of a Jewish learning and piety more richly various, loosely organised, mythically attuned, mystically driven, solar-obsessed, than the later Hebrew Bible canon and Talmud allow. But it returns all the rest of Jewish culture – the wilder shores of mystical tales, the existence of incantatory magic in late antiquity (known through thousands of Babylonian incantation bowls) – from the esoteric margins to the centre of Jewish religious practice and storytelling.

Some of it is mesmerisingly, crazily, wordy. The War Scroll, for

example, would not have helped much as a manual of arms against the Romans since it spends an inordinate amount of space detailing exactly what must be inscribed on trumpets, banners and even weapons in the battle array of the Sons of Light. 'On the point of their javelins they shall write "Shining Javelin of the Power of God" . . . and on the darts of the second division they shall write "Bloody Spikes to Bring Down the Slain by the Wrath of God".' We are going to write the enemy into capitulation! Surrender to our verbosity or else! Precise measurements are issued for the size of polished bronze shields, and the spike of the spear 'made of brilliant white iron, the work of a craftsman, in its centre, pointing towards the tip shall be ears of corn in pure gold'.[75] If the Ultimate Battle could only be decided by literary excess and sumptuous schmeckerei it would be a cakewalk for the Sons of Light.

It never was. But if the stirring call to arms recorded in the War Scroll, with its invincible belief in eventual victory, was, in fact, shared in the common culture and not just in one separatist community on the Dead Sea shore, then even an annihilation as total as Titus' could be treated as but a prologue to the ultimate triumph of the Lord of Hosts and His covenanted people. Hope was not extinct. Freedom (and the word was used on the coinage of the next generation of rebels) was round the corner along with the Messiah. The Temple would be restored once more. The Lord of Hosts would saddle up and ride on the side of His People. It's not over till it's over. To be continued.

Hence the recurrence within sixty years of not one but two immense Jewish insurrections against Rome, both of which, to the astonishment of the empire, required many legions to put down. More remarkably still, the first took place in the reign of Trajan between 115 and 117 CE across a broad swathe of the Mediterranean diaspora, from Cyrenaica, sweeping through Egypt, reaching a terrible paroxysm in Alexandria that all but wiped out that great community, and also affecting the Syrian cities of Antioch and Damascus. We have even less to go on for an account on the Jewish side of the revolts than our dependence on Josephus, but it seems likely that they must have owed something to the widespread messianic ferment that pulses on the unorthodox Qumran scrolls; the perfervid belief that the End of Days was at hand; that the Sons of Light would triumph over the Sons of Darkness; that

in some immense battle God the Redeemer would fight for His Children. Certainly we know from Roman sources like Cassius Dio and Diodorus Siculus about the scale of the uprising, the ferocity of the violence and the horrifying massacres, looting and arson that did for those Jewish cities what Titus had done in Jerusalem.

Perhaps surprisingly, perhaps not, given the trauma of 70 CE, the Jews of Palestine did not rise while their brethren and sisters were being slaughtered in Libya, Egypt and Syria. But around 132, a rebellion broke out in Judaea which, according to sources like Cassius Dio, took 50,000 troops and three years to suppress.[76] Even allowing for hyperbole, there is no doubt that the magnitude of the insurrection took the Romans by surprise. The emperor Hadrian himself at one point assumed command when things seemed to be going badly, and the orator Fronto compared this second Jewish War to the long slogging battles the Romans had fought in damp and misty northern Britain.

There is no Josephus to give us even an approximation of how the revolt started, nor its immediate causes, although Hadrian's institution of a city he called Aelia Capitolina on the site of mostly destroyed Jerusalem was almost certainly the greatest provocation. It was once thought this was the result and not the cause, but coins minted around 130–1 with that new Roman name for the obliterated Jerusalem make it clear that this was indeed a prime cause. Whether or not the leader of the rebellion, Simon bar Kosiba, imagined himself to be the Messiah, the kind of fervent expectations documented in the Qumran scrolls (not to mention the existence of a truly messianic Christian religion) made his claim plausible, even to the likes of a Pharisee like Rabbi Akiba, who became committed to the rebellion and was, after Simon, its most famous victim.

It was Rabbi Akiba, invoking prophecy given in Numbers 24:17 that 'a star shall shoot forth out of Jacob and a sceptre out of Israel', who consecrated the rebellion by endowing the leader with the Aramaic, more messianically fitting name 'Simon bar Kochba, Son of a Star'. But Bar Kochba also styled himself 'nasi', or prince, and played to the messianic insistence that – unlike the Hasmoneans, for example – a true redeemer of the Jews had to come from the line of David (as indeed was said of Jesus of Nazareth). He was a stickler for Sabbath observance, and presented himself as a kind of neo-Davidian leader

of the holy nation. Much less is known about the course of the revolt than the first war against Rome, although a cache of letters to and from the leader was discovered in a cave in the Judaean desert in the 1960s.[77] The portrait they offer is of an effectively brutal guerrilla leader, with a well-organised chain of command, dividing his territory into seven commands and subdivided again into local districts, all presumably taxed to support the revolt. More revolutionary than mere rebel, Bar Kochba exhibits the necessary punitive ruthlessness without which he would barely have lasted. He signs his own curt, direct, adamant letters and even in their tersest form they breathe a kind of intensely charismatic force, palpable after two millennia. But the inscription on his coinage – 'For the Freedom of Jerusalem' – was wishful thinking as it is evident from the distribution of those coins that he never took the city. Yet even more than the great war two generations before, the rebellion showed a consciousness of being fought for the 'Jewish Freedom', also inscribed on the coinage. It was, obviously, a defiant response to the famous Roman coinage minted after Titus of the forlorn 'Judaea Capta' weeping beneath a palm.

The tears would still come. At the height of his success, around 133, Bar Kochba held only Judaea and Samaria, his capital established at Betar. Galilee as well as Jerusalem seems to have remained under Roman control throughout. In the end, and wisely, the Romans opted for a war of attrition, pushing the rebels back towards the fortified desert caves facing the Dead Sea where the letters were found, many of them from the last years of the revolt increasingly desperate about food and supplies before the end came in 135. With its extinction came the end of Judaea itself, renamed by Hadrian before his death the province of Syria Palestina.

But was it possible, even if you weren't one of Yohanan ben Zakkai's disciples, to sidestep history altogether? Along with the remains of a group of thirty, apparently well-to-do Jewish fugitives from the Romans found in a cave in the Judaean desert, was the correspondence of someone who tried to do that, or rather just go about her business while the javelins were flying. Her name was Babatha and she came originally from the village of Maorza in Nabatea, across the Jordan and the south-eastern end of the Dead Sea, not far from the great rosy-pink Nabatean city of Petra. Ethnically Babatha was

Idumean, but that people had been converted more than two centuries before, and when she bore a son to her first husband he was identified specifically as Jewish in the Roman legal archive.

Her world and her fortune were the dates which, as anyone who has eaten them from the tree in that part of the country will tell you, are beyond compare for fleshy succulence and honeyed intensity of flavour. You take your time with a Dead Sea date. Babatha inherited a grove from her father and, as a result of her first marriage to a man called Jesus, expanded her property. In 124 she was a widow; in 125 a wife again to another grower named Judanes who had already had a wife called Miriam and a daughter with the rather beautiful name of Shelamzion. The Torah sanctioned polygamy, but since Judanes had date palms in Ein Gedi on the western shore of the Sea, where at some point Babatha settled, it is entirely possible that Judanes kept wives and date groves in both places.

In any event Babatha had what it takes to look after herself. In 128 she lent her husband the princely sum of 300 denarii so that he could make a good dowry for Shelamzion's marriage, and on terms in which she was able to ask for repayment whenever she chose. When Judanes died, suspecting she might have trouble with that repayment Babatha immediately seized the Ein Gedi date groves as collateral. This did not make Miriam, the first wife, at all happy. She sued in the Roman court for restitution, and she had one big card to play: a connection with the new Bar Kochba regime through a kinsman or friend, Yehonatan, who was the Star's commander at Ein Gedi.

History was suddenly closing on Babatha and her tenaciously made and precariously held fortune. Undaunted, she took herself off to Ein Gedi to defend herself in the case and was swept away by the acrid wind of calamity. Fleeing the Romans all the way into the caves at Nahal Hever (with their soldiers perched right above them on the cliff face), Babatha knew enough about how the world works to hang on to her little legal archive, if need be to the bitter end. If God was kind and she survived, she knew that she would need the archive to be the mistress of the precious groves of date palms in her own right. But some Son of Heaven had fouled her destiny and there she perished along with the well-off Jews from Ein Gedi amid their few mirrors and combs and little black pots of unguent.

Not much remains of the Bar Kochba revolt, that last spasm of

Jewish defiance, except for the coins that numismatists collect and some of them even prize, minuscule overstrikes though many of them are. Often, they are poignantly beautiful, for they represent what had been lost: the colonnaded Temple in particular, and often the four species brought to it on the Feast of Tabernacles. One silver coin brings together imagery, Temple memory, messianic redemption and the first slogan of revolutionary liberation known to the world, for encircling the trumpets that once blew from the walls is the slogan, written in self-consciously archaic Hebrew characters, linking it to the first writing of the Bible: 'To the Freedom of Jerusalem!'

Other coins bear on their face *tamar* – or date palm – echoing the menorah candlestick, one of the most repeated emblems in Jewish imagery. It is a commonplace that the date palm was a symbol of the fruitfulness that God had promised His covenanted people.

The date palm had another association too. It had been known to the Egyptians and to all successive cultures as the tree that never died but endlessly renewed itself, new leaves replacing those that withered and browned, hanging loose down the trunk before falling. You can see this for yourself, especially in Israel and Egypt. In that sense at least, the date palm was immortal, and became an image of redemption and resurrection. Which is one more reason why the pious pseudo-Messiah, Simon, guided by the priests we know surrounded him, might have chosen it.

But so did another set of messianic believers, much preoccupied with resurrection, which is why, when the image of the Christian cross first appears, it does so as a date palm.[78]

PART TWO

mosaic, parchment, paper

5

THE MENORAH AND THE CROSS

I. Side by Side

November 1933: not a good time for the Jews, not in Berlin. Not an especially happy time to be an American for that matter. One in four of the workforce was unemployed, more in places of desperation like Chicago. Could the new president be the messiah of the slump or was the American economy, the hope of untold millions, done for? The gloom even leaked into places where life went on much as it had before the crash: Yale, for example, where boys with Roman numerals pinned to their surnames ra-ra-ed over cocktails.

Clark Hopkins was not one of them. Archaeology was where he went to restore his strong spirits in the midst of so much melancholy. If only, he thought, as he shuffled photographs from the site of his dig in the Syrian Desert, some astonishment would materialise, something as spectacular as Carter's Tutankhamun, it might give those stuck in despair something to boggle at, another time and place to go to, far from the present pit of dreariness. Now what would be wrong with that?

It was touchingly unworldly, this faith in the elixir of archaeology. But then Hopkins was an optimist. He'd become director of excavations at Dura-Europos, an ancient fortified frontier town on the upper Euphrates, hidden for centuries beneath high embankments of sand. When the sand was swept away in the late 1920s, a great city, packed with walled streets and temples, revealed itself. Calling Dura 'the Pompeii of the desert' was overreaching for public recognition, but there was no question that the place was an unexpected marvel. How

those frontier soldiers lived! Founded by the Seleucid Greeks around 303 BCE as a citadel against threats from Iran, and sited squarely on the trade route between Babylon and Palestine, 'Europos', as it was known, fell to the Persian Parthians late in the second century BCE. As was their wont, this latest edition of Persian imperialists was relaxed about the flourishing of any and every cult, so that alongside their own temples, shrines to local Syrian gods sprang up alongside the Hellenistic ones. Through the Parthian centuries, the new power in the region – Rome – knocked on the doors of Dura, but it was not until 165 CE that Lucius Verus, Marcus Aurelius' co-emperor, staved them in entirely. In their turn, the Romans held it for barely a century, before finally and terminally Dura fell to the immense army of the new Sassanian Persian king, Shapur I, in 256 CE.

At which point, aside from the odd Christian hermit drawn to the barely protruding ruins, and the occasional mule and camel train plodding along by the river, Dura-Europos stayed uninhabited and unexplored. Had the Sassanians made it a Persian city again, they might have radically altered Dura but, as it was, it slept intact beneath its mantle of dirt. The logistics of its last sieges had buried it alive. The city had twice changed hands between Romans and Persians with defenders and attackers alike building enormous ramped earthwork embankments, within and without the western desert-facing walls, filling in buildings abandoned by their civilian occupants. Sandstorms completed the shrouding of what Dura-Europos had once been, so that it stood as an enormous sand-mound high between the Euphrates and the Syrian sky.

In 1920, C. M. Murphy, a British army officer, poked at it with his swagger stick and met resistance. Shovels were imperially summoned for the *fellahin*, the farmers and villagers, and before long eroded foundation forms of mud-and-plaster buildings emerged, followed by standing walls bearing rudimentary paintings which, Murphy thought, looked very ancient. His senior officer was alerted; the senior officer wired the formidable Gertrude Bell, then busy concocting a constitution for the British-created kingdom of Iraq. Official support was offered – on the usual parsimonious and hum-hawing terms – and the tentative work of uncovering began. But Dura-Europos – halfway between Mesopotamia and Palmyra – fell within the Syrian territory mandated to French control by the League of Nations. Slow to the holster in the

duels of colonial archaeology, the French had been beaten to the draw by an American Egyptologist, James Breasted, who began digging in earnest in 1921. Asserting their excavation rights the French took over, but from 1928 they pooled their resources with the Americans in a joint expedition organised under the auspices of Yale University.

For five seasons jaw-dropping splendours were revealed: eleven pagan temples and shrines – Roman, Greek and Mithraic – some with murals. Armour, papyri, ceramics, jewellery were scooped up as the dirt was brushed away from them in dwelling after dwelling. Inscriptions were found in a babel of languages: Greek most of all, but also Aramaic (of many local dialects), Parthian and non-Parthian Persian, Latin, Semitic-Arab and Hebrew. Most astonishingly, the earliest known Christian building of any kind: a baptistery chapel dating from the early third century BCE and thus well before the Roman Empire adopted Christianity in the reign of Constantine. The chapel too was painted, albeit crudely, with scenes from both the New Testament – the healing of the paralytic, the three Marys at the tomb of Christ – and the Old – stories like the slaying of Goliath by David, which were read as prophetic prefigurations of the coming of Christ and the victory of the Gospel.

The Yale director of Dura-Europos, Professor Michael Rostoftzeff, had assumed – and certainly hoped – that the discovery of *pre-Byzantine* Christian iconography would astonish the world. To his dismay the world beyond the recondite groves of academic archaeology didn't seem to care that much. Greece and Rome were still the big draws and Egypt, archaeologically colonised by the British, got all the headlines. What could you do with narrow-minded unimaginative Christians? Now the Jews, they were a different story . . . If only, he confided to Clark Hopkins, a synagogue could be unearthed at Dura-Europos in the upcoming sixth season, then the vital significance of the site would be grasped at last, and due acclaim given to the unearthers.

And lo, came November 1933.

A little unfortunately, Hopkins compared his epiphany to his experience of a train crash:

> I had no recollection of the moment between the shock when I was thrown from my seat and when I began to pick myself up from the bottom of the overturned car. So it was at Dura. All I can remember

is the astonishment, the disbelief, as painting after painting came into view. The west wall faced the morning sun which had risen triumphantly behind us revealing a strange phenomenon. In spite of having been encased in dry dust for centuries the murals retained a vivid brightness that was little short of the miraculous . . . Aladdin's lamp had been rubbed and suddenly from the dry, brown bare desert appeared paintings not just one nor a panel nor a wall but a whole building, scene after scene, all drawn from the Old Testament in a way never dreamed of before.[1]

That they were looking at a synagogue, one of the earliest known, created just a century and a half after the Roman destruction of the Jerusalem Temple, seemed inconceivable. For this building had something unknown in any other ancient synagogue: paintings. All four walls of a spacious chamber – the largest public room in the entire city – were packed, end to end, floor to ceiling with frescoes. How was this possible? Surely the Jews didn't do pictures, especially not in their place of worship. Exodus 20:4, repeated by Deuteronomy 5:8, had proscribed the making of graven images 'of anything that is in heaven above and the earth below'. Rabbis, cultural critics, much of the received wisdom of the Gentile and Jewish worlds would have echoed that assumption. The only exception, it was commonly said (notwithstanding one of the richest traditions of manuscript illumination in the world, including daily and festival prayer books and the Talmud), was the Passover Haggadah, and none of those were known before the tenth century CE, nor printed ones of course before the sixteenth. It seems odd, in retrospect, that more scholars never bothered to consider what exactly the Hebrew text of the Second Commandment meant.

It is difficult to pinpoint exactly when it became a truism inside and outside Jewish opinion that the Torah flatly proscribes picturing, especially of human forms. Even by the fourth century CE, writers and codifiers of the Talmud were still interpreting the Second Commandment to mean a ban only on objects, mostly three-dimensional, of idolatry. And for good reason. Exodus 20:4 and Deuteronomy 5:8 use two Hebrew words to characterise the forbidden objects: *pesel* and *temunah*. The first, from a root meaning to carve, without any question means not paintings or mosaics but wrought figures – sculptures and

reliefs – precisely the category of cult objects, common in the ancient Near East and the classical world, that a religion of a formless deity would want to reject. *Temunah* is more complicated, as it derives from *min* meaning a species, a class of things sharing identical defining characteristics. Extended somewhat, then, it seems to have come to be used as 'likeness' or 'copy', not unlike the sense of the Greek *eikon*. The ban was on such 'likenesses' of things 'existing in *heaven* and earth', which again strongly suggests fashioned objects of idolatrous devotion. The very next verse in Exodus (20:5) makes it clear that the criterion of their offensiveness was their capacity to command vain worship.

A famous, lovely *aggadah* (exemplary story) from the second/ third-century CE law code of the Mishnah – in the tractate dealing with idolatrous objects – makes exactly this distinction between incidental ornament and devotional images. The patriarchal sage Rabban Gamaliel is splashing away in 'Aphrodite's Bathhouse' in Ptolemais (Acre), when a know-it-all Greek, Peroqlos (Pericles) Pelopsos, calls him out for not obeying the Torah's strictures on shunning places with statues. 'Answers aren't given in a bathhouse,' says the rabbi and goes on scrubbing. But as the two men exit he tells the Greek, artfully, 'I never went into her bathhouse. She came into mine! They don't say, "Let's make a bathhouse as an ornament for Aphrodite"; they say, "Let's make Aphrodite as an ornament for the bathhouse."' And just in case he hasn't made it clear that since the bathhouse is scarcely a temple no one could accuse him of idolatry, he adds, 'Even if someone gave you a lot of money you'd never walk into a temple stark naked . . . and take a piss in its [the statue's] presence . . but look there it is [the statue] . . . and every- one's pissing away right in front of her.'[2] Point taken, Rabbi. In a culture where statues were everywhere, one could scarcely avoid them when going about one's business.

But the paintings at Dura were not in a bathhouse; they were in a synagogue where the pictures and the Bible text lived inseparably as objects of devotion. The Torah itself was surrounded by them. Projecting from the south wall – that is, facing Jerusalem as all syna- gogues now did – is an arched niche, flanked by twisted 'Solomonic' columns, almost certainly modelled on those of classical and oriental paganism. Clark Hopkins's wife posed for a photograph seated on what she imagined was a sort of stone bench or throne. There is

some evidence of 'seats of Moses' in early synagogues but this was probably a low stone shelf. In the pagan temples the shelf would have been used as a pedestal for a statue of the venerated deity. At Dura, the niche functioned as an Ark to hold the scrolls of the law. Holes drilled above it suggest that curtains hung down over it, in direct emulation of the purple-crimson 'veil' protecting the impenetrable sanctity of the Temple Holy of Holies. The flat surfaces of the 'Ark' were decorated with images meant to sustain the memory of the destroyed Temple and faith in its rebuilding (perhaps at the hands of the oncoming Persians who had made this happen before!). That Temple itself was described by the painting of a recessed-columned portico. A seven-branched candlestick was pictorially recovered from its Roman captivity and painted in yellow to suggest the gold. Close by were symbols of the pilgrimage festivals embodied in the 'four species' – the palm spear, the citron, sprigs of myrtle and willow – that had been brought to Jerusalem to celebrate the Feast of Tabernacles. And, as elsewhere in early synagogues, the akedah appears: Abraham's binding of his son Isaac in obedient preparation for the appalling sacrifice demanded by YHWH as a loyalty test. The 120 Jews who could easily have been accommodated in the Dura assembly hall would have grasped the complicated resonance of the sacrifice, averted by the outstretched hand of God and the providential supply of a ram 'caught in a thicket' as an alternative. The cult of animal sacrifice in the Temple (as well as the ban on consuming animal blood) was the affirmation of abhorrence at human sacrifice, but Abraham's act of blind faith was to be repaid by the sealing of a covenant between YHWH and His people, symbolised by the nick of the knife on the foreskin. A promise had been made. If Jews kept their side of it, then the further promise of a liberating, redeeming messiah and the rebuilding of the Temple, would be assured. So at the very edge of the Roman Empire, what Rome had wrought on Jerusalem, was undone in the synagogue painting.

Many of the biblical subjects lining the walls may well have been chosen to carry this message promising of an eventual redemption. Two key figures in the furthering of that promise – Moses and David – are shown at the beginnings of their prophetic roles. David is anointed by Samuel, both of them wearing togas and Roman haircuts.

In a wonderful painting, Pharaoh's daughter holds the infant Moses,

standing amid the Nile waters, its reeds and rushes indicated by curls of the painter's brush. The picture is at once naturalistically human-ised and formally ceremonious, as befits so fateful a moment. The young woman, who after all has been bathing, is clad in nothing more than a transparently wet himation, in contrast to the modestly clothed figures of Moses' mother Jochabed and his sister Miriam, looking anxiously on behind her. Before the princess is the bobbing crib – designed like a little ark, also typical of the cradles of its time and place – in which the child had been found. Not realistic at all are the expansive open-armed gestures, one made by the princess, the other by the infant, the mutual echo almost an anticipation of Madonna and Child – but in this case open to the awareness of the destiny that will unfold from this moment in the waters. The picture is at once formal and informal, hieratic and popular, mysterious and accessible, literary and iconic. If you were a Jewish father or mother in Dura-Europos and you were with your children in that synagogue there would be much to tell them, pointing this way and that at the painting.

The two human pillars of the Judaic story reappear again and again: Moses at the Burning Bush and, as an Aramaic inscription makes clear, 'cleaving the sea'; David enthroned as a Jewish Orpheus, holding crea-tion spellbound, and defeating the Philistines.

The principal patron-benefactor of the Dura community – the first Maecenas of the diaspora – was one Samuel, hence the prominence given to his namesake in the anointing of David. As was often the case in this earliest period, the synagogue (like Christian chapels of the time) had begun within his house. Samuel must have been wealthy enough to have afforded the ambitious expansion which followed, requiring the demolition of exterior walls and the creation of a fine roof-ceiling embellished with painted ceramic tiles. But socially, the Jews of Dura would have been as mixed a bunch as those of Elephantine half a millennium earlier. Like their Egyptian forebears they were mercenary soldiers, artisans and tradesmen, and some were even local officials, tax collectors – though unlike in Elephantine, some of them would have been slaves or ex-slaves made bondsmen by the Roman conquerors. Few, however, would have been ignorant of their Bible, certainly not while they could practically learn it from the glowing, brilliant frescoes. At Dura they had, through images, both synagogue and place of Judaic study all in one. It was a people's Beit

Hamidrash, an academy of study as well as a place of prayer, but visual, accessible, instinctive.

For those who were already more learned, every one of the chosen biblical scenes would have resonated with specific messages of consolation and hope. Ezekiel's vision of the dry bones become breathing fresh life *was* a prophecy of the moment a dead Jerusalem would be resurrected. The humbling of the Persian Judeophobe Haman, forced to lead Mordecai's horse (albeit painted in lustrous Persian colours in a strikingly different hand from the finding of Moses), proceeds in a lightly made-over version of a Roman triumph, while a resplendent, heavy-browed Queen Esther sits enthroned behind a Persian-trousered King Ahasuerus. This too was an immediately recognisable image of hope. Though the painting was almost certainly done while the Roman legions were still holding off the Persians, it made an obvious appeal to the latter's history in rebuilding the Jerusalem Temple. The ascendant Sassanians liked to claim they were the second coming of the ancient Achaemenid dynasty of Cyrus, Darius and Artaxerxes himself, so should they get the upper hand, the festival of Purim might yet turn out to be prophecy as well as history. It all fitted together, past and present, mourning and festivity, exile and return.

And this was 240 CE: the *beginning*, or very close to it, of what synagogues were meant to be for a post-destruction, diaspora community. For that matter, Dura was placed right between the two poles of Jewish rabbinic learning – Palestine and Mesopotamia – so there is no possibility that the painted synagogue in Syria was some sort of heretical aberration of which the sages would have disapproved. Everything suggests, on the contrary, that this was an exemplary synagogue.

It was also a response to the neighbouring religions that were themselves flourishing at Dura and thus evidence of how observant Jews lived among pagans and Christians. The synagogue was situated directly opposite a Temple of Adonis; there was another devoted to Zeus a few blocks away; there were also shrines to the Roman sun-cult of Mithras. And all of these would likely have featured the late-Roman painting from which the synagogue unmistakably borrowed its figurative style, as well as the Parthian 'frontal' convention of lining figures parallel to the picture plane all staring in the same direction, outward at us.

But if the synagogue designers and artists were borrowing from

the pagans to confound them, they also had in mind the more imme-
diate competition of the Christians, who, in a chapel that also began
as a private house, had used Jewish characters – like David standing
over the fallen Goliath – to declare in images that the Hebrew Bible
had been the prophecy of their Messiah, and that Christianity was,
in effect, the fulfilment of Judaism, not its opposite. In a figurative
version of the spirited back-and-forth of the theological disputations
between Christians and Jews that had already begun, in the Dispute
between Justin Martyr and the Jewish 'Trypho' (who may or not have
been the Rabbi Tarfon of the Talmud), the synagogue paintings
responded to the iconic challenge. Since the very word *Christ* meant
'anointed lord' in Greek, what could be a more pointed way to reclaim
David for unrepentant Judaism than to show him anointed by the
prophet Samuel? Even more strikingly there is something about the
heroic stature of the frontal Moses, bearded, virile and princely – clad
moreover in an imperial toga, significantly ornamented with a single
purple stripe – that seems to act as a kind of counter-Christ for the
Jews; the giver of laws, the maker of the Jews, touched by the pres-
ence of the Almighty yet emphatically not celestial himself. Significantly,
the bush itself, flames behind it, is green and sprouting, a symbolism
already freely used by Christianity to suggest the New Life which
here, however, begins with the first revealed law.

Inscriptions made on the surface of the paintings have been read
as suggesting that the splendour of the Dura-Europos synagogue was
enough to draw admirers from afar – perhaps from Palmyra where
there was a substantial Jewish community, some of whom were
converts, or even from the Mesopotamian cities to the south-east. The
painted synagogue might well have been a kind of pilgrimage place
for the Jews of the whole region. If so, they must have made haste,
for all those painted promises of redemption were of no avail. The
enlargement of the synagogue and its painted decoration were in
place for scarcely more than a decade before the Sassanian Persian
king conquered Dura and left it abandoned to the drifting sand.

In the years since the Dura synagogue was discovered in 1933,
nothing like it has come to light, which is to say no other place where
painted Judaism was so stunningly realised. But that's not the end of
the story of profusely decorated ancient synagogues. The abundant
picturing, which was evidently part of Jewish expectations of how

their places of gathering and worship would look, was merely trans-
ferred to a different, and more durable medium – mosaic – both in
the diaspora and, more profusely, in the very heart of the rabbinic
remaking of Judaism: Palestine itself and especially Galilee where
Judah I, the 'nasi' patriarch, presided over the 'Sanhedrin', or assembly.

Not right away. There was a period – no more than a century –
following Hadrian's cultural annihilation of Judaea when new syna-
gogues were not built. This, however, did not make the period a Judaic
dark age. Many if not most modern Jews grow up with a tragically
overdetermined view of the two centuries following the destruction
of the Temple: a Jewish ground zero, the vast mass of them deported,
enslaved; a pathetic remnant furtively hanging on in Palestine; the
Jews of the diaspora huddling together in austere cells to pray and
study what was left to them.

This was not what happened. The Hadrianic laws banning Torah
study, circumcision, Sabbath observance and the like were all repealed
in the reign of his successor Antoninus Pius who began his rule in 138,
just three years after the suppression of the Bar Kochba revolt. A tradi-
tion has the learned emperor and the Jewish nasi meeting and even
becoming friends, a relationship sustained into the reigns of Severus
and Caracalla. And it is certainly true that the bargain struck between
Yohanan ben Zakkai and Vespasian – that Jews would conduct them-
selves as loyal subjects of Rome in return for the unmolested protection
of their ancestral religion – was reaffirmed. The status quo ante Jewish
revolts, with Judaism recognised as a religio licita, a lawful religion, and
Jews given a high degree of legal and local self-governance, was restored.
Only the ban on entering and residing in Jerusalem, save for the annual
lamentation on the 9th of Ab, the date of the Temple's destruction,
was preserved.

Synagogues outside Judaea – especially in Galilee and on the plain
of Jezreel, as well as on the coast which had been built earlier – were
not pulled down. Others in the wide diaspora that extended the length
and breadth of the Mediterranean (the Book of Acts in the New
Testament is a virtual gazetteer of Jewish communities from Corinth
and Ephesus to Lydia and Iconium in Asia Minor) flourished and even
assumed grandiose proportions. Many had vestibules and courtyards
with fountains at their centre – the association between their playing
waters and Paradise deliberately incorporated into synagogue design.

The colonnaded synagogue built at Sardis (in today's Turkey), prob-
ably in the fourth century in what had been the *palaestra*, the gymnastic
centre of the town, would become in successive expansions one of
the most magnificent of the entire Jewish world: a full eighty metres
long, complete with a spacious atrium vestibule, mosaic floors, a step-
terraced seating area at the back facing the Torah shrine niche, and
a stone reading table with lions and eagles![3]

It is true, however, that the greatest and most enduring edifice of
Judaism created in this period was built of words not stones. Mishnah
came before mosaic. The sages of this time took the opportunity
offered by the permanent destruction of the Temple elite to redefine
Judaism, and appoint themselves its codifiers and judges. With breath-
taking audacity, set out in one of the books of the Mishnah, Avot –
occurring, oddly and abruptly, within a larger book dealing with rules
of equity in damages – the sages (known later as *tannaim*) redefined
what 'Torah' was. When they wrote that 'Moses received the law at
Sinai' they did not mean merely the 613 written commandments, but
an indeterminate and unspecified body of oral wisdom whose custo-
dians they had eventually become. Avot is entirely devoted to this
genealogy of collective self-authorisation. From Moses this version of
'Torah' is passed to Joshua, then to 'the elders and prophets', followed
by 'the men of the great assembly' (whatever that was – perhaps the
Great Sanhedrin, possibly not), and so on down to the per-Hasmonean
high priest 'Simon the Just', thence through many generations of
teachers, a long chain of names, some famous like Hillel and Rabban
Gamaliel, the son of Judah the Patriarch, and Yohanan ben Zakkai of
Yavne, others unfamiliar to even the most learned such as 'Nittai the
Arbelite' and 'Aqabiah ben Mehallel'.

The obscure sages (and for that matter the famous ones as well)
mark their place in this descending ladder of wisdom through epigram-
matic (and sometimes gnomic) utterances, the *pirkei avot*. Simon the
Righteous begins movingly: 'He would say: "On three things does the
world stand: on the Torah, and on the Temple service and on deeds
of loving kindness."' Others follow with shameless promotion of their
own brethren: 'Yose b Yoezer of Seredah says: "Let your house be a
gathering place for sages. And wallow in the dust of their feet and
drink in their words with gusto."' Hillel's words have become famous
for the moving union of human self-consciousness and enigmatically

unanswerable philosophical suggestiveness: 'If I am not for myself, who is for me? And when I am for myself what am I? And if not now when?' Shammai (as usual) is given not much more than fortune-cookie platitudes: 'Make your learning of Torah a fixed obligation. Say little and do much. Greet everybody cheerfully.' Rabbi Levitas of Yavne says: 'Be exceedingly humble, for the hope of humanity is the worm.' And so on.

None of these utterances have any discernible connection with those that precede or follow them in the text. Aside from the famous names we have little clue about historical chronology other than an internal one. In the tenth century, Jacob ben Nissim ibn Shahim in Kairouan, now Tunisia, asked the leading Babylonian *gaon*, Sherira of Pumbedita, who were the writers of the Mishnah and got back the line of sages: *tannaim* (the Mishnah writers), *amoraim* (the teachers and elaborators of it), two or three generations later – approximately fourth and fifth centuries – the completers of the Talmud, and finally the *sevoraim* and then *stammaim*, in the following two centuries.

But lineage of the Mishnah sages is scarcely a genealogy, and it is certainly not history. As far as the inheritors are concerned, Jewish history – of the kind narrated in Kings and Chronicles, in Esther and the apocryphal Maccabees – comes to an end with the destruction of the Temple. History is no longer the business of the Jews, except as the abrasive edges of the empires they rub up against, regimes that can be checked against the descriptions given in Daniel and elsewhere, indicators of the ticking of the messianic timetable. Even as the sages are creating it, the Mishnah is designed to be not so much unhistorical as supra-historical, something to float free above wars and empires and states. By becoming liberated from historical eventuality and lodging instead in memory and oral tradition, the Mishnah – and the Talmud that grows up around it like a great coral reef of commentary, biblical exegesis and interpretation, endlessly and organically ramifying into a vast hypertext – will live as long as it takes for the Messiah to come, for Jerusalem to be returned and the Temple rebuilt. And perhaps even longer than that.

What, then, is the alternative to history? Law, but in the form of an exhaustive encyclopedic guide to living as a Torah-abiding Jew from circumcision to burial. Nothing is too trivial for the remit of the Mishnah. Should you want to know the precise specifications of the shoe which

THE MENORAH AND THE CROSS 185

had to be removed by a widow if she wanted to let her brother-in-law off the otherwise bounden duty to marry her, the Mishnah will leave you in no doubt. Only a *heeled* leather sandal capable of walking at least four cubits will do. A felt sock? Not a chance. Worried that a dog consumed carrion (including nibbling a human corpse) before dying from his lethally disgusting meal while stretched out across your threshold? You should be. Mishnah insists that the aforesaid threshold is ritually defiled and in urgent need of purification. Perhaps you're fond of pickled cucumbers (what Jew isn't?) and you panic when you discover that you are out of supplies, but since it's not that much effort, think a little bit of surreptitious pickling on a slow Sabbath afternoon can't get up the Almighty's nose. Woe betide you, O illicit pickler! This counts as work and is thus forbidden. On the other hand, a little light brining, just some salt water you happen to have on hand and which might, you know, somehow, mysteriously, accidentally, get splashed on the previously cut cuke, is just *fine*. But whatever you do and however much you're tempted, never, ever break the seal of a jar to satisfy your craving for a dried fig.

The Mishnah can strike the unwary reader as an orgy of the picayune. Yet packed inside its immensity – which claimed (unpersuasively) to be no more than a helpfully subject-indexed elaboration of the original 613 commandments, together with explanations of the cryptic and resolutions of the apparently contradictory (and because Deuteronomy had a certain way with Leviticus there are plenty of contradictions: locusts kosher in the former, not kosher in the latter, for instance) – the writers offer judgements on deeply serious ethical matters. It is the Mishnah which delivers – without appeal, and vexingly often without any clue as to how the judgements were arrived at – the first, self-consciously, decisively *Jewish* way of everyday living. There is something counter-intuitively powerful about the wiring established between quotidian habit and connection with the Almighty. From minutiae comes sanctification down to the last shoe and the locust which might be trodden underneath. The Mishnah resists the possibility separating the realms of the sacred and the humdrum: holiness pervades all; and the least action, the least creature, the least custom is to be considered in the light of the righteousness of divinity. Though dealing with small things, this is no small thing. It bestows a kind of radiance on the world itself, not through abstract nostrums but from

the actual, concrete matter from which a day, a week, a life is made. For Jews, the mistake made by Paul and all those who followed his way of thinking was their imagining the Torah to be a mere inventory of obligations, and one moreover laid down by an un-elect, when as they are unwound in the Mishnah scroll (for that was the way it would have been read) they are the beginning of meditations.

Even this was not enough for the Mishnah writers. For while they pretend to do nothing more than elaborate the law, they end up, of course, remaking it. This ambitious self-authorisation is communicated by the Hebrew in which it is written, which as a linguistic form strives for a kind of sonorous modern classicism. Knowing that the daily language of the people to whom it was addressed was either Aramaic or Greek (and occasionally Latin), it is self-conscious about moving the idiom out of scripture and into the world of social judgement. Accordingly, the Hebrew is flexibly multivocal: judicious and even laconic for its arbitrating utterances and pronouncements of law; more relaxed and informal for the rich and almost chatty narratives of debates and disputes among the rabbis – the *aggadah*. You can take or leave *aggadic* opinion, siding on this page with Rabbi Gamaliel II and on that page with Rabbi Eliezer as if in a disputatious boxing match; but at other times, unequivocal judgements are given – as if in response to formal questions to the rabbi. The resulting *halakha* has the force of law. 'He who steals wood and makes it into utensils [or] steals wool and makes it into clothing pays compensation with the value of the wood (or the wool) at the time of the theft.' No more arguments; that's that. The Mishnah has spoken.[4] *Sheqet*. Zip it. And like that issue of the equity of compensation or the nature of offences for which judicial damages must be paid, the Mishnah is not all finicky small claims and hair-splitting distinctions. In the case of the grounds by which a man is or is not duty-bound to marry his widowed sister-in-law, immense burdens of right hang on the judgement; as they do on guidance as to how someone might be properly buried should the death occur far from home, as it so often must have done.

So the great bulk of the Mishnah is an intensely practical, social text, but not only that. While it invokes chapter and verse of the Bible surprisingly sparingly, and even less often offers a *midrash* interpretation of a particular scripture, in its *aggadic* excursions and lovely ramblings it often resembles the biblical and Apocryphal

Wisdom Books. 'Yose b Yohanan of Jerusalem says, "Let your house be wide open; seat the poor at your table."' So far so good, the rabbi sounding not altogether unlike that other famously pithy rabbi, Jesus of Nazareth. But then he adds, in un-Jesus-style, 'And don't talk too much with women.'⁵ Some of the counsel is not much more, but no less, than early (and uncannily wise) practical psychology: 'R Simeon b Eleazar says, "Do not try to make amends with your fellow when he is angry, or comfort him when the corpse of his beloved is lying before him . . . or seek to find absolution for him at the moment when he takes a vow, or attempt to see him when he is humiliated."' It is evident that the Mishnah writers go well beyond their own self-described remit of merely adumbrating the Torah and wrestling with its contradictions and obscurities. Little or none of that social advice about doing right by your fellow man (and, occasionally, woman), taking into careful account his claims to both justice and consideration, has been prompted by any specific text of the Torah. But this and ethical precepts like it, in often stunning superabundance, somehow knit together in the Mishnah to make a whole fabric of moral assurance. Wisdom and comfort and even clarity seem to come both from the spontaneous process of a conversation with the sages, even one in which they are caught in constant mutual interruption and contradiction (a good sign with Jews), and from the mouths of real people, not quasi-celestial, oracular seers. In a way not always true of St Paul or John the Evangelist, say, you listen to the sages and you can imagine them eating soup or picking dirt from their fingernails.

How real, though, is the Jewish world the Mishnah inhabits? In many ways, not at all. It was written and organised by a circumscribed rabbinical elite, men dreaming of what they imagined the perfect Temple-centred Jewish world had once been, and could yet again be if their people were given a temple of words, laws and instructions that would repair the damage of fallen masonry and the extinction of the sacrificial fire. The *tamid* could be relit, made to be as constant as its Hebrew name, just by reiterating its remembered practices. Hence the bizarre amount of space given to precise regulations governing the sprinkling of blood of sacrificed animals – something of no possible practical interest at all to post-Temple generations. The logic was that, should the Messiah suddenly appear and the miracle

of the Temple restoration be accomplished, everything ought to be good to go as it once was. But there is almost certainly another important aspect to the immense inventory of procedures and rituals that no longer have any practical purpose. Memory, if not God, does indeed lie in such apparently gratuitous details. The excessiveness of Mishnaic recollection is not unlike that of people desperately trying to summon the substance of a vanished beloved in their memory by recapturing minute, apparently insignificant details of dress or gait. From those details a whole person somehow reassembles itself. At its core, the Mishnah is a thousand-page act of yearning.

Yet for all its idealism, its dream-world obsessions, the Mishnah does dwell in the here and now, amid actual, argumentative, sceptical, often intolerant, captious Jews. Indirectly, from the inventory of habits *not* to be countenanced, it gives us one of the most vivid social portraits of what second-century Jews living in the late imperial Roman world were actually like. Do not, says the Mishnah, use the Temple Mount as a short cut (which makes it clear that many must have done); do not sleep or chatter in sacred premises – standard practice. On the Sabbath do not, O women, go out gussied up in woollen or linen ribbons or with bands around your head, or a tiara in the 'golden city' style (seen in mosaics), or with nose rings, or head bangles 'when not sown on with hairnet' (don't ask). Men, do not go to your Sabbath synagogue in nail-studded sandals or – speaking to the many Jews who as at Dura might have been soldiers again – wearing helmets, cuirasses and greaves. Although none of these violations of Sabbath decorum was so serious as to require a 'sin offering', if on the other hand a woman carries a spice box, a perfume flask or a pin in a snail-form (also of course the shape of the inner ear), then Rabbi Meir at least thought that was a punishable offence. Not a good idea to recycle a menstrually stained cloth for your Shabbat dress (as if). Forgo ankle chains and garters as they are both 'susceptible to uncleanness'.[6]

And there is something else, quite beside the 'Manual for Living Jewish' aspect of the huge text, that hovers over it like an immense spectre and that is, paradoxically, the phantom of the Temple itself. The Mishnah was written by men who could not possibly have known the real thing directly, though their grandparents and perhaps even their parents might have done. But they write sometimes as though it still endures as the central fact of Jewish life. Much of the book is

devoted to staggeringly abstruse issues of animal sacrifice and cereal offerings as if the routine of the Temple were still happening. What blemishes rule out an animal for the sacrifice? An ox with an undescended testicle, for a start. (Yes, the Mishnah also gives fail-safe instructions on how to find out.) What *human* blemishes disqualify men from serving in the Temple? Men with heads shaped like turnips, for sure. Also the flat-nosed (which would have ruled me out); men with cauliflower ears (the Mishnah says sponges, which is somehow more exactly picturesque); and even – this is a bit rough – the bald. What is bald? 'Any who do not have a row of hair from ear to ear'. So the Mishnah conjures up a line of anxious comb-overs queuing for Levite auditions as if the Roman destruction had never happened! More sweetly it pretends to recall the 'ten wonders that were done for our fathers in the Temple': women never miscarried; the meat for sacrifice never went off; a fly never made an appearance in the slaughterhouse; a high priest never suffered nocturnal emission on the eve of the Day of Atonement (I should hope not); the rain never put out the altar fire; no wind ever blew away its smoke; no pair of loaves for the shewbread table was ever disqualified; when a jammed crowd of people stand there is little room but when they prostrate themselves they have plenty; neither snake nor scorpion ever bit anyone in Jerusalem; and the biggest miracle of all at pilgrimage time – the accommodation shortage was never a problem. 'No one ever said to his fellow, "This place is too crowded for me to stay in Jerusalem."'[7]

How to rebuild Jerusalem in the imagination and memory: that was the task. Could it be done with just words words words? That would once have seemed to be the authentically Jewish answer. Now, thanks to the Dura revelation, we know that the density of texts could be matched, and augmented by a complementary density of pictures. Not only were the two ways of remembering and sustaining Torah memory not in contradiction, they actually nourished each other. Even more unsettling to our usual assumptions about Judaism at the moment it was taking form is the knowledge that the site in which word and image went most closely together was the synagogue itself! Dura *was* unusual, but only in that its dominant imagery was on the walls. There were other spaces that could be filled with the signs and symbols of shared Jewish recognition, and they were horizontal. The ceiling at Dura was in fact covered in painted tiles, many of which

featured those familiar emblems – menorot and the like. But the surface of synagogues built in the budding time of the third to the sixth centuries – both inside Palestine and the diaspora – which was packed with pictures was the floor, and the medium was mosaic.

This was not evidence of backsliding. That same seed time of Judaism was the moment when the mighty Mishnah was defining the good Jewish life. Yet there is no reason whatsoever to suppose that there were Mishnaic-strict synagogues and flashy mosaic-covered ones. For that matter, the Mishnah is conspicuously and uncharacteristically skimpy in its discussion of images. Such as it is, it occurs in a tractate within the larger book on 'Damages' and is immediately packed with *aggadic* contradictions. Rabbi Meir takes the hard line, saying flatly 'all images are prohibited', but is followed by unnamed sages who say only those featuring 'a staff, a bird or a sphere' are forbidden. Almost certainly 'sphere' meant the sun or moon and their worship, but evidently no one took any notice. The rest of the tractate is devoted entirely to the *asherah* devotional trees and fashioned idols and what kinds of purposeful desecration may be applied to rob them of their aura: 'cut off the tip of [their] ear, nose, finger', and so on.[8] (This is part of the compulsive anachronism of much of the Mishnah since *asherot*, those carved or standing trees, had in any case not been around for many centuries.)

About painted images the rabbis have nothing at all to say and silence was obviously taken as assent, especially since the writing of the Talmudic books and the appearance of synagogues happened at exactly the same time. The single surviving synagogue of the original eighteen that once flourished in Sepphoris in Galilee was built and decorated in the city where the Mishnah was first essayed and where Judah the Prince's assembly sat. It is at once a city of classical elegance, deep piety and eye-popping mosaics.

In the diaspora of late antiquity, too, there was no furtiveness about synagogue mosaics. No less than *forty* such floors have been excavated and uncovered so far inside Palestine and out, and there is every chance of finding many more.[9] Profusely decorated synagogues, in the centuries when the institution was being created, were the norm, not the exception, from Asia Minor all the way to the western Maghreb. At Hammam-Lif (or Naro, as the Phoenicians called it) on the coastal outskirts of Carthage in what's now Tunisia, a fourth-century

synagogue has some of the most brilliantly vivacious mosaics of the ancient world.[10] Much of the decoration is purely geometric and ornamental into which the usual emblems of the lost Temple – menorah and shofar – have been inserted. But another chamber is a mosaic menagerie. One band teems with birds; another has a more mysterious arrangement of a dolphin and a great fish, oddly separated by a pair of ducks. Beneath them two peacocks flank a playing foun-tain. And it is this fount of life which gives the clue that the Hammam-Lif mosaic is not just a playful bestiary but an evocation of the paradisial Creation itself. Whether the fine, plump-cheeked, though sharp-toothed fish lurking in the deep is the sinister leviathan or (as I prefer) an emblem of happiness, apt for a Tunisian seaport, depends on which scholarship you find most persuasive.

With mosaic this splendid, the benefactors who made it possible ensured they would be credited and remembered by having their names recorded in Aramaic inscriptions amid the pictures. 'Juliana *of her own funds*,' one such inscription emphasises, 'paved the mosaic of this holy synagogue of Naro for her salvation.'[11]

That a Jewish woman celebrated her benefaction at Hammam-Lif should come as no surprise. The tightly confined role assigned to women in the Mishnah, principally as the recipients of male judge-ments about their rights and claims, may be an inadequate guide to social reality. That reality was that women and men sat together in these synagogues with no separation whatsoever. In fact neither the Torah nor the Mishnah has anything to say on the subject, and from the wealth of evidence available from synagogues of this period, not one sign of any gallery or other kind of partition has ever been found. Like much else assumed to be immemorial Jewish practice, the obli-gation was instituted many centuries later. It was an innovation, not a tradition. The same goes for the abandonment of full prostration – probably from a need to differentiate from Muslim practice (doubly ironic, since Islam almost certainly took prostration, along with many other of its rituals like the removal of shoes, from the Jews). The relevant verse in the Mishnah book Avot *assumes* prostration as regular practice.

But then the profusely decorated synagogues of the third to sixth centuries shake up all our preconceptions about Jewish houses of Torah reading and prayer. They make it clear that Judaism as it was

being remade was, in some respects, actually constituted from images almost as much as texts. In this crucial respect it was linked to, not separated from, the cultures which surrounded it. To begin with, those mosaics – not just of animal and plant life, but also of the human figure – could of course be seen in any well-to-do private house in towns like Hammam-Lif, Tiberias, Scythopolis (Beit She'an) or Sepphoris. Synagogues in those towns – like Jewish life in general – were strikingly an *extension* of the culture at large rather than an immured withdrawal from it. The style and iconology of the mosaics were drawn from the pagan world amid which Jews had lived relatively unproblematically. Vines, date palms, dolphins, lions were the shared cultural property of both monotheisms (as was the Hebrew Bible of course) and, for that matter, of pagans as well. As at Dura, David or Daniel are as likely to show up in churches as in synagogues.

If more evidence is needed of the openness of Judaism to the cultures amid which it dwelled and prospered, there are the calendar girls who stare moodily out at us from the mosaic floors of synagogues built in this seed time of rabbinic Judaism. They are personifications of the seasons, characterised in months. So, at Sepphoris in Galilee, perhaps the most spectacular of all these floors, Tevet, the winter girl with the teardrop face, looks out wistfully from beneath the folds of a gown (uncannily like a modern Islamic hijab) concealing her hair, more from seasonal chill than any obligation of modesty. Nissan, the springtime girl, on the other hand, has thick tresses of golden hair piled up and held with exactly the kind of showy headband the Mishnah frowned upon for Shabbat wear. Worse, or better yet, from her left ear dangles an unmistakably bling-heavy pendular earring. Tammuz, the summertime month, sometimes associated with the moment the fickle Israelites took to worshipping the golden calf, sports a spiffy flat-top beret and an enticingly bare shoulder.

In cities like Sepphoris, mosaics of female beauties, as well as the full repertoire of what we think of as profane pagan imagery – animals, in particular rabbits, ducks, and deer – could be found on the floors of the opulent houses lining its streets and avenues. With every new excavation, yet more of these spectacular decorations reveal the city to have been drunk on paradisial and arcadian imagery.[12] Sepphoris is *so* lavishly ornamented, and shows so many signs of the Romano-Greek style – a substantial theatre (close to the surviving synagogue), the

grand colonnaded avenues of the cardo and the decumanus – that its aesthetic looks unmistakably pagan-classical. But Sepphoris was not, in fact, pagan-Gentile. It was overwhelmingly a Jewish city, the membership of its town council (the *boule*) predominantly Jewish. The theatre was made for Jewish, not Roman, audiences who regularly went there as indeed they did elsewhere in the late-Roman Empire, as well as flocking to chariot races and gladiator shows. There is no reason to suppose that the extravagantly built and decorated houses – such as the 'House of the Nile' with its painted festival of Osiris and a complete Egyptian river bestiary (crocodiles, hippos, the lot) – did not belong to a Jew. And the most exquisite mosaics in the entire city – including a ravishingly beautiful woman, possibly Aphrodite, as well as Hercules and other standard classical themes – decorate the 'Villa of Dionysos', situated on the western slopes (not far from the theatre and synagogue) in an area known from the discovery of painted menorot and the like to have been densely Jewish. To whom might this Villa of Dionysos have belonged? There is much disagreement but some scholars at least are open to the startling possibility that the house might have been the residence of Yehudah Hanasi, patriarch friend of emperors, redactor in chief of the Mishnah and head of the Sanhedrin assembly.[13]

The basic urban form of wealthy, cosmopolitan but also pious Sepphoris had taken the shape we see now in the second and third centuries, when it was renamed Diocaesarea, but in the middle of the fourth century the city suffered two catastrophes, one political, the other natural. In 351, it was the centre of a violent revolt against the government of the co-emperor Cestus Gallus, partly a matter of tax impositions. Its leader was one 'Isaac of Diocaesarea' who succeeded in fielding a force formidable enough to take strongholds as far south as Lydda before succumbing to defeat in a battle somewhere near Acre. The price of the city's involvement in this last of the great rebellions against Rome was its military destruction. Twelve years later in 363, a massive earthquake with its epicentre in Galilee brought down what remained. Sepphoris/Diocaesarea was rebuilt, the great streets restored in fine late-classical style, and among the new buildings were synagogues, one of which is the surviving basilica-shaped structure, long and narrow, which boasts the mosaics that seem to translate, so unproblematically, images from residential to communal sacred space. If they are not of quite the quality of the Villa of Dionysos, they are still exceptionally

impressive, not least as evidence that Judaism, in the generations of its rabbinical formation, made a place for pictures.

Modern Jews grow up with an assumption that images in houses of prayer and Torah, where they are present at all, are confined to the occasional, modestly stained-glass window. But here in one of the places where synagogues took their original shape and form, images – the great majestic sweep of a carpet-floor mosaic, running from end to end of the space – dominate everything else, optically expanding what was in fact a narrowly confining barn-like gable-roofed space. Nor would these images have been hidden by seating or an assembly of standing congregants. Though there are no stone benches at Sepphoris, we know that worshippers would have sat – probably on wooden benches – along three sides of the perimeter beneath the roof of the Jewish basilica. So from any position they would have had a good view of those pictures, which would help the power of memory defeat the facts of politics.

As you might imagine of Jewish iconography, they are wordy images. Texts, inscriptions and labels are themselves embedded in the mosaics in Greek, Aramaic and Hebrew, indicating the zodiac signs, the months, the names of benefactors. There is also the strong sense of the Bible scenes being informed by the beginnings of *midrash*, the systematic interpretative discussion of the Torah and the Bible that was proceeding alongside the elaboration of the Mishnah into the Talmud. Contrary to received wisdoms about the Jewish tradition, texts and images work with each other, not against each other. The pictures are not some sort of illustrative accessory to textual Judaism. For the Jews who came to this and other synagogues – and who in all likelihood were very different in education and inclination from the rabbinical community of the Beit Hamidrash, or house of study (but who, as we can tell from the revolt, were fierce Jews nonetheless) – the pictures structure their understanding of what it was to inherit Jewish memory, and to translate that memory into actual social practice. They trigger visual mnemonics. The calendar girls, and the great wheel of the zodiac at the centre of many synagogue floors of this period, coexist with icons of the lost Temple – the menorah candlestick, the shofar trumpet and the shewbread table – and stories from the Bible that (as at Dura) are weighty with redemptive meaning.

None of these images were arbitrarily chosen. The fact that they

not only recur in synagogues as far apart as Beit Alpha on the hilly eastern edge of the valley of Jezreel, and at Hammath Tiberias, much closer to Sepphoris, means that from the fourth century at the latest, there must have been some sort of standardised pattern book of mosaic imagery for synagogue floors which mosaicists, whatever their sophistication or lack of it (and the Beit Alpha work is cartoonishly crude), would be expected to follow. More strikingly, such a pattern book must have won the approval of rabbinical authorities for it to have recurred so frequently and identically. Mishnah and mosaic were, then, not at all mutually exclusive but complementary: just as at Dura, a word-and-image programme for Jewish gathering and worship.

The formal division of the floor space was crucial to the way this programme worked on the eye and mind. Closest to the entry were the Bible stories and references, invariably featuring the Binding of Isaac, often the consecration of Aaron (as would befit a mini-temple) and sometimes the visit of angels to Sarah. Mosaicists (or those who commissioned them) were then free to vary the anecdotal details which could be very charming but always loaded with small matters of big significance. The Sepphoris version of the Binding of Isaac touchingly includes two pairs of shoes, one for father Abraham and a much smaller pair for Isaac. (All early representations of the scene make Isaac a young boy, not the thirty-something of later Talmudic insistence.) Side by side, the shoes poignantly humanise the unnatural demand YHWH is making of Abraham, but they also allude to the sacred space on Mount Moriah requiring the respectful removal of shoes.

The detail would have cued other moments of significant bare-footed epiphanies in the Jewish story – such as Moses at the Burning Bush, the memory of which (again as at Dura) would have been perpetuated by barefooted worshippers in their contemporary syna-gogue. Rows of sandals by the door would have linked the Sepphoris Jews to the lives of their ancestors. Likewise the presence of the providential substitute, the ram, would have been a reminder of Temple sacrifices, above all the Passover, and of its symbolic memento included in the Passover meal. Both Christian and Jewish cults at exactly this moment were heavily and mutually preoccupied with lamb icons and meanings.

At the far end of the synagogue floor, closest to the Torah shrine,

or aedicule, were gathered the visual signs and symbols of the lost Temple, for which the synagogue was not so much an approximation as a kind of memory chamber. Centrally placed was a stylised image of the Holy of Holies with recessed, multiple doors and sometimes (as at Dura) twisted Solomonic columns. On either side were guardian-protector lions or twin menorot candlesticks, as though they were being liberated in Jewish mind and memory at least from Roman captivity. Around them were arrayed the furnishings and implements of the Temple: the trumpets that summoned worshippers at the beginning of fasts, festivals and Sabbaths; incense shovels and (occasionally) tongs; the golden shewbread table. So, while the scriptural origins of the covenant were depicted at the near end, the realisation of the covenant covered the far end.

The scriptural making of the covenant and its establishment at the Temple were both organised in horizontal bands of images. Between them, though, is the great wheel of the zodiac, which because it seems to orbit on the floor is always the most spectacularly arresting and dynamic area of the mosaics. It is also the most directly indebted to pagan iconography. The calendar girls themselves are classical icons of the seasons, but at the centre of the zodiac wheel is the very unrabbinical figure of Helios the sun god, the special favourite of Antoninus Pius and many of the last pagan Roman emperors. Solar devotion as a kind of emanation of the otherwise formless Creator had an ancient history in Yahwism, which long pre-dated classical culture.[14] At Sepphoris he is euphemised into a burst of rays pulled by a fiery chariot team, but at Hammath Tiberias and Beit Alpha, the full face and form of the celestial being is unblushingly depicted. Within the wheel are arrayed the signs of the zodiac, their names given in either Hebrew, Greek or Aramaic, sometimes a mix of all three, and with very little regard for what one might (unhistorically) suppose to be Judaic canons of modesty. When the signs call for human figures, as with Gemini or Aquarius, the mosaicists supply them: winsome childlike twins at Sepphoris and a muscle-rippling full nude for the Aquarius at Hammath Tiberias. The centrality of the Helios images seems at first sight astonishingly out of keeping with Judaism in the period of the Talmud's creation. But Judaism has always been a calendrical religion, its festivals and holy days closely following the agricultural year. All the mosaic floors feature baskets of first fruits and the 'four species' – palm, myrtle,

willow and citron – that had been brought by pilgrims to Jerusalem at the autumnal Feast of Tabernacles and brought into the synagogue then as now. And among the Dead Sea Scrolls are documents that make it clear that an absolute commitment to Judaism was not at all incompatible with an intense engagement with astronomy – and astrology. Some of the scrolls are filled with heaven-scanning observations and speculations. This was another instance, of course, of Jews taking on a passion of the classical world, but without any sense at all that to do so was to flirt with paganism. Helios the sun god could only have occupied that central place on the carefully designed synagogue floors of Galilee if he had not in some sense been understood as an attribute of YHWH – the source of light. The sun-chariot at the heart of the cosmos could have been associated with the *merkavah*, the chariot of ascent to the heavenly palaces that was already appearing in mystical writing and poetry at exactly this time.[15]

In other words, there was nothing about the crowded, beautiful mosaics of the third- to sixth-century Palestinian synagogues which is likely to have scandalised the rabbis, even in the town that, two centuries before, had made the Mishnah. But images and texts were directed at two different kinds of Jewish gathering. The Mishnah was tailor-made less for synagogue Jews than for the other institution also begun in these generations: the Beit Hamidrash, the ancestor of the yeshiva academies. There, indeed, the vulgar, rackety, profane heterodox world was to be excluded, the better to distil to their essence the words of the Torah and the words spoken and written *about* the words of the Torah that was the beginning of the endless web of interpretation, exegesis and commentary that would become the Talmud. On almost every page it is aware of how it was that righteous Jews should act in the outside world, yet often it seems a windowless enclosure, a place in which the minds were to be turned inwards, concentrating on the autonomous power of the sacred word alone.

The fabric and images and inscriptions of the late-antiquity and early-medieval synagogues, read carefully and with a cautionary awareness of their particular moment and place in Jewish history, give us something other than that rabbinical view of places of hushed inward devotion. They flesh out the living reality of what it was like to be a Jew in one's synagogue, and indeed a Jew in the world. They were institutions connected with, rather than cut off from, the character,

hubbub and style of the town. Their daily vernaculars – Greek mostly, and often Aramaic – were incorporated into the mosaic inscriptions. The names of the Mishnah are the names of rabbis and sages. The names of the synagogue, written on floors and walls, are the names of ordinary Jews, often with their occupations given: merchants, dyers, doctors. The first are legendary, the second actual, staking their claim to the honour of remembrance (as they still do). 'May they be remembered for good' is the formula conventionally used. Sepphoris, for instance – where a number of prominent families seem to have been the dominant figures in the creation of their long, narrow synagogue – brings back to life the ghosts of 'Yudan, son of Isaac the priest, and Paregri, his daughter. Amen Amen' or 'Tanhum, son of Yudan and Semqah, and Nehorai, the son of Tanhum'. When I think of Sepphoris I might think of Judah the Prince but I will certainly always remember Yudan and Paregri. With names like that who wouldn't?

So early synagogues were certainly not places where observance was conditional on shutting out the rest of the world and its visions. They had to be exposed to enough light for the reading of the Torah and their basilica-like forms were always pierced with clerestories, or open colonnades and wide doors. We know from the inscription of its 'archisynagogos' Theodotos of a synagogue built in Jerusalem while the Second Temple was still standing, and from similar Egyptian inscriptions, that synagogues began as community centres rather than houses of prayer, hostels that would receive pilgrims and travellers, feed them, provide them with water. When they mutated into places concentrating on prayer and Torah reading, not all of this social character disappeared – and so indeed they remain.

Cultural history sometimes suffers from being written serially, a succession of isms, each entirely superseding the other, or leaving its predecessor as defensive and marginalised, on its way out. This emphatically did not happen to Judaism in the years between the destruction of the Temple and the establishment of Christianity as the state religion of fourth-century Rome. It was not a case of an original monotheism being almost wiped out, and then marginalised by the incoming all-conquering Gospel. This was a period when *both* Judaism and Christianity were being made and remade; and for some time – three centuries perhaps – and in spite of the fact that their respective stories seemed to demand it, they were not mutually exclusive, not to the

point of requiring mutual annihilation.[16] Both cults were certainly competing for the allegiance of monotheists. Crossovers were legion – both human and customary. Many ritual practices originating in the Torah were still observed by those who called Jesus Lord and those who didn't. Sabbaths were kept and, despite Paul's adamant insistence that the 'new covenant' embodied in the sacrifice of Christ had superseded the old 'fleshly' circumcision, plenty of those who thought of themselves as Jewish Christians continued it. That was precisely the issue that bitterly divided two born Jews – Peter and Paul – at Antioch where, to the horror of the latter, Peter would not share a table with the uncircumcised.

During the second and third centuries, while both religions were still subject to pagan imperial authority, the two contending cults shared the same urban space without the obligation of mutual hatred. Sometimes, remarkably, they even competed with each other in their zeal for *Jewish* martyrs. In Antioch there was a *Christian* cult of the seven Maccabees (including old father Eleazar and his wife), some of whom were reputedly buried out at Daphne a few miles from the centre of the city where the Jews had the most famous of their synagogues. That Jews were forbidden to bury at a synagogue site did not in any way diminish the credibility of the legend or prevent it from eventually becoming a church. But the notion of the Maccabees as objects of intense Christian devotion speaks volumes about the entanglements of the two faiths and their stories in their formative years.[17]

Nothing suggests this echo effect – the style of the pagan-classical past maintained into the monotheist present, and bouncing between the two religions – more dramatically than the way Roman Jews buried their dead.[18] Jewish catacombs, the 'Vigna Randanini' on the Via Appia Antica to the south of the city, and others to the north at the Villa Torlonia, were originally discovered on farmland at the beginning of the seventeenth century and were naturally assumed to be Christian. That view did not change when they were more systematically uncovered in the middle of the nineteenth century, and it was on this basis that the landowners obtained permission from the papal authorities to proceed with excavation. Not far from the stepped entranceway leading down into the tunnels of the necropolis, an unmistakable seven-branched candlestick appeared painted red on the walls. Many more followed, often accompanied by inscriptions in Greek and occasionally

Hebrew ('*Shalom*' reads one of them), putting the affiliation of the catacombs beyond question. What was being revealed was a purely Jewish underground cemetery, available to all classes of Roman Jewry from the most modest to the grand.

Constructed at the same time or a little later than Christian catacombs, the Jewish versions assumed identical styles of cubicles, chambers and niches. At Vigna Randanini, though, there are some *kokhim* – burial spaces cut at ninety degrees to the underground gallery rather than parallel to it. So that in some respects at least, the Roman Jewish catacombs were also a translation of prototypical Jewish burial chambers before and after the destruction of the Second Temple, especially at the enormous necropolis at Beit Shearim just west of Galilee, begun in the second century. That, in turn, owed much to Hellenistic underground burial galleries, the *hypogea*. In Rome, most of the spaces are shallow cavities running parallel to the direction of the tunnels, including the numberless tiny shelves made for the bodies of infants and young children, interspersed with much larger subterranean cubicles for the wealthier and more eminent. Very occasionally there is a full-scale decorated sarcophagus; more often they are just spindly menorot and homely mottos and epigrams from a stock repertoire. The vast majority of Roman Jews in this period were modest or poor: ex-slaves and their descendants brought into captivity, but also artisans and shopkeepers. Not so poor, though, that they wouldn't give their small children who had perished from one of the usual epidemics their own little wall niche, sometimes accompanied by heartbreaking painted or scratched farewells, and eulogies to the innocence of the departed child.

Deeper into the warren of tunnels were places provided for the more substantial folk of the community. One inscription mourns a husband who was the community's 'grammaticus'– its all-important secretary – and it affects Roman flourish and poetic manner. The evidence of a particular style of wall painting makes it clear that the catacombs go back to the fourth century CE, when there was a substantial Jewish community both at Rome and its seaport, Ostia, where there is also a synagogue (decorated with geometric mosaics), but which was also the period when Christianity was declared the state religion of the Roman Empire. So it may well have been that the better-known and more populous Christian catacombs were modelled

on Jewish practice, not the other way round, since Jews had simply translated burial customs from Palestine to the diaspora.

Even more surprising (unless one knew the borrowings at sites like Hammam-Lif and Sepphoris) is the pagan style of wall and ceiling decoration in the grandest of the family tombs – chapel-like chambers – in the deepest recesses of the catacombs. At Vigna Randanini they belie yet again the assumption of a Jewish aversion to decoration, especially in burial, since the graceful designs – wall-to-wall and up in the scooped-out vault – incorporate vegetation, flowers, animals and, in some cases, unmistakable images of the Muses, mythical figures like Pegasus, and deities who look very like Diana, Venus, Apollo and Mercury. One such chamber, the vault painted celestial blue as if to bring the light of eternal skies into the cells of darkness, is so delicately festooned with these images that archaeologists believe it might originally have been a pagan burial chamber. At some point it was taken over by the Jews, who evidently found its graceful decorations not only inoffensive but entirely to their funerary taste. The most exquisite of these decorated chambers (although not the largest) is almost a perfect cube, with date palms (that ancient Jewish symbol) at all four corners, the walls whitewashed and covered with such a delicate profusion of flowers, bounding gazelles and surging dolphins that it represents, unmistakably, a vision of the embowered Paradise, the *gan eden* or Garden of Eden, to which, in their imagination and poetic fancy, Jews consigned their beloved departed ones. Like so many of the assumptions governing what immemorial Jewish experience was supposed to have been (separation of the sexes in synagogues, for instance), the idea of burial practices of the utmost austerity is belied by the actual evidence of what Jews did in this early formative phase of their culture. Underground, taken from the light, every effort was made to decorate and ornament those resting places – with mere menorot and little inscriptions and valedictions for the modest and poor, an entire underground garden or grove for the well-to-do – the paradisial vision of heavenly salvation. This vision of the garden of the Jewish dead has survived even through the centuries in which the later rules of stony severity imposed themselves (though, as we shall see, with only intermittent and partial success). 'Bye-bye, darling, sleep in the *gan eden*,' was the last thing my mother said to my father when she saw his dead body in the Hampstead hospital and kissed his cold

brow farewell. Observant herself, she would have been perfectly happy to have had Arthur Osea rest, in one of his striped deckchairs, in just such a leafy chamber of heaven.

II. Breaking Apart

Strictly speaking, the trouble between Jews and Christians was a family quarrel. That, of course, did not prevent it from going lethal, early; perhaps it guaranteed it. For it was one set of Jews, the followers of Jesus of Nazareth, who first planted in the mind of Christians the truism that the unconverted among their people were inhuman monsters, God-killers. It is not just that Matthew's version has the Jews avidly volunteer for their own perpetual guilt: 'Let his blood be upon us and that of our children.' Much, much worse, is the moment in the Gospel According to John, when Jesus himself makes clear that he will be killed by a people whose defining characteristic is that of diabolically possessed murderers.

The passage occurs in the eighth chapter of John when, following Jesus' defence of the woman taken in adultery, the confrontation with the indignant Pharisees takes an ominous turn. It may be the barest, deepest moment in the entire New Testament, the one from which all Judeo-Christian misfortunes, misunderstandings and mutual mischaracterisations would wretchedly unfold. 'Who art thou?' ask the Pharisees, the keepers (as they saw it) of Torah law. 'Even the same that I said unto you from the beginning,' Jesus gnomically responds, going on to speak of his Father. Sensing that at least some of his listeners will hear him out, Jesus encourages them, saying 'ye shall know the truth and the truth shall set you free'. This is the sort of thing that a human messiah, the anointed Jerusalem-liberator, was supposed to say. But not everyone is impressed. Those who have heard it all before respond (a little illogically) that thanks all the same but we are already free for 'we are Abraham's seed'. 'I know that ye are Abraham's seed,' Jesus responds, suddenly turning testy, 'but ye seek to kill me because my word hath no place in you . . . if ye were Abraham's children ye would do the works of Abraham.' And then

he repeats, 'But now ye seek to kill me a man that has told ye the truth.' On the defensive, the Jews interrupt, sensing the imminence of something ugly, protesting they were the children of 'one Father, God'. No, says Jesus, the righteous anger hotly rising, were you that, you would love me since 'I proceeded forth and came from God'. You, on the other hand, will not hear and cannot understand because your true allegiance is to another father altogether and it is he who stops your ears and blinds you to the light. What paternity would that be? 'Ye are of your father the Devil and the lusts of your father ye will do. He was a murderer from the beginning and abode not in the truth because there is no truth in him.' Before long the antagonists are trading in mutually diabolical abuse. Appalled, the Jews, in their turn, accuse Jesus of being the real Devil, no better and maybe worse than a Samaritan, not least for promising perpetual immortality to those who would follow him.

Four hundred years later, in 386 CE, another John, the presbyter, revered for his asceticism and his eloquence – hence the later honorific 'Chrysostom', the Golden-Tongued – stood in the pulpit of a church in the equally golden city of Antioch, lodged between the Syrian mountains and the sea, and warned his flock, lest they be curious, that the synagogues of the Jews, and especially Matrona out in the sylvan suburb of Daphne, were the resorts of demons, worse than brothels. 'In their synagogues stands an invisible altar of deceit,' John raged, conjuring up places of sinister diabolism, 'in which they sacrifice not sheep and calves but the souls of men.'[19] But it was the women of Antioch who were the most susceptible to the lure of the devils, for they were in the habit of going there for entertainment and inspiration. Since the *midrash* elaborations on the Torah, if not the actual readings themselves, were conducted in Greek, they could be understood by gullible Christians who had been drawn to the synagogues by the trumpet blare of the shofar on the New Year. 'Rush not to those trumpets,' John commanded, 'you should stay at home to weep and groan for them [the Jews].'[20] Then added: 'Are you not afraid of dancing with demons?'[21] And if they were too brazen in enjoying a day out with the Jews, he turned to their husbands (a great believer in the closeness of marriage was John the Golden-Tongued): 'Are you not afraid that your wife will not come back afterwards?' Flee their

gatherings! Shun them as you would houses contaminated by plague! For 'Judaising', as this flirtation with the Jews was called, was indeed a terrible disease and could ensnare the naive in the trap set by the Devil.

For was it not notorious that the Jews practised the black arts of sorcery? At Paphos had not St Paul confronted the wicked Jewish wizard Elymas, a veritable 'child of the Devil'?[22] 'Insult the sorcerers!' John demanded. 'Drive them from your house!'[23] From some of the first descriptions of them in Greek antiquity, Jews were thought to be masters of esoteric knowledge, adepts along that creatively blurred line of magic and medicine, and they were certainly sellers of amulets – some containing writings, some preservative stones (against infertility or abortions), some as rings and bracelets.[24] With this potent wisdom to hand, the Jews made themselves available to recite blessings over fields and vineyards to ensure a healthy harvest, and from the fury of the preachers it was clear that many Christian cultivators thought such blessings could do no harm at all. From Chrysostom's fury at the offences (and from the objections of other fathers of the Church) we know there were a host of reasons why Christians were in the habit of going to the synagogue. They went there to hear Greek homiletic sermons of famous eloquence. They went there to have contracts signed because they evidently trusted the Jewish courts more than their own. They went there to swear oaths since (Chrysostom reported with incredulous scorn) they believed somehow oaths sworn in the synagogues were more solemn. If any one or all of such reasons gave Christians justification to make a visit, then the presbyter at least wanted to offer a Christian prophylactic: 'Make the sign of the cross on your forehead and the evil power that dwells in the synagogue immediately takes flight. If you fail to sign your forehead, then the Devil will take hold of you naked and unarmed as you are and he will overwhelm you with ten thousand terrible wounds.'[25]

The timing of Judeophobic attacks has always been the same. A city or a country or a state goes into crisis; trouble, strife, want and panic have already crossed the threshold; still more hideous things are knocking on the door. Quick, blame the Devil-people; stick it to the Jews. What ailed Antioch in 386–7 was the possibility of catastrophic Roman retribution for an act of insulting temerity on the person, or at least, the likeness of the emperor Theodosius and his new wife,

Galla. The populous, luxurious, cosmopolitan city, third in the empire after Rome and Alexandria, was also the front-line command and control centre against the perennial threat from the Sassanian Persians (who a little more than a century later would bring about Antioch's destruction). Its defence was expensive, especially for the geographically overstretched Byzantine Empire. A new tax in gold was to be levied on the sybaritic city, but it had been going through hard times: drought; food shortages, rising prices, disruptive outbreaks of the plague. Grumbling turned into riot, riot into iconoclasm.

There was a Christian edge to the agitation. Antioch may have been notoriously pleasure-living and grandiose in its monuments, theatres, baths and villas, but it was at the same time home to fierce ascetics, many of whom lived as hermits and monks in the surrounding hills. The two aspects of the city – pious and profane – were a mutually nourishing cultural fit.[26] The wicked hedonists of Antioch did what they liked and were then laid about by ferocious preachers like Chrysostom for being so heedless of the poor and the Saviour's compassion for them. Of course the hedonists enjoyed that too; such dramatic performances. There were plenty of poor in the city and on the marshy plain where rice was grown – a back-breaking crop if ever there was one. Nowhere did saints and sinners live so closely together. Antiochenes took pride in their famous Christian history. It was in their city that according to Acts the word 'Christians' was first coined. It was in their city that Paul had dwelled for eight or nine years turning the direction of the evangel from 'the circumcised' to Gentiles. A whole congregation of already famous saints and martyrs rested there and were the object of popular affection: Pelagia the Penitent Harlot, once the fanciest courtesan in town, who after baptism freed her bejewelled slaves, gave all her riches to the poor and disappeared into a remote hermitage where she assumed the identity of a holy eunuch, her true sex discovered only on her death; Babylas, the defier of Roman persecution who asked to be burned in chains; Thecla the Equal-to-Apostles, follower of Paul, who dumped her betrothed, cut off her hair and became instead bride of Christ, surviving successive attempts to kill her off with lions, bulls and snakes.

Against such paragons, what was a mere emperor? The rioting crowds went round Antioch pulling down statues and busts of the imperial couple and dragging them through the streets like prisoners.

This did not sit well at Constantinople, especially since Theodosius had only recently remarried after the death of his first wife. A price would be paid. And it was while the city waited like a captive with a rope around its neck, that a host of black-robed bearded monks and hermits, led by an ancient called Macedonius, descended on Antioch 'like a troop of angels', said Chrysostom, who deemed it a miracle. The monks and he pleaded for mercy and more or less got it with a mere eleven exemplary executions ordered by the emperor.

It was in this frantic atmosphere that Chrysostom launched his eight homilies *Against the Jews*: the rhetorical onslaught which, literally, demonised the Jews, made them all creatures of the Devil and their synagogues annexes of his lair. Its impact was immediate and long-lasting because Chrysostom was famous as a brilliant rhetorician (he had studied with the pagan teacher Liabanus). He was also deemed an irreproachable holy man who had returned to Antioch only when a life of self-mortification threatened to kill him should he persist with it. John had work to do: the most urgent task was to separate Christians from Jews, once and for all.

For they had long lived side by side in Antioch – if not always in harmony, then not always in antagonism. Jews had been in Antioch since its foundation in 300 BCE by Seleucus the Macedonian, most likely as mercenary soldiers (one of their favoured professions) who had been granted land for their service, as in Egypt. After the rebellion against Antiochus IV Epiphanes, the Hasmoneans had become involved in the civil wars of the Seleucids, at one point sending an army of thousands to fight for one of the contenders, Demetrius Nicator. Their reward was to have an established place in the city: a self-governing *politeuma*. The connection with Jerusalem and Judaea was close.

When the city fell into the orbit of Herod, it was added to his long list of building projects. A fine, colonnaded, covered *stoa* walkway along the major road running north to south was Herod's doing. The city already had a wealth of pagan temples and an amphitheatre; the Romans added a great hippodrome for chariot races and gladiatorial contests, put a colonnaded stage up in the biggest theatre, and created the indispensable baths. Every indication is that the Jews enjoyed all of these urban pleasures as much as their Gentile neighbours. Their lifestyle was such that it could attract wealthy immigrants, even from

Babylonia, like Zamaris, who rode into the city with a train of five hundred horsemen and a hundred relatives and family hangers-on, bought an estate outside town which farmed the local speciality of rice, and settled down to a Jewish-patrician Antiochene life.[27] The opulent suburb of Daphne, where a temple of Apollo had been built by the Greeks, turned into a resort of spacious villas boasting the usual mosaics and fountains. The better-off Jews lived there and were the elite who congregated in the Matrona synagogue, evidently so handsome a building that to Chrysostom's scandalised horror, Christian women would make excursions to hear the blasts of the shofar on the New Year and applaud with the Jews at the readings in Greek and at sermons delivered in the same language. Such shocking apostasy!

There were plenty of Jews who didn't live the Daphne life, and their district was the Kerateion in the south-east of the city, where one of the newer amphitheatres was also located. Their synagogue (and in all likelihood there were many more around the city) was called Ashmunit, named surely for the Hasmonean connection. It too drew the Christian creed-tourists who provoked Chrysostom's wrath, but also the more modestly provided Jews, artisans and vendors of the crafts and trades in which Jews even then specialised: silver and goldwork, fine leather goods, woven and embroidered textiles. A little way out in the country, Jewish landowners grew Syrian rice and some of those who rented from them and worked the crop were also Jews. A whole constellation of synagogues in the countryside bordering Mesopotamia – at Apamea and Misis (Mopsuestia) – with the usual mosaics and donor-inscriptions (including Noah's Flood) testifies to the vitality and richness of this world, which was and wasn't diaspora. From inscriptions at the Beit Shearim necropolis we know that many of the better off who died in or near Antioch, including one 'Aedesios head of the council', had their bones reinterred there, as close to Jerusalem as they could reasonably get, on the anniversary of their death.

The Jews of Antioch, then, even when they had to survive expulsion threats and periodic outbreaks of animosity, were deeply rooted in their home city, organically part of its society and history. But it was precisely the sense that cohabitation was impossible, between those who had accepted the Saviour and those who continued to deny him, that drove the vehemence of John Chrysostom. The blind and

the saved needed sorting out from each other, a clean, clear difference marked – otherwise the *corpus christianum*, the body of Christians, which was, truly, the enduring body of Christ himself, would be home to that which would corrupt it.

The two monotheisms had not always been so starkly, mutually, exclusive. Since there was little or nothing in Jesus' own reported teachings which required the repudiation of the Torah, it was possible to be a Jewish Christian, and considerable numbers in the first generations after his death were just that, both inside Palestine and beyond. Justin Martyr, in his combative dialogue at Corinth with the Jew 'Trypho', written in 140 CE, called these Jewish Christians 'Ebionites', from the Hebrew *evyon* for 'poor'. (They were sometimes referred to by the rabbis as *minim*.) The name may have had less to do with their place in society as the poverty they embraced in the spirit of Jesus' sermon on the Mount. In the spirit of the Matthew gospel (the only one they would read), the Ebionites accepted Jesus as the Messiah, but in the human guise in which the Hebrew Bible had prophesied he would appear. He was the 'Son of Man' coming with the clouds of heaven, to whom the 'Ancient of Days' in Daniel 7, 'the hair of his head like wool', had promised 'dominion and glory . . . everlasting'. Which made the Ebionite Jesus human and corporeal, born of Joseph and Mary and very definitely not through virgin birth. They rejected all notion of his divinity, and what to any kind of Jew was the confrontationally blasphemous notion that Christ was coexistent with God (rather than created by Him), for that would violate the ultimate truth of One-Ness, affirmed daily in the *shema*. The resurrection of this man-messiah they could accept, however, for it was no more implausible than many of the miracles related in the Bible – although the notion that Jesus' death wiped away the sins of mankind was beyond them.

There was much about the practices of the Ebionites related by Epiphanius of Salamis that echoes what we know of the community at Qumran. Both had an elaborate cult of angels; both set their face against the Temple establishment (for although the Pharisees are cast in the New Testament as the adversaries of Jesus, the target of so much of his preaching was rather the aristocracy of the Sadducees); both were compulsive bathers and purifiers. With one crucial exception – their opposition to the animal sacrifices demanded by the Torah

(for the Ebionites were strict vegetarians) – they observed all the rest
of the strictures of the Torah: fasts and festivals, the dietary laws and
the Sabbath. James the Just – Jesus' brother and the founding head of
the 'Church of Jerusalem' (the first organised gathering of Jesusites
after the resurrection and ascent) – is said to have been anxious to
avoid hindering the recruitment of Ebionites by requiring the outright
and complete repudiation of Torah law as a condition of joining the
Christian community. Peter, whose first mission was primarily to the
'circumcised', had the same view as James. It was possible for neophytes
who believed in Jesus as the Messiah to continue with Jewish ritual
and still be received into the Church.

Not, however, for Paul, the true founder and maker of Christian
theology, who took the drastically harder line which ultimately made
it impossible to worship at both church and synagogue.[28] The
Jewishness of James and Peter inclined them to want to present
Jesusism as a form of Judaism, steeped in and prophesied by the
Hebrew scripture and reinforcing rather than abandoning the Torah.
In some important respects Paul also thought of Christianity not as
a repudiation of Judaism but as the ultimate fulfilment of its promise.
But Paul read the Bible backwards for its messianic promises.
Abraham's covenant with God was ultimately for all mankind; the
patriarch himself would be, as Genesis said, the father of *many* nations,
his trust in God even as he was binding his son for sacrifice (another
prefiguration) was above all an act of faith, and so on. Paul believed
that the Bible had declared its own supercession, or rather the super-
cession of the law of Moses by the new covenant, the new faith. Paul
compared that law to a 'schoolmaster', its instruction needed, but the
kind of teaching that locked men away from the revelation of faith.
It was now redundant.

Paul made much of his Jewish birth, but in the opposite sense from
James and Peter. Who better than the officious persecutor of Christians
to grasp the gulf separating the old version of Israel from the new?
In Antioch, he and Peter played out their bitter argument over the
residual claims of Torah observance. Paul took Peter's refusal to eat
with the uncircumcised as a kind of moral cowardice (akin perhaps
to the three-times denial), flinching from the brave gospel truth that
the new covenant of Christ's blood had made the old mark on the
flesh redundant. 'In Christ Jesus neither circumcised availeth any thing

nor uncircumcision, but a new creature.'[29] To cling to the old way
was to shrink from the salvation offered by the sacrifice. It was not
just that the law of Moses was now redundant, it was that its obliga-
tions were actually a cloud shrouding the hard light of pure faith. 'No
man is justified by the law in the sight of God, for the just shall live
by faith . . . for the law is no faith.'[30]

When Paul moved the heart of Christian theology from Christ's
life to his death, it made the implication of the Jews in his killing not
just unavoidable but central to the new religion's teaching. And since
Christ was inseparably of the same substance as God the Father, that
made their crime deicide. That in turn sharpened the difference
between Jewish explanations for the destruction of the Temple. For
the *tannaim* sages it was (as had been the case for the First Temple)
punishment for not obeying the Torah; for Paul it had happened
because they had not disobeyed enough or at least accepted its super-
cession. Having been the custodians of the old law and of its proph-
ecies of the Messiah, it was all the more incomprehensible and
unforgivable that they failed to acknowledge the meaning of (as he
saw it) *their own scriptures*. Only a kind of devilish possession could
account for such obtuse and wilful 'hard-heartedness' (a term that
entered Christian descriptions of Jews almost from the beginning).

Despairing of his own people, the Jews, ever accepting the ultimate
point of their own religion, Paul was grateful to be given the wide
world's mission to the Gentiles. For it stood to reason that while the
Jews insisted that the Torah was for them alone, Christ's sacrifice must
necessarily have been to absolve the sins of all mankind; otherwise
what was the point? So Paul brought all the universalising elements
in the Bible – and there were plenty from Genesis on – to bear on
the ecumenical character of the gospel. Gentiles were, in the lovely
metaphor, the 'wild olive' that was grafted on to the old trees. And
of course it was helpful that the more painful, not to say over-stringent,
aspects of the Mosaic Law could now be cast aside for the broad
church of pure faith.

How inexplicably vexing, then, for Paul and those who followed
him to discover that not only Gentiles but even some among those
who called themselves *Christians* were unaccountably drawn to the
rites of the Jews, to the services of their synagogue, to their trumpets
and readings, their fasts and feasts, the Passover meal rather than the

Eucharist! For there is every sign not just before Constantine made Christianity the state religion of the Roman Empire, but afterwards too, that somehow the old covenant persisted alongside the new, and that Judaism had not simply been superseded in its entirety by the gospel. Some of this was of course the doing of the Church fathers themselves. The Jews had to be preserved as witness to Christ and as recruits to the conversion that would herald his return. But it must have been unsettling to discover that Christian ecumenism was actually matched by rabbinical dispensation for Gentiles who wished to observe the essence of the Torah. The six 'Noahide laws', which a tradition held had been already given to Adam in Eden, asked only that Gentiles refrain from idolatry, blasphemy, theft, murder, fornication and consuming the meat of animals that had been strangled and which therefore retained their life blood (it was assumed that blood-eating was abhorrent to all humans). Revealed again to Noah following the flood, a seventh had been added, namely the provision of courts of law. (How the Jews loved their law.) Those who abided by these core precepts, while not being admitted to the covenant of the Jews, would, as 'righteous Gentiles' or 'God-Fearers', be assured of redemption in the *olam haba*, the world to come. If the Ebionites were Jewish Christians, could there have been something approximating Christian quasi-Jews? Some tantalising evidence survives of at least one community, at Aphrodisias, in Caria (present south-west Anatolia), where Jews and God-Fearers nonetheless shared a synagogue, for a long list of donors is made up of sixty-eight Jews, fifty-four God-Fearers (or Ebionites) and three outright proselytes.[31]

The intensity with which Gnostic versions of the gospel insisted on the *two* natures of Christ – human and divine – only increased the possibility of some sort of synthesis, even if ultimately unacceptable to the strict guardians of both doctrines. There were, after all, still so many crossovers: the breaking of unleavened bread – matzo – and the drinking of wine at the Passover meal an obvious echo of the eucharistic consumption of bread and wine as the body and blood of the Saviour. The inclusion in the Seder meal of a shank bone of roasted lamb as a memory of the Temple 'passover' – the name for the sacrifice itself – is another echo of the lamb image of the Saviour. It was as if the two religions, *both* works in progress, were constantly looking over each other's shoulder. And since the Torah had nothing

to say about any kind of Passover meal (only the sacrifice and reading of the Exodus), it has even been daringly suggested that the rabbinical invention of the Seder might have been in response to the Easter rites rather than the other way round.[32] That the two religions were engaged in a contested Passover–Easter dialogue at this formative moment is not in doubt. Even after the Council of Nicaea in 325, with Constantine himself present, separated out the two holidays and made sure that should they fall on the same day it would be the Jews who moved their Passover, that combative dialogue continued.

It was Constantine who gave Chrysostom his mission to disentangle the two religions once and for all. In his letter sent to bishops unable to attend the Council of Nicaea in person, Constantine made his own intensely Pauline position brutally clear:

> It was improper to follow the custom of the Jews in celebration of their holy festival because, their hands having been stained with crime the minds of these wretched men are necessarily blinded . . . Let us therefore have nothing in common with the Jews who are our enemies, let us studiously avoid all contact with their evil way . . . for how can they entertain right views on any point having compassed the death of the Lord . . . [let not] your pure minds share the customs of a senseless people so utterly depraved.

Chrysostom might say that he was but following the spirit and the letter of the first Christian emperor's instruction which somehow had not been executed. The beginning of a salutary alteration was the recognition that it was truly impossible to be Christian and Jewish at the same time. 'The difference between the Jews and us is not a small one,' Chrysostom said; 'why are you mixing what cannot be mixed? They crucified the Christ whom you adore as God.'[33] Such was the flirtation of his own flock with the Jews of Antioch that he would settle for nothing less than a physical separation. And to accomplish that, it was not enough that the Jews be characterised (as they had been by Justin Martyr in his dialogue with Trypho) as simply blind, obtuse and obstinate. They had to be turned into sinister subhumans.

What Chrysostom brought forth in his eight homilies of the late 380s was well beyond Pauline vexation; it was, for the first time, a true social pathology of the Jews. It borrowed from ancient demonologies

of the kind that had already been circulating in antiquity – the Jews as conspiratorial ravening kidnappers, required by sacred rites to devour Gentiles they had fattened for the purpose – but added to those stories the new certainty that Christ-killing was just an extension of their inborn propensity for homicide. They had murdered Christ, but then why wouldn't they have done this, since by their own admission (he said) they had murdered their *own sons and daughters*? 'It is obvious,' he thunders in the second homily, 'they are enmeshed in murder.'[34] Feeding off two lines in Psalm 106 which almost certainly referred to the appalling sacrifices of King Manasseh, Chrysostom made those ancient atrocities (supposing they happened) sound as if they occurred but yesterday. 'They sacrificed their sons and daughters to devils, outraged nature . . . they have become worse than wild beasts and for no reason at all with their own hands murder their offspring to worship the avenging devils who are the foes of our life.' Even if this did happen many generations ago, Chrysostom railed that the Jews still had the taste of blood on their tongues. His sixth homily begins with the horrifying analogy of ravening beasts who, once tasting flesh and blood, could never get enough of it. Those beasts were the Jews.

There was more. They were all, it seemed, loathsomely fat, 'no better than pigs' (the metaphor carefully chosen), abandoned to voluptuary swill (a particular abomination for an ascetic like John, of course).[35] Their lust was well known; the ancients had written of it – another reason why their pretended devotion to Mosaic circumcision was a pretext to heighten their desires. Notoriously they were all 'hucksters and wicked merchants' who would rob you as soon as look at you. 'What else do you want me to tell you? Shall I tell you of their plundering, their covetousness, their abandonment of the poor [an astonishing accusation since the Jews were already famous for their charity], their thefts, their cheating in trade? The day will not be long enough to give you an account of these things.'[36] Unfit for true work, John advised 'they are [however] fit for killing'. That is why, he says, Christ said 'as for these my enemies who do not want me to be king over them, bring them here and slay them'.[37]

If they could not all be killed, at least not yet, then at the very least the 'Judaising' – the casual fellowship, the outrageous visits to synagogues on the Jews' holy days – had to stop. From express bans on

Christian clerics going there we can infer that even they had caught the synagogue habit.

> Many, I know, respect the Jews and think that their way of life is a vener-able one. This is why I hasten to uproot and tear out this deadly opinion . . . let no man venerate the synagogue because of the holy books, let him hate and avoid it . . . Must you share a greeting with them, exchange even a bare word? Must you not turn away from them since they are the common disgrace and infection of the whole world? . . . Do you not shudder to come into the same place with men possessed who have so many unclean spirits, who have been reared amid slaughter and bloodshed . . . what manner of lawlessness have they not eclipsed by their blood-guiltiness . . . they sacrificed their own daughters to demons?[38]

There was only one recourse for a proper, decent Christian: to avoid all contact with these walking infections, except to remind them at all times of the gospel truth 'you did slay Christ, you did lay violent hands against the Master, you did spill his precious blood. This is why you have no chance for atonement.'[39]

These views were not those of some unhinged outlier on the wilder shores of Christianity but came from the mouth of 'Golden-Tongued': the most revered and influential preacher, not just in his native city, Antioch, but in all of eastern Christendom. John's was held to be the voice of authentic piety, one that could cut through the wordly ease of the cosmopolitan city to remind the complacent of their true duties. It is the kind of voice that combined a fiercely unforgiving call for austerity with fanatical battle cries to confront the enemies, the slayers, of Christ. This was, for the Jews, a fatal combination they would have to face over and over again in the Christian centuries.

How far would the call to make them a pariah tribe go? Whom would it reach? Would the laws of the empire protect them from physical attack if it came to that, or would the state stand by lest the enraged turn their hatred on them, accuse them of indifference to Christ's urgings? It was not as if Chrysostom was ignored or unheeded. That the homilies survived by being written down and circulated by those who heard them is itself evidence of how much attention contemporaries paid to them. In 398, just eleven years after completing them, John was elevated to the patriarchate of Constantinople which

put him as close as he could want to the seat of imperial power. This must have been gratifying since the intensity of his phobic outpourings was determined, at least in part, by the memory, still frighteningly vivid, of the apostate emperor Julian who, in Antioch itself in 362–3, had promised to restore the Jews to Jerusalem and rebuild the Temple.

Julian's brief but dramatic campaign of de-Christianising the Roman Empire, restoring pagan temples and cult holidays and tolerating all religions equally was particularly galling to the Church since he had been brought up by Christian parents. His father was the half-brother of the first Christian emperor Constantine who, while upholding the right of Jews to worship according to their traditions, referred to them as 'impure in their crimes . . . justly stricken with blindness'. Julian would be different, a philosopher-prince. The People of the Book did not particularly love him for his epicureanism, and he looked on the contents of that book with some distaste, taking particular exception to the special covenant implying that only the Israelites enjoyed the true blessings of God; but he saw no reason why they should not, like any other people, be protected in the worship of whatever god they happened to favour, as long as – unlike the Christians – they did not seek to foist it on everyone else. And his humanity went out to the modern Jews who had lost their Temple and their golden city. On the one day permitted for their pilgrimage, the 9th of Ab (the anniversary of the destruction), the remnant western wall of Herod's Temple had already become not only a site of public and vocal lament, but a tourist attraction for Christians with mixed feelings. One traveller in 333 wrote of their coming close to the statue of Hadrian which stood on the Temple site and 'mourning, loudly tearing their clothes after which they go home'.[40]

Chrysostom would have felt the sudden chill most acutely because the theatre in which this sudden, extraordinary understanding between the last of the pagan emperors and the Jews was played out was his own Antioch. Julian went there in 362 to muster the forces he would take into battle against the Persians. Some sources, mostly anti-Julian, have the emperor convening a deputation of Jews from the city and throughout Syria and asking them why they were not making sacrifices to their God as required by the laws of Moses. The laws of Moses, they replied, do not allow us to sacrifice outside Jerusalem. 'Restore to us the city, rebuild the temple and altar and we shall make sacrifices

as we did of old.' The violently Judeophobic preacher Ephrem Syrus painted a picture of an unholy alliance, the Jews rejoicing in the evil of 'Julian the magician and idol worshipper': 'The circumcised blew their trumpets and behaved like madmen.' But it seems much more plausible to assume that at least some of the Jews would have had mixed feelings about the project, given that the advent of the Messiah was supposed to be the precondition of restoration.

Suddenly the project appealed to Julian, the ambitious shaper of history, not least because it would dramatically confound the Christian truism that the ruins of the Temple would serve forever as a reminder of the consequences of rejecting the Saviour. But it is still an aston-ishing fact that a Roman emperor, much less one born of Christian parents, should have thought that the 'great monument to perpetuate the memory of his reign', as the contemporaneous Roman historian Ammianus Marcellinus put it, would be the restoration 'at enormous expense . . . of the once magnificent temple at Jerusalem' destroyed by his own people.[41]

By the spring of 363 matters were moving fast. To oversee the project, Julian appointed the Antiochene he trusted most, Alypius, who had served as governor in Britain. A letter to the patriarch Hillel II requested an estimate of the cost of rebuilding, a tax collector was appointed to receive the monies collected by Jewish communities for the project (a reminder of the old shekels imposed for the upkeep of the Temple), limestone and timber supplies were moved towards Jerusalem, and a temporary synagogue was actually established by one of the half-destroyed porticos of the building. On his way to campaign against the Persians, Julian announced that 'I am building with all zeal the new temple of the most high God'.

And then, as far as the Christian fathers were concerned, God unmistakably gave His verdict. According to Ammianus Marcellinus, at the end of May, 'fearful balls of fire burst forth near the founda-tions, burning several workers and making the spot inaccessible. Thus the very elements, as if by some fate repelling the enterprise, it was laid aside.'[42] The explosions were almost certainly shocks from a Galilean earthquake, but of course they were greeted as vindication by Christians in Palestine and Syria. Lest there be any further doubt what the Almighty thought of the premature restoration, Julian was killed by a Persian spear while on campaign a month later.

Christians breathed a sigh of relief and offered fervent prayers for their escape from the clutches of paganism and Judaism. The nightmare of a Christian world turned upside down had passed, but it had made the Church fathers acutely aware that perhaps a Christian Roman Empire was more precariously rooted than they had imagined. And yet the weight of punitive repression after the Julian interlude fell more severely on pagans than Christians. Judaism was still preserved as a *religio licita*; paganism was not. Its temples were destroyed, its cults were suppressed, and it became a crime to practise pagan cults even in the privacy of a home. Although the more militant of the Church fathers wanted to press the imperial government into making the lives of Jews more difficult – the better to encourage conversion – they contented themselves with reinforcing the separation of the two communities: no intermarriage (at a time when the rabbis were making that easier); no circumcision of Gentile servants or slaves; no blessings of Gentile crops and fields; no sharing the table with Jews.

There were two constraints on the campaign to marginalise and even dehumanise Jews and Judaism. First, the most eloquent and learned of the Church fathers were themselves divided on how aggressively to pursue their conversion and ostracise as pariahs those who stubbornly resisted. Jerome, who spent years in Palestine and had learned Hebrew to make a Latin translation from the original Bible text – the Vulgate – was physically closer to Jews, especially his convert teachers, but adamant about their wilful perversity and their blood guilt for the crucifixion. 'He that is not of Christ is anti-Christ.' Everything about the Jews had to be read backwards from their part in the crucifixion, including the unwholesomeness of their practices, the contemptible absurdity of their fleshly circumcision, their vulgar obsession with the letter of the law. Augustine, remarkably and exceptionally, came to see the Jews and their Torah more historically. Since God had singled them out to receive His law, how could it possibly be thought of anything but worthy, even circumcision, which, to Augustine's understanding, in its 'putting off' of the flesh, was actually a prefiguration of Christ's own shedding of the flesh. Had not Paul himself, so angry about the Jews' refusal to see that circumcision had been superseded, had Timothy circumcised? Likewise, Augustine made the effort of historical imagination to register to the full the Jewishness of Jesus and the apostles. And now, he wrote to Jerome in

a series of subtly argued polemical exchanges, it was necessary to preserve Jews in the undisturbed observance of their traditions and laws, for God must have wanted them to be universally dispersed, wandering the face of the earth, as custodians of the Bible's prophecies of Christ – a living museum of perpetual anticipation. To be sure they would only be saved by conversion, but that had to be accomplished, in the fullness of time, if God so wished it, and through persuasion not coercion.[43]

The second constraint was the legalistic conservatism of the dominant imperial figure in the later part of the fourth century, Theodosius I, who while doing everything he could to uproot paganism and thus pre-empt any possibility of another Julian revolution, stood by the old implicit compact. As long as the Jews were loyal (and the substantial presence in Persian Babylonia made that an important matter), then they were entitled to the protection of the law against any physical harassment or worse. Chrysostom had barely finished his homilies when the effect of his verbal violence tested Theodosian firmness. The year 388 saw an epidemic of mob attacks against synagogues all over the eastern empire including Alexandria, but especially fierce in Syria. At Callinicum on the Euphrates, the synagogue was burned to the ground by a crowd egged on by the local bishop. At first Theodosius responded with exemplary severity, ordering the synagogue to be rebuilt with the bishop's own funds, but the decision provoked a storm of protest from clerics horrified that Christians would be forced into funding a place for the Jews. One of the horrified bishops, Ambrose of Milan, already incensed at the order of Magnus Maximus a year earlier which forced the rebuilding of a Roman synagogue, bearded the emperor with the impiety of his sentence, casting himself as the prophet Nathan to Theodosius' erring David. With a nice sense of the histrionic (and a patrician education in classical rhetoric) Ambrose offered to substitute himself as the culprit, receive punishment and even martyrdom if necessary rather than have the Church pay any recompense to the Jews. 'I am present,' he declaimed to the emperor, 'I am here. I proclaim that I set fire to the synagogue or ordered others to do so so that no building should be left standing where Christ is denied.' Since God had ordained the destruction of the synagogue by whatever instruments Ambrose chose, he would indeed have done it himself had the opportunity arisen. As for the Jews, 'do not thou pray

for this people, nor show mercy to them'.[44] After a personal confrontation Theodosius rescinded his penalty, ordering instead that civic and state funds be used, and even that went unenforced. It was a very bad sign.

Worse was to follow, though. In the next century the rulers of the divided Christian Roman Empire, embattled on every front – against the barbarians in Europe, against the Persians in Asia Minor, conspiratorial and murderous among themselves, and deeply suspicious of the loyalties of the Jews – were more open to the Church's campaign to make them less than Romans. A succession of edicts issued between 435 and 438 during the reign of Theodosius II made a Jewish communal life as anomalous and as difficult as possible in the Byzantine Empire. Not only were no new synagogues to be built, but repairs to the fabric of old ones were also forbidden. This was tantamount to giving a blessing to arson, since Jews were now disallowed from seeking redress for damage. Clerics could (and did) arrive at the scene of a half-destroyed synagogue and immediately consecrate the ruin as a church, converting the fabric if not its worshippers. No Jews were to hold any kind of public office except for the responsibility of collecting some taxes which would make them bear all of the odium and none of the privileges. Nor were they to serve in the army, which would seem to be a redundancy for they had long been exempt, but this brought to an end the long tradition of Jewish soldiering in Egypt and Graeco-Roman Asia Minor.

The Jewish thread, long woven into the cultural fabric of Graeco-Roman life, was unravelling. The symbol of the connection between the empire and the *Ioudaioi* – the patriarchate, which had begun with the legendary understandings of Judah the Prince and Caracalla and Antoninus Pius – ended with the death of Gamaliel VI in 425. A successor was not appointed and four years later the office of the Patriarch of the Jews was officially done away with, making Jewish anxiety about their becoming an entirely subject population stripped of the protection of the law even more acute. Some of the more dreadful fables, seeping from the pulpit of Chrysostom and the paranoid teachings of Simon Stylites and Ephrem Syrus, began to take root in Christian folk culture. The festival of Purim came under particular suspicion, possibly because of its Persian associations and the central role played by the Jewish Queen Esther. Stories abounded

that, celebrating the feast, Jews staged a mock crucifixion under the guise of the executed Haman. Worse, it was said that young Christian boys were being abducted for the purposes of torture and crucifixion. At Inmestar, not far from Antioch, a riot ensued in 414 after rumours spread that Jews had taken one such child for a Purim killing. A millennium and a half later, the same kind of story was still finding believers in Syria, though the festival of Jewish homicidal conspiracy had shifted to Passover and the crime involved the draining of Christian blood for the baking of matzo. From Chrysostom's insistence that as far as the Jews were concerned, once a bunch of murderers always a bunch of murderers, to the actual accusation of child torture and sacrifice, it was but a small step.

The possibility of an urban world shared between Jews and Christians – even one lived on theological suffrance, on the Augustinian conditions of tolerance without encouragement – was perishing. Along with it went the legal protection Judaism had enjoyed throughout the Roman Empire both before and after its Christianisation. When the code of the emperor Justinian was issued in 532, for the first time there was no mention that Judaism was still a *religio licita*. In synagogues from Africa to Syria, the chilling omission would have been noticed. Three years later, in 535, a still more forbidding edict was issued. All synagogues in the empire were to be converted into churches.

III. A Different Place

But twilight was fast descending on the empire which Jewish poets identified as the fourth, ten-horned, iron-toothed, brass-nailed beast of Daniel's delirious dream of apocalypse. It too would pass; indeed the ten horns would turn and attack the beast from which they had sprouted. There was only so much an embattled Roman emperor, even one with such mighty dreams of a united Christian Rome, could do, and Justinian's decree converting synagogues into churches was never executed to any serious degree. Only one significant case is known – at Jerash, east of the Jordan – where a handsome, fourth-century synagogue

was made over into a church in the early 530s. The Jewish building was evidently too scandalously flashy for the Christians who occupied it, for its mosaic of Noah's flood (fragments of which have independently survived) was broken up and replaced with a more sober geometric design, though some of the animals – sheep, deer and bulls – still graze serenely amid the stone chips.

Justinian himself must have known that there would be no overnight mass conversion, for much of his programme was designed in a more Augustinian way to bring the Jews round rather than bludgeon them to Christ. They were now forbidden to read the Mishnah, a measure which, while extreme in its meanness, obtusely overlooked the fact that the work had begun as oral law and that the vast bulk of it had been internalised into Jewish social and legal practice. In another decree, Justinian declared Greek as the language for the reading of the Torah through its three-year cycle in synagogue, but in many places it already was. The version to be read was that of the Septuagint of Alexandria, translated by Jews from Second Temple Jerusalem.

If it imagined it could hurry Hebrew to extinction, the Christian Roman Empire was already too late. Far from becoming redundant, the Bible language was entering a new phase of intense vitality and muscular inventiveness. The twin Talmuds – 'Yerushalmi' (though Galilean) and 'Bavli', written in the Babylonian academies of Pumbedita, Nehardea and Sura – had added to the Mishnah a vast web of further commentary, the Gemara. With this, they had created an immense, surprisingly chatty body of Hebrew *literature*, which ranged free and far from the sacred mysteries of divinity down to legal briefs in the case of accidental ox-goring. The Talmud was big and baggy enough to be plumbed not just for legal guidance, daily rule-checking, enlightenment and discussion, but for inspiration and even for entertainment.

The Talmud was the religious empire of the academy sages, the *amoraim*. Another kind of Hebrew literature was also beginning at this time, meant not for the scholars and judges but for the voices of the synagogue. Synagogues in Babylonia were most commonly owned privately by the rabbis, often housed in their own homes (as is still the case with many of the rebbes), an extension of their Beit Hamidrash, the schools of study, and attended mostly by their students. But in Palestine, increasingly beleaguered as it was by an aggressive

Church and hostile imperial decrees, the synagogues were still communal places, where those disdainfully called *am ha'eretz* ('the people of the land'), of neither social nor spiritual aristocracy, could come together along with priests, Levites and local notables – those whose names were grandly embedded in the mosaic. The new poems, the *piyyutim*, written in a fierce, seething Hebrew, were for them a consolatory binding for the congregation in the face of adversity, a sung or chanted emotional release between the formal prayers – already prescribed to be the *shema* and the daily *tefillin* or *amidah* (the standing prayer) of eighteen blessings and invocations – and before and after the readings from the Torah. Some of the earliest were expressly written as high-pitched prefaces to dramatic moments of solemnity – the repeated blowing of the shofar during New Year, for example – and in different later versions the *piyyutim* still work that way. The most familiar and best-loved ones that even the occasionally observant Jew knows – *Ashrei, Adon Olam, Yigdal, Ein Keiloheinu* – were later medieval compositions. Although the dating is notoriously tricky, since the poems are mostly known from fragments preserved in the great storehouse (*geniza*) of Judaica in medieval Fustat, Old Cairo, the earliest have been dated on clear stylistic grounds to the sixth and seventh centuries.[45]

There is a lot of letting off steam in their fiercest verses, a poetic counter-attack on the oppressors from whom they had become bitterly estranged. They are, in fact, unsparing in their hatred. 'Would that the ruler of Dumah [Edom, aka Rome] be humbled, brought low and lick the dirt like a worm,' runs one from the hand of Yannai. 'Let there be great slaughter in Edom's lands, may fire glow from its fields.' Eleazar ben Qillir, his pupil, was if anything even more given to bloodthirsty poetic retribution: 'Bring down on Esau's sons, the insolent villains, the loss of children and widowhood.'[46] It may be that all this fire and brimstone extended to their own relations, since Yannai is said to have become so jealous of his pupil Qillir that he murdered him with a scorpion set in his shoe. But the earliest of all the poets – Yose ben Yose, writing in Palestine in the sixth century – used the Bible and its interpreters as a vehicle for both lament and messianic hope. His voice is that of the synagogue itself, personified as the bride from the Song of Songs, awaiting, with increasingly desperate sorrow, God in the form of a bridegroom. Unrighteousness has made Him

flee and He is sought in vain in His old dwelling places the sea and the wilderness. A grain of hope endures: 'Forever will He make me the seal on His heart as once under the apple tree He raised me up with a voice.' Birdsong joins the lament as if the mourning voice of the dove. 'The sparrow from Egypt has cried in the wilderness / The dove of Assyria sent forth her voice / Visit the sparrow, seek out the silent dove / Blow for them the trumpet.'[47] Cue the shofar itself, and the hope, through repentance for sin and expectation of redemption, of a messianic moment round the corner when the bridegroom returns to the synagogue, Edom falls, and Jerusalem is restored. Just sampling the fragments of lines it becomes possible to feel the synagogue service as it is still observed today coming together (as was its counterpart in the churches): an orchestration of prayer, reading, sermon, all interspersed with devotional poetry and songs of praise.

Whether or not they were exported to the diaspora and Babylon, the early devotional poems were very much a product of a community under pressure; still gripped by acute Jerusalem-yearning; so near and yet so far. The Babylonian Talmud, written by those whom Yose ben Yose beautifully describes as 'eating the bread of carefulness', is at the opposite pole of emotional temperature from the exalted intensity of the *piyyutim*. And it is also as worldly in its way as another poetic genre, deriving from Qumran mysticism – the *hekhalot* literature, named after the celestial palaces through which a pure devotee ascends to behold the face and form of God Himself seated on His chariot throne – is other-worldly.

But then the Talmud is the product of a world – Persian Babylonia under the Sassanians – that was largely free of the acute fears and constant demonisation with which Jews in Christian lands were afflicted. No Jew was implicated in the death of the prophet Zoroaster; in fact his death was scarcely mentioned in the holy book, the Avesta. In the four centuries after the Persian conquest, life in the Mesopotamian cities on the Tigris and the Euphrates – Nehardea, Pumbedita, Sura and Mahoza, a suburb of the Sassanian capital Ctesiphon – was not entirely free of harassment. There were two periods of persecution in the middle of the fourth century, under kings Yazdegir II and Peroz, but in most ways that were missing from Byzantine Christendom, Jews and Judaism could flourish under Persian protection. While in the Byzantine world no Jew could testify against a Gentile or even

appear as witness, in Persian Babylonia they had the same legal rights as everyone else, and as a result Jews used Persian courts as much as if not more than their own. 'The [civil] law is valid law,' one of the senior rabbis, Samuel, declared unequivocally. Their *resh galuta*, the exilarch, was a recognised authority with the status of a minor Persian nobleman, who lived in high style and enjoyed direct access to the Sassanian court. In an altogether different realm from the rabbis and sages of the Talmud academies, the exilarchs gave themselves the airs of descendants of Yehoiakim, the last descendant of the royal line of David who went into exile after the destruction of the First Temple. Stories circulated of the mutually respectful familiarity between exilarchs and kings. At the beginning of the fifth century, the exilarch Huna ben Nathan was at an audience with King Yazdegir I when the belt of his robe, identical with the Zoroastrian *kustig*, slipped, whereupon the royal hand thoughtfully adjusted it.[48]

All this was because Judaism was not part of the Zoroastrian story, much less a deicidal part, so the Persians felt unthreatened even as many of the precepts of the two religions showed some affinity. They certainly shared purity obsessions concerning the dead, belief in the uncleanness of menstruation and the nocturnal emission of semen, and it seems likely that the peculiar Jewish requirement of burying nail clippings came directly from Persian-Zoroastrian practice. Certainly there were none of the assumptions that when the Jews sold amulets and charms (a thriving trade in Babylonia as elsewhere) they were trading in works of the Devil.

Living in one of the most densely urbanised and sophisticated societies in the world, Aramaic-speaking Jews inhabited rich and poor strata and everything in between. They were river traders and porters, moneylenders and mule drivers, physicians and landowners. And because the Talmud writers wanted to speak to all kinds and conditions of Jews it sometimes offers a rich ethnography of their differences. The Mishnah had been content to include women's cosmetics among things forbidden as 'leaven' during Passover.[49] The Talmud sages won't leave it at that and offer views about depilatories used by teenage girls. Clearly expert on the matter, Rav Yehudah says 'poor girls apply lime [ouch], rich girls use fine flour and princesses [the first time the Jewish princess takes a bow in literature] six months with oil of myrrh'. In the way of their unstoppable free association

this leads naturally to a discussion of 'what is oil of myrrh?' which the rabbis then argue heatedly about, all with competing inaccuracy since they seem to think the essential oil comes from unripe olives, whereas in fact it is extracted from the fruit of the thorny commiphora tree. Unless, that is, in Babylonia olive oil was being sold as a depilatory, in which case the rabbis needed to rule on cosmetic fraud. Mostly, though, they want the rich girls (a subsection of the princesses) to stop using flour on their skin during Passover. And while they were at it, they wanted to leave nothing in doubt about the ingredients *not* to be used for a dip at the Passover Seder: no Edomite (Roman) vinegar for sure, no 'Median' beer made with barley, which in turn (and for no discernible reason) led the rabbis to offer views not just on cosmetics but food that will stop or loosen the bowels. Unsurprisingly, it's what the *am ha'eretz* – the common folk – eat that 'increases faeces, bends the stature and robs a man of one five-hundredth of the light of his eyes', and that would be black bread, uncooked vegetables and quickly brewed beer. To reverse all of these, you need bread with refined flour, vintage wine and fatty meat, preferably from a she-goat which has not yet had kids.[50] Which puts the nutrition expertise of the sages in about the same class as their advice on depilatory cosmetics.

However questionable the advice given in almost every conceivable department of life, the Talmud is a work engaged with flesh-and-blood experience, not some sort of arid legal manual. It is also unmistakably not a product of cultural segregation, but comes from a world in which a Jewish life was open to the culture which surrounded it, without any sense that the result would somehow be a compromised version of Torah Judaism. In this sense the Talmud canvasses all the questions and perplexities, all the 'how open, how closed off?' issues that have gone along with diaspora living ever since. Interestingly, precisely because Persian-Babylonian social customs converged so much with Jewish practices, especially on matters of purity, the issue of how far to adopt and adapt them for Jewish use divided the Talmudists, as well as the *am ha'eretz*. Persian law took an inclusive view of who was entitled to bear witness in court cases, which some of the rabbis followed and some did not. Living in the upscale, suburban world of Mahoza, Rabbi Nahman ben Yaakov, a relative of the exilarch, for example, deemed it perfectly acceptable that a man

suspected of carrying on with a married woman could still be a witness. Likewise, Rava, a prolific Talmudist, saw no obstacle in allowing a Jew notorious for enjoying non-kosher food testify, while Rabbi Abaye, from the more narrowly Jewish world of the Pumbedita schools, would have none of it. The divide was beween the wealthy, laid-back elite of the Babylonian Jews even when they were rabbis, and those in the simpler, more enclosed worlds of the academies. Many rabbis in the former category were routinely polygamous in the Persian style, sanctioned the taking of 'temporary wives' when abroad, did so themselves and saw no reason why this should require them to be divorced from wife number one.[51]

Divergence of opinion among the Talmudists was not, of course, just a matter of social geography; those who took the narrow and those the broader ways of interpreting Torah and Mishnah did so through their own roads of apprehension. The remarkable thing about the Talmud is its elasticity: the way it swelled to accommodate the whole multivocal, mutually interrupting, sometimes cacophonous inter-generational conversation. It was the world's first hypertext, in the way it made room for commentary upon commentary, source upon source on the same 'page' – mind-bogglingly, the different treatises, hands, even languages when they included Aramaic translations, would have crowded a space on the scroll, as codices (the early form of books) were not used by Jews until the ninth century. So the scroll form must have made the formal looseness of what the Talmud was even looser, its rolling bowling succession of free associations, its wonderful vagaries between law, story, vision, disputation. Its whole authority was bound up with orality, with its leaps from intuition to conversation, its sudden shafts of illumination that no one could bear to suppress, never mind their relevance to anything ostensibly the issue. Wherever you dip into the Talmud you don't so much read it as hear it.

And you see it too. Two rabbis, important ones, Hiyya and Jonathan, walk through a cemetery. The fringes on Jonathan's garment, the *tzitzit*, brush the ground. 'Lift it up,' says Hiyya, 'so the dead don't say, "Tomorrow they will join us but now they're mocking us."' Jonathan replies (while lifting his fringes and walking, or have they stopped to do some finger-jabbing at each other?), 'What do you mean, what can the dead know? Does not Ecclesiastes say "the dead know

nothing"?' Hiyya gets excited. 'Please, if you had read properly you would know that by the "living" is meant the righteous who even after they are dead are called living, and the "dead" who know nothing are the wicked who "know nothing" whatever their physical state.'

The treatise on the Sabbath is punctuated by pure storytelling, especially of Hillel and Shammai. To promote the virtues of patience, a story is told of a man who laid a bet he could provoke to anger Hillel, legendary for his calm. On the eve of the Sabbath 'Hillel was washing his hair' (the Bavli Talmud loves these details) when the gambler beats on his door. Hillel hastily puts on a gown and asks what he wants. 'I have a question. Why do Babylonians have round heads?' Hillel doesn't even shrug. Because their midwives aren't up to scratch. Oh, right. An hour later he's back. 'Why do people from Palmyra have sore eyes?' 'My son, a good question, because they live in such a sandy place.' This goes on. Not a trace of annoyance from the great man even when the obnoxious stranger warns 'I have a lot of questions'. 'Ask all you want.' 'Well, they say you are a prince. There can't be many like *you* in Israel.' 'Why not, my son?' 'Because you've just lost me 400 *zuz*.' Hillel goes in for the kill, with terminal sweetness. 'Better you should lose 400 *zuz* than Hillel lose his temper.'[52]

Like the Mishnah around which it lays its heavily planted beds of interpretations, commentaries and folk-wise stories, the greater Talmud has, even when the text seems to turn on minutiae, ethical reflections of the deepest importance. When may a wife be rightfully divorced (agreement only on when she has been unfaithful for 'I detest divorce said the Lord God of Israel')?[53] When do matters of life and death override Sabbath observance (always, so you must heat that water if it's needed)? Movingly, and tellingly (and surely inflected with the sorrows of Palestine in the Yerushalmi, or perhaps that fifth-century time when the Sassanians turned on the Jews), the sages ask themselves what to ask of Gentiles seeking to convert. 'We say to him: why do you wish to convert? Are you not aware that nowadays Israelites are careworn, despised, stressed, harassed and persecuted? If he responds "I know and I feel unworthy [to share their troubles]", we accept him at once.' He is told of the commandments that are hard to keep and those that are easy; of the punishments for violation and the rewards for observance.[54]

But to be admitted to Talmudic Judaism, however easier life might

have been (and not always) in the Babylonian diaspora, was to share not just in the memory of loss, but to feel it, see it and hear it as if it were still happening. What *were* the Levites singing, a chapter asks, as they stood on their platform on the 9th of Ab while the Babylonian armies finally smashed their way into the Temple? What was it *like* when Betar fell to Hadrian's army and the 'Temple Mount was ploughed over'? And they would share too in the world of messianic expectations that when certain things had come to pass – the fall of 'Edom', the return of the bridegroom God to His bride the Synagogue, Jerusalem, to which they all looked as they prayed, read the Torah, sang the *piyyutim* poems – the golden-gated Temple with the veiled Holy of Holies at its heart would be restored.

Sometimes, the Talmud rabbis, the exilarch and his court, and the multitudes of the *am ha'eretz* thought the darkest of times conceals light. So it was with the Byzantine emperor Heraclius at the beginning of the seventh century, who went the whole way in missionary fanaticism, decreeing that there was nothing for it but for the Jews to be converted, forcibly if necessary, as only through Christ could they attain salvation, and so long as they were blind they were also dangerous – the creatures of the Devil. While he was at it Heraclius also banned weekday services and, seeking to rip out the heart of Judaism, forbade the recitation of the *shema* at any time. (Cantors were said to circumvent this by inserting it at arbitrary moments during the service.) Only one community in the Byzantine-Roman diaspora is known to have suffered mass forced conversion: that of Borium in the Maghreb.[55]

For before the Heraclian vision could be executed, a moment heavy with messianic possibility suddenly happened. Early in the seventh century the Sassanian king Khosrau II decided to appeal to the Jewish population of his realm to support a military campaign against the Byzantines led by his general Shabahraz. The son of the then exilarch, Nehemiah, is said to have mobilised an army of 20,000 Jewish auxiliaries to fight with the Persians. The march cut through the Byzantine defences. Antioch, the glory and the heart of Christendom, was taken, after which Jewish auxiliaries led by one Benjamin of Tiberias, drawing recruits from the heartland of Galilean Jewry – Sepphoris, Nazareth, Tiberias itself – rallied to the Persian army. Into Judaea they swept and after a three-week siege, Jews took back their city, for the first

time since the Hadrianic ban, establishing an autonomous city state within the Persian Empire.

Martyrologies describe traumatic destruction inflicted on churches and Christians. Archaeology has found very little of the former, but skeletal remains have been discovered on at least one Jerusalem site, by the Mamilla pool, now an upscale shopping mall and residential development. Whether or not Jews took revenge on their oppressors, the moment turned out to be less than messianic. Almost before work of clearing and rebuilding could begin, the Persians, finding themselves embattled elsewhere, decided to leave Jerusalem and the Jews to their fate. In 628, just fourteen years after they had been defeated, the troops of Heraclius returned and exacted a terrible retribution. The Christians must have imagined that, once again, the disappointment of the Jews was the result of their deluded recognition that there would be no Messiah other than the returning Jesus. The Jews ought to end their delusions, accept that the dominion of Christ would prevail in Jerusalem forever.

It may have been the Christians who suffered the greater delusion. Only ten years lapsed between their recovery of the city and the Muslim conquest of it by the second caliph, Umar, in 638. According to later Jewish and Muslim sources, Jews accompanying Umar's army led the caliph to the site of the Temple Mount from which Muhammad was said to have ascended to the heavens, consulting on his way with Jewish prophets. Dismayed by the mounds of rubbish with which Christians had deliberately polluted the Temple site, Umar reportedly ordered a clean-up with, naturally, the Jews volunteering for the work. In response, seventy families from Galilee were permitted to live in Jerusalem and even build a synagogue close to the Temple site. Thus was born a culture of coexistence between Jews and Muslims.

That, at any rate, was the story.[56]

6

AMONG THE
BELIEVERS

I. Muhammad and the Cohens of Arabia

Crated cheetahs, lions and the odd rhinoceros lay in the holds of ships moored in the harbour of Yotabe along with chests filled with myrrh and spikenard.[1] To the west was the southern tip of Sinai, to the east the northern coast of Arabia. The shark-shaped island (now known as Tiran) lay plumb in the middle of the narrows, impeding passage for vessels wanting to sail north from the Red Sea or south from the Gulf of Aila (now Aqaba). All of this made Yotabe the perfect place to extract customs and tolls, and the historian Procopius of Caesarea tells us that the Jews who lived there had been doing just that for generations. Except for a small number of Christians, Yotabe was a Jewish island, with a population thought to have settled there after the Roman destruction of Jerusalem; but since the Jews went island-hopping well before the first century CE, their commercially strategic presence on Yotabe might have begun much earlier. Upfront money talked, especially to overstretched empires, so the Yotabe Jews had a good thing going, furnishing the ready in exchange for the right to collect, and profiting from anything over and above their prepaid disbursement. The arrangement suited whichever treasuries were the beneficiaries, enough for the Byzantine Empire to grant Yotabe the status of an autonomous micro-state: an eighty-square-kilometre miniature commercial republic of Jews.

Until, that is, the middle of the sixth century, when the overweening emperor Justinian, with his deluded obsession of making the Christian Roman Empire whole again, chose to end the liberty of the island.

The misfortune was predictable. Justinian was not prepared to cede strategic command of the straits to any party not fully committed to the long-running wars against the Persians. And Jews on the frontier were notorious for hedging their bets. But, even after they had been reduced to subject status, the Jews of Yotabe stayed put, collected their fees and surveyed the cargoes of African wild animals bound for the last (and officially illegal) games, the *venatores*, organised by the languid aristocracies of Rome and Byzantium, bored with watching mere bear and boar torn to pieces in their private circuses. Along with the big cats and elephants, the riches of Arabia came under the eyes of the Yotabe customs post, and all were lucrative: musk; frankincense used by Christians, Jews and pagans alike for incense; perfumed oils and gummy resins; gemstones and the coral taken then, as now, from the Red Sea reefs, and worn as protective amulets, suspended from silver or gold chains. Ever since the earliest Greek reports had described them as communing with the stars, Jews had been thought to have access to potent, esoteric mysteries – secret concoctions and formulae extracted from plants, minerals and animals, and these too found a taxable market. From further off came Asian silks going north and west, exchanged for Egyptian linen travelling south and east.

The force of Yotabe's extractive grip on shipping depended on the bottleneck of the Red Sea being corked up at the other, southern end, where another populous community of Arabian Jews were settled in the port of Aden, commanding the exit out to the Indian Ocean, as well as incoming traffic from the Horn of Africa. Between Yotabe and Aden, moreover, lay a long chain of Jewish settlements and towns strung along the camel routes of the Via Odorifera, up from Yemen along the oasis-scattered periphery of the desert into the Hijaz, the north-western flank of the Arabian peninsula, and into towns like Hegra, Ula and Tabuq.[2]

This, then, was the social geography of somewhere most people cannot imagine ever having existed: Arabia Judaica, the home of Judaised Arabs and Arabic Jews – a phenomenon that now seems to us oxymoronic, but in the two centuries before the arrival of Islam was the most natural thing in the world, flourishing both economically and culturally. From the Nabateans of the Negev and the hills of Moab they had acquired skills in catching and conserving precious, sudden downpours and channelling underground currents so that date palms might

flourish. Their ties in one direction with the Jews of Palestine and in the other with the communities of Mesopotamia gave them a pre-established network of trade. From inscriptions we even know about their connections between the towns of Arabia itself. One such tomb inscription at Hegra from the middle of the fourth century declares it to have been built by 'Adnon, son of Hmy, son of Shmwl [Samuel] Prince of Hegra for his wife Monah, daughter of Amrw . . . son of Shmwl Prince of 'Tayma'.³ Jewish clans and tribes whose names are known to us from early-Muslim histories owned date-palm groves and forts and were busy in the trans-Arabian camel caravans (indeed many of them followed the herds as Jewish Bedouin), and, before the appearance of Muhammad in 610, dominated fortified market towns like Tayma, where they were powerful enough to impose Judaism on the city and on any pagans or Christians who had a mind to settle there. In Khaybar, an oasis town of towers and fortified walls where there was enough water streaming from surrounding hills (stored in catchment tanks) to irrigate date palms and vines, landowning Jews specialised in making and warehousing weapons, armour, catapults and whole siege engines as well as dealing in the silks and textiles brought from the southern kingdom of Himyar. Some of the estates of Khaybar, especially in the garden oasis of Fadak, were owned by the clan of Banu Nadir who had been among the founders of Yathrib a hundred kilometres further south, the town which grew into the most populous and powerful of all the cities of the Hijaz. There, in the place where Muhammad created his community of Believers, the Jews, at least 60 per cent of the population, were landowners, market overlords, goldsmiths and silversmiths speaking and writing *yahudiyya*, the Jewish dialect of Arabic. But there were also *kahinan*, as Muslim sources call them – *cohanim*, the priests, some said by the Talmud to be descendants of thousands who had fled into Arabia when the Temple was destroyed, others sent as Jewish missionaries (for contrary to conventional wisdom there were many) from Tiberias and other towns of Byzantine-Roman Palestine. They were, in effect, the Cohens of Arabia. There was also a Levite community and some of the words at the heart of their faith – *nabi* for prophet; *sadaaqa* for righteous obligation, charity and justice; *rahman* for mercy – would pass intact into Islam. There were Arabian Jewish sailors, sculptors, scribes and poets, merchants, peasant cultivators and pastoral nomads living in tents: a complete culture.

Customer name: Doran, Pearse

Title: Discover Paris / this edition written and researched by Catherine Le Nevez, Christopher Pitts, Nicol
DCPL0000805161
Due: 13-11-17

Title: Silence : [dvd]
DCPL4000007362
Due: 13-11-17

Title: Loitering with intent : The child.
03335379711004
Due: 13-11-17

Title: The story of the Jews : finding the words : 1000 BCE - 1492 CE / Simon Schama.
DCPL0000729870
Due: 13-11-17

Total items: 4
Total fines: €0.90
23/10/2017 19:31
Checked out: 4
Overdue: 0
Hold requests: 0
Ready for pickup: 0

Thank you for using the self service system.
You can visit us online at
www.dublincitylibraries.ie

It seems natural to us to imagine the antiquity of a Christian Arab population because that community survives to this day as a coherent culture. But we have to add to that scene of the fourth to sixth centuries a Jewish Arab population – both ancient and newly converted – energetically contesting with the rival monotheism for the allegiance of pagans. According to the church historian Philostorgius, when the emperor Constantius II sent missionaries to Arabia in 356, they found themselves frustrated by heavy and successful competition from Jewish proselytisers, those whom Muslim sources called the *rabban'iyun*.

By the late fourth century, just as life for Jews in Christendom was beginning to turn starkly harsher, Judaism made its most spectacular conquest in Arabia, when the Kingdom of Himyar (corresponding, territorially, to present-day Yemen, and the dominant power on the Arabian peninsula for 250 years) converted. For a long time, it was assumed that the Himyar conversion was confined to a narrow circle around the king – the last of the Tubban line, Tiban As'ad Abu Karib – and perhaps the warrior aristocracy. There is still a lively debate around the extensiveness of Himyar Judaism, but the evidence of both inscriptions and, more significantly, excavations at the mountain capital of Zafar uncovering what seems likely to be an ancient mikvah purification bath, suggests to many recent scholars (though not all) that the dramatic conversion was more profound, widespread and enduring.[4] It may have been that Himyarites were devotees of the 'sun and moon' as well as practising eighth-day circumcision, but then the cult of the sun, as we have seen from synagogue mosaics of the period, was also uncontroversial in Jewish practice. Indeed, according to the chronicler ibn Abbas, one of the major sources of suspicion that Ka'b al Ahbar, the companion of the caliph Umar at the conquest of Jerusalem, was a false Muslim was because he claimed that at the day of judgement the sun and the moon would be taken to judgement 'like castrated bulls', a view said to be typically Jewish![5] Since the Himyarite elite sent their remains to be interred in the great necropolis of Beit Shearim there is no question about the direction of their religious allegiance or the closeness of their connection with Jewish Palestine. Later Muslim sources even write of rabbis coming from Tiberias to instruct the Himyarite court. Whether or not that report is true, it is evident that in the centuries before the appearance of Muhammad in 610, the Jews were far from a tenuous,

alien presence amid the ethnically Arab world of the Hijaz and
Himyar.

The conversion of Himyar was only possible because it would never
have occurred to the converts that the belief they were adopting was
in any way foreign. Jews were so anciently and deeply planted in Arab
lands that they had become an organic part of its world. In recent
excavations at Zafar, built inside a range of volcanic craters, an intaglio
carnelian signet ring was found, dating to the second or third cen-
turies, inlaid with the symbolic image of the Torah shrine, stylised
in exactly the same way as it appears on the mosaic floors of early
synagogues, and with the name Yishaq bar Hanina engraved in mirror-
image Hebrew.[6] Jews like Yishaq and his descendants spoke Arabic as
well as Aramaic, and some like the warlord Samw'ayal ibn Adiya of
Tayma wrote Arabic poetry of enough bragging eloquence to merit
a *diwan* anthology of his verses collected by Muslim redactors of
warrior literature. They carried Arabic names, dressed indistinguish-
ably from Arabs, were organised in semi-tribal extended family clans
like Arabs, and – not just in Himyar, but throughout the entire region
from the Indian Ocean to the Negev and the Sinai – many of them
were ethnic Arabs.[7]

There had been so many conversions over the centuries since the
Hasmoneans forcibly imposed Judaism on the desert-dwelling, ethni-
cally Arab Itureans and Idumeans, that it is impossible to differentiate
Arabian Jews who had originated as emigrants from pre- or post-
Temple destruction Palestine, and the multitudes of erstwhile pagan
Arabs who had chosen Judaism rather than Christianity as their mono-
theistic faith. Recent studies on the DNA of modern Yemeni Jews by
the geneticist Batsheva Bonne-Tamir have confirmed their ancestral
origin in south-western Arabian and Bedouin conversions.[8] This pre-
Islamic merging of Arab and Jewish identities was reinforced when
the last and most militantly proselytising Jewish king Dhu Nuwas,
Lord of the Curls (also known as Yusef As'ar), was defeated by the
Christian Aksumite king of Ethiopia, Kaleb, in an all-out battle in 525.
Prior to that, it looked as though the Lord of the Curls would take
his aggressive Judaism deep into the Arabian peninsula. Evidently
driven by wanting to exact retribution on Christians for the persecu-
tion of Jews in the Byzantine Empire, as well as the burning of syna-
gogues in the predominantly Christian city of Najran, Dhu Nuwas

took prisoner and executed Christian merchants travelling through Himyar to Ethiopia. Word of the killings lit the fires of revolt in Najran which Dhu Nuwas repressed with terrible ferocity, a massacre that immediately became the stuff of martyrologies spread by surviving local monks and priests. Byzantine power – and access east and south – was now suddenly threatened by a nightmare belligerent combination of Persian and Jewish power. Committed to hold the frontier against the Sassanians, Emperor Justin I appealed to the newly baptised Christian African Aksumite kingdom to intervene. At the head of a huge army (perhaps as many as 60,000) the Aksumite King Kaleb invaded Himyar in 525 and defeated Dhu Nuwas, ending the history of the Jewish Arabian kingdom and the life of its most colourful monarch. The story of Dhu Nuwas riding his horse over a cliff into the sea is merely legend, but the last and most aggressively Jewish king of Himyar certainly did not survive the fate of his vanquished army, and nor did the dream of a Jewish pan-Arabian federated state.

But the shattering of Jewish Himyar in 525 only sent its Judaically loyal population north into the Hijaz where they augmented an already strongly Jewish–Arab population in the towns and oases. (Some of them certainly remained under the Aksumite Christian lordship but retained their Judaism, for the great antiquity of Yemeni Jews was unbroken from the Middle Ages to their mass emigration after the Second World War.)[9] It meant that Judaic monotheism had deeply penetrated Arabia for almost a century before Muhammad declared his revelation in 610 in one of the towns – Makka, or Mecca – in which those Himyarite emigrants had settled. It was precisely because Arabian monotheism (as distinct from the confusing three-in-one version preached by Christianity) had such a strongly Judaic colouring – *was* in effect Arab Judaism – that Muhammad, who had lived among Jews all his life, could assume at the very least a sympathetic hearing among them, even that they might be the most receptive of the population to his prophecy, not least the part about Islam being the true Abrahamic faith.

It is not hard to see the grounds for Muhammad's optimism when, in 622, after his failure to win over Mecca, he made the *hijra* journey north to Yathrib/Medina where, as it would turn out, Islam would triumphantly prevail and create its first governing institutions. It may be that the Jewish clans in Yathrib – and there were many of them –

were no longer politically and socially dominant in the city, but there is equally no doubt that they were still there in both economic and cultural force. Islam, then, was born in a Jewish urban crucible. Muhammad's belief that the Jews would be his most natural allies is explained by an affinity between the two one-God religions. But the connection is even stronger than that. Himyarite-Arabic Judaism may have been, in a deep sense, the direct parent of Islam, for it makes no sense historically to classify Muhammad's core doctrines as anything but *essentially* Judaic – evident in the indivisibility of the one unseen omnipotent God (referred to in Himyarite and Arabian Judaism, after all, as 'rahman, the all-merciful and compassionate who art in heaven and earth'); the coming of the Last Days (a central belief of the Qumran community); the hatred of idolatry; the righteous commandment of charity (*sadaaqa* in Arabic, *tzedaka* in Hebrew); the strict prohibition not only against pork but also against consuming meat with its living blood still in the flesh; the insistence on ritual washing and purification, especially before prayer. It is no surprise, therefore, that until his stinging repudiation by the Jewish clans of Yathrib, Muhammad commanded the Believers to pray in the direction of Jerusalem, not least because he thought of himself firmly in the succession of the biblical prophets. Other of his strictures – multiple daily prayers (also required by Zoroastrianism); ritual purifications; a fast on the tenth day of Tishri (the Jewish Day of Atonement), only later replaced by Ramadan, as well as weekly fasts on Mondays and Thursdays; the obligation of circumcision – were all standard Jewish practice.

It is entirely understandable, then, that just like later Christian critics of Talmud-based Jews, Muslim writers would insist that Islam was the true fulfilment of the Jewish Bible; that in its pages, especially in the epics of Abraham/Ibrahim and Moses/Musa, were to be found the promises eventually fulfilled by Muhammad, and that the religion to which contemporary Jews clung was a modern rabbinical-Talmud invention unauthorised by divine revelation. This, after all, was a view also held by Samaritans and the new congregation of Karaites who rejected any rabbinical additions to the laws laid down in the Torah.

So why did the Jews of the Hijaz *not* respond more positively to Muhammad, in fact reject him so abrasively that in Yathrib, at least, they invited their own uprooting and physical destruction? The answer lay in a rewritten version of the Bible, Genesis in particular, that

offended against the now closed Torah canon. Had Muhammad appeared on the scene six centuries earlier, his variations would not perhaps have seemed so heretical, given that the Dead Sea Scrolls are themselves full of pseudepigrapha that fundamentally rewrite not just the stories of the patriarchs (and more dramatically the matriarchs) but the account given in Genesis of the very Creation. And as we have seen, that was also a time trembling with anticipation of a manichean drama of Last Days that was virtually a prototype for Islam's account, not to mention room made for all kinds of latter-day prophets and celestially informed messengers from the Almighty. Like many of the prophecies and the literature of the *merkavah*, the mystic chariot that bore messengers into the heavenly realms and back, Muhammad claimed to have been in heaven, and he, like those travellers in Paradise, recited mantric prayers and cloaked himself in a mysterious mantle. Muhammad's problem was one of timing, appearing before the Jews of Yathrib and the Hijaz long after the sages had categorically declared an end to the prophets.

For many of those Jews, and especially for those the Quran calls the *rabban'iyun*, their rabbinical establishment, Muhammad was a presumptuous, if not dangerous, pretender, all the more so since he came bearing only word of mouth of a personal revelation which he nonetheless insisted superseded the written authority of the Torah. Where was a written Book of his revelation, something comparable to that which had been 'found' in the Temple in the days of Josiah and miraculously preserved through the Babylonian exile, restored to Jerusalem by the scribe-priest Ezra? And by what right did Muhammad garble and alter the Torah and make Ishmael (Ism'ail), not Isaac, the object of God's commandment to sacrifice his son, or have Abraham visit Ism'ail and Hagar in their desert exile to bestow his benediction? Even worse than this blasphemously cavalier rewriting was the shameless insistence that those who had written the Torah were frauds and forgers, requiring timely correction by the Quran.

Once they had taken on board all these affronts, the indignant guardians of Jewish tradition in Medina were not shy of making the magnitude of the heresy known. They did it, moreover, through the classically Arabic medium of public poetry, often recited in the open-air marketplaces which in Medina were still run by the Jews. There had long been a Bedouin tradition of such recitations, and along with

other adopted Arabian practices, the Jews had slipped easily into the role of that declamatory versifying. Now they used their skill to biting polemical ends. The most fateful of those interventions was in 622 by the venerable poet (said to be 120 years old) Abu Afaq, when he poured scorn on Muhammad's pretensions, and urged any believers in the one God to desert and steer clear of his message and person. The earliest biographies of the Prophet record the extent of Muhammad's fury at the challenge. 'Who will deal with the rascal?' he is reported as asking, a request which was quickly taken up by one of his most devoted followers, Salim ibn Umayr. 'A hot night came and Abu Afaq slept in an open place. Salim ibn Umayr knew it so he placed a sword on his liver and pressed until it reached the bed. The enemy of Allah screamed and the people who were his followers [the Jews] rushed to him, took him to his house and interred him.' In some traditions a woman convert to Judaism, and also a poet, Asma bint Marwan, was so antagonised by the murder of Abu Afaq that she launched into her own public satirical denunciation and was herself murdered, surrounded by her twelve children, the smallest of whom had to be torn from her nursing breast before she was stabbed to death. Jewish women poet-singers – some of them like one Hirra al Yahudiya from the Himyarite southern region of Wadi Hadhramaut, where there may have been a tradition of their public performance – seem to have been among the most vocally hostile to Muhammad's claims, and invariably paid a price for their temerity.[10]

Matters changed drastically in Medina. Provoked by the rejection of the Jews, Muhammad changed the direction of the *qibla*, the orientation of prayer, from Jerusalem to Mecca. Politically he had been welcomed in many quarters as a figure who might transcend the quarrels of the tribal clans – which, it should be emphasised, were not Jews versus Arabs, but several Judeo-Arab groups in temporary alliances or contentions with one another. Instead of the dispassionate arbitrator, Muhammad plunged – with a good deal of astuteness – into these intra-factional battles. But by 622 it was evident that he would take an increasingly hard line with the most senior and powerful of the Jewish clans, all of whom were dangerously allied one way or another with various of his adversaries. The fact that it was thought they could bribe non-Jewish clans to joining the anti-Muhammad alliance only made matters worse. In some cases, that economic

prominence might have backfired against the Jews, for it may have helped recruit loyalists who could (and did) profit from their eviction – especially in the case of the Banu Nadir clan who dominated the date-palm groves around Yathrib and at Khaybar. The Banu Qaynuka were principally artisan goldsmiths, and their inventory might have been another incentive for hostility. Both were summarily driven from the city of their ancestry, moving north to Khaybar and, according to the Muslim chroniclers, on to south Syria, perhaps Palmyra. For the most dominant of the clans, the Qurayza – who made the fatal mistake of allying with Muhammad's most obstinate enemies in Mecca (possibly because the clan had its own family members in that city), following an abortive siege that gave him control of Yathrib – the Prophet had a much more brutal response to the 'treachery'. In an attempt at mitigation, the Qurayza claimed they had in fact contributed baskets and trench-digging spades to the defence of Yathrib, but their credibility had been fatally compromised. Asking a Believer from one of the local tribes, the Aws (which also had a Jewish clan), what should be the punishment of the Qurayza, it was determined that all the men (beween four hundred and nine hundred of them, depending on the historical source) should be put to death and their women and children taken into slavery and forcibly converted. Some of the slaves were sold to buy arms for the troops of the Faithful, others married off to Muslims, including one Rahaina who became the Prophet's wife. The pitiless massacre was duly carried out.

Although the truth of the slaughter has been disputed in modern times, the brutal story was rehearsed and repeated in all the earliest biographies of the Prophet, and was not, after all, an especially unusual event in sixth- and seventh-century Medina. The Himyarite Jews had done as much to the Najran Christians a century earlier. But if we are to credit a document which also appears in those eighth-century biographies and which has generally been accepted to be historically authentic, the Qurayza were not the last Jews of Medina or the other towns of the Hijaz. Many of those remaining sub-clans were named in this document, known as the 'Constitution of Medina', which was a compact with submitting tribes setting out the basic structure of authority in the *umma*, the community of Believers. Of the fifty-nine articles of the document, no fewer than ten are made specifically with the Jewish clans presumably remaining in Medina following the

massacre and expulsion of the major three tribes. But surprisingly, the document of the *umma* assumes a solidarity of military alliance between Jews and Muslims, specifying that the former would pay 'their share of the expenses' as long as they fought beside each other. The very next clause says something even more at odds with the way Jews would eventually end up being treated as a People of the Book. It is complicated by the fact that the tribe it refers to – the powerful Banu Aws – had within it Muslims as well as Jews. But the text could hardly be more explicit in asserting that even were they to remain Jews they would still be considered not outside but *inside* the *umma*, in other words legally indistinguishable from Muslims. 'The Jews of Banu Aws are a community with the Believers: the Jews have their religious law and the Muslims have their religious law.'[11] This note of brotherly coexistence was made even more emphatic by the use of the word *din* – identical in Hebrew and Arabic to suggest the expression of religion in and through law. It was also evident from the 'treaty' that should the Jews choose not to fight alongside Muslims, they would be expected – as members of the *umma* – to compound for this by paying their share of the expenses of the campaign.

Solemn though this compact was between Muhammad and these non-Believers, it was not how matters unfolded (massacres aside) even during his own lifetime. The first city to be taken after breaking out from pacified Medina was, inevitably, multi-towered Khaybar, where the local Jews had been badly compromised by alliances with Muhammad's enemies from his own tribe of Quraysh. Expelled from Medina the Banu Nadir had gone north to Khaybar where many of them already owned land. The place was armed to the teeth but, as it turned out, fatally divided between the three towers – Nataq, al Shiqq and Katiba – each of which lodged their own extended clan and who, in the siege which followed in 628–9, were concerned with their own survival. Muslim histories make the battle for Khaybar a decisive epic, Muhammad sending fake guests inside the walls who turned on their hosts at feasts and killed them assassinating the chief of the Banu Nadir, Huyayy ibn Akhtab, killing his son-in-law and taking his daughter Safiyya who became Muhammad's second Jewish wife. The Prophet's cousin and son-in-law Ali takes on Marwab, the most formidable of the Jewish warriors, and splits the Jew's helmet in two, piercing the champion's skull.

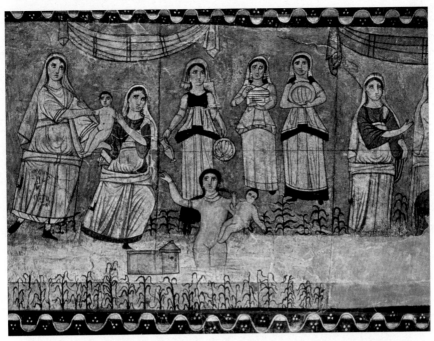

Third-century CE wall paintings from Dura-Europos synagogue which demolished the assumption that Judaism abhorred images. In the earliest synagogues quite the opposite was the case. (*Above*) The finding of Moses by Pharaoh's daughter; (*below*) detail showing King Ahasuerus and Queen Esther.

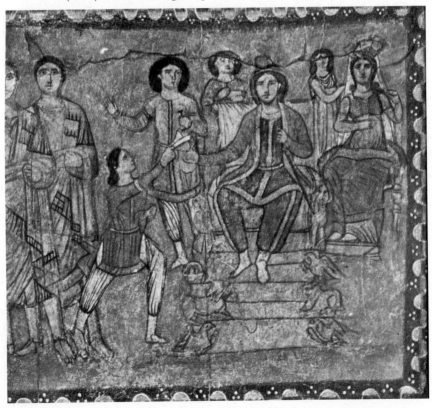

Fifth-century floor mosaics from the synagogue at Sepphoris in Israel:
(*above left*) the month of Tevet representing winter; (*above right*) the month of Nisan
representing spring. (*Below*) Emblems of the Temple: the golden candlesticks,
the holder of the 'four species' for the Feast of Tabernacles, and the shofar trumpets.

Painted decorations of a date-palm grove in the Jewish catacombs at
Vigna Randanini near Rome, fourth century CE.

Floor mosaic of a dolphin from a synagogue at Hammam-Lif in Tunisia, third/fifth century CE.

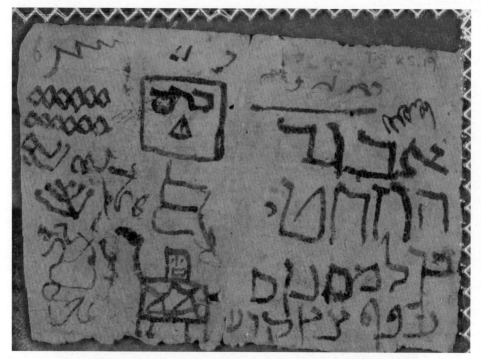

A child's Hebrew exercise book with a doodle of a camel; from the Cairo Geniza, the repository for documents of an entire medieval Jewish world. Most are in Judeo-Arabic (Arabic written in Hebrew characters), itself evidence of cultural crossings.

A 'cheque' or commercial bill of payment in Judeo–Arabic with Arabic, from the Cairo Geniza.

A thirteenth-century stained glass window at Lincoln Cathedral showing, on the right, the 'boy of Bourges' being put in an oven by his father (in the conical red hat); on the left the son sits safely in the oven thanks to the interceding haloed Virgin who inclines her head protectively towards him.

A Judeophobic caricature captioned 'Aaron fils diaboli' (Aaron Son of the Devil), from a thirteenth-century English Exchequer record.

The Jews being beaten out of England, from 'Chronica Roffense', fourteenth-century vellum.

A page from the Book of Donations in Maimonides' *Mishneh Torah*, with a miniature of Moses receiving the tablets of the Law, and a running deer at the head of the page, which often symbolised Israel. From late thirteenth-century France.

The Birds' Head Haggadah, Germany, *c*.1300.

The title page of Moses Maimonides' *Moreh Nevuchim* (*Guide to the Perplexed*), from Huesca in Spain, 1356, the philosopher-doctor's treatise on how to reconcile faith and reason and proceed on the quest for perfection.

Some Muslim sources have Muhammad deciding to expel the Jews of Khaybar for their temerity in allying with his enemies. Following the surrender, though, and perhaps mindful of other means of pacification, he is said to have agreed to their own proposal to be allowed to remain and practise their religion in return for a payment of half their harvest produce. Whether or not this is historically true, there's no doubt that the submission of Khaybar became a template for the terms on which Islam settled with the populations it conquered with such stunning speed and force. But the most prodigious of the warrior caliphs, Umar I, in many ways the architect of Islam's military-religious empire, overrode the Khaybar compact by declaring in 642 that before his death ten years earlier, Muhammad had insisted that there could be only one faith in Arabia itself. All unbelievers – Christians as well as Jews – had to remove themselves or be removed by whatever means it took. By official decree, Arabia was cleansed of the Jews who had lived there for at least half a millennium. Undoubtedly, many submitted to Islam; and especially in the erstwhile Himyar, Jews remained, probably until the mid twentieth century. Other small communities in the Hijaz – at Wadi Qura and Tayma – may have clung on as well, for letters from those towns dating from the eleventh and twelfth centuries have been discovered amid the material found in the storehouse known as the Cairo Geniza in the Ben Ezra synagogue of Palestinian Jews in Fustat, Old Cairo. Though he had not seen them in person, the twelfth-century traveller Benjamin of Tudela described the 'Rechabites', peripatetic communities of Jews, warriors, cattle breeders and herders, with their own leader or *nasi* wearing black, eating no meat and drinking no wine but keeping the traditional feasts and fasts. At Khaybar, Benjamin even claimed there was a community of fifty *thousand* Jews. Less reliably, the traveller Obadiah of Bertinoro in the late fifteenth century claimed there was a tribe of Jewish giants calling themselves 'Arabians of *Shaddai*' (the name of the Almighty), so strong they could carry a camel on one shoulder. But apart from the communities that certainly did persist in Khaybar, Tayma and the Yemen, Jewish Arabia was a thing of the past.

Yet if the Jews lost Medina, they gained Jerusalem. In the generations after the conquests of Muhammad, his successor Abu Bakr and Umar, some went in one direction to Syria, Palestine and Egypt, some in the other to the Mesopotamian cities, conquered from the Persians,

where the Talmud was being completed. And in all of these places, as well as the countless other towns and islands and countries over which Islam swept, Jews found a way to persist. The Arabian expulsion would turn out to be the exception not the rule. Nowhere else would be off limits to them; and unlike Christian Europe and Byzantium there would be no enforced confinement within a town to any particular quarter. Nor, again unlike Christendom, would any occupation be denied to Jews other than employment in the public administration and government of the *umma*. Most important of all, as 'People of the Book' along with Christians, they were protected in the practice of their religion, on the acceptance of certain binding conditions.

According to later Muslim historians those conditions were regularised in a 'Pact' or 'Treaty' said to have been drafted by Syrian Christians on their submission to Umar I. But it stretches all credulity to suppose that the conquered were in any position to lay down the terms of their surrender to the conqueror, and to do it, moreover, in the Arabic of which at that time they were entirely ignorant. It is far more likely that it was the eighth-century caliph Umar II who may have formalised the position of the People of the Book in the lands of the *umma*.

In many respects this must have promised an incomparably more benign existence than under Christendom. Jews had angered but not killed the Prophet so none of the stigma of God-killers was attached to them, nor were they ever dehumanised as living demons and consorts of the Devil. This made a difference. On the other hand they were not to be considered as equal to Muslims and incorporated within the community of Believers (as had been the case in the 622 document of Medina). They were *dhimmi* – the tolerated benighted. And on the precedent of Khaybar, their protection was conditional on payment of an annual poll tax – the *jaliya* (or *jizya*) – in gold dinar pieces, the number from one to four depending on both their fortune and where they lived.

Unbelievers, and the Jews in particular, were to be reminded of their humiliation and degradation in the sight of Muslims, in almost every aspect of their lives. It was one thing to forbid any public demonstrations of their religion (more of a trouble for Christians denied processional displays), or that their synagogues should never rise above the height of mosques; another to be banned from riding horses, and even when seated on donkeys ordered to ride side-saddle

in the humiliating position of women (and with a distinctive saddle). More dangerously, Jews were banned from ever carrying weapons, which left them prey to harassment, assault and violent robbery (especially on the journeys they were habitually taking). Their second-rate status was further defined by their evidence being disallowed in Muslim courts, and a strict prohibition on Jewish men marrying Muslim women (while the reverse, the marriage of Muslim men with Jewish women, was perfectly legal). And precisely because it was impossible to tell who was a Jew and who a Muslim from their appearance, they were required to wear distinctive clothing in a honey-mustard colour and forbidden at the same time from wearing turbans or other forms of dignified Muslim dress (although enforcement of these requirements was far from universally applied). Their hats were to be of a particular shape and style; a yellow badge was ordered by the Abbasid caliphate in Baghdad and extended throughout his realms; and Jews were required to wear not a belt but a loose girdle about their robes as a sign of their defence-less subjection.

It is of course hard for our contemporary minds to see yellow badges as anything except the inauguration of something which would assume murderous implications, not just in the twentieth century but in the Christian Middle Ages and beyond. See the Jew, despise the Jew, attack the Jew. And this did indeed frequently happen in medieval Islam. But it is equally important not to project backwards too much and make episodes of brutality and massacre the norm, for they were not. What is true, however, is that the Jews who had been so deeply woven into the world of Arabia and the Near East were unpicked from that seam-less coexistence. This does not mean, though, that amid the Believers they could not make a new, sumptuously rich cultural fabric.

II. Birds of Paradise, Pigeon-fanciers and Paper-pushers

What is the colour of flame? Orange? Gold? Blue? Red? All of the above, each tongue flickering in and out of the spectrum? What it was *not* was the dull yellow that Jews were supposed to wear in the Islamic world as an indicator of their baseness. At any rate, flame was

the colour Salama ben Musa ben Isaac – originally from the port city of Sfax in Tunisia, but like so many others an immigrant to Egypt – insisted on wearing so that he might cut a figure on the Day of Atonement. Clearly, vanity was not one of the sins Salama was repenting, for the robe he was ordering sometime in the mid-eleventh century was the latest thing: 'short and well-fitting, and of fine not coarse material'.[12] But then other than the stringently exacted annual poll tax, the *jaliya*, the requirements for *dhimmis* (laid down centuries before in the 'Pact of Umar') bore little relationship to the way in which Jews actually lived in the vast Muslim world, which by the end of the ninth century stretched from Spain and the Maghrebi coast through Sicily and southern Italy to Egypt, Aden, Palestine and Syria, Iraq and Iran.

Business letters found among the hundreds of thousands of discarded documents in the Cairo Geniza of the Ben Ezra synagogue in Fustat, read at times like a fashion catalogue. The Jews of Egypt were heavily involved in the textile trade (when and where are they not?) of all kinds of fabrics – linens and silks, and many kinds of silks at that: the heavy *ibrisim* and the light *khazz*; *lalas*, the 'fine red silk', and *lasin*, the downmarket cheaper one.[13] They bought and sold, and they dyed. Indeed, dyers specialised in one particular hue: sumac, purple, indigo or saffron. They spun, embroidered, brocaded and wove. The most menial of them spent their days disentangling flax fibres from the seeds that would be pounded into oil; others unwound fine, thin yarn from the cocoons of silkworms. The grandest bought and sold the fabric itself to be made into shawls and robes, scarves, cushions and rugs.

And if many were in the business, still more were avid consumers of spectacular cloth and clothes, for the Jews of Fustat were not a people who went around with their heads bowed, austerely dressed. In fact they condescended to Jerusalemite Jews who were the only ones in the Muslim world confining themselves to black with the odd note of red trim. In Fustat and the innumerable places to which they sent cloth, tastes were much more glamorous, both for women and men. Silks and linens (like the *sha'zab* interwoven with gold) that seemed to breathe and ripple were in high demand, the Jews moving among the streets and courtyards and *dar*, or 'houses,' of the bazaars in materials that shimmered and glinted. The subtler of them might

adorn themselves in 'gazelle blood' crimson, musk or deep violet. On wedding days the well-dressed groom would be clad in pistachio green, for that was said to be the colour worn by the righteous in Paradise. The trousseau of one mid-twelfth-century Jewish bride comprised six white robes, three cloud blue, three blue and gold, one pomegranate red, three pearl-coloured, two ash grey, two deep green and two saffron – and this was for a bride of average means. She would also have had an entire array of veils, for Jewish women, as well as their Muslim counterparts, were veiled on the street. On average 40 per cent of the wealth a bride brought to the match was invested in the finery of her clothes, so the quality and colour of the garments would always be precisely specified in marriage contracts. During the early Fatimid period in the tenth century it seems clear that these requirements of mustard-coloured dress were seldom enforced, and in any case there were beautifully mixed dyes made to get around the restriction, not just 'flame' but brilliant colours named after the spices of turmeric and saffron.

And entirely different headdresses appear as the stock-in-trade of the Cairo Geniza documents – in fact precisely the high-status turbans that Muslims wore and which were officially denied to Jews. The documents also include orders for fine cloth for the *wa-mi'jarha*, a woman's turban which wound many times till it piled up about the crown of the head, then came down around the face under the chin, from where it fell over the neck and shoulders: white if the effect was to be gracefully demure, green linen or silk threaded with gold if they had something else in mind. Male turbans worn by Jews could be just as spectacular. A *baqyar*, the last word, was ordered for the great scholar-merchant-poet-community leader Nahray ben Nissim, that when unwound would stretch – so it was said – a full twenty-five cubits, or rather more than a hundred metres. For the grand only the best would do, especially when it was a *hulla*, a complete costume for the festivals. A twelfth-century India trader made sure to order a high-status *dabiqi* for his son (probably in celebration of a birthday) with his name embroidered on it.[14] An early-eleventh-century trader was happy to have a fine feathered garment for the community elder, Abu Zikhri, but complained about the tone of the yellow robe he had received from his shippers, and wanted, in addition, another of deepest red. A heavy damask robe, though of 'extreme beauty' in blue and

white, was not what had been ordered which was 'blue onion colour' – meaning, the translator S. D. Goitein surmises, the palest shade of an opened onion, probably the colour produced by the skin of red or purple onions.[15]

Where could the fancy-dressers of medieval Fustat and their counterparts in Quayrawan, Sfax, Damascus and Baghdad show off their gorgeous get-ups? At private drinking parties and poetry-heavy banquets, greeting or saying farewell to eminent guests, business partners or far-flung relatives (and all three may often have combined in the same person), but not in public processions for weddings or funerals or feast days, for Jewish attendance of those stayed strictly illegal (as it was for the Christian *dhimmis*). However relaxed the regimes (and not all were), the Jews in this world were never the legal or social equals of Muslims and there were plenty of occasions to remind them of their inferiority.

The most aggressively punitive was the annual payment of the *jaliya* poll tax taken from all classes as the condition of the continued toleration of their religious observance. The *jaliya* was a ritual and symbolic expression of subjection and helplessness, and some medieval Islamic jurists prescribed in intimidating detail the procedures of humiliation. Collectors were supposed to keep their payers waiting, then shout at them, seize them by the scruff of the neck and even slap their faces. On no account was the payer's hand to be raised above the hand of the receiver, a requirement demanding a physically contorted form of dextrous subservience. Payment was of course also a punishing hardship for the countless numbers of the less well-off. In the earlier centuries following the Arab conquests, there had been provision to exempt the truly indigent but even this seems to have been made less indulgent by the time we have records in the Cairo Geniza – from the early eleventh century on. For those hard pressed, the tax was the terror of their lives. Without the *bara'a* – the receipt certifying payment – they could be threatened, physically assaulted and imprisoned for months on end, where they languished for lack of even minimal food, and were mercilessly beaten on whim, so that, for a tax defaulter, jail was as good as a death sentence. Often, the only recourse was flight, separation from family, but since *dhimmis* were strictly forbidden to travel without carrying their tax certificates, the jeopardy for the tax runaways was now doubled. But invariably,

personal disappearance simply transferred the burden and the fear to the remaining family members (who could be extended kin), who were held liable for the fugitive's arrears. Sometimes those arrears could be deemed collectable from kin even after the death of the defaulter. A plea for help written in the twelfth century by an elderly silversmith from Ceuta in Morocco, fallen on hard times, sounded all these notes of desperation. He was, he wrote, 'marked by illness, infirmity, want and excessive fear since I am sought by the controller of revenue who is hard on me, seeks out runners to track me down and, I am afraid, will find my hiding place. If I fall into their hands I shall die under their beating or will have to go to prison and die there. Now I take up my refuge with God.'[16]

But the picture the Cairo Geniza draws is not of a community that, tax troubles aside, lived in fear and trembling. Every so often an unstable ruler might come along – as in the case of the unhinged Fatimid caliph Hakim bin Amr Allah in the early eleventh century – who might suddenly and without much warning revert to intimidation or persecution of the *dhimmi* communities. After 1012 and a period of conventional toleration, Hakim ordered that Jews wear the loose black girdle (rather than the more dignified and secure belt) about their robe and be restricted to black turbans. On the street they would have to don a 'calf necklace', and in the bathhouse, a bell to indicate their identity. (Christians were stuck with an iron cross.) More seriously, Hakim ordered the destruction of churches and synagogues.

Mercurial tyrants like Hakim were, however, the exception. The Jewish world documented in the Cairo Geniza is rich in dinars, ideas, poetry and religious (and not so religious) philosophy; family loves and family plots; dice games on Sabbath afternoons (provided the stakes were nothing more serious than seeds); pigeon-racing from the roofs of synagogues (something of an obsession of the Jews of Fustat and Alexandria); weekly visits to the bathhouse where women friends gossiped and bonded; drinking parties in courtyard gardens and orchards in which (despite the stern prohibitions of the Quran, widely ignored) Muslim partners and acquaintances would mingle with Jews and listen to their Arabic poetry; receptions and feasts to greet incoming eminences and more again to wish them farewell and a safe voyage. The Geniza world sounds with the muttering and groans of innumerable litigations and appeals; negotiations for marriage and

supplications for divorce; disputes over wills; questions put to the religious courts; complaints of the body put to the physician; of improper commercial dealing put to the courts; petitions to the well-placed; appeals for charity, mercy, consideration, favour, promotion, retribution, recognition, satisfaction and vindication, even in the here-after. The letters form chains of connections between family, friends, relatives, even commercial competitors and adversaries, from India to the Horn of Africa to the Maghrebi west and Spain, to Sicily and Italy. What they connect are the fates and fortunes of all those peoples: fears of attack apprehended and realised; sorry tales of shipwreck and drownings; of caravans lost to marauders (or just lost); of whole communities in distress and sudden destitution; captives of the Crusaders who need to be ransomed; other Jewish societies that have come into munificence; even of entire far-off kingdoms like those of the Khazars or Kuzari, who have come to Judaism. In other words, what we have here is a civilisation.

And for the first time, too, a Jewish world of paper. Not for every-thing: the great alterations of life – marriage contracts, divorces, manu-missions liberating slaves – were deemed too solemn for paper and continued to be written on that kosher parchment. But that still leaves around three hundred thousand separate paper documents in the Geniza: the greatest empire of paper to have survived from the medi-eval world. Sometime in the late ninth century, the time of the Talmud's completion, a letter arrived in Fustat from one of the Babylonian yeshivas, written in Hebrew, on a thick leaf of paper. It is the earliest surviving paper document from the mills of Baghdad that had been established barely a generation earlier. The arrival of paper in the Islamic world has long been associated with a fable relayed by the Islamic historian Thaalibi in his *Book of Curious and Entertaining Information*.[17] In this long-cherished tradition, the jealously guarded art of Chinese papermaking was said to have been disclosed by captives from the Tang emperor's army defeated by troops of the Abbasid caliph at the battle of Talas in Kazakhstan in 751 CE. But Thaalibi was writing three centuries after the purported technology transfer and there is, in any case, plenty of evidence that paper made from rag-linen or beaten flax was known in Central Asia long before this date.

But not by Arabs, or Muslims of any kind including the Iranians who were closest to the Asian world of paper, nor to the Indian

cultures which continued to use palm leaves. Once the new medium
had caught on, however, there was no stopping it. To begin with it
seems likely that Egyptian Jews imported sheets from the Iraqi makers,
and from Syria as well where paper of high quality was made. By the
tenth century, the high price of imports led to the obvious conclusion
that there was no reason why the technology of the Mesopotamian
rivers could not be reproduced along the Nile, and Fustat was perfectly
situated for the industry. By the early eleventh century, paper and ink
(in two kinds – brownish from gall and black from carbon, sometimes
the one superimposed on the other) had become an integral part of
the Jewish working world. The Cairo Geniza is full of it: judgements
of the religious courts written on sheets two feet long and seven
inches wide, nubbly and heavy with gravitas; little promissory notes
and early forms of cheques in which the signer vouches that he is
good for sums to be made available in far-off places like Aden and
India so that a supplier of nutmeg or camphor or copper would release
his stock to the merchant's agent. To reinforce his credit-worthiness,
little scraps, sometimes as small as three or four inches square, have
certifying assurances written in three languages – Arabic, Aramaic
and Hebrew – with the word '*emet*', the truth, crossing the fold or the
join of bigger sheets. There was even 'bird's paper' beaten to such
thinness and lightness that it could be attached to the pigeons who
staffed the postal services – without slowing down their deliveries.

 And how word-hungry these paper-scribbling Jews were! Unlike
judicial and administrative edicts issued in Baghdad, where perfect
Arabic calligraphy was heightened by the lavish use of space, the Jews
ran their words over every millimetre, filling margins, turning the
sheets this way and that and starting again, leaving just enough space
on an exterior fold to indicate a recipient and address, for there were
no envelopes. The hands writing Arabic in square-form Hebrew char-
acters are urgent, greedy, possessive, abhorring emptiness, the page,
as Goitein perceptively noticed, resembling nothing so much as a
densely woven carpet. Or perhaps there was another model to which
they approximated and that was Talmudic commentary with its
multiple voices, arguments and counter-statements crowding the page
in all sizes, columns and styles. Here too in the paper world, quite
different pieces of life would meet on the sheet: recipes for medicines,
shopping lists, learned utterances, trousseaus, business accounts – the

one kind of act jostling with the other as they do indeed in life.

So when Solomon Schechter, the Romanian-born, Vienna-educated Cambridge lecturer in Talmudic studies, climbed a ladder propped against the end wall of the ladies' gallery of the handsome (though perpetually restored) Ben Ezra synagogue in Fustat in Old Cairo in December 1896, peered through the arch-shaped hole and beheld what he described as 'a battlefield of books . . . *disjecta membra*', he was looking at nine centuries' worth of paper as well as parchments of that community. It was, he (and the great scholar of the Geniza, S. D. Goitein) would emphasise, the opposite of an archive; rather a pell-mell depository of anything written in Hebrew characters. The immense chaos included damaged or discarded sacred books – festival and daily prayer books, the *siddurim*; editions of the pentateuch; Talmudic writings – which came under the prohibition on destruction. Writing and reading had, as we have seen, been the condition and means by which a Jewish identity had come into being in the first place, its books fashioned through memory and portable, even miniaturised forms, to survive the destruction of other institutions. It was natural, then, for books which through time had 'died' to be treated with the reverence accorded to the Jewish people themselves. The living personality of the books, their vital essence, their *nefesh*, may have fled, but the remaining residual husk of their bodies needed to be stored or interred some place where they might naturally atrophy into dust. To burn or rend them was as brutally abhorrent as if the bodies of persons were likewise maltreated.

Schechter had come to Cairo after an electrifying discovery earlier that year. One of the parchments brought back to Cambridge from Egypt by two middle-aged Scottish Presbyterian sisters, Agnes Lewis and Margaret Gibson, he recognised as a manuscript of the Wisdom of Jesus ben Sirach, the apocryphal book known in Jewish tradition as Ecclesiasticus. Though both the sisters and Schechter are often classified as the 'discoverers' of the Cairo Geniza, the storehouse had been known for a long time, at least since Heinrich Heine's picaresque great-uncle Simon von Geldern, the captain of a band of Judeo-Arab brigands, had run across it at the end of the eighteenth century. Thereafter many had noted its presence without being much bothered to explore its contents. After all, it was a paper and parchment dump rather than an archive, and the nineteenth century was the heyday of

archival organisation right across Europe. Plus the Geniza papers in all their weltering abundance were neither aesthetically beautiful nor immemorially potent. There had been exceptions to this indifference by figures with a special interest, such as Firkovitch the Karaite, but it was Schechter who, following the trip to Fustat, made it his life's passion to keep in one place as much of the Geniza as humanly and financially possible – fearing (correctly) in the age of cultural robber barons that it might be dispersed to places as far apart as St Petersburg and New York – and that that place should be the University of Cambridge, where he taught. Schechter had a patron and mentor in the great orientalist and Bible scholar of Christ's College, William Robertson Smith (whose portrait hung in the Old Combination Room where I used to have lunch in the 1960s and 70s). There followed of course the usual tug-of-war with the deadly tooth-and-claw rival – the Bodleian in Oxford, whose collection of illuminated medieval Hebraica was rivalled only by the Vatican Library. But Schechter – a forceful cigar-chewing personality – was not, in the end, to be denied.

In the original University Library, housed in what is now called 'The Old Schools' where the university administration lodges, Schechter got down to work reading, translating, sorting, identifying, trying to find a path through 100,000 leaves of writing. Sometimes there was more than one document to decipher on a single page of parchment, for when every conceivable space and corner had been filled, the original surface was shaved down and a second page of writing superimposed on the first, making a palimpsest. So there was much to clear away in his head if, following the great Ecclesiasticus discovery, Schechter could track down more monuments of Jewish learning and sacred knowledge: commentaries on commentaries; philosophical-religious enquiries; responses to urgent questions put to the Fustat courts and yeshivas. Incomparable illuminations were indeed lying in wait to gratify his painstaking research, including an autograph by the eminent medieval philosopher, physician and rabbi Moses Maimonides, over forty *piyyutim* liturgical poems from the sixth century by the master Yannai, and others by his hated pupil Qillir. And much more.

All this was and is precious, as was the immense mass of documents that Schechter would have passed over as so much junk but which for social and cultural historians (of whom Goitein has been the

non-pareil) are in fact the purest gold. For it turned out that it was not only religious and high-minded books and manuscripts that were sent to the Cairo Geniza, but virtually everything coming through the community that had been written in Hebrew characters, even when the actual language was Arabic or Aramaic. They too had the dispensation of Geniza retirement and, as it turned out, imperishability (even when stained and damaged). Much of this history (though not all) was written on paper, and it is staggering in its social comprehensiveness. Scattered amid the collection are shopping lists and recipes both for feasts and medicines; formal and informal poems; primitive forms of bills of credit and exchange; household and business accounts; *responsa* from the religious courts or community leaders like Moses Maimonides to questions sent by the perplexed, distressed or merely curious from all over the Jewish world of the Islamic lands; alphabet exercise books of children, complete with doodles when the boy or girl tired of endlessly repeating their letters and preferred instead to turn them into cats or camels. There are personal letters from survivors of shipwrecks; begging letters from the suddenly or not so suddenly impoverished; those irritated complaints of textile orders that were incorrectly fulfilled; troubles with advance payments in distant lands needed to secure goods to be imported back to Egypt and on to customers elsewhere; prenuptial betrothal contracts; arbitrations of abstruse matters of observance where the Talmud had confused the reader or (not infrequently) contradicted itself. In other words, a world, a universe, a *cosmos* of being Jewish was all there in the Cairo Geniza. It is not just the richest and most remarkable of Jewish source collections; it may well be (for so much remains still to be translated and elucidated) the greatest of all medieval archives.

It is packed full of stories, pictures, maps, images – even when all of those things are in the writing of Judeo-Arabic. It tells us, as the excited and possibly over-optimistic Goitein would insist, about what he called the 'symbiosis' of Jewish and Islamic cultures in Egypt and beyond. Symbiosis is a big word – it assumes true, organic and functional interdependence, which may be overstating it – but in comparison, especially, with medieval Christian societies, it is quite true that, in crucial defining ways, Jews and Muslims did indeed live *with* rather than just rub up against each other.

In two respects in particular, the countless lives of the two cultures

belonged to the same realm: where they lived and how they worked. Unlike their counterparts in the Christian world, the Jews of Islam were not legally confined to any district of a city. If they chose to congregate in a particular quarter it was (as it had been in Antioch and classical Alexandria) for proximity to the synagogue on which so much of their life was centred. In Fustat there were three distinctive communities – Babylonian, Palestinian and, radically different, the Karaites who rejected all post-biblical rabbinical authority. Just which of the rabbanite synagogues a Sicilian or a Syrian or a Yemeni Jew might attach himself or herself to was a matter of taste, or the connections of relatives, friends or business partners. Each of the synagogues, though, had their particular forms of Torah-reading, prayer and incantations.

Those of the Babylonian or Iraqi Jews had behind them the authority of the heavyweight Talmud, completed in the ninth century, and the academies of Sura and Pumbedita were said (often, of course, by those who wouldn't be seen dead there) to be grander, graver, and very much longer than the Palestinians'. The Babylonians had the cantors, but the Palestinians had choirs of boys, the most beautiful (so they said) scrolls of the law, and since they read the Torah over three years, their portions were shorter. The Karaites preserved many of the customs which they insisted had been copied by the Muslims rather than the other way round: the removal of shoes, prostration and the like.

The Ben Ezra synagogue of the Geniza in Fustat was deep in the area known as 'The Fortress of the Lamp' and close to a number of churches (as it still is). The houses of worship of both *dhimmi* communities were not separated from the rest of Muslim Fustat. Since there was no Jewish call to prayer they were hardly bothered by the ban on building taller than any mosque – they had no need of a tower. As elsewhere and in other times and places, the synagogue functioned as far more than a prayer house: as a school (for girls, taught by the same women teachers who taught small children, as well as boys); a hostel for Jewish travellers from afar; and, most important, a court which sat twice a week, all its beauty and authority concentrated on the interior.

Though it has been restored and partially rebuilt many times, especially after a major fire in the late nineteenth century, the Ben Ezra synagogue is said to have preserved the essential aspect of the great

medieval synagogue it once was. The arched space has at its centre the *bema* reading table, which, originally movable, became fixed in finely fashioned and polished marble. At the far end was the Ark, the *aron hakodesh*. Congregants stood around the perimeter as they had in Sepphoris and Antioch or sat on the cushions and rugs which were provided by members of the community. Whether or not it was in response to Islamic custom, men and women in the world of the Geniza had come to be separated, the women provided with a wooden gallery and a carved screen through which they could follow the prayers, chants and readings – since many of them had Hebrew, Judeo-Arabic and the more learned some Aramaic. Bronze oil lamps lit the space, casting a glow on the textiles, stone and carved wood surfaces, throwing reflections on the crowns and pomegranate bell *rimmonim* decorating the finials of the Torah as it was carried around the synagogue.

So although there was a Jewish presence concentrated in one area, Jews and Muslims lived among each other. The Geniza documents reveal that sometimes a Jew lived above a Muslim-owned shop or vice versa. A Jewish judge lived in the street of perfumers, many but not all of whom were Jewish; another prominent Jew lived in the street of the wax-makers. And precisely because Jews were not restricted in their occupations (the bearing of arms aside), very often they shared a workshop with Muslims or were business partners in short-term ventures and commercial voyages. Though there were some trades and industries in which Jews were conspicuous – textiles and dyeing above all, but also drugs and pharmaceuticals, and also in the closely related scent and perfume trade, shipping ambergris from the Hispanic Atlantic, frankincense from Arabia, musk from further east – there were so many other professions and businesses practised by Jews that because they were gathered in streets devoted to their speciality, and to the *dar* houses or bazaars, they must of necessity have worked and sold alongside Muslims and Christians in the same line of trade. The Jewish crafts and trades are so richly various that just to list them is to smell them and feel them: sugar-making; paper shipping; the making of leather bottles; copper, tin and the bronzeware that used both; the making of kohlsticks; owning and even crewing merchant ships; import and export of spices – cinnamon, nutmeg, cardamom; also fine carpentry; glass-making (a big Jewish speciality); gems, corals and crystals (the Jews dominated the gemstone bazaar); confectionery and

preserves, almond-paste sweets, and rose marmalade, another big favourite of sellers and customers alike.

There was nowhere Jews wouldn't go for something precious to sell, some commodity that would find its market either in Fustat itself or shipped on west and north. If it took four months to get to Sumatra, a long and dangerous voyage, for the best camphor in the world, then off they went. There were three great geographical axes of long-distance trade. One went west to Sicily, Tunisia, Morocco and sometimes farther on to Muslim Spain, so that the Geniza business records are full of dynasties with relatives posted all along this route. A second, much more ancient trade, was north-east to Syria and Palestine and onwards to Iraq and Iran, connecting at the Caucasus with the silk road routes from the Far East. A third was the most adventurous of all: south-east, down the Red Sea to Aden and across the Indian Ocean to the Malabar and Coromandel coast, the source of many of the most valuable bulk spices. Along the way at the Horn of Africa, it might have been possible to trade for the Sudanese gold that everyone wanted a piece of. All sorts of commercial agents were posted en route and at the point of purchase. It was assumed that the most reliable would be drawn from members of the extended family – sons, but also cousins, uncles and nephews – an assumption regularly belied by the archive of intra-family disputes and feuds found in the Geniza. More dependable (though not immune from complaint) were family slaves, established at port offices and houses throughout the stations of a long-distance business, thought of as part of the dynastic business and personally valued as such, though not always enough to earn their freedom. Back in Fustat, the powerful figure of the *wakil* acted as official warehouse keeper of goods in transit and destined for the home markets; there was also a kind of clearing house and authorisation centre for payments. But the distances were so great, and sending hard money abroad through a third party (for it was forbidden to Jews) so hazardous, that networks of credit developed along the route, working on a basis of personal or familial trust and expressed – seemingly for the first time – in paper promissory notes and obligations, in effect the first cheques.

Every kind and condition of working Jew appears at some point in the melee of the Geniza papers, which itself is a clue to something important about Jewish life in the Islamic world: even when it was in

business, money was not the be-all and end-all. Not that either the little or the big fishes (and there were some very big ones indeed) were exactly indifferent to material fortune, but in the synagogue, in the yeshiva, in their feasts, fasts and ceremonies, listening to the Saturday-afternoon *derash*, paying respect to the *muqaddam* who would lead prayer and make decisions about marriages and divorces, waiting on the *rav* to give his response to a question, or petitioning the secular *rayyis* – the big-shots with connections to high-ups at court – on behalf of distressed family or friends in some far-off place who might need money, intercession or liberation from cruel captivity, the Jewish world crystallised around its ancient sense of ethics. Its wealth, as ever, was moral and spiritual. And so we should not be surprised to discover that the status enjoyed by even the grandest of the grand came not from the size of their fortune so much as their reputation as a scholar, a wise and pious man or woman. Nor should we be amazed to find hard-pressed and preoccupied businessmen taking time off to compose poetry. Abraham ben Yiju, the India trader who settled on the Malabar coast for many years, was much given to trying his hand at poetry; some poems were flagrantly derivative of the great *payetanim* writers of liturgical verses, others closer to Arabic style. But then ben Yiju evidently had a romantic side, manumitting his Indian slave handmaid, Ashu, before her conversion into the Jewess Berakha (Blessing) and marrying her. In Aden, this did nothing to dispel the narrow-minded suspicions of censorious locals who refused to regard either Berakha or their son Abu as legitimate. 'They stunned and hammered me,' ben Yiju wrote in a verse vindication, 'struck me . . . And plundered and tangled me . . . maligned me.' But there were many less colourful than ben Yiju, for whom poetry and philosophical learning was not just a cultural adornment but a basic humane accomplishment without which wealth was merely a kind of gilded boorishness. So the men of trade, with their thousand-dinar fortunes, hunted for scholars as husbands for their daughters and steeped themselves in Talmud and *midrash* commentaries on the Bible texts. They craved respect in the Beit Hamidrash as much as in the marketplace and the *funduq* ware-house. They wanted their names inscribed in reverent memory.

Distances meant absences. Long periods of separation often led to estrangements and disruptions of family life; uncertainties for the women whether their spouse was alive or not; agonising solitude,

painful decisions about whether or not to accept the worst and seek
the formal permission of the court to be free to remarry, and anxieties
as to whether their absent husbands might themselves take a permitted
second wife. Milah had moved away from Fustat to Alexandria, wanting
to give her seven-year-old a schooling superior to local instruction.
Once there, however, she was racked by fears that her husband would
marry again and take the boy back from her.[18] The nagging sorrow
of separation went both ways, though. An advocate, married to the
daughter of a judge in the Nile delta town of al-Mahalla, moved to
Cairo to better his own career and into an abyss of miserable longing
for the wife he had left behind, Umm Thana.[19] The age of the lonely
husband is not known but he certainly rode the adolescent roller
coaster of torment between self-pity – 'there is no one who loves me O
Umm Thana except you' – aggrieved petulance (he knows she is virtuous
but so is he) and desperate threats of quasi-suicidal disappearance.
Our unhappy hubby had obviously been drinking deep of Arabic and
perhaps Hebrew poetry! – 'Come then, or else I will forsake this country
and vanish.' But such vanishing acts had certainly been known. Less
histrionic but deeply touching was the merchant for whom Friday
night when, in the absence of his wife he had to light the Sabbath
candles himself, was the worst ordeal, because in keeping with the
strictures of the Mishnah, that was the night recommended for onah,
the giving and taking of sexual bliss. So the act of celebrating the
arrival of the holy day meant the solitary husband being eaten up
with desire, and perhaps, guiltily and in violation of one of the strictest
religious prohibitions, doing something about it. 'When I light the candle
and put it on whatever table God has provided, then I think about you. God
only knows what comes over me.'

Emotional blackmail could work both ways. The Geniza has letters
from wives who responded to their husbands' endless moaning about
the aches and pains of body, brain and heart, by sighing, 'listen if you
think you've got troubles, try mine'.[20] And, it need hardly be said that
the Geniza has its share of grieving Jewish mothers complaining their
sons don't write. One peerless virtuoso of the maternal guilt trip,
neglected by her bad boy right through the summer when she expected
at least one letter (was that too much to ask, already?), complained,
'You seem to be unaware that when I get a letter from you it is a substitute
for seeing your face.' Don't worry, be cheerful, do your thing, whatever,

I'm all right, this is just *KILLING* me. '*You don't realise my very life depends on getting news about you . . . Do not kill me before my time.*' So all right if you won't send a letter at least, if it's not too much bother, Mr Always Busy Big Shot, at least send your *dirty laundry,* a stained shirt or two, so a poor abandoned mother could summon up her boy's body and have her 'spirits restored'. What an artist.[21]

The Geniza papers are full of every kind of strong woman, most of whom being illiterate and not generally encouraged to acquire writing skills, would have had letters written for them by scribes. But some of the brightest were certainly fully literate for there are elementary school teachers among the women of the Geniza, some instructing boys as well as girls, although one, the daughter of the principal of the Baghdad yeshivah, taught the boys from a window, screened, so that her instruction came from an invisible mouth. Others with less cultural pretensions worked outside the family home as embroiderers and weavers, but not as some sort of ornamental pastime; rather with the wholly practical aim of adding to household income. Others made a reputation as a 'broker' which, since it meant advertising and crying up the wares in the market and in the bazaars, presupposed they worked and walked in the world of men. By Jewish tradition women were required to dress modestly but covering headdresses (as with the orders for turbans) could be designed for colourful elegance with a nod to the demands of propriety.

And every so often there bursts from the Geniza outsize personalities who belie all the commonplaces about family life in this world. One of the 'brokers' was evidently a fully-fledged businesswoman-banker, not just a marketing woman – since she became very wealthy, leaving a fortune of some 700 dinars. Her name was Karima though she was more widely known as Al Wuhsha the Broker, the daughter of a family of bankers, and Goitein says that she recurs more often in the papers of her time than anyone else.[22] And no wonder, for she was as scandalous as she was successful and powerful. An early marriage of the usual kind proved brief and presumably unhappy since she took as lover one Hassun of Ascalon and became pregnant by him. Even during the pregnancy (during which she appeared, outrageously, at the Iraqi synagogue on Yom Kippur, the Day of Atonement, clearly not much into penitential prayers) the always practical Wuhsha began to worry that the illegitimacy of the child

would disqualify him or her from receiving a proper share of inherit-
ance.[23] She and Hassun had gone through some form of ceremony
before an Islamic official, but on the advice of an acquaintance known
as the 'Diadem' who was familiar with the requirements of Jewish
law (not that Wuhsha was any slouch in that department herself), she
arranged to be discovered in bed with Hassun, thereby proving that
it was after all a Jew who was the natural father of their boy Abu.

Once he had served his purpose Wuhsha unburdened herself of
Hassun who slunk off (or possibly ran for his life) back to Palestine.
She never married again, though there was a daughter too. She cut a
dangerous, glamorous figure in Fustat, notorious enough to be denied
much fellowship of the synagogue. But she knew very well how to
take revenge on the self-righteous for her ostracism. In her will (which
specified that Hassun should be left 'not a penny' – what *had* he done?),
Wuhsha bequeathed funds to the synagogue which had kept her at
arm's length – money for oil lamps so that young men could study
deep into the night, and for the upkeep of the fabric – and generously
enough that the elders could not, in all conscience, decline the gift.
On her death, and surely well before it, the invincible donor had the
satisfaction of knowing that the name of Al Wuhsha the Broker would
be invoked in both inscription and spoken remembrance on all the
great days of communal life.

III. What Hebrew Could Say

Sometime around the middle of the tenth century, a Jew at the western
end of the known world took up his quill, dipped it in gall ink, and
wrote to another Jew, at the eastern end, who was, as it happens, also
a king. The writer, Menahem ibn Saruq, was undertaking the task for
his patron and master Hasdai ibn Shaprut, indispensable man to the
caliph of Al-Andalus in the Iberian peninsula, Abdalrahman III. It was
what he was paid to do, illiberally, he sometimes thought. Menahem
was accustomed to addressing letters to the mighty, since Hasdai was
often trusted by the caliph to negotiate with Christian powers: the
emperor of the 'Romans' in Constantinople, or the Spanish king of

Leon to the north. Direct contact between the Christians and Muslims was unthinkable, but the Jew Hasdai, who spoke every tongue imaginable and seemed to have kin or agents in every port and town of the world, and who was famous for cloaking his astuteness in disarming courtesy, could do the caliph's diplomatic bidding where Muslim emissaries were barred. Hasdai would unravel the knot of difficulty. The Jew understood the political balm of gifts. His high taste and discernment would select the right balm for the king of the Franks or the Alans, and he would cast an eye on what was received in return before passing the gift on to his master. And then a prisoner would be released, or a tactical alliance could be arranged with the Byzantine empress, directed against their common adversary, the usurping Abbasid caliph in Baghdad. One way or another matters got settled, but it was always Menahem, the pen of his master's thoughts, who summoned the words which opened the gates of understanding.

This latest task, the letter of introduction, greeting and enquiry to Joseph, the Jewish king of the Khazars, demanded more than the customary formalities. Hasdai's passions and yearnings, Menahem knew, were engaged in this matter, not just his formidable commercial and strategic intelligence. From one such gift-bearing embassy – Persian Khorazan – Hasdai had learned of a vast Jewish kingdom lying on the high grasslands of western Asia, watered by the lower Volga, bordered by the Caspian (then known as Jorjan) Sea to the east, the Black or 'Constantine' Sea to the west and the Caucasus mountains to the north. All of Crimea, and apparently the city of Kiev, lay in its power. The unexpected news, confirmed in 948 by a Khazar Jew who met with one of Hasdai's own men in Constantinople, had excited and dumbfounded the caliph's man, who prided himself on his knowledge of the geography of the dispersion. The sense that the entire earth was filled with the comings and goings of Jews, forever busy except on the days of Sabbath, fasts and feasts, turned the bitterness of exile into a consolation. But to hear of a Jewish state lying to the east of Slavs, Christians and Muslims was as though the body of the Jews had suddenly extended an arm unimaginably far into Asia. 'We were amazed, we lifted up our head, our spirit revived and our hand strengthened.'

From the Khazar in Constantinople Hasdai learned that these distant Jews had originally been tented warriors, pagan devotees of the sky god Tungri and his shamans, dwelling for the most part in yurts. Their

'emperor', or khagan, was himself a sacred figure, but there were surprising limits to his power. On succeeding he would be asked by the lords how long he intended to rule and should he outstay his promise would be swiftly killed. Now and again he would face a challenge from his general, the *bek*, who himself aspired to regal authority. Over the past few generations, towns like the capital, Atil, had been planted in this high country of the kaghanate where brick palaces overlooked the herds and fields of a prospering people. It was almost as much of a miracle as the kingdoms of lost Jews that the traveller Eldad the Danite had sworn worshipped the one true Almighty God on the scorching uplands of Africa. Hasdai wanted to be sure that this latest information was no travellers' tall tale, and questioned another embassy from Constantinople, recently come to Cordoba, who assured him that the Jewish kingdom of Al Kuzari was indeed real, that it lay fifteen days' sea voyage from their own capital, that the present ruler was called Joseph and that hides, fish 'and wares of every kind' were sent from their land. Following this information, Hasdai lost no time in sending his own men to Constantinople with orders to make their way to the realm of the Khazars. But after six months attempting to organise the journey they were told imperiously to desist, that it would be too dangerous to attempt for 'the sea was stormy' and unnavigable in the present season. Hasdai suspected that the perils were all in the minds of the Christian empire, which though on friendly terms with the Khazars, might have been unsettled by the prospect of a connection between the Muslim caliphate of Al-Andalus and a Jewish warrior state to the east.

But Hasdai was haunted by the vision of that Jewish kingdom and now it was Menahem's task to prise open with his words the gates that the Christians had shut. They would have to be Hebrew words, too, not the usual language of diplomatic exchanges, but how else could there be understanding between the Jews of Al-Andalus and Khazaria? And who better than Menahem ibn Saruq, since his life's work was the first ever Hebrew dictionary? He had come to Cordoba as a young man from Tortosa, far to the north-west. There, in the great city of the Umayyad caliph, amid the garden pools and dovecots, Hasdai's father, Isaac ibn Shaprut, had taken Menahem under his wing, in return for the composition of occasional poems and ceremonious inscriptions, including one celebrating Isaac's donation to the grandest

of Cordoba's synagogues. When Isaac died, Menahem composed the proper eulogy and did the same to console Hasdai for the loss of his mother. All he had wanted to do at that point was go back to Tortosa and make whatever modest living was needed to allow him to pursue his real passion of Hebrew grammar.

Then Hasdai, himself deeply versed in Torah and Talmud, rose to unexpected eminence at the caliph's court. There were two things expected of Jews in the Muslim world, two ways they might advance: medicine and money. Hasdai's entrance was afforded by the first and his staying power guaranteed by the second. Vipers' flesh had much to do with it, for that was the indispensable ingredient (it was said) of the *theriacum*, the miraculous cure-all common in antiquity but since lost to physicians. *Theriacum* was an antidote for both known and presumptively unknown poisons – a regular hazard of life at the caliph's court – but it would perform all manner of wonders: make barren women fertile and impotent men virile; banish the falling sickness; give the hard of hearing the alertness of a deer in the forest; loosen the costive bowel and brighten the eye. And Hasdai ibn Shaprut, physician, who had studied the medicine of the Greeks and Romans – as well as being a man of commerce, literary refinement and pious learning – claimed to bring its secrets to the court of Abdalrahman III. Whether or not the drug performed as advertised, no one, not even jealous court physicians, ever accused Hasdai of pharmaceutical deceit. On the contrary, once brought to the caliph's attention, his usefulness brought him further advancement. If there was odium to be risked from collecting taxes, let the Jews take the chance. Thus Hasdai was given the post of customs collector for the river trade on the Guadalquivir flowing through Cordoba, and in tandem the treasury of the caliph and the fortunes of the Jew prospered.

Menahem's letter to King Joseph shows every sign of artful calculation. Hasdai needed to present himself as the eminence of the Jews of Cordoba, perhaps of Al-Andalus in its entirety, but without presuming to address the king as an equal. On the contrary, the panegyric had to be in the manner of a literary abasement without, however, any disagreeable fawning. And Menahem was pleased enough with his efforts to slip a little self-credit into the opening flourish by making an acrostic, spelling out, in the initial letters of each line, not merely the name of Hasdai ibn Shaprut but that of Menahem ibn

Saruq as if they were of comparable station – a subtle impertinence he would live to regret. The first task of the letter, however, was to establish a Jewish comity, to place the Andalusian Jews in the long line of history.

> I Hasdai, son of Isaac, may his memory be blessed, son of Ezra, may his memory be blessed, belonging to the exiled Jews of Jerusalem in Spain, a servant of my Lord the King, bow to the earth before him and prostrate myself towards the abode of Your Majesty. From a distant land I rejoice in your tranquillity and magnificence and stretch forth my hands to God in heaven that he may prolong your reign in Israel.
>
> But who am I and what is my life that I should dare to write a letter to my Lord the King? I rely however on the integrity and uprightness of my object. How indeed can an idea be expressed in fair words by those who have wandered after the glory of the kingdom has departed, who have long suffered afflictions and calamities? . . . We are indeed the remnant of captive Israelites . . . dwelling peacefully in the land of our sojourning for our God has not forsaken us nor has his shadow departed from us.

With a few lines Menahem turned Hasdai into a noble of the exile, worthy to address himself to a king. An ancient tradition asserted that the first Jews in Spain had been taken there in the time of Titus the Conqueror on the request of his consuls who believed they had the makings of useful colonists. Nonetheless they had suffered through the Roman era and then, more bitterly, through the centuries of the barbarian Visigoths, who, as Christians, inflicted a persecution on the small Jewish population. Menahem attached this history to the Bible's long chain of calamities laid across the backs of the Jews by God to punish their perennial transgressions. But when 'God saw their misery and toil and that they were helpless, He led me [i.e. Hasdai] to present myself before the king and has graciously turned his heart to me not because of my own righteousness but for his mercy and the sake of his covenant. By this covenant the hands of the oppressors were relaxed . . . and through the mercy of our God the yoke was lightened.'

Then followed, in Menahem's most lyrical vein, an extravagant, elated, encomium to Al-Andalus. If it was not true Zion flowing with milk and honey, of all possible places of exile, Sefarad 'as it is called

in the sacred tongue' was surely the best, a treasure house of nature, a place of repose.

> The land is rich, abounding in rivers, springs and aqueducts, a land of corn and oil and wine, of fruits and all manner of delicacies, pleasure gardens and orchards, fruitful trees of every kind including the leaves of the tree upon which the silkworm feeds of which we have great abundance. In the mountains and woods of our country cochineal is gathered in great quantity; there are also mountains covered by crocus and with veins of silver, gold, copper, iron, tin, lead, sulphur, porphyry, marble and crystal. Merchants congregate in it and traffickers from the ends of the earth from Egypt and neighbouring countries bringing spices, precious stones, magnificent wares for kings and princes and all the desirable things of Egypt. Our king has collected such large treasure of silver, gold and precious valuables such as no king had ever amassed.[24]

Notwithstanding all this abundance, and the mild benevolence of the caliph, should it be true that the 'Israelitish exiles anywhere form one independent kingdom and are not subject to a foreign ruler . . . then despising all my own glory abandoning my high estate, leaving my family I would go over mountains, hills, through seas and lands till I should arrive at the place where my Lord the King resides that I might see not just his glory and magnificence but also the tranquillity of the Israelites. On beholding this my eyes would brighten my loins would exult my lips would pour forth praises to God.'

There was so much Hasdai wanted to know about this Jewish realm of the east. How extensive was the kingdom, how populous, how many cities and towns were within its borders, how was it governed? But there was another question he hoped King Joseph might be able to answer, a computation of the almanac of redemption. It had been almost a millennium since the Romans had destroyed the Temple. Perhaps the Almighty worked in round numbers? Might the day of the Messiah be at last drawing near? Was the correspondence of two Jewish eminences stretched across the world itself a sign? For all his understanding of heavenly arithmetic, Hasdai still felt himself in the dark. Perhaps King Joseph – who must surely have been appointed by God, a Solomon of the east – had some divination, some particular knowledge of the hastening of the day for 'which we have been waiting

so many years while we have gone from one captivity to the next, from one exile to another'?[25]

King Joseph, as it turns out, was in no position to contemplate the long-term calendar of Jewish history, for his own realm was about to join the chronicle of its disasters. Beset by the armies of Kievan Rus (Scandinavian and Slav), and periodically by the Byzantines, the Khazar Empire – Jewish for probably only a century – was already contracting. Within the next half-century it would be entirely overrun and the royal capital of Atil put to the sack.[26] Khazars would commemorate the disaster of a thousand years before all too exactly. Most of the population would remain and submit to their conquerors and their religions, although some stubbornly Jewish Khazars became in their turn wanderers, two of them showing up in Toledo in the next century as students, their presence in Spain – a possible spur for the *Kuzari*, the poet Yehudah Halevi's great philosophical dialogue-novel defending his own Judaism, written around 1140.

Yet hard-pressed though he was, it seems that King Joseph did have the time and desire to respond to Hasdai, in some form or other, over the thousands of miles that separated them. Two versions of a 'reply' exist, one published as long ago as 1577, a fuller version in the late nineteenth century.[27] In both King Joseph himself relates angelic visions which prompted an ancestor, King Bulan, to be drawn towards the religion of one God. He was succeeded by a pious son, Ovadiah, who stages a debate between spokesmen for the Muslim, Christian and Jewish religions in which the other two monotheisms expressed their view that the faith of Israel was to be preferred over that of their immediate rival. Ovadiah (who seems to have artfully staged the event with prior knowledge of its outcome) could then publicly choose Judaism.

As fantastical as all this seems, at least some of the history was not fable but the truth. In 837 and 838, coins (discovered in a number of hoards from Crimea to Viking Scandinavia) were overstruck bearing the legend 'Moses is the Messenger of God' on one side and 'Land of the Khazars' on the other. Thus Moses displaced Muhammad in the familiar affirmation and evidently some sort of conversion took place in the first half of the ninth century. More information on how and when is supplied by tantalising fragments of five letters evidently not from the hand of the Khazar king himself but almost certainly

dictated by him, and discovered by Solomon Schechter in the vast pile of the Cairo Geniza. Those letters make it apparent that there was indeed written contact between Jewish Khazaria and Cordoba. Written in Hebrew (this itself is something of a miracle) the author identifies himself as a Khazar Jew, but instead of a sudden epiphanous conversion, tells a more drawn-out history of a 'return' to Judaism. It was when the Byzantines defeated the Persians in the middle of the seventh century, and the emperor Heraclius' policy of forced conversion was at hand, that Greek-speaking Jews in some numbers fled from places in the Balkans and Bosporan Crimea, especially the town of Pantikapeum where they prospered for centuries, over the Caucasus to the safety of the still pagan Khazaria.[28] There they received a hospitable welcome and remained for many generations, intermarrying and, in the words of one of the fragments, 'became one people', most of them, as is the way, losing the letter of strict observance which became little more than the practice of circumcision and keeping the Sabbath. But precisely because over time they had become fully Khazar, one of the Jews became a *bek* of their armies and after a particularly spectacular victory, was elevated to the kingship. The *bek* who became known by the Hebrew word for king, *melekh*, is likely to have been the Bulan in the 'reply', and although estranged from the religion was encouraged by his wife Serakh, also of Jewish descent but more faithful, to stage the famous debate which might indeed have been a historical event. Torah scrolls were produced from a Qumran-like cave library that rose from the plains of Tiyul and became the means of full instruction. Bulan took the theophoric name of King Sabriel, circumcised himself and his nobles, imported 'sages' from Baghdad and Persia, built synagogues and a grand sanctuary and kept fasts and feasts. Hanukkah and Passover especially were held in such importance that the *bek* would come from the plains to Atil for their celebration. The Geniza fragments make it clear that the Judaising reforms extended through the whole population (which in any case had a kernel of Jews from the Armenian flight), and that some six kings followed Bulan/Sabriel in the same path called by Hebrew names – Obadiah, Hezekiah, Menashe, Benjamin, Aaron and eventually Joseph. But the century of official Jewish Khazaria may not have been long enough to have rooted itself sufficiently to withstand the invasions from the Rus. When that happened, just two decades after the opening

between Cordoba and Atil, it is impossible to say what proportion of the Khazar Jews left and how many stayed under the new religions.

If Jewish Khazars were on the threshold of disaster at exactly the moment when they made themselves known to the Jews of Al-Andalus, so was the man whose Hebrew had made the connection. It was not long after the Khazar correspondence that Hasdai imported from Baghdad a new and younger light of Hebrew writing, Dunash ben Labrat, and, as it turned out, there was no room for both Menahem and Dunash in Hasdai's circle. They were oil and water, and, more ominously for Menahem, Dunash represented a wholly new way of Hebrew writing. His first name suggests a Berber origin and he had been born in Fez, but Dunash had come of age as a writer in Babylonian Sura where he studied with the great sage Saadia the Gaon. The teacher was himself the embodiment of finding a way to strengthen the teaching of both Torah and Talmud yet turn it confidently towards the philosophical and literary culture in which he lived. This was, momentously, the rediscovery of Greek philosophy transmitted through Syriac Arab sources. No one could remotely accuse the deeply pious and learned Saadia of flirting with alien wisdoms (although they would accuse Dunash of exactly that), but Saadia's great work, *Beliefs and Opinions*, was the first attempt since Philo of Alexandria almost a millennium earlier to justify the core principles of Judaism through rational enquiry, indeed to make the reasoning method the sign of God's particular blessing. Significantly, although Saadia was himself an unimpeachable master of the Talmud and even the definer of its canon, his book returns instead to the Torah and the Bible, possibly as a direct response to the new sect of the Karaites who, from around the ninth century, rejected post-biblical rabbinical commentaries and laws entirely. Even more significantly, in the Graeco-Arabic manner, it follows the long treatise on biblical meanings with a guide on how to lead a truly Jewish contemporary life. Chapters – and for the first time this is a Hebrew *book*, not a scroll – on sexual desire, the urge to wealth, right dealing with neighbours and the like depart entirely from the digressive, elaborate bed of Talmudic discussion and just give clear directions, invariably pointing to restraint while acknowledging the sensual and instinctive force of those cravings.

This two-way response – reinforcing tradition by registering the strength of the physical world – was strongly imprinted on Arabic

poetry and philosophy and it was what Dunash carried with him to Cordoba, determined to turn Hebrew the same way. To accusations that he was an Arabiser, Dunash could reply that on the contrary he was aiming to replace the ideal of *arabiyya* with something no one, other than Saadia, had yet grasped – *yahudiyya*, a language fit not just for chanting and liturgy but philosophy, poetry and who knows what else. And he would do this by injecting the breath of new life into true biblical Hebrew that had become aridly mechanical. Arrogant in his sense of the intellectual superiority of Saadian-Babylonian wisdom, Dunash lost no time heaping scorn on Menahem's arid language studies and in particular on his Hebrew dictionary, the Mahberet, with its obsessional emphasis on the three-letter roots of each and every word in the Bible, which Dunash wrote off as owlish myopia. It didn't help that Menahem knew nothing of Saadia's own philological and lexical work that had prepared the way for Dunash's adventures in the New-Old Hebrew. A little culture war, ugly and vicious, broke out in Cordoba over the fate of Hebrew, its authenticity, traditions, and present and future life, both men mobilising their followers to sling poisoned barbs at each other. Ridiculed by Dunash as a laborious narrow-minded pedant, the humiliation for Menahem was acute, and it only worsened when Dunash wrote and circulated liturgical poetry for inclusion in worship that was swiftly adopted around Jewish Andalusia. Dunash had somehow squared the circle: taking the forms of Arabic metre and rhyme patterns but making them reinforce rather than weaken what he claimed was authentic Hebraic tradition in all its ancient vigour. He studded his poetry and his liturgy with vocabulary taken straight from the Bible. And his *wife* wrote verses. Thus he was new and old at the same time: an invincible phenomenon.

Hasdai fell headlong for all this, and for its smart young spokesman. It must have seemed to the man who had spent his life within high Arabic and Muslim culture that he could now fully embrace its elegance of thought and expression without in any way compromising his Judaism. Dunash's way was the way to reinvigorate a Hebrew that had been in danger of calcifying. On the defensive, fighting for his professional life, Menahem publicly retorted that this was precisely what the suddenly fashionable Dunash literature did: betray the ancient tradition for thinly disguised flirtation with Islam. But as Saadia's prize student – one on whom the teacher, on seeing Dunash's verses, had

proclaimed them to be 'nothing like anything yet seen in Israel' though at the same time deeply orthodox – the younger writer was invulnerable to Menahem's critical flailings.

The culture war escalated and it became fatal. Menahem was not going to hold his tongue, not when he knew his enemy was bent on destruction as surely as if he had attacked him with a dagger. Hasdai looked on, enjoying the gladiatorial contest and ultimately giving a lordly thumbs up to Dunash. When Menahem (and his loyal students) refused to be silenced, Hasdai took it personally. The war over Hebrew was not an academic game. The offending old secretary was violently assaulted in his own house on the Sabbath, his hair torn out by the roots, and marched off to prison. It was a savagely vindictive end to a long, loyal career. Evidently it did not pay to push the great Hasdai ibn Shaprut too far.

Desperation spurs genius, though. Menahem wrote his old patron a letter using exactly the formal rhymes his rival sneered at, but flooding them with memories and a heavy load of guilt directed at Hasdai's conscience. In trouble? Wheel on the sainted parents, may they rest in peace! 'Remember the night your noble mother died . . . By God you came to me on foot at midnight / To bid me compose a eulogy, rhyme a dirge / You found me already writing . . . When your father died / I wrote a great eulogy / Which all Israel recited, one each day / All the days of mourning / I made the pages of your panegyrics swift rider / I made the tale of your glory, chariot wheels in every city.'

Hasdai was unmoved. Even if Menahem was released from prison (and it is by no means certain that he was) he was a broken man. It was left to his embittered disciples to take up his cause, and their version of what they took to be a truly sanctified Hebrew would, in fact, have another chapter in its history. Hebrew authenticity will be fiercely debated as long as there is anyone who can read it. But for the moment Dunash and his style – at once emotively biblical and sharply contemporary – triumphed, with a Hebrew that stole the silk of Arabic form and set it about the shoulders of a handsome new Hebrew literature. *Yahudiyya* had arrived. And because Dunash's verse forms were free and flowing, they were easily adaptable for song. Some entered the liturgy; others lent themselves to the earliest music of informal observance: the songs of the eve of the Sabbath. Menahem's ghost hung around in the academies of the devout, but

Dunash crossed the threshold into hearth and home, sung before the Sabbath candlelight.

IV. Poetry in Power

There are certain things poetry can't do: prolong the life of doomed states, for example. What Dunash had begun would have a long and thrilling future among the Sephardic Jews of the Iberian peninsula, but it would not unfold in Umayyad Cordoba. In the spring of 1013, twenty-three years after Dunash ben Labrat died, Abdalrahman III's grandiose city was put to the sack by the disgruntled Berber warriors who had originally been brought there to defend it. Nearly everything of Cordoba except the vast, glowing mosque at its centre was destroyed. Next time, pay the Berbers.

One of those leaving Cordoba in a hurry, just before it was reduced to ruin, was a young Jew called Shmuel ibn Naghrela.[29] It was said that his father, Yehosef, had been learned and pious enough to send his son to study with the fabled sage Hanoch ben Moshe who, if you can believe the story (and you really shouldn't), was said to have waited on the caliph with seven hundred students, each in their own grand coach. Naghrela would not be remembered for the depth of his piety, but for something else entirely: the startling union, in his person, of poetry and power. He was as politically astute as Hasdai ibn Shaprut and at least as learned in the usual array of disciplines – medicine, philosophy, literature – but unlike Hasdai, he was his own poet. A fourteenth-century Muslim chronicler of Granada describes Naghrela as a paragon of both the arts and sciences who 'went deeply into the principles of the Arabic language, and was familiar with subtlest works of the grammarians' as well as 'excellent in . . . mathematics and astronomy'.[30] He would become the *nagid* of the Jews of Granada, their guardian-protector, and the *wazir*, the chief minister to two of its Zirid dynasty kings. Even more astonishingly Naghrela was, if not the general-in-chief (and he may have been), certainly a high officer in the armies of the Berber amirs of Granada, the strategist of victory.

Yet all this pales beside what he accomplished in his verses. Naghrela

would take the Arabised verse forms inaugurated by Dunash and use them for a radically new kind of Hebrew poetry: sensual and earthy; witty and passionate; steeped in the blood and bragging of battle; drowsy with the all-night wine parties held beside blossom-freckled pools, and even in the visceral slop and stench of the chattering souk. In a shattering poem whose climax is a denunciation of all those who imagine themselves above dumb animals awaiting the butcher's knife, Naghrela takes the reader – or the listener, since the poetry was meant for recital, often with musical accompaniment of flute (halil), the stringed oud and the drum – through 'a market where sheep and oxen stood side by side . . . cattle too many to count . . . and flocks of fowl were all awaiting death / Blood was congealing over clotted blood / While slaughterers were opening veins'.[31] When you are inside a Naghrela poem all your senses are on high alert. 'What I would not do for the youth / Who awoke in the night to the sound of the skilled flutes and lutes / And seeing me there, cup in hand, said to me "Here drink the grape's blood from my lips." Oh, the moon was a yod [the Hebrew letter that resembles an apostrophe] writ small / On the cloak of the dawn in watery gold.'[32]

Though busy with matters of state and community Naghrela seldom seems to have put his pen down. When he quartered his regiment overnight in 'an old fort, razed long ago by war' he has the reader see the sleeping soldiers bunked down amid the ruins: 'And I wondered . . . what had become of the people who dwelled here before us / Where were the builders and soldiers, the wealthy / and poor, the slaves and their lords? . . . They settled across the back of the earth / but rest in the heart of the ground – their magnificent palaces turned into tombs, / their pleasant courts to dust.' But the poet-general is no elegiac sentimentalist. He might be swooning with love, craving the girl or boy dribbling wine into his goblet one moment, but the next he wants you to know he has seen it all. 'First war resembles a beautiful girl we all want to flirt with and believe / Later it's more a repulsive old whore / whose callers are bitter and grieve.' So, inside the fort, the snoring horsemen stretched out on the grass, in his mind's eye he parades the caravan of its earlier occupants only to flinch from the prospect: 'if they could lift their heads and emerge / they'd take our lives and pleasure. In truth my soul, in truth and soon / I'll be like them and these sleepers.'[33] There

had been nothing like him before, and though other great poets would follow, there is still nothing quite like him to this day. His is not a parochial literature. You can read him (even without the elastic sense of rhyme and rhythm in the Hebrew) with no special dispensation for his time or religion; read him as you would Donne, Baudelaire or Brodsky.

For in Shmuel ibn Naghrela the reader encounters, for the first time in Jewish literature, an unapologetically outsized ego, a hand-pumping, back-slapping, rib-whacking, hairily muscular personality, capable nonetheless of inward self-examination and erotic pathos. Even when at his most ruminative, brooding on the inexorable wasting of the years, Naghrela is the earthiest of all the great poetic presences in medieval Hebrew. If it is at all conceivable that a Hebrew poet could also be a field warrior and a politician, then it had to happen with Naghrela whose every motion of mind and muscle suggested the battles of power not least inside his own tight-strung frame.

His bravura was on parade from the beginning. When the young Naghrela left behind broken Cordoba, it was not with a sighing glance backwards at a lost home. He's off, much provoked by presumptuous friends who assume he's leaving to find 'ease or gain'. That wasn't it at all, he wrote, just the opposite in fact. 'By God and God's faithful – and I keep my oaths / I'll climb cliffs / and descend to the innermost pit / and sew the edge of desert to desert, / and split these and every gorge / and sail in mountainous ascent / Until the word "forever" makes sense to me / and my enemies fear me / and my friends in that fear / find solace.'[34]

It is shamelessly boastful, affecting the tone of Muslim warrior poetry. But he enjoyed fighting words. A tradition had the young Naghrela debating the respective merits of Judaism and Islam, no holds barred, with the Arabic writer Ibn Hazm. Later, Ibn Hazm would be provoked to outbursts of hatred against Naghrela and the Jews for daring to question the Quran and the Prophet. Yet much of the strongest Hebrew poetry owed its force to a sense of combat. It's sometimes assumed, misleadingly, that a 'golden age' of Hebrew poetry unfolded in a serene atmosphere of mutual sympathy under stable Muslim governments in Spain. In fact it flourished amid the chaos and violence that followed the collapse of the Umayyads. For as long as Muslim factions and mini-states were busy plotting to destroy

each other, the Jews, disqualified from rulership, were presumed innocent of political ambition.

They were not, however, immune from battles, sieges, random affrays on the highways. Carrying weapons of self-defence was denied them on pain of dramatic penalties. The saddlebags of their mules were a prime target. Notwithstanding his adolescent bluster, Shmuel ibn Naghrela was for a while reduced to keeping a spice shop in the port city of Malaga. Later biographies, especially the Jewish twelfth-century history of Ibrahim Da'ud, had him discovered there by servants of the *wazir* of Granada who realised he was a master of the elaborate Arabic needed for matters of state. The writing opened doors. Naghrela was bidden to come to the fortress hill city, became secretary to the *wazir*, and proved to be so dependable in war and diplomacy that, on the *wazir*'s death, he became his successor.

Once in high office, Naghrela knew how to keep it. On the death of his patron, Habbus, in 1038, the amir's two sons both claimed the succession and were prepared to fight over it. Going against the majority of his own community, who were both proud and nervous of the high place their most famous son had achieved, Naghrela sided with the younger Prince Baddus who, despite the odds, prevailed. Thereafter, the Jewish scholar-warrior-poet – to an extent not even dreamed of by Hasdai ibn Shaprut – became the unchallenged governor of Granada, the manager of its revenues, the high officer of its armies. And all this in a state that was, for a while, the dominant power in east Al-Andalus. Later commentators made it clear that some were shocked by the Zirid amirs entrusting the fate of their realm to an Unbeliever, but politically Naghrela was the beneficiary of his own ineligibility for the amirate itself. He was, as one of the chroniclers put it, 'free from the lust for power', or at least from the suspicion of it.

In so many ways (except the one that ultimately counted) Naghrela was indistinguishable from the Muslims he served so efficiently, and this very accomplishment would be fateful for his son and successor. His Arabic was polished, his manners refined, his courtesies exquisite, his capacity for ruthlessness, when called on, proven. If anyone personified and naturalised a union of Islamic culture and power with unapologetic Judaism, it was Naghrela. This is why Arab commentators like Ibn al Khatib, wary as they were of Unbelievers, and slightly shocked by the possibility that a Jew could effectively be charged with the

government of a Muslim state, admitted that 'although God did not inform him of the right religion' Naghrela had to be regarded as 'an extraordinary man', 'combining . . . a solid and wise character with a lucid spirit and polite and friendly manners'.[35] A later Arab source reported, more resentfully, that when Naghrela was seen in public with his master the amir, beautifully attired, it was impossible to tell who was the leader and who the led. His poetry, too, followed Arabic forms: the rhyming *muwashshah* 'sash' poems with their colloquial two-line '*karja*' pay-off at the end. Their favourite subjects – those all-night parties, when half-stupefied drinkers lost somewhere between slumbrous collapse and erotic awakening reach for a goblet or the boy or girl serving them – were equally violations of Islam and Judaism and equally sensually indulged. 'I in bravely bibbing company / upon a bed of almond blossoms sit / And watch the fair young cupbearer pour out / the drink, and to and from the wine cask flit / while a swain with inkless pen writes music on the lute and crosses it. / Life is but a dance / the earth a maiden laughing with her castanet / The sky a tramping army camped by night / In front of each man's tent a lantern lit.'[36]

Many of the poems of Naghrela (and those who came after him, like Moshe ibn Ezra, also a Granada rabbi poet) are unambiguously homoerotic. '*Emet!*' begins one poem which might be translated confessionally as 'OK, it's true, I *am* in love with' that boy who has been picking roses in your garden. Or again (after a row), '*Le'at!*' – 'Give me a break, will you? My heart isn't made of iron and your anger, my love, right now, is more than I can take.' The *tzevi*, the deer who 'ravished the heart', is unquestionably male (a doe would be *tzeviyah*). And because the same erotic poets write lines of the deepest spirituality, embarrassed or incredulous commentators have insisted, against all the evidence, that the amorousness is metaphorical rather than actually carnal, an inheritance from the biblical Song of Songs in which the body of the beloved is described in lingering close-up detail but thought to be an expression of longing for union with God. However, since Arab sexual culture at that time is known to have countenanced bisexuality, there is absolutely no reason to suppose the same could not have been true of Jewish courtier-writers who lived in the same world. The same *saqi* cup-bearers, trained in flirtation, the girls with their hair cropped like boys, were on hand in Arab and Jewish gatherings, and the same temptations were available, to be resisted or enjoyed.

Naghrela had a famous biblical antecedent in his simultaneous absorption in the sexual and the spiritual: King David the adulterous voyeur, David the brutal warrior politician, David the anguished penitent, with whom Naghrela self-consciously, if a little presumptuously, identified. Like his exemplar, Naghrela was so equally steeped in Judaism and sensuality that his most daring lines could verge on the blasphemous. When he commanded a lover to take 'breast and thigh' he was outrageously invoking the choice body parts of the ram of consecration reserved for the Temple priests who made the sacrificial offering to God.

Naghrela, the *wazir*, was a big fish in a small pond. But neither was Granada a power to be trifled with. It fought battle after battle – against Almeria, Seville and other Berber states – and almost always prevailed. We will never know whether or not the Jew was also the commander-in-chief of a Berber army, but no scholar thinks he imagined his war poetry from some cushion in a walled garden. The lines are soiled with dirt and blood. Many of them, as you would expect, follow the conventions of Arab battle epics, the dastardly foe crushed before the victors. There is much animal and bird imagery; lions with their claws tearing the flanks of fleeing deer. And true to form Naghrela imports from his own tradition some of the more high-pitched archaic poetry of the Bible, although some of the lines are graphic, almost documentary:

> During the day the heavens were noisy with the tumult of horses
> while from their motions the earth shook and trembled . . .
> I saw a crowd break through, hurling stones and then I heard
> jubilant shouts and trumpets.
> We climbed to the top on a ladder made of bows and flying
> arrows . . .
> we made a path to their gates for all who would plunder and
> we entered their courts as one penetrates a broken city . . .
> we made mounds of earth dyed with their blood, a highway from
> the dried corpses of their lords
> As you walked you trampled on a body or a skull and heard the
> screams of the mortally wounded.[37]

Naghrela was both the beneficiary of the endless wars of the Zirid Berber amirs, and the predictable victim of their relentlessness. The

last campaigns, when he was in his middle age and saddle-sore, exhausted him and turned his mind to brooding on the futility of triumph when the ultimate victory was always Death's. Some of the most touching reports from the field he sent to his son Yehosef, born in 1044 and still a youth when his father was a greybeard veteran. In the end, the Naghrela story – and by extension the story of the Jews in Zirid Granada – is all about a father and his son.

It is because of Yehosef that we know as much as we do of the father, for he was his anthologist, editor, the creator of the two *diwan* anthologies, whose Bible-invoking titles *The Little Book of Proverbs* and *The Little Book of Ecclesiastes* (meditations) were presumably Shmuel's idea. So it is the son who supplies the poem testifying the strictness of the homework instructions of the father, even, or especially, while on campaign. From the battlefield itself he sends Yehosef a book of Arab poetry 'copied by me while the sword was drawn' to ensure his son has sufficient mastery to succeed him. 'Even as the grave yawns about me I can't stop educating you.' (These Jewish fathers!) 'Mark what I say, the cultured man is like a fruiting tree; even its leaves will heal the sick / while fools are like forest wood good only to be consumed by fire.'[38] The most beautiful of all moments of father–son communion is set beside a garden pool. Yehosef – who evidently can wind his father round his finger – beckons him in: 'It's never been so full of flowers . . . and I've put in a lawn I can loll on / and have run a brimming channel around it / that rims it like the sky the earth.' They stretch out under pomegranate and chestnut while a servant fills two crystal cups, sets them on a 'raft of mottled reeds / And floated them to us across the water / As if they were two brides on palanquins / And we their grooms / we tossed them down / And stowed them with the empties on the deck, for their return to the barquetender / who in a jiffy filled them up / and with a "Down the hatch sirs!" / sent them back'.[39]

It is a scene of the sweetest intimacy and companionship; a last glimpse before trouble comes calling. Worn out, brooding darkly on his end, Shmuel ibn Naghrela died in 1056, leaving his twenty-one-year-old boy as successor. For all the years of close tutelage Yehosef seems not to have been ready to assume the mantle, although the only accounts we have of the misrule of Yehosef the *wazir* come from bitterly alienated Arab sources. Those chronicles paint a portrait of

an arrogant, overbearing young man, presumptuous, corrupt and even sinister, making the amir his creature by having him drink himself into a stupor, perhaps lacing the wine with some mysterious Jewish potion designed to keep him tame and dependent. Suddenly all the proscriptions forbidding a proper Muslim ruler from putting Jews in positions of authority over Believers were invoked, ancient stereotypes refreshed by new venom. The hatred spilled over from Yehosef himself to all his co-religionists who were subjected to ferocious diatribes cataloguing all the ancient prejudices against the Jews. Ibn Hazm, Shmuel's old literary sparring partner, was especially vicious. The Jews, he wrote, 'are prone to lie . . . [and] whenever there is difficulty they want to wriggle out of it'. Their Torah is full of ignorance and immorality. 'By God it is the way of the Jews. You will not find among them with rare exceptions anyone but a treacherous villain . . . Let any prince upon whom God has bestowed his bounty . . . get away from this dirty stinking crew beset with God's anger and curse, wretchedness and misfortune, filth and dirt like no other people there has ever been. Let him [the Jew] know that the garments in which God has wrapped him are more contagious than elephantiasis.'[40] Abu Ishaq al Ebiri was an even more violent castigator of the amir for 'choosing an infidel as his *katib* . . . the earth trembles at this immorality'. How dare the Jews (now some thousands in their quarter on the hill) give themselves airs and graces when 'they used to wander around in tatters . . . covered with contempt and humiliation they would rummage among the dungheaps for a bit of filthy rag to serve as a shroud for the burial of their dead . . . Pious Muslims are in awe of the vile infidel ape who has seized Granada's revenues . . . dressing in exquisite garments while you are forced to wear the basest clothes . . . therefore make haste to kill him, slaughter and sacrifice him and offer him, fat ram that he is.' The same had to be done to all his kind: 'do not consider killing them as treachery / no it would be treachery to leave them scoffing'.[41]

The demonisation worked. In December 1066, ten years after becoming *wazir*, Yehosef was assassinated, and the Jewish area subjected to a mob attack in which the lives of most of Granada's Jewish community were taken, some four thousand according to the not necessarily reliable Arab sources. We will never know for sure how high-handed and arbitrary Yehosef ibn Naghrela was, for the accounts of his misrule

came from bitterly disaffected quarters. Rather than any particular misdeed, it may have been just the fact of a Jewish dynastic succession in the governance of Granada which fed suspicions of Naghrela's plotting to turn it into a Jewish state.

There was, after all, one of Yehosef's pet projects which might have confirmed those suspicions. On the Sabika hill stood the ruins of a small ninth-century fortress known from its brick as Al-Hamra, the red one. In his passion to ground the Zirid dynasty in Granada's antiquity, Shmuel had excavated what was left of its foundations, planning to create a new palace that would rise from the ruins. Since the Jewish quarter was nearby it would do no harm to them to be associated with this act of architectural piety and power. The plans evidently passed to Yehosef who may have begun to expand them to include a full palace and gardens. Thus it was that the Alhambra began as a Judeo-Muslim project, but it could have been this very fact, the creation of a fortified residence from which the Jew and his like could run the kingdom as their fief, which provoked the murderous backlash. After the bloodshed and the plunder, Jews would return to Granada, but plans for the Alhambra were put into abeyance. Two successive waves of conquerors from Morocco, the Almoravids who took the city in 1070 and the even more militantly puritanical Almohades in the following century, meant that it would be two centuries before the Naghrela vision for a palace on the hill would be realised under the Nasrid dynasty, and achieve in Andalusia the most perfect expression of Muslim architectural poetics the world has ever seen.

V. Blown Over the Deep: The Wandering of Yehudah Halevi

The secluded courtyard garden, was the place where the Jews of Al-Andalus best fitted the Muslim world. Like the poetry their writers had mastered, it had form and measure within which nature's profusion blossomed. Pomegranate trees overhung the paths and pools, shedding oily leaves. Jasmine climbed the brick walls, and as the sun dimmed over Granada and Cordoba, its intense, complicated perfume

would suddenly catch the senses unawares. The strings of an oud would begin their chords while the heel of a hand beat a rhythm on a dull drum. Guests would arrange themselves on cushions, receive the first goblets of wine from the 'gazelles' and when the songs and the wine had diffused woozy pleasure through the company, recitations might begin on the usual matters: the cruelty of beauty, the torment of desire, the fullness of lips, the suppleness of limbs, the velvety night, the feckless vanity of the beloved, the consoling cup. The Hebrew was sonorous, the Arabic interpellations witty. The poets rose to the challenge to best their friends and rivals and shrugged off defeats. The poetical Jews seemed as pleasurably intertwined with this world as the snaking forms of the sash poems, the *muwashshah*, that epitomised it.

This is what the adolescent Yehudah Halevi, son of Levites, must have expected when he made the long journey south to Granada from his home town of Tudela in Christian Navarre, as the first black hairs popped forth on his chin, an event demanding, and getting, a verse or two. It had been twenty years since the Granada massacre. The terror had abated and Jews who had fled returned to the Sabika hill. They prayed, they traded, they still collected taxes but were nervously diplomatic about the manner in which they went about that business. They avoided extravagance. They even continued to write poetry. The most accomplished among them, Moshe ibn Ezra, was from an old Granada courtier family which had somehow survived the throat-slittings of 1066 and had returned to quiet, careful, prospering work. Twenty years older than Halevi, ibn Ezra's attention had been caught by the boy's poems, presumptuous self-introductions, persistently sent from the north. They were good enough, for an invitation had been sent to the precocious teenager who, on arrival, sometime around 1088-9, turned out to be by turns playful and devout. He had the old refrains down pat, but what made Halevi different was his eye–hand coordination. He saw things differently and then he found the words for them. A 'gazelle' would wash her clothes in the pool of her rejected lover's tears, and then would lay them out to dry in the heat of her own splendour. Halevi was sunstruck, heat-happy. Auburn hair fell over a damp 'crystal' brow (fire and ice always a good combo) and then at night's end would dissolve into the perfectly exhilarating sunrise, the afterburn of desire: 'reddening the clouds with flames'.

Halevi was welcomed into the garden of ibn Ezra's poetry and into his house. He may even have briefly served as the older man's secretary, the standard apprenticeship for such protégés. But he barely had time to smell the jasmine before the walled peace was broken forever and Jewish Granada finished. At the end of the eleventh century what had happened to the Umayyads at the beginning repeated itself. Berber warriors from Morocco, called in to reinforce the Muslim states against Christian advances, succeeded all too well, turning on their patrons and taking the whole of Andalusia including Granada as their own power. As with previous moments of Islamic renewal, the warriors were ascetic, militant, hostile to laxness and luxury, and all of that – needless to say – was Bad for the Jews. Under the new puritanism, it was unthinkable that Unbelievers should hold high office. Moshe's brothers left Granada for good as their property and possessions were taken. The poet stayed on a few years longer before leaving Sabika hill and embarking on a bitter life of journeying across frontiers, lost Andalusia always on his mind. Later on, when he was middle-aged, Halevi would write Moshe lines recalling the time when 'no one harnessed or rode / the wagons of wandering road . . . our days were unbroken and whole / Time bore us separately but love which bore us [as] twins / raised us in her spice garden / suckled us with guzzled wine'.[42]

Having imagined a serene life with a benevolent mentor in Granada, Halevi became very familiar with those 'wagons of wandering'. The map of his travels is hard to trace with any exactness, but it seems as though after leaving Granada he moved west to Lucena, the Andalusian city that was predominantly Jewish and where Halevi knew the head of the yeshiva school. But its Judaism made it a prime target for the Almoravid conquerors who exacted brutally punitive taxes as the price of avoiding forced conversion to Islam. Halevi moved on to Seville, surviving by being, in effect, a jobbing poet, writing for weddings, funerals and any grand occasions in the increasingly constrained life of the Andalusian Jews. The poems from these years – which still startle by their freshness and conversational immediacy – most often arise from this unsettled state: partings, separations, absences, longings. Bound 'ruthlessly' in captivity by a 'doe' and then forced to take leave, the pining lover turns 'to an apple for succour / whose fragrance recalls your breath like myrrh / its shape your breast / and its colour the flush that races through your cheeks when you blush'.[43] Another

poem, probably from the same period, onomatopoeically echoes in Hebrew the sound of a groaning sigh, each line ending in 'ach' while the deserted lover complains conversationally she doesn't call, she doesn't write . . . 'why darling have you barred all news / from one who aches for you within the cage of his own ribs / you must know a lover's thoughts / care only for the sound of your hellos? / At least if parting was the fate reserved for us / you might have lingered till my gaze had left your face.'[44]

Eventually, sometime in the first decade of the twelfth century, Halevi decided he had had enough of the Almoravids and moved across the religious and military frontier to Toledo in Christian Castile. It was not as though he was entering terra incognita. His childhood had been spent in Tudela, further north in Christian Navarre. The Castilian king Alfonso VI had shown himself hospitable to Jews precisely because of their helpful knowledge of the language and culture of their Muslim enemies, but his hospitality went beyond strategic convenience. There was a large and thriving Jewish community in Toledo which now included Halevi's old mentor Moshe ibn Ezra, as well as the famous Yosef ibn Ferruziel, a powerful grandee in the town and the king's own doctor. It may have been the demand for Jewish physicians that prompted Halevi to become one himself as a way of supplementing his income. But although Halevi stayed there for twenty years, married, had three children, it seems never to have been a place where he felt secure or especially happy. The doctoring was drudgery; Moshe ibn Ezra had moved away under the shadow of a scandal involving a niece; his friend Shlomo ibn Ferruziel, Yosef's nephew, was murdered on a highway, prompting an outpouring of grief and rage at the Christians. Two of Halevi's three children died, a misery which drew from the bereaved father one of his most heartbreakingly beautiful poems, written in three voices – of himself, his wife and the dead child: 'Were I to cry / whole rivers for her / Still she would lie / In a wormy pit / Deep-sepulchred / Earth-bonneted / My child there is no clemency / for death has come between you and me.'[45] Death would not leave him alone in Toledo. In 1109, following the demise of the benevolent Alfonso VI and awaiting the succession of his son-in-law the king of Aragon, yet another violent onslaught took place against the Jews.

Where did a place of safety lie in Spain? Nowhere, for Castile was

making the life of Jews difficult, and the Almoravids who had relaxed their harshness somewhat were, for that very reason, about to be succeeded by yet another warrior tribe, migrating from the place where endless waves of puritanical cleansing were stirred up between the Atlas mountains and the sea: Almohades. They would make life for the Jews near to unbearable, subjecting them to waves of violence, the destruction of synagogues and communities, forced conversions at the edge of a sword. For the moment, though, the Almoravids were hanging on, enough at any rate for Halevi to load his wagon sometime in the late 1120s and for the second time in his life migrate south, back towards the swallows of Andalusia. The place he himself roosted for a while was the city where a century and a half before, the new Hebrew poetry had begun: Hasdai's Cordoba.

All this perilous shuttling between rival sets of persecutors had changed Halevi. He was now middle-aged and, perhaps understandably, given to raining curses on the persecutors of the Jews, Christian and Muslim alike. A dawning, bitter conviction that the Jews could expect no refuge, no succour, no understanding from anyone except their God and their religion, was drawing him away from the possibility of a genuine coexistence with either Muslims or Christians and towards an intense communion with his Judaism. His knowledge, from correspondents in Cairo, of the killing of Jerusalem Jews by the notorious Crusaders and the burning of their synagogue, only deepened his despair and resolution.

But the lingering ghosts of Jewish Cordoba prompted Halevi to think again both about his poetry and his Judaism. Yehudah Halevi, in whose hands Hebrew poetry, following Arabic models, had achieved an extraordinary consummation of vitality and grace, now began to summon up that old, bloody war of duelling poets so brutally adjudicated by Hasdai ibn Shaprut over a century earlier. Like all skilled versifiers Halevi had followed Dunash ben Labrat's emulation of Arab forms, and perfected them. But now he thought about the apparent loser, Menahem ibn Saruq, literally beaten for his presumption that the Hebrew of the Bible and the liturgical *piyyutim* should find its own way forward. Perhaps Menahem and his followers had been right. Perhaps it should be possible to write an intensely spiritual Hebrew that kept faith with everything Judaism held sacred. If love poetry that also sang of love of God in tones of deepest, physical yearning was to

be written, why not do it in the language of the Song of Songs, not Arab wine poetry? And so Halevi's poetry began to change, to take on weight, gravity and ancient passion. It was as if Menahem ibn Saruq, bare patches on his scalp where the hair had been torn from the roots by Hasdai's thugs, was standing over Halevi's shoulder, finally satisfied with belated vindication.

There was another memory of that time which fed even more momentously into Halevi's preoccupations: the letter written by Menahem on Hasdai's behalf to the king of the Khazars. In Toledo, driven by a bitter realisation that sharing language, living space, even elements of belief, with Muslims and Christians ultimately counted for nothing when they chose to turn violently on the Jews, Halevi had begun to write a work of unapologetic reaffirmation of the singularity of Judaism and of the unique history that flowed from it. The memory-mirage of a distant kingdom in which Jews and Judaism might actually have held their own (and who knew, perhaps still did?) fed his increasing indignation at their contemporary defencelessness. Deprived of the power of arms, Halevi would see to it that they asserted the power of their language and religion. The *Kuzari* took the form of a dialogue between a learned rabbi and the unnamed king of the Khazars who became persuaded to convert himself and his empire to Judaism. But it was in Cordoba, where the memory of the actual historical moment of this episode, nearly two centuries earlier, was still alive, that Halevi completed his paradoxically philosophical attack on the presumptions of metaphysical philosophy. And tellingly, he wrote a book which among other things was a repudiation of the dependence of Hebrew on Arabic *in* Arabic, the language in which Greek philosophy had been transmitted and of course the language of those who expressed their habitual contempt for the inferior Jews.

Halevi, the literary dramatist of revenge and vindication, sets up the king for the predictable surprise illumination. His story follows the legend of an angelic dream visitation to the king after which he summons representatives of Islam and Christianity to advocate the claims of their respective faiths. No champion of the Jews is called on for they were so universally despised it was unthinkable that their peculiar creed could possibly emerge superior from the debate. Yet while both the priest and the imam concede the ancient Judaic founda-tion on which their respective religions were based, they denounced

that of each other as utter falsehoods. The rabbi has little to do other than appear for the king to be won over. For if it was true that the later monotheisms were mere amendments to the original – one, moreover, tainted by pseudo-paganism, the other suspect for its claims that God still spoke directly to a latter-day prophet – why not embrace the foundation-faith? Journeying to a cave where the scrolls of the Jews had been preserved, the king is formally converted, circumcised and returns to his capital full of projects to build synagogues and educate his people in the principles and practices of the new religion.

It is impossible to read the *Kuzari* without feeling that Halevi is writing as much for his own self-clarification as for the enlightenment of others. Some of the most impassioned sections make the case for the irreducible uniqueness of the 'first language' (as he thought), Hebrew, as the perfect vehicle for every kind of expression, both practical and spiritual. It is as if – writing in Arabic – he wanted to purge Hebrew of its long Arabisation. Similarly he wanted to liberate Judaism from Graeco-Arabic enquiries into the nature of God. The book, written in Arabic, had the subtitle of *An Argument for the Faith of Israel* and he means it to stand free from the hermeneutic principles informing Greek metaphysics. That kind of questioning, inherited from Plato and Aristotle and designed to yield *knowledge* of God, through study of His Creation, graduating progressively from the understanding of natural phenomena towards the revelation of the Prime Cause, was an exercise doomed to futility since the Jewish God was intrinsically and ultimately unknowable. Instead of embarking on this rationalist's fools errand, Judaism counselled communion and was thus a state of longing, more like the inexpressible unassuageable cravings of lovers, rather than the reflexive, self-fulfilling enquiries of pure reason. Increasingly Halevi was making his own poetry express that yearning with an intensity that took him to the very edge of the boundary between life and death:

> All my desire is here before you
> whether or not I speak of it
> I'd seek your favour for an instant then die –
> if only you would grant my wish
> I'd place my spirit in your hand
> then sleep and in that sleep find sweetness.[46]

Surrender to that longing did not signify an indifference to social wisdom. On the contrary, the Torah abounded in such ethical necessities. Admonitions to love parents, abhor murder, adultery and the covetousness that is the overture to crime were all social and rational instructions. But significantly they followed the opening commandments which were non-rational affirmations and prime principles: 'I am the Lord your God, have no other gods before me, take not my name in vain', and so on. And much of Judaism was simply the resolution to embrace this singularity, observe the laws that flowed from it, maintain the customs (the *tefillin* phylacteries bound on hand and brow; the fringed *tzitzit*) as a way of living constantly and uninterruptedly with the presence of the sacred.

So while repudiating the self-sufficiency of reason, or even the need, argued in Philo a millennium before and by Moses Maimonides a century later, of opening religion to enquiry, Halevi's Judaism is not mystical. Far from it, the doctor (however reluctant) is at pains to tell the Khazar king that the Jews were anciently expert in astronomy, had given the world calendrical divisions of time that have since been universally accepted, and the rest day of the week that also passed into common use. The Torah, he insists, might seem eccentric but, as the rabbis and sages of the Talmud endeavoured to explain, is in fact packed with material instruction, for example, on how to determine blemishes or impurities in animals that might render them unfit for both sacrifice and human consumption. Halevi's attitude to unearthly sacred matters is, unsurprisingly, poetic: the essence of God shrouded from the view of reason, absent from the workaday world, embodied only in forms of godly names, but needing verbalisation and vocalisation in common, whether through prayer song or poetry.

Although, predictably in this kind of work, the Khazar king is often reduced to exclamations of excited wonder at the rabbinical illuminations set before him, there are striking moments when he impersonates that side of the poet who is constantly taking Yehudah to task for vacillation, contradiction and moral cowardice. The critical moment comes when Halevi describes exile from Zion as a kind of sleep; an awakening would happen when the Jews returned to the land where the covenant was made, the laws were received and the prophets opened to vision. Even though the *shekhina*, the divine presence, no longer dwells there, the rabbis and sages have said that 'it is

better to dwell in the Holy Land even in a town mostly inhabited by heathens than abroad in a town mostly populated by Israelites for he who dwells in the Holy Land is compared to him who has a God whereas he who dwells elsewhere is compared to him who has no God'. To be buried there is to be buried beneath an altar, he goes on.[47] At which point the king retorts, 'If this be so thou fallest short of the duty laid down in thy law by not endeavouring to reach that place and make it thy abode in this life and death although thou sayest, "Have mercy on Zion for it is the house of our life."'

And this is indeed the self-accusation which increasingly agonised Halevi in Cordoba. The logical end of his withdrawal from Muslim and Christian culture was the personal journey back to Zion itself. The fact that Jerusalem was now in the hands of the Crusaders and that Jews had been massacred there somehow made this vocation more not less urgent. Intensifying belief was making Halevi listen to his inner voice which told him that when there were enough Jews standing on the Mount of Olives facing the Temple Mount, the *shekhina* would return to the ruined shrine from which she had fled; and when she was manifest, even the Messiah might reappear. In the *Kuzari* his rabbinical alter ego had told the king as a spur to conversion that good intentions were of no account without the deeds that followed. So now he regularly reproached himself, eaten up by a sense of being only half alive in the exile which he described as a kind of sleep. The Ark, he had written in the *Kuzari*, was a heart and now it was plain that his own lay east of the Sefarad of the Iberian peninsula:

> My heart is in the East
> And I am at the edge of the West
> How can I possibly taste what I eat?
> How could it please me?
>
> I'd gladly leave behind me
> all the pleasures of Spain
> if only I might see
> the dust and ruins of your Shrine.[48]

Not quite glad enough, though; not yet. Instead of embarking on an eastward-sailing vessel, Yehudah Halevi embarked on a procrastination

extending many years, alternately flaying himself for his cowardly irresolution, and plunging into terror at what such a journey might hold. Those fears were understandable. Even had the Holy Land not been embroiled by holy war, the perils of such a journey were daunting for a man well into his fifties. The kind of square-rigged vessel which would take him from Seville to either Egypt or Palestine, a journey that could take two months, would be cramped, squalid and uncomfortable. There would be no respect for his grey beard. He would get no more than a wooden pallet to sleep on, as comfortless as a living coffin. Crammed into the tight space there would be nowhere for him to stretch his legs and he would be forced to squat on the swaying deck when he could no longer bear to stand. The nights would be alive with the scuttle of rats and foul with the stench of vomit as the ship bucketed about in squalls. Discomfort would give way to terror when the ship pitched so violently it seemed it must be wrecked. It happened all the time. And from the ransoms he had had to raise for Jewish captives, Halevi was well aware that the eastern Mediterranean was the choice hunting ground for pirates.

In the spirit of trying to exorcise fright by summoning it, Halevi wrote one of his most intensely felt poems in advance of his eventual departure, upbraiding himself for his equivocation as the days of his life ran short: 'try to appease your Creator with your dwindling hours . . . be like a lion to please him . . . your heart at sea will not fail'. Fighting words, but picturing himself out of sight of shore, caught in dirty weather, the poet is overcome by the panicky helplessness all around him: 'decks and compartments rattle / stacked within the hull / men pull at the ropes / in pain, while others are ill . . . the cedar masts are like straw / ballast of iron and sand is tossed around like hay / everyone prays in their several ways / but you turn to the Lord'. All but lost, he prays and of course his prayers are answered. The mountainous waters fall back obediently into a perfect calm; the moon appears, most beautifully described as an Ethiopian, veiled in gold. The shining stars reflected in the mirroring sea turn into a myriad of water-borne Jews, exiles and fugitives, bobbing on the surface. And suddenly the imagining poet catches a marine epiphany. Sea and sky melt into one in the velvety darkness: 'the two seas are bound together / between them lies a third, my heart, / pounding with waves of praise'.[49]

Eventually, sometime in the summer of 1140, Yehudah Halevi finally

packs up and goes. Travelling with him is Yitzhak ibn Ezra, the husband of his only surviving child who leaves behind both his wife and son, Yehudah, named for his grandpa, and one Shlomo ibn Gabbai. The poet makes a great show of cutting loose from home, country, even the wife of many years who does not seem to have had any great hold on him. Only the thought of perhaps never seeing his grandson again snags his heart. But, he tells beckoning God, 'these are trifles beside your love . . . soon I will enter your gates with thanksgiving . . . I'll raise a tombstone in your land / There as a witness to myself'.[50] The voyage is every bit as hellish as he had imagined and generated another wind-whipped sea poem once safely in Alexandria in early September.

And there another obstacle to the fulfilment of his vows presented itself: celebrity. Letters preserved in the Cairo Geniza have revealed Halevi as the object of a near cult following among the well-to-do, the pious and the culturally ambitious of both Alexandria and Cairo. Letters pass between them expressing their excitement at his impending arrival, their concern at its delay, intense competition among the poet-hunters as to who would offer him hospitality, pangs of deadly jealousy when the Great Man was said to have graced one home but, inexplicably, not theirs! This seems to have taken Halevi by surprise and, to begin with, once he had got his land legs back, yet more conflicted feelings. Had he not come as a pilgrim, stripped of possessions and worldly vanities, wanting only to get himself to Palestine as quickly as possible and there 'kiss the dust, as sweet in the mouth as honey', of its sacred ruins? But oh dear, after all the battering at sea, another journey, whether overland on the caravan route or by sea again to Acre, suddenly seemed a bit daunting for his old bones. For that matter Rosh Hashanah, the New Year, and then the Day of Atonement and then the Feast of Tabernacles, Sukkot and then the Rejoicing of the Law (how could he not rejoice?) were imminent, one after the other, and by then, the bad weather would have set in that would make a second sea voyage an appalling prospect. And people in Alexandria were so very kind, falling over each other to be hospitable, especially Aharon al-Ammani, the pillar of the community, who had opened his doors, well, insisted really on his resting a while in his mansion so beautiful, with its *bustan* of tended trees and plashy fountains . . .

So for over two months, Yehudah stayed, along with the son-in-law

and the friend, grateful for al-Ammani's lavish provision of comforts, the fine food, the peace of the courtyard, disturbed only by fans hammering down the doors to tug at the hem of his garment. Winter was closing in on the sea routes but if he wanted it as badly as he said he did, Halevi could still go to Fustat, where a competing group of admirers, including his old friend Halfon ibn Natanael, were crying out for the pleasure of his company, and organise a place in a caravan destined for the Holy Land. Sometime before Hanukkah he made the trip up the Nile, lodging with the *nagid*, the head of the Cairo community, Shmuel ibn Hananiah, who attempted, not too strenuously, to fend off the pursuing hordes of hospitality-hounds. At some point during the winter it seems that Halevi attempted the overland journey, as arduous in its way as the sea voyage, saddled on a jolting, swaying camel for hours on end, the route much further south than the normal trains. Whether because of the discomfort, sickness or anxiety, he abandoned the caravan and returned to Fustat, amid, for the first time, much clucking of tongues, shaking of heads and 'I told you so's by those who had said all along it was too much for a greybeard in his mid-sixties. What was so wrong with Egypt after all?

Not much, the poet-prophet of redemption and Zionist return would concede, when every so often he escaped to the great river. Was he not allowed to enjoy it? Had not Joseph prospered? Had Egypt been in the plans of the Lord? And as he ceased to berate himself, and the margins of the river suddenly broke into green, the old Yehudah, much given to drinking in the pleasures of life, produced a last burst of springtime celebration:

> Has time taken off its clothes of trembling
> and donned its finest gown and jewels
> is the earth now wearing robes of linen
> richly woven, threaded with gold . . .[51]

But it's not just nature the old boy is gazing at:

> girls wander beside the river
> their hands weighed down by bracelets of brass
> their walk confined by anklets.

And he is a boy in Granada again who can't take his eyes off the beauties:

> the heart forgetting its age, is tempted
> and finds itself thinking of Egypt's Eden
> its young there by the river gardens
> along its banks across its fields
> where the wheat has turned reddish gold.

He is writing once more an Arabic-style *qasida*, in which it is allowed, expected, to begin with desire as long as one ends in piety, which Halevi has no trouble with. That breeze is coming from the west, bidding him sail again, back from Alexandria this time, to reach his last destination.

The poem, filled with two kinds of longing, was so immediately popular that Halevi could not help writing another to his Alexandria host al-Ammani even more shockingly sensual, featuring those girls with all the hardware on their wrists and ankles, 'burdened by silver bells of apples and pomegranates', their hair as 'black as the gloom of goodbyes' or so fair that 'One look at the sun from them and it would get sunburned . . . luscious, lithe or lanky I could fall for them all and their perilous red mouths'.[52] In the second half of the poem Halevi properly reverts to piety, picturing himself as a barefoot pilgrim in Zion, flooding its ground with his tears, but the lip-smacking ogling of the earlier lines, coming as they did from the dilatory old boy, were disturbing enough for an acquaintance who had organised the abortive overland caravan to carp at its frivolousness to al-Ammani, who in his turn doesn't seem to have minded it a bit.

It was, in any case, a final outburst of worldly delight. Passover in Egypt came and went and Yehudah Halevi at last faced the east in his prayers with more than just a formal gesture. The solitary journey he had said he would make was now upon him, for his son-in-law Yitzhak told him that he was staying in Cairo and Shlomo ibn Gabbai was not coming either. On 7 May, alone, unquiet in his mind and heart, the poet boarded a ship that had come from Kairouan in Tunisia and was bound for Acre. For another week, the prevailing winds were from the east. Then they shifted. The sails billowed; the vessel moved out of the harbour and Yehudah Halevi was seen no more.

For centuries Jews wanted to know what had become of him.[53] The traveller from Halevi's home town, Benjamin of Tudela, claimed to have seen his tomb close to Tiberias right on the shore of the Sea of Galilee. But no subsequent witnesses verified it, and given Halevi's fame and the tenacity of Jewish pilgrimages, it seems unlikely that such a site would have been neglected. In any case, Jewish longing for Jerusalem projected on to Yehudah Halevi, who longed for it more eloquently and desperately than any other Hebrew poet before or since, a story that could match the intensity of that craving. In the sixteenth century the Italian Jew Gedaliah ibn Yahya claimed in a Hebrew collection published in Venice in 1586 that Halevi had indeed got to the gates of Jerusalem where he had been trampled to death beneath the hooves of an Arab rider's horse.

Was it even conceivable that he had got that far?[54] Assuming he had survived the relatively short voyage from Alexandria to Acre, sometime in late May or early June 1141, it might have been possible for Halevi to have gone to Jerusalem near the fast day of the 9th of Ab, falling on 18 July that year, when the ban on Jews was relaxed to allow them to mourn the destruction of both Solomon's and the Second Temple. The old practice of walking round the city perimeter and praying at the gates was frowned on by the Crusaders, but Halevi might still have been able to climb the Mount of Olives and look towards the Temple Mount where the Dome of the Rock had been turned into a church. It would have been like him, having got that far, to want to approach a gate, perhaps even prostrate himself in the dirt which he had said over and over again would be scented like myrrh and taste as sweet as honey.

THE WOMEN OF ASHKENAZ

I. Sacrificial Lambs

Such beautiful names, such terrible ends. Doulcea, the sweet one, *eshet chayil*, the woman of worth, price above rubies to her husband the Pietist rabbi Eleazar bar Yehudah, known as the Perfumer, cut to pieces on the streets of Worms in 1196, trying to summon help while her daughters Hannah and Bellette lay dying inside the house; Licoricia, tough as nails, twice-widowed, moneybags loaded, who survived *three* spells in the Tower of London, only to be murdered in her Winchester house along with her Christian maidservant in 1277; Zipporah of Worms, the bird caught in a suicide trap, in the spring of 1096, Crusader bands shouting for the blood of the Christ-killers, imploring her husband to kill her first so she might be spared the sight of her son slaughtered by his father's knife; Sarit of Cologne, the comely bride, sliced up the middle, groin to throat, by her father-in-law Judah the Levite, her nuptials turned into a blood wedding; the women on the bridge, two from Cologne, two from Trier, watching their sisters dragged mercilessly to the baptismal font, resolving on a defiant counter-baptism, jumping to a drowning death in the dark waters of the Mosel; the nameless convert who had married Rabbi David Todros of Narbonne, pursued by her outraged family, finding sheltering obscurity in Monieux until a crusading gang killed Rabbi David, seized two of their children for captive conversions, leaving the widowed proselyte destitute with her infant boy.[1]

And then there was Poulceline, whom everyone would hear about, fair Poulceline, close – very close, according to Ephraim of Bonn – to

Thibaut, Count of Blois, seneschal of France, the king's brother-in-law, none of which was any help when the Jews of Blois were being burned alive on a pyre in 1171, Poulceline included. What had she done? What had any of the beautiful names done? As usual, nothing except to be born Jews. What they were *said* to have done, though, was kill children, especially Christian children. No actual body was needed for the accusation to become credible. No one in Blois ever found a body, nor was any child missing, but in May a serving man happened to be watering his horse by the Loire when he saw something small and pale slip from the grasp of a Jew beside the river. What that Jew had been holding was in fact a batch of untanned hides, but when one splashed into the water, the servant reported to his master, his horse shied and refused to drink, a sure sign that something foul had been committed to the river. A skin was a skin. The incident was reported to Count Thibaut who judged it serious enough for the man to be subjected to the water ordeal to test if his word was true or false. He survived; and the thirty or so Jews of Blois were arrested and imprisoned, shackled to each other and to the floor in the usual style of the time. Poulceline alone was spared the incarceration, much to the fury of Countess Alix whose enemy she had become. But such was the power it was feared the Jewish woman might have over the count that Poulceline was prevented from speaking to him. Like so many women in the Ashkenazi world of northern Europe, Poulceline was a woman of substance, a moneylender to poor and rich, Jew and Christian alike, and as such she had been useful enough to the count to enjoy his esteem and perhaps more. Every so often she remonstrated with him over the injustices inflicted on her co-religionists. This may have made things worse, for whether it was her cash or her body or both that had recommended Poulceline to Thibaut, she had become a figure of intense unpopularity in the town. Before long she joined the rest of the Jews in prison and on 26 May died with them in the flames of the market square. Perhaps the tale of the child dumped in the Loire had been concocted just to bring Poulceline down.

Reported in letters sent by Jews in Orleans and Loches, the judicial massacre was sufficiently horrifying to embolden a deputation by the Jews of Paris to King Louis VII. A letter reporting the royal response announced the good news that the king had 'benevolently inclined his heart towards us'. Surprisingly, Louis warned that if Thibaut had

acted unjustly he would be punished. 'Now, you Jews of my land, you have no cause for alarm over what the persecutor has done in his domain. People levelled the same accusation at the Jews of Pontoise and Joinville and when the charges were brought before me they were found to be false . . . be assured Jews in my land, I harbour no such suspicion. Even if a body were discovered in the city or in the countryside I should say nothing to the Jews in that regard.'[2]

The hand-wringing came too late. Jewish Blois had been wiped out in a single day as the result of a baseless accusation, though by some miracle (probably involving money), the books and scrolls of the community were saved. It had taken little more than a horse allegedly refusing to drink river water for an entire community to be indicted as slayers of Christian children. The popular paranoia about what Jews did to children, including their own, went back to antiquity. Josephus and Philo of Alexandria had had to take accusations of Jewish child abductions seriously enough to refute them. And John Chrysostom in Antioch repeatedly accused the Jews of diabolically inspired, bestial sacrifice of their own young. The texts were twisted to fit the paranoia. The Bible's profound abhorrence of the pagan revivalist King Manasseh's child sacrifices to Moloch was turned into a historical confirmation of the practice. Abraham's willingness to make a sacrifice of his son Isaac, at the command of God, notwithstanding the last-minute restraining angel, was given a sinister gloss. And medieval Christians knew both 2 Maccabees and Josephus' *Antiquities* and *Histories*, in which, at the height of the Seleucid campaign against Judaism, a Jewish mother embraced the ghoulish sacrifice of her seven sons rather than have them submit to pagan desecrations, especially the eating of pork. Famously the last son was offered all that Antiochus could give – fortune and status – if he would capitulate, while his mother urged him to join his brothers. When he enters heaven she tells him to seek out Abraham and inform him that while he had one altar, she could boast of seven. The story ends with the mother throwing herself from the ramparts to her own death.

By the late twelfth century, it was supposed by those Christians who were ready to believe this kind of thing, that Jewish mothers and fathers were capable of killing their own children rather than see them brought to the light of the gospel truth. But the animus of horror was focused most intensely on murderous Jewish mothers who

appeared in Christian lore as a demonic counterpart to the purity and maternal love of the Virgin. Both had made sacrifices of their sons, but while the loving parents of Christian theology, God the Father and Mary the vessel of the incarnation, had made their sacrifice as an act of compassion for the salvation of mankind, the Jewish mother, perhaps under diabolical influence, had killed her children in sin and incomprehensible butchery.

The Jewish version of those same events – both at the time of the Maccabees and the First Crusade – was precisely the opposite. By the time that Crusaders came to inflict massacre, Jews would have had available the Hebrew version of Josephus, the *Josippon*, written in tenth-century Italy. In its pages, the mother of the seven sons (called Miriam bat Tanchum in the Midrash) appeared not as a heartless fanatic but as someone who had robbed tyrants of their victory; had asserted godliness over profanity. Likewise, the embrace of a distinctively Jewish martyrdom, even to the point of parents killing their children to avoid death at the hands of Gentiles, was presented as a victory over the Christian ideals of martyrdom which were everywhere in their culture at exactly this time. We shall never know whether the three Hebrew chronicles that relate the stories of those martyrdoms (often in unbearably gory detail) record what actually happened in the Rhineland in 1096, because other than allusions to some of the events that show up in Christian narratives, there are no independent sources to verify them. Equally, however, there is nothing to say that in their core or even in their details they are *not* true histories.[3] And what is indisputable is that the self-destruction of Jewish families to escape other kinds of demise – by baptism or massacre – is the way these early Jewish histories chose to remember the place their religion had in the heart of catastrophe.

In any event there is no question that, in 1096, seventy-five years before the incident at Blois, something unimaginably terrible did indeed happen to Jewish mothers and their children, something that shadowed Jewish memory ever after. Not long after Pope Urban II at the Council of Clermont in November 1095 had called for a crusade to liberate the Holy Land from the unclean custody of the Saracens, it occurred to popular preachers in France and the Rhineland, like Peter the Hermit, that this work of cleansing need not wait for Christian swords to reach Palestine. Were there not enemies of Christ

dwelling in their very midst, in the cities and towns of the Rhineland
– Speyer and Mainz, Worms and Cologne? When those who had taken
the cross were about to spend blood and money on their holy cause,
'why should we let them [the Jews] live and tolerate their dwelling
amongst us? Let us use our swords against them first and then proceed
on our way.'[4] The blood of the Saviour could be avenged as a san-
guinary baptism at the start of the sacred war, and the ill-gotten gains
of the Jews would be put to proper use. It was so very tidy. The
miserable, impenitent, bloodsucking Jews would continue to pay for
their crime by subsidising the armies that would deliver Jerusalem
back to Christ.

This was ominous. The Jews of France and the Rhineland, like
everywhere else in Christian Europe, had lived under St Augustine's
dispensation that they had been punished for killing the Saviour by
the destruction of the Temple, their banishment from Jerusalem, and
their scattering about the world. This was said to be a penance so
severe that it was 'a life worse than death'. And in such a miserable
dispersion they were to be preserved as a people who, in their entirety,
bore the mark of Cain, living witnesses to the contrasting triumph
of Christian salvation. Hence the need, according to this view, of their
preservation. Wiping them out would have the unfortunate effect of
precluding the great conversion that had been set as the precondition
for Christ's Second Coming. In the late eleventh century Pope
Alexander II expressly reminded the flock that killing the Jews was
tantamount to a blasphemous defiance of God's own mercy. So while
they were to be reminded constantly of the deplorable nature of their
life outside of Christ, and prevented from defaming or defiling the
works and memory of the Saviour, it was the responsibility of the
Church and of obedient, godly princes to protect the Jews, not perse-
cute, much less harm them, so that they might eventually be brought
to the light.

Besides, they were economically useful. Since Christians were
forbidden by canon law to lend money at interest, the Jews had become
a major (though not exclusive) source of the hefty capital needed to
maintain and enlarge the glories of Christendom. Notwithstanding
the prohibitions, there were, in fact, Christian moneylenders –
Cahorsins and Lombards – but their interest rates were more exorbi-
tant than the Jews'. Moreover, the absolute dependence of the Jews

on the protection of lords, kings and prelates made them conveniently available for sudden arbitrary taxes, confiscations, massive death duties, or even the outright cancellation of debts should those become too onerous. As medieval rulers became more expansively ambitious, laying down the marks of their power in abbeys, cathedrals, palaces and armies, so the need for ready cash became more urgent. However much they claimed to be oppressed and generally put upon, the Jews always seemed to have enough of the ready to pay off those importunate master masons, captains and busy household stewards.

Hence the Jews were treated hospitably enough under the terms of a charter originally issued to them by the Frankish ruler, Louis the Pious, to encourage them to settle in his realms. They were allowed to travel freely, build synagogues, were exempt from certain taxes and tolls and granted the rights of self-government for their own communities. They were excluded from the professions (other than medicine, for Christians could no more do without Jewish doctors than Muslims) and the many occupations requiring membership of a trade guild. But this seemed good enough when life in the Latin south, the Greek east and in the decreasingly tolerant Islamic world was becoming more difficult. Communities took root. Rabbis and teachers arrived, the most prodigious being Reb Solomon ben Isaac, known as Rashi, who revolutionised Bible commentary in his academy in the town of Troyes.

But before long it became apparent that Urban II's crusading call unloosed passions that were out of the control of bishops and kings. The Latin chronicler Albert of Aachen wrote of those days in the early part of 1096 that 'people burned with fire and the love of God . . . but along the way wild goings-on started and knew no limit . . . would-be Christians failed to keep their distance from deceitful men, sinners and criminals, and sinned disgracefully, speaking of a goose as though it had the spirit of God on it and they said the same of a goat. Then the spirit of cruelty came on them.'[5] Peasant armies led by violently menacing preachers and hitherto obscure counts, like Emicho of Flonheim, had every interest in plundering as they moved through the countryside and the Jews were the plainest target. Why not kill them while they were at it? Whether they would get the opportunity depended crucially on how determined lay and clerical powers were to stop the unruly bands in their tracks for the sake of 'their' Jews.

Typically, Jewish quarters and the synagogues at their centre were built close to a cathedral and the bishop's palace, precisely with these frightening eventualities in mind. But a willingness to put themselves in the way of trouble varied from diocese to diocese. At Trier the well-intentioned Bishop Engilbert, despairing of persuading the Jews to convert and save themselves, also discovered that his own life was threatened as an odious Jew-lover and beat a swift retreat, leaving the worst to happen. In Speyer, on the other hand, Bishop John and the leader of the community, Yekutiel ben Moses, took pre-emptive action, bringing all the Jews of the city inside a heavily fortified court of the episcopal palace – and later shepherding them to an even safer stronghold outside the city.[6] Those who threatened the Jews had hands chopped off, which must certainly have acted as a disincentive.

In Worms, matters did not go so well.[7] Even before Emicho's exterminating army, complete with its sacred goose, appeared before its walls, Worms had been worked into a lather of hatred by rumours that Jews had boiled a Christian alive, buried him, given the remains a good stir and then dumped the slurry into the city wells to poison the population. Despite the sinister implications of this lunacy, not all Jews availed themselves of the opportunity to move into the bishop's palace and it's not hard to understand their reluctance. They believed in the reliability of their protectors and they refused to believe their neighbours would turn murderous. For all their mutual suspicions (and the choice abuse they heaped on one another's religion) Jews and Christians who dealt with each other every day in a town like Worms did not live in a state of perpetual hatred. They walked the same streets, dressed mostly the same way (for there were not yet the obligatory outward marks of difference on their costume), could understand each other's language, shared the same habits. Let peasants and rabble foam and rave; the townsmen and women of Worms would not behave badly. But they would be disabused of their optimism. Townsmen in some numbers, though not all, did indeed join the haters and baiters, and those Jews who had stayed put were the first to be massacred. Even those who did take the opportunity of sheltering inside the bishop's walls became victims of a siege as burghers, artisans and peasants joined forces with Emicho's men. The memorial book of Worms' martyrdom claims that eight hundred perished in two major attacks in May 1096, but

the eventual figure of the murdered may have been closer to a thousand – virtually the entire community.

It was in Mainz, one of the oldest and most flourishing centres of Judaism, that the greatest horror ensued. A threatened extermination was made the more credible as the horde of Crusaders had swollen into a real army, some 12,000 strong by the time they reached the city gates. The nervous Bishop Ruthard did what he could, bringing the terrified Jews into the sanctum of the cathedral and palace compound. As elsewhere, the abandoned Jewish quarter was plundered and set alight. For two days, the armed mob was held at bay, but in the end the force of numbers told. The gates were broken through and the soldiers of Christ swarmed into the palace grounds shrieking for Jewish blood.

There could be no question of what lay in wait for the Jews. They were to be made to disappear, either converted at sword point into Christians (although taking the cross was no guarantee of immunity from physical harm), or they were to be put to death, children included – for they could not be permitted to grow and in turn breed more generations of haters of Christ. Three Hebrew narratives – one compiled from disparate reports written close to the time, known as 'Anonymous of Mainz'; another, the longest, the twelfth-century account of Solomon bar Samson; a third, that of Rabbi Eleazar bar Nathan – all supply the unspeakable details of what followed.[8] Faced with the choice between conversion and death, many of the Jews, though emphatically not all, chose the latter. Self-killing is expressly forbidden by the Torah, but the wars of the Maccabees, the collective suicide at Masada in the first century narrated in Josephus, and what had passed into memory as the exemplary martyrdoms of Rabbi Akiva and Rabbi Hananiah at the time of the persecutions of Hadrian, had generated a body of rabbinic literature debating whether death, self-slaughter in particular, was preferable to forced transgression. Some of those opinions had insisted that forced transgression *in private* was acceptable, unless Jews were being coerced into acts of incest or murder. But if forced to commit iniquities in public, the acceptance of death was the holier option. Such deaths, moreover, were described as victories for God, indeed ordained by Him over the powers of evil and thus an act of glorification: *kiddush hashem*, the Sanctification of the Name, uttered in the last extremity. The reward (just as it was

promised to Crusaders) was instant admission to Paradise for the slaughtered. Closely echoing the speech made to the last defenders of Masada by their leader Eleazar bar Ya'ir, the chronicle of Solomon bar Samson relates one of the Mainz leaders saying 'let us be strong and bear the yoke of holy religion . . . for only in this world can our enemy kill us . . . but our souls in paradise will live eternally in the great shining reflection of divine glory . . . Happy are we to do his will.'⁹

The deeds seem, however, no less horrific for being acts of desperation at the last extremity, and the narratives – especially the most grimly elaborate of them, that of Solomon bar Samson – describe a terrible febrile enthusiasm in setting about the fatal work. The stately daughters of 'Mistress Rachel' in Mainz sharpen the knives that will cut their own throats, to make sure there were no nicks or dullness of the edge, as if preparing for the slaughter of sacrificial animals, which is exactly what they become.

None of this happens impassively in the Hebrew chronicles, nor with the demented unswerving resolution that characterises the mother of the seven dead sons in 2 Maccabees. 'The courageous women' hurl rocks and stones at the besiegers who throw them back, cutting and bruising their faces and bodies. Mistress Rachel, who seems to act like a soul possessed, all maternal feelings suspended, becomes once more a distraught mother when a companion hands her a sharpened knife. At which point the chronicler says 'when she saw the knife she let out a great and bitter cry, smiting her face and crying "Where is your loving kindness O Lord?"'¹⁰ In one version Rachel is so given over to horror-stricken grief that the companion has to kill the girls. The mother then hardens herself, and kills Isaac, the younger of her two sons. At which point something remarkable happens in the story, and in startling contrast to Christian martyrological literature in which the blessed accept their fate with the same kind of holy resignation as Christ's sacrifice. In one of the most unbearable scenes of all, the older of the two sons, Aaron, cries out in terror, 'Mother, mother, do not butcher me,' and hides under a chest. But the mother's fanatical purpose will not be deflected, as she tells him while tugging him out from his hiding place by one leg. After completing his death, Rachel seats herself, stretching out the long sleeves of her gown to form a basin that fills with the blood of her children. When the Crusaders

burst in and find her they demand to see what 'treasures' she has hidden under her sleeves. She shows them and they kill her. The last scene of the calamity unfolds when her husband arrives, witnesses the horror, and falls on his own sword, eviscerating himself (as the narratives insist on telling us), then dying while sitting in the road with his entrails falling out of his body.

Whether the unspeakably gruesome details of these stories are true or not (and there is no prima facie reason to *dis*believe them), the striking character of the Jewish martyrologies is the credible narration of actual human terror, resistance, revulsion and even tormented indecision at the heart of so many of them. It is what gives this terrible chapter of the Jewish story the stamp of truth – whether the truth of the mind or that of the actual body. The case of Isaac bar David, the *parnas* – or synagogue warden – of Mainz, unforgettably drama-tises tragic indecision. The Crusaders have already murdered his wife Skolaster (fine name for a Jewish girl), the daughter of Rabbi Samuel the Great, and to save his children and his mother who lies in bed bleeding from her wounds, he decides to convert. Three days later, bitterly repenting his decision, he takes his daughters to the synagogue of which he was custodian, slaughters them *in front of the Ark*, and sprinkles its columns with their blood. Then he returns to his house and, against his mother's wishes, burns it down with her inside. Finally he goes back to the synagogue, sets light to it at each corner and, with the crusading mob asking him to exit in time to be saved, goes 'repeatedly from one corner to another his hands spread forth to the sky to his heavenly father and praying in the fire out loud in a pleasant voice' as he perishes in the flames. Solomon bar Samson, the narrator, does not rejoice at this victory over conversion. Instead he interrupts the narrative to declare: 'For these things do I weep. My eyes flow with tears.'

The same merciless exposure of mixed feelings, agonies of doubt and terror, recur in the story of beautiful Sarit, the intended bride of Abraham, son of Judah the Levite. The Cologne Jews had been moved to nearby villages, but not far enough off to escape the killing bands. Through a window the prospective bride looked on in horror at the killings, wanting desperately to escape. But she was seen by her father-in-law, who dragged her into the room. In a macabre parody of wedding rites, Judah (rather than the still living bridegroom) kisses

Sarit on the mouth and proclaims: 'Behold, all of you . . . this is the *huppah* [wedding canopy] of my daughter. They all cried, sobbing, wailing, mourning and moaning.'[11] Sarit is then thrown on the bosom of Abraham, at which point her father-in-law cuts her in two 'through the middle', as the chronicle euphemistically has it, bottom to top, and then slaughters his own son to complete the blood wedding.

We will never know how many other Jews, most of them doubtless devout, who could not stomach the 'Sanctification of the Name' either for themselves or those they loved, especially their children, accepted conversion instead. Some did so only after they were tortured and beaten within an inch of their death; others reverted, as soon as they could, sometimes even before the Crusaders had departed, and paid the price. Most remarkably, the German emperor Henry IV issued an edict one year later, in 1097, allowing forcibly converted Jews to return to their faith. This was dramatically at odds with a strict Church prohibition on permitting baptised converts to revert, but then Henry IV (himself famously in conflict with Pope Gregory VII) had been outraged by reports of the massacres and promised severe punishment for the perpetrators.

The enormity of what had been inflicted on the Jews in the spring of 1096 sobered some of the courts of Christian Europe. Henry IV's son and successor, Henry V, maintained his father's watchful benevolence and even eased some of the restraints on Jews as an encouragement to resettle in towns stained by mass murder. In France, as we have seen, Louis VII appears to have been a caustic critic of the more paranoid strains of Judeophobia. The result was that Jews did indeed return to Worms and Cologne and Rouen, resumed their old lives of trade and prayer, Torah and Talmud study and charity. For some time now historians of medieval Jewish life (even those specialising in the tragic narratives of the Crusades) have been at pains to insist on the uniqueness and exceptionalism of the horrors of 1096.[12] In fact the Crusaders marched through much of Europe leaving Jews unscathed; successive Crusades did not trigger massacres on the scale of that first annihilation. Even when the Crusaders took Jerusalem in 1099 and burned down their synagogue, it is not entirely clear whether Jews were burned inside it at the same time. Many were ransomed, many more taken captive, so they at least survived. Life for the Jews was not all convulsion and expulsion.

Up to a point. The usual scholarly pendulum may have overswung. For every sobered-up Christian ruler there were successors who reverted to paranoid type. The response of Louis VII's son, Philip Augustus, to news that a Christian had been executed for murdering a Jew in the town of Bray (or possibly Brie), and that unseemly celebrations had taken place connecting the guilty man with Haman, the villain of the Purim story, was to order the killing of the entire community. So a chronic sense of insecurity on the part of Jews in the Ashkenazi world was not a figment of their imagination, not least because it was impossible to know how resolute both Church and state would be in containing the worst impulses of the Judeophobic mobs. Even when churchmen like Bernard of Clairvaux or Peter the Venerable, the abbot of Cluny, went out of their way to forbid and deplore violent assaults on the Jews, they made sure at the same time to refer to them as the most despicable of all races. And for their part, even though they knew that not every day would be a day of murder, what had happened in 1096, and what every so often, as at Bray, continued to happen in this time of Christian excitement, entered the historical self-consciousness of Jews, and would not easily depart. New prayers and liturgical poems enshrined the memory of the martyrs, most famously *Av Harachamim*, Father of Mercies, still sung on the high holy days. The *memorbuchen*, the memorial books, coloured future expectations with tragic memory. The nightmare vision of Jews killing each other in frantic desperation to avoid, as they thought, a worse fate at the hands of their persecutors, would not go away with the calendar round of festivals, a marketplace haggle, or the rejoicings of circumcisions and weddings. Henceforth those who could, built their houses and their synagogues in stone. That said everything.

As the historian Salo Baron insisted, Jewish history is certainly not all 'lachrymose'. Yet it is the glaring, relentless evidence, not emotional predisposition or tragic overdeterminism (oh those *sighing and sobbing* Jews), which tells us that it has not all been honey cakes and wine, either. Terrible things continued to happen to medieval Jews because high scepticism and low paranoia did not exist in separate cultural realms; and as in the case of the vengeful king of France, highness did not preclude vindictive paranoia. In other cases, at other times, there was simply nothing princes or prelates could do about vulgar hatred other than to stand back a little until it was spent. Richard the

Lionheart, the Crusader king of England, is known to have been angry at what befell the Jews of his kingdom, both on the day of his coronation on 3 September 1189 and in the months that followed. But what happened happened all the same.

Indeed it happened for the worst of reasons. The historian William of Newburgh describes a throng of well-intentioned Jews, leaders of their respective communities in provincial towns like York as well as London, coming to the capital to offer their congratulations, and gifts to match, to the new king. The Jews had been brought to England from Normandy by William the Conqueror with a mind to their usual cash-and-carry services, and they were closely tied to the fortunes of the Norman–Angevin monarchy. Other than Hebrew, their language was Judeo-French, and their *raison d'être* was to supply revenue and funds for soldiers, horses, churches and palaces.

None of this cut much ice on Richard's coronation, a day which William points out with tight-lipped glee was known on the old calendar as 'Evil' or 'Egyptian', and so it turned out for the Jews whose timing was poor and eagerness to please, excessive. Though a royal proclamation had been published expressly forbidding them from Westminster Abbey while a Crusader king was being crowned, according to William they thronged to the gates of the palace where the subsequent banquet was under way, the king in his 'glorious diadem'. Beefily indignant at the presumption of the Jews, the officious gatekeeper pushed back hard as gatekeepers will. The usual collapsing domino effect ensued amid the enormous crowd, which when combined with the roaring of the gatekeeper, triggered violent attacks on the Jews. A fistfight turned into a headlong brutal onslaught; sticks, stones and broken bones. At least thirty of the Jews died in the violence, some trampled underfoot, others beaten to a pulp. One who barely survived was Benedict, living in York but the agent of the greatest moneylender in England, Aaron of Lincoln, the creditor of some of the ringleaders of the riot. With him was the community leader of the York Jews, Josce. Both were badly roughed up, but Josce managed to escape while Benedict was dragged in his bloody state to a nearby church and forcibly baptised. Later, on the road, trying to get back home to York, he died from his many wounds.

'In the meantime,' William cheerily notes, 'an agreeable rumour that the king had ordered all Jews to be exterminated pervaded the

whole of London with incredible celerity.' Another monk-historian, Richard of Devizes, was likewise gratified that 'on the same coronation day at about the hour at which the Son was sacrificed to the Father, they began in the city of London to sacrifice the Jews to their father, the Devil'.[13] London and Westminster were packed with people. In no time at all an armed mob gathered 'eager for plunder and for the blood of a people hateful to all men by the judgement of God'. After the morning's violence, the surviving Jews had fled back to their houses, prudently stone-built, and had locked themselves in. Unable to break them down, the crowd set the roofs on fire and then either killed those exiting in terror on the spot or let them burn to death inside. 'The horrible conflagration,' writes William, 'destructive to the besieged Jews afforded light to the Christians who were raging in their nocturnal work.' Much of the rest of the city burned with them, but the extent of plunder taken from the Jews allowed their killers to be 'satisfied with the slaughter they had committed'. The smoky havoc finally reached the sensitive nostrils of the king amid his banqueting nobles. One of them, the justiciar Ranulph de Glainville, a man 'both prudent and powerful', was sent, belatedly, to restrain the mob. In turn he and his men were faced with threats, alarming enough for them to abandon the attempt, Richard of Devizes says, smirking in his Latin prose that it took the destroyers of the Jews so long to finish their work 'that the holocaust [the burnt offering] was barely completed the second day'.[14]

The disaster of coronation day, however, was just a prelude to a cascade of misery and massacre. Just before Richard embarked for Normandy where he would meet with the king of France to seal the pact for their Crusade, a portent appeared in the sky in the form of a milky apparition in the likeness of the 'banner of the Lord' with the image of Christ crucified. The usual crusading madness then took no time at all to catch fire, as in the Rhineland with the Jews its immediate victims. The pretexts varied; the result was always the same. In Lynn (now King's Lynn) in Norfolk, a Jewish convert was rumoured to have been pursued by angry co-religionists into a church, which was enough for killing to start. The familiarity the local population had with a well-liked Jewish doctor who treated Jews and Gentiles equally did not stop him from being among the fatalities. At Stamford during the annual fair where crosses were being taken by

those who would join the holy war, a youth who had deposited money
with a Jew was murdered by robbers but rapidly turned in the fevered
minds of the locals into the Jew's victim. There were more terrifying
assaults on Jews in Dunstable, Colchester, Thetford and even the village
of Ospringe in Kent.[15]

The most infamous horror unfolded in York on 17 March 1190
(Shabbat Hagadol, the Sabbath before Passover) when, unsatisfied with
the death of their bête noire Benedict, a mob broke into the house of
his widow, killed her and her children and helped themselves to what-
ever lay to hand. Frightened, a number of Jews led by Josce, the survivor
of the coronation riot, got permission from the warden of the castle
to seek its safety. Having granted it, he changed his mind on returning
to the castle and finding it impossible to get through the furiously
besieging crowd, urged on by a white-coated Premonstratensian friar.
The Jews, the warden complained, had taken over the castle. Instead
of pacifying the violence he thus stoked it further. Those Jews who
remained outside the keep were given the usual choice of conversion
or death, many accepting the cross to save their lives. Among those
trapped in the tower was a famous biblical and Talmud scholar, Yom
Tov of Joigny, who had composed an elegy for the massacred Jews of
Blois nearly twenty years earlier. For Yom Tov, only one possibility
remained: to follow what had been done a century before in Mainz
and Worms, and he made a speech to the terrified Jews, once more
echoing Josephus' version of Eleazar bar Ya'ir's suicide appeal at
Masada. 'Thou should not ask,' William of Newburgh has Josce saying
as he endorsed Yom Tov's grim message, 'God who dost this, for he
has commanded us to lay down our lives.' Another self-butchery
followed, Yom Tov killing his own family, bidding the men do the same,
before doing away with himself, as fires burned around them.

As in the Rhineland towns, not all wished to share this apocalyptic
fate. The following morning, the survivors stood on the battlements,
lamenting the dead and expressing their wish to be 'united with the
body of Christ'. The principal debtor and crowd organiser, Richard
Malebisse, encouraged them to come down and exit as true Christians.
As soon as they emerged, they were killed on the spot. A last burning
then took place, not of people but of debts. On the floor of York
Minster, the entirety of those debts, inscribed on wood and paper,
were ceremoniously incinerated, completing the destruction. When

the king caught up with the news, he is said to have become angry, in particular at the offence given to his royal dignity by the tumult, furious enough to order the Bishop of Ely to march on York with an armed force to apprehend and punish the malefactors. The leaders of the havoc, Malebisse included, had already taken flight to Scotland and, needless to say, no one else in York professed to know who had been responsible for the crime, leaving the king's indignation to be satisfied by the levying of hefty fines.

York was the most dramatic tragedy in the cycle of English Jew-killings, but the murder of fifty-seven Jews on Palm Sunday in the Suffolk town of Bury St Edmunds was even more ominous for it was the result of an old obsession that would have a long run in Christian England: the conviction that Jews were in the habit of abducting Christian boys around the time of Easter and Passover, and subjecting them to the torture of a mock crucifixion – a devilish parody of the Passion.[16] In 1144, the body of a twelve-year-old apprentice skinner (hides and skins play a recurring part in these fantasies), one William, had been found in the woods of Mousehold Heath outside Norwich. The Jews who had only come to the town a few years before were immediately suspected of the crime. One convert, Theobald, swore that William had been lured to his doom by a Jew and that his murder had been planned by a secret conclave of Jews from all over the country who would meet to enact the mock crucifixion with the unfortunate lad on the second day of Passover. An immense hue and cry broke out; the boy's body was brought to Norwich Cathedral for solemn burial close to the high altar. Although the sheriff was appalled at the superstition, brought the Jews within the security of his castle, and resisted any attempts to bring them to trial, the tomb continued to be a site of veneration from which miracles were said to abound.[17]

It is possible to see where the fantasy that Passover solemnities were a form of anti-Passion, a repetition of the crucifixion, came from. Christians, especially those unfamiliar with the Jewish religious calendar, as was the case in relatively recently settled England, had got the wrong festival, confusing Passover with the preceding Purim. Purim, commemorating the narrow escape that the Jews of Persia had had (courtesy of Queen Esther's favour with King Ahasuerus/ Artaxerxes), did in fact often involve a mock hanging of an

effigy-villain, Haman, who plotted Jewish extermination, and a carnival play of triumph and rejoicing. It is also the case that as crusading fervour gripped northern Europe, the anti-Christian rhetoric of Jews became much more vitriolic and unguarded. Any malicious convert wanting to persuade his new fellow Christians that his old people were up to no good, would have had no trouble at all in citing some of the more ferocious of these insults and curses. Christians also became convinced around this time that the Jews would stop at nothing to prevent one of their number from converting, or from attempting to re-Judaise them. In Lynn, it had been the rumoured Jewish pursuit of a new convert into the church that triggered the massacre there in 1190. And knowledge of what the Jews had done to their own children in 1096 in the Rhineland became perverted into an allied fantasy that Jewish fathers would feed their own sons into the oven if they suspected that they had taken Communion with Christian friends.[18] William of Malmesbury included the tale in his mid-twelfth-century collection of stories of intercession by the Virgin. Failing to stop her husband from baking her son, one desperate mother appeals to Christians who rush to the scene only to discover a miracle: the boy stays cool in the oven, thanks to the intercession of Mary who, in another account, is said to have made the heat like a 'dewy breeze'.[19] In many versions of the tale – which had wide currency in France, Spain and Germany as well as England – the boy amid the flames is visited by a vision of the Virgin and Child, the epitome of Christian family love, the opposite of demonic, infanticidal Jewish cruelty. In the stained-glass window in Lincoln Cathedral the Virgin bends tenderly over the Boy in the Oven. As Miri Rubin points out, ovens, whether filled with buns or not, are the place where children are 'cooked up' and can be the abode of nurture or, as in this case, places of monstrous ordeal. Both Jews and Gentiles would of course have been aware of the miraculous deliverance of Meshach, Shadrach and Abed-nego in the fiery furnace of Nebuchadnezzar related in the Book of Daniel. Once again, the Judeophobic version takes a biblical story in which Jews have been the sacred heroes and transforms them instead into quasi-pagan killers of true believers. In this case, the monstrous figure of the immolating Jewish father yields, via the Madonna-Mother, to the benevolence of the child's true Father – God Himself.

Fantasies of the Jewish paschal anti-Easter in accounts like that of Thomas of Norwich drew in elaborate detail a graphically precise picture of this new Passion acted out on the bodies of young boys: the scourges; the crowns of thorns; the piercing of the child's body, the lance wound in the left side faithfully copying that which was inflicted on Jesus; and finally the mock crucifixion on a wooden cross customised for the junior stand-ins for the Saviour. 'The Jews of Norwich brought a Christian child before Easter and tortured him with all the tortures wherewith our Lord was tortured and on Long Friday hanged him on a rood in hatred of our Lord and afterward buried him.' Since the boys would not die of being merely attached to the cross it was often said that the wounds, especially the side-piercing, would produce copious effusions of blood that the Jews would gather in a ritual cup. The extra detail of what became thus known as the Blood Libel, that this blood was collected in order to bake Passover matzo, was a later addition, but the basic elements of the drama were already all there.

Following the cult of William of Norwich, a rash of boy-saints victimised by the Jews broke out. In 1168, a circumcision party in one of the community's houses in Gloucester turned into an abduction story featuring a boy named Harold, said to have been tortured and thrown in the Severn. No self-respecting abbey or cathedral could be without its boy martyr. The cult of Robert of Bury, which ended in the massacre of 1190 and the expulsion of the Jews, had been inaugurated in 1181 and owed something to the local abbot noticing how successful his counterpart in Norwich had been in attracting pilgrims.[20] Two years later in Bristol, up pops Adam who, said to have been lured to the house of the Jew Samuel (who had also, it seems, murdered his own wife), was killed in the privy, but not before being visited with a vision of Jesus who embraced him. The result was that Samuel's latrine became a site of sacred mystery and miracle, not least to its owner who was henceforth unable to use it without a visit from a fiery angel of recrimination or possibly more unsettling still a vision of the Virgin cradling the spotless child martyr in her arms. Winchester – which in 1190 unaccountably spared what the chronicler Richard of Devizes calls its 'worms' or 'vermin' – boasted no less than three child-murder accusations, in 1192, 1225 and 1232; and there was yet another in London in 1244 in which a child's body,

found in St Benet's churchyard, was said to have had a mysterious Hebrew inscription cut into the flesh proving the boy had been abducted for sinister ritual purposes by the malevolent, murdering Jews. The corpse was carried by the canons of St Paul's to their church and buried with all solemnities by the high altar where as usual it was said to have instantly begun delivering wonders and miracles.

The most serious of all took place eleven years later in Lincoln where a nine-year-old, Hugh, was discovered in a cesspool. The child had been missing for three weeks, but because of the well-established assumption that conventions of Jews were held each year, the wedding party of Belaset, daughter to one of the wealthiest Jews of Lincoln, to which guests from all over England had been invited, suddenly assumed sinister significance. King Henry III just happened to be nearby, and demanded a guilty party. One was duly produced. After brutal torture one of Lincoln's Jews, Copin or Jopin, made a 'confession', was dragged over the cobblestone streets, tied to the tail of a horse and what was left of his shredded body was hanged at the gallows. But this was deemed to be a collective crime. Virtually all of Lincoln's Jews were rounded up and taken to London for trial. Eighteen of them insisted that they should be judged by a mixed jury of Jews and Christians, a demand that was taken as a confession of guilt and instead of being granted their due process they were summarily hanged. The remainder were imprisoned for a while and eventually released through the intervention of Richard, Duke of Cornwall, who like the king had many dealings with the Jews, but unlike him had some elementary sense of justice (not to mention a vital interest in preserving his own Jewish milch cows). At Lincoln, 'Little Hugh' was buried in a magnificent shrine in the cathedral that had been built mostly from Jewish money lent by the great magnate Aaron of Lincoln. Canonised as a martyr, Hugh was venerated over the centuries and immortalised in stained glass and in the *Canterbury Tales*, where Geoffrey Chaucer recycled all the most disgusting infamies and libels in 'The Prioress's Tale'.[21] It took seven hundred years for the myth to be explicitly repudiated by the Church of England and a statement of regret posted at the site of the tomb, including the commendably fraternal interfaith greeting: *Shalom!*

II. The Business

On the other hand . . . those beautiful names were never just so many victims, martyrs folded into the tomb. Doulcea, the sweet and pleasant one, the wife of Rabbi Eleazar, the Perfumer, did not expire helplessly on the streets of Worms. If we are to believe the Perfumer's eulogy (in both prose and acrostic verse), Doulcea went down fighting to save what was left of her family. The girls, Bellette and Hannah, were already gone, but her son and husband were alive though badly wounded. Doulcea forced her way past the surprised marauders, running into the street crying out for help, knowing the villains to be after her. That was the point. Once they were outside the house, she slammed the door (I like to think with a hefty back kick) and Eleazar locked it from the inside saving his own and his son's life. Separated from their loot the assailants took out their rage on Doulcea. At some point Eleazar surfaces from his grief to write his eulogy to the slain *eshet chayil*, the woman of worth.

Eleazar can think of no higher praise than his wife never angered him. But the portrait he paints is not of a doormat for his pious grandeur – quite the opposite; Doulcea did all the things expected of a religious and dutiful helpmate – feed his many students, make the candles used for Shabbat – and much more. She may possibly have been the kind of multitasker admired by Rashi of Troyes, who described women simultaneously 'teaching ideal wives a song for a fee, watching the vegetables cook, spinning flax and warming the eggs of silkworms at her bosom'.[22] Even Doulcea might not have managed all that, at least not at the same time, but Eleazar recalls that she not only went to synagogue every day, morning and evening (well beyond what was required and expected of women), but also led the women of the congregation in prayers and song. Since not many Jewish girls had been taught Hebrew (Doulcea, from a famous learned family, was an exception), in all likelihood she took the service in Judeo-German, either in a separate adjacent building or in the screened-off area reserved for her sex. Eleazar's verse eulogy expressly describes her as 'singing hymns and prayers and reciting petitions' and 'teaching women in all other towns to chant songs'.[23] Women taking an active

part in religious services in the Ashkenazi world was not uncommon until a wave of objections beginning in the fourteenth century made it more difficult. The gravestone of another woman in Worms active in the thirteenth century, Urania, tells us that as the daughter of a precentor-cantor, she followed in her father Abraham's vocation by being a prayer leader. For that matter Rabbi Eleazar and others saw no reason why they should not pray, read from the Torah and recite blessings as men did. The *Sefer Hasidim*, the book which collected the teachings and prescriptions by which Eleazar and his family lived, expressly instructed fathers to teach the commandments to their wives and daughters.[24] Even though women were not expressly instructed to do so in the Torah, there is some evidence that women in this period even wore the fringed garment the *tzitzit* and prayed with the *tefillin* phylacteries on forehead and arm, enough for later authorities to take exception to the practice. Much to her father's delight, the younger of the girls, Hannah, could recite Hebrew prayers like the daily *shema* and she sang with the kind of full-throated, pleasing voice with which Doulcea would have led her women. Until marginalised by more censorious figures like Rabbi Meir of Rothenburg and Samson ben Tzadok in the thirteenth century, women were often at the heart of ritual. Despite much rabbinical frowning and the incorrect modern assumption that women, especially mothers, were invariably excluded from the circumcision of their infant sons, plenty of evidence survives to show that this was not the case in Ashkenaz until, at the earliest, the late thirteenth century.[25] They were at the centre of a little home ceremony on the morning of the circumcision, the eighth day after birth, in which the mother drank wine to signify her healing (and probably the cut about to be made for the covenant). It had, after all, been Moses' wife Zipporah who had been the first circumciser, of their son. In the late-medieval period, a campaign to make the *brit milah* an all-male ceremony reduced women's role to carrying the beautifully swathed child through the streets to the synagogue where the circumcision took place. At its door, the baby would be handed to the *sandek* who would hold him on his lap while the circumcision was carried out. But both Samson ben Tzadok and Rabbi Jacob Moellin make it clear they were fighting a widely accepted custom which granted the mother a central role in the ceremonies both outside and inside the synagogue. The mother, as one would expect, might carry

her own son through the streets (despite Rabbi Yekutiel bar Moses' advice that 'it is better to walk behind a lion than a woman') and then act herself as the *sandek*, holding him on her own lap, seated among the men, while the circumcision was performed. It was this natural mingling which upset rabbis like the Tashbetz (Rabbi Shimon ben Zamakh Duran), lest while both walking among men and sitting as the *mohel* leaned over her to cut the foreskin, some sort of licentious thoughts should cross the mind. Worse still, the mother-*sandek* would be 'beautifully dressed', stirring temptation even further. Warming to his anxiety the Tashbetz goes on to say that even were the *mohel* the father and husband, not everyone would necessarily know that. If the pious saw a woman with the baby on her lap, they should leave the synagogue at once.[26]

Doulcea may not have been a *sandek*, but whatever she could do, she did: make bindings for religious books; sew and embroider no less than forty mantles for the scrolls of the law, as well as the binders that tied them; bathe the bodies of the female dead and put them in their shrouds. Though we think of Muslim Spain or other parts of the Islamic world as more easy-going for Jews, women were more visible in Ashkenazi Christian society. They were unveiled, travelled freely, were not confined yet to any sort of ghetto, and could plead their cause in courts of law – and given the number of family disputes, especially over whether they could reclaim their dowry after the death of a husband, this was just as well. They could own property and chattels, and although it was usually legally and technically forbidden, many of the better-off had Gentile maidservants and took their children to Christian wet nurses, sometimes all day long; their version of helpful day care. Some of them were midwives and healers, known as *nashim khakhamim*, wise women. Others might be marriage brokers for which there was a keen demand in a culture in which women often outlived the men and in which there was a surprisingly high rate of divorce. Since the parties were commonly betrothed while they were still children, the rabbis, especially the Pietist *hasidim*, were at pains to insist that although children ought to respect their parents' decision in such matters, they could not be forced into an incompatible marriage nor kept in one if it proved distasteful to either side.

Doulcea's generation and those that followed were the first to benefit from new rulings laid down by Rabbi Gershom ben Judah of

Mainz in his book *The Light of Exile* (views shared by many of his contemporaries), the most radical of which was to ban polygamy, still in effect in the Sephardi–Muslim world. By the same token, the strictures laid down in the Mishnah and the Talmud about the physical as well as spiritual union of husband and wife were taken very seriously. Husbands were forbidden from beating or harming their wives or forcing any sexual submission on them that displeased them. To do otherwise, the rabbis said, would be to treat her like a whore. Just as women were commanded to please their husbands sexually, vice versa was also a sacred obligation. No sexual practices or positions inside the marriage were banned except the spilling of semen outside her body, and husbands were required to do everything to please and satisfy their wives, especially since their only route to the *shekhina*, the divine radiance, was through her delight. It was incumbent, then, on a husband to share whatever bed she might have prepared for them both, even if, as one treatise said, this meant leaving a bed of gold graced with embroidered linens for one laid on rocks and covered with nothing but straw. It was his duty and his happiness to lie beside her. Frequency and timings of sexual union were similarly spelled out, twice a week being optimal, especially on Friday nights. (For Jews living in the Muslim world, special dispensation was made for those whose work took them by camel since that would lead them farther away from the conjugal bed, though mule-train men were expected to report home more frequently.) And should, somehow, husband and wife displease each other physically, that would be good enough grounds for divorce, always assuming the wife agreed. Unlike conventions operating in the Muslim world no wife could be divorced against her will. But should a husband be so repellent (for whatever reason) that she fled his company, he could be obliged to grant her a divorce.[27] So although there were endless and strict rulings about purification in the ritual bath, the mikvah, both during menstruation and after childbirth, Jewish wives had every reason to expect attentiveness from their mates.

There was something else that made Doulcea the pillar of her community: managing its money. She was the one to whom her neighbours and co-religionists trusted their fortunes and she managed it as best as she could, lending some of the funds out, almost certainly just within the local Jewish community, but in her way, the wife of the Perfumer was also the friendly banker of the Pietists, the *hasidim*

whom Eleazar led. It was undoubtedly that fact that brought on her disaster, for although the robbers may have worn crosses (at the time of the Third Crusade), it was the money they were after when they broke into the Perfumer's house in November 1196.

Doulcea wasn't the only one. There was a surprising number of Jewish women who became bankers and creditors to the high and mighty in Christian society: bishops, abbots, counts, queens and kings. (Poulceline of Blois was one who paid the price for it.) In England we know of a whole cohort of matriarchs, wives and widows who ran substantial loan businesses: Chera of Winchester and her daughter-in-law Belia, Chera's great rival Licoricia, Belaset of Oxford, and many more. Their names, and their dealings, have been preserved because among the casualties of the coronation riots of 1189–90 were the records of those who owed money to the Jews. Since the Crown considered 'its' Jews a personal asset, and was accustomed to lean on them when needs must, it was Richard's interests that had been damaged as well as those of the Jews. Henceforth an Exchequer of the Jews would be responsible for recording all their transactions, along with monies owed, the loans themselves, the 'tallage' taxes and fines due. Since those fines extended to mundane matters such as permission to change marital status, the Crown Pipe Rolls supply the social history of the five thousand or so who comprised the Anglo-Jewish community up to the expulsion of 1290.

Not all Jews were moneylenders and not all moneylenders were Jews. Although canon law forbade loans at interest there were Christians, the Lombards in particular, who offered similar services and who evidently were indifferent to the threat to their mortal souls, for they not only charged exorbitant interest rates, they insisted on charging interest for the whole life of the originally contracted loan even when early repayment had been made. As a subject population, the Jews, on the other hand, were strictly regulated in the interest they could charge and the terms of the loan. Their international links across Europe gave them access to hard capital and the security they took on their loans – land, manors, abbatial estates, urban property – became themselves negotiable items. When a Jewish lender died, a third (at least) of their property reverted to the Crown, so that the hard bargains the Jews might have driven became a source of instant profit for the ever-voracious treasury. The Jews were obliged to do

the dirty work and get the odium while the Crown got the profit. Above and beyond those arrangements, sudden, crushing demands could be made on a helpless population, and in default anything could be seized at royal will. When the Jews were faced with an unanticipated levy, or a forced loan, they had to call in their own loans to avoid immediate imprisonment; a choice between provoking hatred and inviting suffering. In most years, money in effect stolen from the Jews through such stratagems counted for a seventh of the Crown's entire revenue.

The biggest bonanza of all was in 1186, with the death of the supermagnate Aaron of Lincoln. Aaron had built a stupendous fortune around the newly expansive needs of both Church and state. He had funded Becket and Henry II; had lent money to the Bishop of Lincoln (secured, naughtily, on the diocesan plate) so that the bishop might build himself a splendid palace, and had in fact made the cathedral itself possible, just as his money had built Peterborough Cathedral not far away. When he died, Aaron was, in liquid assets, the wealthiest man in England, which made his estate irresistible for the constantly embattled Henry II. The *entirety* of his estate, including the massive ledger of debts owing, was confiscated by the Crown. Its gold and silver was sent immediately to France where Henry was at war with Philip Augustus – and, in a providential act of justice, was lost when the ship carrying it to Dieppe sank. The remaining assets were a vast pile of loans owed by 450 debtors from the king of Scotland to the Archbishop of Canterbury. The estate was of such staggering and complicated fortune that a separate department of state – the Saccarium Aaronis, the Exchequer of Aaron – had to be created to manage it. It took the Aaron Exchequer five years to sort out its details before exploiting the gold mine.[28]

Aaron was hardly typical. Before the Jews became restricted to a particular number of towns, they spread throughout the kingdom and many were lenders to much smaller fry than Aaron's grand clients: local knights and squires, modest convents, abbeys and churches, burghers of the market towns. Many were in the ancillary businesses – gold- and silversmithing, gem-trading and jewellery-making – but there were also wine sellers (another business that profited from family connections in France), traders in wool, salt and spices, as well as the usual professions of doctors and apothecaries. It is known, too, that

kosher cooks and caterers supplied food for non-Jews, and there were even more surprising occupations. The second Lateran Council of 1139 had attempted, optimistically, to ban the use of the crossbow by Christians against fellow Christians. But no warlord worth his salt was going to do without them, so Jewish crossbowmen were trained as a special corps for the king, and became famous for specialising in the weapon throughout the kingdom. In the reign of Henry III there is at least one recorded instance of being required to pay for the upkeep of a particular crossbowman known as Seman or Simon who may have been a convert but who was kept in livery and weaponry by David of Oxford. And it is hard to know who would have been more offended by a Jewish painter of holy images, especially the Virgin: the rabbis who might have taken it as a violation of the Second Commandment, or Christians who were regularly treated to stories of Jews desecrating images of the Madonna. Perhaps our painter squared it all by telling himself that it could be no sin to paint *another* religion's idolatrous icons?[29]

But it was the great moneylenders, specialising in mighty clients and taking the corresponding fall, who were the potentates of England's Jews: Aaron of Lincoln; Benedict Crespin of London, whose beautiful mikvah bath in green sandstone was excavated in 2002 and can be seen in the Jewish Museum; Moses of Bristol; and David of Oxford. They built themselves stone houses (with an eye both to grandeur and defence), which, like many of the Jewish quarters and their small synagogues, were sited sufficiently close to the town castles and jails in case they needed sudden shelter from rioting mobs, which was often the case. Many of them had multiple properties in several towns including London, and some like another Benedict, Licoricia's son, even acquired country manors – in his case, thirty-nine acres in Northamptonshire, containing tenant farms, parkland and hunting forests, and ample livestock, including, shocking to relate, 'young porkers'. Some of the Jewish grandees evidently had a thing for fine mounts.

One of these palfrey-fanciers was David of Oxford. Like the rest of the town's Jews he had somehow survived the relentless depreda-tions imposed on them by both Richard (departing for the Crusades and then ransom money to get him back) and his notoriously insatiable brother John, who in 1217 had levied a crushing tax, and then simply

let his Magna Carta barons lay their hands on absolutely anything they wanted from the Jews who could be accused of being in arrears. David emerged from the rack and ruin and rebuilt his fortune lending to expensively inclined clients from Northamptonshire and Warwickshire to Berkshire and Buckinghamshire. Locally it was his funds that built both Oseney Priory and Oxford Castle, a stronghold the Jews had an interest in seeing built even if they became, from time to time, involuntary residents. One document records a quittance from the 'hard hand' of David, but there was every reason for him to drive a hard bargain in his loans since he could never be quite sure whether he would see the money again. Richard had been in the habit of bribing noble followers to crusade with him by altering, at will, debts incurred to such as David: sometimes reducing or waiving the interest; sometimes just forgiving the debt altogether. The tactic was too successful to be abandoned after the abortive Crusade, for John was as much at war as his brother, and the boy-heir Henry III was overseen by nobles who got similar dispensations for sundry military services to the Crown. David endured thirty such loan wipeouts in less than fifteen years. The insurance against bearing the entire burden of such disasters was going into partnership with other money men he could trust and spreading a little, both profits and losses.[30]

Hard-handed or not, David prospered. He built a fine stone house in the Oxford Jewry south of Carfax, the very street known to dons and undergraduates forever as St Aldate's, and another round the corner in St Edward's Lane. David's fortune was evidently grand enough for him to become anxious about the lack of heirs from his marriage to Muriel. And then sometime around 1242 he ran into his destiny: Licoricia of Winchester.

Licoricia was a widow with three sons by her first husband, Abraham of Kent, who had been implicated but not executed in yet another child-murder trial seven years before. Like so many wives as well as widows (such as Belia, the shrewd daughter-in-law of the even more famous and formidable monied widow, Chera of Winchester), they acted as partners in their husband's business while the men were still alive, signing contracts and quittances for them in Hebrew (hence they were literate as well as numerate). Licoricia had come of age in the Winchester dominated by Chera and her clan, and doubtless learned a great deal from her example, for in short order she became

a powerful operator in her own right, and perhaps with that name she had to be. When she met David she was already well off, but it is improbable, given David's already colossal fortune, that making it even bigger with an alliance could have been a motive for what followed. More likely he just fell for her. The travelling widows must have been irresistible. They journeyed on business in much style; often had spectacular wardrobes – we know of 'bluet silk' and 'blood red gown trimmed in rabbit fur'.

If Pope Innocent III had had his way, there would have been one sartorial blemish on their costume: a badge shaped like the twin tablets of the Ten Commandments, 'four fingers by two'. At the Fourth Lateran Council in 1215, the Pope had demanded this distinction, precisely because it had become impossible, by dress demeanour and language alone, to tell who was who, thus risking in the Pope's view the danger of intermarriage. The Pope's action may well have been prompted by cases such as the notorious affair of an unnamed deacon in Oxford who, according to the chronicler Matthew Paris, became passionately infatuated with a Jewess and so 'ardently desired her embraces . . . that he agreed to her demand that he convert and showed his seriousness by self-circumcision. When he had done what she bade him he gained her unlawful love. But this could not long be concealed and was reported to [Archbishop] Stephen of Canterbury.'[31] In 1222, Archbishop Langton summoned a council in Oxford which degraded the impenitent deacon who is said to have repudiated what he called 'the new fangled law' and offered into the bargain some choice comments on the subject of the Virgin Mary. This was unlikely to appease the archbishop, much less the notoriously ferocious Sheriff Fawkes de Bréauté, who sent the deacon straight into the flames. Nothing more was heard of the Jewess other than she escaped both the scandal and the stake, doubtless without donning the *tabula* on her gown.

Despite the apostate deacon in Oxford, the requirement of the distinguishing badge of the tablets of the law seems to have been unenforced for most of the reign of Henry III, so it is unlikely to have much bothered Licoricia and her travelling sisters of the money trade. They were entirely accustomed to dealing with the Christian world, were independently minded, could read, write and banter and hold their own arguing with the roughest, toughest barons and bishops,

some of whom clearly went weak at the knees when they had an interview with the likes of Belaset or Licoricia. Since they, too, needed to work in partnership with other Jews all over the country, they clearly went well beyond the domestic and religious preoccupations of a Doulcea of Worms, though this did not mean they would necessarily have been worldly at the expense of their faith. Licoricia seems to have been a stickler for kosher food. But nothing much could daunt these women. They travelled with armed escorts, sitting high in the side-saddle or in a basic form of carriage cart, dismounting en route to stay the night with Jewish communities before going on their way, often to destinations that might have intimidated the less confident. Licoricia regularly met high and mighty customers in the Great Hall at Winchester Castle, much visited by Henry III.

Whatever it was that attracted David – and it might just have been Licoricia's proven fertility – it was powerful enough to make him act with shocking abruptness and announce a divorce from Muriel, more or less by unilateral fiat, and probably without telling her himself. But since the reforms introduced by Gershom ben Yehudah of Mainz and his contemporary rabbis, not only was polygamy strictly forbidden, it had also become unlawful to divorce a wife without her consent, except in the scandalous circumstances in which she had committed adultery. That was clearly not the case with Muriel and she had no intention of going quietly. Even the Muriels of this world knew their rights and were not shy of asserting them. Other Jewish women of this period appear in marital disputes and wrangles over the fate of dowries when they are widowed, fully aware of the law. One Milla, for example, fought off a predatory Samuel, wanting to get his hands on her dowry by claiming they were married 'by virtue of the commerce and contract they had between them', meaning the sexual kind. Milla snorted, went to law and won the case. Another independently minded woman, Gentilla, belied her name by forking over a tidy sum to the royal officials in order to *avoid* marrying a designated match. Muriel was evidently cut from the same strong cloth, if not quite a match for her rival from Winchester, but then few were. Muriel's Lincoln family were mobilised and her brother Peytevin, himself a man of substance who had built his own synagogue and was clearly practised in both Jewish and Gentile law, took over the case. He submitted it first to a group of French rabbis safely beyond

the reach of any strings David might pull, and to whom their English counterparts often deferred, as the disciples of the great Rashi of Troyes. The French responded in Muriel's favour and with the wind at her back Muriel and Peytevin organised a *beth din* rabbinical court at Oxford which followed the French opinion, and nullified the divorce.

David and Licoricia regretted taking Muriel for granted but now they went on the offensive, even if it meant appealing not to a Jewish but a Christian authority, no less than the Archbishop of York. Among those beholden to David was none other than the king himself, to whom David had tendered at a sensitive time a sweetener of a hundred pounds. After that, as far as Henry was concerned, David could do no wrong. For his part the archbishop resented the presumption of any rival courts of religion, and after summoning Muriel's side, in turn quashed the decision of the Oxford *beth din* and decreed the divorce valid. More seriously the Close Rolls have a letter directly from the king to the 'masters' who had adjudicated the dispute forbidding them 'to distrain' David 'to keep that wife [Muriel] or any other'. Doing otherwise, the letter warned, would 'incur grave punishment'.[32]

So now there was nowhere else for Muriel or her brother to take their case. For the time being, and in keeping with the *halakha* religious laws she was provided for in the shape of David's smaller house at the corner of St Edward's Lane and Jury Lane. And perhaps she got some grim satisfaction from the fact that Licoricia and David got to enjoy their marriage for a mere two years before David died in 1244 – long enough, however, for Licoricia to produce the heir he had desperately wanted, whom they called after David's father, Asser or Asher, but who would be known throughout his life (and in keeping with the confectionery of his mother's name) as Sweetman or Sweteman.

But instead of being able to enjoy her late husband's fortune, Licoricia, along with the infant Sweetman, was clapped in the Tower of London, while David's estate was subject to the scrutiny and appropriation of the Crown. Normally the king was entitled to a full third of such estates, but the worrying example of Aaron of Lincoln was on everyone's mind when big legacies came up. Locked away in the Tower of London (though doubtless paying to be able to walk about, have kosher food brought in and the like), Licoricia was held hostage to the Crown's satisfaction while King Henry perused David's

magnificent library, ostensibly to reassure himself it contained no items injurious to either Christianity or Judaism but actually coming away with some choice items like a psalter. Even more satisfactory to the king was the confiscation of David's fine house at the top of St Aldate's and its transformation into the royal *domus conversum*: a house to accommodate converts who, taken to Christ's grace, could be provided for from David's kitchen and eat off his plate, use his utensils and avail themselves of his and Licoricia's wardrobe. The settlement of the estate to the satisfaction of the Crown's agents took many months, but in the end the king took possession of the immense sum of 5,000 marks, more than £3,000 of the day. Since £100 would build and fit a fully equipped ship, this was a formidable amount and it was earmarked for Henry III's pet project of rebuilding Westminster Abbey and in particular creating the shrine to Edward the Confessor that is there to this day. Much of the heart of the abbey where royalty is crowned comes from the estate of Licoricia the Jewess and her husband David of Oxford, a detail the guidebooks mysteriously manage to omit. If you want to see what became of a Jewish fortune, take a look at the spectacular Cosmati ceramic tile pavement paid for (along with much else in that part of the abbey) by David and Licoricia. The shrine was not just an incidental item: it became the sacred heart of the abbey, the mausoleum of the Plantagenet kings and queens including, to be sure, those of Henry III's son, Edward I, who a half-century later after much suffering and distress, unceremoniously got rid of the Jews altogether from his kingdom.

III. Destruction

On a spring morning in 1277 Licoricia's body was found on the floor of her house in Winchester along with her maid Alice, both of them dead from stab wounds. Jews were not supposed to have Christian maids, but then there were a lot of things Jews weren't supposed to do and Licoricia did most of them. After David's burial in the Jewish cemetery at Oxford where Jews now kick up the daisies, it being the University Botanical Garden, Licoricia had taken Sweetman back with

her to her old stalking ground of Winchester where she again played the role of the great queen of money and sometimes overplayed it. When one of her many debtors, Thomas Charlecote, was found floating face down in a pond on his Warwickshire manor, Licoricia moved in to collect on the estate. Charlecote's debt had indeed been secured on his land, but protocol required she wait until his son and heir, Thomas, had had his portion duly settled. Licoricia was not the waiting type, nor was she especially forgiving. She seems to have had Muriel turned out of her Oxford house and now she took possession of the Charlecote land and proceeded to asset-strip it down to the bone – livestock, hunting forest, tenancies all sold off.

So like Poulceline of Blois, Licoricia would have had enemies even though she seems to have retired from active business by the 1270s. Did those enemies kill her? An inquiry pinned the crime on a saddler called Ralph, in which case the murder would have been a matter of almost random robbery which certainly happened to Jews. But Ralph may have been a scapegoat for someone of more consequence eager to get rid of his debt by getting rid of the creditor. The times and their refreshed hatreds killed Licoricia and many more Jews who followed. For their fate had been closely linked to Henry III, who, however opportunistic and unscrupulous in the random descents he made on their fortunes through suddenly imposed taxes and confiscations, did at least largely fulfil his end of protection. Yet that very favour was one of the prime grievances laid at the feet of the king during the baronial wars led by Simon de Montfort, both a debtor to and a hater of the Jews. Though de Montfort was eventually defeated, Henry's successor, Edward I, who came to the throne in 1272, shared many of his prejudices, reinforced by his time as a Crusader.

The 200-year-old arrangement – by which the Jews rendered money-lending services in return for protection and freedom of travel around the kingdom – was torn to shreds. The first sign was the sudden enforcement of the wearing of the badge of difference, the *tabula*. Now they were marked people. Then, the towns in which they were allowed to reside were limited; whole communities now moved elsewhere. When Edward got back from the Crusade it got worse. A statute on the Jews in 1275 forbade moneylending, the essential activity, whatever its odium and perils, that supported what would otherwise be indigent communities. Official fantasies were spun about the Jews

learning and practising new crafts and trades but without any real means for them to do so, especially since the guilds were still to be closed. By a small miracle it had been Licoricia's son by her first marriage, Benedict, who had been close enough to the mayor of Winchester, Simon Draper, as to allow the mayor to admit him to the city guild – an astonishing breakthrough which almost immediately brought down uproar and obloquy on the head of the offending mayor who hastily had to amend the measure to some sort of honorary status.

And one year after his mother's murder, Benedict the not quite guildsman was himself dead at the end of a hangman's rope in London. A campaign of crushing terror and violence had been launched in 1278–9 in which the Jews of England, en masse, were accused of 'coin-clipping' (the shaving of silver and gold off coins to be melted into blocks, so adulterating the currency). It was doubtless a crime and along with the many Christians guilty of the offence there may have been Jews passing 'light' coin and doing some clipping.[33] But the consequence was the incarceration of virtually all the Jews in the country, all brought to London and packed so tightly into prisons, that improvised jails had to be created, including Henry III's elephant house at the Tower, vacant since the rapid death of his jumbos not long after they arrived. The quarters were reputed to be jumbo-sized at least, because there is a record of one forlorn and elderly Jewess pathetically petitioning to be incarcerated in the elephant house.

Perhaps she was saved by the peculiar accommodation. For the city became sown with gallows, from which 269 Jews were hanged. This was London in the first years of Edward I; Jewish body after Jewish body, among them Licoricia's Benedict, swinging over the streets; an abhorrent and unforgivable crime that has gone unremembered, un-lamented, unacknowledged in English history ever since.

The mass hangings broke the community. Their leading men and women, their protectors, champions and safeguards, had been destroyed at one fell (for once the word is not a cliché) swoop. Those who were left were poor, broken and terrified. There was no practical hope, really, of their fulfilling the social transformation purportedly desired by the king. And Edward's ostensible eagerness for their social reformation had now robbed the Jews of any further utility. When he had expelled the Jews from Gascony Edward had discovered that

the Flemish and the Genoese would come up with the needful when occasion called. All that remained for the Jews was a disposal job. So when it came in July 1290, Edward's expulsion order, his *coup de grâce* – much to the delight of both his mother Eleanor of Provence, who had been a regular client and thus a Judeophobe, and his queen Eleanor of Castile who nurtured even more extreme malevolence – could not, then, have come as altogether a surprise. And there was a strictly pragmatic reason to capitalise on their removal. When he returned from campaigning in France in 1289, the Crown had so exhausted its coffers that only a punitive levy on all English subjects, nobles and the Church included, could fill the fiscal void. The sweetener for this otherwise unacceptably bitter pill was to be the expulsion of the Jews, or more specifically the outright cancellation of all bonds and debts owed to them. Needless to say, this was a popular solution. On 5 November it was decreed that 'because of their crimes and the honour of the Crucified Jesus the king has banished the Jews as perfidious men'.[34]

The expulsion edict would be a template for the even more traumatic expulsion (because of the far greater numbers involved) in Spain two centuries later. The Jews of England were given four months to depart, were entitled only to the principal of outstanding loans and not any interest, and were permitted to take with them only the possessions they could carry. Under those brutal constraints, houses were picked up by predatory buyers for ludicrously discounted prices as the Jewries of England emptied. Pathetic carts and footsore lines of Jews trudged their way to the ports, to Dover and Southampton with some departing from the docks on the Thames. A story was told of a ship's captain recommending his passengers exercise their legs on the mudflats at Queenborough exposed by the high tide, and then, having pocketed the fares, set sail without them as the tide turned, leaving them to drown. What particularly roused the anger of royal officials was when they suspected that the exchequer may have been done out of any share of the spoils, no matter how trivial. A lively dispute broke out in 1291 in Norfolk over the sheriff's brother who had seized goods and chattels taken from Jews aboard a ship off Burnham with intent to pocket the proceeds, and whether proper taxes had been paid on the goods. Altogether incidental to the dispute was the fact that every Jew on the ship had been killed as well as

robbed for they were, after all, as the sheriff said, 'evil doers and disturbers of the king's peace'.[35] One of the more enduring images from this year of woe is of a gang of English Christians, clubs raised high in the air over the heads of Jews, beating them, gleefully, out of the kingdom.

It was about this time that the legend of the Wandering Jew became popularised in the Christian mind. It was not some generalised vision of dispersed exiles but a particular story of a Jew, in some versions (such as that recorded by Matthew Paris, the gloater over Jewish misfortunes) the shoemaker Cartaphilus who had prodded Jesus on the way to the crucifixion reproaching him for being a slowcoach to death. Jesus replied that he would rest while his tormentor would find no repose at all. And thus the Jew was doomed forever to walk the face of the earth like Cain, in perpetual witness to his own sin and that of his people, denied the respite of death until the Second Coming. Perhaps watching the exhausted stragglers board their ships, Christian England took satisfaction that in its way, it had fulfilled another of the Saviour's prophecies.

8

TRIALS

I. Choosing Life

Wasn't it already hard enough to be a Jew without other Jews making it well-nigh impossible? That's what crossed the mind of Moses Maimonides when he read the response given by a rabbi to some poor fellow who had asked whether, when forced at sword point to choose between death or conversion, he could be forgiven for taking the latter option? Just a bit, you know, going through the motions, saying the words, enough of them to save his life, but always of course staying Torah-true within? What else could he do? If he were killed his orphaned mites would be taken away as captives, made Muslim, lost forever to Judaism.

Back came the adamant reply. In such circumstances, may they never befall you, God willing, but in such circumstances, the righteous Jew must choose death over transgression. Sanctify the Name as had the blessed martyrs in the time of the Maccabees, Rabbi Akiva in the time of the persecutor Hadrian (may his bones be ground to dust), the many holy men and women suffering slaughter when the Crusaders came to the Rhine. Perish by your own hand, stretch your throat to the blade and you enter Paradise where you would be made whole again, your blood staunched with heavenly balm. To imagine otherwise was idle delusion. Utter the *shahada*, the Muslim profession of faith, and God would turn His face from you, casting you forever into impenetrable darkness.

No, no, no, choose *life*, Moses Maimonides thought. It wasn't that he disrespected the sacrifice of the martyrs, but the simplicity of absolute ideals, across all religions, he found alien and disrespectful

of the injunction to save life clearly enjoined in the Torah. What moved him most, as he made clear near the beginning of his great reworking of the Mishnah, the *Mishneh Torah*, was the passage in Leviticus 18:5 that required Jews (or Israelites as Maimonides liked to call them) to live by the commandments, not die by them.[1] Intrinsic to the gift of the Law was free will; the possibility of choice. To those who insisted there were circumstances in which no choice was possible, he invoked Deuteronomy 30:15, the keystone to the arch of his philosophy which was built to support both faith and reason: 'I have this day set before you a blessing and a curse; life and death; therefore choose life.'[2] There was another way to 'sanctify the Name' and that was to live a decent life in accordance with the precious gift of the Law. 'If a man has been scrupulous in his conduct, gentle in his conversation, pleasant towards his fellow creatures, affable when receiving them, not retorting even when affronted, courteous to all even those who treat him with disdain, conducting business with integrity . . . devoted to the Torah, wrapped in the *tallit* [prayer shawl] crowned with the *tefillin* [phylacteries] avoiding extremes and exaggerations, then such a man has sanctified God.'[3]

Besides, what did these armchair Talmudists know of the agonies endured by the man who rashly asked if he might transgress to save his life? He and his father, Rabbi Maimon ben Joseph 'the Sephardi', did know. Oppression had followed them around like a snapping hound. It had come to graceful Cordoba where Moses had been born around 1035, and where his family had lived for many generations. Arabic came as naturally to him as Hebrew. The Berber rulers, the Almoravids, had begun as sword brandishers for the Prophet. But the streams of Al-Andalus had cooled their fury and everyone had settled down with everyone else and the Unbelievers had been left once more to say their prayers and read the Torah and attend on the rulers when they fell sick, for when was there ever a time when Jewish doctors were not sent for? As so often before, the rage of doctrine had yielded to worldly traffic. Yet this accommodation with life was precisely what so incensed the next cohort of Berbers, the Almohades, riding down from the slopes of the Atlas, spurred on by their leader Abd al-Mu'min who sliced his way through the compromisers in the name of a purer way to follow the Prophet. What was it, anyway, about the mountains of Morocco that bred such belligerence, such implacable certitude?

For these followers of Abd al-Mu'min could not be bought off or argued with. All they knew was eye-rolling, prostration and cries of zeal. In their minds they had been called to cleanse a profane *umma*, for only the clean and the strong would be able to withstand the advance of the Christian Franks, whether in Spain or Palestine.

The Almoravids yielded to the madder fury of the Almohades and the days of worldly accommodation in Al-Andalus passed for good. The Almohades ordered the closing of many synagogues, the razing of others. God help any Jew caught saying his prayers in public, even furtively beside some shady wall in a far-off village at the setting of the sun. Henceforth there would be no possibility of Muslims and Unbelievers scandalously occupying the same house (even as masters and servants) and risking polluting intercourse, for the *kafr* would now be so costumed as to make such confusions impossible. The Jews would be required to wear a long black shapeless garment reaching to the ground so that they trailed their hems in the grime of humili-ation. The *jaliya* tax would be taken from them in such a way as to remind them of their subjection, with slaps and grimaces and yelled abuse as they forked over their gold, to remind them, clink clink, that they were apes, donkeys, pigs, dogs. Oh, and their women, their wives and mothers were all whores, that too.

The olives of Andalusia tasted bitter now. Rabbi Maimon ben Joseph prepared the family to depart from Sefarad, from all they had known. The carts trundled over the arched Roman bridge on the River Guadalquivir and into a daunting life. Everything was unknown except that wherever they landed there would be Jews fasting on the Day of Atonement, rejoicing on the Day of the Giving of the Law, chanting the Torah, binding their arms every morning with the *tefillin*. Mysteriously, though, Rabbi Maimon took the family south, crossing the Mediterranean to Morocco, and settling them not, as one might suppose, as far away from the Almohades as he could possibly get, but in the lofty stronghold of their doctrine: Fez. It was as if he imagined, in a rabbinical kind of way, that by bracing himself for the worst, anything short of an ordeal might seem disproportionately blessed. And though Fez was a famous centre of Islamic law and doctrine it was much more than that too: an enormous city, perhaps 200,000 souls within its walls, a great hub of trade, business routes radiating out like spokes to the desert caravans, the coast and the hills.

And where there was trade there were Jews, plenty of them, shutting their ears to the din of the new aggravation, going about the tasks of the perennial calendar, bending their heads over the Talmud. Ancient synagogues opened from low, studded doors. Candles glimmered from arched windows that overlooked lanes where the hooves of mules trampled yesterday's dung. In the great souk, people sneezed and spat yellow and red dust inhaled from heaps of spices, while crooked men emerged from doorways to tug at their sleeve. It could have been worse.

And it could have been better. So when Moses, himself now a scholar and commentator of Torah and Talmud, learned of the *responsum* to the hard-pressed Jew trapped between death and conversion he became angry. In those days, he reflected much later, he had often been quick to fly off the handle. The truth is that he never really mellowed. Intensity and urgency followed the beat of his pulse. How could he not take offence at such inhuman severity, such easy freedom from the merest shadow of doubt? Was this any better than the persecutors with whom they were obliged to live every day? His father had already written a little consolatory tract, insisting that, faced with disaster and persecution, it was better to cling to the Torah in whatever way one could contrive than to let go of what he called, poetically, a rope suspended from heaven, and so plummet into the pit of self-destruction.[4] Secret prayer would commend the pure at heart to God. Moses' *Letter on Forced Conversion* (*Iggeret hashemad*) was written with a mind to the many who, under coercion, had already converted to Islam while trying to maintain their Judaism in secret. The respondent rabbi's instruction had been widely circulated so that Moses felt it incumbent on him, young as he was, to offer a kinder way so that the *anusim*, the coerced, might know there would be a path back to the open profession of Judaism when safety permitted. The *Letter* was written in Judeo-Arabic but translated into Hebrew, and its reassurance could as easily have been applied to the Ashkenazim of northern Europe who had been faced with the same brutal alternatives at the hands of crusading Christians. Unless the demanded transgression was murder, idolatry or coerced sexual congress, the young Maimonides wrote, saving of life was the highest obligation. How else could Jews be saved for God who wished Jews to *live* the Torah? To take one's own life rather than transgress under duress made one the author of

one's own killing, the profaner, rather than the sanctifier of the Name. Outward utterance was of no consequence for it was not the seat of true belief. God saw into the innermost soul of conviction. Hence it was indeed permissible to assume the forms of Gentile religion while remaining true to the Torah wherever and howsoever was possible, without fearing that an act of idolatry had been committed.[5] Most dramatically, the young teacher assured the anxious party that those who kept true faith in secret would be as assured as any other Jew of salvation in the afterlife.

Could Maimonides have been talking to, and convincing, himself? Scholarly biographers have suggested that he may actually have followed his own advice and submitted, for a while, to a temporising conversion to Islam.[6] For two years, from 1163, the second Almohad caliph Abu Ya'qub Yusuf had borne down harder and harder on Unbelievers and it may finally have been too much even for the family of Rabbi Maimon. But there was a way to escape both death and conversion, namely flight, and Maimonides pressed it on his correspondents and then again to the distressed 'master of sciences and learning' who wrote to him in a similar plight from Yemen in 1172. Never mind the attachments of home or family, he said, offering cold comfort, take yourself to wherever it might be possible to follow the Torah in freedom; best of all, to the Land of Israel, the land of their fathers.

There was a touch of disingenuousness, or convenient forgetfulness in this instruction. Maimonides had been there himself along with his father and brother David in 1165, but had not, in the end, stayed. This was despite the solemn injunction in his *Mishneh Torah* that it is better to live in Palestine amid heathens than in a city outside Israel amid many Jews, and that dwelling there was itself a way to atone for sins and wipe the slate clean (an assumption shared by the Crusaders). The relentless mutual hammering between Christians and Muslims was an opportunity for the Jews only in that at this particular moment both of the warring armies hated each other more than either did the Jews. Neither side excluded the Jews from the whole land of Palestine, though it was not easy to live there. A scattering, concentrated mostly in Galilee, visited the tombs of the forefathers, peddled, prayed and stooped over the Talmud. The Crusader kingdom had reinstated the old ban keeping them from Jerusalem except on matters of business and days of prayer and fasting, when the Christians looked with grim

satisfaction on the Jews going through their grieving beside the ruined western wall of the Temple precincts. This was why they kept the Jews around, they reminded themselves, as perennial witnesses to their own blind error.

By the time Maimonides and his family made the journey, there was already a set of diaspora expectations built into the pilgrimage (just as there are now), not least from the ecstatically intense poems of longing, the great storms of the soul, stirred up in Yehudah Halevi's verses, well known around the Sephardic world. Maimonides duly got his tempest about a week into the voyage, and recorded both his terror that the ship might be dashed to pieces by a towering wave, his trembling prayers, and his relief that God had seen fit, eventually, to abate the storm. He would, he vowed, fast and offer prayers of thanksgiving every year on the day of their deliverance. (Maimonides was in the habit, as many Jews of this period probably were, of inventing a personal calendar of piety and rejoicing connected to the great events of their life.)

The voyage from one of the north African ports, probably Ceuta, was by the standards of the time not unduly long – perhaps a little over a month – but it was no Mediterranean cruise either, and as anyone knows who has run into dirty weather, sea-time has a nasty way of prolonging itself into what seems an eternity of misery. Moses, his father and brother were squashed together with another four hundred souls in the hold, along with animals and sundry clobber like the heavy saddles they would need on arrival and certainly did not want to have to buy from the leather-goods pirates of the souk in Acre. For obvious reasons the Jews would have brought most of their own food (buying water from the crew) which meant below decks there would have been non-stop cooking along with equally non-stop puking. On other bodily inconveniences it is best not to dwell. But the real problem with such journeys was less the physical discomfort than with the fact that such pilgrims were trapped in unrealistic expectations about what they would find on arrival. No one imagined it to be the antechamber to Paradise, but as Maimonides wrote, walking even four cubits on its soil would assure the pilgrim of the afterlife. Yehudah Halevi had disappeared before he could communicate any hint of disenchantment; what remained were his enraptured paeans of yearning and joy. Maimonides might, as he recommended

to others, kiss the rocks and ground on the threshold of the land. Yet he also kissed it goodbye after little more than a year.

Perhaps the rule of the Crusaders turned out to be more onerous and upsetting than he had bargained for. Palestine had been Christian for some seventy years and would stay that way until Saladin's conquest in 1187 – though significantly this reversion to Islam, and the possibility that Jews would be allowed to live in Jerusalem once more, was not enough to persuade Maimonides to return. Compared with the place he ended up in – Egypt – he may have felt Palestine a cultural backwater. Acre, where they arrived in May 1165, would have been his first experience of a Christian city, albeit of a very distinctive kind: a massively fortified port; streets that were a lot wider and grander than anything in Fez, or even Cordoba; grandiose buildings for the orders of the Knights Templar and Hospitaller; churches everywhere. In the middle of it, a Jewish community of a few hundred (in a city of 40,000) led by three rabbis, one of whom, Tzadok, was master of the local yeshiva. In all likelihood Rabbi Maimon and his sons would have been well received. It's possible that the local Jews might even have known Moses' early work on logic and the famous letter on forced conversion. But there would already have been a well-trodden route of piety for the family to follow: across Galilee to Tiberias, Sepphoris and Safed, the home of a gathering of Kabbalistically inclined mystics. Tomb tourism had been established and would have begun with the site where the first author of the Mishnah, Yehudah Hanasi, 'saint and prince' as Maimonides called him, was said to have been buried just outside Sepphoris. 'Guides' with a gleam in their eye and their promise of bargain-price accompaniment had to be brushed away like buzzing flies. The tombs of Rachel, the prophet Jonah son of Amitai, the one in the valley of Kidron said to be the resting place of David's rebellious son Absalom, and the 'Cave of the Patriarchs' in Hebron were all obligatory stops, as they still are today.

Jerusalem of course was the ultimate destination, the point of it all, but for whatever reasons it took Maimonides six months before he finally got there. Perhaps the prospect of measuring reality against sacred poetry, inevitable to his sharp intellect, was itself a reason for procrastination. For he was no exception to the rule that the Jerusalem of the grieving imagination preceded and conditioned any actual experience. Maimonides doubtless did follow his own advice that, on

beholding its ruins, Jews should utter lines from the Book of Isaiah on the laying waste of the Temple. He might have recalled Halevi's words that for their sins Jews had been punished by the transformation of the city of David and Solomon into the 'lair of owls and jackals'. His first view, like all those who approached, would have been from the Mount of Olives, from where he would have seen the area that had been the Haram al-Sharif, and once the Temple, turned into a congregation of churches. He was much given to introspection about whether or not, even in this state of degradation, Jews should actually enter the precincts of the ruined Temple, impure as they were, but he seems anyway to have done so, perhaps also rending raiment like a mourner, as he prescribed – and not just a token snip or snag either, but a fierce ripping into shreds and rags, layer after layer 'until the very heart is laid bare'. Maimonides made sure to add that what was left of the garment could only be repaired with a crude ladder-stitch, the kind that would fall apart at the merest tug.

It was hard, perhaps impossible, to live in the sight of such rack and ruin. A handful of Jews did so, outside the walls, but they were shouters, beggars, spongers, draggers to rocks and tombs, exploiters of the Torah to the credulous. Better to keep the holy vision in the mind. And there was something else that might have made him want to move off again. His father had died, and was buried in the land of Israel as he doubtless had wished. But prayers could be said for him wherever the brothers were. Why should they stay forever at his tomb? So Moses was off again a year after he had come, travelling south to the place he would describe to a Yemeni correspondent as 'home', the place Jews were endlessly instructed to leave but to which they somehow always returned: Egypt. Where else should he go? Fez had become intolerable under the Almohades or whatever variation of Berber ferocity succeeded them. Al-Andalus was lost forever. Since the Almohades conquest, a Jewish emigration from the Maghreb centres – Kairouan, Marrakech and Fez – east to Fustat had been gathering pace. Egypt was still in the hands of the Shi'ite Fatimid caliphs, though not for very much longer. Yet Fustat was not just a thriving centre of commerce and culture but also one in which piety and philosophy were inseparable, and that may have been one of the attractions for Maimonides.

As with so many Jews before him it was his fame as a learned and

skilled physician which opened doors for Maimonides at the court of
the caliphate. In what seems to have been no time at all, he became
doctor to the caliph's vizier, Shawar, and the powerful minister al-Qadi
al-Fadil, who saw in the young Jew a fellow scholar and philosopher.
It did no harm to his prospects that Maimonides wrote in elegantly
rhymed prose. Nor that he was a doctor with a complete set of skills,
one of which, like Hasdai ibn Shaprut before him, was a speciality in
antidotes for poisons, always a popular talent in the dangerous world
of competing Muslim powers. Maimonides would go on to write
treatises on practically anything that ailed people, from impotence
(rubbing the challenged member with crushed saffron ants suspended
in an emulsion of oils was his secret recipe for securing and sustaining
a strong erection) to haemorrhoids and asthma.

Dr Maimonides was evidently so good that, probably to curry favour
with his Crusader ally Amalric I, the vizier Shawar wanted Maimonides
to go and treat the Christian king of Jerusalem then camped at Askelon.
And Maimonides was already sufficiently indispensable to be able to
decline without suffering negative consequences. After all, wrote
another friend and admirer of his, the poet ibn Sana al-Mulk, 'were
the moon to ask him for treatment . . . it would receive it to perfec-
tion . . . and on the day of the full moon he would deliver a cure for
its freckles'.[7]

Nor did the overthrow of the Fatimids by the next power along
the line – the Kurdish dynasty of the Ayyubids – damage his career
prospects, not least because the incoming warriors were Sunni and as
it happened Maimonides' patron and friend al-Qadi al-Fadil was himself
a Sunni even when he had been working for the Shi'ite Fatimids.
When the minister nimbly switched allegiance, his brightest and best
protégé went along with him. Maimonides settled in the district of
Mamsusa, close to the old Roman fortress, and – strikingly late for a
Jew – got married in his mid thirties, to the daughter of an old Fustat
family. His affiliation was with the 'Iraqi' synagogue rather than the
'Palestinian', each, one need hardly say, worshipping in their different
chants and styles with no love lost between them, though Maimonides
appears to have preferred praying at smaller places of study. In any
event he became enough of an authoritative figure in the community
that he was called on as a 'rav' to issue legal judgements on inquiries
laid before the religious courts and, more startlingly, to become for a

short time *ra'is al yahudiya* or head of the entire community of Jews in Egypt, responsible for mediating between them and the government, not least in matters of taxes. Maimonides may have been flattered by the confidence but he also knew it was a thankless job, a guarantee of hatred from both sides, and extricated himself from it by 1172 after only a year. There was only so much multitasking even he could manage, and being doctor, religious judge and authority – while also working at night on his great study of the Mishnah and much besides – was consuming his hours and, as the physician knew, his health. But the appointment as *ra'is* was evidence that Maimonides was admired and trusted by his counterparts in the Muslim world and he in his turn drew deeply from their translations and editions of Greek philosophy, above all Aristotle.

Every so often, though, something happened to pull Maimonides out of any complacency that he was living in some sort of unforced cultural community with Muslims. In 1172, he received a letter from Yemen – the place that had once been a Jewish kingdom – reporting on an appalling campaign of coercion inflicted on the Jews by a messianic rebel, whose regime made the Almohades seem by comparison positively lenient. Of such evil tidings he quoted the Book of Samuel: '"Whoever hears of them has both ears tingle." Indeed our hearts are weakened, our minds are confused and the powers of our body are wasted because of the dire misfortunes which have brought persecutions on us from the two ends of the world, East and West.'[8] In Yemen, Jews were being subjected en masse to forced conversion, but the penalty for any sort of heterodoxy – not to mention failing to pray at the appointed times, drinking or other such iniquities – was death, applied by the Mahdist rebels with brutal enthusiasm. The letter was evidently so distressing and painted a picture of such suffering that Maimonides put down everything else to respond in an *Epistle*, meant in the first instance as consolation and reaffirmation to the beleaguered Yemeni Jews, but also circulated far beyond them as a kind of defiant reassertion of the superiority of Judaism over the pretences of competing monotheisms of 'Jesus the Nazarene' and 'the Ishmaelite' (Muhammad). Within the long essay is a poignant but forceful enquiry into the perennial character of Judeophobia, rooted as Maimonides believed in the insecurity the other religions had when facing the incontrovertible and simple majesty of Judaic faith and the Mosaic

Law. It was the doctor's cure for misery: for once an explanation of
suffering not merely based on punishment for their own sins, but on
the vicious obtuseness of the newcomer monotheisms with their
bizarre quasi-pagan demands to worship some entity other than God
Himself, or heed spurious prophecy. At one point, the darling of the
Ayyubid elite (to whom he was, by 1172, giving lessons in science and
philosophy in his perfect Arabic), celebrated for his thoughtful cour-
tesies and studious decorum, sweeps aside his counsel to others to be
moderate in all things and turns fiercely immoderate, emitting a cry
of pain and rage against the majority culture. 'Be angry only for a
grave cause that rightly calls for indignation,' Maimonides wrote in
his *Mishneh Torah*. What was happening in the Yemen seemed just
such a cause and made him reflect, when he thought of the Almohades'
persecution of the west as well as the oppression of the east, that this
could happen anywhere in the Muslim world; that the politeness and
even the trust extended to such as he was merely a concession given
on the condition of institutionalised subjection, cultural crumbs
thrown from the fist of masters. 'Remember,' he writes to all the
readers around the Muslim world he knew would be reading copies
of the *Epistle*,

> on account of the vast number of our sins, God has thrown us into
> the midst of this people, the Arabs, who have persecuted us severely
> and passed baneful humiliating legislation against us . . . never did a
> nation molest, degrade, debase and hate us as much as they . . . We
> have borne their humiliations and falsehoods and the absurdities that
> are beyond the powers of humans to bear . . . we have trained ourselves
> young and old to endure this humiliation as Isaiah decreed 'I offered
> my back to those who flogged it and my cheeks to those who tore out
> my hair' and still we do not escape their constant outbursts. We prefer
> peace with them yet they prefer strife and war.[9]

A year later, in 1173, Maimonides was overwhelmed by a calamity
that could not be blamed on the Arabs: the death of his brother
David while crossing the Indian Ocean on a business journey. Eleven
years younger than Moses, David had been the great man's particular
love, his 'son, brother, pupil' as he wrote, still stricken in inconsolable
sorrow eight years later, to a correspondent in Acre. While an apt

and precocious scholar of the Talmud himself, it had been David, trading in gems, particularly pearls, who had carried on the business that had allowed Moses to get on with all his other work, not least the great studies on the Mishnah. This had been especially important since Maimonides refused to accept any payment for his work for the community as religious judge and scholar, and in fact heaped scorn on those who, declaring 'I am a great sage', added 'now support me'. Maimonides believed the sages of Jewish antiquity had all had working jobs – drawers of water and hewers of wood – and still managed to study at night, and he took pride that his own working day as a doctor would be in that tradition of the nobility of labour. So David's business was needed to put food on the table for two families, especially since Moses made much of the obligation on the Sabbath to have a full three meals of as much lavish splendour as the household could afford.

So it was to be expected that, every so often, David would have to undertake the long journeys east to buy precious goods that could be sold on the Egyptian market or re-exported. At the same time Moses was beset by the anxieties that went along with such perilous ventures. On the desert section of the route, gangs of murderous thugs waited to set upon the slow-moving camel caravans. By sea, pirates descended on ships, carried off cargo and captives for ransom (on the same waters where they still flourish). The vessels themselves were notoriously leaky and prone to foundering in storms. Doubtless David himself shared many of these qualms, but there were Jewish long-distance traders who did the journey all the time and he put a good face on the dangers.

The first leg was the uneventful journey on the Nile from Fustat to Cus, then further upstream to Luxor. Thereafter the route was overland, an arduous three-week camel-plod across the desert, distances between the oases stretching ever further, the travellers attempting to protect themselves from the murderous sun as best they could. Eventually they made it to the port of Aydhab on the Red Sea from where David sent his brother a letter (miraculously surviving to this day) describing his exhaustion, the dismay at seeing the main body of the caravan straggling into the port as the victims of a violent robber attack, his disappointment at finding nothing except a little indigo to take back to Egypt, and his decision as a result to take ship

down the Red Sea and across the Indian Ocean where there was a thriving community of Jews on the Malabar coast, from which he was confident he could find proper goods and cargo to take back home. Knowing his older brother well, the great swoops and plunges of Moses' moods (despite being the world's most famous champion of even-tempered moderation), David did what he could to ease Moses' anxieties even as he couldn't help describing the privations he had endured. 'He who saved me from the desert will save me from the sea.' But at the end, a slightly chilling note of fatalism creeps in as if somehow the younger brother had a presentiment he might never see the older again. 'Wa-ma fat fat,' he concluded, using an ancient Arabic proverb, 'what is done is done'.

It is not known exactly when or where on the journey David was lost, only, according to Maimonides' heart-rending letter, that he was drowned. With him, Maimonides added, was more or less the family fortune needed to buy the gems. Now the main breadwinner of the extended family was gone, and Moses would himself have to provide for his widow and children. But the loss of the person he loved most in the world brought on a kind of traumatic paralysis that left him 'prostrate and in bed' for over a *year* with severe inflammation, fever and mental confusion. This was the malady which Egypt's greatest doctor could not cure. Every time he came across a letter or a piece of business in David's handwriting, he was broken in pieces all over again.

When he slowly, painfully, emerged from the darkness, Maimonides was irreversibly changed by the twin disasters: the collective one inflicted on his people in Yemen and the personal in the form of his terrible loss. Now, even though he was still only in his late thirties, he felt a fierce urgency to address himself to the matter of survival and endurance; to cut to the quick of Jewish life, undeluded by complacency or superficially protected by ritual routine. The essence of his position was this: that survival in adversity required thought and not just fidelity to habit or to unexamined tradition. The greatest gift that God had bestowed on men, and particularly on his people, was the intellect. It was what distinguished men from beasts, and it was made to be used. 'It is by virtue of it that we are constituted as substances.' In the *Guide to the Perplexed* he endorsed the opinion of Alexander of Aphrodisias, a commentator on Aristotle, that the appetite for dispute arose from

three prime causes: first, the impulse to dominate; second, the sheer knotty subtlety of the matter under debate; and third, the ignorance of those contending for an unanswerable conclusion. To that list Maimonides added the dead weight of habit, to which he attached a vehement criticism of 'those wretched preachers and commentators who think that a knowledge of words and interpretation of words is science and in whose opinion wordiness . . . is perfection'.[10]

 Maimonides was not rejecting the Talmudic way, its limitless appetite for chatty dispute, multiple contradiction, abrupt yet interminable divagations and digressions, its relish of the incidental, its lip-smacking, fist-punching relish for detail, its procedure through indirection, its endless and unresolvable enquiries into what some sage must have meant by his comment on an obscure passage in the Bible only to be confounded by an equally viable counter-interpretation. But all this *wordiness*, Maimonides implied, was a luxury, an abstruse game for the initiated, an endless hunt for the ultimate *aha*, pursued moreover in a language – Aramaic – that was not authentically 'Israelite' and which fewer and fewer Jews could comprehend and which had ever less meaning in their own daily lives. And it was, above all else, directed to the interior of Jewish life, though Maimonides had always stood facing outward as well as inward, dealing with the powers that be – indeed serving them as best he could without ever compromising the staunchness of his Judaism. From this outward-facing position, he drew both a sense of defensive urgency and the intellectual sustenance to deal with the crisis of his people, a crisis that seemed to have lasted as long as their post-biblical history. He believed that the narrow straits into which the Jews had been confined by the two monotheistic powers were getting ever narrower, for all the courtly good humour of Saladin's government and its cultivated literati. Given the darkening horizon, it was not enough simply for Jews to retract still further into their esoteric puzzling. They were going to have to defend themselves in trial with something more powerful than turning their backs and pulling on their beards, namely with the minds that God had given them. It was to sell the Torah, the Bible and the Mishnah short to imagine that it could not be strengthened rather than vitiated by the exercise of philosophy; insulting, in fact, to the divine endowment of the intellect. To be sure, as he had said and would say again, there were categories of laws that defied rational analysis and had to be

accepted; but for the most part, God had given the laws to and through Moses so that their ethical and social rationality would command observance, not just dumb obedience.

At this formative moment, not just in his own career but in the long history of his people, Maimonides stood at the apex of Jewish experience, viewing it as if from Mount Sinai itself. There was a strong element of self-consciousness about the import of what he was doing, a donning of the mantle of vocation. 'I Moses the son of Maimon the Sephardi' *was* both Moses the legislator and Maimonides the Greek-named philosopher. He was Moses the Israelite tending to the welfare of the Jews and Maimonides the famed man of science invoking principles that were universal, to be understood and thus accepted by the rest of the world. He was both Jew and the personification of common humanity too, and the history of all this rushed through his articulate eloquence. Faith would stand supported by the pillars of reason and the temple of wisdom so constructed would stand forever until another was built in Jerusalem by the liberating Messiah.

His challenge, then, one which occupied the rest of his life (he died in 1204 in his late sixties), was first to clarify and fortify the essence of Jewish life embodied in the Torah so that it could be internalised in everyday conduct; second, to construct a body of argument that could armour-plate the Jews from the coming attack, almost certainly violent, on their beliefs, perhaps on their very existence. He had begun the first part of the work, the *Commentary on the Mishnah*, while still in Fez. That great foundation stone had been so thickly covered by the organic burgeoning of Talmudic interpretation that it had been obscured. Reverting to the Hebrew of late antiquity in which it had been written (neither the Hebrew of the Bible nor that of the hyperbolic synagogue poetic liturgy), Maimonides wanted to create – or recreate – a pure, classical language, a strong but transparent vessel for the communication of fundamental truths. To do this meant clearing away the huge clutter of rabbinical opinions and counter-opinions, forgoing the long trail of conversations for the heart of the matter, an economy he practised in the extended version, the supreme expression of his intentions, the *Mishneh Torah*. That work was both philosophical statement and, in the spirit of the original Mishnah, a practical guide for Jewish living.

Maimonides must have known the philosophical introduction, the *Sefer HaMada* (*Book of Knowledge*), would be controversial, replacing as it did a recitation of the generations of sages, although at its core was an unimpeachable statement of the origins of Jewish law in the Mosaic theophany at Sinai. In his later work, the *Guide to the Perplexed*, written in Arabic and intended, Maimonides wrote in rather Platonic mode, for the already sophisticated (open-ended enquiry being fraught with dangers for the ignorant), he took on the issue of God's act of Creation itself, against those like Aristotle who believed in the un-caused eternity of the universe. (Maimonides also took a sideswipe at all those who cringed before the authority of the Greek, and who thought it a disgrace to disagree with him.) For Maimonides, the existence of the world without the presupposition of a prime cause and prime mover was logically unsustainable, however the matter of the world came into being. Biblical description should be understood every so often allegorically as much as in other places (the story of the exodus above all) historically. But in both the introduction to the *Mishneh Torah* and the *Guide to the Perplexed*, Maimonides was the first great master of Jewish hermeneutics, believing that an enquiry into the nature of understanding and knowledge was not at war with faith but, on the contrary, its indispensable condition.

The *Mishneh Torah* simplifies and clarifies the categories of commandment and practice of the original, and although it purports to abide by blessings, the calendar of festivals, the timings of prayer, the rules of purity, matters of tort, at almost every place along the way Maimonides adds instances of why the prescriptions should find support in reason. And there are passages – the long paradoxically impassioned argument for moderation and a golden mean – which had no place in the original Mishnah at all. But Maimonides felt himself to be both the repository of ancestral wisdom and its refurbisher for contemporary life. The polemic against immoderation was directed to asceticism, much in vogue as a result of the Sufism that had flourished under the Fatimids, and threatening to become an influence on Judaism as well. There was, Maimonides felt, something self-indulgent in the fanatical other-worldliness of extreme ascetic practices that he hated almost as much as the relentless literalism of the Karaites or the default traditionalism of the ultra-Talmudists. God and His Mosaic legislation were about this world and how to live in

it, and everything in its exhaustive content was amenable to the intellect. This was Dr Maimonides speaking, for whom sound health of mind was an intrinsic element in the body of belief and practice.

The *Mishneh Torah* is thus packed full of behavioural doctoring. Do not ask someone to dinner knowing they will decline; avoid the odiousness of flattery; when you disagree with someone never ever do it in such a way that it exposes the corrected to public shame and humiliation; eat and drink well (especially on the Sabbath) but do not gorge yourself senseless for bear in mind the injunction against gluttony in Malachi, 'Behold, I will spread dung on your face.' Right. Reside only in towns or villages where you know the following are available: a physician, a surgeon, a bathhouse, a lavatory, reliable sources of flowing water, a school, a teacher, a scribe, an honest treasurer of charity and a court. Prayer is all-important and therefore must not be idly or habitually undertaken, not, for instance, when one is drunk, or still chortling at a joke, or when the words that come out of the mouth are at odds with the thoughts in one's head of business. Write your own personal scroll of the Torah so that it can become as much yours as the *tefillin* on your head and arm, and if you cannot, hire a scribe to do it for you. Honour the Sabbath with a meal that stands out from the run-of-the-mill food of the week, two loaves three times a day, plenty of good wine, but of course adjust to your means as best you can. Husbands, share in the preparation for the Sabbath: shop, clean, be a good helper. The Sabbath, to be sure, was made to remind us that on the seventh day God rested from His Creation – but in a typically Maimonidean fashion, he went from the philsophically worrying notion of a seven-day creation to the historical exodus when arguing that the Sabbath was also made to remind the Jews that they had been slaves, unable to determine how long they would labour or when they might take a respite from its rigours. In that spirit, too, it behoved employers to pay their workers on time, never withholding wages. In business, the highest degree of ethics was commanded. Maimonides would not have approved of intra-corporate short-selling since he abhorred any attempt to conceal blemishes in whatever you were selling to a potential customer. To acquire something and not pay for it right away, he stated, was tantamount to a desecration of God's name, yet he also detested the raw swagger of money and insisted that of the many acts of charity commanded, none was more

sacred or pleasing to God than bestowing generosity on the poor. Not
for nothing, he observed, are those who refuse it called 'Belial', the
Hebrew name for a particularly atrocious species of demon. But – and
this is Maimonides the social behaviourist at his most attentive – never
bestow that charity in a spirit of haughtiness or with a brusque or
downcast demeanour, but in agreeable cheerfulness. To find employ-
ment for the poor was to fulfil a great *mitzvah*. And perhaps the ethical
wisdom of the Torah was most profoundly exemplified in the obliga-
tion to eschew any kind of finery in the burial of the dead, no matter
how rich the deceased and their family. God wished, indeed
commanded, only the simplest of shrouds so that the poor, already
distraught in such circumstances, should not have to be further humili-
ated. Indeed the rich man should be honoured to be buried in the
same fashion as the impoverished.

Choose life. Sacred though the Sabbath was, violate it to save a life
and do not, as some suggest, wait until it is over before starting treat-
ment for the sick. Begin at once and without hesitation or reservation.
Choose life. Never condemn a man to death on his own testimony
alone, but only on the strength of at least two witnesses.

Maimonides was both exceptional and typical of Jewish thought
and writing in that he was torn, every day, between the demands of
the physical and the political. Close as he was to the powerful in
Saladin's government and even to the ruler himself whom he attended,
he understood politics on a practical as well as a philosophical level.
(He warned against kings falling into the vices of drunkenness and
concupiscence lest they undo not just their authority in the eyes of
their own subjects but the handling of public affairs.) And he thought
of the Laws of Moses as, in their way, constituting a true polity on
the notoriously self-dividing Israelites. But he did not want his immense
gloss in the *Mishneh Torah* to be merely what he called a *nomos*, akin
to a Greek *vade mecum* on civic governance: a compendium of eth-
ically charged usefulness. In the end, Maimonides was after bigger
game, indeed the biggest: the quest for perfection.

This step-by-step programme was set out in the *Guide to the
Perplexed*, a work which while wonderful in its intellectual intensity,
yields as many perplexities and inconsistencies as it claims to resolve.
Yet such is the sharpness and, occasionally, beauty of Maimonides'
thinking and the prose in which it is set that readers can't help but

be swept along for the ride. Increasingly those readers were Jews, especially after Maimonides consented to have the work translated into Hebrew by a younger friend, Samuel ibn Tibbon. Three kinds of self-perfection are well understood, he writes. The first, of course the vainest, most vulgar and self-deceiving, is perfection in property, goods and the like, for this is but the dross of life. The second, physical perfection of body, should have as its end soundness and vigour of constitution and is needful in that (as he had had many occasions to observe, not least when he was his own patient) it is impossible to turn one's mind to the higher things when attacked by sickness. Yet this too is but a feebly blinkered search for perfection, for inevitably all bodies decay as time and God decree. The third search, as indicated in the readings of the Torah to which his own work drew attention, was more significant, in that it led to the Good Life, lived both by individuals and communities. But even this was not the true end. Right and fitting, indeed unequalled in the world, though the commandments and prohibitions of the Torah were, their surface prescription concealed deeper meanings, the purpose of which was to lead the observant to the ultimate and only perfection: closeness to the nature of God. If this sounds suspiciously metaphysical coming from an old Aristotelian (who took issue with the Greek master), that is because it indeed was. Maimonides was at pains to insist that the essence of God would always remain shrouded from the intellect, just as his ancestral namesake had been denied knowledge of the essence of God, who had refused him His face and shown him merely a glimpse of His back. Moses and the Israelites who studied the Torah would get no nearer than God's attributes, divined through the exercise of what he called the 'rational virtues'. But for Maimonides that itself would be a numinous revelation, and would bring men to a kind of blessed proximity. Strikingly elegant and forceful writer though he was, Maimonides was no poet, not at any rate in the league of the great patriarchs of Hebrew verse – Shmuel ibn Naghrela, Solomon ibn Gabirol, Moshe ibn Ezra and Yehudah Halevi. Yet the poetic chord in him responded with complete understanding to the Song of Songs in which the yearning of Israel for union with God takes the form of a graphically erotic poem. That was it, he thought, and counselled those who sought nearness to love God, consummately, physically, exactly as a lover obsessively dwells every minute of the

day and night on the features of the beloved, all in high-coloured
close-up. Thought, then, even of the exacting kind Maimonides took
to be an act of gratitude to God for having endowed humans with
the power of reflection, had its limits. Even knowing they might never
be exceeded, his advice was to press against them, to catch even a ray
of celestial godliness of the kind that made the face of Moses shine
with the radiance of the *shekhina*. A whole book of the *Mishneh Torah*,
the one concerned with daily prayer and devotion, was called *Sefer
Ahavah*, the *Book of Love*.

The intensity with which he felt this was, however, in inverse
proportion to his capacity to reach such a consummation himself.
This was not from a want of desire, but a lack of time. There were
just so many hours in the day and they all seemed to be filled by the
needs of everyone who wanted him, and they wanted him non-stop.
So while at one moment he was given to a little gentle boasting about
his reputation far and near as a great master of medicine, someone
moreover who treated it as a humane art and would minister gratis
to the poor as well as the mighty, he also proved himself, in a long
letter to Samuel ibn Tibbon preserved in the Cairo Geniza, a consum-
mate moaner, a king of the *kvetch*:

> I dwell in Fustat while the king [Saladin] lives in Cairo and there are
> four thousand cubits, two Sabbath limits separating the two [somewhat
> over a mile]. I have a very difficult appointment to the king. I have to
> see him at the beginning of every day. When he is weak or one of his
> sons or concubines are sick I cannot leave Cairo and spend most of
> the day in the palace. Then I have to attend to the officers of the king
> as well every day. One or two of them are invariably ill and I have to
> see to their treatment.
>
> So in sum I go up to Cairo every morning and if there are no
> mishaps I get back to Fustat by midday . . . As soon as I arrive, raven-
> ously hungry, I find the halls of my house packed with Gentiles, the
> grand and the humble, judges and magistrates, a mixed crowd who all
> know exactly when I am showing up. I get down from my mount,
> wash my hands and go and persuade them to wait a little while I
> manage a light meal . . . Then I go to heal them and write whatever
> prescriptions they need. Sometimes they are coming and going all hours
> until two hours into the evening falls and . . . sometimes my fatigue

is so great that I have to speak to them while lying down . . . When night falls I am so totally wiped out that I can't say a word.

The result of all this is that no Israelite can manage to speak to me except on the Sabbath when they all come after the morning prayer and I instruct the community on what should be done for the coming week. They study light matters until noon then go on their way but some come back and study again until the evening service.

So this is what my daily schedule is like, and I have told you only some of what you would actually see, with the help of God, may he be exalted.[11]

He was not exaggerating. Among the work omitted from the letter were his daily obligation to render judgements on whatever questions, complaints and suits that came his way in the *majlis*, or council. Some of these that survive in the Geniza are as brief as they possibly can be, sometimes indeed barely more than a word but with the precious signature attached. But then delegation seems not to have been an option. Anyone failing to render judgement in such matters, he had written, a little grandly, makes the divine presence shrink from the room. And then of course there was the work of editing his own commentaries on the Torah and Mishnah which was an ongoing task, as well as the many volumes of medical advice concerning different ailments, including the impotence of Saladin's nephew (if no saffron ants are available try black pepper, honey and wine for pumping up the blood flow). Maimonides thought wine the best medicine for most things, which was yet another instance of the obtuseness of Islam in prohibiting its consumption.

The price of all this Mosaic omniscience was a kind of Mount Nebo exhaustion, cumulatively debilitating as his years advanced. With all the demands on his time and presence, he routinely declined to see the many people who wanted nothing better than to stand in his presence and perhaps put one of their own perplexities to him. His diet – in which chickens and eggs featured prominently, the latter cooked with a little cinnamon in oil, the Egyptian way – thinned out. Insomnia overtook him and wine was of little avail against the affliction of manifold aches and pains. Writing his book *The Causes of Symptoms* around 1200, he was himself a mass of them, seemingly multiplying out of his control, dictating from his bed, unable to attend

the sultan. Egypt itself, hit by epidemics and even a famine at the end
of the century, seemed to be waning along with his own vigour.
Sometimes Maimonides would get frantic at the loss of time to study,
think and write, reproaching himself for getting bogged down with
trivia. His two sons, Abraham and David, could take some of the
strain; David was the money-earner and Abraham a scholar and
commentator in his own right, and after his father's death *rav* of the
community and faithful, though not uncontroversial, custodian of his
teachings. Some of Abraham's Maimonidean reforms, like the adop-
tion of Muslim worshipping practices (all of which had originally
been Jewish) – full prostration and the raising of palms – were bound
to provoke resistance, and confirm the hostility of those who had
been suspicious of Maimonidean openness to other cultures all along.

Despite the confident announcement in the *Guide to the Perplexed*,
that apparent contradictions and what seemed to be unresolvable
inconsistencies in both the Torah and Talmud would yield to his
reasoning, Maimonides was increasingly struck by the provisional
nature of his own methodology. The knottiest of problems resisted
unravelling, and there was in any case an unresolved tension between
the logician and the believer. Often he found his own disciples run-
ning ahead of him, especially when he learned that they claimed he
disbelieved in the return of the soul to the body on the day of its
resurrection. He thought nothing of the kind, he made clear. His
name was being taken in vain. But then he should not have been
surprised to be occasionally misunderstood, for he had enabled a new
way of being Jewish to come into existence, one that had been antic-
ipated by Philo in Alexandria and Saadia in Babylon but never so
completely or forcefully articulated until Maimonides. That way
presupposed it was not just possible to be both devout and rationally
alert, but impossible to be truly devout *unless* the questioning intellect
was working full-time. From such rationalist optimism, a rejuvenated
Judaism would take strength. Whether the result was, as Maimonides
had hoped, the kind of invigoration that could withstand the attacks
on Jewish minds and bodies that seemed to be the lot of his envied
and despised people, it was hard to tell, short of the longed-for appear-
ance of the Messiah. Even then, he had warned, the true Messiah of
the House of David was just a man, not a demi much less a full God,
and when he had rebuilt a purified Jerusalem, the rest of the world

would turn on its normal course. The lion and the wolf would not lie down with the lamb. But perhaps, at least, they could be made to desist from their ceaseless, bloody, ravening?

II. Smoke

It takes a while to reduce parchment, vellum and ink to ash. Unlike paper, which embraces the fire, animal skins resist their destruction, smouldering as they curl and shrivel, surrendering to the incineration only after releasing beads of vestigial oil locked within the dermis. So it wasn't until two days had passed that the public executioner could report to his superiors in Paris that all the Talmuds, convicted of blasphemy by a jury of the University of Paris the year before, had been satisfactorily cremated. All through a day and a night in June 1242, twenty-four cartloads of them had bumped and jolted over the cobbles towards the place de Grève and their appointment with the public executioner; more than 10,000 manuscripts, thrown this way and that, the most precious bindings made from the uterine vellum of foetal calves, only the flesh side, still the milky colour of shrouds, used. The bigger books were so densely packed with leaves that at night they took on an amber glow, thickening the Paris air with a sweetish animal stink. A mass of spectators had come to goggle and shout as the big books were pitched onto the crackling pyres. Every so often a breeze would pick up from the Seine, and flames bearing Hebrew letters, their edges lit with curls of fire, would do an aerial dance over the crowd before descending on the heads of canting friars as clots of soot.

Somewhere amid the hooting throng was a mourner, wanting to give vent to his grief, not least because he came from a tradition that treated sacred books with as much respect as human bodies. The aged and the damaged books were sent to a *geniza* or allowed to decompose slowly and peacefully, some were even buried in a formal ceremony. Judaism did not shred, tear or burn the word of God. To set fire to a book was as if a living body had been burned on the pyre. Such thoughts may have been running through the distressed mind of the

young pious student Meir ben Baruch of Rothenburg, who had come
to Paris precisely to study the Talmud he was watching being
consumed by the flames.[12] The Pope, Gregory IX, had ordered the
confiscation; the king, Louis IX, he of such Christian zeal, had ordered
the burning. Meir had come to France because it was there that the
scholarly disciples from Rashi's school in Troyes – the 'Tosafists' most
respected for interpretations and judgements in the oral law – had
gathered to perpetuate the exhaustive work of their master. But faced
with new challenges the Tosafists were also composers of the liturgical
poems, the *piyyutim*, which since the seventh century had been sung
or recited in synagogue services. Many of them were laments, and as
soon as he could, Meir ben Baruch added another to the litany, a
poem owing much to another penned centuries earlier by Yehudah
Halevi, which played with the terrible arc connecting the fires of
Mount Sinai with the immolations of Paris:

> How could it be that you who were given in the divine
> all-consuming fire
> Could be consumed by mortal fire while your alien enemies
> were not even scorched by those hot coals? . . .
> Moses shattered the tablets, another repeated his folly
> Burning the law in flames . . . is this the end of the
> double penance?
> Into the public square like booty taken from an apostate city,
> they burned the spoils of God on high.[13]

Worse, a matter for the wringing of hands, was the fact that Jews had
been the abettors, unwitting or not, to the destruction. Its immediate
prosecutor was an apostate Jew, Nicholas Donin, who had brought
thirty-five charges of blasphemous abuse against the Talmud and set
them before the king and the Pope. At some point Donin may have
been a Karaite, the sect which rejected the authority of any 'oral law'
and adhered only to the strictures of the written Torah. The convic-
tion of the Karaites (mostly concentrated in the Muslim world) that
the Talmud was actually a usurping impediment to the observance
of true Torah Judaism, and that the tradition claiming Moses had
been given an oral as well as a written law on Sinai was false, found
a receptive audience among Christian theologians wanting to separate

contemporary Jewish practices (rabbinically indoctrinated and bad) from their shared common scripture (prophetic of Jesus and good). But no Karaites had gone so far as to propose burning the offending work, much less – like Pope Gregory IX writing to Louis IX – declaring that 'no punishment would be sufficiently great or sufficiently worthy of the crime' of those who perpetuated the fraud.[14]

Yet the notion that Christian authorities might take offending Jewish works out of circulation, if not destroy them physically, came from rabbinical, not anti-rabbinical quarters, most prominently in southern France, and their target was not of course the Talmud but the radically subversive works of Maimonides. As far as Rabbi Solomon bar Abraham of Montpellier and his pupils were concerned, the latter-day Moses had a cheek to imagine himself the heir to the original model when everything he wrote, and especially the way he wrote it, undid the epiphany on Sinai. By presuming to uncouple the Mishnah from its cladding in the great richly woven garment of the Talmudic commentaries and supplements, and by setting it forth in naked simplicity, as if it were the entirety of the oral law, had he not made the Talmud appear redundant in the eyes of the Gentiles? In addition, by introducing the alien reasoning of the Greeks into the holy texts, had he not compromised their purity and made them fodder for enemy sophists? It was, they thought, as if he had dragged the Talmud into a pagan temple, making it the philosophical plaything of those who wished it no good. It had got so bad that any jumped-up yeshiva boy with a saucy tongue in his head could quote half-digested gobbets of Rabbi Aristotle as if he were the equal of Rabbi Gamaliel and Rashi, may they rest in peace! Jews of good faith argued among themselves in their own way, with respect for the accumulated wisdom of the sages, but Maimonides had exposed the Talmud to the malicious questioning of outsiders. He had imagined himself to be giving tonic to the oral law but who, if you don't mind, had asked him to the bedside of the Talmud anyway?

Maimonidean loyalists blamed these blinkered, carping critics for the flames of Paris. Hillel of Verona (albeit writing sixty years later) claimed that not even forty days had elapsed between the burning of Maimonides' books and the inferno of the Talmud.[15] They had been so shocked at the *perpetual* anathema, applying to all Jews everywhere, put on the works of their master – especially the *Book of Knowledge*

and the *Guide to the Perplexed* (now in ibn Tibbon's Hebrew translation widely circulating in France) – that they had issued a counter-ban, a *kherem*, against Solomon bar Abraham and those who thought and spoke like him. Things got so bad that the anti-Maimonideans who were actively trying to recruit support in northern France claimed to have been physically assaulted in Orleans.

It was at this point, with the culture war bitterly escalating, that the anti-Maimonideans took the extreme step of asking the heresy-hunting friars stationed in the south where the Cathar heretics had been strongest, to extend their inquisition to Maimonides. In the polemical account of their approach given by the passionate Maimonideans the ibn Hisdai brothers, the Jewish heresy hunters had asked why the friars bothered crusading at the ends of the earth pursuing heretics when the Jews too had their own dangerous philosophers who were leading people astray? And since Aristotle was regarded as a dangerous influence on Christians too, the friars are likely to have been receptive to the appeal. If the Jews were divided, that itself might give them an opening for converting one or other of the estranged parties. Whether or not Maimonides' books were actually burned, there is no question that their destruction was what the aggrieved rabbis had in mind.

This unhappy outcome would have caused Maimonides the deepest anguish (mixed in with a burst of rage), as it did his son, Abraham, the custodian and perpetuator of his father's legacy. Instead of allowing philosophy to arm Judaism against Christian attacks, obtuse and doctrinaire traditionalists had indicted it as anathema to God's law. Riding a wave of hostility towards Aristotle's learning, they had invited Christians into a Jewish dispute, and had handed them a stick with which to beat rabbinic Judaism in its entirety. This misguided opportunism, as the Maimonideans saw it, would have consequences all Jews would rue, especially since the new orders of preaching friars, Dominicans and Franciscans, were fast acquiring the Hebrew which would allow them to pore, prosecutorially, deep into the texts of the oral law. Worse, they would get expert, learned help from a cohort of converts who had been brought up in traditional Judaism: Nicholas Donin and the Aragonese convert who had once been Saul and now called himself Pablo Cristiani, Paul the Christian. These men would be the zealots of the war on the Talmud and by the thirteenth century

they felt they had Church authority on their side. In 1215, at the Fourth Lateran Council, Pope Innocent III, the militant champion of an undivided Crusading Christian dominion, not only imposed dress distinctions on the Jews, by way of making the price of 'obstinacy' as punitive as possible, but also gave his blessing to a campaign of aggressive proselytising that would accelerate the timetable of the Last Days and the longed-for Second Coming of Christ.

This newly hostile scrutiny of Hebrew texts from within resulted in an ominous shift of attitude towards the place of Jews in a Christian society. For centuries, the approach set out by St Augustine – that Jews must be protected in their own observances and traditions, as living witnesses to the consequences of their own error – had set the guidelines for the Church. It had been acknowledged as a matter of course that there could have been no New Testament without the Old, and that the Hebrew Bible was full of prophecies of which Christ's life and death were the realisation. Hence popes and bishops had repeatedly sought to protect and even sustain the Jews until the moment of their conversion, and had issued expressions of abhorrence against the misguided who inflicted violence and harassment against them.

Though popes, kings and bishops still paid lip service to this principle of protection, over the course of the thirteenth century the ancient dispensation retreated and all but disappeared. Once Christians, guided by apostates, became aware of the extent to which rabbinic Judaism rested on the authority of the Talmud, they began to argue that the Jews had disqualified themselves from protection by leaving Bible Judaism behind and adopting instead an entirely new religion: Talmud Judaism. Even in the twelfth century the powerful abbot of the Cistercian order at Cluny, Peter the Venerable, stigmatised the Talmud as the true *Jewish* enemy, threatening to 'drag the monstrous beast from its lair and show him off in the theatre of the world for everyone to see'.[16] Increasingly, the theological shock troops of militant Christianity uncoupled Talmud from Torah, representing the former as the nemesis of the latter. While the Jews might argue that the Talmud's purpose was to illuminate the Bible, it was evident to these new readers that it actually obscured it. If there was no doubt that God had indeed revealed the written law to Moses on Sinai, there was equally no doubt that the rabbinical claim that he had also received a similarly divine 'oral law', which later generations committed to

writing for the benefit of posterity, was a fraud and a fable, concocted
to legitimise the usurpation of those who called themselves 'sages'.
Unlike the Torah, the Talmud was merely and purely the work of
men, fraudulently masquerading as the interlocutors of God. Not only
that, but the concocters of the work had the temerity to make their
Talmud *much* longer than the Bible itself! Sidestepping the inconven-
ience of biblical prophecies foretelling the coming of Christ, the
Talmudists then had the impertinence to set their sages above the
authority of biblical prophets like Isaiah, Ezekiel and Daniel.

Their heretical presumption had snapped the chain binding Jews and
Christians together in reverence to the Hebrew Bible, to the Laws of
Moses, the House of David, the visions of the prophets. The reason
for the imperviousness of the Jews was at last crystal clear. Enslavement
to the usurping Talmud explained why they remained blind to the
otherwise obvious message that Christ's life was the consummation of
what had been prophesied to the Israelites. They had been kept from
the gospel truth by the falsehoods, insults and circumlocutions of the
Talmud. Indeed, as Pope Innocent IV, Gregory's successor, explained,
Jewish children were actively discouraged from studying the Bible and
delivered instead to the casuistical, ensnaring net of the Talmud. The
rabbis claimed theirs was the most ancient of one-God religions and
that Christianity was a spurious novelty, but in fact *theirs* was the upstart
religion. Was it not, then, incumbent on Christians to destroy the
fraudulent authority of the Talmud *for the sake of the Jews themselves*?

Hence the pyres of Paris. But they were merely the sentence passed
after a full-scale trial, launched by Louis IX and convened under the
auspices of the University of Paris under its chancellor Odo of
Chateauroux, following the order from Pope Gregory to round up
and confiscate the offending Talmud. Although (according to Louis
IX) an unnamed rabbi had been invited to Cluny to debate with a
convert and had been been struck by the crutch of an elderly Christian
knight for daring to deny the divinity of Christ, this was the first time
that representatives of French Jewry had been formally summoned to
answer the apostate Donin's charges laid against the Talmud. The
most serious offences amounted to gross blasphemy against Christ,
the Virgin and the holy Church. And those blasphemies and insults
put in question whether such inveterate enemies of the gospel could
be tolerated amid the Congregation of the Faithful. It was pointed

out that Pope Innocent III had reaffirmed protection for Judaism *on condition* that it did no harm to Christianity. But now it appeared that the observance of Talmudic Judaism actually *required* the Jews to offend and harm Christianity and, Donin claimed at one point, it actively encouraged them to kill Christians. In this reading, there was a plain connection between Talmudic insults against the Virgin and the Saviour, and the increasingly common reports of Jews said to have desecrated holy images and especially the Eucharistic host – the wafers in which Christ's presence was physically embodied at Communion. Now that properly informed Christians understood what was at stake – an apparently implacable mutual war – was it not the case that rabbinically led Jews were not just an anomaly but an actual threat, and as such had forfeited their protection? The Jews, some said, were a more immediate danger than the Saracens, for their abominations were committed in the very heart of Christendom.

Thus it was that in 1240 in Paris and 1263 in Barcelona the Talmud was put in the dock in a show trial of Judaism, with the object of extracting admissions of its guilt. Unlike in Paris, where the existence of the Talmud was imperilled, the Barcelona trial did not necessarily involve confiscations, much less burnings. But it was a tournament of belief all the same, staged with the ardent hope that the Jewish champion, Rabbi Moshe ben Nahman (known as Nahmanides), would be so confounded that his moral destruction would trigger a mass conversion. Observing the spectacle were the princes of the Church, leading theologians of the Dominicans and Franciscans (including those learned in Hebrew) and members of the blood royal. Louis IX's mother, Blanche of Castile, who yielded nothing to her son in her hatred of the Jews, was present at the Paris proceedings, and in Barcelona King Jaime I of Aragon presided in person. Needless to say, Jewish and Christian, Hebrew and Latin accounts of how the contests went diverge about as far as they could. The Christian narrative includes two of the three rabbis in Paris 'confessing' to the crimes and sins of the Talmud, while the Hebrew version features an indomitable and ingenious Rabbi Yehiel ben Joseph fighting his way out of his corner. The Christian account of the Barcelona disputation has the convert zealot Pablo Cristiani routing Nahmanides, while in the rabbi's retelling in his own *Vikuah* (meaning debate or disputation), he triumphs conclusively over everything thrown at him and the Talmud.[17]

In some details, though, the reports converge. At both the Paris and Barcelona disputations, the rabbis refuted the notion that the Talmud was some sort of recent innovation (while slightly overdoing its antiquity). Since that same Talmud had been known and found unobjectionable through many Christian centuries and by unimpeachable popes and bishops, how was it, they argued, only now that it apparently posed such a threat to Christianity itself? Knowing that most of the incriminating evidence would be taken from the more extravagant passages of the Talmud, the rabbis were at pains to disabuse the Christians of any notion that the *aggadic* portions from which offending passages were lifted were in any way binding on Jewish readers. There were two kinds of Talmudic writing, Yehiel and Nahmanides patiently but pointedly explained: *halakha*, which was indeed binding law; and the play of comment and opinion in *aggadah*, which Jews could take or leave as they thought fit. Invariably the choice items of abuse against Jesus or the Virgin belonged to the latter category. Look, said Nahmanides, I don't believe much of this stuff myself, and I don't need to; it's just catnip for debate. Another tactic adopted by Yehiel ben Joseph in Paris was to concede that some of the more abusive passages singled out by Donin did indeed occur within the *aggadah*, but that he had misunderstood entirely to whom they applied. The 'Jesus' who was said to be standing in boiling excrement in the underworld was not Jesus of *Nazareth*, or he would have been so identified, for there were many other Jesuses at large in those preachy days (as indeed there were). When Donin snorted at the disingenuousness of the reply, Yehiel cheekily asked whether or not there were, after all, many Louis in France other than the king. Pushing the mistaken-identity line further he asked in wide-eyed innocence whether it was remotely conceivable that 'Miriam the hairdresser', who was the object of further insults including the suggestion that she was a harlot, could be the mother of Jesus for no Jew had ever described Mary as established in the beauty business. Nor should the 'Gentiles', on whom curses and imprecations were rained, be understood as Christians but rather pagans, those same 'heathens' upon whom the Almighty was asked to 'pour out thy wrath' on the Day of Atonement.

The rhetorical shadow-boxing that characterises both Jewish and Christian accounts of these momentous days gives a misleading sense

of symmetry between the debaters. But of course the sides were not remotely equal. The rabbis were fighting for the life of their people's religion, and they were doing so in the intimidating presence of theologians, preachers, aristocrats, the king himself in Barcelona, an expectant throng eager to witness the humiliation and abasement of the wretched, purblind, arrogantly obstinate Jews, and even more satisfactorily, at the hands of one who was formerly of their benighted persuasion. Yet while the three rabbis in Paris could lean on each other for support, in Barcelona Nahmanides was quite alone, powerless, but heroically unbowed by his terrifying predicament, the bravest of the brave.

Like Maimonides, Nahmanides was both physician and rabbi, and better known throughout Catalonia and southern France as pacifier rather than combatant. In 1232, he had attempted, not altogether successfully, to reconcile Maimonideans and anti-Maimonideans across a schism which he knew could only end in damaging Jews everywhere. He believed the Maimonideans were in the wrong for excommunicating Rabbi Solomon bar Abraham and his would-be book burners. But he felt those hostile to the doctor-philosopher were even more in the wrong for caricaturing Maimonides as playing fast and loose with the law, and even encouraging apostasy, when on many points he was more stringent than the Talmud itself. The *Guide to the Perplexed*, Nahmanides believed, was not meant as a seduction into pagan rationalism but, on the contrary, sought to bring back into the fold those who had already been intellectually persuaded by classical philosophy and needed to have its methods yoked to the essence of Judaic belief. Their perplexity had been caused by the exertions of their God-given reason, and they were now trapped in a false dichotomy between faith and intellect. All that Maimonides had done was to show them how the two could be brought together in the bosom of Judaism.

Though his conciliation efforts had not been successful, Nahmanides was much loved in the *juderias* of Aragon and Catalonia, the high-walled alleys of great towns like Zaragoza, Huesca and his own Girona, set close to the bishop's palace and cathedral for timely protection, and also in the gable-hung lanes of overgrown hill villages like Albarracin, Fraga and Montalban. Nahmanides was thought of as less world-savvy than Maimonides, but when it counted he showed that he knew very well how to conduct himself manfully amid the

intimidating ranks of knights and friars lined up on the benches. Casting himself as the hero of his own drama, and showing the same kind of self-possessed eloquence characteristic of Maimonides at his most persuasive, Nahmanides knew that the sympathy of the king was essential if he was to have any chance of holding his own. And he undoubtedly felt that the eyes and ears of all the Jews of Spain, in Muslim as well as Christian lands, were on him. It was of paramount importance, then, to engage with rather than alienate Jaime, and he proceeded to do so with a disarmingly light touch, shamelessly playing to the royal gallery. It was Jewish stand-up, deadly serious in intent, playful in form, the most important there has ever been, and played to the most hostile house conceivable, and it took place in Barcelona on four hot days in late July 1240.

Nahmanides had been given licence to speak as freely as he wished, always provided he did not blaspheme against Christianity. But he came dangerously close to it in a moment of mock-innocent satire when he offered a paraphrase of the New Testament narrative. 'It seems a little odd,' he drolly ventured, 'that the Creator of Heaven and Earth should have repaired to the womb of a certain Jewish woman where he grew for nine months, was duly born as an infant, grew, was betrayed to his enemies and executed, restored to life and to his place . . . The mind of a Jew, or for that matter anyone else, simply cannot tolerate such assertions.' Nahmanides would end up paying dearly for the chutzpah, but in the way of all great performers, there was no stopping him. Brazenly, Nahmanides again turned directly to the king who had, after all, sanctioned the freedom of his speech and told him that Jaime had 'listened all your life to priests who have filled your brain . . . with these doctrines so that by now they are second nature and you accept them by pure force of habit. But if you were to encounter them for the first time as an adult you could not possibly believe them.'[18]

When Pablo Cristiani singled out the passage in Isaiah 53 prophesying a 'suffering servant' of God, a 'man of sorrows' whom the Lord would 'bruise', 'stripe' and 'afflict' for men's sins, Nahmanides feigned mock surprise that anyone should think these passages referred to Jesus when everyone knew that the wounded figure was of course Israel itself, which God knows had suffered, but that was quite another matter from imagining a saviour figure sent to absolve mankind from

collective sin. And while they were at it, might he point out, respect-
fully, that Judaism did not believe in collective guilt, much less a sin
inherited from Adam 'any more than we inherited the sin of Pharaoh'.
There was, then, no universally fallen state from which such a messiah
was required to save mankind. The Jewish Messiah – who by the way
was 'not fundamental to our religion' – would be sent with an alto-
gether more modest agenda, though to be sure of great significance
for the Jews. All that he would redeem would be Jerusalem, enabling
the Temple to be rebuilt. Such a messiah would never dream of
claiming a portion of divinity, for that would violate what *was* a
constitutive principle of Judaism, recited three times daily in the prayer
of the *shema*, namely the indivisible unity and singularity of God. And
then in a move of shameless rhetorical charm, Nahmanides again
turned directly to Jaime explaining that the Jewish Messiah would be
a king, but of the strictly mortal earthly kind, born like other kings
from the union of a regular man and a woman, moreover attached
to the womb by a placenta which could not have been the case of a
messiah sired by some sort of spirit. The Messiah would then be a
sovereign much like himself. 'You are a king and he is a king', which
meant at this particular moment King Jaime was far more important
to him than King Messiah.[19] History does not record the breadth of
King Jaime's smile.

But since, Nahmanides went on, for Christians it seemed that the
recognition of Jesus as the messianic Christ was a big, if not indeed
the whole, deal, then might he also point out that the reign of universal
peace, said to be inaugurated with his sacrifice, did not seem to have
materialised according to plan, neither at the time, immediately after-
wards or in the twelve centuries of the Christian era that had followed.
Quite the contrary, in fact: 'from the days of Jesus till now the whole
world is full of violence and plunder'. War continued relentlessly, he
said, adding in one of his sly asides that he wondered what the assem-
bled knights would in fact have to do if war was taken from them.
Pablo Cristiani, stung by all this condescension and rabbinical derision
(Nahmanides kept referring to him with heavy sarcasm as 'our clever
Jew'), retorted that it was typical of the Jews to measure everything
in crudely physical, superficial terms or 'carnally' as Christians said;
but Christ had descended into the underworld, hell had been harrowed;
the righteous dead had been saved, had risen again and the triumph

of the Church showed that Christ had indeed not come in vain. Really?
responded Nahmanides. As far as he could see, Christendom had not
been established, unchallenged 'from sea to sea' as the passage cited
by Pablo had prophesied. Was not the sway of the Roman Church
confined to what had been the old Roman Empire – or rather less?
An inconclusive verdict then – at best!

Game, set and match to the rabbi, at least if the account in his
own *Vikuah* is to be believed, although much good it did him. The
upshot was different in each of the trials. In France, the Talmud was
confiscated, suppressed and burned. In 1247, however, the new Pope,
Innocent IV, initially just as ardent a Talmud-baiter as Gregory IX,
backtracked a little. Informed that without the Talmud the Jews could
not properly grasp the Bible, and believing that such an understanding
was the precondition of their conversion, Innocent ordered the Talmud
returned to the Jews but censored to omit passages considered blas-
phemous or insulting to Christianity. The Barcelona show was always
meant as a bloodless corrida, with the victor winning moral credits
and the laurels of suasion. But the Dominicans who had been its stage
managers made sure that it did not end with the disputation itself.
Nahmanides reports that on learning that the king himself would
preach in the synagogue on the Sabbath, he decided to delay his return
to Girona so that he might refute the royal sermon after it was deliv-
ered. Putting himself at still greater risk, he did just that.

Yet the king was really just a warm-up act for Raymond Penaforte,
the great codifier of canon law under Pope Gregory and the Master
of the Preaching Dominicans. A zealot for Jewish and Muslim conver-
sion, it had been Penaforte who had encouraged the king to allow
Nahmanides to speak his mind freely but then had been disconcerted
that he had taken advantage of the liberty so skilfully. The Sabbath
sermon in the Barcelona synagogue and its captive congregation would
be a return bout with himself arguing more expertly than Pablo
Cristiani. When challenged by the rabbi on the self-contradictory
nature of a Trinity that was at the same time One, Penaforte made
the tactical mistake of comparing the Trinity to wine possessed of
taste, smell and colour and yet remaining just wine. Nahmanides
retorted that on the contrary, those characteristics were three entirely
separate 'accidentally' linked properties, each one of which was capable
of being removed under certain conditions to alter fundamentally the

nature of the liquid. Evidently one of them had been thinking of (and possibly sampling) wine to more profit. Petulantly, Pablo Cristiani – who had been sulking, and perhaps seeing an opportunity for belated vindication in the eyes of the king – then got up and asserted that nonetheless the Trinity was a truth but one so mysterious that even princes and angels could not properly fathom it. 'I stood up,' wrote Nahmanides, a little pleased with himself, 'and said "Well, it is obvious that a person cannot believe what he does not know and therefore the angels must not believe in the Trinity." And Fray Paul's [i.e. Pablo's] companions made him keep silent.'[20]

Neither Paris nor Barcelona had the effect the Christian impresarios had hoped for. There was no mass conversion. In fact, the exercise had shown Jews could mobilise in the court of their adversaries and were far from toothless in their own defence. This was just as well, since from the mid-thirteenth century on, and by papal order, Jews were forced, physically if need be, to listen to Christian sermons in front of the Ark containing the Torah scrolls, and they would not always have such articulate and irrepressible defenders as Nahmanides. The friars selected not only the Sabbath when they knew the Jewish congregation would be most plentiful, but the holiest days of the year – the Day of Atonement, Passover, Tabernacles – to storm in through the synagogue doors whenever they saw fit and subject the Jews to a violent harangue on the iniquity of their blindness. The violation of their sanctuary space must have been deeply traumatic. The profound sense of desecration at having to endure a pelting rainstorm of abuse and, as they saw it, falsehood, was dispiriting if not terrifying. But the thunder of the friars was meant to be leavened with the promise of salvation for those who saw the gospel light. Encouragement was needed as well as intimidation, for conversions were of the utmost importance to the friars who were working to an ever-accelerating timetable of the impending Last Days. (The Jews, too, believed that their year 5000 would bring their own Messiah.) For the Christian zealots, with Jerusalem still in Saracen hands and little immediate possibility of its reconquest, it was in the synagogue now that crusading victories could be won. And they were not deluded. There is no doubt that as their relentless campaigns turned more intense, conversion rates climbed, especially in Spain.

Nahmanides and the authors of the Hebrew narratives of the Paris

trial did not need to be told about the threat. The more friars trained to read Hebrew and become familiar with the Talmud, and the more converts available to guide them to choice texts for their polemics, the greater the danger. Thus, David–Goliath stories like the *Vikuah*, pitting lone Jews armed only with the slingshots of their keen minds against the giants of the Church, were designed to put heart into Jewish readers. The worst that Christians could throw at them, including their own apostates, would be vanquished with God's help. All of Nahmanides' ironic asides, his vivid descriptions of the scene, were meant for entertainment as well as vindication, not least the little coda in which he and King Jaime part on a note of mutual respect. The day after the sermons in the synagogue the king, who has already expressed his admiration for Nahmanides' powers of argument, now receives him again, gives him 300 dinars and bids him return to Girona to dwell 'in life and peace. And I took my leave of him with great love.'

All this seems too good to be true, and it was. Any improbable rush of affection arising between the rabbi and the king certainly did not survive Dominican antipathy. Instead of being permitted to retire to Girona and live unmolested, the Dominicans brought capital charges against the rabbi for his account of the proceedings, especially perhaps the passages where he pokes fun at the virgin birth. The king managed to have them heard before an independent tribunal where Nahmanides insisted he had added nothing to what had been said unobjectionably at the disputation. Nonetheless the *Vikuah* was duly burned and its author sentenced to two years' banishment, to gratify the Dominicans, especially Penaforte, who was clearly a sore loser. Before much time had passed that sentence was converted into perpetual exile. Nahmanides moved across the border to Provence, but then, in his seventies, made the arduous journey to Palestine where he encountered the two Jews who he said were the only men of his religion then living in Jerusalem. He moved to Acre where he presided over a circle of pupils, dying in 1270 and buried, like Maimonides, in a place unknown but perennially guessed at. A modest but authentically medieval synagogue in the Jewish quarter bears his name, or rather the posthumous nickname of 'The Ramban', an acronym of his rabbinic title and Hebrew name (Maimonides, confusingly, being 'The Rambam'). Every day there is the bustle of Orthodox Jews in the

Ramban *shul*, rushing and shushing, exclaiming and bobbing, perhaps as Nahmanides would have enjoyed, but then again, since he was famous for his studious self-mastery, possibly not.

III. Picturing Jews

The joust of minds was the stage on which the battle of faiths was played out before princes, prelates and preachers. It was driven by the firm belief of Christian theologians that they ought to win the battle against Jewish 'obstinacy' and 'blindness' through persuasion not force, and through books cherished by the Jews themselves. Surely, then, they would see that fidelity to the Bible required the *abandonment* of the Talmud, not a dogged adherence to it.

But much of what happened between Jews and Christians in the late Middle Ages was not this elevated. The adversarial drama played out more often in the pit of the senses. Its natural theatre was the body not the mind, and its medium was that of images not words. Its power was visceral not philosophical, and the erudite scrutiny of texts yielded to a theatre of cruelty, suffering and horror. One set of torments thrown into bright relief, those said to be regularly inflicted by the Jews on Christians in ritual repetition of what they had done to Christ, was imaginary. The other set of torments, those done to Jews by Christians, was all too real and involved mass murder.

Blood was everywhere in both the fantasies and the realities. Every Good Friday, it was widely believed in the Christian world, blood streamed from the anuses of Jewish men in helpless atonement for the bloodshed of the crucifixion. Had not Matthew said of Christ and the Jews, while Pilate was washing his hands, 'his blood be upon us and our children'?[21] The first Jew to experience something like this penitential haemorrhage had been Judas Iscariot, whose intestines bloodily erupted from his body cavity when, in remorse for his betrayal, he hanged himself on a fig tree (figs, it was noted, were emblems of fistula, among other things). Since his soul could not ascend, the route through which it exited Judas' body was via the lower orifice. The guts of Judas became a popular theme for passion plays, especially in Jew-free

late-medieval England where the sausage-stuffers of York supplied a long chain of chipolatas spilling from the exploded body of the false disciple at the crucial moment in the Play of the Saucemakers.[22]

A medieval tradition developed, evident in the writing of Thomas de Cantimpré, for example, attributing to Jews a particular propensity for bloody haemorrhoids which, when the ritual calendar came round to Easter, would copiously rupture. (The fact that the doctor Maimonides was known to have written an entire treatise on haemorrhoids could only have confirmed these suspicions.) A few centuries later this fantasy would mutate into the even odder commonplace that Jewish men menstruated like clockwork. But in the late Middle Ages, the bloody flux said to beset them was enough to enrich the grotesque image of Jewish unwholesomeness. At least one story, related by the thirteenth-century chronicler Caesarius of Heisterbach, featured a Christian clerk who fell lustily for a Jewish girl (as often happened in the medieval imagination), and turned on the fact that the only opportunity for their consummation came in the week leading to Good Friday when, she claimed, her father would be too busy swabbing his arse to pay close attention to her movements. The Latin obscenity *verpus*, used by Roman satirists like Juvenal for the circumcised penis, came to be applied to the bent back middle finger used in an attempt to plug the anal flow, and subsequently as a synonym for a Jew himself. The middle finger jabbed high in insult, still very much in use in the United States and Latin Europe, might have originated with this particularly malodorous fantasy.

In the more feverish realms of the late-medieval imagination Jews were unnatural, vampirical creatures, doomed never to escape their own blood-curse. Stories allied to the anal haemorrhage generated an entire mythology of unstanchable open wounds, the curse of the blood-shedding Jews. The intended contrast of course was between the blood of the Lamb which would wash humanity clean of sin and the impure effusion of Jewish anal flux that testified to the race's perpetually damned impurity. Circumcision, perfect for Christ (and obsessively pondered and visualised), had been made redundant with the blood sacrifice on the cross, but since the Jews wilfully perpetuated the practice it was thought that they suffered a blood-deficit. That of course would account for their notoriously anaemic pallor and disgusting smell. Although the full blood libel would not arrive in the

repertoire of Judeophobic demonology until some centuries later, it was widely assumed in the later medieval period that Jews were obliged to resort to occasional top-ups, if at all possible from the bodies of freshly slaughtered juicy young Christians.

Fortunately, the crimes of the Jews could be thwarted by blood-effusions on which they had not counted. During the thirteenth century, the physical torments endured by the suffering Christ became a compulsive fascination for the evangelists. *Imitating* the life of Christ as the friars urged meant experiencing his ordeals in literally excruciating detail: the scourging, the crown of thorns, the piercing of his side by the lance of Longinus. The instruments of the Passion – the flail, the tongs, the nails, the ladder, the hammer – all became extensions of the cross itself, each with their own particular penitential and salvific power. Paintings of the Passion became more viscerally graphic, and as they did the image of the Jews who had inflicted all this torment on the body of the Saviour became correspondingly more vicious. Obscure stories that represented the Jews as given over to gratuitous cruelty developed their own cult. The Jew said to have presented a cloth soaked in vinegar or 'rotyn wyn' for the agonised cross-bearing Jesus to mop his brow and scourged body was one popular example; the Levite teacher who had slapped Jesus' face at synagogue school was another.[23] Spitting Jews and hooting Jews, jeering Jews and poking Jews began to populate Christian devotional images, some with gratifying punishments like the Jew who presumed to touch the body of the Virgin at her funeral and whose hands and arms became miraculously glued to her bier in punishment, until they were amputated or he was released by his conversion.[24]

By the lights of these Judeophobic obsessions, the blood thirst of the crucifiers could never be slaked. Come Easter, it was popularly rumoured, they could not forbear from re-enacting the Passion on Christ's material person as it was embodied in the Eucharistic host. An entire pan-European madness took hold of the popular Christian imagination, from the thirteenth century on, in which Jews plotted to procure a host by any means possible and then desecrate it by stabbing, and other forms of mutilation, after which it would be buried, boiled or ground to powder in a mortar, or any combination of the three.[25] The demand made by the friars that Christians should separate themselves physically from Jews, and especially avoid working

in their households, either as wet nurses or servants, was intensified by the paranoid suspicion that those who were in the domestic orbit of the Jews could be persuaded, or blackmailed, into procuring a host for their acts of desecration. The charge of usury thus became connected to that of blasphemy when it was said that Jews actively ensnared Christian women in debt, the better to offer forgiveness of the loan in return for a purloined host wafer.

The rest of the fantasy – visualised in altarpieces such as Uccello's at Urbino and Jaime Serra's at the monastery of Sigena in Catalonia, and in stained-glass windows – unfolded just as richly. The Jews would proceed to stab the host which to their consternation spurted blood back at them in great, reproving gouts. Often, too, from within the pierced wafer a perfectly undamaged boy would arise who the dumb-founded Jews would realise was the Christ-child in person. In other variants, the Jews would conceal their mutilated host underground or elsewhere but would inevitably be found out by similar miraculous manifestations.

All this might have been no more than another elaboration of the demonisation that had begun at the latest with the sermons of Chrysostom a millennium before. But in the thirteenth and fourteenth centuries it had lethal consequences. Stories of host desecration, especially in turbulent times, were enough to unleash immense waves of killing. The most influential Dominican preacher in Florence in the early years of the fourteenth century, Giordano da Rivalto of Pisa, took the Jews to task for grinding the host in a mortar, and when some thousands were slaughtered as a result rejoiced that 'all the Jews were killed so that it was impossible to find one in all of the province. It was a blessed thing that we could kill them.' In 1298, a popular army led by the knight known as 'King' Rintfleisch swept through 146 communities in Franconia in south Germany, massacring the entire Jewish population on the strength of such rumours. At Gamburg in Lower Franconia, 130 Jews died at the stake; in Nuremberg, 728 perished despite fleeing to the protection of the local castle, including rabbin-ical scholars such as Yehiel ben Menahem Hakohen; another 840 were killed in Würzburg. This was a culture in which Jews were also repre-sented in cathedral sculpture as so thoroughly dehumanised and demonised, it comes as no surprise to learn of a second wave of massacres forty years later in the Rhineland, the so-called 'Armleder'

riots in which the leading part in the killing was, as the name suggests, played by leather workers. Most ominously for the Jews, there were almost no sections of the German population – peasants, burghers and knights – who were not part of these armies of Judeophobic mass killing.

Even in an age when slaughter was commonplace it is possible to slit the throats of small children as they hang on their mothers' skirts, torture, mutilate and murder an entire cultural population, only if those defenceless people are made over into agents of satanic depravity, walking vectors of epidemic, and habitual infanticides. This was how popular Christian culture came to see the Jews, even (or especially) when actual Jews had been expelled from their presence. It was at this time that the caricature of the Jew began to appear in sacred art and sculpture: the hook-nosed, black-haired, bulbous-lipped tormentors of Christ and abductors of children. The ugliness of their physiognomy was the unmistakable sign of their moral filthiness. They became in the Christian imagination a species of beast, given to beastly habits; hence the appearance on the sculptural decoration of German cathedrals and churches at Wittenberg, Regensburg, Bamberg, Magdeburg, Colmar, Strasbourg and many many more, of the *Judensau* – Jew-Sow – Jews sucking from the teats of a sow and opening their mouths wide to ingest its excrement.

At which point, something truly remarkable happened: an act of spontaneous resistance to pictorial denigration, a flowering of spectacular images within the very heart of Judaism. It was as if the wordy defiance of Nahmanides had translated itself into the mind's eye and thence to the scribe's resolution and on to the artful hand of the illuminator. It was the first time since the mosaics of late antiquity that Jewish religious practice, and the texts which ordered it, took to delighting the eye as well as instructing it. The profusion of images made by the illuminators of Hebrew manuscripts did not stop with elaborately decorated capital initials beginning chapters of the Bible. They encompassed an immense bestiary of animals and birds – crows and doves, eagles and ducks, camels and ostriches, cats and mice, lions and elephants, snakes and tortoises, and many others.[26] Nor was this some sort of randomly encyclopedic menagerie. If the Germans knowing the Jews had a thing about swine made them their carnal companions, Jewish scribes would take back the bestialisation. Drawing

on a wealth of animal imagery from the Bible, and Spanish Jewish poetry, by identifying the deer with Israel they would be the hart and hind pursued by the baying dogs of Christian persecution; or they would be the fleet-footed hare outrunning the foxes.[27] Depending on context, the same animals could appear on different sides. Eagles, notorious as the first creatures to kill on departing from Noah's ark, could be either ravening predators or protecting guardians of beleaguered Israel. Lions might appear as wild things, tamed by God into crouching cats, or because they had been the arms of Judah, son of Jacob, the rampant defender of Israel. Hybrid creatures and fantastic animals would also appear in this counter-iconography, sometimes liberated from Christian use. The unicorn, often represented with its head in the lap of the Virgin, returns to being the one-horned *re-em* of the Old Testament. Dragons, too, are everywhere in the Hebrew manuscripts, almost always with the scaly body of a serpent and the wings of a bat or bird, their mouths alight with hostile fire.

And there were some fanciful creatures which were adapted in the illuminations to act the part of the Jews themselves: most spectacularly the gryphons who populate the Birds' Head Haggadah, an early illuminated manuscript made in late thirteenth-century Ashkenazi Germany, possibly in Mainz. Their birdiness is confined to their beaked heads. Otherwise they are dressed like Jews, notably sporting the inverted funnel-shaped Judenhut of the German Ashkenazim, and they act out the story of the Passover.[28] The opposing Egyptians, however, do not have any sort of animal characteristics. Much worse, they are entirely blank-faced, featureless. The German world (in contrast to Spain and Italy in particular) often read the Second Commandment narrowly to mean a ban not just on 'graven images' (idolatrous sculpture) but on the 'likeness of all living things in heaven above and earth below'. Meir von Rothenburg, elegist of the Paris Talmud burnings, and a Pietist in the spirit of Eleazar of Worms, made known his disapproval of any pictures occurring in sacred books as a profane distraction from devotional prayer.

He comprehensively lost the battle of images, however, especially in the Passover Haggadot. For those books were meant to be used not in the synagogue but in Jewish homes, the shared possession of an extended family, along with friends and neighbours. Sometimes, the most richly illustrated might even be commissioned by a wealthy

Dedicatory inscription to Samuel Halevi Abulafia in the synagogue known as El Tránsito in Toledo, Spain, mid–fourteenth century.

Profuse Mudejar stucco decoration on the eastern wall of El Tránsito, mid–fourteenth century.

Moorish horseshoe arches in the 'New Synagogue' (known as Santa Maria la Blanca) in Toledo.

Carpet page illumination by Joseph ibn Hayyim, from the Kennicott Bible of Isaac de Braga, La Coruña, Spain, 1476.

A Barcelona Haggadah from the mid- to late fourteenth century, showing the Seder. The father of the family is setting the dish of matzot on the heads of his children, a Sephardic custom that seems to have ended with the expulsion from Spain. The brilliant decoration of fanciful beasts is typical of the Haggadot illuminated in this period.

An illumination by 'Joseph the Frenchman', from the Cervera Bible, Spain, 1299–1300.

Illustrations by Joel ben Simeon Feibush, from a North Italian Haggadah, 1469: (*above*) 'Avodim Hayinu' ('We were slaves in Egypt'); (*below*) 'Ha lachmah di' anya' ('This is the bread of affliction') shows two figures holding up the basket of circular matzot. This still happens in modern Seder services.

Illuminations by Joseph ibn Hayyim
from the La Coruña Kennicott Bible:
(*above*) Jonah and the 'Great Fish';
(*right*) Temple candesticks with a
protective lion crouching below.

The colophon page from the La Coruña Kennicott Bible.
It reads: 'I, Joseph ibn Hayyim, illuminated and completed this book.'

(*Facing page*) In an art form unique to Jewish culture, a border of micrographic figures formed from Hebrew characters in Ashkenazi script surround the text of Genesis 32. These sometimes microscopically tiny letters often have nothing to do with the text they ostensibly illustrate.

בעיניך ויהוה ליהו	יעקב כפר חונין משז	אלהי דאברהם ואלהי
תירין וחכדרין עאן	משריתא מין קדם יי	דחזור דרנין ביננא
ועבדין ואמהן ו	דא ויקרא שמאדז	אהא דאבוהון וקיים
ושלחית לחואה	דאתרא ההוא מחנים	יעקב כד דחיל ליה
לרבוני לאשכחא	פ פ אין	לאבוהי יצחק ודחל
דחמיב בעיניך ז	הלת חלקי מין נכל	יעקב זבח דבחה זיה
וישבו המלאכים	**וישלח** יעקב	ויקרא לאחוהי לאכל
אליעקב לאמיר	מ ח	לחם ויאכלו לחם
באנו אל אחיד אל	מלאכים לפנוי אל	וליליה בהרו ונבית
עשו אל אחיד אל	עשו אחיו ארעה	יעקב נכסתא פטירא
עשו הלך הלך לה	שעיר שרה אדום	ויקרא לאחוהי למיכל
לקראתך וארבע	ושלח יעקב אזגרין	לחמא ואכלו לחם
מאוה איש עמיה	קרבוהי לות עשו ז	וביתו בטורא וישכם
ותדל אזגדיא ליות	אחוהי לארעא דנן	לבן בבקר וינשק לבנו
יעקב למימר אז	רשעיה להקל ארי	ולבנתיו ויברך אז
אתינא לות אחוך	דארום ויריצן אתם	אתהם וילך וישב ז
ליות עשו ואח אתי	לאמירכה תאמירון	לבן למקימו ויעקב
לקיראותך וארבע	לאדני לעשו כה	הלך בצפרא ונשיק
מאה גברין עימיה	אמיר עבדך יעקב	לבנוהי ולבנתיה וב
ודחירא יעקב מיאד	עם לבן גירתי ואחר	דיך יתהון ואזל
ויעצר לו ואין את	עד עתה ויהי לי	ותב לבן לאתריה
העם אשר אתו ו	יתהון לביעיר כרנן	ויעקב הלך לרגבי ?
ואתה צאן ואת	תימירין לרבוני לעשו	ויפגעו בו מלאכי ז
הבקר והגמלים לש	כרנן אמיר עבדך יז	אלהים ויעקב אזל
לשני מחנות וחזל	יעקב עם לבן דרית	לאורחיה וערעו ביה
יעקב להרא ועקת	ואוהרית עד כען	מלאכיא דייי ויאמר
ליה ופלאי יה שא	ויהי לי תור וחמור	יעקב כאשר ראם
דעיניה ויתרענא	צאן ועבד ושפחה	מחנה אלהים זה
ויתתורי ותלולא	ואשלהה להגיד	ויקרא שם המקום
להרין משרין דז	לאדני למ?יצא הן	ההיא מחנים ואמר
ולאמיר אם יבא עשו		

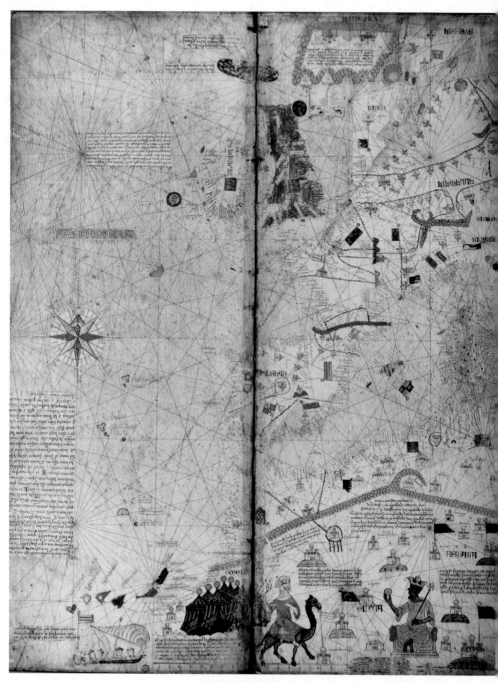

The fourteenth-century 'Catalan Atlas' (*mappa mundi*) by Cresques Abraham
and his son Jafuda Cresques. In the bottom left-hand corner Jaume Ferrer
can be seen in his ship, and the king of Mali in the bottom right.

patron to serve the whole community. And in Aragon and Catalonia, and particularly in France and Italy (but also in some parts of Germany), as the custom became more popular through the late thirteenth and fourteenth centuries, so patrons and scribes swept aside objections to portraying Bible figures with human faces, and still more significantly engaged in the act of Passover remembrance themselves. The craze for depiction would extend beyond Haggadot to the *mahzorim*, which collected the rites and prayers of the festivals and fasts of the Jewish year, to *siddurim* prayer books used every day and Sabbath, to the Pentateuch Torah, divided (their beginnings spectacularly ornamented) into the *perashot* portions to be read each week at the communal Sabbath service, and eventually into entire Hebrew Bibles and even works of philosophy, among which the veneration given to Maimonides' *Mishneh Torah* would be registered in exquisite, sumptuous illuminations.[29]

But it was through the Passover Haggadah that the Jews took back their sense of who they were, liberated themselves from the dehumanisation of Christian polemics. So it was no coincidence then that it was exactly at the time they were most hard-pressed by conversionary campaigns, urban slaughters and rabid paranoia, that they responded with their own imagery. It was one of those moments, which Jews sometimes find it difficult to imagine, when words *alone* seemed not enough. Most obviously, most dramatically and most courageously, they were answering the blood charge implicit in Easter, its sanguine martyrology and its gory demonology. One extraordinary Spanish Haggadah from the early fourteenth century makes the counterpoint dramatically clear by arranging the participants in a Passover Seder according to the conventions of the Last Supper! This may have been the spontaneous response of a Christian illuminator commissioned by the Jewish scribe and patron, or it may actually have been the intended thrust of a conscious iconic counter-attack.

In glowing, brilliant, often very beautiful images, the devotional imagery of the life and Passion of Christ was answered with the life of Moses. There were times when the story in pictures extended further back – even to Creation itself where the Sarajevo Haggadah, for example, represents the radiance of divine Creation through a burst of sunrays hovering over the deep, and to Abraham's close call with filial sacrifice, Jacob wrestling with the angel (fully represented)

and Joseph in Egypt, the prefiguration of the Moses cycle. Salvation through sacrifice thundered at Jews in the synagogues helplessly vulnerable to enforced Christian sermons, was countered with the theophany on Sinai, the giving of the Law, the making of the Jews. A thousand persecutions from time immemorial were graphically countered by the inspirational chronicle of Pharaoh's humbling before the plagues (the illuminators, especially in the Aragonese 'Golden' Haggadah, had a wonderful time with frogs, locusts, wild beasts and, in a gloriously cartoonish way, lice).

And the sense, intrinsic to Seder nights, that the founding liberation epic was a perennial vindication, the army of the oppressor, drowned in the Red Sea, was emphasised by representing Pharaoh and his soldiers in the standard costume of contemporary medieval Europe. Pharaoh wore the crown of the kings of France or the German emperor, and his soldiers wore chain mail and helmets as they sank beneath the waves. Still more tellingly, in many fourteenth-century Haggadot, Jews and Gentiles have indistinguishable bodies, heads, faces; the Spanish Jews sometimes wearing the hooded headdress, the *houce*, but sometimes not. Images of Miriam and Israelite women rejoicing at the destruction of the Egyptian army have the Jewish women as graceful, long-limbed singers and dancers (including a player of the tambourine). Aaron and Joshua likewise appear as heroic figures, liberated from the grotesque caricatures. Even the Israelite slaves toiling for Pharaoh in Egypt have the same human features as everyone else. Occasionally, too, they have the unmistakable rough faces of the Jewish labourer, the *shtarke*.

Many of these types were borrowed, to be sure, from Christian iconography, but that was exactly the point. Embattled and beleaguered as they were, the Jews had emerged from fearfulness, to take what they needed from the host culture and indeed to employ their best artists when their own were not yet skilled or in short supply, and unproblematically apply their work to an act of visual restoration.

And, not least, they represented themselves. Not as birds or beasts (though the hares and the deer were always hounded Israel) but as men, women and children, fathers and mothers and their progeny gathered round the Seder table, or sometimes (though more rarely) inside the synagogue free of the intimidation of the friars. More than one such picture of the interior of the synagogue strikingly shows

men *and* women, on the same level, albeit with the women standing
behind the men, yet another corrective to assumptions about the
conventions of worship in the medieval period. These scenes of Seder
constitute the most eloquent reproof imaginable to the hideous
versions of their Passover as conspiracies of child-killing. If one wants
the opposite of the stereotype of Jews stabbing the Eucharistic host,
one need look no further than a touching Seder scene in which the
dish of matzot (the non-Eucharist) along with the bitter herbs, the
maror (often represented as an artichoke), is passed along the table,
touching the heads of each of the participants (a Sephardi rite that
seems to have disappeared) as if sealing the significance in their
memory boxes.

In another fifteenth-century Haggadah drawing made by the most
accomplished illuminator of all, the Ashkenazi Joel ben Simon Feibush,
two women dressed exactly as their Gentile contemporaries would
have been together hold a basket of matzot in the gesture commanded
at the same time as Jews say '*ho lachmah di'anya*', 'behold, this is the
bread of affliction our forefathers ate when they came out of Egypt'.

Many of the scenes of preparation for Passover and the meal itself,
including a compelling one in which a wealthy and grandly enthroned
Jew hands out matzot and *haroset* (the paste of fruit, nuts and wine
symbolising the mortar used for the Egyptian buildings – the sweet
counterbalancing the bitter) to the less fortunate lines of children and
their mothers, thus fulfilling the obligation to charity, reverse the
Christian accusation of unfeeling inhumanity that Jews have towards
their children. Children and domestic affection are everywhere in these
pictures.

Some of the most stirring moments of self-liberation from both
the atrocities of Christian stereotyping and the asperities of rabbinical
obligation are the simplest, such as when on the pretext of inserting
an illumination for a blessing prayer or a festive ritual, a Jew just
appears doing something quite indifferent to, or even at odds with,
any sort of solemn commandment. Even Moses had his days off.
Which means that in those embattled times, when Jews commissioned
pictures or drew them themselves to rally the troops, they were capable
of comedy. The blessing over wine, for instance, in a German *mahzor*
prayer book, is represented with unique irreverence, as a man bent
back, propping himself up on a table, draining the jug of its very last

dregs. Even better, tucked away in a margin of an illustration of the preparations for Passover is a perfect image of a fancily dressed young Jew bending his knuckles in the unmistakable act of examining his nails. Of course, if pushed the illuminator and the scribe would defend his inclusion in a sacred book by claiming it was the merest speck and crumb of leaven which might have got lodged under the nail. But if you believe that you also believe in kosher unicorns.

None of this is to claim that Judaism, the religion of the word, had suddenly become a culture of icons. Nothing could be further from the truth. Jews were undoubtedly aware of the devotional spell cast by Christian images which were, after all, not only set above altars but carried through the streets of Christendom, and the veneration they received they regarded as further proof, if any were needed, of the idolatry of that religion. For the Jews, picturing was the handmaid of words, significantly confined, therefore, to books, although when the pages were covered with gold, and radiant colours of blue and scarlet, crimson and viridian, they ceased merely to be 'books' of instructional commandment or Talmudic interpretation. Without any sense of compromising the sovereignty of the sacred word, the Jews had decided to delight themselves with pictures. It would not be the last time.

But this was possible only so long as words and images were seen as complementary; or rather that somehow the words and the letters that formed them had themselves a mysterious visionary power, akin (without blaspheming) to the Kabbalistic-mystic tradition, spelled out in the *Sefer Yetzirot*, the *Book of Creation* which maintained that God created the universe and the world *through* letters. Letters were primary forms. So perhaps we should not be surprised to discover that, aside from all the borrowings from Gothic art (and indeed architecture), the one form of picturing *unique* to Judaism were figures made from letters and words. 'Micrography' – the stupendous writing of miniature letters, sometimes so tiny that they are difficult to make out with the naked eye (at least middle-aged eyes like mine) and seem beyond any conceivable feat of fine motor control – is said to go back as far as the ninth century.[30] A practical explanation would declare that, for a culture constantly loading the carts and running for its life, it made sense to compress what was already portable in the books of the Torah even further, so that the entirety of, say, the Book of Esther

could be on one folio page, or for that matter a dish or a sheet of paper. It was also true that enriched texts of the Torah and Bible demanded pronunciation guides – the *masorah* – which needed to be inserted somewhere on the margins of the page, and some of the earliest micrographia do just this. But when, in the fourteenth century, Hebrew turned to picturing lions and dragons and gryphons and eagles and dogs and *kings*, evidently something else was afoot. Coiled within these writhing, helical, dancing forms, the ribbons of word-images, are the cellular materials of the Jewish tradition, perpetually morphing, adapting, self-renewing, and once set free in the world, they would always elude the grasp of those who aimed at their extinction.

9

EXILE FROM EXILE

I. The Wide World Over

It was when the abscess on the left arm of Charles the Wise stopped weeping and crusted over that the king of France knew his end was near. Many years before, a learned doctor had been summoned from Prague to drain the mysterious royal fistula and had pronounced that should it ever dry, he would have two weeks to settle his affairs before expiring. And so it came to pass. The sticky sore, periodically tended, had oozed reassuringly for many years beneath the plated rerebrace of his armour, as the king grimly battled to retake territories conquered by the English Plantagenets. But just as that life's mission seemed to have been realised, the shades were unfairly closing in, quite possibly hastened by the periodic seasoning of arsenic spicing up the royal fare. The Wise are not without enemies.

Before he succumbed on 30 September 1380, leaving the kingdom to his eleven-year-old son (who as Charles the Mad would lose everything his father had gained), the king had indeed done something wise. Around 1375 he had instructed his envoy to the court of Pere the Ceremonious, king of Aragon, to procure from the Jews of Palma de Mallorca (who had become famous for this kind of work) one of their *mappae mundi*, the 'cloths of the world'. The great work known to posterity as the 'Catalan Atlas' is documented joining 917 other items in the royal library in November 1380, so it is possible that the mortally stricken king never set eyes on the six double sheets of vellum on which the whole known world was mapped – from the isles of the far west, the Canaries, named for the *canes*, or wild hounds, who barked through the volcanic hills, to the isles of the farthest east, the

archipelago of seven thousand islands in the seas off Catayo that Messer Polo had claimed to have counted, or the waters of Trapobano where the natives devoured raw fish and drank seawater. Instead, the folding lengths of painted vellum – crowded with Catalan text, webbed with the lines of the winds, brilliant with gold and silver, vermilion and viridian, the personifications of the zodiac, things fabulous and things charted – would have been perused by the usual gang of shifty uncles ominously attending on the boy king, Charles VI, or perhaps by the lad himself.[1]

The Majorcan atlases were made to be thrown over the cabin tables of ships' captains, to graph from first-hand reports the precise details of safe and unsafe water, threatening reefs and banks, welcoming havens and treacherous straits.[2] Though the great Catalan Atlas (still to be seen in the Bibliothèque nationale) was custom-designed and painted as a royal gift, it was nonetheless a practical as well as a visionary object, and the boy king, the guardian uncles and the royal librarian could have walked round it as if they might compass the earth. A year later, in 1381, the infante of Aragon, Joan, ordered from the 'jueu [Jew] the master of mappae mundi and compasses' another such map expressly for Charles VI, as a gift to seal what he hoped would be an alliance between Aragon and France.

That Jew was Cresques Abraham, who with his son Jafuda had spent years making an atlas more spectacular and better informed than any that had gone before. Technically Cresques was not the map-maker so much as its illuminator, and was described as buxoler in Catalan (brujulero in Spanish): compass-maker and painter of the boxes in which cork-mounted magnetic needles bobbed and floated to mark the directions.[3] The line between the job division is more shadowy than some recent scholars have allowed, and the commission of the infante leaves no doubt that Cresques and his son (who had been shown particular honour by King Pere as 'royal familiars') were deemed the true masters and authors of the overall work.

When they plotted, drew and painted, Cresques and Jafuda stood on high with the angels. They caught the span of the orb – 180,000 stadia, or 24,000 miles, in circumference, just as Ptolemy had said – in their widened eye and nimble fingers: the corrugated seas rendered in azure, the crumpled shore, the bald or bristling wilderness, hump-backed hills and even the mires of Irlandia, tufts of grass poking

through the bog. Thus they retraced the work of the Almighty without ever presuming, God forbid, on His infinite ingenuity.

Who better to compass the earth than Jews who were its ceaseless wanderers and were to be found in every corner, save those from which they had been mercilessly expelled? There were Jews in Cathay protected by the khan, Jews in torrid Nubia, Jews in the Indian kingdom of Delli where the sovereign boasted seven hundred elephants, Jews on the Malabar coast and Jews in the Maghreb, where Cresques planted a six-pointed star of David in the neighbourhood of Fez, a thing never before seen on a map of the world. Jesus Christ – who in the Ebsdorf and Hereford maps of a century earlier still sat on high atop the earth – had disappeared altogether from the Catalan Atlas. The omission is so startling that the enthroned figure in the imaginary Far East, in the neighbourhood of Gog and Magog, is sometimes said to be Christ in Paradise, sometimes even less plausibly the Antichrist, but his crown and beard suggest it is more likely to be David – making the vegetation held rising from his hands the stem of his, and the Saviour's, line a diplomatically Judeo-Christian conflation. At the site of the monastery on Mount Sinai, the devotional reference to St Catherine is inscribed but also its identification with the place where 'Moses gave the Law'. Still more tellingly, the north-west arm of the Red Sea is cut through by a narrow white space, identified in an adjoining text as the road through which passed 'the Children of Israel' (not a phrase much used by the Gentiles).

Cresques and Jafuda also made sure to cater to the grandeur of those for whom the atlas was intended. Away from the compressed, minute topographical and nautical detail of the Mediterranean and European shores, the map is filled with the images of kings and queens installed in their respective realms. The most striking is the African 'Mussa Melli', the king of 'Gynia' (Guinea), in actual fact Mansa Musa who had ruled the kingdom of Mali, a swathe of West African territory from Senegal to Nigeria in the early fourteenth century, and who had sat at the centre of a gold trade so prodigious that it tempted the voyaging governments of Iberia down the coast to prospect its riches. Loosely robed in fine green muslin, bearded and barefooted, 'Mussa Melli' sits enthroned and crowned in gold, holding high a disc of the same precious substance as if he had caught the sun between finger and thumb. A little north and west a whey-faced Tuareg lord flails his

dromedary before an oasis of dark tents. The ancient, perennial, equatorial face-off south of the Sahara between animists and Muslims, the pale and the black, slave-capturers and slave-traders, was known even then, especially to the Arabic-speaking Jews of Majorca, many of whom had come from the Maghreb and the Atlas.

And since the *mappa mundi* was meant to be recent history as well as geography, Cresques and Jafuda painted the ship of Jaume Ferrer, who had set sail down the African coast in 1346 in a single-masted, square-rigged *uxer* galley, the kind usually used to transport horses, bound for the mouth of the fabled river the 'Rio d'Oro' that, once discovered, would lead Europeans into the heart of the realm of gold.[4] On the Cresques map, the sail of Ferrer's galley billows with a following south-westerly that would have brought him back home laden with riches and knowledge perhaps of the real rivers of Senegal or the Gambia. The king of Aragon, and recent conqueror of Majorca, was said to have crusading designs on the Canaries from which perhaps he could have launched the usual mission of preaching and profit on the Muslim-dominated mainland. But Ferrer was never heard from again. From the round stern of his little craft the Aragonese pennant is flying – a brag to the French, for this was the time when the kings of Aragon had taken to the seas to create a trans-Mediterranean state stretching from Valencia and Catalonia to the Balearics, Sardinia, Corsica and Sicily, a mini-empire so extensive that even the fish were said to sport the gold-and-scarlet bars of Aragon on their tails.

Nothing is steady-state on the surface of Cresques and Jafuda's world. The map itself needs turning about and around to read the texts depending from its features. The earth is alive with animation. Men are in motion, crossing frontiers, albeit at the pace of a camel's padding tread or the tacking of a cog across the Persian Gulf. On their way to Chanbaleth, the capital of Kublai Khan's Cataya – twenty-four miles in circumference, guarded by mighty walls – Marco Polo's caravan moves over the Caucasian plateau into deep 'Assia', rimmed by mountains, somewhere along the Silk Road. Teams of camels are in the van, followed by a guard of foot soldiers, and then the travellers themselves, bearded Polo himself at their head, chatting and smiling to an unimpressed Tatar. One of the company is slumped imprudently dozing in the saddle, thus opening himself, as Cresques warned, to visitations from malign spirits of the night.

The figures move this way and that, south-east to lower Danubian Burgaria and Oumania, north to Polonia, Rusia, and wild and rocky 'Archania' (the Orkneys) – places shrouded in darkness half the year, lit through the night the other half. The illuminating hand moves with the travellers up the Nile (shown rising in the western Sudan, as was supposed for centuries) into Nubian Ethiopia where Christians and 'Sarracens' (the map's name for Muslims) endlessly war, then sails through the Persian Gulf where naked men dive for pearls, east into the land where diamonds were harvested by strewing raw meat on the hills and waiting for the wild birds that would cram flesh and gems in their beaks, obligingly dropping the stones when transferring crop from bill to gullet.

Legends and facts, painstaking reports and compulsive fantasies, new discoveries and ancient traditions all crash into each other in the heavy traffic of these men in motion. And in this sense the Catalan Atlas is the cartographic projection of Talmudic *aggadah*: a colloquy of gossip, knowledge, received wisdom, fanciful folly, without dominating adjudication, the mutually interrupting voices replaced here by the swerving winds and the swivelling, twitchy compass.

Which compass is, for the first time ever, set down on a *mappa mundi*: the rose of the winds, painted at the beckoning limit of the western ocean, thirty-two wind directions, projecting from the eight major ones, without any controlling magnetic pull, save that of curiosity and avidity, the two forces that would alter the world. Jerusalem is still set at the centre of the earth, the Holy Sepulchre prudently delineated by the Jewish draughtsmen for their Christian patrons as if it were not now irretrievably in the custody of the 'Sarracens', although here it is rendered on the scale of just another church. The recapture of Jerusalem and the Holy Land, the force of the crusading knightly mission, had not disappeared from the Christian imagination, especially not in Spain where nothing remained of Islam save the enclave of Granada. But where in other maps the Levant was signified by a cross, in the Catalan Atlas the eastern point develops a stylised pattern that some have seen, perhaps over-imaginatively, as approximating a menorah.

The vision is omnidirectional, wheeling this way and that with the gusts of opportunity. Whether or not Cresques' family ever travelled except in their mind's eye and the graphic imagination with which

they read the already imaginative account of Marco Polo, the atlas represents freedom from confinement, even at exactly the time when most Jews in Palma were having to reside in the district set aside for them – the Call, not an abbreviation of the Spanish word for street, *calle*, but a corruption of the Hebrew for community, *kahal*. More importantly the atlas is a document of its makers' ethnographic curiosity, not restricted to Jews (as Polo's career and story makes evident), but somehow strikingly unburdened by crusading obsessions with the unity of Christendom, the global mission of conversion that would bring on the Second Coming. The Jews were here, there and everywhere, and though many had arrived in Majorca in the thirteenth century along with its Christian conquerors, much of their value to their lords was precisely as intermediaries with the Muslim enemy. They spoke and read Arabic, brought Arab-based knowledge of astronomy, medicine and philosophy into the Christian world, and most important were able to trade with the powers and ports of the North African Maghreb and Egypt. Jews were not permitted to own vessels themselves, but the independent kings of Majorca and the Aragonese sovereigns after them ordered Christian shipowners to receive cargo originating in Muslim lands and shipped by the Jews. They were the only section of the population in Majorca who could travel freely, if not always safely, across the Mediterranean borders of language, religion and custom. The coastlines most densely marked with ports and nautical information bear the imprint of their comings and goings, through the contested Aegean or more daringly out into the Atlantic islands. West of the long curve of the Guinea shore, archipelagos lie beckoning (albeit not exactly pinpointed) – Madeira, the Canaries and isles given names meant to stick in the imagination as well as on the map: Caprara, the isle of goats; Brazil, the isle of fire; Corvo, the isle of crows.

Majorca itself may not have been the land of milk and honey, but during much of the fourteenth century it was a home in exile for most of the thousand-odd families who had settled there from North Africa and other parts of Spain following the thirteenth-century Christian reconquest, not just in Palma de Mallorca but in Inca and Sineu in the centre of the island, Alcudia in the north-east and Soller in the north-west.[5] In all these places, as they had elsewhere in Christian Europe, Jews often lived close by the citadels and churches, some on

the scale of cathedrals that dominated the hilly topography of Majorcan towns. And this said something about the compatibility between those institutions and the possibilities of Jewish life. The Church and Crown authorities (for a while an independent monarchy; after 1343, a province of the Crown of Aragon) promised to keep the Jews safe while they also attempted to persuade them of the blindness of their religion, and pending their conversion were prepared to profit from the regular delivery of revenues. In the state of perpetual warfare along the Mediterranean, they would need sudden injections of funds every so often, and the Jews were there to supply it or else. Every so often, too (especially under the Majorcan kings), there would be unfortunate riots, confiscations of property and even synagogues. Then matters would settle back into an understood social reciprocity.

Under the government of Pere IV of Aragon, the Jews of Majorca had reason to feel insulated from the storms of hatred and fanaticism that thundered about their heads elsewhere. The Crown expressly forbade the preaching friars from invading synagogues and forcing Jews to listen to missionary sermons. Humiliating distinctions of dress were largely ignored. Jews could not be arrested on Sabbaths or festivals, and when testifying in Christian courts were allowed to swear on the Ten Commandments. For the most part they were governed and judged by their own autonomous institutions. In Majorca, no one accused them of bringing on the Black Death. In Strasbourg, nine hundred had been massacred in a convulsion of paranoia; in Toledo there was a bloody riot in 1349.[6] In Majorca, there was no talk of them poisoning the wells or setting infected lepers at large to destroy Christians. On the contrary, favoured Jews like Cresques Abraham, glorying in his elevated status as 'royal familiar', were given rights to draw water from the superior well in Palma, and even divert some of it to make a flowing conduit for a Jewish ritual bath.

Jewish culture blossomed with as much energy and virtuosity as it had amid the caliphates of Granada and Cordoba. The debates between Maimonideans and anti-Maimonideans persisted, with the latter now invoking Kabbalist mysticism as a revelatory alternative to the analytical machinery of Greek logic. Rabbis of the one and other persuasion arrived in Majorca not because they had to but because they wanted to. And among them, as there had been in Cairo and Cordoba, there were sophisticated interpreters of the sciences that had come through

Arabic sources, mathematics and astronomy especially. The star-measuring rabbis like Leon Mosconi, Ephraim Gerondi and Isaac Nifoci, clock- and astrolabe-maker to the court (along with quadrants and sextants), had special status (allowed, among other privileges, to carry a sword or poniard – no small thing in the fourteenth century) as did the usual company of physicians, for wherever they went Jewish doctors were still thought to carry special knowledge and healing powers. Indeed, the Christian population among whom they lived, not just in Majorca but the entirety of Christendom, could be divided into those who welcomed the ministration given by Jews to their bodies and those who were disgusted and terrified of it, believing their touch was that of the murderer and their potions the secretions of Satan.

The sign of a flourishing or at least stable community is the diversity of the ways in which Jews made a living and where they did so. As conditions stabilised, the Jews established themselves, by their own choice, in the south-east of Palma, in an area leading down from a small square towards the three gates of the Temple, Santa Fe and Calatrava. The fact of those three gates suggests the ease with which Jews could come and go. The Call was not yet a ghetto. Within the Calatrava in Majorca – and other towns where they settled, like Inca and Soller – there were silversmiths and goldsmiths, as one might expect, but also saffron growers and traders, and wine merchants (kosher wine, like kosher meat, did a brisk trade with the Gentiles). There were dyers and silk and linen drapers, soap-makers, and due to the close connection with Barcelona where the business was strongly Jewish, a speciality in paper, bookbinding and bookselling (another Nifoci trade), from account books to works in both Hebrew and Arabic as well as their translations, including the illuminated manuscripts that were increasingly prized. It was not a perfect life on Majorca, but then where was that to be found? It was a possible life, one in which the round of Jewish life – the Passover Seders, the weddings and funerals, the market days and the solemn fasts – could mostly proceed without terror. If there were, as always, waves of hatred and violence threatened and enacted from some of the villages and towns like Inca, where there was a murderous riot in 1373, the Jews living under Pere IV could expect to be protected from the fury, and for their assailants to be punished (as most often they were).

And yet, ten years after the great atlas of Cresques and Jafuda had

been delivered to the French king, the Majorcan Jewish society in which it was made lay in ruins. By 1435 it had vanished completely, living on only in the secret life of the forcibly converted, the *chuetas*, with their furtive candle-lighting on Friday nights and remnants of food memories in the bean-rich, saffron-spiced *adafina* stew cooked overnight in bakers' ovens on the Sabbath eve, a society whose descendants only now are discovering their Jewish ancestry. What had happened?

The rolling disaster which fell upon the Jews of Majorca, as it did on every major community in Sefarad in the summer of 1391, began with a voice. Historians are sometimes averse to explanations of causes reduced to the magnetism of individuals. And it is true that what happened in Spain was part of a pan-European insurrectionary movement in country and town against established authorities of the Church and royal state, perhaps a delayed response to their incapacity to protect their subjects from the death of one in three during visitations of the bubonic plague. But it was voices that dared to speak or shout shocking, violent things that the mighty dismissed as the howling of animals, until the howling brought down their walls and their thrones, and which turned resentment into havoc, shouting into mass murder.

In Spain the voice belonged to Ferran Martinez, the archdeacon of Ecija, about fifty miles west of Seville. What Martinez lacked in theological sophistication and learning, he more than made up for with the brutal clarity of his rhetorical violence. It was exactly his unsophisticated force and outrageous willingness to defy royal authority in the name of a Higher Power which gave Martinez his popularity among the common people of town and country.[7] For in a panicky world in which a third of the population had been carried off by the plague, and which believed it had been brought on as either a punishment from heaven or a demonic confederacy of Jews, heretics and lepers, such people had no time for the traditional Augustinian philosophy which preserved the Jews as witnesses to Christ's salvific passion, nor the patience to persist with a slow drip of persuasion. Thwarted in the Holy Land, the fear and anger begged for a crusade, close and immediate, and if not the Saracens (mostly already defeated in Iberia), why not the devil-Jews?

So what Martinez preached from 1378 on, principally in the towns of southern Castile, was brutally simple: attack the Jews, wherever

and whenever you can. Since by the Church's own ordinances it had been illegal to build synagogues – 'the house of Satan' where 'Christ and Christians are cursed three times a day' – the solution was simple: tear them down and right away. As for those who frequented these sties of devilry they were to be offered a simple choice: immediate conversion or death.

In his way were the authorities of the Crown, outraged by Martinez's denial of the Jews' right to self-governance and communal justice under its protection, and even more scandalised by his claim to put them under his own jurisdiction. Repeatedly, under two kings and a regency, Martinez was ordered to retract these assertions and to stop preaching against the Jews. Any synagogues that might be damaged or destroyed as a result of his fulminations would have to be rebuilt on his account, a mighty empty threat. Many of the prelates of the Church, especially in Seville, where Archbishop Barroso came to view Martinez as a heretic and a rebel, were equally horrified; but others were just as wary of the power the friars had to whip up a canting mob. The fate of the Jews thus turned into a trial of strength between official and popular forms of Christian piety, and between the will of the Crown to hold the leaders of violent crowds to account, and its nervousness about stoking anti-establishment rage. Because there was a community of Catalan merchants in London, it was common knowledge how close a call it had been in 1381 for Richard II of England at the hands of Wat Tyler and the priest John Ball. In Spain there were similar men on the margins: soldiers and sailors, overdue for pay and looking for a fight; testosterone-charged apprentices with scores to settle, waving flags with crosses; wild-eyed friars who imagined they were hastening the Second Coming by converting or killing Jews; townsmen and peasants who believed the Jews were all extortionate usurers, bloodsuckers of the people. The issue for urban authorities was both how fiercely to resist popular agitation and how severely to punish malefactors. When exemplary punishments were carried out, the result was not encouraging for the forces of order and moderation. Two ringleaders of Martinez's crowd publicly whipped for incitement on the orders of the mayor of Seville, the nobleman Guzman, resulted in his barely escaping the wrath of the people with his life. When King Juan I died in 1390 after falling off his horse and Castile fell into the hands of his son Henry III – yet

another pre-adolescent boy – a vacuum of authority opened. Pressed by leaders of the self-governing *aljama* Jewish community who had even gone to the Holy See to extract a papal condemnation of Martinez, the Regency Council made the usual pronouncements and the archdeacon as usual ignored them. Martinez was turning from a nuisance into a revolutionary, and each time his defiance went unpun-ished he was reinforced in the sense that he – not the king or the archbishops – was seen to be enacting the true will of Christ. By early 1391 he had become unstoppable, giving orders on his own authority to the churches of Castile to destroy all synagogues forthwith.

The membrane holding in all these centrifugal forces of violent disorder was easily broken through. In March 1391, attacks on the Jews in Seville were put down and punished. But in the first week of June, the onslaught on the *juderia* (now the quarter of Santa Cruz) began with a crowd of youths forcing the gates, urged on by Martinez and his friars, and rapidly turned into a holy war, with only one side armed. In a few days thousands were killed (some sources say four thousand, but that number is almost certainly too high), their bodies heaped on the streets. Of the synagogues in Seville which Martinez had said were earmarked for destruction, most were small and were burned to the ground with or without people inside them. Two of the three largest – including what is now the church of San Bartolomé – were imme-diately consecrated to Christ. Screaming women and children were pulled by the hair to baptism; those continuing to resist were sliced at the throat. Frantic multitudes of the innocent accepted, even begged for, conversion; their ancient and beautiful names were replaced by those of their godfathers and godmothers.

Elsewhere, very big fish were caught in St Peter's net. The revered rabbi and tax-farming grandee of Burgos, Solomon Halevi, became the impassioned Christian, Pablo de Santa Maria, claiming retrospec-tively to have been philosophically persuaded by the teachings of St Thomas Aquinas rather than by the argument of the sword and the mob, and this was good enough for him to rise to become bishop of his city and, eventually, chancellor of the kingdom of Castile. His prize yeshiva pupil and disciple, Joshua Halorki, initially thunderstruck by his teacher's apostasy, eventually overcame his revulsion to become the ardently evangelical priest Geronimo de Santa Fe, physician to the Pope. The apostasy was only the beginning of the harm they would

inflict on the people of their former faith. But they were among the most relentless of the proselytisers. Halorki/Santa Fe argued the Christian case against his former fellow rabbis at a disputation held in Tortosa in 1413–14 (at some points using his knowledge of Kabbalism to demonstrate that the name of Jesus was immanent in the letters of Judaic mystery), and claimed, without much evidence, that he had converted two of them. Halevi/Santa Maria persuaded his two brothers to be baptised along with him and had his daughter and four sons baptised as well, though they had no choice in the matter. His wife of twenty-six years, Joanna, would have none of it and left him to stay faithful to Judaism. She died that way in 1410 – which did not, however, prevent the husband-bishop from having her interred in his cathedral, where she still remains.

In the months that followed, the butchery engulfed nearly every major centre of Jewish life in the expanded kingdom of Castile, many of them ancient centres of learning and culture: Cordoba, Lucena, Toledo. The signals to begin the march on the Jews became brazenly theatrical, often a peal of church bells or, as in Tortosa, a minstrel beating a drum and shouts of holy water or death to the Jews.[8] In July, the terror spilled over from Castile into Valencia, now part of Aragon, where 250 died, and then into Catalonia, to Nahmanides' Gerona, and finally in early August to Barcelona, where one way or another – mass conversion or mass slaughter – the entire ancient community was wiped out. Rabbi Hasdai ben Abraham Crescas, an anti-Maimonidean Talmudist, who had been treated by King Juan as an unofficial chief rabbi of Valencia, and had often been in his company, was in Barcelona during the worst of the carnage and left a graphic description of the murder inflicted on the defenceless, 'the table of our disaster, set with poisonous plant and wormwood . . . Using bows and catapults they fought against the Jews gathered in the citadel, beating and smashing them in the tower. Many Sanctified the Name of God, among them my own [and only] son, an innocent bridal lamb; some slew themselves, others jumped from the tower . . . whose limbs were already broken before they reached halfway down . . . many came forth and sanctified the name [killed themselves] on the open street, and all the rest converted, with only a few finding refuge . . . and because of our sins today there is no one left in Barcelona called an Israelite.'[9] According to Crescas, that went for the whole of Valencia

and Catalonia. What still exists is Montjuic, a nice park for the tour-
ists and once the cemetery of the Jews, hence its name. Its stones are
scattered about Barcelona, extracted for the construction of this and
that building in the elegant town.

No Jew in Majorca supposed the sea would keep the horror of
Castile and Aragon from crossing to their island. When news arrived
of the slaughters and mass conversions in Valencia, the leaders of the
aljama went to the royal governor and asked for protection, as Jews
had done to his counterparts all over Spain. Like them he did the best
he could, gathering the Jews inside the Call at Palma, locking the
gates and forbidding penetration by Gentiles of what became the
Jewish compound. All over the island, apprehensive Jews in outlying
villages came to the smaller towns on their mules, donkeys and carts
as fast as the ponderous animals would permit, and many went on
to Palma, its citadel being, as they thought, their only hope of survival.[10]
The great centre of the roving Jewish mind, the community of astro-
labe- and atlas-makers, the star-measurers and compass-makers, was
now a camp for the terrified victims of confinement, half shelter, half
prison. Cresques Abraham had died in 1387, the same year as his patron
Pere the Ceremonious, but his son Jafuda was still very much in busi-
ness along with Nifoci and the rest of the geographers.[11] They were
there when the gates were slammed shut against a suddenly materi-
alising army of seven thousand enraged *provinciales* brandishing flags
with the crosses. The governor of the island attempted to temporise
with the crowd who had been joined by the bandit gang of Antonio
Sitjar, but against the enormous numbers he made no impression and
was lucky, here as elsewhere, to escape with his life. Now the three
gates of the Call were a liability as they spread the guards thin, and
sooner or later one gate was stoved in and the massacre could begin
in earnest. In two days there were at least three hundred bodies lying
in the streets before the doors and inside the houses of the Jews, many
of them women and children. The usual desecrations followed:
synagogues destroyed or consecrated as churches, the Torah scrolls
elaborately defiled and torn, and the holy grail of the crowd's efforts
granted – the destruction of documents of debt and contracts.

Jafuda Cresques and Isaac Nifoci, who had managed to get them-
selves into the citadel, were among the hundred or so (in a community
of over two thousand) who opted for baptism rather than death, the

map-maker taking his godfather's name and becoming Jaume Ribes. And for Jaume, sometime Jafuda, baptism delivered on its promise of rewards in this world as well as the next. Along with his former apprentice, Samuel Corcos (now known as Mecia de Viladesters), he was able to continue his map-making and painting, and in 1399 received another commission for a grand, royally scaled *mappa mundi*. At some point he moved from Majorca to the royal courts in Barcelona and Saragossa. The 'New Christians' were, in fact, in a prime position to cater to the demand among Old ones for Hebrew illuminated Bibles, psalters and breviaries which they decorated with all the flourish they had brought to illuminated maps. Scribes, bookbinders and booksellers all thrived in this business, and the '*conversos*' were confident enough of their new identity to have the island's leading architect, Guillermo Sagrera, build them their own church of Nostra Senyora de Gracia. Another group in the church of Santo Domingo forthrightly but paradoxically declared themselves to be of the '*natione israelitica*'. The confidence seemed mutual. After the spasm of violence subsided, the royal authorities moved in hard on those who had been the ringleaders of the mobs, both in Majorca and elsewhere in Aragon. Queen Violant was said to be especially indignant at the defiance of royal authority. The bandit Sitjar and the mob leader Luis de Bellvivre were taken and hanged. Demands were made for the return of plundered property and there were even edicts allowing those who had been forcibly converted to return to their faith.

Yet for all the map and book men who did well and settled for the new faith, there were many who never recovered from the breaking of their communities. The Jews of Inca, Soller, Sineu and Alcudia never came back to their towns in the hills and by the sea. Despite an official attempt to prevent them leaving Majorca and depriving it of the asset of its Jewish communities, the vast majority had changed their minds again about which of the two monotheisms offered less chance of persecution, and crossed the Mediterranean to Muslim North Africa where they settled in distinctive communities in Algiers and Fez, where Cresques Abraham had painted the six-pointed star of David.

However much the Crown and the mayors and *alcaldes* of local towns were sorry to see the Jews go (and said so), many in the radicalised Church thought good riddance. It had been one way to get

shot of the obstinate Jews. Another way had been to kill them. But had the third way, conversion – precisely the goal so many had long argued and yearned for (including the Majorcan theologian Ramon Llull)[12] – truly worked? How Christian, really, were the New Christians? Was it not a sign that they congregated in their own churches, even presuming to call themselves 'Israelites'? These suspicions had multiplied quickly all over Spain once the blood had dried and the dust settled after the traumatic upheaval of 1391. Perhaps the *conversos* had accepted baptism merely to escape death but remained inside their hearts, heads and homes loyal to their blind old faith and its ways. Even worse, might not those secret Jews corrupt sincere converts to return to the old religion as (in a long-hallowed phrase of Christian paranoia) 'a dog returns to its vomit'?

It was these fears and suspicions that brought the most famous of the militants, Vicente Ferrer, to Majorca in 1414–15. It was the year after another show dispute-cum-trial of Judaism held at Tortosa, before an audience of almost a thousand, including courtiers, bishops and cardinals, seated, according to Solomon ibn Verga's account in his *Shebet Yehuda*, on seventy thrones and presided over by the schismatic Pope Benedict XIII.[13] For the Pope it was an opportunity to establish his credentials as the true personification of the faith militant, and he opened the proceedings by announcing that 'I have not sent for you in order to prove which of our two religions is true; for it is a known thing that my religion and faith is true and that your Torah was once true but was abolished'. Geronimo de Santa Fe began ferociously by quoting Isaiah to the effect that if the rabbis refused to 'reason', 'ye shall be devoured with the sword'. But his line of argument was familiar to anyone who had studied the Barcelona disputation, namely that the man-made Talmud had fraudulently usurped the divine authority of scripture to disguise the fact that the Bible had prophesied so precisely the Messiah Jesus Christ, and so on.

The persuasion trials were already out of date as a tactic. Ferrer's methods, while also claiming to be a campaign of persuasion rather than force, were altogether more intimidating and physically histrionic. More eloquent and charismatic than Ferran Martinez, Ferrer appeared dressed in the coarsest of robes, a divine fulminator bearing on his scourged back the weight of sinful procrastination. Accompanying him were small armies of flagellants, walking in penitential processions,

carrying torches and thrashing themselves with knotted leather scourges until the blood saturated their robes, throwing open the doors of synagogues. Ferrer himself, at their head, carried a cross in one hand and a scroll of the Torah in the other. Jews were forced to stand before their Ark while being treated to rants and chants. Every Jew over the age of twelve, of both sexes, was *required* to attend these preachings. Often, mere reports of the approach of the flagellant friars was enough to send Jews to the mountains or woods beyond the town.

This was nothing compared to the upheaval that Ferrer demanded of Jewish lives. The annihilations of 1391 had torn Sefarad into three parts, each perhaps of 100,000: the first were the dead; the second the converted; the third, those who somehow decided to remain Jews whatever the oppression that lay in store. With those numbers in mind Ferrer demanded that the Jews be removed from any possible proximity to both the New Christians, lest they be 'Judaised' back into error, and also to Christian society itself. A great segregation was determined on and for Majorca, promulgated in 1413. This was the strategy of conversion through destitution, expressly meant to make daily life so unbearable that Jews would embrace the relief of the cross, and in countless cases it worked. Although most of the occupations from which they had made a living were not forbidden (especially those which sold goods to Christians, including meat and wine or any foodstuffs, as well as leather goods, gems and fabrics), Jews were to be removed from any residences in Christian districts. No Jew was henceforth allowed to lend money or to be a landlord, an attorney or a tax receiver, or indeed hold public office since any of those might make a Christian subject to Jewish authority. Nor, to the consternation of many of their regular patients, were Jews permitted to practise any form of medicine or barber-surgery, to sell or administer any kind of potion, tonic or syrup. The separation was to be hermetic. No Christian women, from the purest to the most prostituted, were allowed to enter the *juderia* by day or night, or even have a conversation, however ostensibly innocent, with any Jew. Obviously the old practice of wet-nursing Jewish children was over. And in fact through the long list of prohibitions it is possible to see exactly the informal and familiar life that had previously been enjoyed not only in Majorca but all over Aragon and Castile. Christians and Jews could no longer eat or drink together at any time. Jews were

not allowed to visit the Christian sick, nor henceforth could they deliver any presents to them, neither baked cakes and bread nor spiced dishes, fruit and wine.

Then, of course, there were the additional humiliations. No one was ever again to address a Jew as 'Don' or 'Dona'. No Jew was allowed to wear scarlet or any brightly coloured clothes, nor any fine fabric like silk, much less adorn themselves with veils or jewellery of gold or silver. Only homespun fustian dress was allowed, especially for women, which would trail to the ground. All Jews were to wear the identifying badge of the wheel, and the men were forbidden to trim their beards. You needed to know who was a Jew and who wasn't. And not least, Jews were now forbidden to read any books of the Talmud containing texts that could be interpreted as offensive to Christianity.

Though Vicente Ferrer's great segregation was made law in Valladolid in 1412, most of its most draconian restrictions proved impossible to enforce, and many were in any case revoked some years later when the lay rulers managed to reimpose their authority on the mad universe envisaged by the friars and the likes of Martinez and Ferrer. But it turned out to be the royal governors and courtiers and kings who were deluded. The great segregation promulgated by Ferrer in Majorca and throughout Aragon and Castile would return with a vengeance in the 1480s when Jews were given exactly eight days to remove themselves into zones designated as their only residences, usually morally and materially polluted sections of town, where the butchers threw offal, the tanneries stank and whores crowded the alleys. History frowns on anachronism, but what, the crematoria and the shooting squads aside, in the Nazi repertoire is missing from this list?

The *coup de grâce* was provided by a blood-libel case in 1435, which turned the beleaguered community of the Call from demoralisation to panic.[14] The only novelty was that the victim of Jewish parody crucifixion (as usual nowhere to be found) was said to be a Muslim. Tribunals were set up, the mobs of the city and country shouted, a rabbi was tortured, sentences of hanging (by the feet so that the agony was protracted) and burning handed down on four of those who had confessed to the crime. Terrified of a repetition of 1391, most of what was left of the Call fled to mountain caves near Lluch where they

were preyed on by bandits and taken as captives back to Palma. Some days later, there was a collective request for baptism. In the circumstances the death sentences were suspended, the Jews lined up in procession and marched to the cathedral to hear a *Te Deum*. The next day saw the immolation of sacred books and objects: the scrolls of the Law fed to the flames. The sole remaining synagogue was locked, but not before an immense, beautiful candelabrum of three hundred lights – which a fond Majorcan tradition claimed had hung in the Temple – was taken and transferred to the cathedral, where you can still find it.

It is not quite all that is left, though. In the DNA of 20,000 *chuetas* are embedded the Y chromosomes that identify them as the descendants of the converts of the fifteenth century. The Jewish story lives on in their bodies and, increasingly, in their reclaimed culture.

II. Toledo

'Jerusalem in Spain'? Well, that was said of so many places over the centuries by those who hoped and believed there could be a home in exile: Cordoba, Granada, even Seville. But was not Toledo's very name a sign, almost a homonym for *toledot*, Hebrew for the generations?[15] Yehudah Halevi and Moshe ibn Ezra had both lived and written their poetry there (although neither very happily). But, a Toledano might have insisted, just look at this city resting on hills, like the crown on King David's head.

You go looking for that Toledo, and the tourist office close to the great, adamant cathedral is eager to direct you to the town's two restored synagogues and the Sephardi Museum. So you thread your way through the streets lined with marzipan shops, past the windows beckoning tourists to buy a glinting blade of Toledo steel, a carver, a machete, a little sharp something to be apprehended at an airport, past the Café la Juderia offering *sandwich jamon iberico y queso*, doubly unkosher, and you will finally come upon the steep alleys of the medieval *juderia*. And there they are: separated by a few hundred feet, both recovered from neglect and multi-purpose functions in the Jewless

town: church, hospital and asylum for the Knights of the Order of
Calatrava, army barracks, rabies clinic.

They are still known, incongruously but inevitably, by their baptismal
names, hence the oxymoronic Sinagoga de Santa Maria la Blanca and
the even grander building named El Transito, for the Virgin's ascension.
In their different ways they both proclaim the possibility – against all
theological and political odds – of the harmony of the monotheisms.
Santa Maria la Blanca – once known as the Beit haKnesset Chadashah,
the New Synagogue – was built in the first decade of the thirteenth
century, probably by Joseph ben Meir Shushan, from one of the great
Toledan Jewish dynasties serving the Castilian kings.[16] And it is the
most obviously mosque-like of any synagogue imaginable, the interior
dominated by rhyming arcades of horseshoe-arched columns,
surmounted by capitals decorated with pine cones and twining foliage
in the sober style thought to have been promoted by the Almohades
(who had mostly torn down synagogues in the era of their supremacy).
This forest of arches is lit by small circular windows and hanging
Moorish lamps. Though it seems unlike any other synagogue from
the time it was built, it almost certainly wasn't. At least one other
synagogue in Segovia, destroyed by fire in 1900, was built in an almost
identical style, with the same horseshoe-arch aisles, and the hybrid
Judeo-Islamic forms might actually have been a preferred fashion for
a Jewish culture in Christian Spain that was still steeped in Arabic
language, science and literature. In the late thirteenth and early four-
teenth centuries, Toledan scribes like Israel ben Israel, from a family
of multi-generational scribes, were creating Islamic style 'carpet pages'
embellished with palmetto leaves scrolling and twining over the page,
set at the front and back of Bibles, both as protection and ornamen-
tation, a literary transcription of the architecture.[17]

El Transito has an even more startling testimony to the staying
power of the cultural harmonisation, since the inscriptions that feature
in its profuse stucco work include not just passages from the Psalms
in beautiful square-form Sephardic script, but quotations from the
Quran in Arabic, including invocations to 'peace, happiness and pros-
perity'. Muslim Mudejar craftsmen and artisans might have worked
on the stupendous hall of prayer, nine and a half metres high, but it
is inconceivable that they furtively smuggled in lines from the Muslim
holy text. Rather, the great patron of the place, the treasurer to King

Pedro the Cruel of Castile, Samuel Halevi Abulafia, must have specif-
ically commissioned them, not least because his own name and work
is eulogised on the wall. In Cordoba, there is a miniature version of
the great Toledo synagogue, also replete with the lacy weave of
Mudejar stucco, with its multiplying star forms, acanthus leaves and
winding foliage. And there too are Hebrew quotations from the Psalms
and Prophets. But the Cordoba synagogue was created earlier in the
century when there was more sensitivity to the strident complaints
being made by the friars about Jews building new synagogues in
flagrant violation of papal prohibitions to the contrary.

If you build it, make sure everyone knows. That went as much for
Samuel Halevi Abulafia as for modern philanthropists wanting their
wall plaques of gratitude. Abulafia liked to boast of his perfect taste:
the glories of the building, its wrought lamps and the beauty of the
bima, or reading dais. Though those have long gone, the majesty of
the lofty, spacious hall – the grandest imaginable – is perfectly restored,
with its high-perched women's gallery also adorned with Mudejar
decoration and inscriptions. For this kind of synagogue you dressed
up. It was, as the architectural historian Jerrilynn Dodds has acutely
seen, dangerously close to being a palace chapel, a spectacular setting
for the courtier aspirations of Abulafia himself.[18] So it is not surprising
perhaps that it was barely completed before his fall from grace; it might
even have been the reason for it. Pedro, embroiled in a civil war with
his half-brother Enrique (who was to kill him), was unhappy with being
stigmatised as the 'King of the Jews' and compromised by accusations
that courtier-financiers like Abulafia indulged in outrageous displays
of splendour while the people groaned in misery. By dint of his stun-
ning new synagogue, Abulafia was the most obvious sacrifice, and he
was duly arrested and executed. One of the wall inscriptions had praised
the king as a 'great eagle with immense wings', set there by the Jew
who never imagined that he might be the prey.

The Toledo synagogues remained, but the implied declaration of
affinity between Judaism and Islam they embodied gradually turned
into a liability, as the Christian Reconquest struggled to complete its
campaigns against the last holdout fortress kingdom of Granada.
Indeed, anyone who had managed to see the Alhambra there would
have had no difficulty recognising the stucco decoration of El Transito
as an echo of that palatial style. Increasingly hostile Christian writers

and preachers began to invoke the ancient tradition that it had been Jews who had betrayed the Visigothic city to the Arab armies in the eighth century. Indeed, given the brutality of Visigothic–Christian persecution the Jews would have been crazy not to have actively sought an alternative overlord.

But just as Jews were useful commercial and cartographic intermediaries to the rulers of Aragonese Majorca, so their familiarity with Arabic was needed by the Castilians as a conduit to the mathematics and astronomy (and to a lesser extent philosophy) of the Muslim world. The interest was as much strategic as intellectual. In the second half of the thirteenth century under the relatively benevolent rule of Alfonso X, known as 'the Wise', Jewish Toledo became the great centre of translation of Arabic and Hebrew literature – science, philosophy and poetry – into Latin, but more significantly into the tongue that would assert itself as 'Spanish': the Castilian vernacular. Alfonso, who wrote poetry and *cantiga* songs, was eager to become adept at all kinds of wisdom and, like so many before and after, subscribed to the legend that the Jews had access to esoteric knowledge – astrological, alchemical and astronomical. One of the Jewish translators who contributed to Alfonso's multicultural *Book of Astronomical Knowledge*, Yehudah ibn Moshe, was also prevailed upon to translate Hebrew works on magic, in particular the art of conjuring qualities from stones, expressly for the king. By the thirteenth century, the Sephardic community itself was beginning to write as well as speak less in Arabic than in the Judeo-Castilian called Ladino. Not for the first time it is possible that it was through song that the seeds of a common culture were sown. Ladino songs in praise of El Cid, romances of the French, Provençal, Catalan and Castilian kings, princesses and knights – many of them with a lilt that comes straight from the Arabic musical world – are as much evidence of a shared sensibility as the hybrid architecture. Yet it is nonetheless a remarkable thing that some of the earliest romances of Spanish literature were formed in the crucible of the Judeo-culture it would soon be determined to annihilate.

The moment of cultural harmony did not long survive Alfonso X, who died in 1284, except in the carpet pages that illuminated the Hebrew Bibles. Beneath the refinement of elite taste, ugly prejudices (and the beginnings of a friar-driven campaign for Christian conformity) were beginning to make the survival of pluralism difficult and eventually

impossible. In 1349, the rumour that Jews had brought plague to exterminate Christians resulted in bloody assaults in Toledo. Another burst of violence in 1367 burned down almost a thousand houses in the *juderia*. Drawing on the resilience which was by now second nature to Jews, the community learned how to rebuild, repair, restore. Between the sudden nightmares it went on with its business, its studies, its work, settled down, even prospered. Migrants from other towns arrived, putting enough pressure on space that a second area of settlement, the *alkana*, took the overflow. On the eve of the terror of 1391, the two Toledo communities boasted *nine* thriving synagogues and five houses of Bible and Talmud study.

Just because all this was happening under the nose of Toledo Cathedral, the Jews became a target for the friars. On the fast day of the 17th of Tammuz, ostensibly commemorating Moses' destruction of the first edition of the Ten Commandments, Jewish Toledo was hit by the same mob rampage that had destroyed the community in Seville and would go on to Palma and Barcelona and countless other places of their long-settled life in Spain. The desecration of the synagogues and scrolls, the plunder of ritual silver like Torah crowns and the pomegranate-decorated handle finials, the *rimmonim*, as well as the burning of houses and indiscriminate murders, are known from a heartbreaking elegy written by Jacob ibn Albeneh in the idiom of the *maratiyeh*, the Hebrew dirges that were a Toledo speciality. The list of destroyed places and slaughtered men is exhaustively distressing: the *hazan* cantor Saul; the rabbi Isaac ben Judah; Isaac ben Shushan, whose body was perforated with stab wounds; and, worst of all, Abraham ben Ophrit, identified as a *bachur*, which means he might have been any age from twelve to sixteen, for some unknown reason mercilessly stoned, dragged over the cobbles of the streets, shredding his flesh, then partially burned before his corpse was thrown in the river from where it had to be fished out by his 'aged' parents. The Sifrei Torah, the scrolls of the Law, were taken out from the arched New Synagogue and elaborately desecrated before a crucifix was planted between its two Arks. (In some Sephardic synagogues, when a new Ark was built the old one was left in place.) In the royal retreat back from anarchy to order, some of the damage was made good. But in 1411, Vicente Ferrer arrived with his army of thrashing flagellants, and Joseph ben Meir Shushan's New Synagogue became,

definitively, the church of Santa Maria la Blanca. It seemed like the triumph all true soldiers of Christ had been wanting: two-thirds of the Jews were made to disappear, either through the action of Toledan steel, or the baptismal waters; only the stubborn third persisted in their wretched blindness.

And then, all too soon, the victory generated suspicions. Toledo's 'conversos' threw themselves at the Saviour, embraced the rites, the utterances, the penances, took Communion, crossed themselves with the best, indeed were so completely of their new faith that it struck some as, well, a little odd, yesterday's beard today's tonsure. How they strutted their conversion, the Old Christians thought, moving out of the juderia and into the elegant district of the Magdalena near the Alcazar palace, with its stone fronts and walled gardens. And now they were Saved, everything was open to the conversos: marriages with the nobility (who had an eye to their money), their old occupations, and anything which could profit them both in status and fortune through serving the king. The fact that Old Christians were required to welcome them without reservation into the society of the saved, only made this unforeseen situation more aggravating.

It was too good to be true, was it not? For all their new-found fervour, had they not embraced the cross precisely so that they might become a parvenu aristocracy, lord it over the old and oppress the people with even harsher taxes and impositions? So the Old, which is to say real, Christians began to be on the lookout for signs that behind the ardent professions of faith the converts were secretly, still, impenitent Jews. And at this point Jewish historians themselves divide for reasons less to do with evidence than what they want from this post-traumatic, intense and tragically fraught moment. The great Israeli historian of Sefarad and the expulsion, Yitzhak Baer, wished so much to see the conversos and the Jews as in all deep respects one people, that he more or less echoed the view of the Inquisition that their Christianity was an expedient sham. But however baffling and almost inexplicable it is – especially to religious Jews – to contemplate hitherto learned and unimpeachably devout rabbis turning abruptly into ferocious Christian evangelists, this is certainly what happened to many of them. Pablo de Santa Maria and Geronimo de Santa Fe were not, alas, opportunists. Just what percentage of the conversos were authentically true believers in their new faith we shall never know. The

sources are necessarily much richer concerning all those who did indeed hanker after their lost Judaism or much more, in evidence unearthed by the Inquisition in the 1480s and 90s, and accounts given by those who left for countries where they could revert to Judaism.

On the other hand, wishful pieties about Jewish solidarity and Inquisitorial over-reading aside, there is no shortage of signs that many *conversos*, in Toledo and elsewhere, did indeed find ways to remain at the very least connected to their co-religionists in the *juderia*. It was not *that* far a walk, much less a ride, from the Magdalena to the *juderia*, and there was doubtless something about the cooking aromas, the music, the pure force of habit, the Ladino gossip coming through an open window onto the street, that drew them. Some of their enemies knew that their food habits would betray their relapse. The nostrils of the priest-chronicler Andres Bernaldez, no friend to the Jews, were constantly twitching for a telltale whiff of 'onions and garlic fried in oil instead of lard'. Anything fried in oil smelled evil, he thought, as did the Jews who made them their diet. You could tell a *converso* who had eaten at their tables just by the oily-garlicky stink coming off him. Then there was *adafina*, otherwise known as *hamim,* the covered-pot stew full of beans, chickpeas, vegetables and meat that Bernaldez also found disgusting and no one who had eaten it on the Sabbath, cold or warm, could resist. The Jews took it to a baker's oven for slow overnight cooking on Friday so they would not violate the Sabbath day, and any *converso* drooling for *adafina* would have to be careful not to have a Christian servant carry it there.[19] When the Inquisition was in full snooping mode, reports (usually by a servant again) of the mistress of a *converso* house cutting fat and sinew away from the meat (not actually a requirement of *kashrut* dietary laws), or more damn-ingly purging the meat of its blood in salt water, constituted major evidence of their lapse back to Judaism.

The documented ways in which *conversos* kept the connection went well beyond the kitchen to more important things: giving money to the synagogues of the *juderia* for their upkeep and to the routine functions of the *kahal* – the tending of cemeteries, even the mainten-ance of Hebrew schools. And these connections went both ways. In return for the charity, they were given all-important information about the dates of feasts (like Purim, renamed 'Santa Esther') and fasts. Before the most ferocious policing of the Inquisition in the 1480s, with

its horrifying web of informants, the pressure of intimidation and torture of servants and family members, it was still possible to adopt certain customs in the privacy of homes without necessarily attracting suspicion. Candles could be lit on Friday nights. Who, after all, did *not* light candles in the fifteenth century? Food never passed the lips on fast days? Who was to know about something that did *not* happen, especially if the servants were also *conversos*. The master and mistress donned fine yet sober apparel on feast days? But so might they to attend Mass. It was much more reckless to smuggle religious books into *converso* houses – especially the daily prayer book, the *siddur*, or a Passover Haggadah – and there is evidence before the years of the Inquisition of dangerous efforts to teach children, and indeed some adults, to memorise essential prayers of affirmation like the *shema*.

Eventually, these suspicions would turn into confessions extracted under terror and torture, waterboarding and the rack and rope, and would send *conversos* in their tens of thousands to the autos-da-fé – the 'acts of faith' that culminated in live burnings of those 'unreconciled' to the cross. Yet decades before the official introduction of a distinctively Spanish Inquisition in 1480, it was less the suspected relapses or deceits of the *conversos* than their social and political swagger which fed the flames of a New–Old hatred. The impotence (in Enrique IV's case, literal) of a succession of Castilian kings exacerbated the suspicion that they had become the creatures of favourites like Alvaro de Luna, who sustained his own position as 'Constable of Castile' only with the direct help of both Jews and *conversos*. The closeness to Luna of the communal leader of the Castilian Jews, Abraham de Benveniste, his role as tax collector and informal treasurer, and the perception that *conversos* had made themselves a new court and bureaucratic elite, was an affront to Old Christian nobles.

When Luna paid a visit to Toledo, by way of imposing a special tax on the city, bells rang from what had been the New Synagogue and was now the tower of Santa Maria la Blanca. It was a call to arms against Luna, Benveniste and their *converso* allies in the town. The protest began spontaneously and the governor of the Alcazar, Pero de Sarmiento, put himself at the head of a rising that gathered instant support from the townsmen and peasants around Toledo.[20] A direct attack was made on the houses of the most conspicuous *conversos*, like the Cota family of merchants and notaries. Hundreds were

destroyed, the *juderia* also assaulted. Insults were thrown at the king himself, effectively putting Toledo in a state of revolt. In July, with the rebels still in command of the city, Sarmiento took it upon himself to issue a 'Statute of Exclusion', turning out *conversos* from any public office on the grounds that under the skin, they had (and would always have) the impure blood of Jews. 'We declare the so-called *conversos* the offspring of perverse Jewish ancestors to be held by law as infamous and ignominious and unfit to hold any public office in the city of Toledo or to have any authority whatsoever over true Christians.'[21]

As Sarmiento's statement of blood purity violated the Church's teaching that the baptised must be treated all alike, Pope Nicholas V promptly banned the Statute of Exclusion, but the damage had been done and the principle of ineradicable racial distinction set down – indelibly, as it would turn out. In 1467, there was another attempt to launch an attack on the persons and property of the Toledo *converso* families, but they had learned their lesson from the previous riot only too well and had armed themselves with a formidable arsenal of heavy-duty Toledo weaponry, including crossbows and knotted ropes, and appointed a Captain Ferdinand de Torres as the officer of their self-defence corps.[22] This new state of preparation as well as years of bitter putting up with insults against the '*marrano*' pigs (the derogatory term that was coined in these years) may have led to an overreaction when a band of the armed men invaded Toledo Cathedral itself, triggering firstly a fight inside its precincts in which four clerics were killed in the affray, and then a wholesale urban civil war.

The cry of the armed invaders – 'This is not a church!' – was not calculated to win the *conversos* allies among the townspeople of Toledo, much less its priests. What was meant, of course, was that the cathedral had been colonised, institutionally as well as materially, by the politics of their adversaries. What it sounded like, however, was a repudiation of the holy place, complete with the astounding wood carvings that made its choir one of the most intensely felt places of piety in all Christendom. If ever evidence were needed of the suspect loyalty of the *conversos*, that miscalculated war cry supplied it.

This was more than an absurd local fracas. It took place in the city of the tombs of the kings of Castile, and at stake in the civil war between the allies of the *converso* elite and their enemies was the historical identity of Castile and what was coming to be thought of

as Spain. The impotent King, Enrique IV, was incapable of supplying that sense of Christian mission even though, coming to the throne one year after the fall of Constantinople to the Ottoman Turks, it could not have been more urgent. The purification of Spain was now the precondition of its kingdoms taking up the last Crusade, the true Cross. If the banner of Christ was to be lifted from the dust of Constantinople, it must fly over a Spain cleansed of Muslims, Jews and the quasi-Jews who masqueraded as converts. In this way the Jewish question moved to the centre of this struggle for self-definition in the time of its gestation as a supremely Christian kingdom, the next instrument of the coming of the Last Days.

Unity in purity was the message of the most influential of those who spoke to this heavily loaded historical moment: Alonso de Espina.[23] A Franciscan friar, rector of the University of Salamanca, formidably eloquent preacher of sermons and one of the royal confessors, Espina felt *misera Hispania*, as he named it, horribly unequal to the mission to which it was called: the battle which would bring on the Last Days and the Second Coming. In its way were demons, and as was commonly known the Jews were the companions of the Devil. It was they who had suborned Alvaro de Luna and brought about his downfall. Espina had made it his business to spend time with the broken Luna, doubtless pressing on him the transgressions that had brought him to disaster. Indeed, he would not leave the fallen minister alone, walking the last steps with him to the executioner's block.

In his *Fortalitum Fidei* written in 1461 (and subsequently much published around Europe), Espina collected an exhaustive anthology of all the demonologies of the Jews: well-poisoners, host-desecrators, child abductors and murderers. He had in fact been frustrated in an effort to destroy Jews in Valladolid accused in the usual way of child killing. Espina's Franciscan allegiance was significant since the order had become strikingly more militant and aggressively confrontational than the Dominicans, and Espina took his message on preaching campaigns through Castile, especially in the north where his flocks were most attentive. His point was simple: the new Crusade, launched by Pope Calixtus III, could never be accomplished without a thorough cleansing of the kingdom – of the Muslims of Granada to be sure, but also of the Jews who had to be expelled entirely from Spain. If they remained there was no hope of making authentic converts since

they would always be prey to the 'Judaisers' who were everywhere. Nonetheless he urged on Enrique IV an Inquisition expressly designed to weed out the false from the true Christians among the *conversos*. Initially the king embraced the idea, and after some reluctance, in 1461 Pope Pius II authorised it (with some reservations about ceding large powers away from Rome), only for the king to change his mind.

All of which appears as though the death knell had already sounded for the Jews of Spain. But – just as in Germany half a millennium later – an anciently settled Jewish population, inured to some hardships and much hostile screaming, can shut its ears to the clamour. And for all the Toledos, there were many places in Spain – in Aragon, as well as Castile – especially away from the major concentrations of Jews, where one would have been hard put to believe that Espina's horrifying solution of expulsion was just around the corner. One of those places of historical innocence was La Coruña in the north-western province of Galicia.

III. Who by Fire, Who by Water

It is impossible, now, to recapture how young Isaac de Braga must have felt in 1476 when he first beheld the result of his commission. You can go to the Bodleian Library at Oxford University and stand before the glowing leaves of his Hebrew Bible and if you are lucky you may even get to turn them, but still you will never come close to the euphoria that must have enveloped Braga on seeing it for the first time. La Coruña was a provincial place, a seaport, but hardly on the scale of Cadiz or Lisbon. And yet into this backwater, at some point in the fifteenth century, came a preceding marvel, the work known as the 'Cervera Bible', written around 1300 by the scribe Samuel ben Abraham ibn Nathan (whose broken tibia was recorded on its pages), spectacularly painted by the French illuminator Joseph Hazarfati, and with exquisite micrography supplied by one Abraham ibn Gaon. It was surely a look at the Cervera Bible that prompted the commission from either 'the admirable youth', as the scribe described him, or his father 'the late and well-beloved Solomon de Braga, may his soul rest in the Garden of Eden'.[24]

The paradisial book that was the Cervera Bible had been much travelled, staying for a time in the late fourteenth century in Cordoba before ending up in La Coruña, where evidently the Braga family, starting with Solomon, clearly coveted something very much like it. So much so that the scribe of the new book, Moses ibn Zabara, made sure to include the treatise on biblical Hebrew grammar called the *Sefer Mikhlol* by the scholar David Kimchi, which had also been in the Cervera Bible. That work was so unappealingly dry that Joseph Hazarfati had abandoned all pretence at relating his illuminations to its strictures on syntax and the like and had run across the pages with his most imaginative figurations of birds and beasts, a diversion followed by Joseph ibn Hayyim, the illuminator of the Braga book. If in many respects the Braga Bible has an endearingly archaic quality to its design, it is also because both the patron and scribe presumably wished to say something about the vitality of tradition. Though it would be good to imagine the Braga Bible made without a presentiment of calamity, it is not impossible that the uncertainties of that moment, poised between hope and alarm, could have made the Bragas and their scribe and illuminator want to reassert the imperishability of Judaic beauty.

In any event, Joseph ibn Hayyim was restrained neither by any visible sense of foreboding, nor for that matter by conventional canons of reverent decorum. His work glows with intense radiant colour, gold and silver, lapis blue and carnation, and rumbustious narrative animation. Jonah falls into the maw of the Great Fish (for that is the literal translation of the Hebrew); bearded David sits resplendently upon his throne; dragons do their worst, and phalanxes of cats do battle with the enemy mice.[25] The illuminator's name on the colophon page at the end of the work is formed of an eye-popping circus of acrobatic forms, some taken from playing cards, or the more picaresque sculptural decorations on cathedrals. But unlike the sinners who appear in those penitential porches, Joseph ibn Hayyim's naked women and men are mischievous and smiling as they bound and bend over the page. Everyone involved in the production of this Bible must have been cheerfully broad-minded.

That breadth extended to the religious traditions on which the Braga Bible drew for its stupendous imagery. The menorah is there in golden glowing splendour, much as it was on the mosaic floor of

the Sepphoris synagogue a millennium earlier, though in the Bible a lion (serving both for faith in the kings of Castile as well as memories of Judah) is crouched beneath it rather than rampant beside the Ark. But sometimes the space of the Temple is evoked in forms more in keeping with the decoration of the Quran and there are passages where the twin scrolls of the Torah, enclosing passages of its text, are actually framed by the horseshoe arches of Islamic architecture, as close to a perfect synthesis as one could imagine. Likewise, carpet pages of densely formed abstract patterning belong indivisibly to what had come to be the Judeo-Arabic tradition. Gothic imagery is also abundantly present in the bestiary of animals, birds and vegetation that in the earlier days of illumination had been the speciality of Christian artists, but which by the fifteenth century had been fully mastered by their Jewish counterparts.

And this is just as well because very soon, such collaborations between Christian artists and Jewish scribes would be a thing of the past in Spain. In 1483, Ferdinand of Aragon and Isabella of Castile, united as king and queen of Spain since 1474, went ahead with the great erasure of Jewish life in Spain promoted by the Dominican Vicente Ferrer and the Franciscan Alonso de Espina as a condition of Christian triumph. Persuaded that New Christians would always be tempted back into Judaism so long as there were Jews close by, and that the Church was mortally threatened by the presence within it of such Christians of wavering faith, Jews were expelled altogether from Andalusia, deemed the province most infected by the plague of Judaising. In short order they were turfed out of the cities in which they had been rooted for a thousand years, Cordoba and Seville, impoverished and homeless. These were also the places, moreover, where *convivencia*, cultural coexistence between Islam and Judaism, between Arabic and Hebrew philosophy, science and literature, had been most richly produced.

But then the Jews were not persecuted by Christians for keeping themselves apart, for their alleged remoteness. They were persecuted for their dangerous openness, for their cultural nomadism, for their unwelcome closeness. They were never separate until Christians enforced the separation.

Which they now proceeded to do. Beyond Andalusia, the draconian regulations anticipated in Ferrer's provisions of 1412–13 and the Toledo

Statutes of Exclusion fell upon the necks of all Jewish towns, doubt-less including La Coruña. Jews were to remove themselves virtually overnight – the grace period was eight days – from districts in which they had long been settled, and some of which had gates and walls to serve them in times of trouble. New zones of residence were designated by the authorities, most often in the poorest and squalid periphery of the city, set deliberately at a distance from their shops and workshops. And since the plan was to ruin them into conversion, they were forced to sell their properties – which included communal buildings, of course – for a pitiful fraction, usually 10 per cent of their actual value. Thus they were twice defrauded, on the sale and then by the inflated prices they were obliged to pay in their places of re-settlement. With this plan two goals were achieved for its architects: to ruin as many Jews as possible into conversion, and then set a cordon sanitaire around the rest so that they would be hermetically sealed off from both Old and New Christians alike. It was, in effect, an internal expulsion. And it was of course an inhuman degradation.

This was probably not what Isaac de Braga in La Coruña, or Jews in Toledo and Cordoba, Saragossa and Girona, would have been expecting from the new monarchs. It had been during the reigns of weak kings that New Christian courtiers, financiers and bureaucrats were vulnerable to hostile arguments that they had taken over the state. With Aragon and Castile united and Ferdinand and Isabella apparently hospitable to *conversos* like Luis de Santangel, and the usual Jewish doctors and financiers like the *rab de corte* (the chief rabbi Abraham Seneor) entrusted with taxation, expectations were more optimistic than the opposite. Expulsion was the dream of fanatics. How could the kingdom do without Jewish money when it was about to launch a crusade against the obstinately unconquerable fortress kingdom of Granada? So although the views of Isabella's confessor, Tomas de Torquemada, were well known and frighteningly in line with Espina's Jewish solution, there was, in the 1470s, no panicky rush to exit the kingdom.

When the Pope authorised the Spanish monarchs to appoint inquis-itors in 1478, this would not necessarily have caused a surge of alarm among the unconverted Jews, for its jurisdiction concerned only suspect Christians – above all the *conversos* – rather than Jews proper. And indeed when it began its work in Seville two years later, there

was an immediate mass flight of *conversos* to remoter towns and villages beyond its reach. But at the beginning, the Jews themselves may have been divided. For all those who remained close to family members, friends and former neighbours who had left the faith, there were just as many, if not more, Jews who were unforgiving in their attitude to the apostates, to the point where, in the proceedings of the Inquisition, they were prepared to do its bidding and inform on them. It is unlikely that anyone, Ferdinand and Isabella included, could have foreseen the monstrous and self-perpetuating engine of destruction the Inquisition became, when they petitioned Pope Sixtus IV for its authorisation.

The Inquisition was its own dominion of judgement, a state within a state, answerable to no one other than the Pope, the Crown and its own array of imposing bureaucratic regulations.[26] As well as the inquisitors and those who staffed the tribunals of interrogation, a huge army of 'familiars' was responsible for handling the bureaucratic work that oiled the machinery of terror. So many carefully considered regulations surrounded the application of torture, for example, that those who oversaw it constituted the first systematically organised bureaucracy of pain. The Inquisition even had its own miniature armies of protection and intimidation. The Inquisitor General Tomas de Torquemada never travelled anywhere without his own company of horsemen, especially not after an inquisitor had been murdered in Saragossa Cathedral by a desperate group of *conversos*. Notoriously, virtually unlimited powers of torture were granted to extract 'full' confessions from those suspected of relapsing or, worse, those who were impenitent, active Judaisers. Thus the snooping state made its entrance in history: servants, family members, neighbours frightened and cajoled into becoming informers and spies. Even in monasteries and convents, monks and nuns would report on brothers and sisters whom they suspected of looking down when the Host was raised, stumbling over the Paternoster or Ave Maria and saying who knew what in the solitude of their cells. Yirimiyahu Yovel is right to see in this the germ of a malevolent modern institution rather than a medieval relic.[27] It was indeed something fresh in its inhumanity.

And the Inquisition also invented, to a degree unseen since the Romans, the spectacle of public punishment as mass entertainment. Days of auto-da-fé were declared feast days and holidays so the

maximum number could attend the procession of the condemned, who were barefoot and dressed in the conical hat and shapeless robe of the *sanbenito*, the garments of those impenitently unreconciled to the Church decorated with licking tongues of flame, for as the Inquisitors sanctimoniously reminded the unfortunate, better they should be consumed by the flames of this world than be doomed to burn eternally in hell. Grandees, often including the king and queen, would attend these elaborate ceremonies, nibbling at holiday dainties, pomanders to their nose when the smell became disagreeable. When the practice began of exhuming the bones of heretics, often by the hundreds, and burning those in addition to living bodies, the air over the cities of immolation would have been thick with the sickly stench.

Sometimes when the victims of the Inquisition are generically characterised as 'heretics', it is forgotten that these atrocious proceedings – from the interrogations and the torture to the final mass killings when victims were, as the appalling euphemism has it, 'relaxed' to the punishing arm of the lay state – were overwhelmingly directed at those who had once been and were suspected of still being Jews. There were no Spanish Lollards or Cathars brought to the stakes of the autos-da-fé. This was centrally, intensively and catastrophically integral to the drama of Jewish history in Spain. And as well as the rolling wall of tragedy designed to exploit and nourish cruelty and betrayal, it also brought forth qualities of astonishing courage and disinterested self-sacrifice. For all the informers there were also those *conversos* like Diego Marchana who, while remaining Christian, put themselves at risk to help the belatedly 'reconciled' (whose lives and families were permanently ruined) and marked men and women to elude the Inquisitors' trap and who would, inevitably, end up themselves delivered to the fire.

The production line of the purge was powered by formidable energy, starting of course with Torquemada himself. The numbers of those who fell victim to the rolling wave of terror, torture, lies and judicial murder, given the relatively primitive means at their disposal, would do credit to any twentieth-century autocrat of degradation and death: seven hundred in Seville alone by the end of the first year; an auto-da-fé every month, and this before the death machine moved north through Ciudad Real and on to Toledo where it proudly consumed record numbers of live bodies, forty in a single day in 1488,

along with the bones of a hundred exhumed corpses (together with the effigies of those who had somehow escaped).

And yet it remained conceivable that the Jews themselves might have looked on and some of them supposed it was none of their business, that, once locked away in their urban segregation, with one gate admitting access and exit, ostensibly sealed off from 'Judaising' their former kin, they might be left alone. Such illusions may even have extended all the way up to the very greatest who were still working hard to secure victory at Granada and who, like Abraham Seneor, were received at least with politeness and sometimes with deceptive cordiality by the king and queen. He had been confident enough to approach the king and ask him to forbid the most violent sermons preached against the Jews, and rescind the prohibition against baking matzo for Passover. Seneor was even on good personal terms with Torquemada and had, at his request, secured a tax allowance on his native village! As an advocate as well as rabbi and financial potentate, he seemed to be so indispensable to the monarchs that he could not credit they would embark on so self-destructive an act as the expulsion. Such are the delusions of familiarity.

In 1485, Seneor was joined by another eminence, Rabbi Isaac Abravanel, who had held similar status and office with the king of Portugal before being implicated in an aristocratic plot to replace him. Abravanel was obliged to run for his life, and having crossed the border sought and was granted an interview with the king and queen.[28] He seems to have come away from the meeting reassured that active help in financing the war would be repaid by forgoing anything so drastic as an extension of the Andalusian expulsion to the entire kingdom. And it may well be that at that time Ferdinand and Isabella had not themselves made up their minds.

But the queen's confessor had. For Torquemada, one arm of Espina's doctrine – the absolute purification of the converts and their irreversible unification with the body of the Church – was pointless without the second arm: the complete removal of the Jews. It was, in its perverted way, a backhand compliment to the tenacity and persuasiveness of Judaism – its capacity to survive everything that states and powers, mobs and preachers, could throw at it, the forced removals, the burning of books and the cremation of bodies. You could destroy *all* of this, and somehow the thing still escaped extinction; its words

floated free from bodies and parchment, into the air itself like particles of fatal miasma.[29]

And even Torquemada, impatient as he was for this second step, understood that it might have to wait for the fall of Granada. For although the Spanish monarchy was discovering alternative sources of financing for its war – from the Genoese in particular – the army was so large and so ruinously expensive that doing without the convenience of Jewish tax farming, in which money was provided in advance, seemed imprudent. By the winter of 1491, however, the besieging army (which now included English soldiers commanded by Henry VII's brother-in-law Earl Rivers, and French troops in a pan-Christian crusading camp) had swollen to some 12,000, overwhelming enough for King Boabdil to acknowledge, in deep mortification, the inevitability of capitulation and the end of Islam in Spain. Inside Granada, of course, were thousands of Jews and *conversos* who had fled the Inquisition and had reverted to their ancestral faith within the safety of the Muslim refuge. Boabdil made arrangements for the safety of his Muslim subjects but the same accommodation, it need hardly be said, was not made for these now deeply frightened Jews.

There were incentives for the expulsion less edifying than completing the crusading mission of creating a uniformly pure Christian Spain. The nobility with whom the monarchs had been embattled would be delighted at the prospect of the annulment of their debts to the grasping Jews, just as had been the case in Plantagenet England on which the expulsion was modelled. And the monarchs had calculated, correctly, that the value of everything they could seize, confiscate and realise, especially property, would massively exceed what might conceivably be lost in the tax revenues supplied by the Jews. Perhaps, though, there may be timid, lowly souls who might have some anxiety about the sudden disappearance of physicians, shopkeepers, a dependable source of loans, such ignominious concerns. They had to be reminded that the mere existence of the Jews in their midst constituted not just an offence but a mortal threat.

So, naturally, a case of abduction and child murder was concocted, the absence of a body as always being no impediment to the certainty of the crime.[30] An itinerant *converso*, a wool washer and carder, Benito Garcia – on his way back from a pilgrimage, no less – was discovered by the Inquisition at the town of La Guardia near Toledo, with a

half-gnawed wafer of the consecrated Host in his bag, a sure sign of a plot of desecration. It only remained to extract from him, and a mixed bag of ten other *conversos* and Jews, a full confession through the usual fruitfully intensive procedures. One of the Jews, Yucef Franco, was placed in a prison cell above Garcia with a hole cut in the ceilings so that conversations between them could be overheard. A monk masquerading as a rabbi made a visit to Franco and extracted a 'confession' not of the crime but of having been accused of it. A lurid story was cobbled together of the child being abducted from a Toledo street, then tortured in mock crucifixion, and then taken away further to a mountain cave where his heart was cut out for use in rites of black magic. The tale had everything designed to whip up public fury, and to make *conversos* and Jews indistinguishably part of the same conspiracy of murderous evil. The still-missing child became quickly sanctified as 'El Niño de La Guardia' – and around that part of the country still is. The uproar was so general and intense that the king and queen could satisfy themselves that an expulsion order would in fact marshal the outrage in an orderly and productive fashion rather than just let it erupt in destructive mayhem.

So on 31 March 1492, in the palace first conceived and begun by Joseph ibn Naghrela over four hundred years before, and where Isabella and Ferdinand were advertising their triumph over Boabdil by holding court for several months, the deed was done. A lengthy order of expulsion explained that since it had been impossible to make the Jews desist from subverting the faith of the New Christians who, despite the best efforts of the Inquisition, continued to backslide, neither the unity nor the purity of the Church could tolerate their presence any longer. Moreover, they persisted in defaming and abusing the tenets of the Christian religion and, as the most recent atrocity inflicted on the defenceless body of the boy of La Guardia demonstrated, were capable of much worse. By 1 July, in three months, every Jew had to be gone from the realm, and the monarchs' loyal subjects were considerately instructed not to molest or obstruct their departure in any way. No gold or silver or hard money (and there was no other kind) could be taken with them, nor any other valuables such as gems, or precious objects, including those of their religion. Thus Torah crowns, shields, the *rimmonim* finials of the scrolls, the *yad* pointers, as well of course as the synagogues of which they had been part, stood forfeit

to the Crown, which would do a lot of melting down. Neither were the Jews to be allowed to take horses or even mules with them lest beasts of honour and burden be drained from the country. Donkeys would do to pull their carts or carry their old and sick. Their Hebrew books they could take with them, good riddance too to the infamous, blasphemous Talmud and all the rest. Those that remained would be burned along with the scrolls.

For some mysterious reason, public knowledge of the edict was delayed by a month and the breathing space was used by Seneor (whose loyalty to Isabella in her early years always won him a hearing as well as a basketful of high offices) and Abravanel to attempt to dissuade Ferdinand in particular from his chosen course. When arguments for compassion and national interest were to no avail, Abravanel tried money, 30,000 ducats of it, a huge sum. Popular legend has the king wavering, at which point Torquemada bursts in upon them hurling a crucifix to the floor and reproaching Ferdinand for being about to repeat Judas' betrayal of Christ for thirty pieces of silver. Another legend has the implacably fanatical Isabella goading the king that his hesitations were due to the fact of Jewish blood running in his own veins (for there was indeed a *converso* pedigree on his mother's side).

In fact Ferdinand was quite as determined on the expulsion as the queen and the Inquisitor General. At the end of April, as ordained, criers and royal heralds, to the sound of trumpets, assembled the people of the great cities and towns of Spain to hear the decree. No historian, certainly not this one, constrained by the niceties of prose, can recover the horror, dismay, fear and pathetic agony of the Jews who heard the implacable death sentence now imposed on communities which had indeed seemed their 'Jerusalems in Spain', where the language, turned into Ladino, had flowered; where rabbis had studied and written; where songs liturgical and songs loving had been composed, chanted and sung; where dough had been kneaded, confections cooked; where rejoicing had been danced on Purim and Simchat Torah; where wine had been knocked back at a circumcision, brides and grooms had stood beneath the *huppah* and signed the flower-decorated Aramaic nuptial contract, the *ketubah*; where doctors had brought potions and comfort to the sick of all religions; where scribes and illuminators had created things that testified to the infinite creative power of humanity, to Soria, Segovia, Burgos,

Toledo, Salamanca, Saragossa, beloved Girona, Tudela of Halevi's birth . . . all now to be emptied, the Jews who had made homes in exile now to be exiled from that exile. And they noted in their terrible lamentations that the date set, ineradicably, for their final removal (for the king had graciously extended the deadline to the end of July) was the 7th of Ab, two days before the great fast commemorating the destruction of both the First and Second Temples. Now the Temple of their culture was being pulled down about them as surely as if the Romans had returned to hurl down the stones.

Panic set in along with sickening despair. Frantic attempts were initiated to sell everything that was not to be confiscated: houses, shops, bodegas, gardens, cherry orchards, vineyards, olive groves. The example of the Andalusian expulsion would have forewarned the Sephardim to expect nothing but merciless exploitation and opportunism. They were lucky to get that 10 per cent of the value, and then there was the question of finding some sort of means to take it with them over the borders to Navarre and Portugal or over the sea to wherever would receive them. The same edict of course applied to communities in Spanish possessions: Sicily and Sardinia, places of refuge now cut off. Facing destitution and homelessness, at least 40,000 made the decision to convert and join the 100,000 of their predecessors who had become Christians since the riots and massacres of 1391. Among them, not for the first time of course, were the very grandest of court Jews. In July 1492, the chief rabbi himself, Abraham Seneor, was baptised along with his son Melamed (the teacher!) Meir, at the monastery of Guadalupe in the presence of the king and queen who stood as the octogenarian's godparents as he became Ferran Perez Colonel.

Abravanel took a different course, and according to Elijah Capsali – the chief rabbi of Khania in Crete, who spoke directly with many of the expelled – he wrote a reproachful letter to Isabella and even upbraided her in person, 'standing his ground like a lion' for the deluded presumption that this act of heartless brutality would put an end to Judaism. To her affronted response that it was not she but God who had ordained the expulsion, Abravanel asked whether she had considered the many empires stretching back deep into antiquity who imagined that by decreeing exile and dispersion they would end Jewish history and break the covenant of the people with their God. Did she not know that those empires had vanished while Judaism persisted

and would survive to see the redemption brought by the Messiah? And that the sufferings of the Jews strengthened their resolve to endure; that they had the words of their Law bound forever about their heads and hearts?

As the summer drew to its height and the exit deadline loomed, the Sephardim got themselves to ports and frontier posts as best they could.[31] The edict had specified that the penalty for being discovered, unconverted, in the lands of the king and queen after 31 July was death. So there was some urgency to the exodus. Because of the many dangers on the road to Cadiz or the borders of Navarre in the north-east and Portugal in the west, many travelled in convoys made up of their neighbours, family, those they had known in their synagogues. A few chairs, a chest of clothes, cooking pots – especially if they were bound for the sea – and sacks stuffed with precious sacred books were packed on the lumbering carts, along with grandparents and the smallest of the children. Donkeys went at donkey speed, but in any case, the vast majority of Jewish Spain left their country on foot. This made them easy prey for bandits, as well as the host of people in a perfect position to exploit and prey on them: frontier guards (on both sides) who had to be bribed even though there was nothing to pay them with, other than the few possessions they had brought along. Often, when they arrived at exit ports, hard negotiations had to be transacted with unscrupulous captains, and while they awaited space on the ships, the Jews camped and slept in fields where at night they became a mark for local gangs of robbers.

Until the spectacle wearied, people came out from their houses and fields and stood in lines by the side of the road or path to watch the long trains of people moving, as best they could in the broiling heat of the Spanish summer, towards the coast and the Portuguese frontier. And unlike the screams of execration and death that had hounded Jews on the days of riot, they did so in marvelling, chastened silence. Even as bitter a Judeophobe as the priest Andres Bernaldez found himself unexpectedly moved, not least by the dignity and strength so many showed during the ordeal.

They went along the roads and over the fields . . . in much travail, and misfortune, some falling, others standing up, some dying, others being born, others still falling sick, and there was not a Christian who did

not feel sorrow for them and wherever they went they [the Christians] beseeched them to be baptised and some in their misery would convert and remain, but few, very few did so, and the rabbis continually gave them strength and bade the women and girls sing and play tambourines and timbrels to raise the people's spirits.[32]

So the Sephardim left Spain with their beautiful music filling their ears. But why, in particular, did the rabbis call on the women to sing? Because, of course, this was an exodus, one that must have been ordained by God as a new departure as He had when they had been delivered from Egyptian bondage. And along that way, as every man, woman and child who had sat at a Seder table, who had seen one of the illuminated Haggadot would know, it was Moses' sister Miriam who sang and danced after the Israelites had passed safely through the Red Sea and the waters had closed over the hosts of Pharaoh. Bernaldez heard the music and the rabbis say that this time, again, God would provide miracles and lead them from servitude to the Promised Land.

That music would be heard again, in Salonica and Tunis, in Smyrna and Constantinople, in Venice and Khania. It had barely tuned up.

IV. To the Ends of the Earth

Far to the south of the Canaries, beyond the place where Cresques Abraham had Jaume Ferrer's little boat sailing optimistically towards the mouth of the River of Gold, past Cape Bojador, the point after which currents of legendary treachery swept vessels beyond the hope of return, beyond all that, in the midst of the ocean, lay a vast island shield volcano, discovered by Portuguese mariners in 1470 and given the name São Tomé. On which latitude it lay could only be securely identified had the captain making for the island – Alvara da Caminha, Knight of the Royal Household – had the benefit of consulting the astronomic tables of Rabbi Abraham Zacuto, lately of Salamanca but now removed to Lisbon and of much use to the imperial ambitions of the Portuguese monarchy. The volcano had been extinct long

enough for its lava rock to be covered in dense tropical vegetation, but until the Portuguese encountered it, no humans lived on São Tomé. Over the rainforests and the hills descending to the Atlantic shore flew the olive ibis, the tropicbirds and kites, and there, between the rocks and the jungle, in 1494, were some hundreds (some said thousands) of once-Jewish children. Many of them had begun their lives and grown up in Muslim Granada, home to hundreds of Jewish families when it fell to the army of reconquest, and who were immediately expelled. A number had joined the uprooted of Castile and crossed the Portuguese border in response to an offer of shelter from King João II. But this had turned out to be entirely mercenary and conditional. Other than the 630 families the Portuguese king had selected as being economically useful to the kingdom, the remainder of the Spanish Jews, perhaps as many as 80,000, were to move along after eight months and pay a hefty sum for the privilege of their short-term asylum and the right to depart.[33]

Countless numbers of those Jews, ruined by the many robberies, legal and illegal, perpetrated on them in the months of their exodus, were in no position to pay up, at which point João II declared them his enslaved personal property and distributed them as captives to his nobility, whose perennial factiousness could be sweetened by the gift of these bonded Jews who, even with rags on their backs, had their famous wits to commend them. Many he kept for his private reserve, and among them were the children who, once taken from their parents as slaves, could be sent over the seas to colonise São Tomé. Subjected to brisk conversion they would Christianise the island, and breeding with African slaves who were also brought there, would create a loyal, pious enterprising mulatto population which would be granted its freedom in twenty or so years.

If they survived. The numbers who were landed and the numbers who were not killed off by diseases, hunger and hardship (though not by the ravening 'lagarto' – crocodiles – which had been feared) are impossible to pin down with any certainty. A sixteenth-century historian gave their number as two thousand, of whom six hundred survived into adulthood, but the figure seems too high for the modest ships that took them to have accommodated, even if many were very young and very small. Some hundreds there certainly were, and they did indeed remain to create a miniature colonial society growing and

harvesting sugar and eventually the cacao that makes the best choco-late in the world. And they too, like the *chuetas* of Majorca, carry in their genes the indelible chromosomes of their origins.

João died in 1495 leaving no direct heirs, but before expiring he resolved to extinguish Judaism in his kingdom as exhaustively as his Spanish neighbours. The *Jews* on the other hand, once made over into proper Christians, were famously useful iñ two things that mattered to the ambitious Portuguese monarchy: nautical science and global trade. The thing to do, then, was to extirpate their religion. Accordingly, as in Spain, all synagogues and yeshivas were closed and an order went out to burn not their bodies, but their books, notwithstanding the fact that they had brought the new art of printing to Portugal, hitherto untouched by it. In 1493, the Jews still remaining in the country were required to bring to the Great Synagogue in Lisbon all their Bibles, prayer books, Talmuds, commentaries and philosophies, as well as any ritual objects containing Hebrew words like *tefillin* phylacteries and doorpost *mezuzot*, from where they would be taken to destruc-tion. For countless numbers of them, the sacks and chests stuffed with Hebrew books they had been allowed to take from Spain were their only consolation for everything they had lost – house, garden, shop, money, country. They had kept them close through thick and thin, over the rivers and mountains of their exodus. And now their universe of words was being taken from them. Rabbi Abraham Saba witnessed a fellow Jew being beaten mercilessly with leather straps for 'loving his books' and clinging to them. Trembling with fear the rabbi carried the most precious of his own items out of town and hid them in the hollow of an ancient olive tree. Among those book-loving Jews who somehow managed to save their treasure was Isaac de Braga, who had made his way to Lisbon from La Coruña, along with the goatskin box-bound masterpiece. Had he stayed – or worse, had he like so many thousands of others returned to Spain having accepted baptism – any books he carried with him would have been confiscated and burned at the frontier and the world would have lost the most beau-tiful of all illuminated Hebrew books.

This was not the worst that the Portuguese kings could do to their new and unwelcome population of Jews. João II's successor, Manuel, like his predecessor, was of two minds whether the kingdom would benefit more from the removal or the detention of the Jews, although

either way their religion had to be made to disappear. His decision seems to have been made by the politics of royal marriage, for the price that Ferdinand and Isabella set on a match with their widowed daughter, also called Isabella, was that Manuel extend the expulsion to all of Iberia. Otherwise, they reckoned, the border between the two countries would remain porous enough to allow secret Judaisers to return. As it was, many thousands, crushed by destitution in Portugal, had decided to accept baptism and return to Spain, taking advantage of an additional edict issued by the Spanish monarchs in November 1492 – gratifying, perhaps, but also adding to the long neurosis about the true allegiance of the *conversos*.

Although a date was set for the expulsion from Portugal in 1497, Manuel remained eaten up by anxieties about the loss of assets. Could there not be a way, as yet untried, of inducing the mass of the Jews to accept the cross, thus avoiding the need to expel them? Perhaps the fate of the children of São Tomé gave him the idea. For on the night when families were cleaning their houses of leaven and preparing for the festival of Passover, soldiers swept down on the Jews gathered in Evora and then all the towns of Portugal and tore every child aged two and above from the desperately imploring grip of their parents. The joyous candlelight search for leaven turned instead into a hunt for children. Elijah Capsali, who heard the stories from Marranos who came to Crete, wrote that the soldiers searched for toddlers and youngsters 'even in the corners and recesses of the houses'. On the first Seder night itself they returned to 'rob the Jews of their treasure. The children were taken away and never seen again.'

Thousands more of the frantic parents were brought to Lisbon, and told they would be removed at the appointed date. Some of them took the opportunity to try and implore the authorities and even the king for the release of their little ones. Solomon ibn Verga, the author of a chronicle of persecutions, the *Shebet Yehuda*, and a baptised secret Jew who witnessed the misery, wrote of a mother who had lost six children and who in desperation sought out Manuel as he was leaving church after Sunday Mass. 'She went to implore his mercy and threw herself before the feet of his horse begging him to return her youngest child to her but the king did not listen to her . . . The king ordered his servants "take her out of my sight" but the woman continued to plead her case with yet louder screams and they rebuked her

whereupon the king exclaimed "Let her be for she is like a bitch whose pups have been taken away."' We know the names of many others, an endless inventory of heartbreak: Isaac de Rua and his wife Velida, who lost their eight-year-old Jacob, renamed Jorge Lopes; Shemtob Fidalgo and his wife Oraboe, who lost two-and-a-half-year-old Reina, renamed Gracia, and eight-year-old Abraham who became George; Estrela, the widow of Jacob Mankhazina, lost four-year-old Cinfana, adopted, for an unknown period of time, by a Christian cobbler neighbour.

Pending what they thought would be their expulsion – which would, at least, be some form of release – thousands of Jews (the historian Damiao de Gois says, a little improbably, 20,000) were crammed together in an ancient palace, punitively overcrowded, with little air and no privies. But then Manuel's idea was to force conversion through the most brutal incarceration possible and the breaking of families, not to lose his Jews abroad. Every so often he would order the suspension of food and water, sometimes for three days. They were trapped in what was in effect an early version of a concentration camp with no hope of escape or reprieve except through conversion. In that spirit, when their guards had a mind to it, they beat the starving, sick Jews until they tired of the entertainment. Large numbers perished from the maltreatment, and those who barely survived were dragged by their hair to the font, some of them clutching their prayer shawls about them as they were manhandled into Christianity.

One Spanish Jew who escaped this fate was the astronomist and Talmudist rabbi, Abraham Zacuto.[34] He had crossed into Portugal along with the tens of thousands hoping for some sort of benevolent respite if not resettlement. He was already famous, both for his devising of a copper astrolabe which gave more stable readings than the wooden instruments hitherto taken to sea, and more importantly for his *Ha hibbur ha-gadol*, an almanac measuring the positions of the sun, moon and planets with unprecedented accuracy, and written in Hebrew while he was a teacher at Salamanca University. This was Jewish learning, in a discipline which went all the way back to the sky-scanners of Qumran, and which the rest of the world wanted, even when it wished to be rid of its authors. The book had been translated into Castilian Spanish in 1481, and it was because João II's physician Jose Vizinho (also an astronomer) was preparing a Latin

edition that Zacuto received a special welcome. He was taken to the immense monastery-palace of the Templars in Tomar, north of Lisbon, with its serpentine staircases and gargoyle-encrusted columns, and given a cell for his own work. Zacuto's famous presence may explain the survival of a solitary synagogue from late-medieval Portugal, in Tomar: an exquisite and tiny house of worship and study, just a simple room supported by slender piers. And while Zacuto was there, something momentous was happening to his work. A new Spanish edition was being prepared, this time on the movable type that would make it one of the first printed scientific manuals in Iberia.

But Zacuto's *Perpetual Almanach for the Movement of Celestial Bodies* did not have to wait for print to change the world. It had already been taken by Columbus aboard the *Santa Maria*, as he waited impatiently in the roads of Cadiz for the port to be unclogged of all the ships taking Jews to their various destinations and appointments with pirates, shipwreck and sometimes asylum. The two events of the year were never disconnected in his mind. Zacuto's published work had reinforced the advocacy of Isaac Abravanel and the *converso* Luis Santangel for Columbus' voyage west to find a new route to India. And as the lingua franca of the Indian Ocean was commonly known to be Arabic, Columbus made sure to take with him the Jew Luis Torres, skilled in Arabic, as a translator-interpreter, and converted just in time for the proprieties to be observed on the voyage. In the end Torres would be left behind by Columbus in the Caribbean, dealing with the different challenge of understanding and being understood by Carib and Taino 'Indians'. Columbus' journal opened with the mysterious but somehow profound connection playing in his brain: 'Having expelled the Jews from your dominions Your Majesties ordered me to proceed with all sufficient armament to the said region of India.'

For everyone, it was always about Jerusalem. Reaching India by sailing west was the next step to the last irrevocable Crusade, the true reconquest and the onset of the Last Days. But why not try the east? In Tomar, it seems likely that Rabbi Zacuto met with the Portuguese explorer Vasco da Gama before the voyage that took him past Cape Bojador, past the island of orphaned children, around the Cape and suddenly north up the African coast. When da Gama returned triumphantly from his expedition bearing spices, animals and a Polish Jew who had settled in India, Zacuto had long gone, but there

was no question that da Gama's success had been enabled by taking aboard the rabbi's *Perpetual Almanach* which gave him a secure reading of latitude. Thanks to the rabbi, the great captain and founder of Portugal's Asian empire knew, more or less, where he was.

But where was Abraham Zacuto? Where were his people? What had become of them? Where would they go now that the great experiment of living among the Christians seemed to have been eclipsed? Neither copper astrolabe nor celestial almanac were of any use against pirates, and the ship on which Zacuto sailed south, like tens of thousands of his co-religionists, back to the Muslim world of the Barbary States, was twice captured by corsairs, plundered and ransomed. Eventually, around 1504, he made it to Tunis, and there he embarked on an altogether different voyage, one through time rather than space. The *Sefer Yohassin, The Book of Lineage*, is not to be compared with his science.[35] Nor, despite Zacuto's obsession with tracking together the events of the Gentile world with those of the Jews, is it really history. The scientifically minded German Jewish historians of the nineteenth century dismissed it as so much nonsensical fantasy, incapable of distinguishing between myth and truth – but then, equally missing the point, the same thing had been said about Herodotus.

It is true. Rabbi Zacuto's genealogy is not history, not as the readers of this book would recognise it. But it is an encounter with the teeming generations, from the patriarchs through the rabbis and sages to men Zacuto might have known. It is not history because despite the ostensible obsession with chronology, all these people who made up the Jewish past and who inhabited the Jewish here and now seem to be living *at the same time*, coming together in a thunderous cacophony of mutual interruption. There goes Shammai sounding off again; there is Rabbi Ishmael who says 'go tell Rabbi Akiba he has made a mistake'; there is Ben Ha-Ha 'who I have heard is identical with Ben Bag-Bag for they have the same numeric value, that is *bet* and *gimel* equals five'; there is Shmuel not yet Hanagid sitting selling spices in his shop in Malaga with no inkling that he would be the great minister of the Berber king; there, scribbling away in Arabic, is Maimonides whose remains were taken to Palestine where brigands set upon the coffin and would have heaved it into the sea had not thirty men been unable to lift it from the ground, so allowing the great philosopher

to be buried among his fathers at Tiberias. There too at the end are the orphans who had been taken 'to the islands of the sea'.

Whether Zacuto himself died and was buried in the Land of Israel, as pious tradition has it, is not known for sure; but it is certain that he went there at some point towards the end of his life and communed still more closely with the multitudes of Jews he had resurrected in his pages. There was no tomb, however dubiously identified, that Zacuto did not want to see and bow his head before: Nun, the father of Joshua at Timnath; Yehudah Hanasi, the prince and master of the Mishnah, interred at Sepphoris with ten Gaons, five to his right and five to his left; the prophet Habakkuk at Kafr Yakuk; Hillel and Shammai at Meron in Galilee.

And then, by his own account Zacuto made his way to Damascus and from there walked for two days to Aleppo where he was shown what was said to be the tomb of Ezra the Scribe, the writer of books of the Bible, the recoverer of the word for the returned exiles camping amid the broken walls of Jerusalem. There, in some mouldy cell, Abraham Zacuto beheld what he thought to be a miracle of survival: an oil stain on the candleholder which had given the light for Ezra to write his Torah scroll.

Men were sailing to the very rim of creation with his almanac of the sun, moon and planets to guide them. Jews had been scattered again to the ends of the earth. But where were the ends of the earth? Beyond, was there a true void, as Hasdai Crescas may he rest in peace had insisted, the emptiness from which the universe had been made, or was there just space infinitely divided and extended as Abravanel the Aristotelian thought, the ships and caravans moving on and on from one passage to the next?[36] Zacuto's mind, like that of so many Jews, was caught between the ancestral and the visionary, the endless past and the opening future under the charted heavens and the vast ocean. Perhaps the ends of the earth were where the words reached farthest? For all the attempts to burn, expunge and blot them out, to excise and criminalise Hebrew reading, to beat the books out of the Jews, the words travelled on and on through space and time. Sometimes, like men put on auction at slave markets, they were released to life even by their malevolent captors, who childishly were interested by how much they might fetch. Zacuto remembered having seen just such a batch of books, taken by Christians from Portugal,

on sale in Morocco. Similar markets were found on the other side of the world. Francisco de Pinheiro, one of the Portuguese nobles who had sailed on the India fleet of the admiral viceroy Francisco de Almeida, had brought with him a chest of Hebrew books which his father (a magistrate, naturally) had plundered from a Portuguese synagogue and which he supposed might fetch a ducat or two. On the Malabar coast at Cochin where a community of Jews had been anciently settled, Pinheiro sold his trophy library. The books were ransomed into a new life, redeemed from darkness.

Perhaps a psalm was on Zacuto's mind. Every Shabbat and festival, in Sephardi synagogues the nineteenth psalm of King David was (and sometimes still is) sung as part of the *zemirot* hymns. The *Sefer Yetzirah* – which Zacuto, with his fascination for Kabbalah, knew well – maintained that the Almighty had created the elements of the world from Hebrew letters. So the ends of the earth must be where the words rested, where the heavenly voice was heard, through all the imprecations and lamentations of this world. Yes, that was surely it.

> the heavens declare the glory of God
> and the firmament showeth his handiwork
> day unto day uttereth speech
> and night unto night showeth knowledge
> there is no speech nor language
> where their voice is not heard
> their line has gone out through all the earth
> and their words to the end of the world.

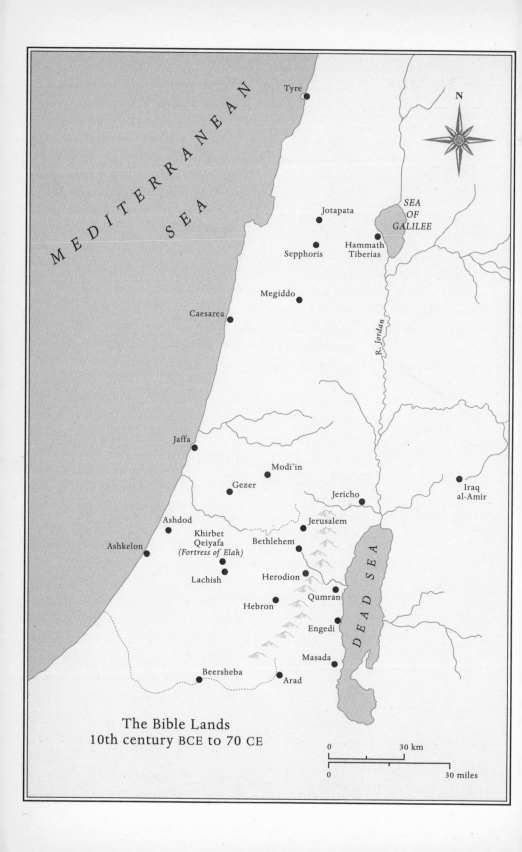

The Bible Lands
10th century BCE to 70 CE

Synagogues in late antiquity

- ◎ Towns with notable synagogues
- ● Towns with large Jewish communities
- ▨ Areas of widespread Jewish settlement

Elephantine ◎
(*destroyed early 4th century BCE*)

MEDITERRANEAN SEA

SYRIA

R. Euphrates

MESOPOTAMIA (BABYLONIA)

R. Tigris

SASSANIAN EMPIRE OF PERSIA

• Edrei

Syrian Desert

Jericho • • Mu'ta

BYZANTINE EMPIRE

• Jerba

A

NEFUD

• Adhruh

Krokodopolis

Sinai Desert

• Maqna

R

A

• Yotabe

H

Tayma •

⚔ • Wadi al-Qura

B

Sandy Desert

PERSIAN GULF

I

al-Qatif • • Hajar

Mada'in Salih *(al-Hijr)*

I

• Fadak

• Yadi'a

J

al-Ula •

⚔ • Khaybar

A

⚔ Uhud

A

N

R

E

⚔ • Yathrib (Medina)

• Badr

D

⚔ Hudaybiyya

S

Mecca •
• al-Taif

E

A

Sandy Desert

N

• Najran

Great Arabian Desert

0 200 km

HIMYAR

• Al-Haid

0 200 miles

Sanaa •

HADRAMAUT

Jewish towns in Arabia on the eve of the rise of Islam, at the time of Muhammad

• Zafar

Zebid •

• Kinda

SABA

ARABIAN SEA

• Aden

GULF OF ADEN

• Jewish settlements in the Arabian Peninsular at the time of Muhammad

⚔ Battles fought by Muhammad

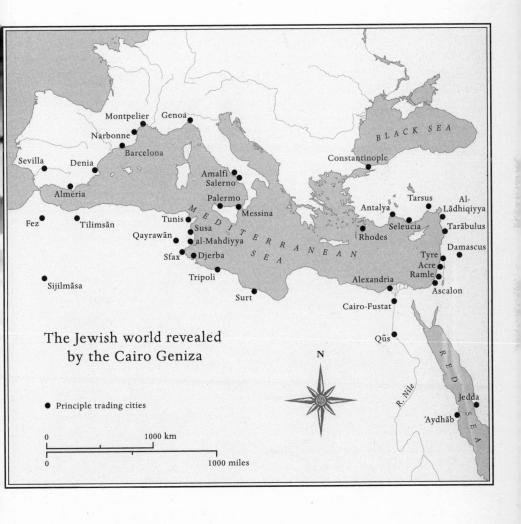

BLACK SEA

Montpelier Genoa

Narbonne

Barcelona

Sevilla
Denia

Almería

Fez Tilimsān

Tunis

Qayrawān Susa

al-Mahdiyya

Sfax Djerba

Sijilmāsa

Tripoli

Surt

Amalfi
Salerno

Palermo

Messina

MEDITERRANEAN

SEA

Constantinople

Antalya

Rhodes

Tarsus

Seleucia

Al-
Lādhiqiyya

Tarābulus

Damascus

Tyre
Acre
Ramle

Alexandria

Ascalon

Cairo-Fustat

Qūs

The Jewish world revealed
by the Cairo Geniza

N

● Principle trading cities

RED

R. Nile

SEA

Jedda

'Aydhāb

0 1000 km

0 1000 miles

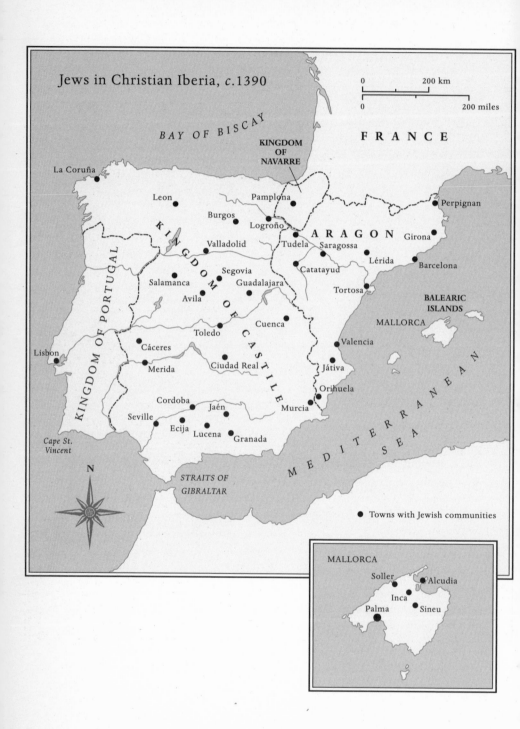

Jews in Christian Iberia, *c.*1390

0 200 km

0 200 miles

BAY OF BISCAY

F R A N C E

KINGDOM OF NAVARRE

La Coruña

Leon

Pamplona

Perpignan

Burgos

Logroño

A R A G O N

Girona

Valladolid

Tudela

Saragossa

K I N G D O M

Segovia

Catatayud

Lérida

Barcelona

Salamanca

Guadalajara

O F

Avila

Tortosa

BALEARIC ISLANDS

K I N G D O M O F P O R T U G A L

Cuenca

C A S T I L E

MALLORCA

Toledo

Cáceres

Valencia

Lisbon

Ciudad Real

Játiva

Merida

Orihuela

Cordoba

Jaén

Murcia

Seville

M E D I T E R R A N E A N

Ecija

Lucena

Granada

Cape St. Vincent

S E A

N

STRAITS OF GIBRALTAR

● Towns with Jewish communities

MALLORCA

Soller

Alcudia

Inca

Palma

Sineu

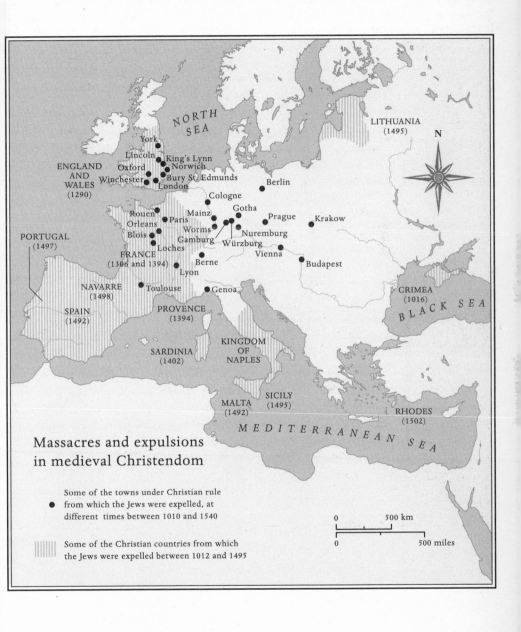

NORTH SEA

LITHUANIA
(1495)

N

York
Lincoln King's Lynn
ENGLAND Oxford Norwich
AND Winchester Bury St. Edmunds
WALES London
(1290)

Berlin

Cologne

Rouen Mainz Gotha Prague Krakow
Orleans Paris
Blois Worms Nuremburg
 Gamburg Würzburg
FRANCE Loches
(1306 and 1394) Vienna
 Berne
 Lyon Budapest

PORTUGAL
(1497)

NAVARRE Toulouse Genoa
(1498)

SPAIN PROVENCE
(1492) (1394)

CRIMEA
(1016)

BLACK SEA

SARDINIA
(1402)

KINGDOM
OF
NAPLES

MALTA SICILY
(1492) (1495)

RHODES
(1502)

MEDITERRANEAN SEA

Massacres and expulsions
in medieval Christendom

● Some of the towns under Christian rule
 from which the Jews were expelled, at
 different times between 1010 and 1540

▦ Some of the Christian countries from which
 the Jews were expelled between 1012 and 1495

0 500 km

0 500 miles

BCE

1500 BCE	**c.1200** Merneptah Stele, an inscribed stone slab, created. It represents the first documented reference to Israel in the historical record
1000 BCE	**928** Israel divides into Israel and Judah
	c.870 Tel Dan Stele created. It contains the first reference to David found outside the Bible ('House of David', *bytdwd*)
	721 northern kingdom of Israel destroyed by the Assyrians
	715–687 reign of King Hezekiah of Judah
	649–609 reign of King Josiah of Judah; Josiah institutes major reforms
	597 Nebuchadnezzar's first siege of Jerusalem and deportation of the elite of Judah
	587 the final destruction of Jerusalem and Solomon's Temple by the Babylonians, led by Nebuchadnezzar
	586 Zedekiah attempts to capture Jerusalem from Babylonians
	588–587 the very last years of Judaean independence
	538 Cyrus, King of Persia, allows Jews in Babylon to return to Jerusalem
	525 Cambyses II's capture of Egypt
	520–515 the Second Temple is built
500 BCE	**445** Nehemiah rebuilds the walls of Jerusalem
	167–161 the Hasmonean revolt against the Seleucid empire, led by the Maccabees
	165–137 the Hasmonean dynasty establishes dominance in Judea
	134–132 Antiochus VII lays siege to Jerusalem
	74 Herod born
	63 the Roman general Pompey the Great enters Jerusalem
	37 Herod overthrows Antigonus and establishes the Herodian dynasty
	4 Herod dies and the kingdom is divided among his three sons

CE

0	**66–73** Judaean Jews revolt against Roman occupation
	70 the Second Temple is destroyed by Rome and Jerusalem is captured
	73 the fall of the fortress Masada
	115–117 the second Jewish-Roman war. Major revolts by Jews in Cyrene, Cyprus, Mesopotamia and Egypt
	132–135 the Second Jewish Revolt in Judea against Roman occupation under Emperor Hadrian
	138 death of Emperor Hadrian and easing of Jewish persecution

There remains controversy over some dates and associated events.
The dates listed above are intended to orientate the reader but may be disputed elsewhere.

220 the Mishnah, the first major written version of the Jewish oral traditions, is redacted by Rabbi Yehudah Hanasi

362–363 Emperor Julian promises to allow the Jews to return to Jerusalem and rebuild the Temple

363 Emperor Julian is killed and the plan abandoned

[late 4th century] conversion of the Kingdom of Himyar to Judaism

500 CE

525 Jewish Himyar falls to the Christian Ethiopians, the Aksumites

570 birth of Muhammad

610–632 the rise of Islam on the Arab peninsula

711 Muslim armies invade Spain and occupy large areas

1000 CE

1013 the fall of Cordoba to Sulayman ibn al-Hakam

1066 massacre of the Jewish community in Granada

1070 Almoravid invaders from Morocco conquer Granada, followed in the early 12th century by the Almohades

1095 Pope Urban II calls for a Crusade to liberate the Holy Land

1096 massacres of Jewish communities in the towns of the Rhineland

1099 the Crusaders capture the Jerusalem Temple (briefly) and massacre the Jews of Jerusalem

1187 Saladin conquers Jerusalem

1190 massacre of Jews in York

1278–79 a campaign of crushing terror and violence in which the Jews of England were accused of 'coin-clipping'. 269 Jews were hanged in London

1290 Edward I issues an edict expelling all Jews from England

1298 massacres led by 'King' Rintfleisch sweep through 146 communities in Franconia in south Germany

1306 the Great Expulsion. Philip the Fair expels Jews from France

1336–38 Armleder massacres

1338 another wave of violence overtakes the Rhineland

1391 anti-Jewish riots and massacres spread across Aragon and Castile

1394 after Louis X of France recalled the Jews in 1315, Charles VI issues a decree expelling Jews once again from France

1467 an attempt is launched to attack the Toledo *conversos* (Jewish converts to Christianity)

1478 the Spanish Inquisition is established to ensure the orthodoxy of those who converted from Judaism to Christianity

1492 Ferdinand orders the expulsion of the Jews from Spain

1497 expulsion of the Jews from Portugal

1500 CE

NOTES

Chapter 1

1 Bezalel Porten, with J. J. Farber, C. J. Martin, G. Vittmann et al., *The Elephantine Papyri in English: Three Millennia of Cross-Cultural Continuity and Change* (Leiden, New York and Cologne 1996), B8, 107–9. Porten's scholarship is the most comprehensive and rigorous work on the Elephantine archives and my account is entirely indebted to it. See also his *Archives from Elephantine: The Life of an Ancient Jewish Military Colony* (Berkeley, 1996).

2 All this can be inferred from the detailed description given in a letter to Jerusalem of what had been destroyed in the rampage of 407 BCE. Porten, B19, 241.

3 This is a point made (over-literally in my view) by Herbert Niehr, 'In Search of YHWH's Cult Statue in the First Temple', in Karel van der Toorn (ed.), *The Image and the Book: Iconic Cults, Aniconism and the Rise of Book Religion in Israel and the Ancient Near East* (Leuven, 1997), 81. Niehr is committed to the view that there may have been some sort of cult statue in the First Temple (though not the Second), hence offerings of bread and animals were for the people of YHWH not unlike those rendered to anthropomorphic gods elsewhere in the western Semitic Near East.

4 Stephen G. Rosenberg, 'The Jewish Temple at Elephantine', *Journal of the American Schools of Oriental Research*, vol. 67 (March 2004).

5 Evidence of Egyptian circumcision can readily be found on tombs and other sculpture from the period of the Old Kingdom (2500 BCE) onwards.

6 Porten, B13, 125–6.

7 For the chronology of the Tamet–Ananiah marriage I follow Porten, 208–51. Boulos Ayad Ayad, 'From the Archive of Ananiah Son of Azariah: a Jew from Elephantine', *JNES*, 56, 1 (1997) gives an entirely conflicting reading, involving the separation of Tamet and Ananiah, their reunion in a remarriage, and the same pattern of separation and reunion followed

by their daughter Jehoishima and her husband, another Ananiah. In a communication to me Professor Porten attributed the discrepancy to a mistake made by Ayad in reading the Aramaic dating of the documents. See also Emil G. Kraeling, *The Brooklyn Museum Aramaic Papyri* (New Haven, 1953); and Edward Bleiberg, *Jewish Life in Ancient Egypt: A Family Archive from the Nile Valley* (Brooklyn, 2002). I am grateful to Edward Bleiberg for allowing me to explore the Brooklyn papyri at an early stage in this project; an enthralling experience.

8 Porten, *Elephantine Papyri*, 242.
9 On the 'Mibtahiah' archive, Porten, 152–201.

Chapter 2

1 I am assuming, along with the most authoritative scholars, like Lester Grabbe, the historicity of Nehemiah and Ezra, and the approximate contemporaneity of the books written in their names with the events they relate. This is, however, by no means an unchallenged assumption, although the major challenges have been made by scholars arguing that *none* of the Hebrew Bible was written before the Persian and Hellenistic periods, notwithstanding the glaring difference between the 'late Hebrew' of this period, a minority language even among Jews, and the 'classical Hebrew' of the late Judaean monarchy. For more on this argument, see William M. Schniedewind, *How the Bible Became a Book* (Cambridge, 2004). On authenticity and authorship issues in Ezra, see Arvid S. Kapelrud, *The Question of Authorship in the Ezra-Narrative: A Lexical Investigation* (Oslo, 1944); and much more recently, Juha Pakkala, *Ezra the Scribe: The Development of Ezra 7–10 and Nehemiah 8* (Berlin and New York, 2004); and most critically the work of Sara Japhet, especially *From the Rivers of Babylon to the Highlands of Judah: Collected Studies on the Restoration Period* (Winona Lake, Indiana, 2006), esp. 1–38 and 367–98.

2 Bizarrely, those who argue for a post-exilic date for the beginnings of Bible writing situate it precisely in the period archaeology has conclusively shown to be most severely depopulated and impoverished, some claiming a shrinkage from the late-Judaean monarchy of as much as 85 per cent . . .

3 The sixth-century BCE cuneiform 'Cyrus Cylinder' in the British Museum confirms the Persian policy of restoring local cults and populations, though it does not specify the Temple or indeed the Judaeans of Yahud.

4 Ezra 3:11.
5 Ezra 6:1–12.
6 John Curtis, review of Amelie Kuhrt, *The Persian Empire: A corpus of*

Sources from the Achaemenid Period, 2 vols (London and New York, 2007), in *Palestine Exploration Quarterly*, vol. 144, 1 March 2012, 68–9.

7 Neo-Babylonian cuneiform tablets from the early sixth century BCE discovered in the 1930s record the oil portions doled out to Jehoiachin, and 'princes' expressly called 'King of Judah'. W. F. Albright, 'King Jehoiachin in exile', *BA* (1942), 49–55. See also O. Pedersen, *Archives and Libraries in the Ancient Near East 1500–300 BCE* (Bethesda, 1998), 183–4.

8 Kyung-jin Min, *The Levitical Authorship of Ezra–Nehemiah* (London and New York, 2004), rehearses the debate over single or collective authorship. See also James C. Van der Kam, 'Ezra–Nehemiah or Ezra and Nehemiah?' in E. Ulrich (ed.), *Priests, Prophets and Scribes: Essays on the Formation and Heritage of Second Temple Judaism in Honour of Joseph Blenkinsop* (Sheffield, 1992), 55–76.

9 On the relationship between vocalisation and writing, and the presumption of gathered audience, see Daniel Boyarin, 'Placing Reading: Ancient Israel and Medieval Europe', in Jonathan Boyarin (ed.), *The Ethnography of Reading* (Berkeley, Los Angeles, Oxford, 1993), esp. 11ff.

10 Deuteronomy 31:11.

11 Midrash, Rabbah Genesis, 1/1.

12 Baruch Spinoza, *Tractatus Theologicus-Philosophicus* (Amsterdam, 1670). See Richard Popkin, 'Spinoza and Bible Scholarship', in *The Cambridge Guide to Spinoza* (Cambridge, 1996), 383–407; Nancy Levene, *Spinoza's Revelation: Religion, Democracy and Reason* (Cambridge, 2004), 77–9.

13 See Karel van der Toorn (ed.), *The Image and the Book*, op. cit.

14 It is ironic that the writing form taken by Hebrew over the two millennia since the biblical canon was closed and the rabbinic codification of oral tradition in the Mishnah was inaugurated in the third century CE, and still supposed, in every synagogue, yeshiva and cheder, to be an authentic Hebrew continuous with the script in which the Bible is written, is actually square-form Aramaic.

15 These texts can be found in James M. Lindenberger, *Ancient Aramaic and Hebrew Letters* (Atlanta, 2003), 125–30.

16 Frank Moore Cross Jr, *Canaanite Myth and Hebrew Epic* (Cambridge, MA, 1973), 123.

17 Frank Moore Cross Jr and David Noel Freedman, *Studies in Ancient Yahwistic Poetry* (Grand Rapids, Michigan, 1975), *passim*.

18 Seth L. Sanders, *The Invention of Hebrew* (Urbana, Illinois, 2009), 113. Inland Hebrew inscriptions, Sanders writes, were the product of a home-grown craft rather than Solomonic enlightenment, and on 113 writes, 'Hebrew was engineered and spread but not monopolised by a geographically wide-ranging group of skilled artisans.' Sanders stresses the uniqueness of this diffusion in the ancient Near East. A more conservative view is taken by Christopher A. Rollston, *Writing and Literacy in*

the World of Ancient Israel: Epigraphic Evidence from the Iron Age (Atlanta, 2010). See also the deeply engaging discussion of the relationship between orality and written chronicle in Robert S. Kawashima, *Biblical Narrative and the Death of the Rhapsode* (Bloomington, Indiana, 2004). Kawashima's work is a response in particular to Baruch Halpern's classic work, *The First Historians: The Hebrew Bible and History* (University Park, PA, 1996).

19 Lindenberger, *Ancient Aramaic and Hebrew Letters*, 62, 125–6.

20 Ron E. Tappy and P. Kyle McCarter Jr, *Literate Culture and Tenth-Century Canaan: The Tel Zayit Abecedary in Context* (Winona Lake, Indiana, 2008).

21 Lindenberger, *Ancient Aramaic and Hebrew Letters*, 55–60, 121–4.

22 Ibid., 50, 109–10.

Chapter 3

1 Bertha Spafford Vester, *Our Jerusalem: An American Family in the Holy City 1881–1949* (New York, 1950), 92–3. The account was given directly to the author by her adopted half-brother, Jacob, after he became a Spafford and lived in the American colony of evangelical 'Overcomers' in 1883.

2 Edward Robinson, *Biblical Researches in the Holy Land in the years 1838 and 1852* (Boston, 1852), 340–1.

3 Yeshayahu Nir, *The Bible and the Image: The History of Photography in the Holy Land 1839–1899* (Philadelphia, 1985); Nissan Perez, *Focus East: Early Photography in the Near East* (New York, 1988); Kathleen Stuart Howe, Nitza Rosovsky et al., *Revealing the Holy Land: The Photographic Exploration of Palestine* (Santa Barbara, 1997).

4 *Journal of Sacred Literature and Biblical Record*, April–July 1864, 133–57. Anyone who wants to understand the peculiar marriage of Christian enthusiasm reconceived as scientific inquiry must read the *Journal*. This particular issue included articles on Eusebius of Caesarea as well as sceptical comments on the 'statistics of Exodus' – meaning the two million said to have left Egypt with Moses!

5 That of course turned out to be the case and in 1868 Walter Besant, a mathematician, returned from Mauritius for his health, and the aspiring novelist and historian became active secretary, keeping the job until 1885.

6 John James Moscrop, *Measuring Jerusalem: The Palestine Exploration Fund and British Interests in the Holy Land* (Leicester, 2000), 63–149. A typically engaging account of the survey is Claude Reignier Conder, *Tent Work in Palestine: A Record of Discovery and Adventure. (*London, 1887*)*.

7 Preface to Edward Henry Palmer, *The Desert of the Exodus: Journeys on Foot in the Wilderness of the Forty Years Wandering* (London, 1872).

8 Arthur Stanley, *Sinai and Palestine in Connection with Their History* (London,

1857), 66, and also xix, 'It is impossible not to be struck by the constant agreement between the recorded history and the natural geography both of the Old and New Testament.'

9 Palmer, *The Desert of the Exodus*, 54.

10 The history of this archaeological revision is rehearsed in Israel Finkelstein and Amihai Mazar (ed. Brian B. Schmidt), *The Quest for the Historical Israel: Debating Archaeology and the History of Early Israel* (Atlanta, 2007). Finkelstein has been a major figure in revising assumptions about sites such as Megiddo Yadin believed to be Solomonic and reassigning them to the Omridic period of the Kingdom of Israel. See Finkelstein and Neil Asher Silberman: *David and Solomon* (New York, 2006) and *The Bible Unearthed: Archaeology's New Vision of Ancient Israel and its Sacred Texts* (New York, 2000). William G. Dever, the other dominant figure in the debate, has moved further away from a sceptical stance; see, for example, *Who Were the Early Israelites and Where Did They Come From?* (Grand Rapids, MI 2006). The ultra-minimalist position has been most assertively argued by P. R. Davies, *In Search of 'Ancient Israel'* (Sheffield, 1992) and T. L. Thompson, *Early History of the Israelite People from the Written and Archaeological Sources* (Leiden, 1992). See the response by Baruch Halpern, 'Erasing History: The Minimalist Assault on Ancient Israel', *Bible Review*, 1995, 26–35.

11 See Morton Smith (ed. Shaye Cohen), *The Cult of Yahweh*, vol. 1, especially the careful and subtle reading in 'On the Common Theology of the Ancient Near East', 15–27. See also John Day, *Yahweh and the Gods and Goddesses of Canaan* (Sheffield, 2000 and 2002); Mark S. Smith, *The Early History of God: Yahweh and the Other Deities in Ancient Israel* (Grand Rapids, MI, 2002); Othmar Keel and Christoph Uehlinger, *Gods, Goddesses and Images of God in Ancient Israel* (Minneapolis, 1998). One of the best surveys of recent scholarly debate on the gradual rise of 'aniconism' in Judahite religion is Karel van der Toorn (ed.), *The Image and the Book*, op. cit., especially: Tryggve N. D. Mettinger, 'Israelite Aniconism: Developments and Origins', 173–204; Ronald S. Hendel, 'Aniconism and Anthropomorphism in Ancient Israel', 205–28; and most suggestively Karel van der Toorn, 'The Iconic Book: Analogies between the Babylonian Cult of Images and the Veneration of the Torah', 229–48.

12 Amihai Mazar, *Archaeology of the Land of the Bible*, vol. 1, 10,000–586 BCE (New Haven and London, 1990), 501–2.

13 R. Kletter, *The Judaean Pillar Figurines and the Archaeology of Asherah* (Oxford, 1996).

14 William G. Dever, *Did God Have a Wife?: Archaeology and Folk Religion in Ancient Israel* (Grand Rapids, MI, 2005).

15 Ibid., 497–8.

16 Nili Sacher Fox, *In the Service of the King: Officialdom in Ancient Israel and Judah* (New York, 2000), *passim*; Robert Deutsch, *Masrim min Ha'Avar (Messages from the Past, Hebrew bullae from the time of Isaiah to the end of the First Temple)* (Jaffa, Tel-Aviv, 1997); *Biblical Period Hebrew Bullae: The Joseph Chaim Kaufman Collection.*

17 The most recent excavations and the history of the work is in Yosef Garfinkel, Saar Ganor and Michael Hasel, *In the Footsteps of King David* (Tel Aviv, 2012). See also Y. Garfinkel and S. Ganor, *Khirbet Qeiyafa Excavation Report, Vol. 1* (Jerusalem, 2008).

18 G. Bearman and W. A. Christens-Barry, 'Imaging the Ostracon', in Garfinkel and Ganor, *Excavation Report*, 261–70.

Chapter 4

1 Matthew Arnold, *Culture and Anarchy* (London, 1869), Chapter IV, *passim*. Arnold conceded at the outset that both 'Hebraism' and 'Hellenism' were 'august and admirable' and cited Heine as an instance of reversing expectations – but the two poles of cultural expression remained for him ultimately not just distinctive but irreconcilable.

2 Josephus, *Antiquities of the Jews*, 11, 5, 256.

3 J. M. Cowey and K. Maresch (eds), *Urkunden des Politeuma der Juden von Herakleopolis* (Wiesbaden, 2001); see also A. Kasher, *The Jews in Hellenistic Egypt* (Brill, 1985); see also Robert Kugler, 'Uncovering a New Dimension of Early Judaean Interpretations and the Greek Torah: Ptolemaic Law Interpreted by its own rhetoric', in Hanna von Weissenber, Juha Pakkala and Marko Mattilla (eds), *Rewriting and Interpreting Authoritative Traditions in the Second Temple Period* (Berlin and New York, 2011), 165ff. For the status and governance of *politeuma*, see G. Ludertz, 'What is the *politeuma*?', in J. W. Henten and P. W. van der Horst, *Studies in Early Jewish Epigraphy* (Leiden, 1994), 204–8.

4 Lee I. Levine, *The Ancient Synagogue: The First Thousand Years* (New Haven, 2005), 81ff.

5 Arnaldo Momigliano, *Alien Wisdom: The Limits of Hellenism* (Cambridge, 1971); the classic Victor Tcherikover, *Hellenistic Civilization and the Jews* (Grand Rapids, MI, 1959); Erich Gruen, *Diaspora: Jews Amidst Greeks and Romans* (Cambridge, MA, 2002); John J. Collins, *Between Athens and Jerusalem: Jewish Identity in the Hellenistic Diaspora* (New York, 1983); Lester L. Grabbe, *A History of the Jews and Judaism in the Second Temple Period, Vol. 2: The Coming of the Greeks* (London, 2008); Joseph Meleze Modrzejewski, *The Jews of Egypt from Rameses II to Emperor Hadrian* (trans. Robert Cornman), (Princeton, 1995), 49.

6 On this and the other 'romances', see Sara Raup Johnson, *Historical Fictions and Hellenistic Jewish Identity: Third Maccabees in its Cultural Context* (Berkeley and Los Angeles, 2004), 113–120.

7 Josephus, *Antiquities of the Jews*, 11, 8, 329–40.

8 *Letter*, 158–9.

9 But not according to the more stringent Deuteronomy which classified locusts as swarming creeping things and thus an abomination.

10 *Letter*, 152.

11 See Christopher Haas, *Alexandria in Late Antiquity, Topography and Social Conflict* (Baltimore and London, 1997); also (and for Roman Egypt), John M. G. Barclay, *Jews in the Mediterranean Diaspora from Alexander to Trajan (323 BCE–117 CE)*, (Berkeley and Los Angeles, 1996).

12 Rob Kugler, 'Dorotheus petitions for the return of Philippa: A Case Study in Jewish Law in Ptolemaic Egypt', in *Proceedings of the 25th Meeting of the Institute of Papyrology* (Ann Arbor, MI, 2007), 387–96.

13 On the rules and customs of sacrifice see (although dealing mostly with the Persian period) Melody D. Knowles, *Centrality Practiced: Jerusalem in the Religious Practice of Yehud and the Diaspora in the Persian Period* (Leiden, 2006), esp. 19–23 and 77–103. Some reformed versions of Jewish prayers (such as the conservative synagogues in the United States) remove from the daily order of prayer, and presumably out of squeamishness, any references to the constant sacrifices offered in the Temple.

14 I follow the arguments here of David Biale, *Blood and Belief: The Circulation of a Symbol between Jews and Christians* (Berkeley and Los Angeles, 2007), especially 26–7 where he discusses the possibility that sacrificial rituals that emphasised the careful sprinkling of blood and the priestly concern with purity might actually have been motivated by wanting to differentiate Jewish practices from the animal sacrifices (goats in particular) of the Greeks.

15 For more, much more, on this subject, see Leonard B. Glick, *Marked in Your Flesh: Circumcision from Ancient Judaea to Modern America* (Oxford, 2005), and, authoritatively, Frederick M. Hodges, 'The Ideal Prepuce in Ancient Greece and Rome: Male Genital Aesthetics and their relation to Lipodermos, Circumcision Foreskin Restoration and the Kynodesme', *Bulletin of the History of Medicine*, 75, 375–405.

16 Baba Batra, 60B; Yebamot, 45A–B.

17 Lee I. Levine, *Jerusalem: Portrait of the City in the Second Temple Period 586–70 CE* (Philadelphia, 2002), 72ff stresses the paucity of archaeological evidence about the precise location of the Akra but it is clear that its construction would have involved disruption of old-established and densely populated districts.

18 Anathea E. Portier-Young, in her excellent *Apocalypse against Empire: Theories of Resistance in Early Judaism* (Grand Rapids, Michigan, 2011)

persuasively argues that the subsequent ferocity of Antiochus IV's massa-
cres and persecutions in Jerusalem were not motivated by his humiliation
in Egypt, but rather by Jason's disloyalty, armed rebellion and capture of
Jerusalem, and his own resulting determination to tear up the 'contract'
Antiochus III had made and impose instead a regime of 'captive by the
sword' on Judaea in which the lives and bodies of the inhabitants were
plainly seen to be at the absolute disposal of the reconquering king.

19 1 Macc. 1:26.

20 2 Macc. 5:10.

21 2 Macc. 1:20–2.

22 Shaye Cohen, *The Beginnings of Jewishness: Boundaries, Varieties, Uncertainties*
(Berkeley and Los Angeles, 1999), esp. 69–135, locates the self-discovery
of 'Jewishness' expressly in the Hasmonean period which he calls a
'redefinition' and in the equation given in the Books of the Maccabees
(especially I assume in 1 Macc.) between differentiating observance (like
circumcision) and collective identity. The argument not quite made (for
me) in this brilliant interpretation is whether or not the moment of
ultra-Hellenistic repression was first and formative in this self-conscious-
ness. A comparable and antecedent differentiation seems to be at work
in Ezra and Nehemiah of three centuries earlier. See also on the place
of the Maccabean epic in Jewish state formation in Seth Schwartz,
Imperialism and Jewish Society, 200 BCE to 640 CE (Princeton, 2001), esp. 32–70.

23 The discomfort would have been most felt by the descendants of
Philistine and coast cultures who were mostly uncircumcised, while
Itureans and Idumeans of the central hill country and Transjordanian
hills and valleys mostly were.

24 2 Macc. 9:10.

25 1 Macc. 2:26.

26 1 Macc. 4:55.

27 1 Macc. 14:8–15.

28 1 Macc. 16:3.

29 Steven Fine, *Art and Judaism in the Greco-Roman World* (Cambridge and
New York, 2005).

30 Josephus, *Antiquities of the Jews*, 14, 3.

31 Jacob Neusner, *The Rabbinic Traditions about the Pharisees before 70* (Leiden, 1971).

32 On this issue see Shaye Cohen, 'Was Herod Jewish?', *The Beginnings of
Jewishness: Boundaries, Varieties, Uncertainties* (Berkeley, Los Angeles and
London, 1999), 13–24.

33 Josephus, *Antiquities of the Jews*, 1, 33.

34 M. A. Knibb, *The Qumran Community* (Cambridge, 1987); A. R. C. Leaney,
*The Rule of Qumran and Its Meaning: Introduction, Translation and
Commentary* (London, 1966); S. Metzo, *The Serekh Texts* (London, 2007).

35 *The Complete Dead Sea Scrolls in English* (trans. and ed. Geza Vermes, revised edn, London and New York, 2004), 234 (hereafter Vermes, *DSS*).

36 Philo, *Legation to Gaius*.

37 See Peter Schäfer, *Judeophobia: Attitudes toward the Jews in the Ancient World* (Cambridge, MA, 1997).

38 Josephus, *The Jewish War*, 2, 12.

39 Ibid., 5, 13, 541.

40 Ibid., 545.

41 The best critical study is Seth Schwartz, *Josephus and Judaean Politics* (Leiden, 1990).

42 Josephus, *Vita*, 11.

43 Josephus, *The Jewish War*, 3, 8, 357.

44 Ibid., 2, 21, 586.

45 Ibid., 4, 9, 560–3.

46 Since Eric Hobsbawm, *Primitive Rebels: Studies in Archaic Forms of Social Protest* (Manchester, 1959), historians have analysed 'brigandage' and 'banditry', and more significantly the popular *reputation* of their leaders as an expression of social antagonism and insurrectionary action as much as the purely criminal classification imposed by the propertied and the powerful. A similar approach was taken by George Rudé in his studies on the French Revolution and also, in a more nuanced sense (for he believed the crime was real) by my old friend and mentor Richard Cobb.

47 For more of these considerations see especially Martin Goodman: *The Ruling Class of Judaea: The Origins of the Jewish Revolt* (Cambridge, 1987) and *Rome and Jerusalem: A Clash of Ancient Civilisations* (London and New York, 2007); Susan Sorek, *Jews Against Rome* (Hambledon, 2008); Neil Faulkner, *Apocalypse: The Great Jewish Revolt Against Rome* (Amberley, Glos., 2002).

48 Aryeh Kasher, *Jews, Idumaeans and Ancient Arabs* (Tübingen, 1988).

49 Josephus, *The Jewish War*, 4, 305–13.

50 Ibid., 4, 327.

51 Jacob Neusner, *A life of Yohanan ben Zakkai* (Leiden, 1970).

52 Yosef Hayim Yerushalmi, *Zakhor: Jewish History and Jewish Memory* (Seattle, Washington, 1982).

53 Josephus, *The Jewish War*, 6, 2, 108.

54 Ibid., 6, 3, 209–11.

55 Ibid., 6, 6, 306–9.

56 Ibid., 6, 4, 270–1.

57 On Josephus in Rome, see the important essays in J. C. Edmundson, Steven Mason and J. B. Rives, *Flavius Josephus and Flavian Rome* (Oxford, 2005).

58 Josephus, *The Jewish War*, 7, 5, 150.

59 Fergus Millar, 'Last Year in Jerusalem: Monuments of the Jewish War in Rome', in Edmundson et al., *Flavius Josephus*, 101–128.

60 There is, however, some scholarly disagreement about the dating of the several books of *The Jewish War*. See the essays by T. D. Barnes and James Rives in Edmundson et al., *Flavius Josephus*.

61 Josephus, *The Jewish War*, 7, 8, 323–35.

62 Barclay, *Jews in the Mediterranean Diaspora*; Silvia Cappelletti, *The Jewish Community of Rome from the Second Century BC to Third Century CE* (Leiden, 2006).

63 Cappelletti, *The Jewish Community of Rome*, takes a persuasively more nuanced view.

64 Seneca's *De Superstitione* is known to us through Augustine.

65 Tacitus, *Histories* (trans. Clifford Moore), (Cambridge, MA, 1929), V, v, 183.

66 Josephus, *Against Apion*, 2, 86.

67 Ibid., 2, 100.

68 Tacitus, *Histories*, V, v.

69 Josephus, *Against Apion*, 1, 60.

70 Ibid. 2, 280. See also W. W. Hallo, *Origins: The Near Eastern Origins of some Modern Institutions* (Leiden, 1996).

71 Josephus, *Against Apion*, 2, 291.

72 On the Dead Sea Scrolls see as an excellent introduction, Philip R. Davies, George J. Brooke and Phillip Gallaway, *The Complete World of The Dead Sea Scrolls* (London, 2002); for recent scholarship, Lawrence H. Schiffman, Emmanuel Tov and James Vanderkam (eds), *The Dead Sea Scrolls Fifty Years after their Discovery* (Jerusalem, 2000). I am still a fan of the translation (and introduction) of Vermes, *DSS*, but a new translation is offered by Michael Wise, Martin Abegg Jr and Edward Cook, *The Dead Sea Scrolls: A New Translation* (New York, 2005). The anti-Essene thesis of a 'Jerusalem Library' is argued by Norman Golb, *Who Wrote the Dead Sea Scrolls? The Search for the Secret of Qumran* (New York, 1985).

73 Vermes, *DSS*, 180.

74 Ibid., 166.

75 Ibid., 170.

76 Cassius Dio, *Roman History VIII* (trans. E. Cary), (Cambridge, 1925), 451.

77 On both the Babatha and bar Kosiba trove of documents see Richard Freund, *The Secrets of the Cave of Letters: A Dead Sea Mystery Uncovered* (New York, 2004).

78 For the palmate early cross, see my *Landscape and Memory* (London, 1995), 214–5.

Chapter 5

1 Clark Hopkins, with Bernard Goldman, *The Discovery of Dura-Europos* (New Haven and London, 1979), 131; Ann-Louise Perkins, *The Art of*

Dura-Europos (Oxford, 1973); Joseph Gutmann (ed.), *The Dura-Europos Synagogue: A Re-evaluation (1932–1992)*, (University of South Florida, 1992), especially the essays by Richard Brilliant, 'Painting at Dura-Europos and Roman Art', and Jacob Neusner, 'Judaism at Dura-Europos'; Annabel Wharton, *Reconfiguring the Post-classical city: Dura-Europos, Jerash, Jerusalem and Ravenna* (Cambridge, 1995); and more recently Gail R. Brody and Gail Hoffman (eds), *Dura-Europos: Crossroads of Antiquity* (Boston, Philadelphia, 2011).

2 Mishnah, Abodah Zarah, 3, 4.

3 Levine, *The Ancient Synagogue*, op. cit., 260–7.

4 Mishnah, Baba Qamma, 1.

5 Ibid., Avot, 4–5.

6 Ibid., Shabbat, 6, 1–3.

7 Ibid., Avot, 5.

8 Ibid., Avodah Zarah, 3, 4, 5.

9 Rachel Hachlili, *Ancient Mosaic Pavements, Themes, Issues and Trends: Selected Studies* (Leiden, 2009); Ze'ev Weiss and Ehud Netzer, *Promise and Redemption: A Synagogue mosaic from Sepphoris* (Jerusalem, 1997).

10 Rather extraordinarily, the great art historian Meyer Schapiro took full and early measure of these, in Meyer Schapiro and Michael Avi-Yonah, *Israel: Ancient Mosaics* (Greenwich, CT, 1960), possibly guided by his co-author, a distinguished historian of late antiquity, though the reading of the mosaics is for Schapiro surprisingly formal and not much engaged with their relationship with the inscriptions or the rabbinic Judaism of the time.

11 Hachlili, 408.

12 See, most recently, Eric M. Meyers and Mark A. Chauncey, *Alexander to Constantine: Archaeology of the Land of the Bible*, Vol. 3 (New Haven, 2012), 269–80.

13 Ibid., 277.

14 Tryggve N. D. Mettinger, 'Israelite Aniconism: developments and origins', in Karel van der Toorn et al., *The Image and the Book*, op. cit., 188.

15 Joseph Dan, *The Ancient Jewish Mysticism* (Tel Aviv, 1993), 9–24.

16 For the dialogue and 'echo-effect' between the two simultaneously forming religions see Israel Jacob Yuval, *Two Nations in Your Womb: Perceptions of Jews and Christians in Late Antiquity and the Middle Ages* (Berkeley and Los Angeles, 2006); Shaye D. Cohen and Edward Kessler, *An Introduction to Jewish-Christian Relations* (Cambridge, 2010).

17 Gerard Rouwhorst, 'The cult of the Seven Maccabees and their mother in Christian tradition', in Joshua Schwartz and Marcel Poorthuis (eds), *Saints and Role Models in Judaism and Christianity* (Leiden, 2004), 183–204.

18 See Adia Karnikoff, *Sarcophagi from the Jewish Catacombs in Ancient Rome:*

A Catalogue Raisonne (Stuttgart, 1986); Leonard Victor Rutgers: The Jews in Late Ancient Rome: Evidence of Cultural Interaction in the Roman Diaspora (Leiden, 2000), and Subterranean Rome (Leuven, 2000), 146–53.

19 John Chrysostom, Adversus Iudaeos: Eight Homilies against the Jews, I, vi.

20 Ibid., IV, 4, 7.

21 Ibid., II, iii, 5.

22 Acts 13:8.

23 Chrysostom, Adversus Iudaeos, VIII, 7, 6.

24 On Jewish amulets see Gideon Bohak, Ancient Jewish Magic: A History (Cambridge and New York, 2008), 370–6.

25 Chrysostom, Adversus Iudaeos, VIII, 8.

26 On Jews and Christians in Antioch see Christine Kondoleon, Antioch, the Lost Ancient City (Princeton, 2000), especially Bernadette J. Brooten, 'The Jews of Ancient Antioch', 29–39; Glanville Downey, A History of Antioch in Syria from Seleucus to the Arab Conflict (Princeton, 1961).

27 Brooten, 'The Jews of Ancient Antioch'.

28 Hyam Maccoby, Paul and the Invention of Christianity (New York, 1986).

29 Galatians 6:15; Daniel Boyarin, A Radical Jew: Paul and the politics of Identity (Berkeley, 1997). For a strong view on the irreconcilability of Judaism and Christianity see Jacob Neusner, Jews and Christians: The Myth of a Common Tradition (Philadelphia, 1991); see also the classic account by James Parkes, The Conflict between Church and Synagogue: A Study in Ancient Anti-Semitism (London, 1932); Samuel Krauss, The Jewish Christian Controversy from Ancient Times to 1789 (Tübingen, 1995).

30 Galatians 2:16–21.

31 J. Reynolds and R. F. Tannenbaum, Jews and Godfearers at Aphrodisias: Greek Inscriptions with Commentary. Proceedings of the Cambridge Philological Society, Supplement 12 (Cambridge, 1987).

32 Baruch M. Bokser, The Origins of the Seder: The Passover Rite and early Rabbinic Judaism (Berkeley, 1984); Hal Taussig, In the Beginning was the Meal: Social Experimentation and Early Christian Identity (Augsburg, 2009); Yuval, Two Nations, 56–75.

33 Chrysostom, Adversus Iudaeos, III, 4, 6.

34 Additional text, second oration.

35 Chrysostom, Adversus Iudaeos IV, 1.

36 Ibid., I, vii.

37 Ibid., I, 3, vi.

38 Ibid., I, 6, vii.

39 Ibid., VI, 2, x.

40 'Itineraria burgdialense', in P. Geyer, Itineraria hiersosolymitana saeculi III–VIII (Vienna, 1898), 22; Michael Avi-Yonah, The Jews of Palestine (New York, 1976), 164.

41 Ammianus Marcellinus, *The Later Roman Empire* (trans. Walter Hamilton), (London, 2004), 255.

42 Ibid.

43 Paula Frederiksen, *Augustine and the Jews: A Christian Defence of Jews and Judaism* (New York, 2008), 243–4.

44 Gavin L. Langmuir, *Toward a Definition of Anti-Semitism* (Berkeley, 1990), 71.

45 See William Horbury, *Messianism among Jews and Christians* (London, 2003), 289–308.

46 Nicholas de Lange, 'Jews in the age of Justinian', in Michael Maas (ed.), *The Cambridge Companion to the Age of Justinian* (Cambridge, 2005) 419–20.

47 Horbury, *Messianism among Jews and Christians*, 151.

48 Yaakov Elman, 'Middle Persian Culture and Babylonian Sages: Accommodation and Resistance in the shaping of Rabbinic Legal Tradition', in Charlotte Elisheva Fonrobert and Martin S. Jaffee, *The Cambridge Companion to the Talmud and Rabbinic Literature* (Cambridge, 2007), 181.

49 Pesachim, 3 (Gemara), Norman Solomon, *The Talmud: A Selection* (London, 2009), 151.

50 Ibid., 148–9.

51 Elman, 'Middle Eastern Culture', 188–9.

52 Shabbat 2, 31 (Solomon, *Talmud*, 104–5).

53 Gittin, 9, 90 (Solomon, *Talmud*, 399).

54 Yevamot, 4, 47 (Solomon, *Talmud*, 306–7).

55 Andrew Sharf, *Byzantine Jewry from Justinian to the Fourth Crusade* (London, 1971), 53.

56 Christian sources told a quite different story of understandings reached between Umar and the Christian clergy by which Jews would continue to be kept out of the holy sites! Yehoshua Frenkel, 'The Use of Islamic Materials by non-Islamic Writers', in Michael M. Laskier and Yaacov Lev, *The Convergence of Judaism and Islam: Religious, Scientific and Cultural Dimensions* (Gainesville, FL, 2011), 97.

Chapter 6

1 Sharf, *Byzantine Jewry*, 33.

2 Nigel Groom, *Frankincense and Myrrh: A Study of the Arabian Incense Trade* (New York, 1981).

3 Gordon Darnell Newby, *A History of the Jews of Arabia from Ancient Times until their eclipse under Islam* (Columbia, 1988), 40.

4 C. Robin, 'Le judaisme de Himyar', in *Arabie, revue de sabeologies*, I, 97–172. G.W. Bowersock's *Throne of Adulis: Red Sea Wars on the eve of Islam*

(Oxford, 2013) appeared too recently for me to take proper account of its exhaustive scholarship.

5 Newby, *A History of the Jews*, 61.

6 P. Yule, 'Zafar, Watershed of Pre-Islamic Culture', online Propylaeum DOK Digital Repository of Classical Studies (2008); see also Yule, 'Zafar: The Capital of the Ancient Himyarite Empire Rediscovered', *Jemen Report*, 36 (2005), 22–9.

7 On the entanglement of Arab and Jewish cultures before the coming of Islam and in its formative period, see Reuven Firestone, 'Jewish Culture in the Formative Period of Islam', in Biale (ed.), *Cultures of the Jews* (New York, 2002) 267–305.

8 Batsheva Bonne-Tamir, 'Oriental Jewish Communities and their Relations with South-West Asian Populations', in *Indian Anthropologist*, 1985.

9 Reuben Ahroni, *Yemenite Jewry: Origins, Culture and Literature* (Bloomington, Indiana, 1986).

10 Charles Pellat, 'Sur quelques femmes hostiles au prophete', in *Vie du prophete Mahome* (Colloquium, Strasbourg, 1980), 77–86; see also Amnon Shiloah, 'Encounters between Jewish and Muslim Musicians throughout the ages', in Laskier and Lev, *The Convergence of Judaism and Islam*, 273–4.

11 Fred Donner, *Muhammad and the Believers: At the Origins of Islam* (Cambridge, MA, 2010), 230.

12 S. D. Goitein, *Letters of Medieval Jewish Traders* (Princeton, 1973), 141.

13 For *ibrisim* see S. D. Goitein, *A Mediterranean Society: The Jewish Communities of the Arab World as Portrayed in the Cairo Geniza, Vol. I: Economic Foundations* (Berkeley, 1967), 60; for *lalas* Indian silk, Goitein, *India Traders of the Middle Ages* (Leiden, 2008), 278; for *lasin* the 'waste silk', Goitein, *Mediterranean Society, Vol. IV: Daily Life* (Berkeley, 1983), 168.

14 Yedida K. Stillman, 'Costume as Cultural Statement: The Esthetics, Economics and Politics of Islamic Dress', in Daniel H. Frank (ed.), *The Jews of Medieval Islam: Community, Society and Identity* (Leiden, 1995), 134.

15 Goitein, *A Mediterranean Society, Vol. I*, 101.

16 Goitein, *A Mediterranean Society, Vol. III: The Community* (Berkeley, 1971), 382.

17 Jonathan Bloom, *Paper Before Print, The History and Impact of Paper in the Islamic World* (New Haven, 2010), 42.

18 Joel L. Kraemer, 'Women Speak for Themselves', in Stefan C. Reif, *The Cambridge Genizah Collections: Their Contents and Significance* (Cambridge, 2002), 196.

19 Kraemer, 'Women Speak for Themselves', 197ff; Goitein, *Mediterranean Society, Vol. II 2*, 219.

20 Kraemer, 'Women Speak for Themselves', 194.

21 Kraemer, 'Women Speak for Themselves', 207; Goitein, *III*, 227.

22 On Wuhsha, Goeitein, *III*, 346–52.

23 Sara Reguer, 'Women and the Synagogue in Medieval Cairo', in Susan Grossman and Rivka Haut, *Daughters of the King: Women and the Synagogue* (Philadelphia and Jerusalem, 1992), 55.

24 A copy of Hasdai's letter is in the Cairo Geniza collection in Cambridge. This translation is from Franz Kobler, *Letters of Jews through the Ages, Vol. 1: From Biblical Times to the Renaissance* (New York, 1952), 98–101.

25 Ibid., 105.

26 P. B. Golden, 'The Khazars', in D. Sinor (ed.), *The Cambridge History of Early Inner Asia* (Cambridge, 1990).

27 See Constantine Zuckerman, 'On the date of the Khazar conversion to Judaism and the chronology of the kings of Rus, Oleg and Igor: A study of the anonymous Khazar letter from the Geniza of Cairo', *Revue des etudes byzantines*, 1995, Vol. 53, 237–70.

28 Kevin Alan Brook, *The Jews of Khazaria* (New York, Toronto and Plymouth, 2006), 80.

29 The sack of Cordoba took place in April 1013, and Shmuel's poem 'On leaving Cordoba' which his son Yehosef, the anthologist of his *diwan*, says was written contemporaneously with his departure, appears to be set in winter, making it more likely that he left before rather than after the disaster.

30 Ibn al-Khatib, Chronicle of Granada, cited in Ross Brann, *Power in the Portrayal: Representations of Jews and Muslims in Eleventh and Twelfth Century Islamic Spain* (Princeton, 2002), 36–7.

31 Trans. (mostly), Raymond P. Scheindlin, *Wine, Women, and Death: Medieval Hebrew Poems on the Good Life* (Philadelphia, 1986), 159. There are now many translations of the great canon of medieval Spanish Hebrew poetry all with distinctive flavours. Peter Cole, *The Dream of the Poem: Hebrew Poetry from Muslim and Christian Spain 950–1492* (Princeton, 2007) is often the freest of the most recent translations, while the scholar Scheindlin is the most reserved, sometimes a little awkwardly but very tight to the text. Readers, especially Hebrew readers (or rusty recoverers like the present author), might like to compare them with the still more in-your-face colloquial manner of Hillel Halkin, *Grand Things to write a Poem On: A Verse Autobiography of Shmuel Hanagid* (Jerusalem, 1999). All in their respective ways are excellent and Scheindlin in particular does his best to preserve something of the metre Naghrela took from Arabic models. There is also a more literal and thus slightly more earthbound translation by Leon J. Weinberger, *Jewish Prince in Moslem Spain: Selected poems of Samuel ibn Nagrela* (Tuscaloosa, 1973), which nonetheless goes to great pains to observe or at least register the rhyming patterns. Weinberger,

Scheindlin and Halkin give the Hebrew texts which helps when comparing respective choices of the image, for example the ending of a famous erotic poem in which a cup-bearing 'fawn' wakes the dozing writer, wanting him to 'drink the grape's blood from between my lips' while a fading moon still hangs in the early-dawn light right behind the boy, as the recumbent gently aroused versifying drinker lies there. But what is the exact shape of this curved blade-like, possibly new, moon? Naghrela's Hebrew is simply *yod*, the 'y' letter that hangs like a single apostrophe, or a suspended comma. Cole chooses 'comma', Scheindlin 'C', and most baffling, Cole opts for a 'D' (or the form of a *daled*), which really can't be what that most picturing poet Naghrela meant us to see.

32 This time, Halkin's truly lovely version, *Yehuda Halevi* (New York, 2010), 29.

33 Cole, 58–9, 66.

34 Ibid., 39.

35 Brann, 36.

36 Halkin, *Yehuda Halevi*, 33.

37 Weinberger's translation (slightly amended), 55.

38 Halkin (with minor changes), *Grand Things to Write a Poem On*, 92.

39 Ibid., 97.

40 Moshe Pearlmann, 'Eleventh Century Authors on the Jews of Granada', in *Proceedings of the American Academy for Jewish Research*, 18 (Ann Arbor, 1948), 283.

41 Ibid., 286.

42 Halkin translation, *Yehuda Halevi*, 85.

43 Cole, 147.

44 Halkin, *Yehuda Halevi*, 60.

45 Ibid., 79.

46 Cole, 159.

47 Yehudah Halevi, *The Kuzari: An Argument for the Faith of Israel* (ed. and intro. H. Slominski), (New York, 1964), 98–9.

48 Cole, 164.

49 Ibid., 166, 167, somewhat modified by me. There are also excellent side-by-side translations of Halevi's sea poems – itself an entirely new genre in Hebrew poetry, unless one claims the Book of Jonah – available in Joseph Yahalom's fine book, *Yehudah Halevi, Poetry and Pilgrimage* (Jerusalem, 2009), 107ff. Hebrew readers will be able to grasp the cleverness of the poet's onomatopoeia, the relentless slamming of the waves, rhymed by the terrified pounding of the poet's heart: *khamu galim*, barutz galga**lim, ve'avim vekalim,** al penei ha **yam** ('whirling waves, whipped spume, hurtling clouds, on the face of the sea').

50 Yahalom, *Halevi*, 108.

51 Cole, 169.

52 Halkin, *Yehuda Halevi*, 211–12.

53 Judah Alharizi's wonderful *Book of Tahkemoni*, written in the late twelfth century and thus not many generations after Halevi's death, mentions all those who were eager to find the place of his end but were thwarted. Judah Alharizi, *The Book of Tahkemoni: Jewish Tales from Medieval Spain* (trans., explicated and annotated David Simha Segal), (Oxford and Portland, OR, 2001), 43, 240–1, 533.

54 In contrast to earlier pre-Geniza historians who wrote off the possibility of Halevi reaching Palestine as wishful thinking, Goitein believed letters in the Cairo Geniza close to the period of his demise prove that he had in fact ended his days there.

Chapter 7

1 A letter from the widow asking for help is in the Cairo Geniza. See Judith R. Baskin, 'Medieval Jewish Women', in Linda E. Mitchell (ed.), *Women in Medieval Western European Culture* (New York, 1999), 79; see also Avraham Grossman, *Pious and Rebellious: Jewish Women in Medieval Europe* (Waltham, MA, 2004); Elisheva Baumgarten, *Mothers and Children: Jewish Family Life in Medieval Europe* (Princeton, 2004).

2 Robert Chazan, *Medieval Jewry in Northern France: A Political and Social History* (Baltimore, 1973), 37–8.

3 For a penetrating and often moving discussion of the problems of factuality in the Hebrew narratives see Jeremy Cohen, *Sanctifying the Name of God: Jewish Martyrs and Jewish Memories of the First Crusade* (Philadelphia, 2004).

4 Jeremy Cohen, *Living Letters of the Law: The Idea of the Jew in Medieval Christianity* (Berkeley, Los Angeles and London, 1999), 155.

5 Albert of Aachen in Kenneth R. Stow, *Alienated Minority: The Jews of Medieval Latin Europe* (Cambridge, MA, 1992), 109.

6 On the way in which each of the Hebrew narratives treats these crises, Robert Chazan, *God, Humanity and History: The Hebrew First Crusade Narratives* (Berkeley, 2000), 32–3 and *passim*.

7 Nils Roehmer, *German City, Jewish Memory: The Story of Worms* (Waltham, MA, 2010), 13.

8 The complete texts are given in Shlomo Eidelberg (trans. and ed.), *The Jews and the Crusaders: The Hebrew Chronicles of the First Crusades* (Hoboken, NJ, 1996); see also David G. Roskies (ed.), *The Literature of Destruction: Jewish Responses to Catastrophe* (Philadelphia and Jerusalem, 1989), 75–82.

9 Jacob Marcus, *The Jew in the Medieval World: A Source Book, 315–1791*, (Jerusalem, 1938), 129; for the Masada trope, and its self-conscious

adoption in the narratives if not as a matter of historical fact, Susan Einbinder, *Beautiful Death: Jewish Poetry and Martyrdom in Medieval France* (Princeton, 2002).

10 Jacob Marcus, *The Jew in the Medieval World*, 167.

11 Cohen, *Sanctifying the Name of God*, 142ff.

12 See, for example: Robert Chazan, *Reassessing Jewish Life in Medieval Europe* (Cambridge, 2010), a work that back-pedals gratuitously from the power and depth of Chazan's work on the Crusade narratives; Jacob Marcus, *The Jew in the Medieval World*; and, in my view least persuasively, Jonathan Elukin, *Living Together, Living Apart, Rethinking Jewish-Christian Relations in the Middle Ages* (Princeton, 2007).

13 Richard of Devizes, *Cronicon* (ed. J. T. Appleby), (Oxford, 1963), 3–4; see also Anthony Bale, *The Jew in the Medieval Book: English Anti-Semitisms, 1350–1500* (Oxford, 2006), 27.

14 Richard of Devizes, *Cronicon*, 4.

15 On these attacks see Anthony Julius, *Trials of the Diaspora, A History of Anti-Semitism in England* (Oxford, 2010), 118ff.

16 For the subsequent cult see Bale, *The Jew in the Medieval Book*, 105–43.

17 Cecil Roth, *A History of the Jews of England* (Oxford, 1941), 9.

18 On the 'Jewish boys in the oven', Miri Rubin, *Gentile Tales: The Narrative Assault on Late Medieval Jews* (Philadelphia, 1999), 10ff.

19 Ibid., 11.

20 Joe Hillaby, 'The ritual child-murder accusation: its dissemination and Harold of Gloucester', *Transactions of the Jewish Historical Society of England*, 34 (1996), 69–109; also Joshua Trachtenberg, *The Devil and the Jews: The Medieval Conception of the Jew and its Relation to Modern Anti-Semitism* (Philadelphia, 1983), 124ff.

21 Sheila Delaney (ed.), *Chaucer and the Jews: Sources, Contexts, Meanings* (London, 2002).

22 Emily Taitz, 'Women's Voices, Women's Prayers: The European Synagogues of the Middle Ages', in Susan Grossman and Rivka Haut, *Daughters of the King: Women and the Synagogue* (Jerusalem and Philadelphia, 1992), 65.

23 Ivan Marcus, 'Mothers, Martyrs and Moneymakers: Some Jewish Women in Medieval Europe', *Conservative Judaism*, 38 (Spring 1986), 42.

24 Judith R. Baskin, 'Women and Ritual Immersion in Medieval Ashkenaz: The Politics of Sexual Piety', in Lawrence Fine (ed.), *Judaism in Practice from the Middle Ages to the Modern Period* (Princeton, 2001), 138.

25 Lawrence Hoffmann, 'Women at rituals of their children', in Fine, *Judaism in Practice*, 99–114.

26 Ibid., 113.

27 Ibid., 142.

28 Roth, *A History of the Jews of England*, 15–16.

29 Ibid.

30 Cecil Roth, *The Jews of Medieval Oxford* (Oxford, 1950), 41ff.

31 'The Deacon and the Jewess or an Apostasy at Common Law', *Collected Papers of Frederick W. Maitland* (online), Vol. 1, 1911.

32 Ibid., 52; Suzanne Bartlet, *Licoricia of Winchester* (Edgware, 2009), 56–7.

33 Zefira Entin Rokeah, 'Money and the hangman in late 13th century England: Jews, Christians and coinage offences, alleged and real', *Jewish Historical Studies*, 31 (1988–1990) 83–109; 32, 159–218.

34 Zefira Entin Rokeah (ed.), *Medieval English Jews and Royal Officials: Entries of Jewish Interest in the English Memoranda Rolls, 1266–1293* (Jerusalem, 2000), 380.

35 Ibid., 393–4. See Zefira Entin Rokeah, 'Crime and Jews in late Thirteenth Century England', *Hebrew Union College Annual*, 55 (1984), 131–2.

Chapter 8

1 Isadore Twersky (ed.), *A Maimonides Reader* (Springfield, NJ, 1972), 47.

2 Deuteronomy 30:15.

3 Twersky, 50.

4 Joel L. Kraemer, *Moses Maimonides* (New York and London, 2008), 103.

5 Ibid., 104–11.

6 Ibid., 116ff.

7 Ibid., 207.

8 Twersky, 438.

9 Ibid., 457.

10 Twersky, 290.

11 Kraemer, *Maimonides*, 440–1.

12 Susan Einbinder, 'Trial by Fire. Burning Jewish Books', in *Lectures on Medieval Religion at Trinity University* (Kalamazoo, 2000), 1ff.

13 'The Dirge of Rabbi Meir von Rothenburg' (trans. John Friedman), in John Friedman, Jean Connell Hoff and Robert Chazan, *The Trial of the Talmud, Paris 1240* (Toronto, 2012), 169–70.

14 Pope Gregory IX to the king of France, 20 June 1239, in Robert Chazan (ed.) *Church, State and Jew in the Middle Ages* (New York, 1980).

15 Hillel of Verona also claimed, wrongly, that both Maimonides' books and the Talmud had been burned on the same site in Paris. If there were burnings of the former at all, they would only have been in Montpellier.

16 Javier Rois and Selma L. Margaretten (trans.), *A Vigilant Society: Jewish Thought and the State in Medieval Spain* (Albany, 2013), 271. It was Peter the Venerable who, in 'Against the Inveterate Obtuseness of the Jews' first insisted on the beastly quality of the Jews: 'I dare not designate

you a man . . . for what is extinguished, buried in you, is precisely what separates men from animals and beasts and raises man above them, namely reason.' Robert Chazan et al., *The Trial of the Talmud, Paris, 1240* (Toronto, 2012), 13; Dominique Ionga-Prat (trans. Graham Robert Edwards), *Order and Exclusion: Cluny and Christendom Face Heresy, Judaism and Islam, 1000–1150* (Ithaca, 2002), 275ff.

17 Hyam Maccoby, *Judaism on Trial: Jewish-Christian Disputations in the Middle Ages* (Portland, Oregon, 1982), offers rich documentation, including Nahmanides' *Vikuah*, and a Hebrew account of a third disputation at Tortosa in Spain in 1413–14.

18 Ibid.

19 Ibid., 119.

20 Ibid., 146.

21 Willis Johnson, 'The myth of Jewish male menses', *Journal of Medieval History*, 24, 3 (1988), 273–95.

22 'Play of the Saucemakers', *Publications of the Surtees Society* (1911), 155ff.

23 Anthony Bale, *Feeling Persecuted: Christians, Jews and Images of Violence in the Middle Ages* (London, 2012), 46.

24 Ibid., 90–2.

25 Rubin, *Gentile Tales*, op. cit., 45.

26 The most comprehensive inventory of the creatures of Hebrew illumination is in Therese and Mendel Metzger, *Jewish Life in the Middle Ages: Illuminated Hebrew Manuscripts of the Thirteenth to the Sixteenth Centuries* (New York and Fribourg, 1982), esp. 19–37.

27 Marc Michael Epstein, *Dreams of Subversion in Medieval Jewish Art and Literature* (University Park, PA, 1997), 16–38, 70–95.

28 Marc Michael Epstein, *The Medieval Haggadah: Art, Narrative and Religious Imagination* (New Haven and London, 2013), 19–28.

29 On the work of Christian illuminators for Jewish patrons see Eva Froimovic, 'Early Ashkenazic Prayer Books and their Christian Illuminators', in Piet van Boxell and Sabine Arndt (eds), *Crossing Borders: Hebrew Manuscripts as a Meeting Place of Cultures* (Oxford, 2009), 45–56.

30 Stanley Ferber, 'Micrography: A Jewish Art Form', *Journal of Jewish Art*, 1977, 12–24.

Chapter 9

1 Fine facsimiles were published to mark the 600th anniversary: Hans-Christian Freiesleben, *Der Katalanische Weltatlas vom Jahre 1375* (Stuttgart, 1977); Georges Grosjean (ed.), *Mapamundi: der Katalanische Weltatlas vom Jahre 1375* (Zurich, 1977). See also Jean-Michel Massing, 'Observations

and Beliefs: The World of the Catalan Atlas', in *1492: Art in the Age of Exploration* (Washington DC, 1992), 27–33; J. Brian Harley, 'The Map and the Development of Cartography', in Harley et al., *The History of Cartography*, Vol. 1 (Chicago, 1987); Evelyn Edson, *The World Map, 1300–1492: The Persistence of Tradition and Transformation* (Baltimore, 2007).

2 On portolans, see Tony Campbell, 'Portolan Charts from the late 13th Century to 1500', in J. B. Harley and David Woodward (eds), *The History of Cartography: Cartography in Prehistoric, Ancient and Medieval Europe and the Mediterranean*, Vol. 1, Chicago, 1987; for the Majorcan connection, see Felipe Fernandez-Armesto, *Before Columbus: Exploration and Colonization from the Mediterranean to the Atlantic, 1229–1492* (Philadelphia, 1987), 13–17.

3 On Cresques Abraham and Jafuda see the excellent, archivally based website www.cresquesproject.net, with articles by Jaume Riera i Sans, 'Cresques Abraham, Master of *Mappaemundi* and Compasses', and Gabriel Llompart i Moragues, 'Majorcan Jews and Medieval Cartography' (trans. Juan Ceva). See also David Abulafia, *A Mediterranean Emporium: The Catalan Kingdom of Majorca* (Cambridge, 1994), 204–8.

4 Gabriel Llompart i Moragues, 'The identity of Jaume Ferrer the Seafarer', at www.cresquesproject.net (trans. Juan Ceva).

5 Abulafia, 75–99; A. Lionel Isaacs, *The Jews of Majorca* (London, 1936).

6 David Nirenberg, *Communities of Violence: Persecution of Minorities in the Middle Ages* (Princeton, 1996), 231ff, argues that well-poisoning accusations rarely occur as a reason for the attacks on the Jews (as well as Muslims), but rather that the plague had been brought about by the accumulation of sins, including their very presence in the midst of Christendom. In 1351, the Bishop of Valencia wrote to the town council that 'by their [Jewish and Muslim] sins, the Lord might wish to send pestilences'. Nonetheless, there were certainly assaults and murders in Barcelona, Cervera and Tarrega, where according to the chronicler Joseph Ha-Cohen three hundred were killed.

7 On Martinez, see Benzion Netanyahu, *The Origins of the Inquisition in Fifteenth Century Spain* (NY, 1995), Vol. 2, 128–48; Yitzhak Baer, *A History of the Jews in Christian Spain* (Philadelphia, 1961).

8 Leon Poliakov, *The History of Anti-Semitism: From Mohammed to the Marranos*, Vol. 2 (trans. Natalie Gerardi), (Philadelphia, 2003) 158–9.

9 'Rabbi Hasdai Crescas gives an account of the Spanish massacres of 1391', in Franz Kobler (ed.), *Letters of Jews Through the Ages: From Biblical Times to the Middle of the Eighteenth Century*, Vol. 1 (New York 1952), 272–5; Baer, *History*, 2, 104–5.

10 Isaacs, *The Jews of Majorca*, 79–90.

11 For Jafuda and others post-1391 see J. N. Hillgarth, 'Majorcan Jews and Conversos as Owners and Artisans of Books', in Aharon Mirky, Avraham

Grossman and Yosef Kaplan, *Exile and Diaspora: Studies in the History of the Jewish People Presented to Professor Haim Beinart* (Jerusalem, 1991), 125–30.

12 On Llull and the Jews see Jeremy Cohen, *The Friars and the Jews: The Evolution of Medieval Anti-Judaism* (Ithaca, 1982), 199–225.

13 Both Jewish (Solomon ibn Verga's *Shebet Yehuda*) and Christian accounts of the Tortosa disputation, with Benedict XIII becoming impatient with Halorki/Geronimo's apparent inability to persuade the rabbis, Maccoby, *Judaism on Trial*, 168–216.

14 Isaacs, *The Jews of Majorca*, 110–17.

15 Yosef Hayim Yerushalmi, 'Exile and expulsion in Jewish history', in Benjamin R. Gampel (ed.), *Crisis and Creativity in the Sephardic World 1391–1648* (New York, 1997), 14. Yerushalmi writes that sometimes 'Toledo' was also thought to be called 'Toletula' from the Hebrew *tiltul* – wandering.

16 Jerrilynn D. Dodds, 'Mudejar Tradition and the Synagogues of Medieval Spain: Cultural Identity and Cultural Hegemony', in Vivian B. Mann, Thomas F. Glick and Jerrilynn D. Dodds, *Convivencia: Jews, Muslims and Christians in Medieval Spain* (New York, 1992) , 113–31; Francisco Cantera Burgos, *Sinagogas espanolas* (Madrid, 1985); C. H. Krinsky, *Synagogues of Europe: Architecture, History, Meaning* (New York and Cambridge, 1985); Ana Maria Lopez Alvarez, *Catalogo del Museo Sephardi* (Madrid, 1987); Ana Maria Lopez Alvarez and Santiago Plaza Palomero (eds), *Juderias y sinagogas de la Sefarad medieval* (Ciudad Real, 2003).

17 For example, the four-volume 'Toledo Bible' (its parts now divided) copied by Israel ben Israel, a member of a family that handed down scribal skills generation to generation. Gabrielle Sed Rajna, 'Hebrew Illuminated Manuscripts from the Iberian Peninsula', in Mann et al., *Convivencia*, 134–6. For the family tree of the ben Israel dynasty of scribes see Katrin Kogman-Appel, *Jewish Book Art between Islam and Christianity: The Decoration of Hebrew Bibles in Medieval Spain* (Leiden and Boston, 2004), 61–4.

18 Dodds, 'Mudejar Tradition', 128.

19 Yirmiyahu Yovel, *The Other Within: The Marranos: Split Identity and Emerging Modernity* (Princeton and Oxford, 2009), 111, 130. Yovel's tour de force of a book has transformed much of the debate about the relationship between the *conversos* and those who remained Jews during the fifteenth century, although the field remains, to put it mildly, contentious. I rely on him for the detailed accounts of countless practical ways in which *conversos* remained in contact with Jews and vice versa, but it may be that he goes a little too gently on the abhorrence with which many religious Jews would undoubtedly have viewed apostates, even if they were known as '*anusim*', the 'forced ones'.

20 Norman Roth, 'Anti-Converso Riots of the Fifteenth Century, Pulgar and the Inquisition' (online, academia.edu.), 368ff; A. Mackay, 'Popular Movements and Pogroms in Fifteenth-Century Castile', *Past and Present* 55 (1972), 34.

21 On the racist implications of the Statute of Exclusion see John Edwards, 'The beginning of a scientific theory of race? Spain 1450–1600', in Yedida K. Stillman and Norman A. Stillman (eds), *From Iberia to Diaspora: Studies in Sephardic History and Culture* (Leiden, Boston and Cologne, 1999), 180–3.

22 Yovel, *The Other Within*, 145–7.

23 Ibid., 149–51.

24 Sed Rajna, 'Hebrew Illuminated Manuscripts', 152–3. See the introduction by Bezalel Narkiss and Aliza Cohen-Mushlin to the facsimile *Kennicott Bible* (London, 1985); also Narkiss, Cohen-Mushlin and A. Tcherikover, *Hebrew Illuminated Manuscripts in the British Isles: Spanish and Portuguese Manuscripts*, Vol. 1 (Jerusalem and Oxford, 1982), 153–9.

25 For the polemical freight of some of this bestiary see Marc Michael Epstein, *Dreams of Subversion in Medieval Jewish Art and Literature* (University Park, 1997), *passim*. Kogman-Appel, *Jewish Book Art*, 214, believes the cats and mice motifs may come from south German iconography.

26 The classic history of the Inquisition was Henry Charles Lea, *A History of the Inquisition of Spain* (New York, 1906–7); see also Cecil Roth, *Conversos, Inquisition and the Expulsion of the Jews from Spain* (Madison, WI, 1995); Henry Kamen, *Inquisition and Society in Spain* (London, 1985). The great classic of modern historical literature, at once formidable in scholarship and deeply moving in literary force, is Haim Beinart, *The Expulsion of the Jews from Spain* (trans. Jeffrey M. Green), (Oxford and Portland, OR, 2002).

27 Yovel, *The Other Within*, 162.

28 Benzion Netanyahu, *Don Isaac Abravanel: Statesman and Philosopher*, 5th edn (Ithaca and London, 1998), 26–41.

29 For the development of the expulsion decree, Maurice Kriegel, 'The making of a decree', *Revue historique* 260 (1978), 49–90; Beinart: *Expulsion*, 5–54, and 'Order of the Expulsion from Spain, Antecedents, Causes and Textual Analysis', in Gampel (ed.), *Crisis and Creativity*, 79–95.

30 Yovel, *The Other Within*, 179–80.

31 For the exit routes and the many ordeals involved in both uprooting from native towns and getting out of Spain by the deadline, see Beinart, *Expulsion*, *passim*.

32 Ibid., 523–4.

33 Francois Soyer, *The Persecution of the Jews and Muslims of Portugal: King Manuel I and the end of Religious Tolerance (1496–7)*, (Leiden and Boston,

2007): on the children of Sao Tome, 130–1; on the seizure of the children and the forced conversion of the parents and other adults, 210–26.

34 José Chabás and Bernard R. Goldstein, 'Abraham Zacuto: Supplemental Note for a Biography', in *Astronomy in the Iberian Peninsula* (Darby, PA, 2000), 6–11.

35 Abraham Zacuto, *The Book of Lineage or Sefer Yohassin* (trans. and ed. Israel Shamir), (2005).

36 Israel Efros, *The Problem of Space in Jewish Medieval Philosophy* (New York, 1917).

BIBLIOGRAPHY

General surveys: At the monumental end of scholarly Jewish histories, nothing can compare with the eighteen volumes of Salo Baron's *A Social and Religious History of the Jews* (2nd edn, New York, 1952–83). Weighing in at seventeen volumes less, but still no lightweight, Howard Sachar's *The Course of Jewish History* (New York, 1958) remains readable though inevitably archaeologically dated. Paul Johnson, *A History of the Jews* (London and New York, 1987), is still an excellent one-volume introduction. Melvin Konner, *Unsettled: An Anthropology of the Jews* (New York, 1987), is a distinctive and in the best way provocative survey, and the great scholar of medieval Hebrew poetry, Raymond Scheindlin, has achieved an enviable feat of compression in *A Short History of the Jewish People From Legendary Times to Modern Statehood* (New York, 2000). Moshe Rosman's *How Jewish is Jewish History* (Portland, OR, 2007) is a brilliant account of the development of Jewish historiography. For the new, more culturally inclusive approach to Jewish history, the crucial work (to which this book is much indebted) is David Biale (ed.), *Cultures of the Jews: A New History* (Berkeley and Los Angeles, 2002), an exceptional anthology of scholarly and interpretative essays, almost all of them provocative in the best sense. A still invaluable collection of primary sources for this period is Frans Kobler (ed.), *Letters of Jews Through the Ages: From Biblical Times to the Middle of the Eighteenth Century*, Vol. 1 (New York, 1952).

On the world of the 'Jewish Troop' in Elephantine: Bezalel Porten, *Archives from Elephantine: The Life of an Ancient Jewish Military Colony* (Berkeley, 1968), and *The Elephantine Papyri: Three Millennia of Cross-Cultural Continuity and Change* (Leiden, 1996); Joseph Meleze Modrzejewski, *The Jews of Egypt from Rameses 2 to the Emperor Hadrian*

(Philadelphia, 1995); James M. Lindenberger, *Ancient Aramaic and Hebrew Letters* (Atlanta, GA, 2003). See also (though at odds with Porten's scholarly edition) Boulos Ayad Ayad, *The Jewish-Aramean Communities of Ancient Egypt* (Cairo, 1976).

On the origins of the Bible and the evolution of Israelite religion: There is now a wealth of exceptional recent scholarly literature, especially in the field of epigraphy, the study of inscriptions. But for the general reader, Karen Armstrong's *The Bible: A Biography* (New York, 2007) is still an excellent, clear introduction to the 'documentary hypothesis', the historicising philology of the Bible that began in the nineteenth century. For close readings of the 'historical books' see the penetrating work of Sara Japhet, *From the Rivers of Babylon to the Highlands of Judah* (Winona Lake, Ind., 2000), and *The Ideology of the Book of Chronicles* (Winona Lake, Ind., 2009). The classic work on the genesis of Israelite religion in Canaanite paganism is Frank Moore Cross, *Canaanite Myth and Hebrew Epic: Essays in the History of the Religion of Israel* (Cambridge, MA, 1973); see also his *From Epic to Canon: History and Literature in Ancient Israel* (Baltimore, 1998). Michael Coogan, *The Old Testament: An Historical and Literary Introduction to the Holy Scriptures* (New York and London, 2011); for the most archaic forms, see Steven Weitzman, *Song and Story: The History of a Literary Convention in Ancient Israel* (Bloomington, Ind., 1997). For the slow, variable and erratic emergence of monotheism from polytheism and henotheism (hierarchically ordered gods): John Day, *Yahweh and the Gods and Goddesses of Canaan* (Sheffield, 2000); Baruch Halpern, *The First Historians* (San Francisco, 1998); Christopher de Hamel, *The Book: A History of the Bible* (London, 2001); Richard S. Hess, *Israelite Religions: An Archaeological and Biblical survey* (Grand Rapids, MI, 2007); Robert S. Kawashima, *Death of the Rhapsode* (Bloomington, Ind., 2004); Christopher Rollston, *Writing and Literacy in the World of Ancient Israel: Epigraphic Evidence from the Iron Age* (Atlanta, GA, 2010); Ron E. Tappy and P. Kyle McCarter (eds), *Literate Culture and Tenth-Century Canaan: The Tel Zayit Abecedary in Context* (Winona Lake, Ind., 2008); Seth Sanders, *The Invention of Hebrew* (Urbana, Ill., 2009); W. M. Schniedewind, *How the Bible Became a Book: The Textualization of Ancient Israel* (Cambridge, 2004); Mark S. Smith, *The Origins of Biblical Monotheism: Israel's Polytheistic Background*

and the Ugaritic Texts (Oxford, 2001); *The Early History of God* (Grand Rapids, MI, 2002); Francesca Stavrokopoulou and John Barton (eds), *Religious Diversity in Ancient Israel and Judah* (London, 2010); Karel van der Toorn, *Scribal Culture and the Making of the Hebrew Bible* (Cambridge, MA, 2007), and *The Image and the Book: Iconic Cults, Aniconism, and the Rise of Book Religion* (Leuven, 2006); Susan Niditch, *Oral World and Written Word: Ancient Israelite Literature* (Louisville, KY, 1996).

On the archaeology of the biblical period: A good, balanced yet critical introductory guide to the earliest period, surveying most recent developments in excavation and interpretation, is Amihai Mazar, *The Archaeology of the Land of the Bible: An Introduction (10,000– 586 BCE)* (New York, 1990); see also his collaboration with the 'dean' of the 'minimalist' school, Israel Finkelstein, *The Quest for Historical Israel* (Leiden and Boston, 2007); and the many works of Finkelstein himself, such as *David and Solomon: In Search of the Bible's Sacred Kings and the Roots of the Western Tradition* (New York, 2006), and with Neil Asher Silberman, *The Bible Unearthed: archaeology's new vision of ancient Israel and the origin of its sacred texts* (London and New York, 2001).William G. Dever, initially a fellow-'minimalist', has moved away from this position to a more flexible position in a number of spirited reinterpretations, see for this shift the passionate *Historical Biblical Archaeology and the Future: The New Pragmatism* (London, 2010); for his earlier position, *Sacred Time, Sacred Place: Archaeology and the Religion of Israel* (Winona Lake, Ind., 2002), *Who Were the Early Israelites and Where Did they Come From?* (Grand Rapids, MI, 2003) and *Did God Have a Wife?* (Grand Rapids, MI, 2005). Important new work is covered in Assaf Yasur-Landau, Jennie R. Ebeling and Laura B. Mazow, *Household Archaeology in Ancient Israel and Beyond* (Leiden and Boston, 2011). The only full account of the important excavation at Khirbet Qeiyafa is Yosef Garfinkel, Saar Ganor and Michael Hassel, *In the Footsteps of King David* (Tel Aviv, 2012).

On the development of Judaism during the Hellenistic and Roman periods and its relationship with classical culture: The great modern authority on the evolution of Judaism is Shaye Cohen, see his collection of essays, *From the Maccabees to the Mishnah* (Philadelphia,

1987), and *The Beginnings of Jewishness: Boundaries, Varieties, Uncertainties* (Berkeley, 1999). See also Jacob Neusner, *From Politics to Piety: The Emergence of Pharisaic Judaism* (Englewood Cliffs, NJ, 1973), *A Life of Yohanan ben Zakkai* (Leiden, 1970) and *First-Century Judaism in Crisis: Yohanan ben Zakkai and the Renaissance of the Torah* (reprint, 2006). On the Bible at the point of its canonical closure, the master work is James Kugel, *Traditions of the Bible: A guide to the Bible as it was at the start of the common era* (Cambridge, MA, 1998); and also Michael E. Stone, *Scriptures, Sects, and Visions: A Profile of Judaism from Ezra to the Jewish Revolts* (Philadelphia, 1980). The best guide to archaeology is Eric M. Meyers and Mark A. Chauncey, *Alexander to Constantine: The Archaeology of the Land of the Bible* (New Haven, 2012) and *Archaeology, the Rabbis and Early Christianity* (Nashville and Abingdon, 1981). See also Elias Bickerman, *The Jews in the Greek Age* (Cambridge, MA, 1988), *The God of the Maccabees: Meaning and Significance in the Revolt of the Maccabees* (London, 1979) and *From Ezra to the Last of the Maccabees* (New York, 1962); Christine Hayes, *The Emergence of Judaism: Classical Traditions in Contemporary Perspective* (Wesport, CT, 2007); the many works of Erich S. Gruen, especially *Heritage and Hellenism: The Reinvention of Jewish Tradition* (Berkeley, 1998), *Diaspora: Jews amidst Greeks and Romans* (Cambridge, MA, 2002) and *Rethinking the Other in Antiquity* (Princeton, 2011); Lee I. Levine, *Judaism and Hellenism in Antiquity: Conflict or Confluence* (Seattle, 1998); Christopher Haas, *Alexandria in Late Antiquity: Topography and Social Conflict* (Baltimore, 1997); Peter Schäfer, *Judeophobia: Attitudes Towards Jews in the Ancient World* (Cambridge, MA, 2007) and *The History of the Jews in the Greco-Roman World* (London, 2003); Sara Raup Johnson, *Historical Fictions and Hellenistic Jewish Identity* (Berkeley, 2005); A. Momigliano, *On Pagans, Jews and Christians* (Middletown, CT, 1987); Victor Tcherikoer, *Hellenistic Civilization and the Jews* (Philadelphia, 1959); Joseph Sievers, *The Hasmoneans and their Supporters: From Mattathias to the Death of John Hyrcanus* (Atlanta, GA, 1990); Steven Weitzman, *Surviving Sacrilege: Cultural Persistence in Jewish Antiquity* (Cambridge, MA, 2005); William Buehler, *The Pre-Herodian Civil War and Social Debate: Jewish Society in the Period 76–40 BC* (Basel, 1974); Daniel Harrington, *The Maccabean Revolt: Anatomy of a Biblical Revolution* (Wilmington, DE, 1988); Martin Goodman, *Rome and Jerusalem: The Clash of Ancient Civilizations*

(London, 2007); Susan Sorek, *The Jews Against Rome* (London and New York, 2008); Shaye Cohen, *Josephus in Galilee and Rome: His vita and development as an historian* (Leiden, 1979); Jonathan Edmundson (ed.) *Flavius Josephus and Flavian Rome* (Oxford, 2005); Frederick Raphael, *A Jew Among Romans: The Life and Legacy of Flavius Josephus* (London, 2013).

On the Dead Sea Scrolls: The classic scholarship is by Geza Vermes, *An Introduction to the Complete Dead Sea Scrolls* (Minneapolis, 2000) and *The Dead Sea Scrolls: Qumran in Perspective* (Philadelphia, 1981); but for a radically different view see Norman Golb, *Who Wrote the Dead Sea Scrolls: The Search for the Secret of Qumran* (New York, 1995); see also Frank Moore Cross, *The Ancient Library of Qumran* (Minneapolis, 1995); Michael E. Stone, *Ancient Judaism: New Visions and View* (Grand Rapids, MI, 2011); the excellent Michael Wise, Martin Abegg and Edward Cook, *The Dead Sea Scrolls: A New Translation* (San Franciscso, 1996); Peter W. Flint and James C. VanderKam, *The Dead Sea Scrolls After Fifty Years: A Comprehensive Assessment* (Leiden, 1997). On the city itself there are wonderful recent books: Lee I. Levine, *Jerusalem: Portrait of the City in the Second Temple Period* (Philadelphia, 2002); Simon Goldhill, *Jerusalem: City of Longing* (Cambridge, MA, 2010) and *The Temple of Jerusalem* (London, 2004); and especially Simon Sebag-Montefiore, *Jerusalem: A Biography* (London, 2012). On the ossuaries: Pau Figueras, *Decorated Jewish Ossuaries* (Leiden, 1983); Eric M. Meyers, *Jewish Ossuaries: Reburial and Rebirth, Secondary Burials in their Ancient Near East Setting* (Rome, 1971); Rachel Hachlili, *Jewish Funerary Customs, Practices and Rites in the Second Temple Period* (Leiden, 2005).

Jews and early Christianity: For brilliant provocative readings and interpretations, Daniel Boyarin, *Border Lines: The Partition of Judeo-Christianity* (Philadelphia, 2007); also his *A Radical Jew: Paul and the Politics of Identity* (Berkeley, 1994). The great traditional authority on the parting of the ways is Jacob Neusner, see in particular, *Jews and Christians: The Myth of a Common Tradition* (Binghampton, NY, 2001). The opposite view is presented by Hyam Maccoby, *The Mythmaker: Paul and the Invention of Christianity* (London and New York, 1987). See also Peter Schäfer, *The Jewish Jesus: How Judaism and Christianity Shaped Each Other* (Princeton, 2012). On Ebionites and Jewish Christians, see Oskar

Skarsaune and Reidar Hvalvik (eds), *Jewish Believers in Jesus: The Early Centuries* (Peabody, MA, 2007); see also Geza Vermes, *The Religion of Jesus the Jew* (London, 1993). On the Mishnah see the fine introduction by Neusner to his superb *The Mishnah: A New Translation* (New Haven, 1988). Helpful explanation of the origination and ramification of rabbinic culture and its manifold commentaries can be found in Hyam Maccoby, *Early Rabbinic Writings* (Cambridge, 1988). On the Talmudic evolution, Talya Fishman, *Becoming the People of the Talmud: Oral Torah and Written Tradition* (Philadelphia, 2011), and, invaluably, Charlotte Elisheva Fonrabert and Martin S. Jaffee (eds), *The Cambridge Companion to the Talmud and Rabbinic Literature* (Cambridge, 2007). On the 'Augustinian dispensation' see the brilliant work by Paula Fredericksen, *Augustine and the Jews: A Christian Defense of Jews and Judaism* (New York, 2008). On the evolution of Jewish religious institutions and ritual, see the monumental, indispensable Lee I. Levine, *The Ancient Synagogue* (New Haven, 2005); Philip A. Harland, *Associations, Synagogues and Congregations* (Augsburg, 2003); the immensely suggestive Baruch Bokser, *The Origins of the Seder: The Passover Rite and Early Rabbinic Judaism* (Berkeley, 1984); Leonard Glick, *Marked in Your Flesh: Circumcision from Ancient Judea to Modern America* (Oxford, 2005); on the implications of sacrifice, the immensely persuasive David Biale, *Blood and Belief: The Circulation of a Symbol Between Jews and Christians* (Los Angeles and Berkeley, 2007).

Judaism and Islam: Bernard Lewis, *The Jews of Islam* (Princeton, 1984), is still the definitive, balanced survey of the relationship, especially at its beginnings; see also his *The Multiple Identities of the Middle East: 2000 Years of History from Christianity to the Present* (London, 1998). See also S. D. Goitein, *Jews and Arabs: A Concise History* (New York, 1955); and Eliyahu Ashtor, *The Jews of Moslem Spain* (Philadelphia, 1992). Bat Ye'Or, *The Dhimmi: Jews and Christians Under Islam* (Rutherford, NJ, 1985), is much more polemically pessimistic, but, all the same, in essentials, not altogether wrong. For many aspects of the complicated relationship, see Michael M. Laskier and Yaacov Lev, *The Convergence of Judaism and Islam: Religious, Scientific and Cultural Dimensions* (Gainsville, FL, 2011), and for a comparative reading, Mark Cohen, *Under Crescent and Cross: The Jews in the Middle Ages* (Princeton, 1994). On Jews and the beginnings of Islam see Fred Donner, *Muhammad*

and the Believers: At the Origin of Islam (Cambridge, MA, 2010), a lively work of scholarly synthesis that takes full account of the most recent scholarship. G. W. Bowersock's *Throne of Adulis: Red Sea Wars on the Eve of Islam* (Oxford, 2013) alas appeared too late for this book to take account of its new scholarship but see the articles (in endnotes) by C. Robin and Paul Yule, *Himyar: Spatantike im Jemen* (Aichwald, Esslingen, 2007) and Iwona Gajdar, *le royaume de Himyar a l'epoque monotheiste* (Paris, 2009), especially for her sceptical reservation, and Reuben Ahroni, *Yememite Jewry: Origins, Culture and Literature* (Bloomington, Ind., 1986). For the discovery of the Cairo Geniza see Peter Cole and Adina Hoffmann's wonderfully readable account, *Sacred Trash: The Lost and Found World of the Cairo Geniza* (London and New York, 2011). Shlomo Dov Goitein spent a scholarly lifetime exploring, editing, translating and interpreting the immense trove of the Geniza. His three-volume master work, *A Mediterranean Society* (Berkeley, 1967–93), has been helpfully and sensitively abridged (Berkeley, 1999) and is the perfect introduction to the subject. See also his wonderful *Letters of Medieval Jewish Traders* (Princeton, 1974), *From the Land of Sheba: Tales of the Jews of Yemen* (New York 1973) and *India Traders of the Middle Ages* (Leiden, 2008). For specific aspects of the world uncovered by the Geniza see his *Indian Traders*. For a post-Goitein survey see the articles collected in Stefan C. Reif, *The Cambridge Geniza Collections: Their Content and Significance* (Cambridge, 2002).

On the Hebrew poetry of medieval Spain there is an abundance of fine but varied translations, most of them with excellent critical commentaries and biographical notes. Peter Cole's *Dream of the Poem: Hebrew Poetry from Muslim and Christian Spain (950–1492)* (Princeton, 2007) covers the entire range from the earliest work of Dunash ibn Labrat (and his wife) through to work produced in Christian Spain not long before the expulsion, including generous selections from the work of the other two giants of Hebrew poetry, Solomon ibn Gabirol and Moshe ibn Ezra. See also the collection edited by Raymond Scheindlin, *Wine, Women and Death: Medieval Hebrew Poems on the Good Life* (Philadelphia, 1986). There is also an excellent – but very freely translated – selection in T. Carmi (ed.), *The Penguin Book of Hebrew Verse* (London and New York, 1981). Ross Brann, *Power in the Portrayal: Representations of Jews and Muslims*

in Eleventh and Twelfth Century Islamic Spain (Princeton, 2002), is a brilliant reading of the weave of inter-cultural influences and conflicts in this literature. On Shmuel Naghrela (Shmuel Hanagid), see Hillel Halkin, *Grand Things to Write a Poem On: A Verse Autobiography of Shmuel Hanagid* (Jerusalem 1999); for a different style of translation, see Leon J. Weinberger, *Jewish Prince in Moslem Spain: Selected poems of Samuel ibn Nagrela* (Tuscaloosa, AL, 1973). For Halevi, Halkin has written a short but inspiring and evocative biography, *Yehuda Halevi* (New York, 2010). On his pilgrimage, there are two very fine books: Raymond Scheindlin, *The Song of a Distant Dove: Judah Halevi's Pilgrimage* (Oxford, 2008), and Yosef Yahalom, *Yehuda Halevi: Poetry and Pilgrimage* (Jerusalem, 2009). On Maimonides, see the excellent biography by Joel Kraemer, *Moses Maimonides* (New York and London, 2008); and a well-chosen and -edited selection from the work by Isadore Twersky, *A Maimonides Reader* (Springfield, NJ, 1972).

Medieval Christian Europe and the Jews: On Judaism's evolution in this period see Ephraim Kanarfogel, *The Intellectual History and Rabbinic Culture of Medieval Ashkenaz* (Detroit, 2013); Lawrence Fine (ed.), *Judaism in Practice from the Middle Ages to the Early Modern Period* (Princeton, 2001). The most prolific scholar in this field of Judeo-Christian relations is Robert Chazan, who in a recent work, *Reassessing Jewish Life in Medieval Europe* (Cambridge, 2010), has called for a more balanced, less tragically determined account of the place and experience of Jewish life in Latin Christian Europe, thinking perhaps of the still readable history of Judeophobia by Joshua Trachtenberg, *The Devil and the Jews: The Medieval Conception of the Jew and Its Relation to Modern Anti-Semitism* (New Haven, 1944). For the definitive long history of the phenomenon see Robert Wistrich, *The Longest Hatred: Antisemitism and Jewish Identity* (London, 1991). See also Leonard Glick, *Abraham's Heirs: Jews and Christians in the Middle Ages* (Syracuse, 1999). For more recent, richly researched scholarship see Anna Sapir Abulafia, *Christian–Jewish Relations 1000–1300* (London and New York, 2011) and *Christians and Jews in Dispute: Disputational Literature and the Rise of Anti-Judaism in the West 1000–1150* (Aldershot, 1998). And for another comparative reading, David Nirenberg, *Communities of Violence: Persecution of Minorities in the*

Middle Ages (Princeton, 1996). And also the texts in Kenneth Stow, *Popes, Church and Jews in the Middle Ages: Confrontation and Response* (Aldershot and Burlington, VT, 2007). For an inescapably tragic moment see Chazan's *In the Year 1096: The First Crusade and the Jews* (Berkeley, 1996); *God, Humanity, and History: The Hebrew First Crusade Narratives* (Berkeley, 2000); and his *European Jewry in the First Crusade* (Berkeley, 1987). The texts of the narratives are collected and edited by Shlomo Eidelberg, *The Jews and the Crusaders: The Hebrew Chronicles of the First and Second Crusades* (Madison, WI, 1977). On the most grievous aspect of both literature and experience see Jeremy Cohen, *Sanctifying the Name of God: Jewish Martyrs and Jewish Memories of the First Crusade* (Philadelphia, 2004); also his *Living Letters of the Law: The Idea of the Jew in Medieval Christianity* (Berkeley, 1999). For Worms see the powerful centuries-long history by Nils Roehmer, *German City, Jewish Memory: The Story of Worms* (Waltham, MA, 2010). On Eleazar and the pietists see Ivan Marcus, *Piety and Society: The Jewish Pietists of Medieval Germany* (Leiden, 1997), and for France see the work of Susan Einbinder, in particular *Beautiful Death: Jewish Poetry and Martyrdom in Medieval France* (Princeton, 2002). For medieval England, Cecil Roth, *A History of the Jews of England* (London, 1964), is still valuable, but the great work of synthesis is Anthony Julius, *Trials of the Diaspora: A History of Anti-Semitism in England* (Oxford, 2010). Brilliant accounts of invariably depressing Judeophobic myths are Miri Rubin, *Gentile Tales: The Narrative Assault on Late Medieval Jews* (Philadelphia 1999), and Anthony Bale, *Feeling Persecuted: Christians, Jews and Images of Violence in the Middle Ages* (London, 2010). For the literary stereotypes, Marianne Ara Krummel, *Crafting Jewishness in Medieval England* (New York, 2011). And on social and economic history: Suzanne Bartlet, *Licoricia of Winchester* (London, 2009); Robin Mundill, *England's Jewish Solution: Experiment and Expulsion 1262–1290* (Cambridge, 1998) and *The King's Jews: Money, Massacre and Exodus in Medieval England* (London, 2010). For the history of Jewish women and families: Elisheva Baumgarrten, *Mothers and Children: Jewish Family Life in Medieval Europe* (Princeton, 2004); Simha Goldin, *Jewish Women in Europe in the Middle Ages: A Quiet Revolution* (Manchester, 2011); Avraham Grossman, *Pious and Rebellious: Jewish Women in Medieval Europe* (Waltham, MA, 2004); Susan Grossman and Rivka Haut (eds), *Daughters of the King: Women*

and the Synagogue: A Survey of History, Halakha and Contemporary Realities (Philadelphia, 1992); Ivan Marcus, *Rituals of Childhood* (New Haven, 1996).

Jewish art, architecture and manuscript illumination: The most stimulating interpreter of this extraordinary body of work is Marc Michael Epstein, *Dreams of Subversion in Medieval Jewish Art and Literature* (University Park, PA, 1997), and his *The Medieval Haggadah: Art, Narrative and Religious Imagination* (New Haven and London, 2013). See also Katrin Kogman-Appel, *Jewish Book Art Between Islam and Christianity: The Decoration of Hebrew Bibles in Medieval Spain* (Leiden and Boston, 2004), and her profoundly enlightening *A Mahzor from Worms: Art and Religion in a Medieval Jewish Community* (Cambridge, MA, 2012). For a comprehensive survey organised by subject, Thérèse and Mendel Metzger, *Jewish Life in the Middle Ages: Illuminated Hebrew Manuscripts of the Thirteenth to the Sixteenth Centuries* (New York and Fribourg, 1982). And there are helpful essays in Piet van Boxell and Sabine Arndt (eds), *Crossing Borders: Hebrew Manuscripts as a Meeting Place of Cultures* (Oxford, 2009), and in Vivian B. Mann, Thomas F. Glick and Jerillyn Dodds, *Convivencia: Jews, Muslims, and Christians in Medieval Spain* (New York, 1992). The catalogue raisonné of British holdings is Bezalel Narkiss, *Hebrew Illuminated Manuscripts in the British Isles* (Oxford, 1982). For architecture see C. H. Krinsky, *Synagogues of Europe: Architecture, History, Meaning* (New York and Cambridge, 1985).

Disputations, Persecutions and Expulsion in Spain: On the mostly ominous direction of Christian theology and preaching: Jeremy Cohen, *The Friars and the Jews: The Evolution of Medieval Anti-Judaism* (Ithaca, 1982); Hyam Maccoby, *Judaism on Trial: Jewish–Christian Disputations in the Middle Ages* (Rutherford, NJ, and London, 1982); Robert Chazan, *The Trial of the Talmud, Paris 1240* (Toronto, 2012). See also the mighty and still important work by Benzion Netanyahu, *The Origins of the Inquisition in Fifteenth Century Spain* (New York, 1995). The classic account of the denouement in Spain is Yitzhak Baer, *A History of the Jews in Christian Spain* (Philadelphia, 1982) but Cecil Roth, *Conversos, Inquisition and the Expulsion from Spain* (London and Madison, 1995) is still important, as is Henry Kamen, *The Spanish Inquisition: An Historical Revision* (New Haven, 1997). There is a

constantly challenging and richly researched account of both the background and aftermath of the expulsion in Yirmiyahu Yovel's *The Other Within: The Marranos – Split Identity and Emerging Modernity* (Princeton and Oxford, 2003); and also in the most powerful of Baer's students, Haim Beinart, *The Expulsion of the Jews from Spain* (trans. Jeffrey M. Green), (Oxford and Portland, OR, 2002). On the terrible unfolding of events in Portugal there is now a masterly and moving work, François Soyer, *The Persecution of the Jews and Muslims of Portugal: King Manuel I and the End of Religious Tolerance* (Leiden, 2007).

LIST OF ILLUSTRATIONS

The streets of Elephantine, courtesy of Oxford Film and Television Ltd

Khirbet Qeiyafa © Tim Kirby

Silver benediction amulet, courtesy of Israel Museum, Jerusalem/ The Bridgeman Art Library

Stone shrine from Khirbet Qeiyafa © Jim Hollander/epa/Corbis

Siloam inscription © Tim Kirby

Asherah statuettes © akg-images/Erich Lessing

Members of the Sinai survey, courtesy of Palestine Exploration Fund, London, UK/The Bridgeman Art Library

Plain of Er Rahah from the cleft on Ras Sufsafeh, courtesy of Palestine Exploration Fund, London, UK/The Bridgeman Art Library

Limestone ossuary with architectural decoration, courtesy of Israel Museum, Jerusalem/The Bridgeman Art Library

Ossuary belonging to high priest Caiaphas © Tim Kirby

Iraq al-Amir © akg-images/Gerard Degeorge

Ceramic candelabrum courtesy of Israel Museum, Jerusalem/Gift of Morris and Helen Nozatte through the Morris Nozatte Family Foundation/The Bridgeman Art Library

Hasmonean *pruta*, courtesy of Israel Museum, Jerusalem/The Bridgeman Art Library

Iraq al-Amir lion and cub © Tim Kirby

'Tomb of Zechariah' © akg-images/Gerard Degeorge

Arch of Titus © Tim Kirby

Fallen masonry from the Jerusalem Temple © Tim Kirby

Wall paintings from Dura-Europos synagogue, courtesy of National Museum of Damascus, Syria/Photos © Zev Radovan/The Bridgeman Art Library

Sepphoris mosaics depicting the months of Tevet and Nisan, courtesy

of Private Collection/Photos © Zev Radovan/The Bridgeman Art Library

Sepphoris mosaic depicting a menorah © akg-images/Bible Land Pictures

Painting of palm grove from Vigna Randanini © Araldo De Luca

Mosaic of a dolphin, courtesy of Brooklyn Museum of Art, New York, USA/Museum Collection Fund/The Bridgeman Art Library

Child's exercise book, T-S K5.13, reproduced permission of the Syndics of Cambridge University Library

Abu Zikri Kohen cheque, T-S Arabic 30.184, reproduced permission of the Syndics of Cambridge University Library

Jew of Bourges stained glass window © Sonia Halliday Photographs

Cartoon of Aaron © The National Archives

Chronica Roffense, courtesy of British Library, London, UK/The Bridgeman Art Library

Mishneh Torah of Maimonides, courtesy of Library of the Hungarian Academy of Sciences, Budapest/The Bridgeman Art Library

Birds' Head Haggadah, courtesy of The Israel Museum, Jerusalem/The Bridgeman Art Library

Title page from Moreh Neruchim by Maimonides, courtesy of The Art Archive/Bodleian Library Oxford

Dedicational inscription in El Transito Synagogue © akg-images/Bible Land Pictures

Mudejar stucco decoration in the El Transito Synagogue © akg-images/Bible Land Pictures

Santa Maria la Blanca Synagogue © akg-images/Album/Oronoz

Carpet page from the Kennicott Bible, courtesy of The Art Archive/Bodleian Library Oxford

Barcelona Haggadah, courtesy of The Art Archive/British Library

The Cervera Bible, courtesy of Instituto da Biblioteca Nacional, Lisbon, Portugal/Giraudon/The Bridgeman Art Library

'We were slaves in Egypt' illustration © The British Library Board (Add. 26957 f.39v)

'This is the Bread of Affliction' illustration © The British Library Board (Add. 26957 f.39)

Jonah and the 'Great Fish' illustration, Kennicott Bible, courtesy of The Art Archive/Bodleian Library Oxford

Menorah illustration, Kennicott Bible, courtesy of The Art Archive/Bodleian Library Oxford

ACKNOWLEDGEMENTS

An enterprise in two media incurs, correspondingly, twice as many debts and even more than is usual in such projects, I am deeply grateful to my colleagues at BBC Television for the kind, wise and unstinting support they have given to this story in all its aspects. Adam Kemp was the first to suggest it, then it was Martin Davidson and Janice Hadlow, Controller of BBC2, who commissioned the series and who have remained staunch, constructively critical mentors. Alan Yentob has been, from a tactful distance, a benevolent party to its achievemnent. Melissa Green, Suzanna McKenna and Mark Reynolds at BBC Worldwide have been believing supporters in every possible way. My television agent, Rosemary Scoular, with constant help from Wendy Millyard, to a degree that exceeds job description, has been as always my constant guardian angel.

The series was made for the BBC by my colleagues at Oxford Films and Television, a peerless gang who give new meaning to the affectionate term *mensch* (of whatever gender), above all my dear friend and creative partner, Nick Kent, without whom this series would have been unthinkable and impossible and who perforce shared all its agonies and ecstasies, Jewishly magnified, as did Charlotte Sacher, whose wise and penetrating research, elegant editing and sustaining enthusiasm has been the life blood of the project. Tim Kirby brought to the task of Series Producer (and director of three of its programmes) a discriminating intelligence, an immense sympathy for the subject, and superhuman stamina, especially when faced with unexpected turns of events. I am grateful to so many others on our team, especially to Julia Mair for serious research, on-location cheer and wise counsel, and to Kate Edwards for triumphing over the challenge of seeing me through all five films and doing much beyond the call of duty, not least reading grippingly the stories of I. L.

Peretz from the back of a car along the fog-shrouded, deeply rutted roads of the Ukraine. My thanks also to the crew of nonpareil Jeremy Pollard, Ariel Grandoli and Anthony Burke, and to the kind vigilance of Jenny Thompson, Annie Lee and Arianwen Flores Jackson. In post-production Hannah Cassavetti was her own particular marvel. Sam Baum and Josh Baum applied their own brand of genius to scribal writing and animation, and Avshalom Caspi, our composer, and Clara Sanabras, our vocalist, became friends as well as vital collaborators.

As usual, my literary agents Michael Sissons and Caroline Michel have been marvels of sustaining wisdom and enthusiasm, believing from the beginning that there would be a receptive public for this work. They have heroically Taken the Strain, especially as the book exploded beyond its original remit as a single volume, as did my publisher Stuart Williams of Bodley Head who could be forgiven for thinking of the book as OverJew. I am grateful to him and to Gail Rebuck of Penguin Random House for finding ways to adapt to an unanticipated plan of publication. At Bodley Head, the book could not have seen the light of day without heroic work from my editor David Milner, copy-editor Katherine Fry, Katherine Ailes (for many tasks), Caroline Wood for picture research, Anna Cowling for kindness and expeditious flexibility in production, proofreaders Sally Sargeant and Ilsa Yardley, and indexer Douglas Matthews. Rowena Skelton-Wallace, Natalie Wall and Kay Peddle have also heroically helped to make the impossible achievable.

For research help on the biblical period and Jewish antiquity, I should like to thank Ester Murdakayeva, and for being my indispensable assistant in pretty much everything inside the libraries and out, Jennifer Sonntag. Provost John Coatsworth was kind enough to grant me the leave from my duties at Columbia University to make filming and writing possible. And I owe it to my late, deeply missed colleague Yosef Yerushalmi, for keeping the flame of Jewish history alive in me in so many ways – his profound and beautiful meditation *Zakhor* remains at the core of my own historiographical preoccupations. Many other scholars, curators, writers and pals have been unstintingly generous with their counsel, before and during filming and writing, especially Rabbi Julia Neuberger, Felicity Cobbing at the Palestine Exploration Fund, Micha Bar-Am and Pnina Shor at the Israel Museum Dead Sea Scrolls Project, Michal Friedlander at the Jewish Historical

Museum in Berlin, Professor Bezalel Porten for a critical reading of the Elephantine chapter, Katya Krausova who was kind enough to share her deep knowledge and photographs of precious sites in eastern Europe, Haim Admor who was my link to the Beta Israel community, and to the wonderful Aviva Rahimi for her unique exodus narrative from Ethiopia to Israel.

This would all have been unrealisable without the generous support of so many dear friends who became accustomed over the years to the low music of my kvetching, as well as my half-articulated notions about Jewish history. To Alice Sherwood I owe a special debt for her constant enthusiasm, critical wisdom and deep belief in the importance of the enterprise. Thanks also to Chloe Aridjis, Clemency Burton Hill, Jan Dalley, Lisa Dwan, Celina Fox, Helene Hayman, Julia Hobsbawm, Elena Narozanski, Caterina Pizzigoni, Danny Rubinstein, Robert and Jill Slotover, Stella Tillyard, Leon Wieseltier and Robert Wistrich.

Chloe, Mike and Gabriel have borne with all the highs and lows they are accustomed to from the author, but it is my wife Ginny who has my deepest gratitude for coping with mood swings of even more dramatic extremes than usual and with the prolonged absences that came with the filming and post-production of the series, and who has done so with her usual, boundless reserves of patience, generosity and love. The two real authors of my Jewish history, my mother and father, are no longer in this world, but something tells me I shall hear from them on the subject in the next.

INDEX